AMERICAN
DRAWINGS AND
WATERCOLORS

AMERICAN DRAWINGS AND WATERCOLORS

IN THE MUSEUM OF ART, CARNEGIE INSTITUTE

Introduction by
HENRY ADAMS

Contributions by
HENRY ADAMS
JOHN CALDWELL
JOHN R. LANE
KENNETH NEAL
ELIZABETH A. PRELINGER

Pittsburgh, Pennsylvania
1985

Distributed by the University of Pittsburgh Press

Publication of this catalogue was made possible by grants from the National Endowment for the Humanities and The Foster Charitable Trust.

Edited by Kate Maloy
Designed by Frank Garrity Graphic Design
Printed and bound in Great Britain by Balding + Mansell Limited

Library of Congress Cataloging in Publication Data

Carnegie Institute. Museum of Art.
American drawings and watercolors in the Museum of Art,
Carnegie Institute.

Includes bibliographies and index.
1. Watercolor painting, American—Catalogs. 2. Watercolor painting—
Pennsylvania—Pittsburgh—Catalogs. 3. Drawing, American—Catalogs.
4. Drawing—Pennsylvania—Pittsburgh—Catalogs. 5. Carnegie Institute.
Museum of Art—Catalogs. I. Adams, Henry, 1949– . II. Title.
ND1805.C37 1985 741.973'074'014886 85-2984

ISBN 0-88039-009-3

Cover: Winslow Homer, *Figures on the Coast*, 1883

CONTENTS

FOREWORD

CARNEGIE Institute acquired the first American drawing in its collection eighty-one years ago. This was a particularly fine Winslow Homer, and at the very outset its purchase set high standards for the future development of the collection. During the eight decades since this initial acquisition, the Museum of Art has quietly amassed nearly five hundred drawings and watercolors by American artists, a holding that is among the remarkable ones of its kind. Yet since 1920 the existence of this collection has scarcely been known even to American art specialists.

The Museum of Art owes a great debt to Henry Adams, curator of fine arts from 1982 through 1984, who was the first art historian to recognize the richness of this collection, to identify its potential importance for the history of both American culture and American art, and to rediscover the fascinating story of its early growth. In an exhibition entitled *Masterpieces of American Drawing and Watercolor*, held at the museum in the winter of 1983, and in an accompanying article in the January/February 1983 issue of *Carnegie Magazine*, Dr. Adams presented his preliminary research findings. These were so promising that he and the museum were straightaway encouraged to undertake publication of the complete collection so that it might become a widely known and utilized resource.

We are grateful to many individuals for their contributions to the preparation of this catalogue: to Dr. Adams for the exceptional leadership he gave to the scholarly dimensions of the project both as general editor and as author of many entries and an introduction that interprets the development of the collection in its cultural context and also adds thoughtfully to the literature on the history of American draftsmanship; to the other authors who contributed texts—John Caldwell, the museum's curator of contemporary art, Elizabeth Prelinger, formerly assistant curator of fine arts, and Kenneth Neal, an extremely capable advanced graduate student at the University of Pittsburgh; to Suzanne Tise and James Weiss for preliminary research; to Marianne Berardi, Rita Cunningham, Lauretta Dimmick, Britta Dwyer, Lynn Ferrillo, Mr. Neal, and Rina Youngner, students who wrote draft entries in a seminar on American drawings that Dr. Adams offered at the University of Pittsburgh; to Janet Marstine for her significant help as a research volunteer; to Ms. Prelinger, Katherine Chan, Susan Higman, and Ms. Berardi for their exhaustive efforts in preparing the checklist; and to Wanda M. Corn, associate professor of art history at Stanford University, and Jan K. Muhlert, director of the Amon Carter Museum in Fort Worth, Texas, for critically reviewing the manuscript.

Barbara L. Phillips, the museum's assistant director for administration and its head of publications, directed the production of the book with uncommon care and concern for its quality. She was ably seconded by Marcia Thompson, publications assistant, Kate Maloy, editor, and Frank Garrity, designer, Tom Barr, photographer, and by Patricia Curtis, Heather Horan, Christine Reusch, Bridgit Schwalm, Lynn Sloneker, Eleanor Vuilleumier, and the museum's workshop staff. Balding + Mansell Limited worked closely with the museum to realize in print Mr. Garrity's design concept, which, while contemporary, is particularly sensitive to the look of the turn-of-the-century illustrated magazines that provided a forum for many of the artists represented in the collection.

The intensive examination of the drawings and watercolors that the cataloguing project required provided an excellent opportunity to assess the state of preservation of the collection. Karen B. Crenshaw, the museum's former conservator, conceived and guided a major treatment program that significantly improved the condition and appearance of many works and established priorities for future work. This was accomplished with grants from the National Endowment for the Arts, the Institute of Museum Services, and the Pennsylvania Council on the Arts, with matching funds from the museum's John Henry Craner Fund.

This catalogue was published with the aid of a substantial grant from the National Endowment for the Humanities, where Gabriel P. Weisberg, director of the endowment's museum program, gave valued counsel and continuous encouragement. Preliminary research funds were provided by the Pennsylvania Council on the Arts.

A generous grant from The Foster Charitable Trust has contributed significantly to the realization of this catalogue and to an accompanying exhibition of works from the collection that will be shown at the Museum of Art in the spring of 1985, followed in 1986 by a national tour that was suggested by and will begin at the Amon Carter Museum in Fort Worth, Texas. We are especially grateful to Milton Porter, a trustee of Carnegie Institute and of The Foster Charitable Trust, for his interest in the museum's American drawings and watercolors in general and this publication and its complementary exhibition in particular. The museum also gratefully acknowledges the general support of its exhibition and publications programs received from the Howard Heinz Endowment and the Pennsylvania Council on the Arts.

1985 is the 150th anniversary of the birth of Andrew Carnegie in Dunfermline, a suburb of Edinburgh, Scotland. The Museum of Art, Carnegie Institute's collecting activity in the area of American drawings and watercolors was begun with Carnegie's funds by the man he personally appointed as the museum's first director, John Beatty. In both process and product the early portion of the collection reflects in a most fascinating way our founder's positivist philosophy. This catalogue is one element in Carnegie Institute's sesquicentennial celebration of Andrew Carnegie's birth, and it is especially fitting that the accompanying exhibition, in addition to its American tour, will be seen at the 1985 Edinburgh International Festival. There it will represent Carnegie Institute in a series of Pittsburgh–Edinburgh cultural events honoring Andrew Carnegie's philanthropic leadership.

We thank all those individuals who—past or present, as donors or as directors and curators—have contributed instrumentally to the development and stewardship of this collection. It is a particular pleasure to mention the names of John Beatty, Sadakichi Hartmann, Edward Duff Balken, Gordon Washburn, Mr. and Mrs. James H. Beal, Leon A. Arkus, Edith H. Fisher, Gene Baro, and Oswaldo Rodriquez Roque, as well as Henry Adams.

John R. Lane
Director

INTRODUCTION

CARNEGIE Institute began collecting American drawings in 1904, eight years after it opened its doors. Just three years later, in 1907, the painter John Sloan, who found nothing noteworthy about the paintings displayed in the building, was impressed by "the collection of drawings by American artists," particularly two striking illustrations by William Glackens and three works by Winslow Homer that he described as "very fine."[1]

Despite this strong and early start, however, the collection of American drawings has not become well known, even to specialists in the American field. Given the quality of the collection this might seem surprising. It contains a number of works, by such draftsmen as Winslow Homer, David Blythe, Ralph Blakelock, and William Glackens, as well as several more recent figures, that stand among these artists' finest works on paper and, indeed, rank among the best American drawings ever made. Not many American museums—even much larger ones than Carnegie Institute—own a collection of American drawings equally fine.[2]

To an unusual degree, however, the appreciation and growth of the collection has been altered, troubled, and impeded by shifting standards of taste. In fact, a glance at a chronological list of accessions reveals that the museum's holdings of American works on paper should be considered as two quite distinct collections separated by a gap of more than thirty years. The first began in 1904, when the museum acquired its first American drawing, Winslow Homer's *Figures on the Coast*. Under the auspices of the first director of fine arts, John Beatty, it grew to contain nearly two hundred items by 1922. From that date, however, the year of Beatty's retirement, no more American drawings were acquired with museum funds until 1954. Then a new director of fine arts, Gordon Bailey Washburn, with his assistant director, Leon Arkus, again began to collect them, a process that has continued without interruption up to the present. These two collections have been formed on radically different lines, the first reflecting a nineteenth-century sensibility, the second a modernist aesthetic.

John Beatty, who started the collection of American drawings, developed his artistic taste when he studied painting at the Royal Academy in Munich in the 1870s. Although he held some progressive views, he believed strongly in the academic tradition. He valued works both of technical virtuosity and of delicately evoked mood; but he had little sympathy for what must have seemed to him the raw, aggressive accomplishments of modern art. In the 1950s, when Washburn and Arkus started collecting, modernism had triumphed, and Beatty's standards seemed completely out of date.

In the years after 1950 some of the finest items came into the museum, particularly modernist works by such artists as Maurice Prendergast, Joseph Stella, Morgan Russell, Franz Kline, and David Smith. At this time, however, the carefully considered selections of Beatty's period were given little attention. Only a decade or so ago, in fact, a proposal was put forward to deaccession a sizable portion of the early drawings collection, although fortunately this plan was never actually carried out.[3]

What makes the collection of the Museum of Art, Carnegie Institute particularly fascinating is that the standards of taste that guided its creation are documented in remarkable detail. The collection was started in a manner that was probably unique for its period. In 1906 John Beatty and his consultant Sadakichi Hartmann, the well-known writer on American art, began expressly to create "a representative collection" of American drawings—that is to say, one that would provide a balanced picture of the development and progress of American draftsmanship.[4] The two developed the collection systematically, from lists they had compiled of the most significant American artists, both living and dead. Other American museums had begun to collect American drawings by this date, but their efforts were haphazard, and none had such clearly defined historical goals.

Consequently, no other collection of American drawings so fully opens to scrutiny the aesthetic standards, aspirations, and prejudices of the early twentieth century and the manner in which these values were later altered, undermined, and attacked. In the field of American drawings, which has been studied surprisingly little, and in which standards of historical importance and aesthetic quality are emerging only gradually, to review this process of changing taste is more than a historical exercise. To discover and evaluate the principles that guided collectors in the past may help to identify both the key movements in the development of American draftsmanship and the issues on which the debate about quality has centered. Carnegie Institute's collection of American drawings challenges us to reassess and to some extent reevaluate many of our current notions about the development of American art.

Why did Carnegie Institute begin collecting American drawings? What standards of quality did it apply? How did taste shift over the years? How should these conflicting standards of taste affect our current approach to the study of American draftsmanship?

These are the issues this essay will address, but to confront them requires a review of the formation of Carnegie Institute and its relation to the smoky city of Pittsburgh. For the collection of American drawings grew directly from Andrew Carnegie's idealistic framework for his institute as a whole, a framework that reflected ideas about the visual arts far less than a vision of cultural progress modeled on the growth of American industry.

ANDREW CARNEGIE'S VISION

Strategically located on three rivers, near fields of coal and other sources of raw materials and fuel, Pittsburgh had emerged by the end of the nineteenth century as the nation's most productive industrial city: the leading producer of glass, steel, and industrial machinery; a major distribution center for coal and natural gas; and the locus for the creation of a host of new industries, such as canned food (H. J. Heinz Company), plate glass (Pittsburgh Plate Glass Company, now PPG Industries), aluminum (Aluminum Company of America), alternating electric current (Westinghouse Electric), and oil (Gulf Oil). As late as the 1890s, however, Pittsburgh still lacked even the pretension of cultural refinement. Blackened with smoke from its mills, largely working class in population, it continued to be a cultural wasteland long after it had emerged as an industrial stronghold.[5] In 1895 and 1896, with the creation

of Carnegie Institute, a combination of library, music hall, natural history museum, and gallery of fine arts, Andrew Carnegie set out to reverse this condition. Using techniques similar to those that had brought him economic success, he sought to create a cultural conglomerate analogous to the industrial conglomerates he had built up in the steel industry.

Andrew Carnegie himself did not develop new products or inventions. His gift was for consolidation and unification, for merging the disorganized, competing energies of industrial production into a single harmonious entity. Carnegie started as a bobbin-boy in a cotton factory, worked his way up to telegraph clerk and operator, and then served as secretary and assistant to the president of the Pennsylvania Railroad. In this position his gifts for large-scale organization became apparent. Recognizing the role that steel would play in the construction of railroads, bridges, and buildings, Carnegie gradually gained control of the immensely profitable Keystone Bridge Works. He then expanded his empire until, by 1885, he controlled steel mills, tributary coal and iron fields, a railroad 425 miles long, and a lake line of steamships. Due partly to his skill at selecting dedicated, capable managers and partly to his willingness to employ the latest manufacturing methods, such as the Bessemer steel-making process, production soared to previously unheard-of levels. After the forceful suppression of the bloody Homestead strike of 1892, an action that kept wages low for decades, and thanks in part to favorable tariff legislation, Carnegie's interests prospered. When he sold out his holdings in 1901 to devote himself entirely to his philanthropic interests, he had assembled the largest corporation the world had ever known, the first with assets over one billion dollars.[6]

Unlike other Pittsburgh multi-millionaires who founded art museums (for example, Andrew W. Mellon and Henry Clay Frick), Carnegie was not a collector. His most prized painting, which hung in his bedroom, was one he valued purely for its subject—a portrait of Captain Bill Jones, the madly driven booster of production quotas, who had died in an explosion while working beside his men to clear a blocked stack at the Edgar Thomson works.[7] The Museum of Art, in fact, was a later addition to Carnegie Institute, which opened first as a library and music hall and was expanded in the following year to include galleries for natural history and art. Remarkably, Carnegie himself seems to have played virtually no role in determining the art museum's purchases. Instead, as he did in industry, he provided the money and the managers required to accomplish the job.

Carnegie was interested in art not for itself but as a manifestation of cultural development and progress. The acquisitions policy he gave the museum reflected no particular standard of artistic taste, but it did manifest a distinctive cultural vision. From its inception, the Museum of Art (originally called the Department of Fine Arts) centered on the annual—or at times biannual—International exhibition of contemporary art.

Carnegie initially proposed that the museum should acquire the finest painting in each International and then hang the purchased works in chronological sequence. In actual fact this idea was never very consistently carried out, partly because of the expense, partly because the prize-winning works were not always for sale, partly because the prize structure and jury selection of the Internationals went through continual

changes, and partly because the taste of the jury of artists often favored works with advanced stylistic tendencies that proved unacceptable to the trustees of the museum. The fine arts collection began, however, with Winslow Homer's *The Wreck* (1896), winner of the Chronological Medal at the first International, and for the first half-century of the museum's existence nearly every major painting acquired for its collection either won a prize in the International or was exhibited there.[8]

Carnegie, who had shifted industrial dominance from Europe to America, attempted through Carnegie Institute to bring about a similar shift in cultural affairs, and to make Pittsburgh, a city without any previous claim to artistic distinction, an internationally known showplace and center for art, music, literature, and science.

While built around an ostensibly international exhibition, Carnegie Institute most strongly supported American art. The unspoken goal of the International, in fact, seems to have been to demonstrate that American artists had finally attained a level of accomplishment that made it possible to show their work without embarassment beside that of their European contemporaries. Consequently, the first two purchases for the museum's collection were American works: Winslow Homer's *The Wreck* (1896) and James McNeill Whistler's *Arrangement in Black: Portrait of Pablo de Sarasate* (1884). Implicit in Carnegie Institute's favoritism towards American art was the expectation that the United States would soon assume leadership in the world of art.

Besides favoring American art, the museum, although controlled by the prosperous elite, tended to collect work that would appeal to the predominantly working-class population of Pittsburgh. Consequently, it preferred didactic, moralizing works. Henry Clay Frick, for example, gave none of his extraordinary old masters to Carnegie Institute, saving them instead for the more sophisticated audience of New York. He did, however, donate a bizarre specimen of nineteenth-century religious art, Pascal Dagnan-Bouveret's *Christ at Emmaus* (1897). Doubtless he hoped that it would encourage Christian virtue in the home as well as Christian productivity in the workplace. Even the purchase of a work of such genuine artistic quality as Homer's *The Wreck* should be viewed partly in this light, for the painting served to encourage values of heroism and self-sacrifice similar to those endorsed by the Carnegie Medal for Heroism, which was established at about the same time.[9]

Significantly, although Carnegie could easily have appointed an eminent European to serve as director of fine arts, he selected instead a Pittsburgh native, John Beatty, an individual whom he felt would be more responsive to local needs.[10] The museum, in fact, led the nation in developing art programs for local schools and in bringing schoolchildren to the museum. Beatty noted proudly that "the influence of the permanent gallery and the annual exhibition . . . has been more noted among the great mass of people than with the few whose wealth and education had given them opportunities for previous cultivation of taste and knowledge."[11]

In its virtually exclusive concentration on contemporary art, Carnegie Institute played a unique role for its period. Until the creation of The Museum of Modern Art in New York in 1929, and the Whitney Biennial in the 1930s, the annual International exhibition of Carnegie Institute served as the chief forum for contemporary art in the United States. This is not to say, however, that Carnegie Institute always proved responsive

to the most exciting and significant developments in modern painting. Unlike The Museum of Modern Art, which was formed when the modern movement had been under way for many years and was guided by a clear understanding of modernism's tenets, Carnegie Institute was based on nineteenth-century ideals and beliefs.

The trustees of Carnegie Institute believed in progress in art, to be sure, just as they believed in progress in manufacturing processes. In the early years of the International, for example, their purchases strongly favored both Tonalist- and Impressionist-influenced work. These two modes of painting represented a quasi-scientific "advance" over previous styles of representation and could be viewed as outgrowths of a more refined and sophisticated understanding of the processes of vision. They found it more difficult, however, to accept radically abstract styles, such as Cubism, which challenged basic conventions of representation and indeed of rationality. Respectful of those who had gained eminence in the art world through politicking and hard work, and suspicious of eccentricity, rebellion, and anything tainted with political radicalism, they saw much of modern art as an attempt at fraud. No doubt John Beatty reflected their views when he declared of modernist art, in a newspaper interview in 1913, "Nowhere did I discover that this so-called school of art is taken seriously by painters who have established reputations. It seems to be considered a passing fad."[12]

JOHN BEATTY, SADAKICHI HARTMANN, AND THE FIRST COLLECTION OF DRAWINGS

In many respects the museum's collection of drawings followed the form of its collection of paintings, concentrating chiefly on works by living artists. Even the first artist included in the collection of paintings, Winslow Homer, was also singled out to be the first represented in the collection of drawings. There were significant differences, however, in the development of the two collections.

The collection of paintings, though it favored American artists, also included European works. The collection of drawings, on the other hand, remained strictly American, in part, perhaps, because American drawings were more available and less expensive. The collection of paintings was acquired gradually, by steady increments. The early collection of drawings, on the other hand, was largely created in a very brief time. A large portion of it came into the museum in a single year, 1906, with money that was left over from the purchase of plaster casts.[13] Finally, the acquisition of paintings for the collection was politically complex; each decision involved several groups with conflicting views, such as the jury of the International, the board of trustees, the staff of the museum, and sometimes outside donors. The collection of drawings, on the other hand, was put together with such modest sums that the director of fine arts exercised virtually complete control over the choice of works. The trustees apparently played no significant role. Thus the collection reflected almost exclusively the judgment and preferences of John Beatty and of his deputy, Sadakichi Hartmann, whom he hired as an assistant and consultant.

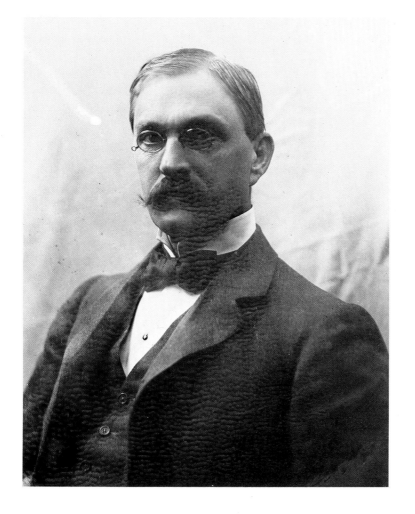

John Beatty c. 1900

Beatty and Hartmann formed an odd team. Beatty, a local boy who had been born in Pittsburgh in 1851, exemplified social propriety. Solidly built, an avid golfer and fisherman, he was also affable, comfortable in clubs and in temperament completely at ease with the financial barons of Pittsburgh. "At a glance one would never take Mr. Beatty for an artist," a writer for the *Pittsburgh Press* noted approvingly. "A satisfied businessman is the impression one gets."[14]

Brought up in a devout Methodist family, as his middle name of Wesley suggests, Beatty was introduced to art by the local "Scalp Level" group of landscape painters, who found him tactful, courteous, and receptive to the opinions of his elders.[15] In 1876 he went to study at the Royal Academy in Munich, but family obligations cut short his stay. He returned home the following year and supported himself by sketching events in Pittsburgh for local and national publications, supplementing his income with part-time jobs that included silver engraving. In 1887 Beatty assumed direction of the Pittsburgh Art School, and, soon after, he further demonstrated his administrative talent by organizing art exhibitions, including one that accompanied the opening of Carnegie

Library of Pittsburgh. In 1896 Andrew Carnegie appointed Beatty to establish and direct a department of fine arts for Carnegie Institute, and in this capacity he organized and established the administrative framework for the first of the Carnegie International exhibitions.

Beatty spent much of each year traveling in Europe to make arrangements for this show, but his association with celebrated foreign artists does not seem to have gone to his head. He remained attached to the locale of his boyhood and continued to paint in his free time, concentrating on Pennsylvania farm scenes. Those who visited his office were impressed by the absence of artistic affectation. As the journalist for the *Pittsburgh Press* observed:

> His quarters in the Carnegie Institute are not indicative of an artist either. A bronze bust stands on the desk, an etching done by himself and a photograph decorate the walls, one or two periodicals are lying around on the table, and that's about all. No easels, canvases, or unfinished sketches. No costumes, curios, models and the like trappings of an artist's studio.[16]

Lean, gangling Sadakichi Hartmann stood out as a more exotic specimen than Beatty. Ezra Pound, entranced by his eccentric style, once declared: "If one had not been oneself it wd have been worthwhile being Sadakichi."[17] Thirty-seven years old in 1904, sixteen years younger than Beatty, Hartmann was born in Nagasaki, the son of a German merchant and a Japanese prostitute. After his mother's death he was raised in a series of households and schools, first in Germany and then in the United States. He set off on his own while still in his teens, supporting himself with menial work for printers and photographers. He also studied painting in a desultory fashion and produced journalistic squibs for newspapers in Philadelphia, Boston, and New York. In 1893 he moved to Boston for a brief time and launched his own art and literary magazine, *The Art Critic*. This venture folded, however, when Hartmann was jailed on obscenity charges for publishing his first play, *Christ*, based on Oscar Wilde's *Salome*.

After this fiasco, Hartmann moved to New York, where he provided sustenance for his successive wives and numerous children by producing vast quantities of art criticism, not only under his own name but under a variety of pseudonyms ranging from the respectable "Sidney Allan" to the irresponsible "Caliban," and including such noms de plume as "Chrysanthemum," "Hogarth," "Juvenal," and "A. Chameleon." Among other ventures, Hartmann served as the most prolific contributor to Alfred Stieglitz's famous journal, *Camera Work*, and labored as art critic for Richard Hovey's *The Daily Tatler*, the only daily literary magazine ever published in this country, which lasted just thirteen days before the staff collapsed in exhaustion. Hartmann also wrote several popular books, including *Shakespeare in Art* (1901) and *Japanese Art* (1903), each completed in less than a month, and *A History of American Art* (1901), which he assembled in cut-and-paste fashion from earlier critical articles and reviews. His prose was lush in the fin de siècle manner, but he wrote sympathetically about a great range of artistic tendencies, including new directions like Cubism and the artistic photography of Alfred Stieglitz. Hartmann also lectured extensively around the country on artistic

Sadakichi Hartmann c. 1896
Photograph by J. C. Strauss,
courtesy Wistaria H. Linton
Collection, University of
California, Riverside

matters, despite a speech defect that rendered him all but unintelligible.

Beatty, an artist but not a scholar, turned to Hartmann because of his credentials as an art historian. Hartmann, in *A History of American Art*, had made the first attempt to survey American painting since Samuel Benjamin's effort of more than twenty years earlier. In many respects the

volume reveals the obvious haste of its composition, being filled with misspelled names (for example, "Rienhart" rather than "Reinhart"), incorrect facts (that Winslow Homer started his career in Buffalo), and strange omissions (the inclusion of Louis Glackens but not his more significant brother, William).[18] For all that, Hartmann was far more cosmopolitan in taste and education than any previous writer on American painting, and he attempted not merely to chronicle facts but to promote an aesthetic point of view—one that favored an emphasis on mood, expression, and evocation rather than on narrative content and realistic transcription. To a remarkable degree, Hartmann's history explicates the aesthetic attitudes that guided the creation of Carnegie Institute's collection of American drawings: for that reason, several entries in this catalogue quote from it. Sometimes, indeed, Hartmann's book singled out for attention one of the very works that he later selected for the museum's collection.

The formal agreement that Beatty and Hartmann signed on May 5, 1906, was composed with the precision of a legal contract. Hartmann agreed to ferret out drawings by artists on a list supplied by John Beatty and to forward these works to Carnegie Institute, where Beatty would make the final decision as to what the museum purchased. For his efforts Hartmann would receive ten percent of the money spent. It is not clear whether Beatty compiled his lists of artists himself or in consultation with Hartmann.[19] In any case, he willingly followed Hartmann's suggestions about making changes. For example, Hartmann wrote to Beatty on July 1, "I added a number of good draughtsmen, notably Gibson, Frost, Shirlaw, Remington, Sterner, Brennan, Glackens, Dodge, Shinn, McCarter, Birch, Verbeck, Newmann, etc."[20] Beatty eventually purchased drawings by all these men, with the single exception of Verbeck. In addition to acquiring drawings through Hartmann, Beatty also turned up several significant works by sending a form letter to a number of well-known American artists or their widows, requesting that they submit drawings for consideration.

Beatty's lists included many artists from the past, some of them long dead, such as Copley, West, Trumbull, and Allston. Hartmann, however, did not obtain drawings by any of these figures, whether because his own contacts were chiefly with living artists or because no market existed at the time for historical American drawings. "Excepting for John Trumbull I have not yet succeeded in getting hold of drawings of any of the early men," Hartmann wrote. "They need special canvassing, and I would like to devote four weeks entirely to them as soon as the first lot has been disposed of. I am on the track of most of them."[21] Whatever track Hartmann was pursuing, however, seems to have led to a dead end. He did not even find a drawing by Trumbull. "The Alfred Trumbull collection was scattered directly after Mr. Trumbull's death," he wrote a few months later. "I have this from one of his intimate friends, so there is nothing to be gotten from that source."[22] Only three or four of the drawings Beatty obtained as director were more than a decade or two old. The earliest, a Joshua Shaw sketch of Pittsburgh made about 1825, was not a purchase but a donation to the museum. In 1922 the museum was finally given a drawing by John Trumbull but, sadly, recent investigation has demonstrated that it is a fake.[23]

With living artists, Hartmann had better luck, although here too he experienced difficulties. He wrote to Beatty:

> The following painters claim that they are not in the habit of making drawings: Vinton, Bensen, Eakins, Duveneck, Ryder, Waterman & Dielman.
>
> George Inness has left no drawings except water color sketches that are owned by the family and not for sale.
>
> Horatio Walker, according to Montross, "does not care to *submit* any drawings;" and La Farge is of the opinion "that the Institute should buy one of his paintings, that he would be better represented by it."
>
> C. H. Davis is in Europe, and Colman, Tarbell, Currier and Msr. Wyant could not be reached, probably for similar reasons.
>
> Chase will make a drawing specially for the purpose during the summer. Tryon won't be able to submit any drawings before next winter.[24]

Of the artists Hartmann mentions here, the museum eventually acquired works by Davis, Dielman, Tryon, and La Farge, the last after the artist's death. Beatty never did, however, acquire works by the other figures, and no more was heard about the drawing that William Merritt Chase intended to make that summer.

Beatty's and Hartmann's agreement authorized Hartmann to approach "living artists, or the representatives of deceased artists, or the owners of drawings by deceased artists."[25] In other words, he was to obtain the works of living artists directly from them. Hartmann paid little heed to these strictures, however, and also solicited works by living artists from the magazines to which they had contributed. He wrote to Beatty,

> I have carefully gone through all the drawings that are in the possession of Scribner's Sons and the Century Co., and have selected the best I could find. They do not all come up to the standard, but I am certain that there are quite a number among them that will prove available. In dealing with these two houses I have succeeded in getting very reasonable prices.[26]

Not surprisingly, Hartmann's methods caused hard feelings among some of the artists he had neglected to approach directly. William Glackens, for example, wrote to Beatty in November 1906 to express his distress that Carnegie Institute had purchased drawings "that were probably gotten from some magazine." He added, "I am sure you will agree with me that Mr. Hartmann, who I believe made the collection, should have consulted me. I should certainly have preferred to make my own selection as to what drawings to send out."[27]

Whatever frictions it may have caused, however, this recourse to the magazines led to some of Beatty's best acquisitions, among them three stunning drawings by Glackens that stand among his finest works and that, as noted earlier, attracted the delighted admiration of John Sloan in the very year of their purchase. Moreover, the prices, as Hartmann had promised, were indeed extremely reasonable. For example, Beatty purchased eighteen illustrations from the Century Company for an average of less than twenty-three dollars an item. The lot included four

Winslow Homers, two Remingtons, a portrait by John White Alexander of the novelist Frank Stockton, and a western landscape by Thomas Moran.

Except for the magazines, there seem to have been few purchasers for American drawings during this period; consequently, prices were difficult to set and varied greatly. *Collier's*, for example, asked two thousand dollars for a Remington drawing,[28] which is probably about what the magazine paid for it, while *The Century* asked only fifteen and twenty-five dollars respectively for the two unusually fine Remingtons that Carnegie Institute purchased. Beatty seems chiefly to have exercised his ingenuity not in reevaluating Hartmann's connoisseurship but in devising ways to obtain drawings for the least possible cost.

Given a choice between two comparable works, he invariably chose the less expensive. In retrospect, this sometimes resulted in a compromise in quality; frequently it did not. The widow of Eastman Johnson, for example, offered Carnegie Institute four drawings by her late husband, priced between five hundred and one hundred fifty dollars. Beatty chose *My Jew Boy*, for which she had asked the least, but offered her only seventy-five dollars, half her asking price. After some consideration she accepted.[29] Similarly, in purchasing works from the widow of Felix Darley, Beatty rejected the costly items and eventually settled on a single wash drawing for which, again, he paid only a fraction of the requested sum.[30] Sometimes, as with Howard Pyle's illustrations for *Otto of the Silver Hand*, Beatty saved money by purchasing only one of an offered group of drawings.[31] In other cases, as in his dealings with Childe Hassam, he bought drawings in large groups so as to get a discount on the individual items. Beatty's peculiar and effective mixture of charm and stinginess is evident in one of his letters to Childe Hassam:

> For two hours or more I have been revelling among your
> sketches. Most of the little things done on scraps of paper are, I
> think, superb, and a new and inspiring revelation of your power.
> I think the entire collection ought to be kept together. I will be
> frank and say I do not see how to do this unless you are willing to
> part with the small ones for a very reasonable amount.[32]

Most artists were not offended by Beatty's techniques. They felt pleased that Beatty wished to include their work in the museum's collection and consequently did not insist on high prices. Hassam, for example, eagerly responded to Beatty's proposal to purchase his smaller sketches, concluding: "Now the only thing for you to say is what you think is a fair price for them as they stand."[33] Hassam was not alone in letting Beatty fix his own price. Edwin Blashfield, for instance, did so also. As Hartmann noted in the postscript of a letter: "Blashfield . . . leaves prices to Mr. Beatty [and] wants no more nor less than other men of his standing and reputation get."[34]

THE NATURE OF THE FIRST COLLECTION

Why did Beatty choose, on his own initiative, to form a collection of American drawings in the first place? What types of drawings did he choose, with Hartmann's assistance, to collect? Although many of Beatty's purchases still stand as masterworks—such as Winslow Homer's *Fisher Girls*, Eastman Johnson's *My Jew Boy*, Ralph Blakelock's *Untitled*,

or William Glackens's *In Town It's Different*—he and Hartmann collected them from a viewpoint very different from that of today. The two types of American draftsmanship that they most favored, illustration and what might be termed "poetic evocation," are both now out of fashion. To understand Beatty's procedures fully we must reconstruct the prevailing taste of his era and review its ideas about the progress of American art.

Beatty's own experience as an artist should not be overlooked. One fundamental reason he decided to collect drawings was their ability to reveal the underlying principles of visual art with unusual clarity and directness. The artist John La Farge, who carefully studied the drawings of the old masters during a youthful trip to Europe, once remarked,

> If I copied the painting from which the drawing had been made I could only copy the surface, without knowing exactly how the master had attained his result. But I knew that in the master's drawings and studies for a given work I met him intimately, saw into his mind, and learned his intentions and character, and what was great and what was deficient.[35]

John Beatty articulated a similar point of view in a prefatory note to a checklist of Carnegie Institute's drawings that was issued in 1912. "Original drawings," he noted, "have always a unique interest, in that they bring us closer to the creative artist, and give us a more intimate understanding of the art of the painter, than perhaps any other medium of expression."[36]

To make the working procedures of artists more vivid, Carnegie Institute, in its early years, acquired many of the objects, such as woodblocks and etching plates, that were used in different artistic processes. Two of the most beautiful and unusual items in the collection, the uncut woodblocks drawn on by Thomas Moran and John La Farge, may well have been acquired chiefly to illustrate techniques.

Beatty's interest in drawing was doubtless also encouraged by his belief that it demonstrated the progress and growth that Americans had made in the visual arts. For, like most men of his time, Beatty seems to have believed that the American painters of his own generation had vastly surpassed the relatively untutored masters of the Hudson River School. Sadakichi Hartmann made downright sarcastic comments about those earlier artists. Of Thomas Doughty he noted that his paintings were "unpretentious as works of art" and that "few men have done so well with so little experience"; of Thomas Cole, that "his drawing was feeble, his sense of color undeveloped, and his touch hard and dry, like that of most of his contemporaries"; and of Asher Durand, that he was "a man of larger technical experience, but of less talent than the two former." John F. Kensett he dismissed as "technically a mere amateur."[37]

If Hartmann's generation found the paintings of the Hudson River School hard and dry, they found their drawings, on the whole, even less significant. For, to the masters of the Hudson River School, drawing had always remained a secondary pursuit: Most of their works on paper were small and slight and were intended not to stand by themselves but only to serve as studies for oil paintings. Often they contained not even a complete motif or composition but only fragmentary jottings. Only a few of the later masters of this school, notably John F. Kensett, made drawings that stand as completed works of art. Probably chiefly for

historical reasons, Beatty purchased a few drawings of this type; for example, two book illustrations by Kensett and a landscape sketch by Daniel Huntington (two early views of Pittsburgh by Joshua Shaw also came into the collection as a gift). The greater number of his purchases, however, belonged to a later period and seem intended to demonstrate that American draftsmanship had transcended its rude beginnings.

To the believer in progress in American art, American draftsmanship provided encouraging evidence of this transcendence. Starting in the 1870s, at about the time of the nation's Centennial, a group of young artists began to return to the United States after long, intensive artistic training abroad. The major skill they had learned was figure drawing, for the course of study in European academies concentrated chiefly on rendering human form by drawing first from plaster casts and then from nude models. Pictorial composition was a secondary consideration and often was not even included in the course of training. For these artists the ability to draw, particularly to draw the human figure, served as their claim to equality with European artists and proof of their superiority to earlier generations of American painters.

Among the works in this catalogue, Kenyon Cox's studies for his murals in the Minnesota State Capitol perhaps most emphatically express this generation's pride in its figural draftsmanship and its consequent claim to connect with and continue the grand traditions of Antique and Renaissance art, which had been based on a similar concentration on the human form. However dry and mechanical such drawings seem to modern eyes, they certainly demonstrate a far greater degree of schooling in anatomy and in figural rendering than earlier generations of American artists had received.

The greatest boost to the prestige of American representational draftsmanship, however, came from the rise of the American illustrated magazines, such as *Scribner's*, *Harper's*, *The Century*, and *St. Nicholas*, which reached their peak of popularity in the 1880s and 1890s. While photographs were reproduced as early as the late 1880s, for many decades they lagged behind drawing as the favored mode of illustration, for their delicate tonalities reproduced poorly, they could not catch fast action, and in general they lacked the vivacity and sparkle of hand-executed work. Photographic techniques could be employed, however, to reproduce drawings with perfect accuracy, particularly pen-and-ink drawings that relied on sharp black-and-white contrasts and did not contain tonal nuances. The accuracy of this new method of reproduction encouraged, for the first time, a mode of illustration that could exploit each artist's personal qualities and eccentricities, without the inevitable changes that engravers had always wrought upon their original drawings.[38]

Artists' styles varied widely, but illustration, by its nature, tended to encourage a certain dash, freedom of handling, and directness in the expression of visual ideas. Most illustrators, in one way or another, established an interplay between passages of precise delineation and more ambiguous areas. Edwin Austin Abbey, for example, a trend-setting figure, developed a distinctive mode of spidery line work that alternated between meticulous transcriptions of form and loose, energetic, altogether abstract scribblings.[39] Curiously, while a number of academically trained artists did distinguished illustrative work, many of

the virtuosos of the genre, such as Abbey and Remington, had little formal artistic training. Their very lack of conventional knowledge made them more experimental and flexible in devising a style appropriate to the new reproductive techniques.

The pay for illustrations from prestigious magazines like *The Century* was extremely good, in fact higher than the pay for writing. Remington, for example, when he sold original drawings at auction, found that they brought far less than the reproduction fees he received for them.[40] Consequently, in the late nineteenth and early twentieth centuries, illustration provided the most common form of income for serious and aspiring artists, including such figures as Winslow Homer, William Glackens, Edward Hopper, and Arthur Dove, who went on to distinguish themselves as painters.

Beatty himself, as a young man, earned his living through illustrating. On his return from Munich he was hired to sketch "all important occurrences in and around the city of Pittsburgh" for the *Daily Graphic*, a local paper. He also received occasional assignments for the *Pittsburgh Dispatch*. As an artist-journalist he made drawings of the disastrous Johnstown flood and the violent Pittsburgh railroad strike, but in keeping with his peace-loving temperament he preferred such nostalgic images as "Old Houses of Pittsburgh" or "A Quaint Old Mountain Village." Gradually Beatty also branched out to illustrate for national magazines, including *Harper's Weekly*, *A Weekly Journal for the Home*, *Leslie's Weekly*, *People's Monthly*, and *St. Nicholas*. Thus, he could evaluate the illustrations he acquired for Carnegie Institute with the eye of a trained professional.[41]

Given the pay and demand for exciting illustrations it is hardly surprising that many American artists made some of their best drawings for this purpose. Americans rapidly assumed world leadership in illustration, for the magazines with the largest circulations and the highest fees for artists were in the United States. Joseph Pennell declared in 1895, "In many ways the illustrative work of America is more interesting than that of any other country."[42] To a figure such as John Beatty, who wished to record and encourage the progress of American art, illustrative drawing provided good evidence of America's emerging leadership in the fine arts.[43]

Not surprisingly then, Beatty and Hartmann concentrated particularly on illustration. They acquired works by nearly all the virtuoso illustrators of the period: Edwin Austin Abbey, John White Alexander, Robert Blum, Charles Dana Gibson, Maxfield Parrish, Howard Pyle, Charles Stanley Reinhart, and Frederic Remington. In addition they bought illustrations by many figures better remembered today as sculptors or easel painters; for example, William Rimmer, Winslow Homer, John La Farge, Thomas Moran, and William Glackens.

Both Beatty and Hartmann, however, believed that art had higher goals than mere representation, and, in addition to illustration, they also acquired works of what might broadly be termed the "evocative" school of American draftsmanship. These works stressed mood and atmosphere at the expense of the careful transcription of form. Hartmann's *A History of American Art* provides much assistance in understanding this side of the collection, for in his evaluations of artists he consistently placed greatest stress on their ability to convey emotion and mood.

Although he disliked the literalness of the Hudson River School, for example, he wrote ecstatic eulogies of Barbizon-influenced American landscape painters like George Inness ("an artist who made use of his landscape to express his own moods and dreams"), Homer Martin ("who contemplated nature with a dreaming sadness"), and Dwight Tryon (who "has reached the calm perfection of Japanese art").[44] While Hartmann was the first to single out the work of Thomas Eakins and Winslow Homer as particularly expressive of the American character, he ranked them both below George Fuller, whom he termed "the greatest genius which the art of our country has produced" and "one of the most powerful exponents of poetic or emotional paint the world has ever seen."[45] Even in illustration Hartmann downgraded the "mere representation" of figures such as Frederic Remington and Charles Dana Gibson and praised the more poetic and imaginative endeavors of John La Farge, Howard Pyle, and others.[46]

In draftsmanship, perhaps even more than in painting, an interest in evocation led to the development of a distinct, identifiable manner of work. Artists in this evocative manner tended to choose papers with unusual textures, colors, or coatings and to favor drawing materials that were either soft and crumbling, such as charcoal, chalk, and pastel, or unusually delicate, such as silverpoint. They eschewed sharp outlines and preferred softened, generalized effects that captured spirit and mood rather than substance. To a very large degree, this direction in American draftsmanship was dominated by landscape painters like William Morris Hunt, Homer Martin, and Dwight Tryon, although certain figure drawings, such as Thomas Dewing's silverpoint of a woman's head in the Carnegie collection, certainly should be placed in this category.

The movement began chiefly through the influence of the French Barbizon School, as is most evident in the work of William Morris Hunt, who closely followed the example of his mentor, Jean-François Millet. This influence is also present in the drawings of Homer Martin, Robert Loftin Newman, and Ralph Blakelock. The work of all these men represents form in broad, simplified masses, whether in wash or charcoal. Later, under the influence of James McNeill Whistler, these central masses of form began to lose their solidity and weight, and attention shifted to flickering, insubstantial outlines. Several artists represented in the collection, including Childe Hassam, John H. Twachtman, and Thomas Dewing, pursued their goal of evocation in a manner that outgrew the influence of the Barbizon School and followed Whistler's example instead. Speaking generally, this evocative school of draftsmanship might be compared with the movement in painting now known as Tonalism. However, it included a greater number of artists. Childe Hassam, for example, whose paintings are less Tonalist than Impressionist in style, made delicate colored chalk drawings that are evocative in intention and closely modeled on the example of Whistler.[47]

Nearly all of Beatty's and Hartmann's choices fall neatly into the category of either illustration or evocation. The drawings of Winslow Homer, however, occupy a special place. Beatty felt a special affinity for the work of Winslow Homer, whose work, he once declared, "made a contribution which is destined long to continue a milestone in the progress of our national art."[48] He worked hard to establish close and friendly links between Homer and Carnegie Institute. Homer won the Chronological Medal at the first International exhibition for a work that

became the first canvas acquired for the collection. He also made the first drawing purchased by Carnegie Institute and served twice on the jury of the Carnegie International, though acting as a judge was a service he rendered for no other institution. It is hardly surprising, then, that Beatty collected a significant group of Homer's works on paper: two watercolors, a monochromatic gouache, and six drawings.

It was more than a respect for Homer's work, however, that motivated these purchases, for Homer's work on paper effectively combined illustration and evocation. Homer began his career as a professional illustrator, and although he later abandoned illustrative work, his drawings retain the best qualities of illustrations—the ability to catch the dramatic aspect of a scene and present it vividly and clearly. Homer was never content, however, with realistic effects alone, but sought to evoke the spirit of what he depicted. As Beatty wrote of his work, "Homer never painted simply for the purpose of representing natural objects or scenes. . . . He learned to see broadly, to separate the essential character from the non-essentials."[49] In drawings such as *Figures on the Coast*, Homer handled charcoal as freely and form as boldly as Barbizon-influenced masters such as William Morris Hunt; but he achieved greater vigor and incisiveness in characterizing the scene. Beatty's first two drawing purchases, Winslow Homer's *Figures on the Coast* and *Fisher Girls*, perhaps best sum up his ideal of American draftsmanship, in their effective combination of illustrative immediacy with poetic and evocative qualities.

THE SECOND COLLECTION OF DRAWINGS

Carnegie Institute's collection of American drawings languished after John Beatty retired: from 1922 until 1954 no American drawings were purchased for the collection. This cessation of purchases came about in part because the Museum of Art's second director, Homer St. Gaudens, took no interest in drawings. An additional factor was the museum's increasingly pinched financial situation. Andrew Carnegie's original endowment had covered the costs of the International exhibition, the maintenance of the museum, and the purchase of works of art. By 1922, however, when Homer St. Gaudens took charge, Carnegie's funds barely covered general expenses, and little money was left over for acquisitions. In 1922 the Patron's Art Fund for paintings acquisitions was created to redress this situation, and it soon became virtually the only source of funds for acquiring works for the collection.[50]

For part of this period, Edward Duff Balken, a wealthy connoisseur and Carnegie Institute trustee, served as unpaid curator of prints and drawings, and the collection expanded almost solely through his personal gifts, some of extremely high quality, such as Maurice Prendergast's sparkling *Swampscott Beach*.[51] The number of such gifts to the museum in these years remained small, however, totaling only thirty-three, an average of about one a year.

The situation began to change after 1950, when a new director, Gordon Bailey Washburn, took charge of the museum, delegating to assistant director Leon Arkus (who later became director himself) the role of curator of prints and drawings. Washburn set out to find new and more varied sources of funding and to redefine the direction of the

Museum of Art. The growth of the collection of American drawings was deeply affected by this shift.

For one thing, the museum's policy changed from one of indifference to modern abstract art to one that strongly endorsed it. The International exhibition, which for years had been dominated by realistic and regional styles, became largely devoted to avant-garde tendencies, in particular to Abstract Expressionism. This new direction caused violent controversy, and Washburn occasionally may have gone too far in repudiating the museum's academic past—for example, when he proposed covering John White Alexander's allegorical murals that decorated the main staircase of the building. To an extraordinary degree, however, time has vindicated Washburn's judgment in supporting the work of Jackson Pollock, Willem de Kooning, Mark Rothko, and David Smith. The Internationals he organized in 1952, 1955, 1958, and 1961, although savagely attacked in both the local and the New York press, stand out in retrospect as events of historic importance.

Along with Washburn's desire to modernize the International came the realization that the permanent collection of paintings, acquired over the years almost entirely from works reaped somewhat randomly from the International, demanded more serious attention. For the first time the museum began to acquire major paintings from the past.[52] This effort, initiated by Gordon Washburn and continued by his successor, Gustave von Groschwitz, came to full fruition after Leon Arkus became director of the museum in 1969. Under Arkus's guidance, and with the generous support of Sarah Mellon Scaife and her family, the permanent collection experienced the most significant growth in its history, and for the first time Carnegie Institute came to rank with the museums of other large American cities.[53]

This expansion of the collection, however, concentrated chiefly on the acquisition of easel paintings, particularly a group of magnificent French Impressionist and Post-Impressionist works. While Arkus was deeply sensitive to drawings (he once declared, "my particular predilection . . . is for drawings"), the growth of the drawings collection lagged behind that of the paintings, and, like the paintings collection, included many purchases that were not American but European. When Arkus produced an article for *Carnegie Magazine* that featured highlights from the drawings collection, he included only one American work, by the Armenian-born Arshile Gorky.[54]

Arkus's most interesting and distinguished drawing purchases were mainly contemporary works by such figures as Sam Francis, Ellsworth Kelly, Franz Kline, and David Smith. Often these acquisitions required complex negotiations, as was the case with the drawings by Smith which were purchased with money the sculptor rejected when he turned down third prize at the 1961 Carnegie International. Most of the pre-twentieth-century American drawings that came into the collection were the result of gifts. For example, portrait drawings by John James Audubon and Charles Févret de Saint-Mémin were donated by descendants of the sitters, and a group of sketches by Benjamin West was given to the museum by Charles J. Rosenbloom, a distinguished collector of Old Master prints.

Among the many donors of American drawings, certainly the most perspicacious and generous have been Mr. and Mrs. James H. Beal, who made their first gift to the Museum of Art in 1944 and their most recent in

1984. For the most part the Beals collected twentieth-century works such as the watercolors by Edward Hopper, Charles Burchfield, and Charles Demuth included in this catalogue.[55] However, Mr. and Mrs. Beal also have acquired nineteenth-century works, and through their generosity the museum was able to obtain two of the most outstanding nineteenth-century drawings in the collection, a pair of satirical drawings by the Pittsburgh artist David Blythe.

In recent years, under Leon Arkus's successor, John R. Lane, and curators of fine arts Oswaldo Rodriguez Roque (1981–82) and the author (1982–84)—both specialists in American art—the collection of American drawings has grown more rapidly than before. Acquisitions have increased, in part because of diminished collecting opportunities in other areas, such as French Impressionist and American paintings, and in part because the value of the drawings collection has been undergoing a serious reassessment.

Several very beautiful Hudson River School drawings have been acquired, including works by John F. Kensett, William Stanley Haseltine, and Worthington Whittredge. Perhaps the most outstanding group of purchases, however, has been among early modernist works. Recently the museum has not only purchased masterworks by such central figures as John Graham and Stuart Davis, but has also acquired, through both purchase and donation, an outstanding group of works on paper by less well known but exceptionally interesting artists like Morton Schamberg, George Ault, Louis Lozowick, Jan Matulka, Rolph Scarlett, Ilya Bolotowsky, Burgoyne Diller, Charles Biederman, and John Wilde.[56] Moreover, a discriminating new Pittsburgh collector, Mrs. James A. Fisher, has expressed her intention to donate major works by Charles Sheeler and Georgia O'Keeffe, among others, that will significantly enhance the museum's holdings in works of this period.

The museum has also continued its longstanding commitment to contemporary art. The late Gene Baro, curator of contemporary art (1980–82) and organizer of the 1982 International exhibition, energetically acquired works on paper, including drawings by Akira Arita, William Beckman, Chuck Close, Brice Marden, and Theo Wujcik, a collecting commitment that his successor, John Caldwell, has continued.

Although the growth of the drawings collection since 1950 has been less systematic than it was during the early years of the museum and has not possessed the self-conscious articulation of goals and principles that characterized John Beatty's and Sadakichi Hartmann's purchasing efforts, it has nevertheless been guided by definable principles of taste, and the acquisitions have tended to fall into definite categories. The first and second drawing collections stand as distinct and contrasting entities, formed with different procedures and based upon radically different standards of taste. Modernism, eschewed by Beatty and Hartmann, has since 1950 been the major target of collecting, with almost equal emphasis on early twentieth-century and contemporary works. In addition, the second collection has paid significant attention to the creations of the Hudson River School and of early American draftsmen, which Beatty and Hartmann largely overlooked; somewhat paradoxically, the literal-minded and often rather naive works of these early American masters have proved compatible with the modernist

aesthetic. The collection since 1950 has acquired virtually no works in those areas that Beatty and Hartmann favored—illustration and what we have termed here the "evocative mode."

Despite the ambitious goals with which John Beatty and Sadakichi Hartmann launched their effort, the Museum of Art's collection of American works on paper, now more than eighty years old, is still far from what today's standards might term a representative collection. Many facets of American watercolor technique and draftsmanship are absent or represented only weakly. Such major watercolorists as John Singer Sargent and John Marin are not included, nor are significant movements, such as that of the American Pre-Raphaelites. Moreover, the collection on the whole is dominated by sketches and small-scale works rather than works like the pastels of William Merritt Chase that emulate the appearance and ambition of easel paintings.

These shortcomings, however, should not lead us to underestimate the significance of the assemblage. Indeed, its exceptional interest resides very much in its unbalanced character and particularly in its strength in two relatively unstudied areas. Thanks to John Beatty and Sadakichi Hartmann it possesses a wonderfully rich assortment of nineteenth-century illustrations, ranging from works by undoubted masters like Winslow Homer and William Glackens to more curious items by artists who are currently out of fashion. Thanks to more recent purchases it contains a challenging group of early modernist drawings, particularly those of the Abstractionists of the 1920s and 30s. Clearly, however, the strengths of the collection are not limited to these areas. The heretofore unexplored richness of Carnegie Institute's collection—both the works of art and the ideas and history associated with them—suggests that American draftsmanship is a fertile field for continuing inquiry.

<div align="right">Henry Adams</div>

NOTES: 1. Bruce St. John, ed., *John Sloan's New York Scene, from the Diaries, Notes and Correspondence 1906-1913*, intro. by Helen Farr Sloan (New York, 1965), 166.

2. For a brief discussion of the collection see Henry Adams, "Masterpieces of American Drawing and Watercolor," *Carnegie Magazine* LVI (January/February 1983): 19-30.

3. Minutes of the meeting of Museum of Art Committee, Carnegie Institute Trustees, 12 October 1972 (Trustees Minutes, V, 91).

4. John Beatty and Sadakichi Hartmann. Memoranda of agreement, 5 May 1906, Papers of the Museum of Art, Carnegie Institute, Archives of American Art, Smithsonian Institution, Washington, D.C. (hereafter cited as Carnegie Institute Papers).

5. The best general account of the growth of Pittsburgh is Stefan Lorant, *Pittsburgh, The Story of an American City* (New York, 1964). An entertaining and well-illustrated short essay on the subject is Edgar Munhall, "Pittsburgh: My Hometown," *Du: Die Kunstzeitschrift* II (1983): 22-63.

6. The most complete biography of Andrew Carnegie is Joseph Frazier Wall, *Andrew Carnegie* (New York, 1970).

7. Stewart Holbrook, *Age of the Moguls* (Garden City, New York, 1953), 347.

8. The story of the Carnegie International exhibition and its contribution to the growth of the Museum of Art's collection has never been written in full, but the following accounts provide a useful introduction to the subject: John O'Connor, Jr., "The Pittsburgh International: Its Beginnings, Development, and Evolution," *Carnegie Magazine* XXVI (May 1952): 162-66, (June 1952): 201-206, (September 1952): 243-46, 249, (October 1952): 263-69; Carnegie Institute, *Retrospective Exhibition of Paintings from Previous*

Internationals (1959), exh. cat. by Leon Arkus; Vicky A. Clark, "Collecting from the Internationals," *Carnegie Magazine* LVI (September/October 1982): 16-27; Gabriel Weisberg, "Tastemaking in Pittsburgh: The Carnegie International in Perspective, 1896-1905," *Carnegie Magazine* LVI (July/August 1983): 20-26, 40-41. From 1896, the title was *Annual Exhibition*; from 1920, the *International Exhibition*; the *Pittsburgh International* in 1950; the *International Series* in 1977; and since 1982, the *Carnegie International*. In the interest of simplicity, this catalogue refers to these exhibitions throughout as the *Carnegie International*.

9. Wall, 894. The national headquarters of this fund was in Pittsburgh.

10. "Essays on Our Leading Citizens: John Wesley Beatty," *The Harpoon* (May 1913). This article commented on Carnegie's selection for director: "When he came to select a head for the department of fine arts in his institution Mr. Carnegie might have gone to Europe and chosen a world-renowned painter whose standing in the artistic world would have added considerable lustre to this branch of the institute's activities. But he knew the kind of man needed for the fine arts department was an affable, diplomatic person who could get along with the public and chiefly the people of Pittsburgh; who would make the art galleries popular and who would get plenty of publicity of the right kind for the institute and incidentally, of course, for A. Carnegie."

11. "A Talk with John W. Beatty About the Carnegie Art Gallery," *The Library*, 8 September 1900.

12. "Old Favorites Will Return; Director Beatty Talks Entertainingly of His Visit to European Galleries; Extreme Art But a Fad," *Pittsburgh Post Dispatch*, 7 September 1913. For a more moderate assertion of Beatty's views see John W. Beatty, "The Modern Art Movement," reprinted from *North American Review* by Carnegie Institute, 1924.

13. Beatty stated the source of his funds in a letter to Sadakichi Hartmann, 9 May 1906, Carnegie Institute Papers. For an account of the collection of plaster casts see Franklin Toker, "The Hall of Architecture, Museum of Art, Carnegie Institute: A Feasibility Report on the Restoration of the Room and Its Casts," June 1983 (Museum of Art files).

14. "John W. Beatty," *Pittsburgh Press*, 14 April 1901. For biographical information on Beatty see Marion Knowles Olds, "John Wesley Beatty: Artist and Cultural Influence in Pittsburgh" (M.A. thesis, University of Pittsburgh, 1953).

15. The village of Scalp Level, located not far from Johnstown, Pennsylvania, was a popular site for painting excursions. Its name became attached to the group of Pittsburgh landscape painters who frequented the spot. See Nancy Colvin, "Scalp Level Artists," *Carnegie Magazine* LVII (September/October 1984): 14-20.

16. "John W. Beatty," *Pittsburgh Press*, 14 April 1901.

17. Sadakichi Hartmann, *White Chrysanthemums: Literary Fragments and Pronouncements*, George Knox and Harry Lawton, eds., foreword by Kenneth Rexroth (New York, 1971), vi. For accounts of Hartmann see Harry W. Lawton and George Knox, editors' introduction, in Sadakichi Hartmann, *The Valiant Knights of Daguerre: Selected Critical Essays on Photography and Profiles of Photographers* (Berkeley, California, 1978), 1-31; "King of Bohemia," *Art Digest* IX (1 December 1944): 3. Hartmann's papers are now located at the University of California at Riverside. For a brief period in the 1970s, at erratic intervals, the University of California at Riverside issued *The Sadakichi Hartmann Newsletter*, edited by Wistaria Hartmann Linton.

18. Sadakichi Hartmann, *A History of American Art* (Boston, 1901), I, 193; II, 131, 259, 98, 113, 232.

19. The author's belief is that Hartmann played a significant role both in devising the wording of the contract and in formulating the lists of artists. The phrase "a representative collection" is one that Hartmann may well have coined, and he later listed among his unfulfilled ambitions that of having "supervised the making of a truly representative collection of American art." See Hartmann, 1971, 19.

20. Hartmann to Beatty, 1 July 1906, Carnegie Institute Papers.

21. Hartmann to Beatty, 1 July 1906, Carnegie Institute Papers.

22. Hartmann to Beatty, 10 October 1906, Carnegie Institute Papers.

23. The bequest of this drawing was announced with considerable fanfare. See "Carnegie Institute Making Important Discoveries in Realm of History and Art," *Pittsburgh Post Gazette*, 23 July 1922. For an account of this group of forgeries see Theodore Sizer, *The Works of Colonel John Trumbull* (New Haven, Connecticut, 1967), xiii-xiv.

24. Hartmann to Beatty, 1 July 1906, Carnegie Institute Papers. In a letter to Beatty dated 5 June 1906, Carnegie Institute Papers, Hartmann reported, "In going about the studios I soon realized that some of our best painters (for instance Thayer, Tryon, Eakins, Benson, etc.), are comparatively poor draughtsmen while others rather mediocre as painters (like Beckwith) excel in point drawing. I think this should be taken into consideration in making a permanent collection of drawings. I try to collect everything that comes under the head of good draughtsmanship."

25. Memoranda of agreement, 5 May 1906, Carnegie Institute Papers.

26. Hartmann to Beatty, 1 July 1906, Carnegie Institute Papers.

27. Glackens to Beatty, November 1906, Carnegie Institute Papers.

28. Harry T. Clinton, art editor of *Colliers*. Letter to John Beatty, 18 June 1906, Carnegie Institute Papers.

29. Beatty to Mrs. Eastman Johnson, 20 July, 17 October, 22 October and 2 November 1906, Carnegie Institute Papers.

30. John Beatty to Doll and Richards, Boston, 2 July and 8 July 1907; Doll and Richards to John Beatty, 5 July and 10 July 1907, Carnegie Institute Papers.

31. An undated, handwritten list from the Century Company to Carnegie Institute, Carnegie Institute Papers. The list offers twenty-six pen and ink drawings, fourteen headings, and four larger drawings by Pyle, all for *Otto of the Silver Hand*.

32. Beatty to Hassam, 17 October 1906, Carnegie Institute Papers. For Hassam's relationship with Carnegie Institute see Gail Stavitsky, "Childe Hassam in the Collection of the Museum of Art, Carnegie Institute," *Carnegie Magazine* LVI (July/August 1982): 27-36.

33. Hassam to Beatty, 22 October 1906, Carnegie Institute Papers.

34. Hartmann, c. 16 August 1906, Carnegie Institute Papers.

35. Royal Cortissoz, *John La Farge: A Memoir and a Study* (Boston, 1911), 94.

36. Carnegie Institute, *Lists of Paintings, Drawings and Japanese Prints in the Permanent Collections of the Department of Fine Arts: A Preliminary Publication, Subject to Revision* (1912); bound with an addendum, 1917, unpaginated.

37. Hartmann, 1901, I, 53, 48, 55.

38. The classic account of pen and ink illustration is Joseph Pennell, *Pen Drawing and Pen Draughtsmen* (New York, 1920). See also "Illustration and Fantasy," in Theodore E. Stebbins, Jr., *American Master Drawings and Watercolors* (New York, 1976), 255-76.

39. Michael Quick, "Abbey as Illustrator," in Yale University Art Gallery, New Haven, Connecticut, *Edwin Austin Abbey* (1973), exh. cat. by Kathleen A. Foster and Michael Quick.

40. The Cadet Fine Arts Forum, West Point, New York, *Frederic Remington: The Soldier Artist* (1979), exh. cat. by Peggy Samuels and Harold Samuels, 18, 21.

41. Beatty's work as an illustrator is discussed by Olds, 1953.

42. Joseph Pennell, *Modern Illustration* (London, 1895), 113.

43. Until the end of the nineteenth century drawings were used mainly in an artist's studio and were seldom publicly exhibited. Consequently, drawing remained primarily a private art form and had relatively little influence on the dissemination of artistic styles. In the late nineteenth century, however, this situation changed suddenly, with the development of reproductive techniques that were better suited for drawings than paintings. Reproductions of drawings became the least expensive and most widely distributed form of visual art and from about 1870 to 1920, drawing probably played a larger role than painting in the promulgation of artistic devices and ideas. Significant

movements in American painting, such as the Ashcan School, drew their inspiration at least as much from the illustrative tradition as from precedents in easel painting. Even movements like Cubism were influenced by comic books, illustration, and other forms of mass-produced graphic art. See Albert Boime, "The Comic Stripped and Ashcanned," *Art Journal* XXXII (Fall 1972): 21-25, 30; Adam Gopnik, "High and Low: Caricature, Primitivism, and the Cubist Portrait," *Art Journal* XLIII (Winter 1983): 371-76.

44. Hartmann, 1901, I, 96, 122, 135.

45. Hartmann, 1901, I, 207, 215.

46. Hartmann, 1901, II, 113, 98.

47. The author knows of no previous account that has so broadly defined the evocative mode of American draftsmanship. Many of the artists this essay considers, however, have been discussed by Stebbins, 1976, in his chapter "The Impact of Impressionism," 219-54. A fine discussion of the most closely corresponding artistic style in painting, Tonalism, is in M. H. de Young Memorial Museum and the California Palace of the Legion of Honor, San Francisco, *The Color of Mood: American Tonalism 1880-1910* (1972), exh. cat. by Wanda Corn.

48. John W. Beatty, *Recollections of an Intimate Friendship: Winslow Homer* (New York, 1944), 226. The original, unedited typescript of this essay is in The Westmoreland Museum of Art, Greensburg, Pennsylvania.

49. Beatty, 1944, 224-25.

50. For an account of the funds for purchases see Betty Griggs Folsom, "The Permanent Collection of Paintings at Carnegie Institute, Pittsburgh," (M.A. thesis, Pennsylvania State University, University Park, Pennsylvania, 1961).

51. Edward Duff Balken was the museum's curator of prints from 1916 until 1928, acting assistant director and curator of prints from 1929 until 1934, and honorary curator of prints from 1934 until 1938. He was a trustee of Carnegie Institute and a member of the Fine Arts Committee from 1939 until his death in 1960. Balken bequeathed his collection of American folk art to Princeton University, his alma mater.

52. In 1958 Creighton Gilbert noted that Pittsburgh was one of only two major urban centers in the United States that did not have a major collection of Old Master paintings. See Creighton Gilbert, "A Rating for United States Art Museums," *College Art Journal* XVII (Summer 1958): 392-403.

53. Donald G. Adam, "An Age He Deserves: Spending Time with Leon Arkus," *Pittsburgh* (June 1980): 36-42.

54. Leon A. Arkus, "On Drawings," *Carnegie Magazine* LI (March 1977): 102-12.

55. See Henry Adams, "The Beal Collection of Watercolors by Charles Demuth," *Carnegie Magazine* LVI (November/December 1983): 21-28.

56. John R. Lane, "American Abstract Art of the '30s and '40s," *Carnegie Magazine* LVI (September/October 1983): 13-19.

Key to Authors

HA Henry Adams
JC John Caldwell
JRL John R. Lane
KN Kenneth Neal
EAP Elizabeth A. Prelinger

Entries are arranged chronologically by date of the drawing.

EARLY AMERICAN DRAWINGS AND THE HUDSON RIVER SCHOOL

BENJAMIN WEST

1738 — 1820

Entrance to the Terrace at
Windsor Castle
c. 1795–1805
graphite and pastel on paper
mounted on card
6 ¹¹⁄₁₆ x 9 ⅜ in.
(17 x 23.8 cm.), sheet
10 ⅞ x 13 ⅝ in.
(27.6 x 34.6 cm.), mount
Gift of Mr. and Mrs. Charles J.
Rosenbloom, 58.35.1

BENJAMIN West was born the son of an innkeeper in 1738 in Pennsylvania, then located on the edge of the American frontier. From this humble beginning he went on to become President of the Royal Academy in London and one of the most successful artists of his time. West used his frontier origins to enhance his mystique, assuring his credulous biographer, John Galt, that he received his first art lessons from the Indians, who taught him the principle of the prismatic colors.[1] In actual fact, West modeled his youthful efforts on European prints and obtained training from the itinerant English artist William Williams, who was active in Philadelphia.

Sponsored by a group of wealthy patrons, West left for Europe in 1760 to pursue an artistic education, never again to return to the colonies. For three years he lived in Rome and studied the Old Masters and ancient statuary. He devised from these sources a solemn, statuesque, neo-classical mode of history painting that reflected the revival of antiquity

West, *Entrance to the Terrace at*
Windsor Castle

being urged in the writings of Johann Winckelmann. West arrived in London in 1763 and achieved immediate recognition. He formed a lasting friendship with King George III despite his sympathy for the rebellious American colonists. In his famous *The Death of Wolfe* (1770, National Gallery of Canada, Ottawa), West established a new direction for history painting by showing heroic events enacted in contemporary costume instead of in classical guise.

In 1772 West was appointed historical painter to the king, and in 1792 he succeeded Sir Joshua Reynolds as President of the Royal Academy, a position he held with only one brief interruption until his death in 1820. West's egotism sometimes caused offense (he casually alluded to one of his paintings as "a little burst of genius"), but he won over the majority of his critics with his even temper and remarkable generosity.[2] For some thirty years West's studio was a haven and training ground for American artists, including John Singleton Copley, Mather Brown, Ralph Earl, Charles Willson Peale, John Trumbull, Gilbert Stuart, Thomas Sully, and Washington Allston.

West's contemporaries often compared his works with those of Raphael and Titian; twentieth-century critics have just as often castigated them as dull and ponderous, concurring with Lord Byron, who referred in "The Curse of Minerva" (1811) to the "palsied hand" of "the flattering, feeble dottard, West/Europe's worst dauber and poor Britain's best."[3] West's drawings, however, possess a freshness and spontaneity that he revealed only seldom in his more ambitious works.

The seven drawings by West in the Museum of Art show considerable variety of subject and technique. Two are quick compositional sketches drawn on the backs of letters. The first contains studies for West's painting *Thetis Bringing the Armor to Achilles* (1805, The New Britain Museum of American Art).[4] The second relates to West's plan to paint the death of the Earl of Chatham, a project he abandoned to make way for John Singleton Copley's painting of the same subject.[5]

West's other five drawings in the museum are more finished, and each still has its original mat with his signature and title for the work on the back. *The Sages of Greece* (c. 1790–1800) has the effect of a study for a painting but does not relate to any known work. Its composition evokes the paintings of Poussin, but the mode of execution, with its free use of a quill pen, was evidently modeled on the work of Guercino, whose drawings were greatly prized in England in the eighteenth century.[6]

Scene at Chevening in Kent (c. 1795) depicts the country seat of the Earl of Stanhope, a residence constructed in 1630 and famous for its gardens.[7] West's use of blue paper, his delicate strokes with pencil and white chalk, his restrained shading, and his grouping of small figures within the landscape all bring to mind French eighteenth-century drawings by Watteau and other masters. West's handling of the architecture, however, has an English solidity, and the couple in the scene are shown in a solemn domestic activity, supervising their gardener, rather than disporting in a *fête galante* as they would in a French work.

Three of West's drawings in the Museum of Art depict the environs of Windsor Castle, the royal residence, where in the 1790s George III allowed West to occupy a studio. West's sketching excursions in the vicinity are mentioned in the diaries of his friend Joseph Farington, and in several works from this period one can recognize the famous Herne's oak, which stood on the grounds at Windsor until it was blown down in 1863.[8]

Landscape Near Windsor (c. 1795) shows seven laborers with picks and shovels in Windsor Great Park, an eighteen-hundred-acre preserve located to the south of the castle. The drawing closely relates to West's painting *Woodcutters in Windsor Great Park* (1795, Indianapolis Museum of Art).[9] *View of Windsor Castle on the Road from Datchet* (c. 1795) shows Windsor Castle as it looked before Sir Jeffry Wyatville doubled the height of the round tower in 1830. West sketched the castle from the northwest, from a point on the road that borders the Thames and leads from the town of Datchet.[10] *Entrance to the Terrace at Windsor Castle* (c. 1795) shows the upper ward of the castle looking toward the Henry III tower as viewed from the Home Park. At the right one can see the west end of the south front of the castle; at the left, under the trees, stands the Queen's Lodge. This was a popular vantage with contemporary artists such as Thomas Hearne and Paul Sandby in the second half of the eighteenth century.[11]

Landscape Near Windsor and *View of Windsor Castle on the Road from Datchet* are executed in pen and wash in a manner loosely modeled on seventeenth-century Dutch landscape drawings of the Rembrandt school. Both drawings contain paste-overs that allowed West to make corrections and changes. *Entrance to the Terrace at Windsor Castle* exhibits a delicate use of pastel and, like the *Scene at Chevening in Kent*, may well have been influenced by French eighteenth-century drawings.[12] Taken as a group, these seven drawings reveal the agility with which West borrowed from the art of the past, altering his style in response to different subjects and motifs.

HA

NOTES: 1. John Galt, Esq., *The Life, Studies and Works of Benjamin West, Esq.* (London, 1820), 18. 2. Robert C. Alberts, *Benjamin West, A Biography* (Boston, 1978), 209. 3. Alberts, 352. 4. Ruth S. Kraemer, *Drawings by Benjamin West and His Son Raphael Lamar West* (New York, 1975), 44-48. West's sketches are on both the front and back of a letter dated 3 June 1775. Because the page is torn, the last name of the sender is cut off and only "Henry" remains. The contents of the letter deal with the favorable reactions of the writer's Yorkshire friends to a painting by West that they had seen. The front of the sheet contains two sketches of male figures, and the reverse shows three studies of nude women, probably preliminary notations for the figures of Achilles and Thetis in The New Britain Museum of Art painting. 5. The two sketches are on the reverse of a letter sent to West's Newman Street residence in London by John Boydell on 18 May 1782. The letter reads: "Sir: I suppose you have done with the two drawings of Alfred, if you have, please to let the Bearer have them. I am Sir/Most obliged Servant/John Boydell." John Boydell (1719-1804) was an engraver who set himself up as a print-seller and publisher of engravings. The drawings of Alfred to which he refers depicted Prince Alfred of England and are mentioned in the Farington Diary in the entry for 22 December 1799 (Joseph Farington, *The Farington Diary* [London, 1923], 276). Both sketches on the letter depict the death of the Earl of Chatham while addressing the House of Lords, an event that occurred on 7 April 1778. With the king's approval, West started work on a painting of this subject but generously relinquished the privilege to John Singleton Copley, who had not enjoyed West's degree of success as a painter. The different media West employed for the two drawings suggest that he may have made them at different times. The upper sketch, rendered in pencil, whose lines are relatively certain, is divided into three distinct figural groups and recapitulates many of the motifs found in West's earlier painting *The Death of Wolfe*. The lower sketch, executed in crayon in a more tentative manner, closely resembles West's sketch (1779, Pierpont Morgan Library, New York) for his planned painting *The Death of the Earl of Chatham* (Kraemer, 14-15). Copley began work on his painting in 1779 and exhibited it in 1781 (Jules David Prown, *John Singleton Copley*, Vol. II [Cambridge, Massachusetts, 1966], 275-91, plates 392-95). West evidently made these two drawings after he had seen Copley's design and while mulling over his own earlier

conception. 6. Theodore E. Stebbins, Jr., *American Master Drawings and Watercolors* (New York, 1976), 19-20. 7. Karl Baedeker, *Great Britain, Volume I: Southeastern England, East Anglia* (New York, 1966), 31. 8. Findlay Muirhead, *London and Its Environs* (London, 1927), 515. The Pierpont Morgan Library, New York, and the Museum of Fine Arts, Boston, own drawings by West of Herne's oak, and Queen Elizabeth II owns a painting of this motif (Kraemer, 76, and Alberts, illus. 78-79). 9. Grose Evans, *Benjamin West and the Taste of His Times* (Carbondale, Illinois, 1959), plate 54. 10. Sir Owen Morshead, *Windsor Castle* (London, 1957). 11. A. P. Oppe, *English Drawings Stuart and Georgian Periods in the Collection of His Majesty the King at Windsor Castle* (London, 1949), 57, plate 56; A. P. Oppe, *The Drawings of Paul and Thomas Sandby in the Collection of His Majesty the King at Windsor Castle* (London, 1947). The Honorable Mrs. Jane Roberts, curator of the print room of the Royal Library, Windsor Castle, kindly provided information concerning West's vantage points in these drawings in a letter to Janet Marstine, 3 July 1984 (Museum of Art files). 12. Watteau spent the year 1720 in England, and a vogue for his work developed there in the eighteenth century. Sir Joshua Reynolds, for example, called Watteau "a master I adore" (John Canaday, "Tender and Poetic Works of Art from Melancholy Genius," *Smithsonian* [July 1984]: 59).

CHARLES BALTHAZAR JULIEN FÉVRET DE SAINT-MÉMIN

B. FRANCE, 1770 — 1852

A MEMBER of the lesser French nobility, Saint-Mémin came to the United States in 1793 as a fugitive from the French Revolution. He soon executed a number of topographical views of New York City and its environs, but he became a successful artist only after taking up portraiture with the aid of a physionotrace. This scaffold-like contraption, invented by Gilles-Louis Chrétien in 1786, enabled its operator to trace a sitter's profile in a few minutes. When it was used to produce simple silhouettes, as it was at Charles Willson Peale's Museum in Philadelphia, it wholly eliminated the need for draftsmanship. For Saint-Mémin, however, the physionotrace was merely a convenient tool that provided a basic outline, which he then worked up into a fully realized likeness.[1]

Samuel Richards is a handsome, sensitively rendered profile portrait of the kind fashionable in Europe and America between 1790 and 1830. The pink bole ground (actually a brilliant orange modified with white and gray) is typical of Saint-Mémin's work. Richards (1738–1823) was the wealthy proprietor of the Batsto Iron Works in Burlington County, New Jersey, and well able to afford the artist's complete package, priced at twenty-five dollars for men and thirty-five dollars for women, which included a framed life-sized drawing, twelve engraved reductions, and the copperplate from which the engravings were made.[2] Richards may have sat for this portrait in Philadelphia or in nearby Burlington, New Jersey, where Saint-Mémin lived between his frequent tours of the major East Coast cities. The Museum of Art also owns a drawing by Saint-Mémin of Richard's daughter-in-law, Mary Morgan Smith Richards, probably executed at the same time.

Saint-Mémin's portraits were in huge demand, and some of the most celebrated citizens of the early Republic, including George Washington, Thomas Jefferson, James Madison, John Marshall, and Charles Willson Peale, sat before his physiognotrace. Over eight hundred portraits survive. Despite his great popularity, Saint-Mémin destroyed his

Samuel Richards
c. 1800
charcoal heightened with white on reddish paper mounted on wood stretcher
22 x 16 ¾ in.
(55.9 x 42.5 cm.), image [irregular]
Gift of the children of Eleanor Merrick: Herbert DuPuy Merrick, Eleanor Merrick Bissell, Lavina Merrick Cooper, Marguerite Merrick Wick, in memory of their grandfather, Herbert DuPuy, 62.17.8

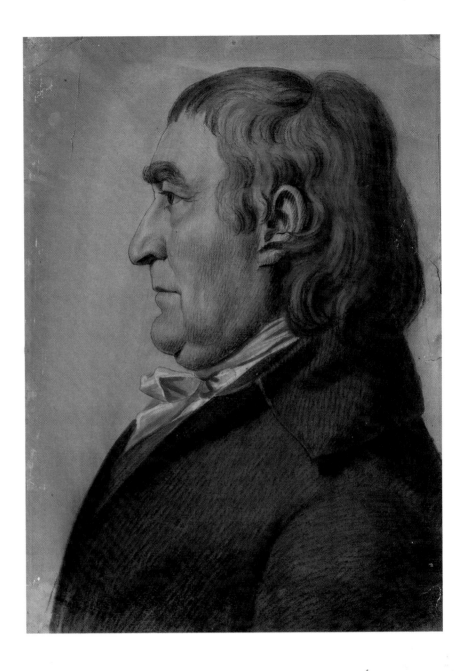

Saint-Mémin, *Samuel Richards*

machine and returned to France when the Bourbon monarchy was reinstated in 1814. He pursued quite a different career in France as the curator of the municipal museum in his native Dijon. There he earned a small but distinguished place in the history of French art as a pioneer in the restoration of historic buildings.[3]

KN

NOTES: 1. For a discussion of the physionotrace and its considerable vogue in Europe and America, see two articles by Mary Martin, "The Physionotrace in France and America," *Connoisseur* LXXIV (January-April 1926): 144-52 and "The Physionotrace in France and America: Saint-Mémin and Others," *Connoisseur* LXXV (May-August

1926): 141-48. 2. Two engravings of the Richards portrait are in Washington, D.C., collections: one is at the Corcoran Gallery of Art; the other, belonging to the National Portrait Gallery, enabled Dr. Ellen G. Miles of that institution to identify the subject of the drawing, previously catalogued as "Unknown Gentleman." This drawing is reproduced in Elias Dexter, ed., *The Saint-Mémin Collection of Portraits* (New York, 1862), 189. A biography of Richards appears in Louis Richards, "A Sketch of Some of the Descendants of Owen Richards, who Emigrated to Pennsylvania Previous to 1718," *The Pennsylvania Magazine of History and Biography* (1882): 79-81. The Saint-Mémin engraving is reproduced opposite page 69. 3. For Saint-Mémin's life and work see Dexter, 1862; Valentine Museum, Richmond, Virginia, *The Works of Charles Balthazar Julien Févret de Saint-Mémin* (1941); Fillmore Norfleet, *Saint-Mémin in Virginia* (Richmond, Virginia, 1942); Corcoran Gallery of Art, Washington, D.C., *Catalogue of Engraved Portraits by Févret de Saint-Mémin, 1770-1852, in the Permanent Collection of the Corcoran Gallery of Art.*

JOHN JAMES AUDUBON

B. HAITI, 1785—1851

AS a businessman, John James Audubon possessed a genius for failure. One of the many victims of his incompetence was the poet John Keats, who in 1820 directed his sister-in-law, "Tell Mr. Audubon he's a fool."[1] The previous summer, Keat's brother George, who had gone to Kentucky to revive the family fortunes, had lost most of his money investing in a steamboat with Audubon. At the moment Keats invested, when Audubon assured him in good faith that the boat was heading south to be sold for a profit, it was actually resting on the bottom of the Ohio River.[2] John Keats, having counted on his brother's success to free him from debt and allow him to marry his beloved Fanny Brawne, was understandably bitter. In the summer of 1819, after a series of disasters culminating in bankruptcy, Audubon wisely abandoned business for a career in art.[3]

Though Audubon had long sketched wildlife as a gentlemanly pastime, he found portraiture far more lucrative. This portrait is one of several he made of friends and family before publicly offering his services. The subject, Benjamin Page (1765–1834), was a successful Pittsburgh glass manufacturer whose daughter had married Audubon's brother-in-law, Thomas Bakewell. Like George Keats, Page had lost a good deal of money on one of Audubon's enterprises, a saw and grist mill at Henderson, Kentucky, in which Bakewell had been a partner. According to family tradition, Page sat for this portrait on his fiftieth birthday while visiting Henderson. The artist, in his formidable French accent, asked Elizabeth Bakewell, "Lizpet', you like your fat'er's picture?" and made the drawing on the spot.[4] There may be some truth to this story, but, according to an inscription in Audubon's hand on the back of the drawing, it was made in September 1819, when Page was fifty-four, at Shippingport, Kentucky (today part of Louisville), where the destitute Audubon was staying with another brother-in-law, Nicholas Berthoud.

Years later, a member of the Bakewell clan remembered Page as a "fine-looking man with large, bright eyes, pleasing manner and a hearty laugh."[5] Few of these qualities are suggested by Audubon's rather hard,

Benjamin Page
1819
graphite, charcoal, and white chalk on a pink ground on paper
11 ⅜ x 9 in.
(28.9 x 22.9 cm.)
Gift of Benjamin Page, 76.66

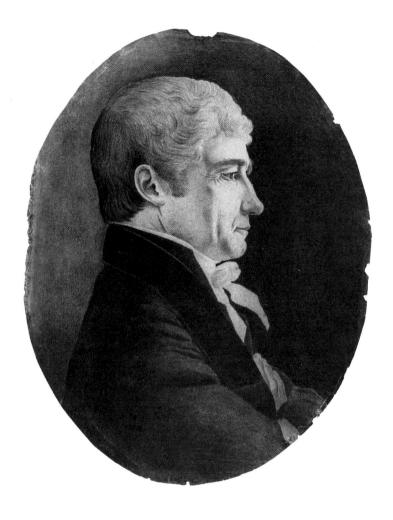

Audubon, *Benjamin Page*

labored rendering. Despite his claim to have studied at Paris with
Jacques-Louis David shortly before emigrating to the United States in
1803, *Benjamin Page* is typical of the profile portraits produced by
countless itinerant American artists of the early nineteenth century,
though with nicer detail and modeling than most. Audubon's work was
nevertheless well received by the citizens of Louisville, and he was soon
able to support his family in modest comfort. Between 1820 and 1826,
while traveling about the country to collect material for *The Birds of
America*, he often turned to portraiture when his funds ran low.

KN

NOTES: 1. John Keats to Georgiana Keats, 13 January 1820, in H. Buxton Forman,
ed., *The Complete Works of John Keats*, Vol. V (Glasgow, 1901), 141. 2. Walter Jackson
Bate, *John Keats* (New York, 1966), 575. 3. Audubon's transition from businessman to
artist is described in Edward Dwight, "The Metamorphosis of John James Audubon," *Art
Quarterly* XXVI (1963): 461-80; Alice Ford, *John James Audubon* (Norman, Oklahoma,
1964); and Alexander B. Adams, *John James Audubon, A Biography* (New York, 1966).
4. "Audubon in Pittsburgh," *The Cardinal* I (July 1924): 17. 5. B. G. Bakewell, *The
Family Book of Bakewell*, *Page*, *Campbell* (Pittsburgh, 1896), 71.

JOSHUA SHAW

B. ENGLAND, 1776—1860

JOSHUA Shaw, a Manchester, England, sign-painter who aspired to the dignity of easel painting, won modest recognition in London for his landscapes in the fashionable Italianate pastoral mode. He also achieved notoriety as a forger specializing in the works of Gainsborough, de Louterbourg, and the seventeenth-century Dutch landscapists Berchem and du Jardin. In 1817, having "long contemplated America as the land of promise,"[1] Shaw immigrated to Philadelphia, where he soon became highly respected in his field. He was one of the first artists to appreciate the distinctive character of the American landscape, anticipating, in the 1820 introduction to his series of engravings entitled *Picturesque Views of American Scenery*, the creed of the Hudson River School:

> In no quarter of the globe are the majesty and loveliness of nature more strikingly conspicuous than in America. The vast regions which are comprised in or subjected to the republic present to the eye, every variety of the picturesque and sublime. Our lofty mountains and almost boundless prairies, our broad and

Environs of Pittsburgh, Pennsylvania
c. 1825
pen and ink and graphite on paper
9 ¾ x 14 in.
(24.8 x 35.6 cm.)
Gift of Guy R. Bolton, 13.1.2

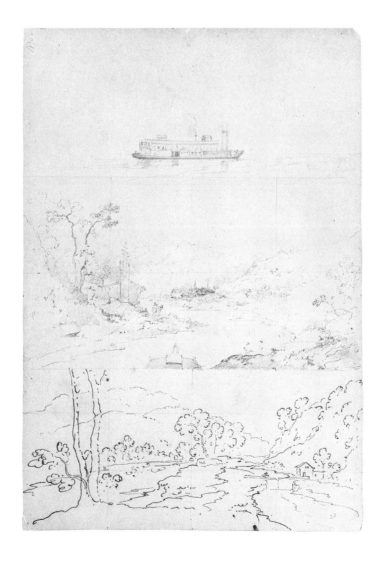

Shaw, *Environs of Pittsburgh, Pennsylvania*

magnificent rivers, the unexampled magnitude of our cataracts, the wild grandeur of our western forests, and the rich and variegated tints of our autumnal landscape are unsurpassed by any of the boasted scenery of other countries. Striking, however, and original as the features of nature undoubtedly are in the United States, they have rarely been made the subjects of pictorial delineation. . . . America only of all the countries of civilized man is unsung and undescribed. To exhibit correct delineations of some of the most prominent features of natural scenery in the United States is the object of the work of which the first number is now offered to the public.[2]

Shaw sketched and painted many views of Pittsburgh and the surrounding countryside. *Environs of Pittsburgh* is traditionally dated 1825 and could not have been drawn earlier, for it depicts the saltworks built in that year by George Anschutz at the confluence of Saw Mill Run and the Ohio River. Although this drawing is a direct and factual field study (note the quickly sketched dugout canoe at the upper right), it gives some indication of the extent to which the artist's view of American scenery was colored by the Arcadian visions of Berchem and de Loutherbourg. Several years later the Pittsburgh artist Russell Smith would use these same saltworks to create an image of early industrial blight.[3] Shaw, however, regarded them simply as picturesque New World counterparts to the ruined towers and temples of classical landscape tradition, and he cheerfully integrated the clouds of smoke and steam, produced by boiling salt water, with the frothy foliage of the woods. His conventionalization is more apparent in *Sketches at Pittsburgh* (c. 1825), a single sheet containing studies of a steamboat and two landscapes; and in *View on the Kiskeminetas* (1838, Department of State, Washington, D.C.), another western Pennsylvania scene, the process of idealization is complete: cows in the Dutch manner rest in the shade of a Claudian mass of trees, while chimneys in the softly lighted distance waft delicate plumes of smoke into untroubled skies.

Shaw's benign attitude toward industrialization in America may have stemmed in part from his having seen worse things in the north of England and in part from his love of technology. He himself patented several inventions in the field of gunnery and received a premium from Czar Nicholas I of Russia for improvements in naval warfare. His inventions occupied a great deal of his time, but he continued to paint until he was stricken with paralysis in 1853.

KN

NOTES: 1. William Dunlap, *A History of the Rise and Progress of the Arts of Design in the United States*, Vol. III (New York, 1834; rev. ed. Boston, 1918), 102. A bibliography for Shaw appears in George C. Groce and David H. Wallace, *The New-York Historical Society's Dictionary of Artists in America 1564-1860* (New Haven, Connecticut, 1957), 574. 2. Joshua Shaw, *Picturesque Views of American Scenery* (Philadelphia, 1820), intro. 3. Smith painted three versions: *Pittsburgh from the Salt Works on Saw Mill Run* (1838-40, collection of Virginia E. Lewis); *Pittsburgh from Saw Mill Run* (1843, Historical Society of Western Pennsylvania, Pittsburgh); and *Pittsburgh Fifty Years Ago from the Salt Works on Saw Mill Run* (1834-44, Museum of Art, Carnegie Institute).

EASTMAN JOHNSON

1824 — 1906

IN the 1860s and 70s Eastman Johnson was celebrated for his portraits and genre pieces; by the time he died, on April 5, 1906, he had outlived his vogue. Sadakichi Hartmann, writing in 1901, had praised him as a pioneer of modern realism, but added that he "sought feebly to utter great thoughts."[1] In a memorial published shortly after the artist's death, the critic Frank Fowler presented him as a figure of primarily historical interest, who represented a vanished era of American life and art.[2] It is hardly surprising that, in 1906, when Johnson's widow submitted four of his charcoal sketches for the museum's American drawings collection, John Beatty selected the least expensive and offered only half the requested sum of one hundred fifty dollars. Anxious to sell her husband's work, Mrs. Johnson accepted the offer.

My Jew Boy
1852
graphite and crayon heightened with white chalk on brown paper
14 1/16 x 12 7/16 in.
(37.1 x 31.6 cm.)
Andrew Carnegie Fund, 06.11

Johnson, *My Jew Boy*

37

Beatty's choice was a shrewd one, for *My Jew Boy* is arguably Johnson's finest work on paper and a great American portrait drawing. Although Johnson created other exceptional portraits, such as *Secretary Dobbin* (1856, Addison Gallery of American Art, Andover, Massachusetts), they are invariably less spontaneous and interesting compositions and less successful in making the transition between tightly handled and more loosely sketched areas.

Johnson made *My Jew Boy* in February 1852 in The Hague, where he had settled six months earlier after studying for two years at the Royal Academy, Düsseldorf. He had embarked for Europe in 1849, by which time he had already achieved considerable success with his charcoal portraits of such notables as Dolley Madison, John Quincy Adams, and Ralph Waldo Emerson. During his four years in The Hague, Johnson won still greater renown and was offered the position of court painter shortly before he left to study in Paris with Thomas Couture.[3] *My Jew Boy* (the model was probably Johnson's servant)[4] represents both the culmination of the artist's early skill in charcoal portraiture and the dawning of his interest in the sympathetic portrayal of ethnic types, which, in the later 1850s and 60s, would produce his remarkable studies of Chippewa Indians and his popular images of American blacks. He was deeply influenced by the character studies of Rembrandt, whose work he admired and copied in The Hague (he became known at the time as the "American Rembrandt"), and Rembrandt's portrayals of Amsterdam Jews may well have inspired Johnson's sketch.

My Jew Boy, which Johnson executed at the height of his powers, is a superb example of the artist's draftsmanship. Having quickly laid down the basic contours with a light, fluid line, he selectively worked up the drawing to emphasize the sitter's face. The features are delineated with precision and delicacy, softly modeled and judiciously highlighted with white. Johnson effected a technically dazzling transition from the sitter's highlighted forelocks to the heavily shadowed back of his head. Below the head the handling becomes progressively broader, less finished, but no less accomplished. The strength of the outlines is varied to suggest the fluctuating qualities of light, and a few velvety black charcoal lines suggest the heavy texture of the model's coat. The result is a drawing of great richness and variety, at once spontaneous and controlled.

KN

NOTES: 1. Sadakichi Hartmann, *A History of American Art*, Vol. I (Boston, 1901), 161. 2. Will H. Low, Carroll Beckwith, Samuel Isham, and Frank Fowler, "Eastman Johnson—His Life and Works," *Scribner's Magazine* XL (August 1906): 256. 3. The best treatments of Johnson's life are Patricia Hills, *The Genre Painting of Eastman Johnson* (New York, 1977) and Whitney Museum of American Art, New York, *Eastman Johnson* (1972), exh. cat. by Patricia Hills. Also useful are John I. H. Baur, *Eastman Johnson, 1824-1906: An American Genre Painter* (Brooklyn, 1940) and William Walton, "Eastman Johnson, Painter," *Scribner's Magazine* XL (September 1906): 263-74. 4. In a letter to John Beatty, 19 October 1906 (Museum of Art files), Mrs. Johnson tantalizingly remarks, "I think there is a note of who that boy was in his letters."

DAVID GILMOUR BLYTHE

1815 — 1865

ESSENTIALLY unknown outside the Pittsburgh area, during his lifetime and for decades after, David Gilmour Blythe is now recognized as the principal satiric genre painter of nineteenth-century America. Born in East Liverpool, Ohio, into the family of an immigrant Scottish Presbyterian, Blythe grew up with a rigid sense of morality that consistently informed his brutal, grotesque caricatures of contemporary life, in which he used the grimy industrial city of Pittsburgh as a showcase for urban horrors. His personality was contradictory. A staunch Protestant, he married a Catholic. Vociferously Republican, he nevertheless counted prominent Democrats among his close friends. And although a number of his pictures graphically depict the evils of alcohol, Blythe himself finally succumbed to "mania potu," or delirium from drink.

The drawings in Carnegie Institute, *Portrait of the Artist* and *A Free-Trade Man*, are two of only five located drawings by Blythe and are images of uncommon interest. Although *Portrait of the Artist* has been known and published for the last half century, further information now suggests that it was made at an earlier date than previously thought, and it bears an inscription heretofore undiscovered. A rediscovered newspaper article substantiates the traditional assertion that *A Free-Trade Man* represents Blythe's Democrat friend William (Billy) Bleakley, and a technical examination of the sheet confirms that, contrary to earlier descriptions by art historians, its appearance was significantly altered at some point long after its creation and probably well after the artist's death.[1]

Portrait of the Artist is one of two known self-portrait drawings by Blythe, the other of which is now lost. Thus it is the only precisely identifiable extant self-portrait (although it has been suggested that his face appears in some of his paintings). The drawing seems to have been important to Blythe, for he retained it among his papers, which were passed down in the family after his death. The sheet was rediscovered in the 1930s when an exhibition of Blythe's work was being prepared by Carnegie Institute; it surfaced among documents in the possession of the artist's nephew.[2]

The drawing, which is signed twice, once in the artist's usual hand across the bottom edge and again in a different style on the right, depicts a full-length view of a young man. Fashionably clad in a top hat and frock coat, legs casually crossed, he leans his right elbow on some kind of post and lintel arrangement and poses his left hand on his hip.

The portrait has formerly been dated to the period 1854–58.[3] Because of its subtle draftsmanship it has been cited as an example of the new assurance demonstrated in the artist's paintings from 1854. Second, *Portrait of the Artist* has been related stylistically to *A Free-Trade Man*, a drawing almost certainly executed in the 1850s.[4]

Upon closer examination, this dating is not as convincing as an earlier date of about 1848. First, it does not seem logical that the young man in the drawing, who looks at us with pensive gentleness, would be the man of thirty-nine to forty-three that Blythe would have been in 1854–58 when the drawing supposedly was made. During this time, Blythe had become

Portrait of the Artist
c. 1848
graphite on paper
8 ¼ x 5 ½ in.
(21 x 14 cm.)
Mr. and Mrs. James H. Beal
Fund, 54.31.5

A Free-Trade Man
c. 1854–58
graphite and pen and ink
on paper
11 ¼ x 7 ¾ in.
(28.6 x 19.7 cm.)
Mr. and Mrs. James H. Beal
Fund, 54.31.4

a widower, lost his father, and experienced crushing professional failure. By 1854, he had become a brittle, caustic satirist and had begun to paint the acid images for which he is best known today.

Further justification for the earlier date is the fact that the style of *Portrait of the Artist* is markedly different from the Bleakley portrait, which has been executed in Blythe's mature style. The careful modeling of the artist's head has nothing to do with the rapid, jabbing motions of the pencil that define the features of Bleakley, with his wizened crab-apple mouth.

Blythe's precocious expertise in the self-portrait may possibly be explained by his use of a photograph, now lost, from which he copied the upper part of his body. The treatment of the upper body, in fact, resembles two extant photographic portraits of the artist, one in the collection of the Museum of Art and the other in the archives of the East Liverpool Historical Society. The photographs, which were probably made around 1862, show an older man than the self-portrait but depict half-length views of Blythe leaning on his elbow in the same fashion as in the drawing.[5] They were taken at a studio in Uniontown, where Blythe was actually a resident in 1848, the year that the postulated photograph would have been taken.[6] His fiancée, Julia Keffer, was a native of that

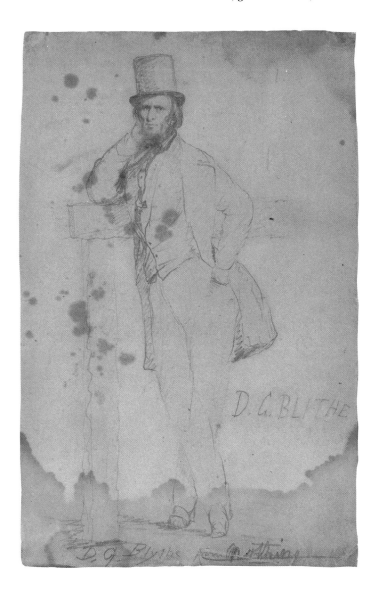

Blythe, *Portrait of the Artist*

town, and 1848 was also the year that Blythe was completing his commission to carve a statue of General Lafayette for the Uniontown courthouse. It is not unlikely that this was when Blythe began to patronize the studio that took his later photographs. What is more, the self-portrait resembles both a print of Lafayette after an 1823 painting by Ary Scheffer, which Blythe used as a model for his sculpture, and, in the long-legged, top-hatted pose, Abraham Lincoln, a fellow Republican much admired by Blythe.[7]

The chance that Blythe worked from a half-length photograph, now lost, would account for the subtlety of handling that has been thought to be beyond the capabilities of the artist at this time. Further, working from a photograph would explain the relative finish of the upper part of the portrait and account for the sketchiness of the lower part, which has been roughed in almost as an afterthought. From the waist down, the body does not fit easily with the torso, and the vertical post on which Blythe is leaning extends awkwardly into an unresolved space.

Until recently scholars never noticed another inscription that lies underneath the words "from nothing." Hidden under that scrawl are the words "from the original." Sadly, the meanings of both inscriptions remain cryptic. Another curious element is the second signature at the right. The signer made the obvious and deliberate pun on the artist's last name, writing "Blithe" instead of "Blythe." Whether or not Blythe, or someone else, wrote this as a simple observation on his present happy mood or as a rueful or ironic comment on his sad fate, and what, if anything, the signature has to do with the inscription, is still obscure. But the drawing seems to have been a rare memento of the confident and successful man the artist had once been, before personal tragedies soured the joy in his life.

Blythe's vehemently drawn portrait of *A Free-Trade Man* represents the artist's mature graphic style. It is signed "Boots," a nickname he came to adopt that may have referred to his rough attire and frequent peregrinations. Although the name of the subject does not appear on the sheet, it was always said that he was Blythe's friend William (Billy) Bleakley. The recently discovered newspaper article mentioned earlier described this portrait as well as its provenance and noted that the sketch was reproduced in an unidentified East Liverpool newspaper.[8] Without question it is the museum's drawing that the article describes, definitely pinpointing the subject as Bleakley.

Bleakley seems to have been a colorful figure in the social and political history of the East Liverpool region, but information about him is regrettably scarce since there were no newspapers in the area until 1869.[9] According to a much later article of June 1895 in the *East Liverpool Tribune*, William Bleakley was born in Liverpool, England, sometime in the early nineteenth century.[10] His two brothers, James and John, had emigrated earlier to Pittsburgh and moved to East Liverpool, Ohio, in the late 1830s. After trying out several business ventures, they joined forces with a pottery firm in East Liverpool where the fledgling industry was becoming enormously successful.[11]

Billy Bleakley was based in Virginia during the 1840s, working as a contractor until he lost his money and joined his brothers in East Liverpool in 1852. The financial panic of 1857 destroyed their pottery firm and probably at this time Billy established himself as a cobbler.[12] The newspaper account documents his admission to the county

Blythe, *A Free-Trade Man*

infirmary, or poorhouse, on September 27, 1858, and he was in and out of that institution until his death on August 8, 1879.

The inscription "free-trade man" refers to Bleakley's role or interest in the current free-trade controversy, which involved the problem of English competition in the ceramics industry. This was an issue that would have greatly disturbed the Bleakley family, and on which the three brothers would surely have taken a public stand. The intent to defeat English imports led to extensive lobbying for protective tariffs and regional conflicts of interest. Bleakley was a Democrat and Blythe a member of the newly established Republican party, and it is not unlikely that the artist was lampooning his friend in a partisan spirit and that his shrewdly observed portrait is a rather biting caricature. Until the local histories now in progress are completed, however, little more can be known of the relationship between Blythe and his elusive friend.

EAP

NOTES: 1. At some unspecified time *A Free-Trade Man* underwent extensive restoration, for the black background surrounding the figure, which has been admired as an effective device "lending it the look of a cutout," is most certainly a later addition. (See Theodore E. Stebbins, Jr., *American Master Drawings and Watercolors* [New York, 1976],

181.) The fact that the ink fills the creases of the old paper, which has also been backed, suggests that the black background was added after the sheet had suffered a lot of wear; it was not part of the artist's original intention and may have been added at the time the drawing was reproduced or perhaps when the sheet was backed by a conservator. 2. See Tom T. Jones, "The Reviewing Stand," *East Liverpool Review*, 1 December 1932. This article describes the discovery of the museum's two drawings among the papers of the artist's nephew Heber Blythe. 3. Bruce W. Chambers, *The World of David Gilmour Blythe (1815-1865)* (Washington, D.C., 1980), 189. 4. Chambers, 32. 5. Chambers, 10. 6. On the mount of the Museum of Art's photograph appear the embossed name and address of the studio and photographer: Leonard/C.C. Kough/Artist/10 1/2 West Main Street/Uniontown, Pa. 7. Jones made the connection with Lincoln. 8. Jones. 9. I am indebted to Mr. William Gates, curator of the Ceramics Museum, East Liverpool, Ohio, for information about the history of the town and about William Bleakley, his brothers, their ceramics factory, and the pottery trade of the region. 10. *East Liverpool Tribune*, 8 June 1895. Reference provided by Mr. William Gates. 11. See Edwin Allen Barber, *The Pottery and Porcelain of the United States* (New York and London, 1901), 192. 12. See Dorothy Miller, *The Life and Work of David G. Blythe* (Pittsburgh, 1950), 76. It is not clear where Miller received this information that Bleakley was a cobbler.

WILLIAM STANLEY HASELTINE

1835 — 1900

WILLIAM Stanley Haseltine, despite Virgil Barker's unkind observation that his "real career was not so much painting as being rich and handsome,"[1] was one of the most talented landscape artists of his generation. Born into a wealthy family, he attended Harvard University, then returned to his native Philadelphia to study under the German landscape and portrait painter Paul Weber. When Weber went back to Germany in 1854, Haseltine accompanied him and there joined the colony of American artists working and studying in Düsseldorf. Two years later he traveled to Italy with his fellow students Worthington Whittredge and Albert Bierstadt. Haseltine lived in Rome until 1858, then returned to the United States and settled in New York City. He was elected an associate of the National Academy of Design in 1860 and became a full member the following year.

Haseltine's finest and most popular works are the coastal scenes he painted during the 1860s. These austerely geometric compositions, in which minutely rendered natural forms are seen bathed in an extraordinarily clear light, fully partake of the mid-nineteenth-century luminist sensibility.

Rocky Coastline, New England, which employs Haseltine's favorite compositional formula of a rugged shore against a broad vista of open sea, is in many respects typical of his work from this period. Here, as in his paintings, the viewer's gaze is immediately caught and held by the details in the foreground. At a time when America's intellectual and artistic climate was largely conditioned by the natural theology of John Ruskin, the artist's rare gift for observing and transcribing geological forms won him admiration. In 1867, the influential critic Henry Tuckerman published a characteristically florid tribute to Haseltine's "rock portraits":

> Few of our artists have been more conscientious in the
> delineation of rocks; their form, superficial traits, and precise

Rocky Coastline, New England
1860s
graphite and ink wash on paper
15 x 22 ¼ in.
(38.1 x 56.5 cm.)
Museum purchase: gift of the
Robert S. Waters Charitable
Trust, 83.34

43

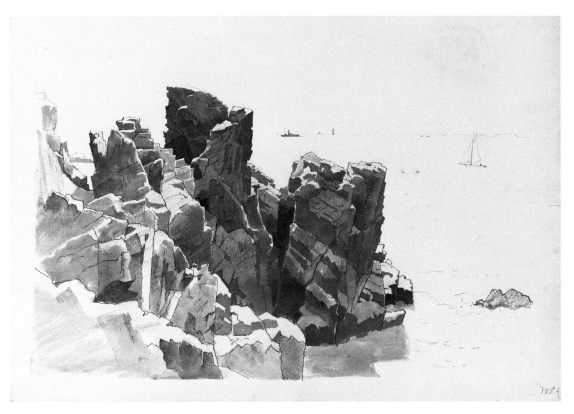

Haseltine, *Rocky Coastline, New England*

tone are given with remarkable accuracy. His pencil identifies coast scenery with emphatic beauty; the shores of Naples and Ostia, and those of Narragansett Bay, are full of minute individuality . . . there is a history to the imagination in every brown angle-projecting slab, worn, broken, ocean-mined and sun-painted ledge of the brown and picturesquely-heaped rocks, at whose feet the clear green waters splash: they speak to the eye of science of a volcanic birth and the antiquity of man.[2]

In 1869 Haseltine again moved to Rome, where, except for frequent visits to the United States, he remained for the rest of his life. He was a leader of the international art community in Rome and was instrumental in founding the American Academy there in the 1890s. Under the brilliant Italian sunshine, his painting became more richly colored, but he never equaled the achievement of his American period.[3]

KN

NOTES: 1. Virgil Barker, *American Painting: History and Interpretation* (New York, 1950), 541. 2. Henry Tuckerman, *Book of the Artists* (New York, 1867), 556-57. 3. The only monograph on the artist is *William Stanley Haseltine, Sea and Landscape (1835-1900)* (London, 1947) by his daughter, Helen Haseltine Plowden. His drawings are discussed in Davis & Langdale Company, Inc. (in association with Ben Ali Haggin, Inc.), New York, *William Stanley Haseltine (1835-1900), Drawings of a Painter* (1983), exh. cat., essay by John Wilmerding.

DANIEL HUNTINGTON

1816 — 1906

Mount Washington
1862
graphite and white chalk on
darkened olive-green paper
10 ½ x 17 ½ in.
(26.7 x 44.5 cm.)
Andrew Carnegie Fund, 06.10

DANIEL Huntington is remembered chiefly for his attempt to establish the great European tradition of historical and religious painting in the United States. He inherited this ambition from his teacher, Samuel F. B. Morse, whose own earlier efforts had met with public indifference. By 1835–36, when Huntington studied with him, Morse had largely given up art for telegraphy, despite the fact that he was president of the National Academy of Design and would hold that office for another decade. In 1839, Huntington traveled to Italy with Henry Peters Gray to absorb the lessons of the Old Masters. He was particularly impressed by Titian, Correggio, and, above all, Guido Reni, whose Baroque fusion of Raphaelesque classicism and degrees of expression ranging from gruesome action to cloying sentiment were greatly esteemed in Europe and America during the first half of the nineteenth century.[1]

Not long after he returned to the United States, Huntington created his single most successful work, *Mercy's Dream* (1841, Pennsylvania Academy of the Fine Arts), illustrating an episode from John Bunyan's *Pilgrim's Progress*. This Italianate rendering of a Protestant subject proved immensely popular as an engraving.[2] Huntington discovered, however, that portraits were in far greater demand than religious subjects. During the 1850s he abandoned his dream of becoming the American Guido Reni and became, instead, New York's most fashionable portraitist. His long tenure as president of the National Academy of Design (1862–70, 1877–91) is a measure of the power and prestige he enjoyed for most of his career, despite the unrelieved banality of most of his *oeuvre*.[3]

Huntington, *Mount Washington*

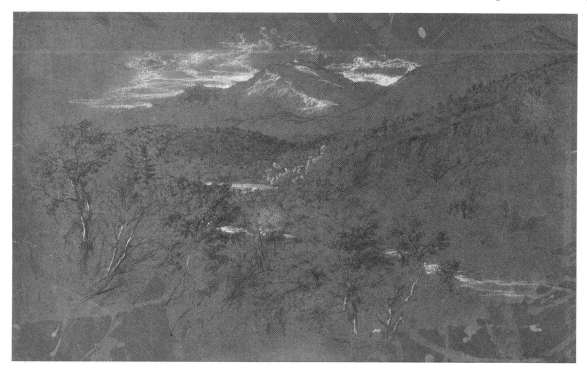

Mount Washington represents a little-known side of Huntington's achievement. His preoccupation with the human figure and with historical and biblical themes would seem to place him in opposition to the Hudson River School, which elevated landscape, traditionally considered an inferior branch of art, to a position of first importance in American painting. Huntington, however, was by no means immune to the school's influence. As early as 1836, when he was studying with Morse, he spent several months painting in the Catskill Mountains. *Mount Washington,* made in the White Mountains at Gorham, New Hampshire, during the summer of 1862, testifies to his continued interest in picturesque American scenery. The beauty of this drawing, a superb example of the Hudson River style, leads one to regret that he did not devote his talents entirely to landscape painting.

KN

NOTES: 1. The nineteenth-century fascination with Guido Reni (1575-1642) is memorably portrayed in Nathaniel Hawthorne's *The Marble Faun* (1860). *St. Michael* (1635, Church of the Capuchins, Rome) and *Beatrice Cenci* (n.d., Galleria Nazionale D'Arte Antica, Rome) were widely considered his greatest works. 2. For a discussion of this work see William Gerdts, "Daniel Huntington's *Mercy's Dream:* A Pilgrimage Through Bunyanesque Imagery," *Winterthur Portfolio* XIV (Summer 1979): 171-94. 3. There is no monograph on Huntington. Nineteenth-century references include Henry Tuckerman, *Book of the Artists* (New York, 1867), 321-32; S. W. G. Benjamin, "Daniel Huntington," *American Art Review* II (1881): 223-28 and "Daniel Huntington," *American Art and Art Collections* I (1889): 18-36.

JOHN FREDERICK KENSETT

1818 — 1872

Elm
1862
graphite on paper
11 ¼ x 8 ⅛ in.
(28.6 x 20.6 cm.)
Mr. and Mrs. George R. Gibbons, Jr., Fund, 84.10

FROM the 1850s until his death, John Kensett was the leading artist of the Hudson River School's second generation. Like his friends and fellow landscapists Asher B. Durand and John Casilear, he began his career as a commercial engraver, a trade he abandoned in the mid-1840s when a legacy from his grandmother allowed him to devote himself entirely to painting.

Most of Kensett's drawings are field studies made during summer sketching tours to serve as models in the studio. As a draftsman, Kensett was concerned chiefly with the accurate, objective rendering of natural forms, and he adopted pencil as the medium best suited to achieve the precision he desired. He rarely made watercolor studies—the effects of color, light, and atmosphere essential to the poetic, contemplative mood of his landscapes were painted from memory and constitute a subjective element in his work. Despite the fact that Kensett's field studies were intended as visual references rather than as finished compositions, many of them are extremely beautiful.

Elm was sketched during the summer of 1862 in the Saranac Lakes region of the Adirondack Mountains. It is, as John Paul Driscoll points out, an extremely accomplished drawing, one that "goes beyond the 'scrupulous fidelity' Durand encouraged of younger artists, and manifests an exploration of the energetic qualities of line and form."[1] Kensett

delineates the intricacies of leaf and branch with extraordinary delicacy and sensitivity. He even manages to suggest, in the lightly drawn contours of the distant mountains, something of the evanescent haze found in his paintings.

On occasion, Kensett also drew finished landscapes to be engraved as book illustrations. The Museum of Art's collection includes two superb pencil drawings made to illustrate Frederick Swartwout Cozzens's *Prismatics*, an anthology of poems, sketches, and burlesques originally published in the *Knickerbocker* magazine under the pseudonym Richard Haywarde. In the preface, Cozzens thanked "those artists, my friends, who have so beautifully illustrated this volume. It was a voluntary offer on their part; but for their suggestions it might, perhaps, never have been printed."[2] Clearly, Kensett was no mere commercial illustrator hired to do a job. His collaborators were Charles Loring Elliott, Thomas Hicks, Thomas Rossiter, and the omnipresent F. O. C. Darley.

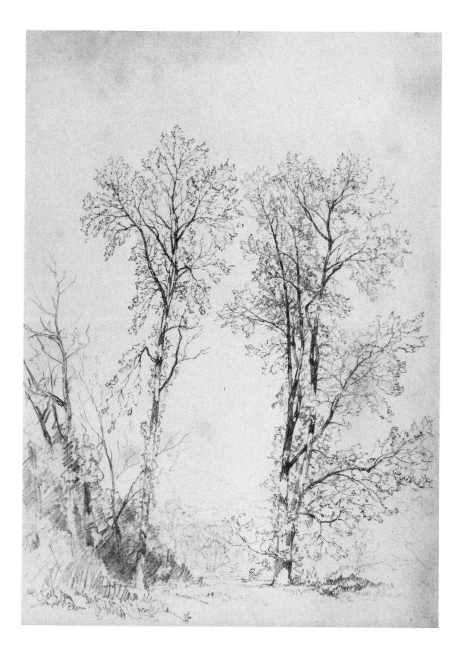

Kensett, *Elm*

For "Hetabel," a flowery, lachrymose recollection of a departed love who "sleeps by her babe beneath the cypress tree," Kensett provided a woodland interior to depict the setting of the poem:

> There's a deep pond hid in yon piny cover
> That's garlanded with roseblooms wild and sweet,
> Enwreathed with pensile willows, hanging over
> Green, bowery nooks and many a soft retreat
> Where Hetabel and I did often meet.[3]

Through dense, framing foliage the ruined mill of the poem can be seen. Kensett also drew a closer view of this mill bathed in romantic moonlight.[4]

Like "Hetabel," "A Babylonish Ditty" also deals with a vanished love, but in this case the nostalgia is embittered by the faithlessness of the "brown-skinned, gray-eyed siren." Kensett seizes on Cozzens's descriptions of the lovers wandering on the shore "amid the sandy reaches, in among the pines and beeches," and of a motionless frigate lying on the "lucid Plain" of the "moveless water," to create a quiet, panoramic landscape in the luminist vein that characterizes many of his best paintings.[5] In *Prismatics* this drawing is slightly reduced, as is the "Hetabel" illustration, and it is also reversed.

KN

NOTES: 1. Museum of Art, Pennsylvania State University, University Park, Pennsylvania, *John F. Kensett Drawings* (1978), exh. cat. by John Paul Driscoll, 78. 2. Frederick Swartwout Cozzens, *Prismatics* (New York, 1853), 9. 3. Cozzens, 53. Kensett's drawing appears above these lines. 4. Reproduced in Cozzens, 55. 5. Reproduced in Cozzens, 133.

THOMAS WORTHINGTON WHITTREDGE

1 8 2 0 — 1 9 1 0

Forest Interior
c. 1882
pen and ink on card
11 11/16 x 11 5/8 in.
(29.7 x 29.5 cm.)
Museum purchase: gift of
H. J. Heinz II Charitable and
Family Trust, 81.104

IN 1859 Worthington Whittredge, a Cincinnati sign-painter turned landscapist, returned to the United States from a two-year sojourn abroad. His experience had been everything an American artist of the day could desire: four years' study at Düsseldorf followed by five years' painting in the golden light of Italy. But, even though he had immersed himself in the landscape traditions of Europe, he was expected by critics and public alike to produce works that would reflect the unique character of the American environment. Anxious to fulfill these expectations, Whittredge set about reacclimating himself to his native land:

> I hid myself for months in the recesses of the Catskills. But how different was the scene before me from anything I had been looking at for many years! The forest was a mass of decaying logs and tangled brushwood, no peasants to pick up every vestige of fallen sticks to burn in their miserable huts, no well-ordered forests, nothing but the primitive woods with their solemn silence reigning everywhere.[1]

For years afterward, Whittredge reproduced his initial response to the American wilderness in a series of woodland interiors. *Forest Interior* is

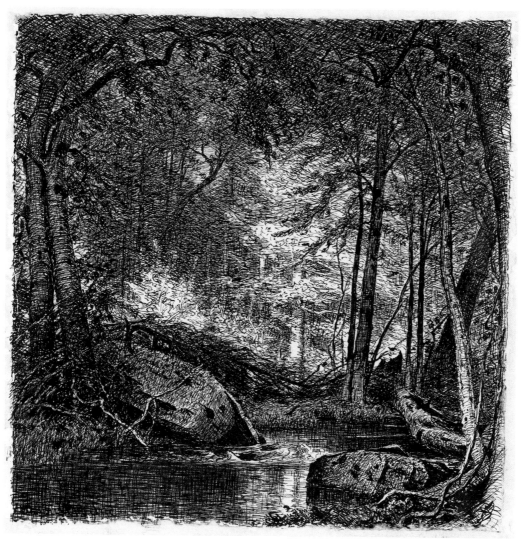

Whittredge, *Forest Interior*

built upon a favorite compositional formula, dating back to the 1860s, of dark trees and water framing a brilliantly lit middle ground (see, for example, *The Old Hunting Grounds*, 1864, Reynolda House, Winston-Salem, North Carolina). *Forest Interior* has an intimate feeling akin to that of the Barbizon painters, though Whittredge had visited Barbizon and thought little of their work. This drawing is closely related to an oil painting of the same title (1882, The Art Institute of Chicago); so closely related, in fact, that it is not a study but a faithful transcription of the painting into a different medium. Whittredge is known to have made etchings after his paintings (there is a copy of an etching after *The Old Hunting Grounds* at Reynolda House), and he probably made Carnegie Institute's drawing to serve as a model for an etching.

KN

NOTES: 1. John I. H. Baur, ed., "The Autobiography of Worthington Whittredge, 1820-1910," *Brooklyn Museum Journal* (1942): 42.

WINSLOW HOMER

WINSLOW HOMER

1836 — 1910

AS a child, Winslow Homer was encouraged in art by his mother, a talented watercolor painter who sent her work to professional exhibitions. Otherwise, he was essentially self-taught. He never graduated from high school, but worked as an apprentice in a lithography firm in Boston and then supported himself as a commercial artist in New York. In the 1860s he became one of the most popular American illustrators, producing designs for *Harper's Weekly* and other magazines that presented an optimistic picture of American rural life. He began to make paintings in 1862, but it was not until 1874 that Homer largely abandoned illustration and began to support himself chiefly by selling his oils and watercolors.

In 1881 Homer left the United States to work for two years in England, where he settled in the tiny fishing village of Cullercoats on the eastern coast. This period has generally been viewed as the turning point in his career, for it is when he first began to deal with marine subjects and to express a new seriousness of mood. On his return to the United States Homer settled not in New York but at the remote village of Prout's Neck on the coast of Maine, where he spent the remainder of his career. From this point on, Homer saw little of artists in New York and grew increasingly eccentric and reclusive. Prolific in watercolor, Homer created oil paintings slowly, seldom completing more than two or three in a year and producing none at all between 1887 and 1889 and between 1905 and 1908. Homer's canvases usually dealt with scenes of hunting or fishing or with life in the wilderness or at sea; they were remarkable for their emotional power and strength of design. By the time of his death in 1910, Homer was widely regarded as the greatest American painter of his time.

Homer's *The Wreck* (1896) won the Chronological Medal in the first Carnegie International exhibition and was the first painting purchased for Carnegie Institute. Homer served twice on the jury of the International exhibition, in 1897 and in 1901, though he was never a juror for any other institution, and he became a close friend of the museum's first director of fine arts, John Beatty, who wrote a memoir of Homer that was printed in Lloyd Goodrich's 1944 monograph on the artist.[1]

The three drawings in the Museum of Art illustrated here show Homer's rapid evolution, in the late 1870s and early 80s, from a commercial artist to a major painter. *Pumpkins Among the Corn* is an example of Homer's work as a popular illustrator who dealt with cheerful themes in a vernacular manner. *Fisher Girls*, made five years later, is perhaps the single most important drawing from Homer's sojourn in England; it reveals a notable increase in his skill as a draftsman and a new monumentality of form and seriousness of theme. Homer once told John Beatty that he had worked very hard in this period.[2] *Figures on the Coast* was created just after Homer's return from England, when he was beginning his first group of major marine paintings, including *The Herring*

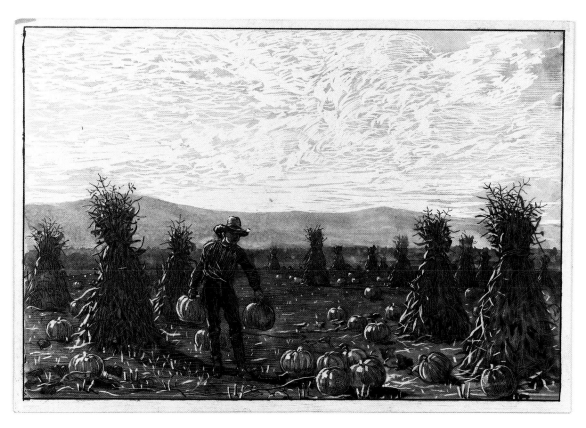

Homer, *Pumpkins Among the Corn*

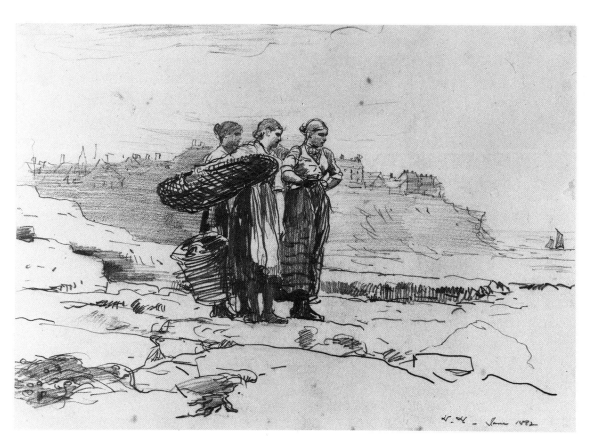

Homer, *Fisher Girls*

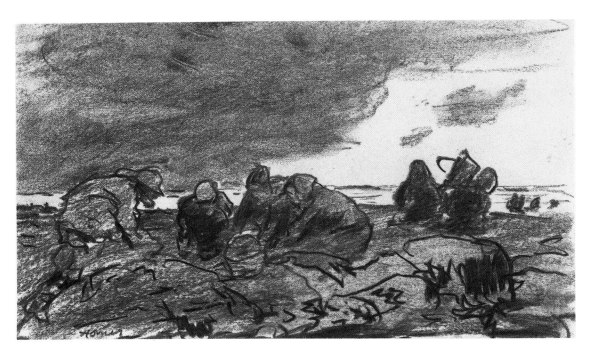

Homer, *Figures on the Coast*

Net (1885, The Art Institute of Chicago), *The Fog Warning* (1885, Museum of Fine Arts, Boston), and *Lost on the Grand Banks* (1886, collection of Mr. and Mrs. John E. Broome). The drawing shows a new freedom of handling, evidence that Homer was no longer concerned with mastering technical skills but was focusing on emotional expression and the broad massing of forms.

Pumpkins Among the Corn was made to illustrate an article titled "Glimpses of New England Farm Life" in *Scribner's Monthly*. In a discussion of autumn in New England, this article noted, "The small forest of maize becomes an Indian village whose wigwams are cornshocks, in whose streets lie yellow pumpkins with their dark vines trailing among the pigeon-grass and weeds."[3] The article also carried another illustration by Homer, *The Sower*, extant only in its published form. That drawing directly imitated, without acknowledgment, Jean-François Millet's famous painting of the same title (1850, Museum of Fine Arts, Boston). *The Sower* provides interesting evidence of the Barbizon master's influence on Homer's work. *Pumpkins Among the Corn*, on the other hand, has a more distinctly American flavor, most notably because of its subject; pumpkins were a popular vegetable in the United States but were not cultivated in Europe.

Pumpkins Among the Corn was used again, in 1882, to illustrate Eugene J. Hall's *Lyrics of Home-Land*, a book that attempted to "picture with fidelity the better side of American life, manners and scenery."[4] The drawing was associated with "A Summer Romance," a poem in dialect about the ill-fated love of Ebeneezer Paine for Cynthiana Cain. It accompanied the stanza, "Amid the shocks o' standing corn, in melancholy mind/all day he worked with look furlorn, an' hated wimminkind."[5]

For the first and perhaps the only time in his career, Homer used a scratchboard technique for *Pumpkins Among the Corn*.[6] First he waxed a sheet of white cardboard and covered it with gray wash; then he scratched away the wash to bring out a design in white. He finished with lines of darker wash to indicate the areas of deep shadow. The effect was easy to reproduce exactly in wood-engraving, also a white-line technique.

Homer's handling of the corn shocks in *Pumpkins Among the Corn* is closely similar to the way he handled the same motif in a watercolor, *Corn Husking* (c. 1874, University Art Collection, University of Arizona, Phoenix).[7] Homer returned to the theme of a boy holding a pumpkin in another watercolor, *For to be a Farmer's Boy* (1887, The Art Institute of Chicago).

Fisher Girls, one of Homer's most masterful pencil drawings, was executed when he was living in Cullercoats, England. At that time Cullercoats was already a popular spot for English artists, and during his stay Homer concentrated chiefly on mastering English watercolor techniques. *Fisher Girls*, dated June 1882, was made from Beacon Rock looking north across Cullercoats Bay, and shows the village of Cullercoats in the distance. Homer's studio was at number 12 Bank Top, the second to the last house visible on the right.[8]

This drawing established the basic figural grouping Homer was to use in *Hark! The Lark* (1882, Milwaukee Art Museum), the major oil painting he produced in England. Homer thought highly enough of this painting to exhibit it at the Royal Academy in the summer of 1882, and in 1902 he referred to it as "the most important picture I have painted" (a phrase, it should be noted, that he also applied from time to time to other works).[9] Somewhat later Homer reworked the design of *Hark! The Lark* for his watercolor *A Voice from the Cliffs* (1882, private collection), and in 1888 he made an etching of this watercolor, restudying the figures from life to create his best composed version of the subject.[10] While these later compositions are more studied and monumental than *Fisher Girls*, they do not have the drawing's vividness and spontaneity. The varying pressure with which Homer applied his pencil and the consequent variations in the intensity and shininess of the graphite line are particularly expressive.

Figures on the Coast, purchased in 1904, was the first drawing acquired by Carnegie Institute (as noted above, Homer also executed the first painting acquired by the museum). Much freer in execution than Homer's earlier drawings, this scene of cranberry pickers was evidently made in 1883, the year Homer returned from England and settled in Prout's Neck.[11] Another charcoal drawing, of boys picking cranberries, was exhibited at the Kennedy Galleries in New York in 1981. Though far more conservative in handling than *Figures on the Coast*, it was probably made at about the same time.[12]

Homer's treatment of this subject may well have been influenced by Eastman Johnson's ambitious canvas *The Cranberry Harvest* (1880, Timken Art Gallery, San Diego), which was based on numerous drawings and oil sketches that Johnson executed over a five-year period. In addition, Homer had made several earlier studies of berry-picking, including his illustrations *The Strawberry Patch*, in *Our Young Folks*, and *Gathering Berries*, in *Harper's Weekly*.[13]

HA

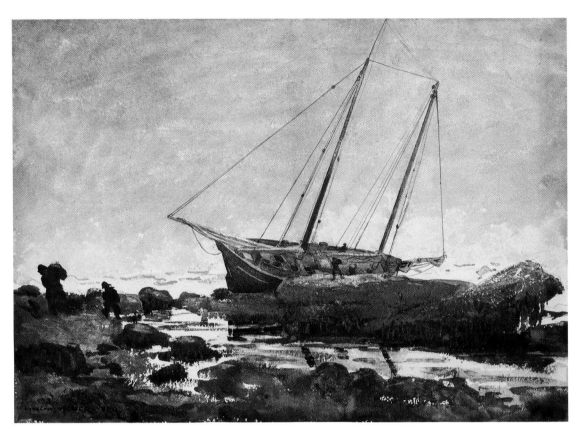

Homer, *A Wreck Near Gloucester*

NOTES: 1. John W. Beatty, "Recollections of An Intimate Friendship," in Lloyd Goodrich, *Winslow Homer* (New York, 1944), 205-26. The original typescript of this essay is now in the Westmoreland Museum of Art, Greensburg, Pennsylvania. 2. Goodrich, 77. 3. "Glimpses of New England Farm Life," *Scribner's Monthly* XVI (August 1878): 526. 4. Eugene J. Hall, *Lyrics of Home-Land*, Vol. VIII (Chicago, 1882), viii. 5. Hall, 77. 6. Gordon Hendricks, *The Life and Work of Winslow Homer* (New York, 1979), 138. 7. Homer made a replica of this watercolor in oil titled *The Last Days of Harvest* (1874, The Strong Museum, Rochester, New York). See Hendricks, 278, 317. 8. Hendricks, 163; William H. Gerdts, "Winslow Homer in Cullercoats," *Yale University Art Gallery Bulletin* (Spring 1977): 18-35. 9. Goodrich, 80-81. 10. Goodrich, 98, 100; Philip C. Beam, *Winslow Homer at Prout's Neck* (Boston, 1966), 55-56. 11. The technique of this drawing is similar to two charcoals of English subjects, *The Last Boat* (Addison Gallery of American Art, Andover, Massachusetts) and *Dark Hour – Tynemouth* (University of Nebraska Art Galleries, Lincoln). Homer probably made all three drawings at about the time he left England and settled at Prout's Neck, around 1882-83. 12. Kennedy Galleries, New York, *Watercolors and Drawings of the Nineteenth Century* (1981), exh. cat., plate 38. 13. Patricia Hills, *Eastman Johnson* (New York, 1972), 87-103.

WINSLOW Homer once told Charles R. Henschel of M. Knoedler and Company, a dealer who handled his work, "You will see, in the future I will live by my watercolors."[1] Today, Homer is generally recognized as the greatest American watercolorist, and this is the medium in which he made his most original contributions. One of the first to appreciate the significance of Homer's works of this type was John Beatty, who organized an exhibition for Carnegie Institute in 1917 of watercolors by both Homer and John Singer Sargent.[2] Beatty particularly admired Homer's tropical scenes, which he once termed "the most amazing watercolors ever produced in this country."[3] Curiously, however, the two watercolors by Homer that Beatty purchased for Carnegie Institute are relatively subdued in color and conservative in technique.

A Wreck Near Gloucester was produced in 1880, when Homer, who was becoming increasingly reclusive, spent the summer on Ten Pound Island in Gloucester Harbor, seeing few people and concentrating on watercolor painting. In December 1880 Homer exhibited over one hundred of the drawings and watercolors he had produced at the firm of Doll and Richards in Boston, selling about one-third of them for sums between five and fifty dollars, for a total of fourteen hundred dollars.[4] The rise in Homer's reputation is indicated by the much higher prices these works brought a few decades later. In 1917 Carnegie Institute paid Knoedler and Company one thousand dollars for *A Wreck Near Gloucester*.

As in Homer's other Gloucester watercolors, the range of pigments in *A Wreck Near Gloucester* is extremely limited, consisting only of muted tones of gray, blue, and brown. The underdrawing shows through the transparent washes in many areas and serves to represent the rigging of the ship, which is rendered with carefully ruled pencil lines. Unlike many of the Gloucester watercolors that are small in scale, informal in feeling, and were probably executed outdoors, *A Wreck Near Gloucester* is a relatively ambitious work, surely produced in the studio. The method of rendering misty weather with an elaborate build-up of delicate washes and carefully stopped-out white areas reflects the influence of English watercolor techniques. In both technique and subject matter *A Wreck Near Gloucester* anticipates the work Homer produced in England the following year.[5]

Although Homer often dealt with the subject of shipwrecks in his later career, he came to the theme only gradually. Indeed, his first treatment of this subject, an illustration titled *The Wreck of the Atlantic*, was not an original composition but a free copy of a work by Daniel Huntington. It represents one of the rare instances in which Homer imitated the work of another artist. In it, Homer did not actually show the wrecked ship, only some debris and the body of a drowned woman that had been cast ashore.[6]

A Wreck Near Gloucester appears to be Homer's first actual representation of a wrecked ship, although, significantly, he did not show the moment of the mishap, only the aftermath in which the ship is unloaded and its cargo salvaged. He did not represent a wreck actually happening until his watercolor *The Wreck of the Iron Crown* (private collection), executed in England in 1881, which he based on a disaster he witnessed on October 21 of that year.[7] From then on, Homer often painted maritime disasters, and a shipwreck was the subject of what may have been his last watercolor, *The Wrecked Schooner* (c. 1908, The Saint

A Wreck Near Gloucester
1880
graphite and watercolor on paper
14 13/16 x 19 5/8 in.
(37.6 x 50 cm.)
Purchase, 17.3.2

Watching from the Cliffs
1892
watercolor on paper
14 x 20 in.
(35.6 x 50.8 cm.)
Purchase, 17.19

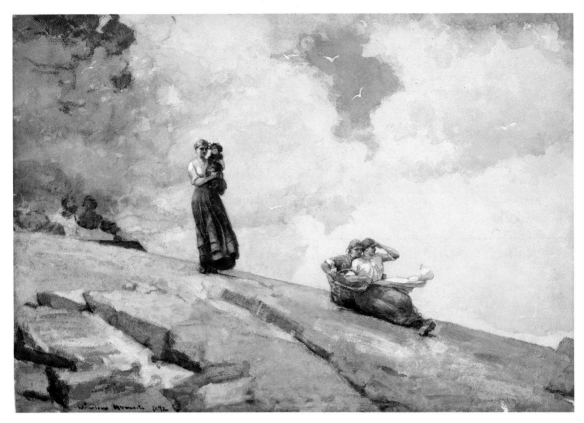

Homer, *Watching from the Cliffs*

Louis Art Museum), apparently inspired by the stranding of the super-schooner *Washington B. Thomas* near Prout's Neck in 1903.[8] Perhaps *A Wreck Near Gloucester* appealed to John Beatty because it dealt with the same subject as Homer's oil painting *The Wreck*.

Although it is dated 1892, *Watching from the Cliffs* does not relate to Homer's Adirondack and Florida watercolors of that period but returns to a subject dealt with in the watercolors made in England a decade earlier. Indeed, the central motif in this work, a woman with a child, occurs in an 1881 watercolor once owned by E. K. Warren. In that work the foreground was a grassy hillside with the same slope as in this one.[9] The use of opaque white in *Watching from the Cliffs* is highly unusual for Homer's work of the 1890s and is not generally found in his watercolors on white paper after the English period. The design also contains one odd inconsistency: the women's garments are shown swirling to the right, but the smoke from the house in the distance is shown blowing to the left.

Homer is known to have reworked his oil *The Coming Away of the Gale* (1883, Worcester Art Museum, Worcester, Massachusetts) in the 1890s, and in 1893 he sold the repainted canvas, retitled *The Gale*, to Thomas B. Clarke.[10] It is likely that he also reworked some of his English watercolors at this time, and Robert W. Macbeth suggested that in *Watching from the Cliffs*, Homer applied watercolor and opaque pigment over an earlier drawing to alter the composition and strengthen the effect.[11] He seems to have added the house in the background, with its illogically rendered smoke, and particularly to have worked over the left foreground, adding jagged rock formations like those found at Prout's Neck.

HA

NOTES: 1. Lloyd Goodrich, *Winslow Homer* (New York, 1944), 159. 2. Carnegie Institute, *Winslow Homer and John Singer Sargent: An Exhibition of Watercolors* (1917), exh. cat. by John W. Beatty. After Beatty retired Carnegie Institute staged *An Exhibition of Watercolors by Winslow Homer* (1923) with a catalogue that included an introduction by Royal Cortissoz. 3. Goodrich, 226. 4. Goodrich, 68. 5. Hereward Lester Cook, "Winslow Homer's Water-Color Technique," *The Art Quarterly* XXIV (Summer 1966): 169-94. 6. The Museum of Graphic Art, New York, *The Graphic Art of Winslow Homer* (1968), exh. cat. by Lloyd Goodrich, figs. 59, 60; Philip C. Beam, *Winslow Homer at Prout's Neck* (Boston, 1966), 12. 7. Gordon Hendricks, *The Life and Work of Winslow Homer* (New York, 1979), 150-51. 8. Beam, 234-39. 9. Information courtesy of Lloyd Goodrich. Two other works by Homer repeat the motif of a woman with a child found in the Museum of Art's watercolor; these are the watercolor *Foreboding* (1881, The Hyde Collection, Glens Falls, New York) and an untitled charcoal drawing dated 1881 (collection of Mrs. Henry Sears). My thanks to Helen Cooper, curator of American painting, Yale University Art Gallery. 10. Goodrich, 81-82; Beam, 112-13. 11. Robert W. Macbeth started a catalogue of Winslow Homer's work, which he passed on to Lloyd Goodrich. The material from Macbeth's notes was kindly provided by Lloyd Goodrich.

ILLUSTRATION

FELIX OCTAVIUS CARR DARLEY

1822 — 1888

The Story of the Battle
c. 1863
graphite and ink wash on paper
12 ¼ x 16 ⅜ in.
(31.1 x 41.6 cm.)
Andrew Carnegie Fund, 07.15

FELIX Octavius Carr Darley was the first American artist to achieve an international reputation creating works almost exclusively for reproduction.[1] Born into a Philadelphia theatrical family, he taught himself to draw by copying prints, especially pictures in European books and magazines. In 1841 he joined the staff of *Graham's Lady's and Gentleman's Magazine.* Two years later he published *In Town and About,* a series of lithographs of Philadelphia street life, and *Scenes in Indian Life,* a series of ethnographic prints drawn from George Catlin, Charles Bird King, and others who, unlike Darley, had first-hand knowledge of the subject. Darley soon became the most popular illustrator in the United States and the object of favorable reviews abroad. Best known for illustrating the works of Cooper, Irving, Longfellow, and Hawthorne, he had a prolific talent that was equally at home in more prosaic contexts, including banknotes and pulp adventure stories.

Darley, *The Story of the Battle*

Darley varied his technique to suit the method of reproduction. For wood or steel engraving he used washes of India ink or black watercolor to create fully modeled images; for lithography he employed an outline style derived from John Flaxman and the German illustrator Moritz Retzsch. Much of his best work, such as the *Compositions in Outline from Sylvester Judd's Margaret* (New York, 1856), illustrating a popular novel of the day, is in this latter style. Because the finished appearance of his work depended ultimately on the engraver or lithographer, Darley often provided little more than a rough sketch to be filled out. Many of his drawings, however, are complete in themselves and were frequently exhibited at the National Academy of Design and elsewhere.

During a visit to the United States in 1861, Prince Napoleon, cousin to the Emperor Napoleon III, commissioned four drawings from Darley on American themes, paying him the magnificent sum of one thousand dollars apiece. Between 1852 and 1860, Darley designed a series of large-format steel engravings on themes from American history, focusing on the Revolutionary War. During the Civil War, he issued a similar series about contemporary military events. Because there is no evidence that he ever visited the front, his battle pieces are presumed to have been concocted in the same manner as his early Indian scenes. He also created genre pieces dealing with the less momentous, but more intimately human, aspects of conflict. *The Story of the Battle* exemplifies Darley's virtues as an illustrator. He animates an essentially static subject through dramatic gesture and facial expression, without resorting to sentimental or melodramatic clichés. The Union infantryman is portrayed, not as a swaggering gallant wooing the farmer's daughter with tales of martial prowess, but as a tattered, thirsty soldier exhausted both physically and mentally by the hardships of war he has just experienced.[2] The farmer's daughter is clearly moved by his story but betrays no inclination to fall in love or even flirt with him. Darley depicts the situation with an honesty and expressive clarity that renders it immediately intelligible.

Thomas Sully, the famous portraitist, so admired *The Story of the Battle* that he painted a copy of it (unlocated) in the summer of 1863.[3] Sully may have worked from a print, but in view of his personal relationship to Darley (his daughter Jane had married Darley's eldest brother) it is possible he had access to the original drawing.

KN

NOTES: 1. The most thorough work to date on Darley is Delaware Art Museum, Wilmington, . . . *illustrated by Darley* (1978), exh. cat. by Christine Anne Hahler. 2. It seems unlikely that a Northern artist would allude to a Northern defeat, but Darley did precisely that in his wash drawing *Cavalry Charge at Fredericksburg, Virginia*, exhibited at the 1867 Paris Exposition. The Battle of Fredericksburg, fought on December 13, 1862, was the most devastating Union defeat of the Civil War. 3. Edward Biddle and Mantel Fielding, *The Life and Works of Thomas Sully* (Philadelphia, 1921), 387, no. 2590. Sully also copied Darley's 1863 steel engraving *Foraging in Virginia*.

JOHN LA FARGE

1 8 3 5 — 1 9 1 0

A Woman in Japanese Costume at an Easel
1868
ink wash and Chinese white on uncut woodblock
5 ¾ x 4 ³⁄₁₆ in.
(14.6 x 10.6 cm.)
Purchase, 18.41.2

BORN in New York in 1835, the eldest son of French émigrés, John La Farge grew up in an atmosphere of wealth, social refinement, and diverse cultural influences. Throughout his career he maintained friendships with leading European and American writers and intellectuals, and he played an important role in expanding the parameters of American art. Drawing on his knowledge of European culture as well as exotic locales like Japan and Polynesia, he created new effects in such varied media as easel painting, watercolor, mural decoration, and stained glass. Widely respected in his lifetime, La Farge served on the jury of the Carnegie International exhibition in 1897, 1901, and 1903 and was honored by an exhibition of his work at Carnegie Institute in 1901.[1]

In *A History of American Painting* Sadakichi Hartmann cited La Farge, along with Howard Pyle, as one of the two key figures in the creation of a "serious" school of American illustration.[2] Although the conjunction of names is somewhat odd, since La Farge's work preceded that of Pyle by some thirty years, both figures helped move American illustration from

La Farge, *A Woman in Japanese Costume at an Easel*

64

literal-minded representation of a text toward freer and more artistic modes of treatment. La Farge himself summed up his ideas about illustration in a letter of January 22, 1860, to his fiancée, Margaret Perry:

> Let me tell you, Dear, that my ideas of illustrations are not common ones. I would no more think myself bound to represent the exact picture conveyed by the poet, than I would think of rivalling him. The artist is at a disadvantage, he has lines and the other has words. If the words were weak the illustrations might be superior—if not so the picture is complete. The same happens in any literal description of a picture—no description can equal the picture itself. The best are commentaries or glosses. The artist should illustrate by a poem of his own as the writer does, by music of his own as musicians do. An example. The lines of Keats upon Chapman's Homer. That, love, is the only way, I believe—I need not reason it.[3]

La Farge's most influential illustrations were produced in the mid-1860s for *The Riverside Magazine*, a periodical for children edited by Horace Scudder. In such designs as *The Wolf Man, The Pied Piper, The Fisherman and the Afrite, The Giant and the Travellers,* and *Bishop Hatto Attacked by Rats* (1866–68), La Farge introduced a note of exotic fantasy into American illustration, along with such fundamentally terrifying themes as loss, danger, and the fear of punishment.[4]

In 1868 La Farge designed a title page for the story "In the King's Garden," showing two women in Oriental costume in a garden bounded by a bamboo fence.[5] *A Woman in Japanese Costume at an Easel* was probably a second illustration for this story. Strongly decorative and Japanese in feeling, it closely matches the title page in style. In addition, it can be dated to the same period, for it is inscribed on the back, in John La Farge's hand: "Illustration for a story—not published/1868."

La Farge evidently kept this drawing for many years in his studio, and it seems to have inspired a poem by Richard Henry Story, "The Lady of the East (On a Drawing by John La Farge)," which was published in *The Century* in February 1883. Of distinctly modest literary merit, this poem addresses the question "Who art thou, Lady of the East?" and comes up with a different answer to this riddle in each of its stanzas.[6]

La Farge was a pioneer in the appreciation of Japanese art. His remarkably early painting, *Roses on a Tray* (c. 1861, Museum of Art, Carnegie Institute), not only makes use of Oriental ideas of design but is actually executed on a Japanese lacquer tray, with a design of a butterfly and a chrysanthemum visible on the back. The work predates Whistler's first "Japanese" paintings by several years. Carnegie Institute also owns a small sketch by La Farge on an uncut woodblock, probably dating from the mid-1860s, depicting a corner of his home in Newport in which a Japanese vase and kakemono are plainly visible.

In addition to documenting La Farge's interest in Japanese art, *A Woman in Japanese Costume at an Easel* provides a record of La Farge's technical procedures. Dissatisfied with previous wood-engravings, which seemed to him hard and linear, La Farge sought a more subtle rendering of tonality. Consequently, rather than making a line drawing, which would have been easy to reproduce, he worked with delicate gradations of wash on his woodblocks, much to the annoyance of his wood-engravers. La Farge's son Grant recalled, "I do not think that either he or Marsh was ever satisfied with the engraved result."[7]

La Farge's keen awareness of the creative aspect of the engraver's work is apparent from a debate he entered with George Inness in 1878, in which he eloquently came to the defense of the so-called "minor arts."[8] Despite his appreciation of the wood-engraver's role, however, La Farge was attacked in his day on the grounds that he overpowered his engravers in an effort to attain painterly qualities and that this gave his illustrations a fussy and finicky style of execution. This claim was expressed most strongly by William James Linton in *The History of Wood Engraving in America*:

> Mr. La Farge's drawings (I speak here only of his manner of placing upon the wood his most imaginative designs) were most unfortunate practice for Mr. Marsh. The broadest Nast drawings, to correct his tendency to subtlety and over-refinement, had been better for him. "No more minuteness" should have been his motto: instead of which, his reverence for the higher qualities of La Farge's work made him the slave of all its deficiencies in execution. Those Riverside drawings,—the *Wolf-Charmer* and others of that La Farge series,—original, labored, and suggestive, were yet of real detriment to the engraver.[9]

Linton recognized, however, that La Farge's collaboration with Marsh "may be considered the beginning of the 'New School'"; that is, a school of wood-engraving that concentrated on optical qualities and nuances of tonality rather than on outline and conventionalized schemes of crosshatching.[10] *A Woman in Japanese Costume at an Easel*, one of the few La Farge drawings on wood that remained uncut, provides a rare look at his technical procedures, which helped bring about a significant shift in wood-engraving techniques.

HA

NOTES: 1. Carnegie Institute, *Retrospective Exhibition of Paintings from Previous Internationals* (1958), exh. cat. by Leon Arkus; Carnegie Institute, *Catalogue of Works by John La Farge* (1901), exh. cat. 2. Sadakichi Hartmann, *A History of American Art* (Boston, 1901), 98. 3. John La Farge, S.J., *The Manner is Ordinary* (New York, 1954), 22. 4. Frank Weitenkampf, "John La Farge, Illustrator," *The Print-Collector's Quarterly* V (December 1915): 472-94; Helene Barbara Weinberg, "John La Farge: The Relation of His Illustration to His Ideal Art," *The American Art Journal* V (May 1973): 54-73. For Scudder see Ellen B. Ballou, "Horace Elisha Scudder and *The Riverside Magazine*," *Harvard Library Bulletin* XIV (Autumn 1960): 426-52. 5. The uncut woodblock of this design is now owned by Mrs. Christine Burnett in Brooklyn, New York. La Farge twice referred to the woodblock in his correspondence with Horace Scudder, once in a letter dated 15 July 1868 and again in a subsequent letter dated "Friday Mng." The Scudder papers also contain a sheet of La Farge's directions to his wood-engraver, Henry Marsh, explaining how the block should be cut. La Farge's somewhat elliptical references to this project in his correspondence suggest that Scudder himself was the author of the story and that it may have been conceived as an independent book rather than as a tale for *The Riverside Magazine*. 6. Richard Henry Stoddard, "The Lady of the East (On a Drawing by John La Farge)," *The Century* XXV (February 1883): 582. 7. Letter from Grant La Farge to Frank Weitenkampf, 24 November 1914, in the Print Division of the New York Public Library, 488-89; see also, John La Farge, *Considerations on Painting* (New York, 1895), 110. 8. John La Farge, "American Wood Engraving," *New York Tribune*, 16 March 1878; George Inness, "A Plea for the Painters," *New York Evening Post*, 21 March 1878, 2; John La Farge, "A Plea for the Engravers," *New York Evening Post*, 20 March 1878, 3. 9. William James Linton, *The History of Wood Engraving in America* (Boston, 1882), 54. 10. Linton, 54.

ON August 23, 1890, the painter John La Farge and the historian Henry Adams boarded the steamer *Zealandia* in San Francisco and set forth for the South Seas. Hawaii, the first landfall of the two voyagers, proved a disappointment. In Samoa, however, they discovered the unspoiled primitivism they sought. The very evening of their arrival they were treated to the Siva dance, performed by five native girls, naked to the waist, whose skin, covered with coconut oil, glistened in the firelight against a background of moving shadows. "La Farge's spectacles quivered with emotion," Adams noted. "No future experience, short of being eaten, will ever make us feel so new again."[1] Another Siva, performed by men, is the subject of this watercolor. The picture records a dance performed at the village of Iva, on the island of Savaii, on October 27, 1890.[2]

For most of their stay in Samoa, La Farge and Adams stayed at another native village, Vaiala, on the island of Upolu. Vaiala was the residence of the two most powerful native chiefs, Mata-afa and Mali-etoa, and was also located near the home of the novelist Robert Louis Stevenson, who for reasons of health had moved to Polynesia. From October 24 to November 1, 1890, however, La Farge and Adams went on a *malanga*, or boat journey, with Seumanu, chief of Vaiala, and some fifty other natives. They traveled from village to village and were entertained with speeches, ceremonial presentations of food, and native dances. Their reception at Iva (a village adjacent to Sapapalii, the original home of the powerful chief Mali-etoa) was perhaps the climax of their trip. "Whatever we came to Samoa for," Adams noted, "we got it this time."[3]

The morning after their arrival in Iva, La Farge and Adams lounged and sketched. At about two o'clock, however, the festivities began. First they were presented with a military review and sham battle that lasted about three hours and was performed by some two hundred men decorated with leaves, feathers, and flowers and armed with clubs, bush-knives, and Snyder rifles. Next came speechmaking and the ceremonial presentation of gifts of food to the visitors—yams, taros, and several squealing pigs, which were later slaughtered and roasted.

Finally came the dancing, the subject of this watercolor, which was broken off briefly for feasting and then resumed until late into the night. Adams described the scene in a letter to his intimate confidante, Elizabeth Cameron: "The sun set with an afterglow like an extravagant painting; the moon rose with a full flood of violet light; and we started in for a new Siva at eight o'clock with only the light of the fire, fed by dry palm leaves, to show the dancers."[4] La Farge, in his book *Reminiscences of the South Seas*, noted that the chant of the dancers was "undeniably a war song" and that each of the performers represented some individual neighboring village.[5] At the bottom of the watercolor La Farge inscribed the names of five of the six performers: Samuelu, Aolele, Tulagono, Aotoa, and Apslu.

The Siva dance preoccupied La Farge during his stay in Samoa and was the source of his greatest efforts and his greatest frustrations. When he tried to draw the dance in motion, the lines "flowed out again like water before I could fix them."[6] He found himself equally dissatisfied when he attempted, using both sketches and photographs as aids, to pose models in the successive motions of the dance. "The drawings and paintings I have made are so stupid," he declared, "from their freezing into attitudes the

Sitting Siva Dance
c. 1894
graphite and gouache on card
13 ¾ x 21 ¹³⁄₁₆ in.
(34.9 x 55.4 cm.)
Purchase, 17.8

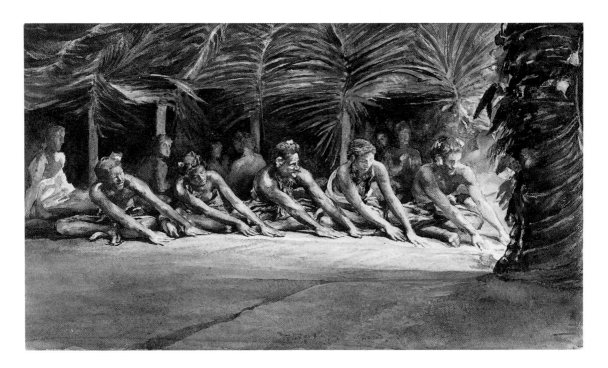

La Farge, *Sitting Siva Dance*

beauties that are made of sequence."[7] As he noted dispiritedly of this composition, "You will see at once that the work is either carried too far, or not far enough."[8]

Carnegie Institute's watercolor is La Farge's second version of this subject and replicates a work in the Isabella Stewart Gardner Museum. La Farge completed the Gardner Museum's watercolor in his native hut in Vaiala on December 19, 1890, several months after witnessing the dance itself.[9] In his account of the dances at Iva, Adams noted, "During the show I toiled over my Kodak, and took thirty or forty views, none of which I expect to find successful, but which, even if only one turns out well, may help La Farge paint a Siva picture."[10] La Farge evidently based his watercolor partly on Adam's photographs, as well as on sketches he had made at the time. After completing the piece, he sent it directly to his son Bancel in New York, including at the top of the work a long inscription that functioned simultaneously as a letter to Bancel, an *aide memoire*, and the rough draft of a South Sea travelogue.

La Farge did not intend to sell his sketch until he had used it as the basis for a larger painting. Isabella Stewart Gardner, however, during a visit to the painter's studio in January 1892, snatched it up without La Farge's permission and carried it off. She seems later to have paid him, but in a letter La Farge wrote her, on October 19, 1890, he expressed disappointment that she had refused to lend the work back to him "as was agreed between us" for use in composing his larger work. In the same letter La Farge also begged Mrs. Gardner at least to lend the watercolor to an exhibition to be held in Paris the following spring.[11]

Presumably, Mrs. Gardner did eventually lend La Farge his watercolor, at which time he must have made the replica in Carnegie Institute. The copy follows the first version almost precisely but shows less hesitation in drawing and is somewhat more vigorous in color. It includes the names of the dancers at the bottom. It does not, however, repeat the long inscription at the top, although this was printed verbatim in the

catalogue of La Farge's 1895 exhibition at the Durand-Ruel Gallery in New York.[12] La Farge did begin work on a large oil painting of this subject, seven by five feet in size, but it remained incomplete at the time of his death. A typed letter from Grace Edith Barnes, the executrix of La Farge's estate, to R. C. Vose, dated January 15, 1912, mentions a large oil version of the picture.[13]

It is unclear whether La Farge included the Gardner Museum's or Carnegie Institute's version of this work in his 1895 exhibition at the Durand-Ruel Gallery in New York and at a subsequent showing at the Champs-de-Mars in Paris. Carnegie Institute's version, however, is the one La Farge used to illustrate his writings on Samoa. It was first reproduced in *Scribner's* in 1901 and later was included in La Farge's book *Reminiscences of the South Seas*, published in 1911, the year after the artist's death.[14] Carnegie Institute purchased the work in 1917 from the well-known New York art dealer William Macbeth.

Despite the artist's own reservations, La Farge's South Sea watercolors proved extremely popular when he first exhibited them. They sold very rapidly, even though their prices, at three hundred to five hundred dollars apiece, were exceptionally high for the period. When La Farge's exhibition of watercolors opened in New York in early 1895, the catalogue listed one hundred forty-five South Sea pictures. By February 1897, however, by which time the show had traveled to both Cleveland and Chicago, only thirty-seven remained unsold. Critical reviews of the South Sea works were also generally complimentary, often noting the coloration of the pieces, whose brilliance was matched in American art of this period only by Winslow Homer's tropical watercolors.[15]

Posterity has generally agreed with Henry Adams's verdict that La Farge's South Sea watercolors, while at times awkward in drawing and labored in execution, are superior to those he executed in Japan and are the freshest and most spontaneous works of his later career. Though they seldom equaled the formal strength of the Tahitian paintings of Gauguin, they are among the finest South Sea paintings made by anyone in the nineteenth century, and they provide a colorful and vivid record of an ancient way of life that was already on the verge of extinction.

HA

NOTES: 1. Henry Adams, *The Letters of Henry Adams*, Vol. III (Cambridge, Massachusetts, 1982), 291. 2. John La Farge, *Reminiscences of the South Seas* (New York, 1911), 188-91; Adams, 312-14. 3. Adams, 313. 4. Adams, 313. 5. La Farge, 188. 6. La Farge, 73. 7. La Farge, 199. 8. Durand-Ruel Gallery, New York, *John La Farge: Painting, Studies, Sketches and Drawings, Monthly Records of Travel, 1886 and 1890-1891* (1895), exh. cat. by John La Farge, 31, cat. no. 98. 9. Durand-Ruel Gallery, 31, cat. no. 98. 10. Adams, 313. 11. The anecdote concerning Mrs. Gardner's visit to La Farge's studio is recorded in a note by John Davis Hatch in the curatorial files of the Isabella Stewart Gardner Museum. Dated January 5, 1935, it was based on conversations with Bancel La Farge and Bancel's son Henry La Farge. According to Philip Hendy, *European and American Paintings in the Isabella Stewart Gardner Museum* (Boston, 1974), 133, Mrs. Gardner purchased the watercolor from the artist on January 30, 1892, only a few months after La Farge had returned from the South Seas. Hendy does not indicate the source of this date and does not make clear whether this was the date of Mrs. Gardner's visit to La Farge's studio or of her payment to the artist. 12. Durand-Ruel Gallery, 31, cat. no. 98. 13. Letter owned by Vose Galleries, Boston. 14. John La Farge, "Passages from a Diary in the Pacific," *Scribner's Magazine* XXIX (May 1901): 680; La Farge, 1911, opposite 189. 15. James Leo Yarnall, "John La Farge and Henry Adams in the South Seas" (M.A. thesis, University of Chicago, 1976), 60.

WILLIAM RIMMER

B. ENGLAND, 1816—1879

Sadak in Search of the Waters of Oblivion
late 1860s
graphite on cardboard
16 ¾ x 12 ¹⁄₁₆ in.
(42.5 x 32.1 cm.)
Andrew Carnegie Fund, 07.10

WILLIAM Rimmer's father, Thomas, believed himself to be no less a personage than Louis XVII of France, spirited to England by Royalists in 1794 and entrusted to the care of a Lancashire yeoman's family. When his claim to the French throne was ignored following Napoleon's defeat in 1815, he married an Irish maidservant and in 1818 emigrated to Nova Scotia, where he supported his family as a cobbler. By 1826 the Rimmers had settled, in impoverished but aristocratic seclusion, in a Boston slum. William, the eldest son, was instructed by his father in a wide range of arts and sciences. As a young man he turned his hand to a variety of trades, including typesetting, soap making, lithography, portraiture, sign painting, and commercial illustration. In the 1840s and 50s he worked as a physician and, though entirely self-taught, became known for his cold-water treatment of typhoid, cholera, and smallpox. He also produced several inventions, among them a self-registering counter for streetcar conductors and an unbreakable trunk, none of which noticeably improved his chronically depressed fortunes.[1]

After 1860, Rimmer devoted his energies to art. Unlike most American artists of the day, he was obsessed with the expressive possibilities of the male nude in violent action and with mystical and allegorical themes. Though he wanted most to be a sculptor, he enjoyed his greatest success as a teacher of anatomy for artists. For the most part, his drawings were studies for projected statues and paintings or illustrations to his lectures, not finished works in their own right.[2] His family, friends, and students, however, eagerly collected them.

Sadak in Search of the Waters of Oblivion probably dates from the late 1860s, when Rimmer executed a number of drawings on decorated album leaves (e.g. *Achilles*, 1867, Museum of Fine Arts, Boston). The subject, in keeping with Rimmer's taste for the exotic, is from James Ridley's *The Tales of the Genii* (1762). In the ninth tale, Kalasrade, the beautiful wife of the noble Sadak, promises to submit willingly to the embraces of her captor, the odious Sultan Amurath, provided he first obtains for her a draft of the Waters of Oblivion. When Amurath, having sworn to comply, discovers that the waters flow only at the center of a remote volcanic island guarded by evil spirits (a fact of which Kalasrade was well aware), he orders Sadak to undertake the mission for him. Rimmer illustrates Sadak's ascent of a perilous precipice near the source of the fabled waters.

In conception the drawing is very close to a canvas of the same name (1812, Southampton Art Gallery, England) by the English Romantic painter John Martin. Martin's work also shows a tiny figure struggling in the foreground of a vast, mountainous landscape. Rimmer admired Martin's work; although he never traveled abroad and could not have seen the original painting, he clearly knew it well, probably from the mezzotint issued in 1841 by Martin's son, Alfred, or from the steel engraving by E. J. Roberts first published in *The Keepsake for 1828* (London, 1827) and later used as the frontispiece of Henry G. Bohn's edition of Ridley's tales.[3] Martin's conception, with its emphasis on

Rimmer, *Sadak in Search of the Waters of Oblivion*

landscape, was not, perhaps, wholly congenial to Rimmer's insistence on the primacy of the human figure in art. Elaborate landscape settings are rare in Rimmer's work. In this drawing the landscape has a sketchy, unfinished appearance. The figure of Sadak, on the other hand, is fully rendered in complete, strongly emphasized, anatomical detail and is characteristic of the sort of powerfully articulated drawings of nudes that Rimmer loved.

KN

NOTES: 1. The basic text on Rimmer is Truman H. Bartlett, *The Art Life of William Rimmer* (Boston, 1882). Bartlett unfortunately glosses over some of Rimmer's peculiarities. These are enthusiastically reported in Whitney Museum of American Art, New York, *William Rimmer* (1946), exh. cat. by Lincoln Kirstein. 2. Some of Rimmer's finest drawings appear as illustrations in his *Art Anatomy* (Boston, 1877). 3. James Ridley, *The Tales of the Genii* (London, 1861).

THOMAS MORAN

B. ENGLAND, 1837—1926

North Peak
c. 1873
graphite, pen and ink, brush
and ink, and gouache on paper
10 x 16 in.
(25.4 x 40.6 cm.)
Andrew Carnegie Fund, 06.3.14

Landscape
1870s
graphite, pen and ink, ink wash,
and Chinese white on uncut
woodblock
6 x 5 ⅛ in.
(15.2 x 13 cm.)
Purchase, 18.41.3

BORN in the bleak Lancashire milltown of Bolton, England, Thomas Moran emigrated to the United States with his family in 1844 and settled in Philadelphia the following year. Though he never received formal training, he benefited from the instruction of his brother Edward, a talented landscape and marine painter, and James Hamilton, a prominent Philadelphia artist called the "American Turner." Moran formed a deep attachment to the work of J. M. W. Turner himself at this time. In 1861 he traveled to England expressly to study Turner's work, though he had already assimilated the British master's style several years earlier. An 1858 landscape by Moran was actually sold as a genuine Turner to the political cartoonist Thomas Nast, an error that went undetected for decades until Moran recognized the painting as his own.[1]

Moran's fame rests on his spectacular views of western scenery. His interest in the West was kindled in 1870, when Richard Watson Gilder, editor of the fledgling *Scribner's Monthly,* commissioned him to rework for publication some crude sketches of the Yellowstone country. Eager to see the area's wonders for himself, Moran joined Dr. Ferdinand V. Hayden's 1871 expedition to Yellowstone. His enormous oil painting *The Grand Canyon of the Yellowstone* (1872, National Museum of American Art, Smithsonian Institution, Washington, D.C.), together with his watercolors (including field studies and more finished sketches) and his illustrations for a *Scribner's* article by Hayden, were instrumental in persuading Congress to declare the region the first national park. From

Moran, *North Peak*

Moran, *Landscape*

then on, the artist was firmly identified with Yellowstone in the public mind. He was known as "Yellowstone" Moran, and the monogram with which he signed his work after 1872 includes the letter Y.

In an interview with the art critic G. W. Sheldon, Moran declared:

> I place no value upon literal transcripts from nature. My general scope is not realistic; all my tendencies are toward idealization. Of course, all art must come through nature or naturalism, but I believe that a place, as a place, has no value in itself for the artist[2]

North Peak exemplifies Moran's approach to western landscape, which remained essentially unchanged until his death in 1927. Though it lacks the often startling color and the more obvious theatrics of Moran's paintings, the drawing is nevertheless a romantically heightened rendering that employs a Turneresque atmosphere, achieved largely through the abstract quality of the broadly applied washes, to convey the grandeur and solitude of the scene.

This drawing probably dates from Moran's second western expedition, in 1873, when he accompanied Major John Wesley Powell to the Colorado River region of Utah and Arizona. The horizontal rock formations are characteristic of the rugged scenery in that area, and the

drawing as a whole is consistent with Moran's illustrations for Powell's "The Cañons of the Colorado" in *Scribner's Monthly*.[3] Although it was never published, the fact that *North Peak* was acquired by Carnegie Institute in 1906 from the Century Company (which took over *Scribner's Monthly* in 1881 and renamed it *The Century*) suggests that it was one of the twenty drawings that Moran agreed to do for *Scribner's* during the 1873 expedition.[4] Carol Clark, a leading authority on Moran's watercolors, has pointed out that the artist often gave or sold his sketches to editors, like Gilder, with whom he was friendly. Had this been the case with *North Peak*, it might have remained in the office instead of entering the editor's personal collection.[5]

During the 1870s, Moran was extremely active as an illustrator, contributing to magazines, travel books, textbooks, and elegant gift volumes, often anthologies of verse, that were popular at the time. He largely abandoned this facet of his career after the early 1880s. Unlike most illustrators, he was adept at drawing directly on the woodblock, a skill he acquired in the 1850s as an apprentice wood-engraver for Scattergood and Telfer of Philadelphia. When he worked in this manner, his original design was inevitably destroyed by the engraving process.

Landscape is the only surviving exception; the block was never cut (hence, never published), so the original drawing remains intact. According to George H. Whittle, from whom Carnegie Institute purchased the block, it was owned by the Century Company and dates "from the early time of *Scribner's Monthly Magazine*," that is, from the 1870s.[6] Moran's monogram on the block indicates that it was made after 1872. It is clear from the format that Moran created this landscape to accompany a poem; he left the blank space at the left to accommodate the lines of verse. The scene, a quaint rustic village with a Gothic church tower, has a markedly English flavor. Assuming that it is not wholly imaginary, it may well derive from one of the sketches Moran made during his 1861 tour of England.

KN

NOTES: 1. Thurman Wilkins, *Thomas Moran, Artist of the Mountains* (Norman, Oklahoma, 1966), 39. 2. G. W. Sheldon, *American Painters* (New York, 1879), 125. 3. John Wesley Powell, "The Cañons of the Colorado," *Scribner's Monthly* IX (January, February, March 1875): 293-310, 394-409, 523-37. 4. See Moran's letter to his wife, 13 August 1873 (Art Gallery, University of Notre Dame, Notre Dame, Indiana, *The Drawings and Watercolors of Thomas Moran* [1976], exh. cat. by Thomas S. Fern, 46), in which he discusses his illustration commitments. 5. Carol Clark, letter to Henry Adams, 1 February 1984; Clark believes *North Peak* is not the true title of the work. Also see Amon Carter Museum, Fort Worth, Texas, *Thomas Moran, Watercolors of the American West* (1980), exh. cat. by Carol Clark. 6. George H. Whittle, letter dated 6 February 1918 to Edward Duff Balken, curator of prints, Carnegie Institute.

FREDERICK DIELMAN

B. GERMANY, 1847—1935

FREDERICK Dielman was born in Germany, but his family emigrated to Maryland when he was eight. At only sixteen he published his first illustration, a drawing of a Confederate raid, and in the next few years produced many more sketches of the Civil War and places of interest in the South. In 1866, to earn money for study in Europe, he took on employment as a draftsman and topographer for the federal government. By 1872 he had earned enough to enroll in the Royal Academy in Munich, where he studied under Wilhelm von Diez and won a medal in the life class.

Dielman returned to America in 1876 and established a studio in New York. There he distinguished himself chiefly through his active roles in artistic societies. A founder of the Society of American Artists and the New York Etching Club, he also belonged to the Salmagundi Club, the American Society of Etchers, the Mural Painters, and the Century Club. He was elected an academician of the National Academy of Design in 1883 and served as president of that institution from 1899 to 1909.

As an artist, Dielman employed two distinctly different styles. In his work as an easel painter, muralist, and designer of mosaics, he generally represented idealized allegorical figures, somewhat reminiscent of those of Kenyon Cox, although not so hard in execution. Dielman's work of this type is exemplified by the mosaics *Law* and *History*, which he designed for the reading room of the Library of Congress, and *Thrift*, for the Albany Savings Bank.

A Visit From the Bumboat, Near Troy
1879
graphite heightened with Chinese white on tan paper
6 x 6 ¾ in.
(15.2 x 17.1 cm.)
Purchase, 06.3.8

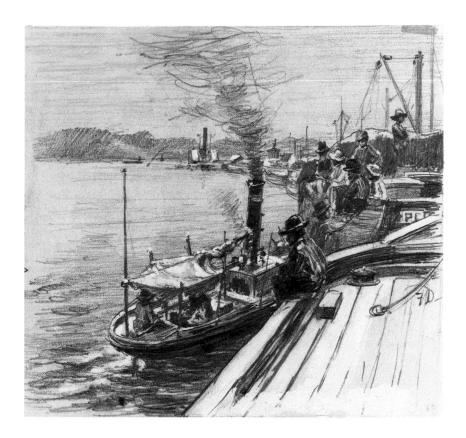

Dielman, *A Visit From the Bumboat, Near Troy*

In drawings and illustrations, on the other hand, Dielman worked in a more naturalistic manner, often representing intimate scenes of landscape and rural life like those in which R. Swain Gifford specialized.[1] *A Visit From the Bumboat, Near Troy,* while somewhat unusual in its subject matter, represents this naturalistic work at its best and also possesses historic interest because of its association with the Tile Club.

The Tile Club (another of the artistic associations to which Dielman belonged) was started in 1877 in the decorative frenzy that swept the country after the Centennial Exposition of 1876 and lasted until about 1890. The members met every Wednesday evening to decorate tiles and amuse themselves with music and conversation and consume beer, cheese, and crackers. In summer they went on excursions of several days, traveling by carriage or boat. The membership, generally only around twelve, included many of the most distinguished American artists, such as Winslow Homer, William Merritt Chase, and Edwin Austin Abbey. In keeping with the somewhat adolescent humor of the group, the members were all known by nicknames like "The Owl," "Polyphemus," "The Pie," "Catgut," and "Horsehair." Dielman joined the club in the winter of 1878 and was christened "Terrapin."[2]

This drawing records an excursion the club made in the summer of 1879. On this occasion the group rented the canal-boat *John C. Earle* for three weeks; furnished it with armchairs, a dining table, a piano, rugs, cushions, drapes, hangings, Chinese lanterns, and other bric-a-brac; purchased meat, provisions, and five tons of ice; engaged the services of three black servants whom they nicknamed "Daniel," "Deuteronomy," and "Priam"; and then set forth on the Erie Canal on a pleasure and sketching excursion from New York to Albany. Dielman's drawing illustrated an account of this jaunt that was published in *Scribner's Monthly* in March 1880 and shows a bumboat (a small boat used to peddle provisions and small wares) supplying the Tile Club's barge when it was anchored off Troy, New York.[3]

HA

NOTES: 1. Alfred Trumble, "A Painter of the Beautiful," *The Monthly Illustrator* V (August 1895): 131-37; James Grant Wilson and John Fiske, eds., *Appleton's Cyclopedia of American Biography,* Vol. VII (New York, 1893-1919), 471; John Denison Champlin, Jr., ed., *Cyclopedia of Painters and Paintings,* Vol. I (New York, 1913), 407; Frank Jewett Mather, Jr., Charles Rufus Morey, and William James Henderson, *The American Spirit in Art* (New Haven, 1927), 116; The National Gallery of Art, Washington, D.C., *An American Perspective* (1981), exh. cat. by John Wilmerding, Linda Ayres, and Earl A. Powell, 127-28. 2. "The Tile Club Ashore," *The Century* XXIII (February 1882): 481-98; Katherine Metcalf Roof, *The Life and Art of William Merritt Chase* (New York, 1917), 76-83. 3. "The Tile Club Afloat," *Scribner's Monthly* XIX (March 1880): 641-71.

EDWIN AUSTIN ABBEY

1852—1911

The Tinker's Song
1880
pen and ink on cardboard
11 ¼ x 7 ⅜ in.
(28.6 x 18.7 cm.)
Purchase, 14.4

SADAKICHI Hartmann called Edwin Austin Abbey "a virtuoso of penmanship, one of the greatest pen-and-ink artists that ever lived."[1] Joseph Pennell thought him "the greatest American illustrator."[2] Indeed, Abbey was an extraordinarily popular artist and a key figure in the flowering of American illustration that took place in the 1870s.

After working as an apprentice wood-engraver for a publisher in his native Philadelphia, Abbey joined the staff of Harper and Brothers in 1870 and soon became the firm's leading illustrator. He settled in England after 1878, where he joined a circle of brilliant expatriates that included Frank D. Millet, John Singer Sargent, and Henry James. Despite his success as a painter (he became a Royal Academician in 1898 and in 1902 was appointed court artist for the coronation of Edward VII), Abbey remained a regular contributor to *Harper's Weekly* almost until his death.[3]

The introduction of photomechanical reproduction in the late 1870s had much to do with Abbey's rise to fame. During his early years at Harper's, wood-engravers with widely varying skills had determined the

Abbey, *The Tinker's Song*

final appearance of his work, but by 1880 his drawing could be exactly transcribed, which gave him full control over the finished image. The new technology allowed him to exploit a brisk, versatile pen technique that would have daunted the most expert wood-engraver, in which a loosely executed web of crosshatching vibrantly conveys nuances of light and texture. Through photo-engraving Abbey's work could appear at its best in inexpensive formats available to a wide audience.

Abbey drew *The Tinker's Song* for *Selections from the Poetry of Robert Herrick*, published by Harper and Brothers in 1882. This commission was in many respects a crucial event in his career: it sent him to England in 1878 in search of background material, and it established him as an illustrator of fine literature instead of just periodical ephemera. Joseph Pennell praised "the charming Herrick" as one of the artist's finest efforts, a work that "every pen draughtsman should own."[4]

Abbey's illustrations to Herrick also marked the full emergence of his great passion for the meticulous reconstruction of the past. One can be quite certain that the setting for *The Tinker's Song* is an authentic seventeenth-century country inn and that all the details, from aprons to beer mugs, are correct for the period. The composition as a whole recalls seventeenth-century Dutch and Flemish tavern scenes, the visual counterparts to Herrick's carousing lyrics. "I feel it is my duty as well as my pleasure," Abbey wrote in 1902, "to be guilty of as few historical inaccuracies as this antiquarian age permits."[5]

Today Abbey's elaborate concern for archaeological authenticity may seem excessive; and some of Abbey's contemporaries, notably the followers of Whistler and the "art for art's sake" movement, attacked it as irrelevant to true aesthetic merit. Most, however, found it a legitimate source of pleasure. Even Pennell, a close friend of Whistler, was susceptible:

> While the superficial qualities of Abbey's work can be imitated by anyone, his renderings of the seventeenth and eighteenth centuries, which he has reconstructed so wonderfully, will never be approached on the lines he followed. . . . No illustrator has realized more beautiful women or finer swaggering gallants, and no one has placed them in more appropriate surroundings. He made the figures real for us because all the backgrounds and accessories are real—drawn from nature.[6]

By the 1890s Abbey's studio, fondly described by Henry James as "the most romantic place in this prosaic age,"[7] had become a veritable museum of costumes, artifacts, and architectural casts; and Abbey himself had become the last major exponent of the already moribund British tradition of impeccably researched historical and literary painting.

KN

NOTES: 1. Sadakichi Hartman, *History of American Art*, Vol. II (Boston, 1901), 109. 2. Joseph Pennell, *Pen Drawing and Pen Draughtsmanship* (London, 1889; rev. ed., New York and London, 1920), 272. 3. The best written accounts of Abbey's life are E. V. Lucas, *Edwin Austin Abbey, Royal Academician: The Record of His Life and Work*, 2 vols. (London and New York, 1921) and Yale University Art Gallery, New Haven, *Edwin Austin Abbey, 1852-1911* (1973), exh. cat. by Kathleen A. Foster and Michael Quick. The latter includes a fine essay by Quick on Abbey's work as an illustrator. 4. Pennell, 272, 278. 5. Lucas, II, 381. 6. Pennell, 283. 7. Lucas, II, 360.

CHARLES STANLEY REINHART

1844 — 1896

REINHART, the son of a prominent Pittsburgh merchant, did not pursue a full-time career in art until he was twenty-three. He worked as a clerk for the Allegheny Valley Railroad from 1859 to 1861; served as a telegraph operator with the United States Railroad Corps during the Civil War; and, upon returning to Pittsburgh, secured employment as a clerk in the steel industry. Encouraged, perhaps, by his uncle, Benjamin Franklin Reinhart, a highly successful portrait painter in London, Reinhart went to Europe in 1867, where he studied first at the Atelier Suisse in Paris and then at the Royal Academy in Munich. After three years abroad, he settled in New York and became an illustrator for Harper and Brothers, where he came to know Edwin Austin Abbey, a fellow illustrator there, and Winslow Homer, who undertook free-lance assignments for the firm. James Kelly, who worked at Harper's during this time, reported that, when Homer was completing a drawing at the office, Reinhart was one of the young men who "gathered around him, and no doubt profited by watching his methods."[1]

Reinhart became one of the best-known illustrators of his day. Sadakichi Hartmann credited him with the introduction of painterly qualitites into American illustration and remarked, "In the early eighties his drawings were remarkably frank and correct, and regularly looked-for events in many quarters."[2] No less a luminary than Henry James made Reinhart the theme of a laudatory essay that declared he had "arrived at absolute facility and felicity."[3] The Art Institute of Chicago honored him with an exhibition of his drawings in 1891. Carnegie Institute owns a number of Reinhart's original illustrations, several of which, including *At the Frontier* and *Merci, Monsieur*,[4] are characteristic of his best work: deft, lightly satirical portrayals of contemporary life that retain much of the freshness and immediacy of on-the-spot sketches.

Reinhart was also a gifted painter, a fact that Henry James genially deplored, observing that the effort put into a single canvas would yield fifty illustrations.[5] During his residence in Paris from 1880 to 1891, Reinhart frequently exhibited paintings at the Salon, where he won Honorable Mentions for *Washed Ashore* (1887, Corcoran Gallery of Art, Washington, D.C.) and *Awaiting the Absent* (1888, formerly Carnegie Institute).[6] In the latter, a genre piece that recalls in both style and content the academic realism of Reinhart's close friend Pascal Dagnan-Bouveret, a group of Breton peasants anxiously scan the ocean for the fishing boats of their kin, presumably long overdue. The gouache study for *Awaiting the Absent* possesses a dramatic energy missing in the final work. The lively, spontaneous brushstroke of the study is wholly suppressed in the oil painting, and the peril of the approaching storm becomes an equally dangerous but certainly less dynamic heavy fog. The Museum of Art also owns a notebook containing figure studies and color notes for this work.

KN

Study for "Awaiting the Absent"
1883
crayon and gouache on blue paper faded to green mounted on canvas
28 ½ x 18 ¾ in.
(72.4 x 47.6 cm.)
Gift of Charles Stanley Reinhart, Jr., Liliane Reinhart Bennet, and John Reinhart Bennet, 51.8

Reinhart, *Study for "Awaiting the Absent"*

NOTES: 1. Quoted in Lloyd Goodrich, *Winslow Homer* (New York, 1944), 45. 2. Sadakichi Hartmann, *A History of American Art*, Vol. II (Boston, 1901), 113. 3. Henry James, *Picture and Text* (New York, 1893), 68. 4. Originally published as illustrations for Lewis Iddings, "The Art of Travel," *Scribner's Magazine* XXI (March 1897): 351-66. 5. James, 75-77. 6. Andrew Carnegie donated *Awaiting the Absent* to Carnegie Institute in 1897; it was sold in 1966.

JOHN WHITE ALEXANDER

1856 — 1915

JOHN White Alexander, best known in both his day and ours for his elegant, evocative portraits of women, achieved international prominence in the 1890s. During his residence in Paris from 1891 to 1901 he was ranked with Edwin Austin Abbey, John Singer Sargent, and James McNeill Whistler as a leading American expatriate painter. His circle of friends included such eminent artistic and literary figures as Whistler, August Rodin, Stéphane Mallarmé, Octave Mirbeau, Oscar Wilde, and Henry James. Following his return to New York, he enjoyed great success as a fashionable portraitist and served as president of the National Academy of Design from 1909 until his death.

Alexander was also closely associated with Carnegie Institute. He had grown up in Allegheny City, now part of Pittsburgh, and since childhood had been a close friend of the Institute's first director of fine arts, John W. Beatty. In 1897 he presided over the Carnegie International's Paris advisory committee and several years later executed a major mural project for the Institute, an allegory of Andrew Carnegie's philosophy of industry and democracy entitled *Apotheosis of Pittsburgh* (1905–15). Carnegie Institute honored Beatty's friend the year after his death with a traveling memorial exhibition of his work.[1]

The charcoal portrait *Frank Stockton* dates from the decade preceding Alexander's rise to fame, when he earned much of his living through magazine illustration. He began this part of his career with *Harper's Weekly* in 1875, but he left this position two years later to study at the Royal Academy in Munich. After a few months there he became one of the "Duveneck Boys," a group of American students (among them his old friend Beatty) who worked with the expatriate painter Frank Duveneck at Polling, Bavaria. Alexander traveled with the Duveneck group to Italy, where he first met Whistler and James, then set up a studio in New York in 1881 and resumed his career as an illustrator. Though he undertook a variety of assignments, including views of New Orleans for *Harper's Weekly* in 1881 and Irish landscapes and genre scenes for *The Century* in 1886, his strong suit, in which he had already made great strides as a painter, was portraiture. His portraits, published in *The Century* between 1886 and 1893, were primarily of literary men such as Robert Louis Stevenson, Thomas Hardy, John Burroughs, and the historian George Bancroft. John Beatty, in his introductory essay for the catalogue of the 1916 memorial exhibition, praised these drawings as "masterpieces of simple and direct delineation of character."[2]

In July 1886 *The Century* published a biographical essay on Frank Stockton, accompanied by two portraits of him by Alexander.[3] Carnegie Institute's sketch was the magazine's frontispiece; the second drawing, a frontal, half-length, seated view, appeared at the end of the article. The portraits are so strikingly dissimilar that at first glance it is hard to believe they represent the same man. This was not due to any incompetence on the part of the artist but to two different interpretations of his subject. The slight, dapper figure of the second drawing, with his large, sensitive eyes, broad forehead, and slim, tapering fingers, portrays the popular image of Stockton, who in 1886 was widely known for his fanciful children's tales

Frank Stockton
1886
charcoal on paper
21 x 16 ½ in.
(53.3 x 41.9 cm.)
Andrew Carnegie Fund, 06.3.1

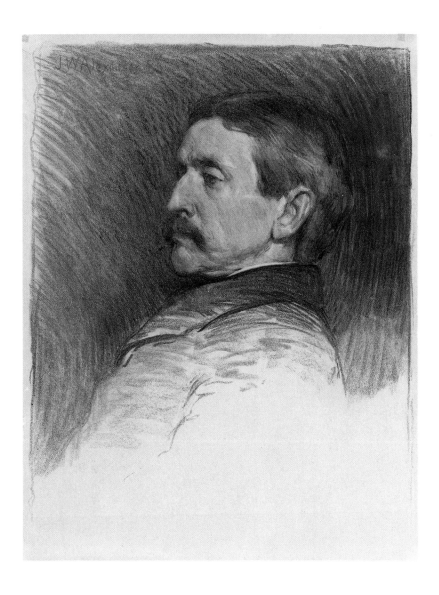

Alexander, *Frank Stockton*

and above all for his clever, perennially irritating conundrum, "The Lady, or the Tiger?", first published four years earlier in *The Century*. The article, however, repeatedly made the point that Stockton was not a mere literary lightweight but a sober, industrious student of human nature. The dignified, serious, introspective Stockton of the frontispiece is meant to embody a solid Victorian author whose stories hold profound moral truths beneath their superficial appeal to children. Stylistically, this portrait is remote from the sensuous, art nouveau linearity characteristic of Alexander's work in the 1890s. Instead it reflects the strong, uncompromising realism practiced by Duveneck and the more progressive Munich artists of the 1870s and 80s. The overall dark tonality is typical of this style, as is the bold, often coarse, handling of the medium.

KN

NOTES: 1. The most extensive treatments of Alexander's life and work are in the National Collection of Fine Arts, Smithsonian Institution, Washington, D.C., *John White Alexander (1856-1915)* (1976), exh. cat. by Mary Anne Goley; and Graham Gallery, New York, *John White Alexander, 1856-1915: Fin-de-Siècle American* (1980), exh. cat. by Sandra Leff. 2. John Beatty, "A Few Words of Appreciation," in Carnegie Institute, *Catalogue of Paintings, John White Alexander Memorial Exhibition* (1916), exh. cat., 9. 3. C. C. Buel, "The Author of 'The Lady, or the Tiger?'," *The Century* XXXII (July 1886): 405-13.

HOWARD PYLE

1853 — 1911

HOWARD Pyle was born in Wilmington, Delaware, into a Quaker family with strong Swedenborgian leanings. He first studied art from 1869 to 1872 in Philadelphia with an obscure Belgian named Van der Weilen. In 1876, determined to break into the rapidly growing field of magazine illustration, he moved to New York and attended classes at the Art Students League. Pyle combined his skill as an artist with considerable talent as a writer, and he soon became a regular contributor of illustrated articles to the leading periodicals. He was also deeply interested in folktales and found a particularly receptive market for his work in the new children's magazines *St. Nicholas* and *Harper's Young People*. Pyle built an international reputation during the 1880s as an author and illustrator of juvenile literature.[1] In 1883 Charles Scribner's Sons published Pyle's first successful full-length book, *The Merry Adventures of Robin Hood*. Carnegie Institute's drawing appeared in *Otto of the Silver Hand*, a historical novel for children first published by Scribner's in 1888 and frequently reissued.[2] The archaizing style of the drawings

There they sat, just as little children in the town might sit upon their father's door step
1888
pen and ink on cardboard
8 ¼ x 6 ¼ in.
(21 x 15.9 cm.)
Andrew Carnegie Fund,
06.19.11

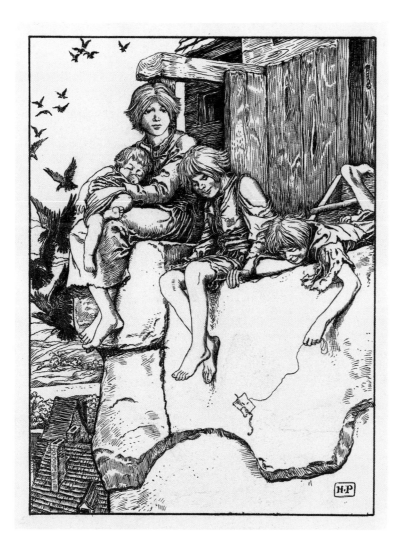

Pyle, *There they sat, just as little children in the town might sit upon their father's door step*

83

(based on the woodcuts and engravings of Albrecht Dürer), their careful integration with the text, and Pyle's use of symbolic head and tailpieces for each chapter all derive from the English Arts and Crafts school of illustration and its emphasis on the well-designed book. The leading exponents of this school, William Morris and Walter Crane, expressed admiration for Pyle's work. In *Otto of the Silver Hand*, however, Pyle suppressed the more decorative elements of this style in keeping with the innovative realism of his text. Instead of perpetuating the charming fairy-tale image of the Middle Ages considered suitable for young readers at that time, Pyle wrote frankly about the cruelty, rapaciousness, and general nastiness of life among thirteenth-century German robber barons. His illustrations reinforce the verbal picture he drew of a "great black gulf in human history." The headpieces have a grotesque, apocalyptic character; the full-page drawings emphasize the coarse, bleak aspect of the age. The great Melchior Tower of Castle Drachenhausen, the setting of *There they sat*, is not a beautiful specimen of Gothic architecture but a "huge square pile" topped with "a crooked wooden belfry, a tall narrow watchtower, and a rude wooden house that clung partly to the roof of the great tower and partly to the walls."[3] The watchman's children, who live there, are dirty, coarsely dressed, and, except for the peculiarity of their residence, thoroughly commonplace.

In the 1890s, in response to the introduction of the halftone reproduction process, Pyle largely abandoned pen and ink for paint, though he returned to his earlier Düreresque manner for a series of books on King Arthur and the Round Table produced between 1902 and 1910. Around 1905, Pyle, like many American artists of the day, was attracted to mural painting and executed panels for the Minnesota State Capitol in Saint Paul and for the county courthouses in Newark and Jersey City, New Jersey. Despite his insistence on historical accuracy in his work, a trait he shared with his close friend Edwin Austin Abbey, it was 1910 before Pyle finally visited the Old World he had so often portrayed. He died the following year in Florence, where he had gone to study Italian Renaissance murals. Pyle was extremely influential, not only through his work, but through his classes at Philadelphia's Drexel Institute (1894–1900), Chadds Ford, Pennsylvania (1898–99, 1901–03), and his home in Wilmington (1900–10). Among his students were many of the most prominent illustrators of the twentieth century, including N. C. Wyeth, Violet Oakley, Maxfield Parrish, Frank Schoonover, Harvey Dunn, and Elizabeth Shippen Green.

KN

NOTES: 1. The best treatment of Pyle's life and work is Henry C. Pitz, *Howard Pyle: Writer, Illustrator, Founder of the Brandywine School* (New York, 1975). Elizabeth Nesbitt, *Howard Pyle* (London, 1966) focuses on the artist's juvenile literature. 2. The drawing is reproduced on page 5 of *Otto of the Silver Hand* (New York, 1888). 3. *Otto of the Silver Hand*, 7.

FREDERIC REMINGTON

1861 — 1909

THE chubby, spoiled son of a newspaper publisher and former army colonel, Frederic Remington proved a poor student when he took a class in drawing plaster casts at Yale. He was more adept at football, but nonetheless dropped out of college before his first year was up. He drifted from job to job and finally headed west to take up sheep ranching in Kansas. After a rowdy party with his friends, during which they ransacked the local schoolhouse, Remington sold this venture at a loss and set off on horseback to sketch in the western Territories. At this time he conceived the ambition of using his artistic talents to record the vanishing West.

When he returned to New York, Remington began sending his sketches to magazines and achieved almost immediate success. One of the first people to recognize his genius was Theodore Roosevelt, who, like Remington, had returned East after failing in a western ranching venture. At the time when Roosevelt sold his first articles to *Outing* magazine, Remington's drawings were also being published in *Outing*, *Harper's Weekly*, and *St. Nicholas*. Roosevelt immediately recognized their incisiveness and vigor, and when *The Century* accepted a group of his articles about his experiences in the Dakotas, he specifically requested that Remington illustrate them.

Remington drew *Texas Type* for Roosevelt's article "Sheriff's Work on a Ranch," which was published in *The Century* in May 1888 and later reprinted as a chapter in Roosevelt's book, *Ranch Life in the Far West*. In this article Roosevelt told of pursuing three horse thieves downriver in the dead of winter and then walking them back to civilization at gunpoint— nonstop, to stay awake and alive.

Used as a vignette on the opening page of Roosevelt's story, this drawing of a self-assured young cowboy, revolver on hip, did not illustrate any specific incident in Roosevelt's account. It represented, instead, the kind of personality that, according to Roosevelt, could survive in the "wild country where the power of the law is little felt or heeded, and where everyone has to rely upon himself for protection. Self-reliant hardihood and the ability to hold one's own under all circumstances rank as the first of virtues."[1]

Roosevelt's reminiscences in *Ranch Life in the Far West*, a classic of American frontier literature, helped inspire Owen Wister's novel *The Virginian* (1902), which created a new genre of fiction, the Western. Appropriately, Wister also chose Remington to illustrate his book, which he dedicated to Roosevelt.

The second work by Remington in the museum's collection, *An Incident of the March*, illustrated "General Crook in the Indian Country," an article by Captain John G. Bourke of the Third Cavalry published in *The Century* in March 1891. This account described General George Crook's campaigns against the Apaches in Arizona in 1871 and 1872. According to Captain Bourke's account,

> General Crook was an ideal soldier in every sense. He stood about
> six feet in his stockings, was straight as an arrow, broad-
> shouldered, lithe, sinewy as a cat, and able to bear any amount of

Texas Type
1888
pen and ink on cardboard
15 1/16 x 8 7/8 in.
(39.7 x 22.5 cm.)
Andrew Carnegie Fund,
06.3.17

An Incident of the March
1891
pen and ink and ink wash on
cardboard
16 3/4 x 21 1/2 in.
(42.5 x 54.6 cm.)
Andrew Carnegie Fund,
06.3.16

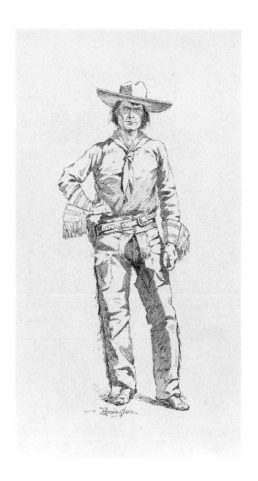

Remington, *Texas Type*

any kind of fatigue. He never touched stimulants in any form unless it might be something prescribed by a physician. Milk was his favorite beverage.[2]

Captain Bourke felt little sympathy for the "savages" who stood in the path of the white man. Remington's drawing was inspired by a passage that spoke of the hazards of life in Arizona at the time Crook took over his command. "No man's life was safe for a moment outside the half-dozen large towns," the article reported. "In the smaller villages and ranches sentinels were kept posted by day and packs of dogs were turned loose at night. All travel, even on the main roads, had to be done between sunset and sunrise."[3]

Remington took this bald recital of generalities and translated it into a specific human incident, a group of soldiers encountering the body of a murdered wayfarer. The corpse, which provides the key element in the drama, remains faceless and indistinct. Remington focused instead on the responses of the bystanders, whom he characterized with considerable subtlety and a certain grisly sense of humor. The bearded man at the far left seems lost in contemplation; the man beside him looks down in dismay; and the young bugler at the far right, obviously a greenhorn, appears pale and quite distraught with shock and horror. In contrast, the dandified figure with the marshal's baton, who nervously twists his mustache, seems quite familiar with scenes of this type, eager to get down to business, and unwilling to allow the event to spoil his dinner later in the day.

Remington's works on paper tend to fall into two categories: pen and ink sketches and wash drawings. The two works in Carnegie Institute

86

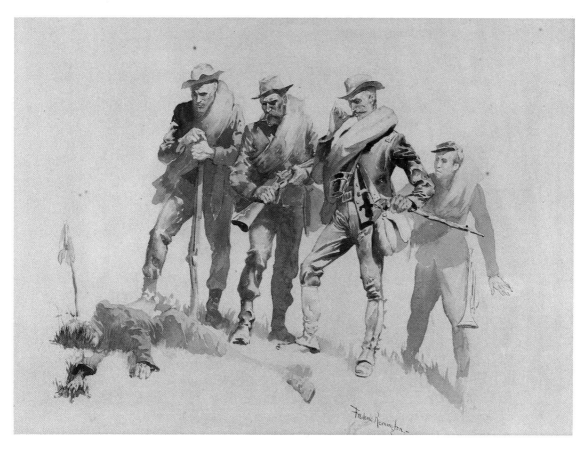

Remington, *An Incident of the March*

provide outstanding examples of both techniques. After 1901, when magazines began to print full-color photographic reproductions, Remington increasingly turned his attention to oil painting, and he also produced notable sculpture, pushing to the limits of the medium in compositions that were daringly precarious, such as his famous bronze of 1896, *The Bronco Buster*.

Sadakichi Hartmann, in *A History of American Art*, complained that Remington's drawings, along with those of Charles Dana Gibson, "enjoy, of late, an undue share of popularity."[4] A contrasting viewpoint, however, was expressed by Theodore Roosevelt. Nineteen years after his collaboration with Remington, while he was President of the United States, he wrote "An Appreciation of the Art of Frederic Remington," in which he declared, "It is no small thing for the nation that such an artist and man of letters should arrive to make a permanent record of certain of the most interesting features of our national life."[5] Despite Hartmann's complaints, the popularity of Remington's art has not diminished even now, and his drawings continue to shape our image of the early days of the "Wild West."

HA

NOTES: 1. Theodore Roosevelt, "Sheriff's Work on a Ranch," *The Century* XXXVI (May 1888): 44. When Roosevelt's account was reprinted in *Ranch Life in the Far West* (New York, 1899), Remington's vignette was moved from the first page of the chapter to the last. 2. John G. Bourke, Captain, Third Cavalry, "General Crook in the Indian Country," *The Century* XLI (March 1891): 652-53. 3. Bourke, 650. 4. Sadakichi Hartmann, *A History of American Art* (Boston, 1901), 113-14. 5. Theodore Roosevelt, "An Appreciation of the Art of Frederic Remington," *Pearson's Magazine* (October 1907): 403.

CHARLES DANA GIBSON

1 8 6 7 — 1 9 4 4

CHARLES Dana Gibson became the most popular illustrator of his day by creating the Gibson Girl, that lush, tightly-corseted paragon of turn-of-the-century American womanhood. It may seem curious that John Beatty and Sadakichi Hartmann selected this wholly atypical drawing to represent Gibson in Carnegie Institute's collection. Hartmann, however, was by no means an enthusiastic admirer of the artist's best-known work. He complained that Gibson and Frederic Remington (Gibson's classmate at the Art Students League in New York in the mid-1880s) enjoyed "an undue share of popularity," continuing:

> They are both close observers of the *immediate* with great facility of expression, the one for society types, the other for rougher specimens of humanity. . . . Remington has a good deal of vigour, Gibson a certain dash, but both only "represent," and "suggest" absolutely nothing.[1]

This drawing no doubt appealed to Hartmann precisely because it is so different, in both form and subject, from the genteel social comedy normally associated with the artist. It originally appeared in *Scribner's Magazine* in 1889 as an illustration for Sarah Orne Jewett's short story "The Luck of the Bogans."[2] In retrospect, this pairing of Jewett and Gibson is strikingly incongruous. Sarah Orne Jewett (1849–1909), one of the best of the post-Civil War regionalist writers, was known for her precise, vivid accounts of life in New England. She was particularly drawn, not to the fashionable Newport "cottages" that fascinated Gibson, but to the rugged coast of Maine that she had known since childhood. "The Luck of the Bogans" is a memorable example of Jewett's realism, a bleak tale of an Irishman who, having emigrated to the United States so that his infant son could grow up to be a "gentleman," dies brokenhearted when the son, Dan, falls into evil ways and is murdered in a drunken brawl. At the story's climax Dan enters his father's respectable saloon with two unsavory companions and, "his boyish face reddened and stupid with whiskey," loudly demands liquor. Gibson's treatment of this episode, showing the effects of the intrusion on the bar's regular customers while reducing the intruders to shadowy presences in the doorway, was taken from the first words of the sentence, "There was a rattling at the door-latch just then and loud voices outside, and as the old men looked, young Dan Bogan came stumbling into the shop."

When he made this drawing, Gibson had been working as an illustrator for only three years, but he was already recognized as a rising star in his field. On the whole, his early contributions to the humor magazine *Life* had been undistinguished, but within a short time he had developed an accomplished fine-line technique by studying the work of prominent pen draftsmen such as Vierge, Menzel, Abbey, and du Maurier. It was this freer, lighter style and the "certain dash" with which Hartmann credited Gibson that soon became the vehicle for the

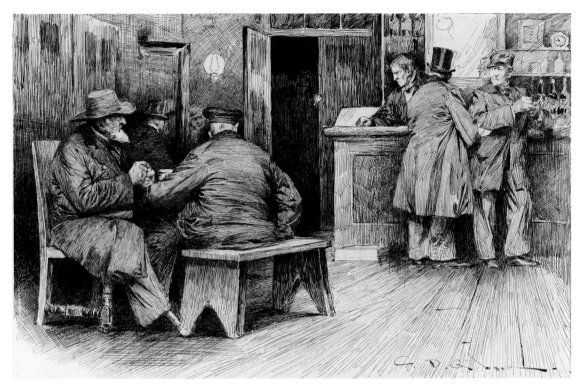

Gibson, *As the old men looked,
young Dan Bogan came stumbling
into the shop*

celebrated Gibson Girl. Indeed, by the close of 1889, the first encomium to the quintessential Gibson appeared in *Scribner's Magazine*:

> Perhaps no American artist in black and white now before the public is the happy possessor of so many of the desired qualities, and in such happy proportion, as Mr. Charles Dana Gibson. And of these qualities, the rarest, and not the least important, is the ability to draw a lady.... When Mr. Gibson undertakes to depict in the pages of *Life* a woman of refinement and gentle breeding he does it in such a manner that we have no suspicion of her using bad grammar when out of the picture. There are plenty of artists who can draw a pretty woman, well dressed and of obvious wealth, but, as far as we can judge from results, there are not a dozen men in England, or half that number in America, who can invest their heroines with the elusive *je ne sais quoi* without which a woman of social pretensions will, at least upon paper, struggle against hope.[3]

KN

NOTES: 1. Sadakichi Hartmann, *A History of American Art*, Vol. II (Boston, 1902), 113-14. 2. *Scribner's Magazine* V (January 1889): 101-12. Gibson's illustration appears on page 111. 3. J. A. Mitchell, "Contemporary American Caricature," *Scribner's Magazine* VI (December 1889): 743-44.

ROBERT FREDERICK BLUM

1857 — 1903

A "Wakaishi"—A Japanese
Bachelor Who Manages Public
Festivities
1891
pen and ink and ink wash
heightened with white on paper
mounted on cardboard
12 ½ x 9 ⅛ in.
(31.8 x 23.2 cm.)
Andrew Carnegie Fund, 06.19.2

BLUM, a figural artist who worked in a wide range of media that included oil, watercolor, pen and ink, etching, and pastel, studied art in his native Cincinnati under the Munich-trained realist Frank Duveneck. He completed his formal training at the Pennsylvania Academy of the Fine Arts. In 1880, during a visit to Venice, he joined Duveneck and his students (including Blum's close friends John Twachtman and William Merritt Chase) and also met James McNeill Whistler. The greatest influence on his work, however, was a man he never met, the Spanish painter and illustrator Mariano Fortuny (1838–1874). So thoroughly did Blum assimilate Fortuny's manner that on occasion he was referred to infelicitously as "Blumtuny."

Blum spent a great deal of time in Venice during the 1880s and excelled at Venetian subjects. His finest and certainly his best-known painting is *Venetian Lace Makers* (1887, Cincinnati Art Museum). As an illustrator, however, he produced his best work in Japan, where he lived from 1890 to 1892. For Blum, the commission from Scribner's to illustrate Sir Edwin Arnold's *Japonica* was the fulfillment of a lifelong ambition. Though the "mark of the beast," Blum's unflattering epithet for Western civilization, was already apparent in the land of his dreams,[1] he was not disappointed:

> I expected to be interested—fascinated; I was even prepared . . .
> to find it go beyond my expectation, but I was hardly prepared to
> drop into a new world. . . . Life is on another—a different plane.
> If one could make the comparison it would have to be with such
> dead and gone civilizations as Greece and Egypt.[2]

The example of Fortuny was much on Blum's mind during his stay in Japan. He wrote to a friend:

> Do you recall in some of our chats about Fortuny my speaking of
> the Orient as a conundrum, which with all their cleverness,
> Gérôme, Fromentin even, failed to answer satisfactorily? It was
> left for Fortuny to solve the riddle. . . . What Morocco, Tangiers,
> was to his genius, that Japan holds out to the first man great
> enough to grasp it.[3]

Blum's debt to Fortuny is evident in the bravura brushwork and glittering effects of light in *A "Wakaishi,"* an illustration for John H. Wigmore's article "Starting a Parliament in Japan" in the July 1891 *Scribner's Magazine*. According to Wigmore, the *wakaishi* were young, unmarried, rather dissolute males to whom arrangements for public merrymaking were traditionally entrusted. On festival days they wore the "special garments of *bourgeoise* [sic] magnificence" shown in Blum's drawing.[4]

Despite the success of his Japanese drawings, Blum gave up illustration and devoted himself to mural painting after he returned to the United

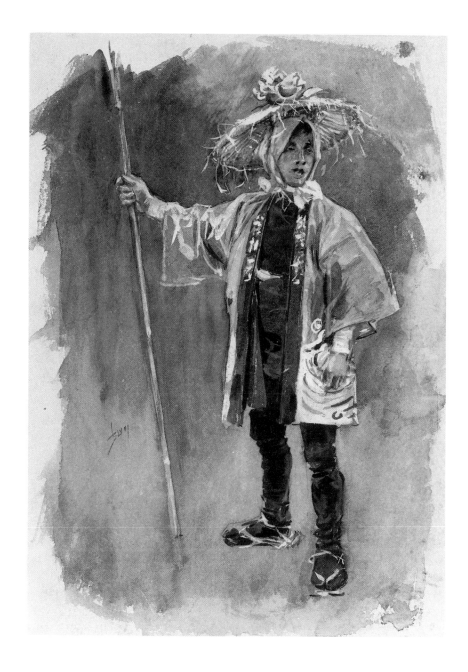

Blum, *A "Wakaishi"—A Japanese Bachelor Who Manages Public Festivities*

States. Between 1893 and 1898 he created a series of murals for the Mendelssohn Glee Club in New York,[5] and he was involved in a similar project for the New Amsterdam Theater at the time of his death.

KN

NOTES: 1. Robert Blum, "An Artist in Japan," *Scribner's Magazine* XIII (April 1893): 406. 2. Blum, 409-10. 3. Blum, 410. 4. John H. Wigmore, "Starting a Parliament in Japan," *Scribner's Magazine* (July 1891): 43-44. 5. The murals are now in the collection of The Brooklyn Museum.

LYONEL FEININGER

1871 — 1956

Old Stove of 1773
1892
graphite and crayon heightened
with white gouache on paper
mounted on paper
7 ⁷⁄₁₆ x 10 ⅛ in.
(18.9 x 25.7 cm.)
Gift of Sara M. Winokur and
James L. Winokur to honor Mr.
and Mrs. Richard M. Scaife,
71.12

LYONEL Feininger's parents, both eminent musicians, did not intend for him to become an artist. The boy grew up surrounded by music, his first and enduring love, and studied violin with his father, performing in concerts by the age of twelve. His parents, both of German ancestry, were neglectful and remote. Except for happy interludes that he spent with a farming family in Sharon, Connecticut, when his parents were away on concert tours, Feininger led an isolated and estranged childhood, a condition that found expression in the somewhat cold, architectonic compositions, usually without figures, that characterize his mature work. Nevertheless a part of him clung to boyhood impressions; he often depicted subjects that had intrigued him as a child, like boats, bicycles, and trains, and his later style bears some relation to children's simple stick-figure drawings.

In 1887, at the age of sixteen, Feininger sailed to Europe alone to study music. Upon his arrival in Hamburg, he abruptly resolved to study drawing instead and, with his father's consent, enrolled in the art academy. His decision was not, after all, so surprising. He had been making drawings since the age of three, and he later remarked, "I have 10,000 drawings to fall back on; this is the secret of my work. Drawings are the elementary seed of art."[1]

Feininger's fascination with drawing served him well in his initial artistic ventures. Like his contemporary William Glackens and other members of The Eight, Feininger began his career as an illustrator and caricaturist, making cartoons in pen and ink for magazines and newspapers in Europe and America. By his late teens, he was already well known and commercially successful, contributing work to the Berlin humor periodicals *Ulk* and *Lustige Blätter*, to the Parisian magazine *Le Témoin*, and to *Harper's Young People* in New York. Each week he also sent frames for two comic strip serials in the *Chicago Sunday Tribune*, "The Kin-Der-Kids" and "Wee Willie Winkie's World." He abandoned art school for these activities, noting subsequently, in a letter of 1924, "Far be it from me to underrate those important years of development as a 'comic draftsman'; they were my only discipline."[2]

Like Glackens and, earlier, Winslow Homer, Feininger was not satisfied with commercial illustrative work, which ultimately left him spiritually empty. When he met his second wife, Julia, he had the conviction to put a halt to the "clowneries,"[3] as he called them, and to turn to the transcription of his urgent personal visions. He thus began a new career at age thirty-five, and it was at this time that his style shifted from a nineteenth-century academic approach to modernist abstraction. Interestingly, his work always retained a highly graphic quality in any medium; the paintings often seem like colored drawings, and the Cubist-related crystalline faceting of form that marks his mature style is profoundly linear.

Old Stove of 1773, executed when the artist was just twenty-one, reveals his mastery of realistic representation and academic drawing techniques as well as his sensitivity to the mute eloquence of objects in evocative settings. Made in 1892 in Berlin, the drawing's rich, graphic naturalism

Feininger, *Old Stove of 1773*

documents at its best this period in Feininger's artistic development. Its careful realism reflects the artist's training at the academies he attended in Hamburg, Berlin, and Paris. Although he later repudiated the style, the museum's drawing shows the artist still exploring in detail the structure of natural forms and deriving delight from the discovery of new ways to render the world. In letters and on drawings sent to his lifelong friend Alfred Vance Churchill, who became the director of the Smith College art gallery, he enthusiastically described his graphic experiments. In a letter from Liège dated October 7, 1890, Feininger elaborated on the technique that he probably used for *Old Stove of 1773*:

> Have you ever tried sketching on tone paper? and getting lighter portions with Chinese white? You would be astonished how simple and effective the method is. I tried it only lately, here in Liège, when I had a couple weeks vacation before the college opened [Feininger was then attending a Belgian Jesuit school] and it has completely changed my ideas about sketching in pencil.[4]

Using a sheet of brown paper to produce the middle tones, Feininger worked with the point of a soft pencil, pushing it hard into the sheet for

the details and leaving heavy, shiny markings that delineate the curves, weight, and texture of the iron cooking vessels and the brick of the stove. The rubbed areas mold the atmospheric shroud that hovers over the scene, which the artist counterpointed with touches of Chinese white to create a dramatic chiaroscuro. The sheet recalls the work of the brilliant realist draftsman Adolf Menzel, who was then still living in Berlin. Menzel employed similar academic techniques and scrutinized the details of life around him with the same probity evidenced by Feininger in his early career.

Old Stove of 1773, an image of nostalgia, clearly had a resonance for the artist, and stoves in fact figure prominently in his recollections. In 1905 he recalled being in the family house in New York as a boy of five and hearing his parents practicing violin and piano:

> The large stove gave heat also to the music room above. The register of the stove was opened for me, that I might hear the better. . . . Waves of delight went through me. . . .[5]

Feininger also never forgot the family of farmers in Connecticut, with whom he found the loving surroundings that had been lacking in his own familial circle.

> As children in America in the country, we roasted apples every night during the winter . . . there we sat . . . my sister Helen and I on a plaid in front of the dear, small, cast-iron stove (the fire was visible through the Gothic tracery of the doors, and we called the stove the 'cathedral'). . . . Behind us sat the farmer's family and told ghost stories.[6]

Perhaps a stove never lost its happy connotations for the artist; in this drawing he conveyed the monumentality as well as the homey, well-worn quality of the stove, tucked neatly and safely, if somewhat awkwardly, into the corner of the ancient room.

EAP

NOTES: 1. Alexander Liberman, "Feininger," *Vogue* (15 April 1956): 92. 2. Letter from Feininger to his former publisher, Dr. Eysler, 19 January 1924, in Hans Hess, *Lyonel Feininger* (London, 1961), 22. 3. Hess, 17. 4. Quoted in Ernst Scheyer, *Lyonel Feininger: Caricature and Fantasy* (Detroit, 1964), 45. 5. Buchholz Gallery-Willard Gallery, New York, *Lyonel Feininger* (1941), exh. cat., unpaginated. 6. Letter from Feininger to Julia Feininger, 18 January 1906, from Berlin, in Hess, 2.

WILLIAM GLACKENS

1 8 7 0 — 1 9 3 8

THE three works by Glackens in the museum's collection go far in supporting his friend Everett Shinn's contention, "William J. Glackens is the greatest draughtsman this country has produced. I know of no other American artist who has equalled his extraordinary ability as an interpreter of contemporary life."[1]

Born in Philadelphia and educated at Central High School there, Glackens began his career in 1901 as an artist-reporter and illustrator on the staff of the *Philadelphia Record* before moving to the *Press*, where he met John Sloan, George Luks, and Everett Shinn, all of whom would join him in the 1908 exhibition that established the group called The Eight or, more derogatively, the Ashcan School. The newspaper job allowed Glackens to finance night classes at the Pennsylvania Academy of the Fine Arts, the only formal training he received. Inspired by Robert Henri, mentor to a generation of painters, Glackens soon focused his interest primarily on painting, and with Henri's encouragement he set forth on a cattle boat to France, where he lived for more than a year, traveling, painting, and studiously avoiding the academies.

Upon his return to America, the young artist took up residence in New York and began to draw magazine illustrations. It was at this time that the group who would become The Eight coalesced, united by a commitment to depict life without sentimentalizing or prettifying it. From the beginning, with the first exhibitions of 1901, Glackens's rare quality of observation and his lively transcription were noted by the critics, and their favorable comments encouraged the modest artist, who, four years later, won honorable mention at the 1905 Carnegie International exhibition with his famous work *At Mouquin's*, now in The Art Institute of Chicago. Glackens finally renounced illustration altogether and devoted himself to painting, eventually working in an Impressionist style reminiscent of Renoir. Heavily influenced by the French painters, he purchased their work for his friend and fellow baseball enthusiast Albert Barnes, whose foundation in Merion, Pennsylvania, became one of the great repositories of French nineteenth-century art in America.

Given the quality and interest of the three drawings in the museum's collection, as well as the often positive response to Glackens's newspaper and magazine work, it is, as his son Ira remarked, "hard to believe that [Glackens] hated to do illustrations—which was the sad fact."[2] There is no doubt, though, that his experience in illustration served him well for his painting, since it fostered his lightning scrutiny of an event and developed his skill at instantaneous transcription or the uncannily accurate retention of details that he could reproduce later at the office. Shinn noted that Glackens always "found his subjects in the teeming, sprawling Metropolitan populace" and affirmed that, "If historians of the future wish to know what America of the city streets was like at the turn of the century, they have only to look at these drawings."[3] Glackens's fascination with real life never waned, and he leveled a

In Town It's Different
1898
graphite, charcoal, ink wash, and gouache on paper
18 1/8 x 11 15/16 in.
(46 x 30.3 cm.)
Andrew Carnegie Fund, 06.18.3

Vitourac Had Never Before Been the Scene of Such a Splendid Fete
1901
graphite and brush and ink on paper mounted on cardboard
9 x 13 3/8 in.
(22.9 x 34 cm.)
Andrew Carnegie Fund, 06.19.7

They Huddled with Heads Bent Low
1902
graphite, charcoal, ink wash, and gouache on paper mounted on board
15 7/16 x 19 in.
(39.2 x 48.3 cm.)
Andrew Carnegie Fund, 06.19.6

penetrating eye on the people who passed by the window of his Washington Square studio, making quick sketches that he would then incorporate into finished works.

Each of these three illustrations, different as they are, reflects Glackens's special gifts. Equally, each demonstrates the artist's proficiency in a different drawing medium, for Glackens used a variety of techniques to obtain different effects both for the type of image and the kind of process by which it would be reproduced. Shinn described the materials used by his friend, noting that Glackens initially worked in pen and ink, later substituting a "fine pointed sable brush for the steel pen." For tonal work that would be reproduced by the half tone process, Glackens used wash, tempera, charcoal, and carbon pencil, sometimes mixing the media if the image required it. He discovered red chalk in Paris, and he favored drybrush over graphite pencil, which he never found as sympathetic to work with as charcoal with its dark, rich tonal effects. "Watercolor and pastel were used to accent his drawings, to give sparkle to some of his illustrations marked for black and white reproduction. The color instinct of the painter was constantly asserting itself."[4]

The papers Glackens preferred were as eclectic as his working methods. His favorite types, again according to Shinn, were grocery wrappings and wallpaper samples.

> The wrapping paper found in grocery shops in the old days had a beautiful surface for drawing, especially for carbon and chalk. The other [favorite] was wallpaper sample books. Some of his best drawings in red chalk were done on the backs of these warm-toned papers that possessed just the right "tooth" for his rapid strokes—No. 2946 Wall, and No. 2947 Border, lie under some of his masterpieces![5]

In fact, *Vitourac Had Never Before Been the Scene of Such a Splendid Fete* and *They Huddled with Heads Bent Low* were made on grocery paper and *In Town It's Different* on wallpaper.

Vitourac is a striking example of Glackens's black-and-white style. Probably drawn with the fine pointed sable brush to which Shinn referred, its free flickering quality evokes a scene of bustling movement, with people, animals, and coaches advancing in all directions. The drawing is one of eight pictures commissioned to illustrate a story published in *Scribner's Magazine* in 1901, "The Stranger Within Their Gates," by Eleanor Stuart.[6] The banal narrative, sprinkled with anti-feminist and anti-Semitic comments, recounts the much-anticipated visit of a celebrity to a small town in the south of France and the disappointing, humiliating discovery that the long-awaited guest is none other than a poodle. *Vitourac*, the outstanding work of the eight illustrations to the article, is, not surprisingly, a crowd scene, for those were Glackens's specialty. "None of us," declared Shinn, "could do a crowd quite like Glackens."[7] Instead of reducing the people in a crowd to an undifferentiated mass, Glackens delineated every person. He placed the viewer directly in the middle of the crowd, to the left of the grandstand so carefully constructed by the local builder, behind a horse, and in the line of sight of the haughty Madame de Bau, who glides through the populace in her elegant cabriolet.

Glackens worked in his most quintessentially Ashcan School manner in the 1902 illustration for *Scribner's Magazine*, *They Huddled with Heads*

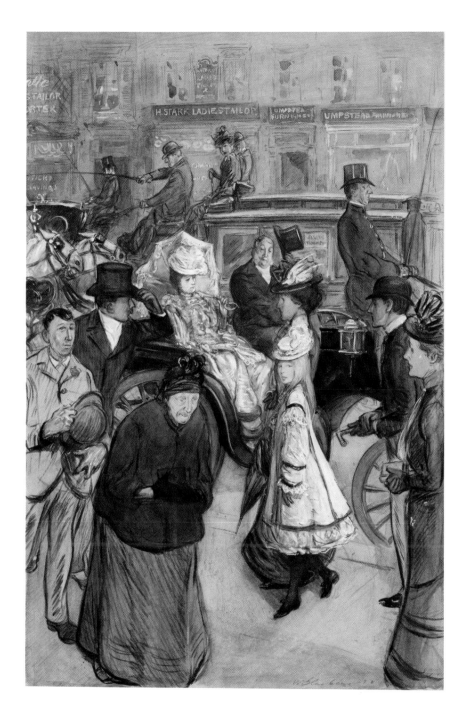

Glackens, *In Town It's Different*

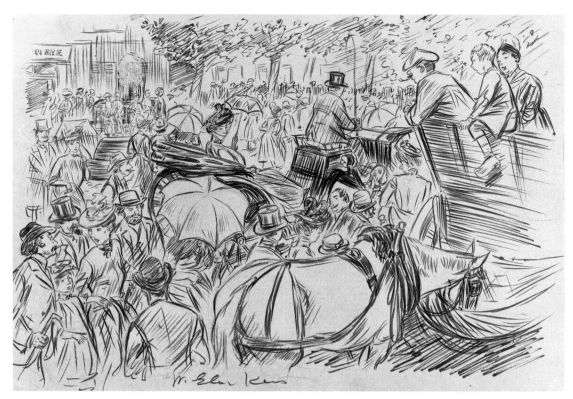

Glackens, *Vitourac Had Never
Before Been the Scene of Such a
Splendid Fete*

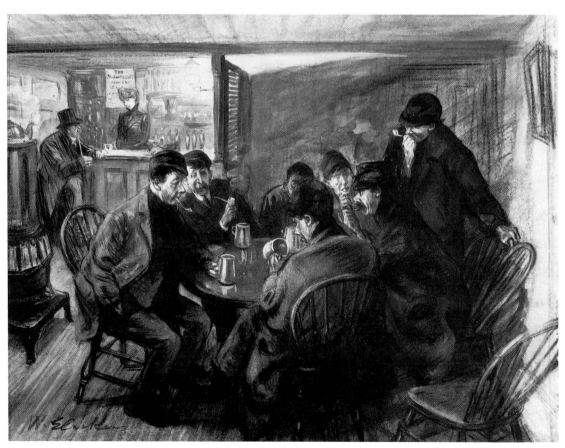

Glackens, *They Huddled with
Heads Bent Low*

98

Bent Low. It was made for a story about a cattle boat, a subject familiar to Glackens, who had traveled to Europe on just such a vessel seven years earlier.[8] The hero of the story, Danny Cadogan, takes over a mismanaged cattle boat during a devastating storm and through heroic, if mutinous, efforts saves eight hundred seventy-two cattle out of eight hundred ninety-eight! At the end of the ten-day gale, the survivors gather to mull over the events:

> In the taproom of a dingy little lodging house on Derby Road, they huddled, with heads bent low over their pewter mugs and sparks from their pipes falling unnoticed upon their clothes. The steamy air was thick with smoke, rank with the smell of beer and tobacco, buzzing with amiable blasphemies, and they were very happy.[9]

It was this type of rather crude image that earned Glackens harsh denunciations from the conservative press, and in 1923 the critic Forbes Watson explained why: "Years ago I remember Albert Sterner speaking of the complaints that used to come to *McClure's Magazine* because Glackens' illustrations were not sweet enough. They were too real, too original, too fresh and amusing to appeal to a public saturated with false illustrations."[10] For this reason, Glackens was rarely assigned a full-page illustration, while more conventional artists like Walter Appleton Clark regularly executed them. It was the art editors who indicated how many drawings were required and what size they should be, though the illustrators themselves decided upon the events to be pictured and chose to draw the scenes that were most challenging or most compatible with their talents.

It is noteworthy, however, that along with his constant survey of the life around him, Glackens also possessed a profound understanding of the conventions of representation. *In Town It's Different,* the earliest of the three Carnegie Institute drawings, very much resembles English and Continental styles of illustration in its refinement and finish as well as in specific details. Shinn, although he noted Glackens's originality, also compared his work to that of the French artists and social critics Forain, Daumier, and Gavarni and documented the fact that Glackens and his group of friends would haunt the galleries to study the work of other illustrators. It was Glackens who introduced his acquaintances to the illustrative work of Charles Keene and George du Maurier, "from whom he derived much inspiration."[11] Glackens certainly drew on other artists' works for some of his types, such as the modestly clad man at the left of *In Town It's Different,* who recalls figures by Jean-François Raffaelli, while the top-hatted young man with the ascot resembles the elegant figures of George du Maurier and Charles Dana Gibson. References to Sir John Tenniel are also discernible, and the abrupt cropping of the image suggests exposure to the art of Edgar Degas. So it is not surprising that Sadakichi Hartmann paid more for this drawing (eighty-five dollars) than for the other two combined. And unlike the two others *In Town It's Different* enjoyed a special place as frontispiece in the August 1899 issue of *Scribner's.* It stood on its own, not side by side with the poem it was meant to illustrate, a frivolous concatenation of rhymed observations about spring entitled "An Urban Harbinger" by the hopeful versifier E. S. Martin.[12]

Again Glackens chose a crowd scene, with the "delectable Sophronia" riding in an ornate coach with her father, and a throng of town types passing by on the sidewalks. Beyond the assumption that the woman is Sophronia, the picture has little to do with the literal events in the poem, another device characteristic of French illustration of the period. Further, this image is not a faithful transcription of life as observed from a window: careful scrutiny reveals how meticulously and deliberately Glackens assembled the elements. The ten foreground figures represent the gamut of sexes, ages, and social class in their expressions, clothes (especially hats), mien, and the direction of their gazes. He stressed, for example, the contrast between the haughty countenance and bearing of the beautiful, elegantly attired child in the foreground, who regards the viewer with such self-possession, and the cowed, sickly, impoverished old woman who apologetically shuffles along the same sidewalk.

EAP

NOTES: 1. Everett Shinn, "William Glackens as an Illustrator," *American Artist* IX (November 1945): 22. 2. Ira Glackens, *William Glackens and the Ash-can Group* (New York, 1957), 27. 3. Shinn, 22. 4. Shinn, 37. 5. Shinn, 37. 6. Eleanor Stuart, "The Stranger Within Their Gates," *Scribner's Magazine* XXVI (December 1901): 750-61. 7. Shinn, 23. 8. Arthur Ruhl, "The Cattle-Man Who Didn't," *Scribner's Magazine* XXXI (January 1902): 110-19. 9. Ruhl, 119. 10. Ira Glackens, "By Way of Background," in Janet A. Flint, *Drawings by William Glackens 1870-1938* (Washington, D.C., 1972), unpaginated. 11. Glackens, 1957, 22. 12. E. S. Martin, "An Urban Harbinger," *Scribner's Magazine* XXVI (August 1899): frontispiece.

JOSEPH PENNELL

1860 — 1926

Caen (Sketch of a Canal)
1899
pen and ink on paper mounted on card
5 ⅞ x 9 ¼ in.
(14.9 x 23.5 cm.)
Andrew Carnegie Fund, 06.12.5

OVER the years Joseph Pennell the author has possibly come to overshadow Joseph Pennell the artist. He is well known to students of nineteenth- and early twentieth-century art for his 1908 biography of his close friend James McNeill Whistler, which he wrote in collaboration with his wife, Elizabeth, and for his many publications on the graphic arts, including *Pen Drawing and Pen Draughtsmen* (London and New York, 1889; rev. ed. 1920) and *Modern Illustration* (London and New York, 1895). As an illustrator and printmaker, however, he has long been considered of only secondary importance, though his success during his life approached that of Edwin Austin Abbey, Charles Stanley Reinhart, and Charles Dana Gibson. In 1901 Sadakichi Hartmann described Pennell as "skillful, but without much individuality." Recently, Theodore Stebbins has observed that, "despite his immense learning, he was never a highly gifted or original draftsman."[1]

In the late 1870s Pennell, despite the opposition of his austere Philadelphia Quaker family, decided to become a professional illustrator. He briefly attended Thomas Eakins's life class at the Pennsylvania Academy of the Fine Arts but was unable to tolerate Eakins's often brutal criticism, a circumstance that may have led him to specialize in architectural rather than figural subjects. Beginning in the early 1880s,

Pennell, as a result of his specialization in architecture, was in great demand as an illustrator of popular travel literature, which required him to spend much of his time abroad. He lived in London from 1884 until 1917 and became prominent in his adopted city both as an artist and as an outspoken, anti-academic art critic whose harsh judgments made him many enemies.

Pennell was influential in launching a vogue for small, inexpensive, illustrated travel books. His first great success in this line was *A Canterbury Pilgrimage* (London and New York, 1885), a joint effort with his wife that shrewdly exploited the contemporary cycling craze by retracing Chaucer's pilgrims' route on a tandem bicycle. Further collaborations followed: *An Italian Pilgrimage* (1887), *Our Sentimental Journey through France and Italy* (1888), *Our Journey to the Hebrides* (1889), and *Over the Alps on a Bicycle* (1898). Pennell also illustrated travel books by other authors, including reissues of Washington Irving's *The Alhambra* (New York, 1896) and Henry James's *A Little Tour in France* (London and New York, 1900).[2] In the spring of 1899 Pennell cycled through France to prepare drawings for the James work and for the Reverend Percy Dearmer's *Highways and Byways in Normandy* (London and New York, 1900). *Caen (Sketch of a Canal)* resembles the illustrations for these books and although it was never published was almost certainly intended for Dearmer's chapter on Caen (James's account deals only with southern France). Dearmer writes of approaching the town from the fields rather than from the canal, and the drawing by Pennell that was actually published is, unlike Carnegie Institute's drawing, consistent with the text.

Until the devastation of World War II, Caen was a charming medieval town, just the sort of place that one would expect Pennell to appreciate. In his autobiography, however, he writes, in connection with

Pennell, *Caen (Sketch of a Canal)*

101

an earlier commission, of going "to Caen that I hated, where there was nothing to draw but history; and the best drawing I made was of a cabstand which hid everything but the spires of the ugly church."[3] Always the dutiful illustrator, Pennell had to include the "ugly church" (actually two churches, both built by William the Conqueror), but he managed to show them obscured by mist or seen from a distance. He undoubtedly preferred the present view, emphasizing the canal and relegating the city itself to the background.

Caen is not, in the strictest sense, a finished work of art, nor did Pennell intend it to be. A consummate draftsman (even his detractors concede him that distinction), Pennell knew precisely how his work would look in reproduction, and it was this rather than the drawing itself that concerned him most. Thus *Caen*, as a pen and ink sketch, seems deficient in detail and modeling compared to much of Pennell's work; but had it appeared as an illustration in *Highways and Byways in Normandy*, greatly reduced in size, it would have impressed the reader as a clear, delicate, fully realized drawing that was still engagingly spontaneous in its overall effect.

During the first decade of the century, Pennell, finding the essentially reportorial function of his art usurped by the photograph, devoted more of his time to printmaking and less to illustration. At the same time his interest in what might be called the Travelbook Picturesque waned, replaced by a fascination with modern technology. Prints of New York skyscrapers and Pittsburgh steel mills, of wartime munitions plants and shipyards, are among his strongest works.

KN

NOTES: 1. Sadakichi Hartmann, *A History of American Art*, Vol. II (Boston, 1901), 139; Theodore E. Stebbins, Jr., *American Master Drawings and Watercolors* (New York, 1976), 258. 2. The Museum of Art owns several of Pennell's drawings for *The Alhambra*; see checklist nos. 318-24. 3. Joseph Pennell, *The Adventures of an Illustrator* (Boston, 1925), 204. A less entertaining but more thorough treatment of Pennell's life is Elizabeth Robins Pennell, *The Life and Letters of Joseph Pennell*, 2 vols. (Boston, 1929).

KENYON COX

1 8 5 6 — 1 9 1 9

KENYON Cox, a leader of the American mural painting movement that flourished between the 1892 World's Columbian Exposition and the outbreak of World War I, is probably best known today as the author of *The Classic Point of View* (1911). In this statement of his artistic creed, Cox pronounced himself the implacable opponent of both avant-garde modernism ("bent upon emulation of the Gadarene swine . . . rushing down a steep place into the sea")[1] and nineteenth-century realism, which he castigated as a mere literal transcription of nature utterly lacking true aesthetic and intellectual value. (Cox's condemnation encompassed such diverse figures as Holman Hunt, Bastien-Lepage, and Monet, but excluded his hero, Millet.) The salvation of modern art, Cox maintained, lay in a return to the tradition of Titian, Rubens, Raphael, and Poussin, wherein "each new presentation of truth and beauty shall show us the old truth and the old beauty."[2] He believed that America, by virtue of its conservative taste, could lead the world in a revival of what he called the Classic Spirit. Although Cox's hyperacademic opinions are fascinating and at times breathtaking (as when he attributes the decline of modern art to, of all people, Jacques-Louis David), his paintings, unfortunately, are neither.

Scale Drawing for the Contemplative Spirit of the East is one of eight preparatory studies in the Carnegie Institute collection for the lunette over the entrance to the State Supreme Court at the Minnesota State Capitol in Saint Paul. This group also includes a number of nude and drapery studies for the individual figures and an oil sketch for the entire work. John Sloan saw these studies at the museum in 1907, shortly after

Scale Drawing for the Contemplative Spirit of the East, Minnesota State Capitol
1904
graphite, sepia, and ink on canvas
23 x 46 in.
(58.4 x 116.8 cm.)
Andrew Carnegie Fund,
06.6.7

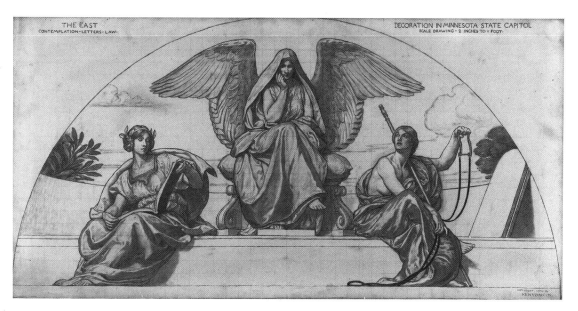

Cox, *Scale Drawing for the Contemplative Spirit of the East, Minnesota State Capitol*

they were acquired, and condemned them as "some painful examples of the labors of 'K. Kox.'"[3] Sloan, an advocate of a robust form of urban realism, naturally had no sympathy with Cox.

The Contemplative Spirit of the East is typical of Cox's efforts to put his ideas into practice. He used the traditional Renaissance format, of a central figure flanked by two subordinate figures, which he held to be "the natural form of composition for the lunette."[4] The subject matter is wholly in keeping with his view that allegory, by expressing complex ideas clearly and by lending itself to decorative handling, was eminently suited to the embellishment of public buildings. The symbolism is straightforward: the personification of Letters reads a book; Law sits near a pair of tablets, presumably the Ten Commandments, holding a scepter and a bridle. Presiding over them is the winged Spirit of Contemplation, plainly derived from the brooding, shrouded figure designed by the sculptor Augustus Saint-Gaudens for the *Adams Memorial* (1886–91, Rock Creek Cemetery, Washington, D.C.). Cox greatly admired Saint-Gaudens, who shared his fascination with the Renaissance, but his *Spirit of Contemplation* retains little of the mystery and fin-de-siècle elegance of its prototype. As a whole, the lunette is an appropriately dignified and erudite decoration for the entrance to the Minnesota State Supreme Court.

KN

NOTES: 1. Kenyon Cox, *The Classic Point of View* (New York, 1911; reprinted, 1980), 20. 2. Cox, 5. 3. Sloan, diary entry for 14 November 1907, in Bruce St. Johns, ed., *John Sloan's New York Scene* (New York, 1965), 166. 4. Cox, 97.

VIOLET OAKLEY

1 8 7 4 — 1 9 6 1

Venetian Girl
1918
crayon on paper
12 ½ x 10 ⅞ in.
(31.8 x 27.6 cm.)
Purchase, 18.25.11

IN the early years of the twentieth century, illustration was the one artistic field in which women competed successfully with men. Feminine gentility, however, prevented many of them from attempting any but the most innocuous subjects. The ideal woman illustrator was, in many respects, Jessie Willcox Smith, whose adorable moppets regularly sweetened the pages of *Good Housekeeping*, *The Ladies' Home Journal*, and *The Woman's Home Companion*. Violet Oakley was a notable exception to the rule. Born into a family with a strong tradition in the arts (both grandfathers belonged to the National Academy of Design), she entered Howard Pyle's illustration class at Drexel Institute in 1897, after having already studied in New York at the Art Students League, in Paris under the academic Symbolist Aman-Jean, in England with the obscure British painter Charles Lazar, and at the Pennsylvania Academy of the Fine Arts. Pyle soon recognized her talent and arranged for her to collaborate with Jessie Smith, another of his pupils, on a new edition of Longfellow's *Evangeline*, published by Houghton, Mifflin and Company. Oakley and Smith became close friends and, with Elizabeth Shippen Green, another gifted member of the Pyle group, formed a communal household that lasted from 1897 until 1911.

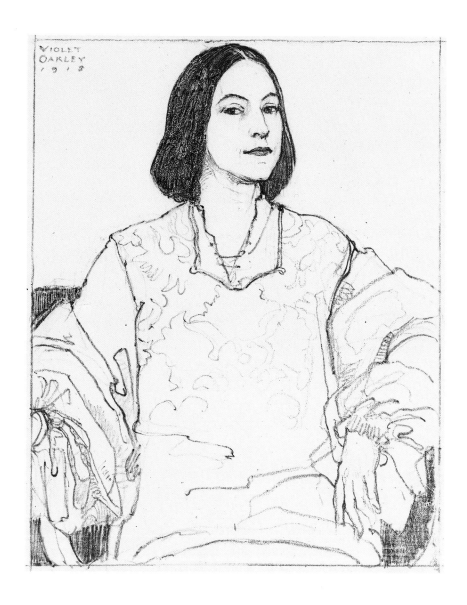

Oakley, *Venetian Girl*

Violet Oakley's unconventionality was not manifest in her style, which was formed under such respectable influences as Edwin Austin Abbey, Burne-Jones and the Pre-Raphaelites, and, above all, Howard Pyle. Instead, it lay in her successful invasion of the masculine domain of mural painting. She scored a major coup in 1902 when she received part of a mural commission for the Pennsylvania State Capitol at Harrisburg. The lion's share of this project went to Edwin Austin Abbey, but after his untimely death in 1911 Oakley obtained further important commissions from Harrisburg. By this time she had largely given up illustration. Her murals bear no trace of the sentimental domesticity expected of women artists of the period, but instead treat weighty historical and allegorical themes that expressed deeply religious, pacifist convictions.[1]

Venetian Girl was Oakley's contribution to a portfolio of drawings published in 1918 to raise money for the American Artists' War

Emergency Fund. Her support for this enterprise in no way violated her pacifism, because the fund's purpose was not to support the war but to aid its victims. The drawing's bold, simple composition, based on Renaissance prototypes, as well as its strong figure outline and spare modeling, are characteristic of Oakley's mural and graphic work. Although the sitter was first drawn in pencil and then finished in crayon, this work retains an informal sketchlike quality like that found in the artist's intimate portraits of her friends. The model was not, in fact, a Venetian girl at all, but Oakley's long-time assistant and companion, Edith Emerson, dressed as a sixteenth-century page.[2] Emerson wears the full costume, including tights and trunkhose, in a painting entitled *The Banquet* (1918, Violet Oakley Memorial Foundation, Philadelphia), where she is seen serving Oakley and her guests, and in *The Lady and the Page*, a series of photographs in which Oakley played a character called Violetta and Emerson one named Giovanni.[3] This private fantasy testifies to their deep affection for both Italy and each other. *Venetian Girl* closely resembles and is clearly related to an unfinished portrait of Emerson (1918, Violet Oakley Memorial Foundation, Philadelphia).

KN

NOTES: 1. See Patricia Likos, "The Ladies of the Red Rose," *Feminist Art Journal* V (Fall 1976), 11-15; "Violet Oakley," *Bulletin of the Philadelphia Museum of Art* LXXV (June 1979): 2-32. Delaware Art Museum, Wilmington, *The Studios at Cogslea* (1976), exh. cat. by Catherine C. Stryker, has a good short biography of Oakley and a list of her published illustrations. 2. Patricia Likos, letter to Kenneth Neal, 20 August 1984. 3. Violet Oakley scrapbooks, c. 1918, on microfilm in Archives of American Art, Washington, D.C.

FREDERICK MAXFIELD PARRISH

1 8 7 0 — 1 9 6 6

Girl by a Fountain
1918
crayon on paper
11 ¼ x 9 ¹⁵⁄₁₆ in.
(28.6 x 25.2 cm.)
Purchase,
18.25.12

WHEN F. Scott Fitzgerald, in a 1920 short story, described the light of a New York City dawn as being "the color of a Maxfield Parrish moonlight," he had no doubt that his readers would know precisely the shade of blue he meant.[1] Beginning in the late 1890s, Maxfield Parrish had entered the national consciousness through a steady stream of book and magazine illustrations, posters, advertisements, and the famous color reproductions that decorated the parlors of countless middle-class American homes after World War I.

The son of a well-known Philadelphia artist, Parrish entered Haverford College in 1888 intending to become an architect. By 1892 he had turned to the graphic arts and enrolled at the Pennsylvania Academy of the Fine Arts, where his teachers included Robert Vonnoh and Thomas Anshutz. He also audited several of Howard Pyle's illustration classes at Drexel Institute. In 1895 Parrish designed the first of his many magazine covers for Harper and Brothers, and within a very few years he had risen to the top of his profession. Because of contemporary developments in color printing, he was able to work simultaneously as both a painter and an illustrator, and his original oils, though avidly collected, were intended primarily for publication.

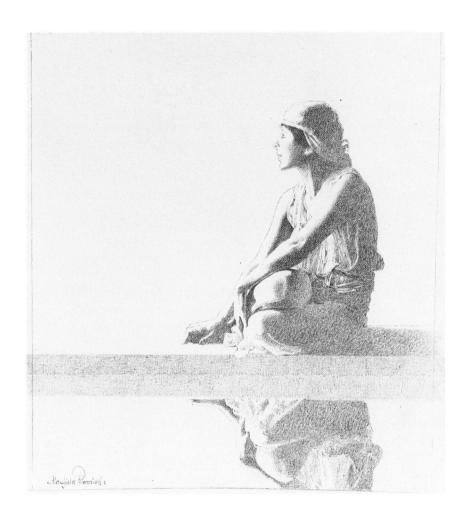

Parrish, *Girl by a Fountain*

Until the 1930s Parrish worked in two modes: a droll storybook style populated by gnomelike caricatures and a "High Art" style, reminiscent of Albert Moore and Sir Lawrence Alma-Tadema, in which beautiful young women did nothing in particular amid poetic surroundings. It was this latter style that recommended his color reproductions to an audience whose taste was largely conditioned by a watered-down, late-nineteenth-century aestheticism.

Girl by a Fountain is a variant of one of the figures in Parrish's first great success in this line, *The Garden of Allah*, which originally appeared on the 1918 Crane's Chocolates gift box and was distributed separately that same year by the House of Art, New York.[2] With the exception of *Daybreak* (published by the House of Art in 1923), *The Garden of Allah* was his most popular print. Inspired by a scene in the stage version of Robert Hichens's 1904 novel of the same name, it is a typical Parrish idyll, depicting three slender maidens (more Greek than Arab) lounging beside a reflecting pool against a lush background of trees and flowers.

The probable genesis of *Girl by a Fountain* can be deduced from the fact that the artist customarily worked from photographs, projecting them onto paper or directly onto the canvas, a procedure that accounts for the photorealistic quality of much of his work. When the American Artists' War Emergency Fund asked him to contribute to its portfolio of drawings, Parrish simply and economically followed his standard

practice, selecting a slide he had recently made, but had not used, for *The Garden of Allah*. The image would have required little if any modification. The elegant silhouetting of the figure against an expanse of blank paper could easily be achieved by *not* projecting a background slide; the model's pose, clearly designed to show her in conversation, can also denote solitary revery. By exploiting the texture of the paper to obtain a soft stippling, Parrish's pencil technique reproduces the airbrushed look of his paintings.

In 1931 Parrish announced, "I'm done with girls on rocks,"[3] and for the next thirty years he devoted himself to American rural landscapes, which reached a wide audience through calendars and greeting cards. Contemptuously dismissed as a purveyor of kitsch during the latter part of his career, Parrish lived long enough to witness a revival of interest in his work during the 1960s.[4]

KN

NOTES: 1. F. Scott Fitzgerald, "May Day," *The Stories of F. Scott Fitzgerald* (New York, 1951), 120. 2. Crane, the manufacturer of Crane's Chocolates, was the father of the poet Hart Crane and a creative individual in his own right—he invented the Lifesaver. 3. "Maxfield Parrish Will Discard 'Girl-on-Rock' Idea in Art," Associated Press, 27 April 1931. 4. Coy Ludwig, *Maxfield Parrish* (New York, 1973) is a thorough, beautifully illustrated treatment of the artist.

EARL HORTER

1881 — 1940

Broadway and 186th Street
before 1920
crayon and wash on paper
16 ⅛ x 11 ¼ in.
(41 x 28.6 cm.)
Purchase, 20.20

A SELF-taught painter and draftsman, Horter began his career as a designer of stock certificates for a banknote company and eventually amassed a large fortune as a commercial artist. He spent much of his wealth on women (four wives and several mistresses) and on modern art, especially Cubist works. On one occasion, according to an account written shortly after his death,

> [He] went abroad with $27,000 and a glamorous girl (no wife) to make the acquaintance of Braque and other French moderns. He did more than fraternize; he bought their works, left the girl with one of them, and returned home broke, but with a collection of modern art.[1]

At one time Horter's collection included twenty-two Picassos and a great many canvases by Braque, Matisse, John Marin, and Charles Sheeler. Through his considerable charm and persuasiveness as a teacher and popular lecturer, he became an influential champion of modernism in his native Philadelphia. "Modern art," he declared, "is as much a part of the Great Tradition as is the Parthenon."[2]

In fine as opposed to commercial arts, Horter was best known as a printmaker. He made his first etchings and aquatints in 1910, and five years later his prints won a silver medal at the Panama-Pacific Exposition in San Francisco. As one would expect, modernist influences appear in his graphic work, though in most cases they are moderated in the direction of realism. Horter's Cubism, for instance, resembles the Precisionism of

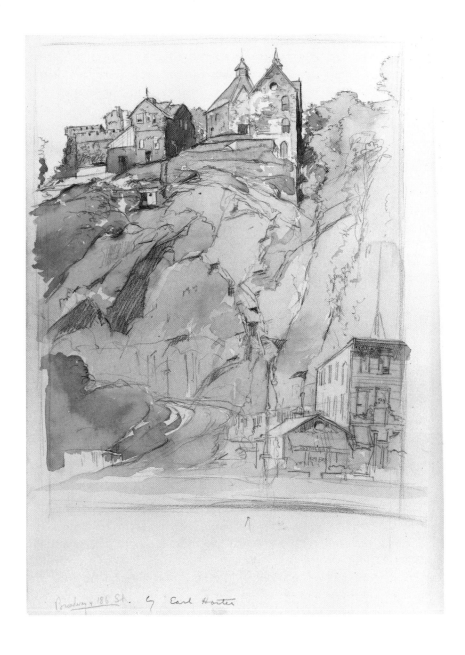

Horter, *Broadway and 186th Street*

Charles Sheeler far more than it does the more radical experiments of Picasso and Braque.

Throughout his career Horter was identified particularly with urban and architectural subjects. The charming *Broadway and 186th Street*, a relatively early wash drawing predating his Cubist-inspired work, illustrates the artist's invariably sharp eye for the picturesque. New York City was his favorite source of images, but he ranged as far as the New England coast and the cities of Europe in search of subjects.

KN

NOTES: 1. "Earl Horter," *Art Digest* XIV (1 May 1940): 12. 2. Quoted in "Philadelphia Honors Its Own Earl Horter," *Art Digest* XV (15 November 1940): 11.

CHAPTER 4

EVOCATION AND IMPRESSIONISM

WILLIAM MORRIS HUNT

1824 — 1879

DURING the 1860s and 70s, William Morris Hunt was Boston's most fashionable painter and a vastly influential teacher and lecturer. Today, his reputation rests less on his own work than on his efforts to encourage American collectors to purchase, and American artists to emulate, the more advanced French art of the day. Born in Brattleboro, Vermont, Hunt grew up in New Haven, Connecticut, and attended Harvard for three years before sailing to Europe in 1844. He studied sculpture in Rome, then enrolled at the School of Fine Arts in Düsseldorf, which at that time was extremely popular with American students. He disliked Düsseldorf, however, and went to Paris in 1846, where he studied with the celebrated history and portrait painter Thomas Couture. In 1851 Hunt fell under the influence of the Barbizon school and became the devoted disciple and intimate friend of Jean-François Millet. He settled at Barbizon in 1853 and stayed there until his return to the United States two years later. The ideas that he later promulgated in Boston grew out of his association with Couture and Millet.[1]

Few drawings remain from Hunt's Barbizon years because his studio, which contained most of his early work, was destroyed in the Boston fire of 1872. *The Faggot Gatherer* is a rare survivor. While the drawing is undated, the subject is clearly French: New England farmers did not wear wooden shoes, nor, given an abundance of timber in the United States, were they compelled to scour the forest floor in search of firewood. Hunt never returned to France after 1855, so the drawing must have been made before that date.

Hunt may well have found the model for this drawing during one of his frequent rambles through the countryside with Millet. The faggot-gatherer (*bûcheron*) was a favorite subject of Millet. His first known drawing on a peasant theme, *Le vieux bûcheron* (1845–47, Cabinet des Dessins, Musée du Louvre), depicts a faggot-gatherer with a great bundle of sticks on his back. In 1853–54, while Hunt was studying with him, Millet executed both a drawing—*Le fendeur de bois* (*Le bûcheron*), (The Metropolitan Museum of Art)—and a related painting of the same title (Musée du Louvre) that shows a peasant breaking down faggots. The theme of the laborer at rest is also common in Millet's work. Hunt owned a painting of a peasant seated by a haystack, which Millet executed in 1851–52. This painting perished in the Boston fire, but a sketch of the main figure survives in the Louvre, and Elihu Vedder had made a copy of the entire composition.[2]

As a teacher Hunt declared charcoal the only really effective drawing medium and urged his students to study Millet's sketches as models. In *The Faggot Gatherer*, however, there is little trace of Millet's stylistic influence. In contrast to the simplified, curiously generic figures found in the French master's work, Hunt's peasant is carefully individualized down to the seams and wrinkles in his clothing. The fluid line and bold modeling that Hunt learned from Couture, his first instructor in charcoal, seem restrained and academic compared to Millet's handling of the same medium, or, indeed, to Hunt's own later sketches.

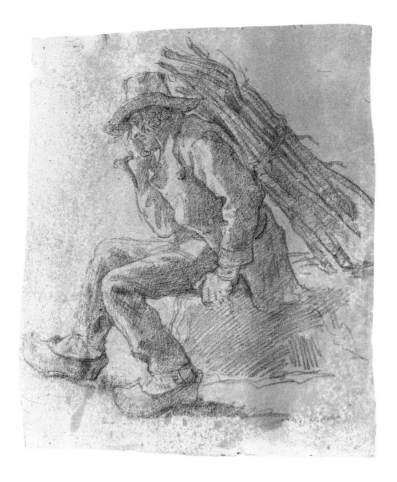

Hunt, *The Faggot Gatherer*

It is in the dignity and sympathy with which Hunt treats his subject that Millet's influence is clearly felt. "When I came to know Millet," Hunt recalled, "I took broader views of humanity, of the world, of life."[3] While living in Barbizon, Hunt took to wearing a blouse and sabots in emulation of the local peasants and of the peasant-born Millet, "for he was a workman, and I was proud to call myself one."[4] Later, as a society portraitist in Boston, he relaxed by sketching street urchins and other members of the urban proletariat. But it was only in the last year of his life, while he was executing a mural commission for the New York State Capitol, that Hunt found the American workingman as worthy a theme for his art as the French peasant. "Do you see that old Irishman?" he asked a visitor to the Capitol, pointing to one of the laborers. "[H]e has more character than an entire Congress. How big his movement is! Doesn't he handle that hoe with the dignity of a king?"[5] His plan to commemorate these workmen in a mural for the Capitol was frustrated when the governor vetoed a legislative appropriation for additional paintings.

KN

NOTES: 1. For Hunt's life and work see H. C. Angell, *Records of William M. Hunt* (Boston, 1881); Helen M. Knowlton, *The Art-Life of William Morris Hunt* (Boston, 1900; reprinted New York, 1971); M. A. S. Shannon, *Boston Days of William Morris Hunt* (Boston, 1923); and Museum of Fine Arts, Boston, *William Morris Hunt: A Memorial Exhibition* (1979), exh. cat. by Martha J. Hoppin and Henry Adams. Hunt's teachings are preserved in his *Talks on Art* (first series, Boston, 1875; second series, Boston, 1884). 2. Reproduced in Elihu Vedder, *The Digressions of V* (Boston and New York, 1910), 261. 3. Knowlton, 12. 4. Knowlton, 17. 5. Knowlton, 173.

RALPH ALBERT BLAKELOCK
1847 — 1919

Redwoods, California
1869
graphite and pen and ink on
paper mounted on board
11 x 8 ⅜ in.
(27.9 x 21.3 cm.)
Andrew Carnegie Fund, 06.18.2

Untitled
c. 1870
graphite, pen and ink, and wash
on paper
5 ⅞ x 3 ¼ in.
(14.9 x 8.3 cm.)
Andrew Carnegie Fund, 06.18.1

THE tragic life of Ralph Albert Blakelock has become as legendary as his visionary paintings of Indians and moonstruck landscapes. Unrecognized and unappreciated by critics and the public until it was too late, the New York artist struggled for years to support his wife and their family of nine children. Eccentric, other-worldly, and easy prey for the unscrupulous but discerning collectors who coveted his idiosyncratic work, Blakelock suffered a mental collapse in 1899 and was confined for seventeen years at the hospital for the insane in Middletown, New York. Ironically, his paintings, neglected for so long, were later so sought after that they had the dubious honor of being forged repeatedly.

Unlike the majority of painters in the post-Civil War period, Blakelock, who was essentially self-taught, did not travel to Europe to study, but instead chose to discover the American West in two trips, in 1869 and 1872. He spent two years wandering and penning views of the land and the Indians. Although his actual route has not been determined precisely, inscriptions on drawings chart his presence in Nebraska, Kansas, Colorado, Wyoming, Utah, Nevada, and California and, beyond American borders, in Mexico, Panama, and the West Indies.

Making six to eight drawings per page in his sketchbook, and usually signing the one at the lower right corner of a page, Blakelock produced over three hundred images of his trips. Only eight are dated, two from

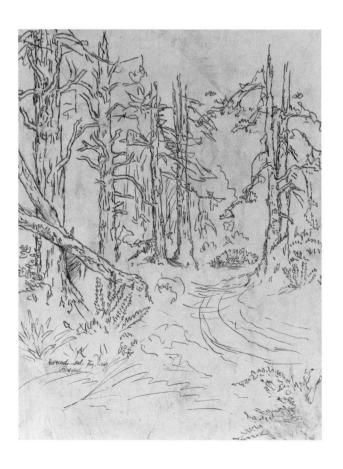

Blakelock, *Redwoods, California*

1869, including *Redwoods, California*, and six from 1872.[1] Throughout his life, the artist rarely dated either his drawings or his paintings, and it is difficult to assign years to them. There does exist, however, a group of drawings that verifiably date from the period of Blakelock's confinement at Middletown, for he continued to work until the end of his life. Blakelock presented the drawings as gifts to one of the nurses, and a relative of hers gave them to the San Diego Museum of Art.

Most of the Middletown drawings are sketches of trees, ponds, and the institutional buildings.[2] The artist made them on scraps of brown wrapping paper or cigar-box covers foraged from the asylum's trash bins, and they tend to be schematic, literal, rather flaccid, and peculiarly vacant. Curiously, a number of them bear the notation "A 1," a cryptic marking that was elucidated in what seems to be the only contemporary account of Blakelock's draftsmanship:

> A request by Mrs. Adams [a benefactor] that he sign one of the pictures he was giving to Mrs. Blakelock discovered the artist's illusion that he must sign nothing while he was in the hospital because a committee of rich men is keeping him there to exploit his name. So he signed himself "A 1" and explained that it stood for "Albert the First." All of Mrs. Adams' persuasiveness could not induce the artist to sign his name to the sketch, but he did promise with apparent interest to paint later a picture especially for her and to sign it "Blakelock" if Mrs. Adams would give him an autograph of President Wilson.
>
> As the conversation centered more on his art Blakelock became noticeably more coherent. Only occasionally would he ramble off into a dissertation on astral bodies and communication with Mars.[3]

In contrast to the detailed, colorful oil sketches executed by his famous contemporaries, Albert Bierstadt and Frederic Church, who made them as studies for their grand, patriotic panoramas, Blakelock's travel sketches in pen and pencil are oddly empty and airless, with their febrile line introducing an emotional dimension into the physical description. Some of his travel pictures are no more than scrawls, ciphers for natural forms. *Redwoods, California*, however, is not only substantially larger than the other travel pictures, but, with its inscription "Aug. 1869," is possibly one of the earliest of the group. It is, furthermore, more elaborated and more finished and functions less as an *aide mémoire* than as a compositional study for an oil painting.

The notations "shadow" and "light" that appear at the middle right edge of the paper, written in lettering that echoes the calligraphic handling of the drawing, are further evidence that Blakelock may have been planning a more intricate rendition of the scene.

In striking opposition to *Redwoods, California*, the untitled drawing is dense and lush. Its shrouded, oppressive aura relates not to the stark, skeletal travel sketches but to the sensuous, opaque oil paintings. On a tiny sheet of paper mounted on cardboard, Blakelock first roughed out the image in graphite. Then with pen and ink he drew a primeval forest scene against layers of blue and brown wash, which create designs like frost patterns and evoke patches of light. Into this minuscule slice of nature, Blakelock compressed the trunk of a great tree rising out of a hillside, exploring its octopus-like roots with their extremities hooked into

the tangled growth of the forest floor. Tense, jagged strokes evoke a jungle crawling with activity; they do not define specific animal or vegetal elements, but they conjure up the pulsing dynamism of life forms that lurk in dark, haunted corners of nature.

Untitled is unique in Blakelock's work and is his finest known drawing. It strongly resembles, in its taut, luxuriant descriptiveness, a little panel painting, *A Forest Clearing* (1870), that has recently appeared on the art market.[4] The painting, one of the few dated works by Blakelock, may be linked to the drawing by an arresting similarity in its sylvan subject, tight handling, treatment of light, and signature, "R.A.B." These comparisons suggest that the most convincing date for the museum's untitled drawing is around 1870, when the artist neared the height of his creative powers.

EAP

NOTES: 1. Vose Galleries, Boston, *Ralph Albert Blakelock 1847-1919: Drawings* (1981), exh. cat., 2. 2. Among the drawings in the San Diego Museum of Art are *Trees; Figures; Buildings; Trees, Hills, Streams; Trees and Lake;* and *Trees and Shrubs.* 3. "Paintings Made at Hospital May Be Means of Restoring Genius of Noted Blakelock," *Middletown Daily Times-Press*, 20 March 1916. 4. Sotheby's, New York, *American 19th & 20th Century Paintings, Drawings and Sculpture* (26 October 1984), Lot no. 38. "This painting has been assigned to Category II, no. NBI 1051, of the Blakelock Inventory, University of Nebraska, Lincoln."

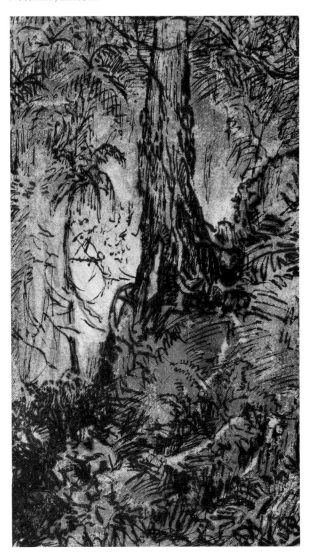

Blakelock, *Untitled*

JAMES ABBOTT McNEILL WHISTLER

1 8 3 4 — 1 9 0 3

BORN in Lowell, Massachusetts, Whistler spent much of his childhood in Russia, studied art in Paris, and painted his most important paintings in England. His earliest canvases related closely to the work of such French painters as Courbet, Degas, and Fantin-Latour; but after his move to London in 1860 he rejected French "Realism" and developed the notion that paintings should depend not on representation or narrative content but on arrangements of form and color that evoke mood somewhat as music does.

Whistler's draftsmanship was both revolutionary and influential; to American artists he was undoubtedly the most influential draftsman of the nineteenth century. His drawings, like his paintings, stress evocation of mood rather than description and are original in both their manner of linework and their choice of media. As David Curry has pointed out, in a recent catalogue, Whistler was deeply influenced by artists of the French eighteenth century, particularly Watteau.[1] From Watteau he derived a delight in colored and textured papers and a love of pastel, chalk, charcoal, and other granular materials. Unlike most French masters of pastel, however, Whistler did not attempt to duplicate the effects of paint and employed little stumping or blending. His drawings remain predominantly linear in execution: in fact, his use of crosshatching and shading, although more shadowy in effect, relates most closely to mid-nineteenth-century book and magazine illustration. This is not surprising considering that Whistler's earliest sketches were copies and imitations of works of this type by masters ranging from Cruikshank to Gavarni.

For both etchings and drawings Whistler favored unusual papers. His friend and biographer Joseph Pennell wrote, in an account of an excursion in Paris, that Whistler exulted in the discovery of three folio volumes of old paper, which had been used to press a collection of dried leaves; and he observed in another account, of Whistler's early years in Paris from 1855 to 1859, that, "he was then already hunting for beautiful old paper, loitering at the boxes along the *quais*, tearing out the fly-leaves from the fine old books he found there."[2] Other artists were directly influenced by Whistler's fascination with paper, as is evident in several drawings in the museum's collection, notably John F. Twachtman's *Low Tide: A Stranded Vessel*. Twachtman made this drawing at the time he met Whistler in Venice and executed it on what appears to be a sheet of old Venetian paper. The large group of Hassam drawings in the museum are also executed on scraps of paper of different textures and colors, and their manner of execution clearly pays homage to Whistler.

Study of a Gown is based on the dress Whistler designed for his portrait *Symphony in Flesh Colour and Pink: Portrait of Mrs. Frances Leyland* (c. 1874, Frick Collection, New York). The sitter was the wife of the shipping magnate Frederick Leyland, who commissioned *Harmony in Blue and Gold: The Peacock Room* (1876–77, Freer Gallery, Washington, D.C.) and who was Whistler's most generous and enthusiastic early patron. Mrs. Leyland saw so much of Whistler during the early 1870s that a rumor, apparently abetted by Dante Gabriel Rossetti, went so far as to suggest

Study of a Gown
c. 1872–74
pastel on brown paper
11 5/16 x 7 1/4 in.
(28.7 x 18.4 cm.)
Andrew Carnegie Fund, 06.12.6

Portrait of a Young Girl
c. 1872–74
pastel on paper mounted on board
8 7/8 x 6 9/16 in.
(22.5 x 16.7 cm.)
Gift of George W. Wyckoff in memory of Elizabeth McKay Wyckoff, 73.37

A Lady Standing
c. 1881
pastel on brown paper mounted on cardboard
10 11/16 x 5 15/16 in.
(27.1 x 15.1 cm.)
Andrew Carnegie Fund, 06.14

that she might leave her husband and run off with him. In the end, however, Whistler never broke through Mrs. Leyland's formal reserve, and in the finished painting she stands aloof and distant, beautiful but untouchable.[3]

Mrs. Leyland originally wished to pose for her portrait in black velvet, like Mrs. Huth, and Whistler made two drypoints of her in such a dress. For the painting, however, Whistler designed a new dress to harmonize with her red hair. He once commented on the underlying affinity between dress design and painting, noting, "in every costume you see attention paid to the keynote of colour which runs through the composition."[4]

Whistler, *Study of a Gown*

The evolution of the design for Mrs. Leyland's gown is documented by eight pastels: six in the Freer Gallery, one in the Hirshhorn Museum and Sculpture Garden, and this one in Carnegie Institute. Probably Mrs. Leyland did not pose for all these drawings; Maud Franklin, Whistler's mistress, posed occasionally for the Leyland painting and probably for some of the drawings as well.[5]

The earliest of the pastel studies, in the Freer Gallery, shows a filmy blue overdress with a pale pink gown underneath. In the remaining drawings, however, Whistler opted for a dress without blue, an elaborately gathered and beribboned gown in orange and white chiffon with a long trailing train—the so-called "pli Watteau." Several of the pastels also show an overskirt, puffed out at the hips, whose folds resemble classical draperies. The effect thus combined elements of French eighteenth-century and classical art and also possessed a certain Japanese quality, a distinctive mixture of styles often found in Whistler's work.

In the painting Whistler simplified the dress further and changed the color scheme from orange to pink. Carnegie Institute's pastel, rendered with very light touches of yellow, orange, red, pink, black, and white is the only study to show the figure seated; the others show her standing, from different angles. In addition to these pastels, numerous crayon studies exist that depict Mrs. Leyland in various costumes and poses. Many of these are in the Freer Gallery and the Hunterian Art Gallery, Glasgow.[6]

Portrait of a Young Girl is a study for Whistler's painting of the youngest daughter of Frederick Leyland, Elinor "Baby" Leyland, who was eleven years old when Whistler began to paint her in 1871. Whistler seems to have felt a particular affinity with this sitter. "How delighted I was to see the lovely Babs," he wrote her mother, "—really, that child is exasperatingly lovely."[7] No doubt in response to Babs's vivacity, Whistler chose a jaunty pose probably based on Velázquez's *Pablillos de Valladolid*. The color harmony was a palette of blues, and the painting was titled *The Blue Girl* in obvious emulation of Gainsborough's *Blue Boy*. According to Pennell, Whistler "wished to paint blue on blue as he had painted white on white."[8] As was often the case, however, Whistler proved unable to finish the canvas to his satisfaction. After his break with the girl's father over payment for *The Peacock Room*, Whistler kept the portrait for some years in his studio. There it was largely destroyed during the confusion that surrounded his bankruptcy in 1879, after a costly libel suit against John Ruskin, which he won but which netted him only a farthing in damages. Only two small fragments, depicting blue-and-white china, were salvaged from the painting at that time. These are now in the Freer Gallery.

The chief records of the painting are a pastel in the Freer Gallery, a pen drawing in The Art Institute of Chicago, and a drypoint made about 1873. Carnegie Institute's drawing relates closely to the drypoint and may have been made at about the same time. Other drawings related to the painting exist in a private collection, in the Munson-Williams-Proctor Institute in Utica, New York, and in the British Museum. Several black and white crayon drawings of Elinor in other poses are in the Fitzwilliam Museum in Cambridge, England, the Freer Gallery, and the Hunterian Art Gallery in Glasgow.[9]

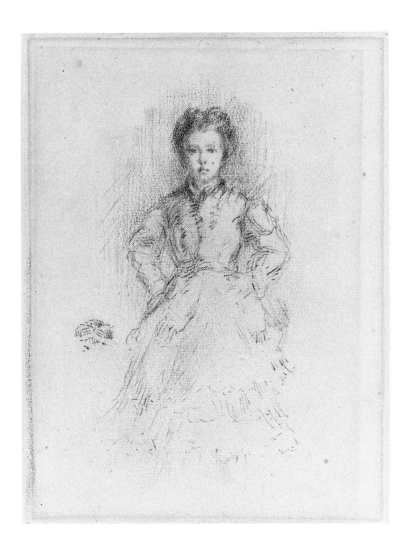

Whistler, *Portrait of a Young Girl*

A Lady Standing was purchased by Carnegie Institute in 1906, three years after Whistler's death, from M. Knoedler and Company, who identified the sitter as Tillie Graves. The name appears to be a corruption of Tinnie Greaves (baptized Alice), the sister of Whistler's two boatman friends, Walter and Harry Greaves, who in the 1860s lived two doors down from him on Lindsay Row in Chelsea. Their father, a boatman and boatbuilder, had rowed Turner about on the Thames, and they performed the same task for Whistler, often taking him out on the river at night so that he could make black and white chalk studies for his nocturnes. Whistler, in turn, let them help with his decorative schemes and taught them to paint in a manner closely imitative of his own style.[10]

The identification of Tinnie Greaves is possible because, during the period of Whistler's first association with the Greaves brothers, around 1863, a fellow artist at a life-drawing class, interested in Whistler's techniques, noted, "I . . . saw, with the tip of my eye, as it were, that Whistler made small drawings on brown paper with coloured chalks, that the figure (always a female figure) would be about four inches long, that

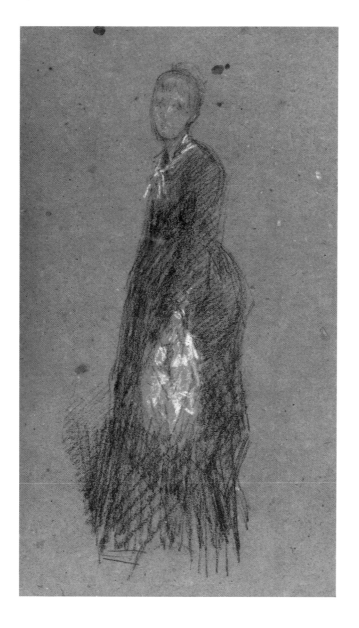

Whistler, *A Lady Standing*

the drawing was bold and free, and not slavishly like the model."[11] Such a description might well apply to this sheet.

Perhaps the closest visual counterparts to this drawing, however, are a group of studies of Whistler's mistress, Maud Franklin, that date from the 1880s. *A Lady Standing* closely resembles, for example, a study of *Maud Standing* (Freer Gallery, Washington, D.C.), which can be dated to about 1881 on the basis of its resemblance to *Harmony in Pink and Gray: Portrait of Lady Meaux* (1881–82, Frick Collection, New York).[12]

HA

NOTES: 1. David Park Curry, "Artist and Model," in *James McNeill Whistler at the Freer Gallery of Art* (New York, 1984), 35-51. 2. Elizabeth R. Pennell and Joseph Pennell, *The Life of James McNeill Whistler*, Vol. I (Philadelphia, 1908), 71. 3. Stanley Weintraub, *Whistler, a Biography* (New York, 1974), 152. 4. Curry, 252. 5. Curry, 251-52. 6. Andrew McLaren Young, Margaret McDonald, and Robin Spencer, *The Paintings of James McNeill Whistler*, Vol. I (New Haven, Connecticut, 1980), 65-66. 7. Curry, 250; Young, I, 69. 8. Pennell, I, 176. 9. Young, I, 69. 10. Pennell, I, 106-108. 11. Pennell, I, 108. 12. Curry, 268.

HOMER DODGE MARTIN

1836 — 1897

Sand Dunes, Lake Ontario
c. 1874
charcoal, crayon, and gouache
on buff paper
12 ³⁄₁₆ x 19 ½ in.
(31 x 49.5 cm.)
Carnegie Special Fund, 04.5.4

HOMER Martin began his career as a landscapist in the Hudson River style, practicing first in his native Albany, then, after 1862, in New York City. Influenced by James McNeill Whistler, the Barbizon school, and his close friend John La Farge, he evolved over the years an increasingly painterly and poetic style culminating in the richly textured near-abstraction of his late works. A degenerative eye condition (by 1893 he was almost blind) probably accelerated his development toward abstraction.

Martin was never a popular artist, but he enjoyed a small following led by Thomas B. Clarke, the discerning collector of American painting. His reputation rose immediately following his death, and in 1901 Sadakichi Hartmann declared, "Homer Martin and D. W. Tryon were the men who brought [American landscape painting] to its highest pinnacle of perfection."[1] Martin also enjoyed a modest reputation for his wit, which was frequently at odds with the elegiac mood of his landscapes. On one occasion, when the purchaser of a woodland interior asked Martin to provide a suitably poetic title, he replied, "Oh! It's the Home of the Telegraph Pole."[2]

Though Martin, taking advantage of an opportunity to travel, drew a series of English landscapes for *The Century* in 1881, he disliked illustration and had little interest in drawing as an end in itself. However, like most landscape artists of the day, he spent his summers sketching in picturesque locales, storing up images for the winter's work in the studio.

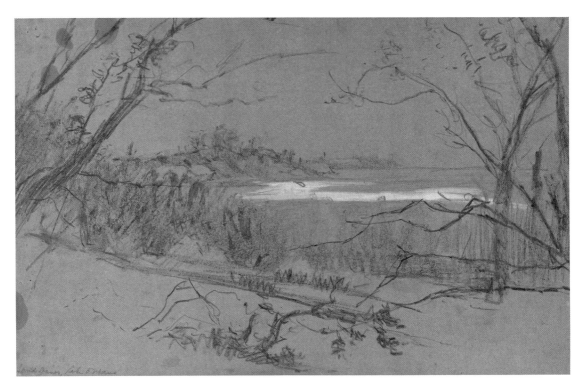

Martin, *Sand Dunes, Lake Ontario*

122

Sand Dunes, Lake Ontario may be one such field study, though its extremely close resemblance to an 1874 painting of the same name (The Museum of Fine Arts, Houston) suggests that it is a final preparatory drawing made in the studio from less finished sketches. Martin often reworked earlier compositions in his later years, and he may have kept this drawing in his studio and turned to it again for a second painting called *Sand Dunes, Lake Ontario*, a simplified version of the same subject done in 1887 (The Metropolitan Museum of Art). The artist Charles Demuth evoked the spirit of these paintings in a sensitive appreciation of Martin's work:

> . . . he painted a country which seemed to be all sand dunes, a dead tree or something suggesting a dead tree in the foreground,—and three dunes and a sky which seems to be more dunes. All very quiet, all almost of the academy,—but, all removed by him into his created world.[3]

Sand Dunes, Lake Ontario anticipates Martin's freer manner of the 1880s and 90s. In this drawing he has begun to eschew the careful delineation of minutiae characteristic of the Hudson River School, anticipating the suppression of detail found in his later work. According to his early biographer, Frank Jewett Mather, Martin began to prefer charcoal to the hard, precise pencil favored by the Hudson River artists only after contact with Whistler in 1876.[4] By the evidence of this drawing, however, he was working in the softer medium at least two years before his first trip to London. His handling of the charcoal brings to mind the loose, painterly brushstroke of his later canvases.

KN

NOTES: 1. Sadakichi Hartmann, *A History of American Art*, Vol. I (Boston, 1901), 101. 2. Frank Jewett Mather, Jr., *Homer Dodge Martin, Poet in Landscape* (New York, 1912), 8. 3. Demuth, "You Must Come Over," unpublished play in manuscript, Weyand Scrapbook No. 1, 82-83; quoted in Emily Farnham, "Charles Demuth: His Life, Psychology and Works" (Ph.D. diss., Ohio State University, Columbus, 1959), 147. 4. Mather, 33.

JOHN H. TWACHTMAN

1 8 5 3 — 1 9 0 2

JOHN H. Twachtman, one of the most important, original, and consistently admired American Impressionists, began his career painting flowers on window shades for his father's business. He received more formal artistic training at the McMicken School of Design in Cincinnati, the city of his birth, and there became friendly with the painter Frank Duveneck, who was one of his teachers. In 1875 Twachtman and Duveneck traveled together to Europe to study for two years at the Royal Academy in Munich. Twachtman subsequently went to Venice to join William Merritt Chase, another of his mentors, and then in 1878 the three artists returned to Munich, where a group of young Americans formed a productive bohemian community around Duveneck. Twachtman journeyed back and forth to Europe numerous times before buying a farm in Greenwich, Connecticut, and settling down to paint the lyrical Impressionist landscapes for which he is best known.

Low Tide: A Stranded Vessel
1880
graphite with traces of pastel on laid paper
8 9/16 x 13 13/16 in.
(21.7 x 35.1 cm.)
Andrew Carnegie Fund, 06.25.1

Twachtman's art underwent several transformations before the 1883 sojourn in Paris during which he finally discovered Impressionism, the style of his maturity. During his early student years in Munich, Twachtman's work had shown the somber tonalities and bravura brushwork characteristic of Duveneck and his "boys," the clique of American pupils. But during the 1880s Twachtman's visits to Venice exposed him briefly to the spell of Whistler, one of that city's most eloquent interpreters.

Otto Bacher, in his chronicle *With Whistler in Venice*, described the American community of expatriate artists in the 1880s, concentrating mainly on Duveneck and his followers. Bacher does not mention Twachtman's name, and at least one scholar claims that Twachtman never met Whistler.[1] Instead, he may have learned of the expatriate's Venetian etchings and pastels through Duveneck and perhaps through examples of Whistler's work that were owned and had been printed by Otto Bacher. A later writer speculated that it was "probably these roughly printed etchings that introduced Twachtman to the magic of Whistler's paper and tone, as well as his free and easy handling of form."[2]

Twachtman made this drawing in 1880, when he was exposed to the compelling influence of Whistler's Venetian prints and drawings. The scene is certainly Venetian: it has been identified as the Zattere, the banks of the Giudecca Canal, possibly the only one of Venice's many waterways that could accommodate boats the size of the stranded vessel.[3] Twachtman worked this drawing lightly, in an abbreviated style, detailing the foreground and then moving diagonally backward to the ship, which slumps like a beached whale. In a reversal of the usual optical convention, the furthest element, the boat, is the picture's darkest and most emphatically delineated area, which draws the eye first.

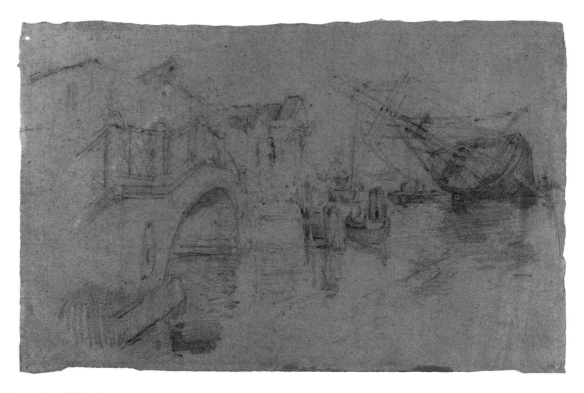

Twachtman, *Low Tide: A Stranded Vessel*

The artist drew *Low Tide: A Stranded Vessel* with graphite on a beautiful, brownish-colored laid paper with specks of pulp and the fragment of a watermark. The sheet is probably quite old; it reflects the interest in unusual papers that seems to have originated with Whistler, who valued their texture for creating the flickering atmosphere characteristic of his Venetian work.[4] Also quintessentially Whistlerian is the faintly nostalgic, vignette-like quality of this scene by Twachtman.

EAP

NOTES: 1. Allen Memorial Art Museum, Oberlin College, Oberlin, Ohio, *The Stamp of Whistler* (1977), exh. cat. by Robert H. Getscher, 166. 2. Allen Memorial Art Museum, 166. 3. We are indebted to Professor William Barcham of the Fashion Institute of Technology, New York, for this identification. 4. Otto Bacher, *With Whistler in Venice* (New York, 1908), 122. Bacher recounts that Whistler often chose to print his etchings "on old Venetian paper, which took on remarkably well because of its matured glue sizing . . . he wandered among all the old, musty, second-hand book shops, buying all the old books that had a few blank pages which he cut out for his printing."

R O B E R T S W A I N G I F F O R D

1840—1905

ROBERT Swain Gifford, a distant cousin of the noted landscapist Sanford R. Gifford, began his career as a marine painter in his native New Bedford, Massachusetts. He did his first works under the tutelage of a Dutch expatriate artist named Albert Van Beest who, in his own work, frequently assigned his young assistant the task of depicting complex ship's riggings. Gifford moved to New York in the mid-1860s and began to exhibit his scenes of sailing vessels and rocky headlands at the National Academy of Design. During the late 1860s and early 70s he broadened his range of subjects, traveling to the West as an illustrator in 1869 and 1874.

The secret of Gifford's ultimate success, however, lay closer to home, in the Buzzard's Bay region of the Massachussetts coast that he had known as a boy. In 1886, introducing the celebrated artist to a juvenile audience, the art critic S. G. W. Benjamin eloquently described the subject that had brought Gifford fame and that he would continue to portray, in endless variations, until his death:

> Many of you have doubtless often seen along our New England coast brown, ragged clumps of solemn weird cedars, whose gnarled and singularly twisted branches spread like deers' antlers. Tufted with tough, spiky foliage, they sway and moan drearily in the gales which scourge the shores, as if they were ancient, age-withered Indian sachems left there alone to wail for their long departed race. These wild cedars, these gray shores, the russet grass which sighs in the autumnal winds on the bare rocks and lonely moors, fading off into the far-off horizon, and canopied by cool gray masses of clouds through which a gleam of light steals here and there, these are what Mr. Gifford has chosen as fit subjects from which to gather inspiration for his versatile talents.[1]

Old Trees
1883
charcoal on laid paper mounted on board
7 ½ x 13 in.
(19.1 x 33 cm.)
Andrew Carnegie Fund, 06.16.2

125

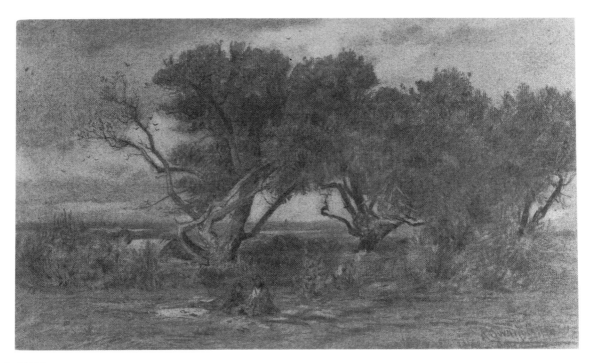

Gifford, *Old Trees*

All the elements Benjamin describes appear in *Old Trees*, a charcoal study Gifford made in 1883 at the height of his powers and reputation.

Gifford's concentration on New England coastal subjects coincided with a loosening of his previously tight facture. In both technique and choice of subject, he was deeply influenced, like many of his colleagues, by the contemporary American vogue for the intimate, painterly landscapes of the Barbizon School. Although the Barbizon sensibility is unmistakable in *Old Trees*, in paintings such as *Near the Marsh* (1880, The Brooklyn Museum) and *Near the Coast* (c. 1883, The Metropolitan Museum of Art) and in many of his etchings, Gifford nevertheless retains the strongly horizontal composition and format of his early marine subjects. This pronounced horizontality, characteristic of his entire production, has its roots in the quieter and more poetic tradition of mid-century American landscape and links Gifford to the Luminism of Heade, Kensett, Lane, and Sanford R. Gifford.[2]

KN

NOTES: 1. S. G. W. Benjamin, *Our American Artists* (Boston, 1886), 55. 2. The only recent survey of Gifford's work is The Whaling Museum, New Bedford, Massachusetts, *R. Swain Gifford, 1840-1905* (1974), exh. cat. by Elton W. Hall.

THOMAS ANSHUTZ

1851 — 1912

Two Boys by a Boat
1895
graphite and watercolor on paper
10 x 13 ⅜ in.
(25.4 x 34 cm.)
Gift of Mrs. Carl Selden, 82.100

T HOMAS Anshutz is best remembered today as the successor of Thomas Eakins at the Pennsylvania Academy of the Fine Arts. Although he supported the dismissal of Eakins from his teaching post, the best qualities of both Anshutz's work and his teaching profoundly reflected Eakins's imprint. Through Anshutz the honest directness of Eakins's approach was passed on to the members of the Ashcan School, Robert Henri, John Sloan, Everett Shinn, and William Glackens. Anshutz also instructed a number of impressive modernist figures, including Charles Demuth, Charles Sheeler, Morton Schamberg, Arthur B. Carles, and Nathaniel Pousette-Dart.[1]

Only one of Anshutz's oil paintings has achieved widespread fame, *Ironworkers: Noontime* (1880–81, Fine Arts Museums of San Francisco), a composition worthy of Eakins, showing some eighteen figures against a factory backdrop. Yet, perhaps because this composition was crudely parodied in an advertisement for Ivory Soap, Anshutz did not concentrate on this vein of social realism.[2] Much of his later work consists of luminous watercolors and pastels, which he exhibited widely and which brought him more recognition in his lifetime than his oil paintings did.

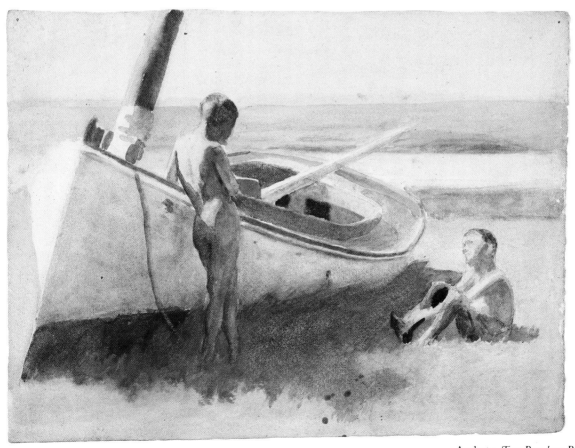

Anshutz, *Two Boys by a Boat*

127

These later watercolors, well exemplified by Carnegie Institute's *Two Boys by a Boat*, directly reflect the ideas Anshutz absorbed in Paris, where he lived for a year in 1892, immediately following his marriage at the age of forty-one. Although he had been teaching at the Pennsylvania Academy of the Fine Arts for more than a decade, Anshutz nonetheless felt uncertain of his abilities and enrolled in classes at the Académie Julian, where he studied under William-Adolphe Bouguereau and Lucien Doucet. At this time he was particularly impressed with the work of Paul Albert Besnard, a minor Impressionist who had studied under Cabanel but taken up the Impressionist technique in the mid-1880s.

The influence of Impressionist ideas is strongly apparent in *Two Boys by a Boat*, one of a group of watercolors that Anshutz produced at the seaside resort of Holly Beach on Cape May, New Jersey, starting in the summer of 1893, not long after his return to the United States. Most of these watercolors depict one or two figures or a boat and concentrate on the radiance of light on different surfaces—sand, water, painted wood, and flesh.

Like Thomas Eakins, Anshutz employed photographs as an aid, although, curiously, he never mentioned their use to his students. His letters to his wife, however, document that he combined elements from both photographs and drawings to assemble his compositions. In one letter, for example, he wrote, "Today I started a picture of three boats coming through the surf sailing—took two boats from my sketches and one from the photograph we took."[3]

A photograph now in the Archives of American Art served as the basis for Carnegie Institute's watercolor and at least two other works done in 1894, the previous year, titled *Two Boys by a Boat* and *Two Boys and a Boat*.[4] Carnegie Institute's watercolor is somewhat looser in handling than these other two.

HA

NOTES: 1. Leslie Katz, "The Breakthrough of Anshutz," *Arts Magazine* XXXVII (March 1963), 26-29; Philadelphia Museum of Art, *Philadelphia: Three Centuries of American Art* (1976), exh. cat., 487-88. 2. Reproduced by Ruth Bowman, "Nature, the Photograph and Thomas Anshutz," *Art Journal* XXXIII (Fall 1973), 33. 3. Bowman, 35. 4. Graham Gallery, New York, *Thomas Anshutz, 1851-1912* (1963), exh. cat. by Sandra Leff, no. 70, illus.; Bowman, 37, fig. 9, 10. See also, Theodore E. Stebbins, Jr., *American Master Drawings and Watercolors* (New York, 1976), 236-37, fig. 197.

MAURICE BRAZIL PRENDERGAST

B. CANADA, 1859—1924

BORN in Newfoundland and brought to Boston as a boy, Maurice Prendergast left school in the eighth grade to work in a dry goods store. His younger brother, Charles, a successful framemaker, devoted himself enthusiastically to encouraging and subsidizing Maurice's artistic career. With Charles's help, Maurice was able, at the age of thirty, to study art in Paris at Colarossi's and the Académie Julian. There he worked only from life, disregarding the advice of Jean-Paul Laurens that he should copy plaster casts. In the mornings he drew from the model in the studio, and in the afternoons he sat in cafés and sketched the people in the boulevards and parks.

A key influence on Prendergast at this time was the Canadian artist James Wilson Morrice, who belonged to a group that gathered at the café Chat Blanc in Montparnasse. Most members of this circle were British, including the painters Charles Condor, Walter Sickert, and Aubrey Beardsley and the writers Arnold Bennett and Somerset Maugham. Morrice had also known Gauguin and had very open-minded tastes. His rooms in the Quai des Grand Augustins were decorated with a Condor fan, a Picasso sketch, and a Modigliani drawing as well as several watercolors by Prendergast. Morrice himself was influenced by the flat color patterns of Bonnard and Vuillard, and his works showing this influence served as a model for those of Prendergast. In some cases the two artists even sketched the same site in Paris from the same vantage point.[1]

In 1895 Prendergast returned to Boston, his home base until 1914, from which he made occasional trips to Europe. One notable visit to Venice, in 1898–99, resulted in a group of splendid watercolors. Like the masters of the so-called "Boston school," such as Frank Benson, Joseph De Camp, Edmund Tarbell, and William Paxton, Prendergast concentrated on the genteel aspects of life, specifically on well-dressed women, whom he treated as decorative compositional accessories without portraying any psychological dimensions of their personalities. Prendergast's formal interests, however, set him apart from the other Boston painters, who were stylistically *retardataire* and worked in either a tightly realistic or an academic-impressionist manner. Only the gifted but uneven Charles Hopkinson, with whom Prendergast exhibited in 1905, ever shared any similar interest in stylistic experiment.[2]

At the time of the Armory Show in 1913, Maurice Prendergast stood out as the most modern and formally advanced artist in America, the first American painter to absorb the achievements of the Post-Impressionists, such as Bonnard, Vuillard, and Cézanne, and the only one to eliminate illusionistic space and concentrate on color and form.[3] Prendergast's art, however, while modernist in tendency, was not based on mental lucubration but on an almost childish delight in color and decorative effects. Charles Hovey Pepper, the Boston artist who painted the only known portrait of Prendergast, once remarked, "Of all the men of genius I have known, Maurice Prendergast had the simplest manner. In conversation he showed the same naive charm that is inherent in the

Woman on a Garden Path
c. 1895
graphite and watercolor on paper
12 ³⁄₁₆ x 9 ⅛ in.
(31 x 23.2 cm.)
Leisser Art Fund, 54.34.5

The Picnic
c. 1902
graphite and watercolor on paper
15 ⁵⁄₁₆ x 22 ⅛ in.
(40.5 x 56.2 cm.)
Gift of Mr. and Mrs. James H. Beal, 73.4

Swampscott Beach
c. 1917
graphite, watercolor, pastel, and gouache on paper
15 ⅝ x 22 ¹⁄₁₆ in.
(39.7 x 57.5 cm.)
Gift of Edward Duff Balken, 49.5.10

129

lovely magic of his work."[4] Once established, his style varied little, and academic attempts at formal analysis of his work have generally proved less illuminating than more informal reminiscences like Van Wyck Brooks's delightful "Anecdotes of Maurice Prendergast," an essay based entirely on conversations with the artist's brother, Charles.[5]

Prendergast won the favor of relatively conservative Bostonians, who had little interest in his modernist tendencies but enjoyed the cheerfulness of his work. His most enthusiastic patronage, however, came from collectors like Duncan Phillips and Albert Barnes whose primary interest was modernist European art. After 1900, Prendergast exhibited frequently in New York, where he could reach a larger audience. In 1908 he joined the controversial exhibition staged by The Eight at the Macbeth Gallery, and in 1913 he showed seven works in the Armory Show. In 1914 he and his brother Charles finally moved to New York and took a studio above that of William Glackens at 50 South Washington Square. Prendergast worked there until his death.

Although Prendergast read widely, in English, French, and German, the diversity of his reading had little effect on his remarkably single-minded devotion to his art. He once wrote in his sketchbook, "Art is the great stimulus of life—I find it year by year more rich, more desirable, and more mysterious." His comment after reading Tolstoy's religious writings was, "God would have made a good painter."[6]

Toward the end of his career Prendergast concentrated increasingly on oil paintings, which he often painted over for years, but the bulk of his life's work was in watercolor. His choice of this medium was doubtless influenced by its importance in the oeuvre of several slightly older American artists; for example, Winslow Homer and John La Farge. Carnegie Institute is fortunate in owning works by Prendergast that reveal the full range of his watercolor technique. Among these are a quick watercolor study from a sketchbook, a finished watercolor of Central Park, and a view of Swampscott Beach that combines watercolor with pastel.

Woman on a Garden Path, a tiny sketch placed obliquely on its page, was probably made around 1895, either in Paris or shortly after Prendergast returned to Boston. The woman's costume, as well as the style of the work, suggest a relatively early date. In Paris Prendergast developed the habit of filling sketchbooks with innumerable outdoor studies like this one. The Museum of Fine Arts, Boston, owns fifty-nine such sketchbooks; others are in the Lehman Collection of The Metropolitan Museum of Art, the Cleveland Museum of Art, and the Delaware Art Museum in Wilmington.[7] In the early 1890s Prendergast also began executing monotypes, also reminiscent of this work, that show, isolated on the page, single women walking in the street or along the Charles River esplanade in Boston.[8]

The Picnic, which Prendergast executed about 1902, dates from the period when he first began to show his work in New York. Prendergast made contact with the Macbeth Gallery through Arthur Davies, and in March 1900 he showed twenty-six watercolors and forty-two monotypes there, selling eleven works in all. Encouraged by this financial success, Prendergast began to make regular visits to New York, and in 1901 he started a series of watercolors of Central Park. Among these works are *Central Park* and *May Day, Central Park* (both 1901, Whitney Museum of

Prendergast, *Woman on a Garden Path*

American Art), *In Central Park* (Addison Gallery of American Art, Andover, Massachusetts), and *Sailboat Pond, Central Park* (collection of Mrs. John F. Kraushaar). The last two are undated but were probably made at about the same time. *The Picnic*, which portrays the park's ingenious three-way transportation system with carriage road, bridle path, and pedestrian walk in three parallel tiers, relates most closely to *The Bridle Path, Central Park* (1902, Whitney Museum of American Art). Prendergast further developed this transportation theme in his oil painting *Central Park* (1903, The Metropolitan Museum of Art). The general scheme of all these paintings was doubtless influenced by the work of Bonnard; for example, by his lithograph *The Boulevard*. Both *The Picnic* and the smaller *Woman on a Garden Path* reveal Prendergast's skill at achieving brilliance of effect with sparkling patches of untouched white paper.[9]

Swampscott Beach was probably executed about 1918, the year it was purchased by Edward Duff Balken. It is unusual for its use of pastel, applied while the watercolor was still wet to create a glowing, sumptuous effect.[10] Prendergast showed such work in pastel only once, in 1917, at an exhibition at the Pennsylvania Academy of the Fine Arts devoted to works created in that year. It appears that he used pastel only for a brief time around 1917, the period following his move from Boston to New York. This watercolor relates to a series of similar designs, such as *Outer Harbor* (not dated, Columbus Museum of Art), *Crepuscule* (c. 1912, Scripps College, Claremont, California), *Cove with Figures* (1914, collection of Nathan Cummings), and *Neponset Bay* (1914, Sheldon Memorial Art Gallery, University of Nebraska, Lincoln). All these works contain friezelike compositions in which Prendergast whimsically interchanged elements to carry color and pattern.

HA

NOTES: 1. Hedley Howell Rhys, *Maurice Prendergast, 1859-1924* (Cambridge, Massachusetts, 1960), 22, 25. For information on Charles Prendergast see Rutgers University Art Gallery, New Brunswick, New Jersey, *The Art of Charles Prendergast* (1968), exh. cat. by Richard J. Wattenmaker; and Hamilton Basso, "A Glimpse of Heaven," *New Yorker* (27 July 1946): 24-30 and (3 August 1946): 28-37. 2. Betsy James Wyeth, ed., *The Wyeths: The Letters of N. C. Wyeth, 1901-1945* (Boston, 1971), 693. 3. Barbara Rose, *American Art Since 1900* (New York, 1967), 31-32; Richard J. Wattenmaker, "Maurice Prendergast," *Allen Memorial Art Museum Bulletin* XL (1982-83): 25-37. 4. Rhys, 19. 5. Van Wyck Brooks, "Anecdotes of Maurice Prendergast," *The Magazine of Art* XXXI (October 1938): 564-69, 604. Also interesting is Ira Glackens, *William Glackens and the Ashcan Group* (New York, 1957). 6. Rhys, 19, 17. 7. Peter A. Wick, *Maurice Prendergast, Water-Color Sketchbook, 1899* (Cambridge, Massachusetts, 1960); Will Roseman, ed., *A Sketchbook of Maurice Prendergast* (Erie, Pennsylvania, 1947); Oklahoma Museum of Art, Oklahoma City, *Maurice Prendergast: The Large Boston Public Garden Sketchbook* (1981), exh. cat. by George Szabo. 8. Davis and Long Co., New York, *The Monotypes of Maurice Prendergast* (1979), exh. cat. 9. My thanks to Carol Clark of the Prendergast Research Project, the Clark Art Institute, Williamstown, Massachusetts, for her help in placing this work. 10. John O'Connor, Jr., "'Swampscott Beach' by Maurice Prendergast," *Carnegie Magazine* XXIV (December 1950): 518-20; Eleanor Green, *Maurice Prendergast: Art of Impulse and Color* (College Park, Maryland, 1976), 161-63, illus., 156.

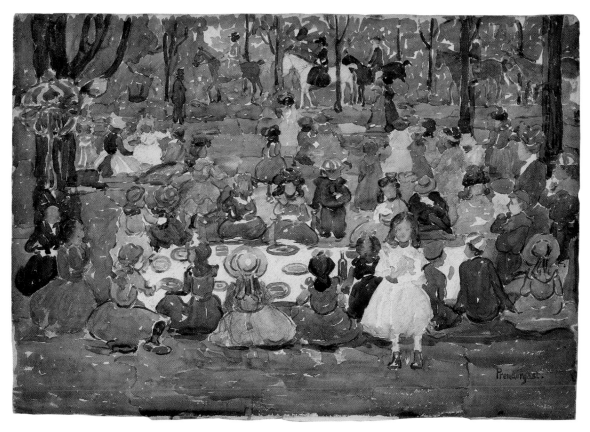

Prendergast, *The Picnic*

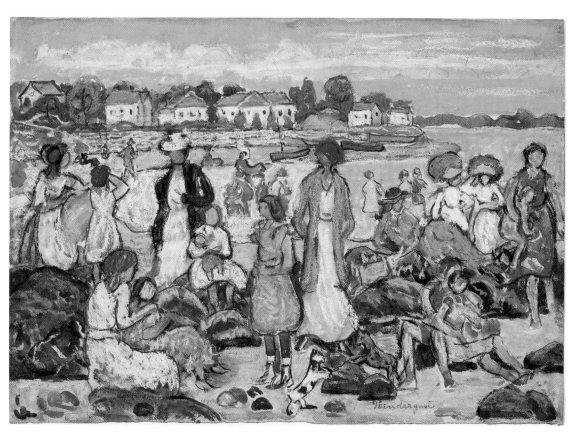

Prendergast, *Swampscott Beach*

ROBERT LOFTIN NEWMAN
1827 — 1912

The Storm
c. 1898
charcoal on board
4 ¾ x 7 ¹/₁₆ in.
(12.1 x 19.4 cm.)
Andrew Carnegie Fund, 07.9

BORN in Richmond, Virginia, Robert Loftin Newman took up portrait painting as a youth in Clarkesville, Tennessee. In 1850 he went to Europe intending to enroll at the Düsseldorf Academy. Instead, at the urging of William Morris Hunt, he studied for a few months in Paris with Thomas Couture. This was the extent of his formal training. In 1854, on a second visit to Paris, Hunt took Newman to Barbizon and introduced him to Jean-François Millet. When he was not traveling, Newman continued to live in Clarkesville until 1864, when he was drafted into the Confederate Army. From the end of the Civil War until 1871 he probably lived in New York, though nothing is definitely known of his activities at this time. Following an unsuccessful attempt to establish a fine arts academy at Nashville in 1872–73, he settled permanently in New York. Here he achieved, in the words of Marchal Landgren, "the equivocal position of recognition without recognition."[1] A solitary, singularly unambitious figure who rarely exhibited, he nevertheless won the admiration and patronage of a small circle of cognoscenti that included William Merritt Chase, Stanford White, Daniel Chester French, and the eminent collector Thomas B. Clarke.

Newman specialized in paintings of sketchy, elegantly drawn, softly glowing figures in dark, moody landscape settings. *The Storm*, a rare marine subject and one of his few known surviving drawings, resembles Newman's paintings in its free handling of charcoal, its ill-defined forms, and its dark tonality. It strongly recalls his painting *Christ Stilling the Tempest* (Virginia Museum of Fine Arts, Richmond) and may in fact be a study for that work. Though *Christ Stilling the Tempest* is undated, it was probably painted shortly before its purchase by William T. Evans in

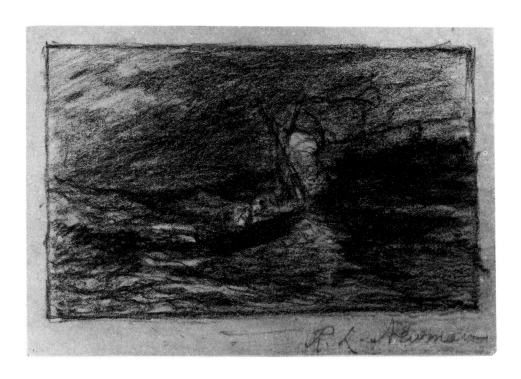

Newman, *The Storm*

1898. This suggests a date of 1898 for *The Storm*. (In both, Newman, a belated romantic, turned to a popular romantic theme, the storm-tossed boat.[2]) Earlier examples of this subject, which range from Géricault's *The Raft of the Medusa* (1819, Musée du Louvre) to Turner's shipwreck scenes, would have been familiar to Newman from his trips and from reproductions. His primary source, at least for *Christ Stilling the Tempest*, was undoubtedly Delacroix's 1854 version of *Christ on the Sea of Galilee* (Walters Art Gallery, Baltimore). Delacroix was one of Newman's favorite artists, and their treatments of the same subject are remarkably similar.

The image of the storm-tossed boat also occurs repeatedly in the work of the American painter Albert Pinkham Ryder, a friend of Newman and another reclusive romantic, with whom he collaborated in 1898 on a marine *Triptych* (collection of Mr. and Mrs. David I. Orr). If, as seems likely, both *The Storm* and *Christ Stilling the Tempest* also date from 1898, it would appear that Newman briefly took up marine subjects in that year under Ryder's influence.

<div align="right">KN</div>

NOTES: 1. Marchal E. Landgren, *Robert Loftin Newman 1827–1912* (Washington, D.C., 1974), 15. 2. For an excellent discussion of this theme in nineteenth-century art, see Lorenz Eitner, "The Open Window and the Storm-tossed Boat: An Essay in the Iconography of Romanticism," *Art Bulletin* XXXVII (1955): 281-90.

FREDERICK CHILDE HASSAM

1 8 5 9 — 1 9 3 5

BORN in Dorchester, Massachusetts, Childe Hassam became a professional illustrator in the late 1870s. He attended evening classes at the Boston Art Club, took drawing lessons from William Rimmer at the Lowell Institute, and studied painting with the Munich-trained artist Ignatz Marcel Gaugengigl. By the mid-1880s he had become an accomplished painter, most skillful in atmospheric urban views such as *Rainy Day, Boston* (1885, The Toledo Museum of Art) and *Boston Common at Twilight* (1885–86, Museum of Fine Arts, Boston). Between 1887 and 1889 Hassam studied at the celebrated Académie Julian in Paris and began to work in a fully Impressionist style. He settled in New York following his return to the United States. In the 1890s Impressionism, no longer considered outrageously avant-garde, was extremely popular in America, and Hassam soon established himself as one of its most successful and prolific practitioners.[1]

From 1896 until his death, Hassam enjoyed a cordial relationship with Carnegie Institute. Over the years he exhibited ninety paintings at the prestigious Carnegie Internationals and at the 1910 International was honored with a one-man show. Director of fine arts John Beatty held the artist in great esteem and frequently sought his opinions on artistic matters. Carnegie Institute was the first museum to purchase one of Hassam's paintings, *Fifth Avenue in Winter* (c. 1892). Several years after Hassam's death, his widow donated sixty of his lithographs and etchings to the museum in recognition of its important role in her husband's career.[2]

White Church, Newport
1901
pastel on onion-skin paper
9 15/16 x 8 in.
(25.2 x 20.3 cm.)
Andrew Carnegie Fund,
07.14.18

The Boat Landing
c. 1906
graphite, pastel, and gouache
on brown paper
7 3/4 x 5 3/8 in.
(19.7 x 13.7 cm.)
Andrew Carnegie Fund,
07.14.15

An earlier and even more significant acquisition than this donation was the collection of thirty Hassam drawings the museum purchased in 1907. "For two hours or more I have been reveling among your sketches," wrote Beatty to Hassam on October 17, 1906. "Most of the little things done on scraps of paper are, I think, superb, and a new and inspiring revelation of your power." Hassam replied, on October 26, "They are many of them the best things that I have, and of course I should not have for one moment thought of showing them even, to people who would not appreciate them. I knew that you would."[3] The drawings do indeed merit high praise. The earliest, *Gateway, Alhambra*, dates from the artist's first trip to Europe in 1883, but the rest were made between the late 1880s and the first years of the twentieth century. Thus they provide a detailed and intimate record of Hassam's creative process during the period of his finest achievement.

Several of the drawings in this collection relate to Hassam's paintings. *Brooklyn Bridge*, for example, is a study for *Brooklyn Bridge in Winter* (1904, Telfair Academy of Arts and Sciences, Savannah); *Arrangement of Nudes and Laurel* is a rough preliminary sketch for *June* (1905, American Academy and Institute of Arts and Letters, New York), for which Hassam won the third-class medal in the 1905 Carnegie International. Two paintings entitled *Gloucester Harbor* (1899, collection of Dr. and Mrs. John T. McDonough; 1909, Norton Gallery of Art, West Palm Beach, Florida) reproduce the pastel drawing *Gloucester, Inner Harbor* with only slight changes of vantage point.

Hassam made many of his best drawings on the New England coast, where he regularly summered at places such as the Isles of Shoals, Cos

Hassam, *White Church, Newport*

136

Cob, Old Lyme, Gloucester, and Newport. No fewer than eight of the thirty sketches were made at Newport during the summer of 1901. All are of singularly high quality, the finest being *White Church, Newport*, a delicate rendering of Newport's historic Trinity Church. Here Hassam demonstrates his remarkable ability to translate effects of light and shade into colored lines, perfectly capturing the glare of brilliant sunlight on the white steeple. Old New England churches had a strong appeal for the artist; beginning in 1903 he painted a number of variations of the Congregational Church at Old Lyme, Connecticut.

The Boat Landing is yet another souvenir of a New England watering spot. Although the drawing is undated, its long, relatively broad strokes, densely applied, identify it as one of the later works in the collection. In *The Boat Landing*, as in many of his sketches, Hassam uses a mixed technique, in this case a blend of gouache, pastel, and pencil. The mixing

of media, especially gouache and pastel, in drawing was characteristic of the progressive tendencies in American art at that time, in contrast to the traditional English method, favored by the conservative American Watercolor Society, of working in pure, thin washes. Appropriately enough, the only pure watercolor by Hassam in the collection is *Hogarth House, Chiswick*, an English subject. The New York Watercolor Club, an organization that Hassam, its first president, helped to found in 1890, actively encouraged the free combining of media. Another thoroughly up-to-date aspect of *The Boat Landing* is Hassam's use of brown paper. James McNeill Whistler had pioneered the practice of drawing on colored paper in the early 1880s, and Hassam, though he never met the great expatriate, was, like many American artists, deeply interested in his innovations. John Beatty was quite correct to describe the drawings as "little things done on scraps of paper," for the artist was quick to seize any stray fragment that appealed to him by virtue of its color or texture. For *The Boat Landing* he used cheap brown wrapping paper; *The Horizon of the Poor*, a highly typical scene of slum tenements, appears on the back of a printed invitation to the reception at The Art Institute of Chicago's twenty-first annual exhibition; and another invitation, to Carnegie Institute's 1902 Founder's Day celebration, provided the brilliant blue support of *Autumn Landscape, Arrangement* (1902). Hassam's casual attitude in this regard underlines the informal, spontaneous character of the collection as a whole.

KN

NOTES: 1. For details of Hassam's career see Adeline Adams, *Childe Hassam* (New York, 1938), and Donelson F. Hoopes, *Childe Hassam* (New York, 1979). 2. See Gail Stavitsky, "Childe Hassam in the Collection of the Museum of Art, Carnegie Institute," *Carnegie Magazine* LVI (July/August 1982): 27-36. 3. Gail Stavitsky, "Childe Hassam and the Carnegie Institute: A Correspondence," *Archives of American Art Journal* XXII (1982): 3-7.

THOMAS WILMER DEWING
1 8 5 1 — 1 9 3 8

Head of a Girl
before 1906
silverpoint on paper
14 ¹¹/₁₆ x 10 ¹/₁₆ in.
(37.3 x 27 cm.)
Andrew Carnegie Fund, 06.7

THOMAS Dewing was a leading American exponent of late nineteenth-century Aestheticism. The son of a Boston milliner, he received an academic training in Paris between 1876 and 1879, then settled in New York. His first major painting, *The Days* (1887, Wadsworth Atheneum, Hartford), is a decorative frieze of classical beauties strongly reminiscent of the work of the English painter Albert Moore. Dewing's portrayal of ideal womanhood, the invariable theme of his mature work, became more abstract and ethereal after Charles Lang Freer, the wealthy Detroit industrialist and patron of the arts, introduced him to Oriental art in the early 1890s.[1] Sadakichi Hartmann described the exquisite creatures of the artist's imagination as:

> . . . beautiful ladies, mostly mature women of thirty . . . who seem to possess large fortunes and no inclination for any professional work. They all seem to live in a Pre-Raphaelite atmosphere, in mysterious gardens, on wide lonesome lawns, or in spacious empty interiors. . . . They love beautiful large flowers and their long tapering fingers like to glide over all sorts of string

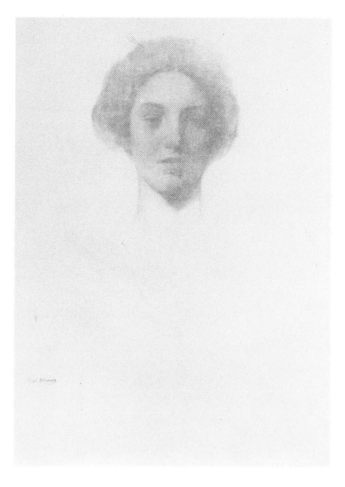

Dewing, *Head of a Girl*

instruments, and there they sit and stand, or dream or play the flute or read legends. . . . They lead, indeed, a life of reflection; they seem to be melancholy without reasons, merely because suffering is poetical. . . . Dewing depicts the romantic tendency of our refined American ladies who . . . read Swinburne, are fond of orchids, and loll about on divans in their large, solitary parlours.[2]

These images, Hartmann observed, faithfully reflected the "refined epicureanism" of Dewing's mind.

In the 1890s Dewing took up silverpoint, a method of drawing upon a prepared paper with a silver stylus and producing an indelible, barely visible mark that darkens over time. The technique, used widely during the Renaissance, was revived in the late nineteenth century in a spirit of artistic antiquarianism congenial to the Aesthetic temperament. This revival, though international in scope, was primarily a British phenomenon, with Frederic Leighton, Edward Burne-Jones, and Alphonse Legros among its leading exponents. Despite the difficulties of the medium (a contemporary critic, Philip Hamerton, believed that only two or three European artists knew how to use it correctly), it was popular enough in the 1890s to warrant the commercial production of silverpoint kits by Winsor and Newton, Ltd.[3]

Dewing made at least a dozen silverpoint portraits—or perhaps it would be more correct to call them ideal heads—over a period of several years. *Head of a Girl* is one of the finest of these, an elegant apparition that represents his vision of femininity at its most nebulous and dreamy. Dewing undoubtedly appreciated the technical difficulty of the medium

as much as its delicate tonal effects, for it gave him an opportunity to display the virtuoso skill and sensitivity of his draftsmanship.

By December 1909 light spots had begun to appear on *Head of a Girl*, and John Beatty wrote to ask Dewing to propose a remedy. Dewing suggested that the silverpoint might accidentally have been wet (a possibility that Beatty denied), and he offered to examine it. Though Beatty sent the drawing to Dewing, there is no record of his diagnosis, and the cause of the spotting is still obscure.

<div align="right">KN</div>

NOTES: 1. For a detailed discussion of Dewing's response to Oriental art, see Mary Ellen Hayward, "The Influence of the Classical Oriental Tradition on American Painting," *Winterthur Portfolio* XIV (Summer 1979): 125-32. 2. Sadakichi Hartmann, *A History of American Art,* Vol. I (Boston, 1901), 301-304. 3. Philip Hamerton, *The Graphic Arts* (New York, 1882), 93. A short account of the silverpoint revival appears in James Watrous, *The Craft of Old-Master Drawing* (Madison, Wisconsin, 1957), 8. For the attitudes underlying the revival see Hillary Bell, "Silver-point: A Neglected Art," *The Monthly Illustrator* V (July-September 1895): 49-51.

ARTHUR B. DAVIES

1862 — 1928

Drawing No. 6
c. 1912–18
colored chalk on two sheets of gray laid paper pasted together, mounted on two sheets of red Japanese paper with gold flecks pasted together
17 ⅝ x 11 in.
(44.8 x 27.9 cm.), sheet
21 ¹⁄₁₆ x 15 ⁵⁄₁₆ in.
(54.9 x 38.9 cm.), mount
Purchase, 18.19

ARTHUR Davies is best remembered today as the tireless, proficient organizer of the 1913 Armory Show in New York. In his own time his advocacy of modernism was sanctioned by his enormous stature as an artist. His cryptically titled arrangements of nudes, gracefully but inexplicably posed in ideal landscapes, enchanted critics with their mysterious air of hidden allegory. (Carnegie Institute owns one such work, *At the Chestnut Root,* c. 1910). Marsden Hartley called Davies's paintings *chansons sans paroles*, and observed that they "lead one away entirely into a land of legend, into the iridescent splendor of reflection."[1] Edward Root praised the artist as "the most comprehensive intelligence that has yet, in America, attempted to express itself in paint."[2] Except for a brief period following the Armory Show, when he experimented with cubism, Davies stood apart from the main currents of modernism, and his work unites, in a highly personal synthesis, a wide range of influences: Böcklin, Hodler, Ryder, Matisse, Botticelli, Greek sculpture, and above all, Puvis de Chavannes.

Davies exhibited with the urban, democratic realists of the Ashcan School as a member of The Eight, but this uneasy association grew from a common dislike of academicism rather than from a shared aesthetic.

Frederick Newlin Price, Davies's dealer, listed as one source of the artist's inspiration, "Isadora Duncan dancing—attending her performances, drawing late in the night hundreds of sketches."[3] Like many of New York's avant-garde in the early years of the century, Davies was fascinated by Duncan's free, natural choreography, inspired by the forms of Greek antiquity. About 1914 he painted *Isadora Duncan Dancers* (collection of Mrs. Arnold Kornfeld), and images of the dance pervade his rhythmic, friezelike compositions. *Drawing No. 6* may be one of the nocturnal sketches mentioned by Price. Executed sometime before 1918, it is similar in subject and style to a canvas of 1912, *Do Reverence* (collection of Mr. and Mrs. Herbert Brill). Both works are single-figure compositions

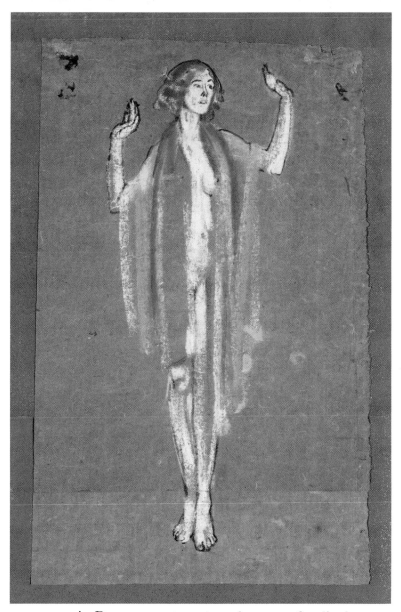

Davies, *Drawing No. 6*

of young women in Duncanesque poses, nude except for diaphanous, loosely hanging shawls or veils; and both have a strong vertical emphasis and an elegant economy of line. Edna Potter, a dancer and Davies's mistress from 1905 until his death, may have been the model for *Drawing No. 6,* as she was for *Do Reverence.* Although she undoubtedly played a major role in awakening the artist's interest in the dance, Davies kept her influence—indeed, her very existence—a secret from all but his closest friends and especially from his wife, a practicing physician in the small town of Congers, New York, whom he visited on weekends.[4]

KN

NOTES: 1. Marsden Hartley, *Adventures in the Arts* (New York, 1921), 80, 81. 2. In Phillips Memorial Art Gallery, *Arthur B. Davies: Essays on the Man and His Art* (Cambridge, Massachusetts, 1924), 64. 3. Frederick Newlin Price, *The Etchings and Lithographs of Arthur B. Davies* (New York, 1929), 16. For a discussion of Davies and the dance see Elizabeth S. Sussman, "Rhythm and Music in the Frieze Paintings of Arthur B. Davies," in Institute of Contemporary Art, Boston, *Dream Vision: The Work of Arthur B. Davies* (1983). This exhibition catalogue also contains essays by Stephen Prokopoff, Linda Wolpert, Garnett McCoy, and Nancy E. Miller. 4. The details of Davies's relationship with Potter are given in Brooks Wright, *The Artist and the Unicorn* (New City, New York, 1978). The basic monograph on Davies is Joseph S. Czestochowski, *The Works of Arthur B. Davies* (Chicago, 1979).

20TH-CENTURY REALISM AND FIGURATION

JOSEPH STELLA

1 8 7 7 — 1 9 4 6

Bridge
c. 1908
charcoal on laid paper
14 9/16 x 23 1/2 in.
(37 x 59.7 cm.)
Howard N. Eavenson Memorial
Fund, 58.62

Old Man Sleeping in a Field
c. 1908
gouache and chalk on paper
11 x 16 13/16 in.
(27.9 x 42.7 cm.)
Copperweld, Hafner and Fine
Arts Discretionary Fund, 84.52

Collage No. 8
c. 1922
paper, paint, and mud on paper
16 5/16 x 11 in.
(42.2 x 27.9 cm.)
Print Purchase Fund, 61.11

JOSEPH Stella's drawings cover a range of styles equaled by no other American draftsman of his day. One of the leading American modernists, who produced fine works in the Futurist manner and in collage, he also made remarkable realistic drawings that reveal his solid academic training. Carnegie Institute is fortunate to possess four very different works on paper by Stella, which suggest both the range and quality of his accomplishments.

An Italian immigrant, Stella arrived in this country in 1896 and enrolled briefly at the Art Students League before studying under William Merritt Chase at the New York School of Art. This training endowed him with impressive technical skills, but he soon tired of copying plaster casts. Leaving the confines of the studio, he began working as a journalistic illustrator, drawing directly from the moving model and seeking out "curious types, revealing, with the unrestrained eloquence of their masks, the crude story of their lives."[1]

In 1905 Stella made a series of probing illustrations of Ellis Island immigrants for *The Outlook*, and in 1907 he produced an equally memorable group of drawings of the Monongah, West Virginia, mining disaster for *The Survey*. He was thus the logical choice when the editors of *The Survey* turned their attention to Pittsburgh in 1908. Stella made over one hundred drawings for this commission, and two of Carnegie Institute's drawings, *Bridge* and *Old Man Sleeping in a Field*, were apparently made at this time, although neither was included in the final publication.

The Survey, while it described itself simply as a "Journal of Constructive Philanthropy," actually specialized in reform-minded, muckraking exposés. The wretched living quarters and life-threatening working conditions of Pittsburgh's poor made a perfect target for the journal's attack. In disgusting detail, for example, *The Survey* described an area surrounding Pittsburgh's courthouse that contained antiquated and indescribably foul privies "that were not only polluting the atmosphere, but were contributing a large quota to the mortality and morbidity of the community by serving as breeding places of disease germs to be distributed by flies."[2]

Stella was too much an artist, however, to produce very effective visual propaganda to support such descriptions. Appalled by the squalor and human suffering in the Steel City, he was nonetheless moved by its astonishing technological advancements and its visual beauty. The "black mysterious mass" of Pittsburgh, which was always "shrouded in fog and smoke," struck him as "a real revelation." Continually "throbbing with the innumerable explosions of its steel mills," it appeared to him "like the stunning realization of the infernal regions sung by Dante."[3]

In the delicately blurred charcoal drawing *Bridge*, a view of the snow-clad Sixteenth Street Bridge spanning the Allegheny River, he endowed the drawing with an evocative delicacy like that found in the work of the nineteenth-century tonalists. Stella later recalled that, under new-fallen snow, "the tragic town of the steel mills seemed transformed. She had

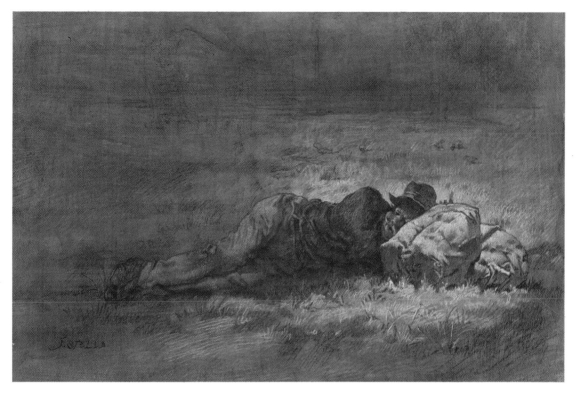

Stella, *Old Man Sleeping in a Field*

lost that oppressive atmosphere of the damned infernal city." Sadly, however, this different persona was only momentary, for the "black imprint" of soot in the snow grew more visible moment by moment. "The true dark personality of the town was ever asserting itself, and this ermine dress was like an ironical dress of the first communion, barely concealing the hard-boiled structure of a civic harpy."[4]

Old Man Sleeping in a Field presents an effect more poetic than *Bridge*, despite the grim implications of its subject. It shows a homeless old man sleeping in a field, using his duffle bag as a pillow, with a slag heap and a factory stack faintly visible in the distance. The photographer Lewis Hine, who also worked on the Pittsburgh *Survey*, recorded such scenes with unflinching directness. Stella, however, rendered it in pastel with an ethereal softness that brings to mind the work of such tonalists as Thomas Dewing and that somewhat subverts his social message. Stella seems to have represented the same model who appears in this drawing in *Profile of a Bearded Man*, formerly owned by the Rabin and Krueger Gallery.[5] He enjoyed rendering figures who seem unaware of any onlooker and during this period often depicted sleeping figures; for example, in drawings such as *Two Men Lying Down*, *Back of a Woman*, *Study of a Bearded Man*, and *Three Men on a Bench*.[6]

The two other works in the museum's collection suggest the variety of Stella's work during the 1920s, after he had been exposed to Italian Futurism while living in Italy from 1909 to 1913. *Industrial Scene* of 1920,

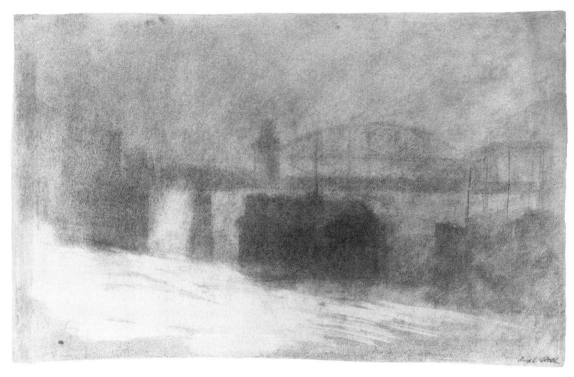

Stella, *Bridge*

while still realistic in effect, stands out as crisper and starker than the two earlier drawings, with a greater emphasis on the abstract geometry of forms. Stella signed the work four times, an indication that he considered it particularly fine.[7] The title *Pittsburgh Night*, which has traditionally been given to the drawing, appears to be incorrect. Stella did not visit Pittsburgh in 1920, and the late style of the work differs from Stella's Pittsburgh drawings. Moreover, the industrial building in this work resembles a cement or gravel factory rather than a Pittsburgh steel mill. The sketch was probably executed in New Jersey, where in 1920 Stella did many drawings of factories like the one shown on this sheet; for example, the charcoal *Crusher and Mixer Building* (1920, Santa Barbara Museum of Art).[8]

Collage No. 8, made at almost the same time, abandons the representational approach of the museum's other drawings by Stella, although it reveals once more his interest in the world of urban poverty and in days "mud-caked with all the cares of petty life."[9] During his lifetime Stella never exhibited his work in collage, although two of them were reproduced in *The Little Review* in the autumn of 1922 on the occasion of Stella's exhibition with the Société Anonyme. Evidently Stella was inspired to take up the medium by the example of Kurt Schwitters, whose works he had seen at the Société Anonyme in November and December of 1920 in a show that also included his own paintings. Unlike Schwitters, however, whose collages emphasize design and pattern in a manner similar to abstract painting, Stella's collages rely less on arrangement than on the patterns of stain and mold on the paper he employed. The materials for these arrangements came, quite literally,

146

Stella, *Collage No. 8*

from the gutter. His friend August Mosca recalled, "he would . . . pick up torn, discolored pieces of paper which would be pasted on color backgrounds that constituted his 'naturelles'; interesting patterns made by footprints, auto tire prints, plain dirt and dirty water."[10]

HA

NOTES: 1. Joseph Stella, "Discovery of America: Autobiographical Notes," *Art News* LIX (November 1960), 41. 2. Paul Underwood Kellogg, ed., *The Pittsburgh District Civic Frontage*, Vol. V of *Pittsburgh Survey, Findings in Six Volumes* (New York, 1914), 92. 3. Stella, 41-42. 4. Irma B. Jaffe, *Joseph Stella* (Cambridge, Massachusetts, 1970), 21. 5. Rabin and Krueger Gallery, Newark, New Jersey, *Drawings of Joseph Stella* (1962), exh. cat. by William H. Gerdts, plates 11, 31, 36, 37. 6. Rabin and Krueger Gallery, 30. 7. Stella often signed his works several times, as noted by Jaffe, 1970, ix. 8. Jaffe, plate 63. 9. Jaffe, 90. 10. John I. H. Baur, *Joseph Stella* (New York, 1971), 42.

CHARLES BURCHFIELD
1893 — 1967

CHARLES Burchfield always resented being linked with the chauvinist views of regionalists such as Thomas Hart Benton, Grant Wood, and John Steuart Curry, whose work dominated art criticism in the 1930s. In a letter to his dealer, Frank Rehn, Burchfield declared: "I am not an Ohio, or a western New York artist, but an American artist—or I should say an artist who happens to be born, living, painting in America. If I paint for an audience, it is to anyone, anywhere who happens to be spiritually akin to me. 'Regionalism'—It makes me sick."[1]

Nonetheless, Burchfield's life and art were centered closely on a particular region of Ohio, western Pennsylvania, and western New York state. Aside from a few unhappy months in New York City, and a stint in the army that took him to North Carolina, Burchfield never left these areas for extended periods. Born in Ashtabula, Ohio, and educated at the Cleveland School of Art, Burchfield settled first in Salem, Ohio, where he supported himself as an accountant, and later moved to Buffalo, where he worked as a wallpaper designer until he quit in 1929 to paint full time. Speaking of the subject matter of his art, Burchfield once wrote: "I will always be an inlander in spirit. The ocean does not move my imagination. Without discounting its awe-inspiring grandeur, it is not for me, and surely it has a worthy rival in a hay or wheat field on a bright windy day."[2]

As an art student, Burchfield loathed figure drawing but excelled in design. From exposure to Art Nouveau he absorbed a love of curvilinear form, a sense of strong design and flat pattern, and a fascination with the principles of natural growth.

Primarily a nature painter, Burchfield celebrated in his art the beauty of field and forest in daylight and moonlight, in calm and storm, and in the passing of the seasons. Man remains a shadowy presence in Burchfield's work but is witnessed in his handiwork, often in decaying farmhouses, industrial buildings, old machinery, abandoned mines, and other objects that reveal the tragic wear and tear of existence. The museum's watercolor *Wires Down* is an example of this theme.

Never comfortable with oil paint, Burchfield worked almost exclusively in watercolor, laying on colors in broad strokes with a heavy bluntness. Toward the end of his career he tended increasingly to piece sheets of paper together to give his designs monumental scale.

Burchfield exhibited frequently at the Carnegie International, where he won second prize in 1936, and he was honored with a one-man exhibition at Carnegie Institute in 1938.[3] In Mrs. James H. Beal of Pittsburgh he found a firm supporter. Burchfield's letters to her, now in the Archives of American Art, constitute a primary document of the artist's aspirations and struggles.

Moon through Young Sunflowers, one of Burchfield's earliest important works, was painted in 1916, when the artist was twenty-four years old and had just returned to Salem, Ohio, after his training at the Cleveland School of Art. At the time, Burchfield worked as an accountant for the Mullins Company five and a half days a week. He produced his artistic

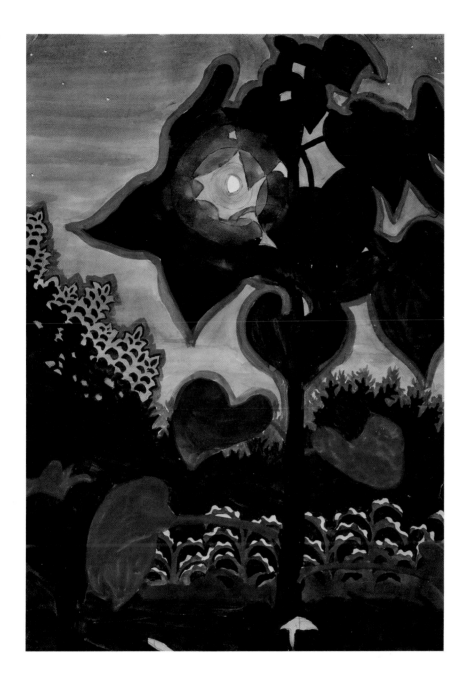

Burchfield, *Moon through Young Sunflowers*

work in the evenings or during a forty-five-minute period he was able to set aside from his lunch break. During these brief respites from mundane routine, Burchfield poured his soul into his work.[4]

Burchfield executed a group of sunflower paintings in 1916, including *Sunflower* (Whitney Museum of American Art), *Dancing Sunlight* (collection of John Clancy), and *Rogues Gallery* (The Museum of Modern Art). In addition, he executed at least one similar moonlight scene, *Moonlight in July* (collection of Dr. Julian Hyman). *Moon through Young Sunflowers* stands out as the most powerful and simplified of these works.[5]

149

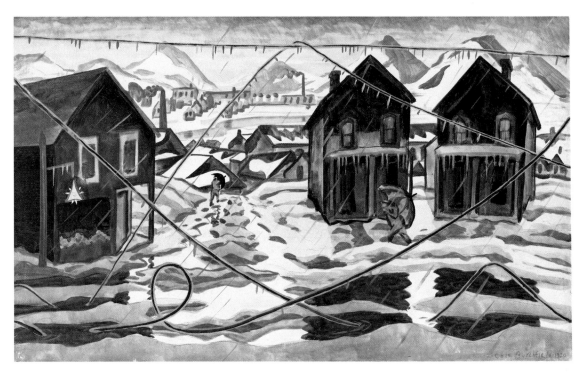

Burchfield, *Wires Down*

Wires Down was evidently executed in 1920, Burchfield's last year in Salem, Ohio, before his move to Buffalo. This period marks a transition between the abstract emotionalism of Burchfield's early work, much of which focused on natural forms, and his more realistic work of the 1930s, in which he concentrated chiefly on the man-made landscape. In the late spring of 1919, Richard Laukhuff, owner of a bookstore in Cleveland, gave Burchfield a copy of Sherwood Anderson's *Winesburg, Ohio*, and this seems to have encouraged a change in the direction of his art. The chapter "Winter Day in Town" seems to have been particularly influential and speaks quite specifically of the personalities of houses. "The houses have faces," Anderson wrote. "The windows are eyes. Some houses smile at you; others frown."[6] *Wires Down*, which brings to mind "the time of cold rains, cold winds" of which Anderson had written, belongs to a series of watercolors in which Burchfield dealt with houses in harsh weather, including *After the Ice Storm* (1920, collection of John Clancy), and *Cottages in the Winter Rain* (1920, Whitney Museum of American Art).[7]

HA

NOTES: 1. John I. H. Baur, *The Inlander: Life and Work of Charles Burchfield, 1893-1967* (East Brunswick, New Jersey, 1982), 168-69. 2. Baur, 224. 3. Baur, 190. 4. Baur, 58. 5. Baur, 40, illus., 48-50, 60; Munson-Williams-Proctor Institute, Utica, New York, *Charles E. Burchfield: Catalogue of Paintings in Public and Private Collections* (1970), exh. cat. by Joseph S. Trovato, 92, no. 591, illus., 99. 6. Baur, 99. 7. Baur, 104-107, 96, 99; Trovato, 49, no. 157.

CHARLES DEMUTH

1 8 8 3 — 1 9 3 5

TWENTY years after Charles Demuth's death, a critic observed that with "a little less eccentricity and a little more boldness" the artist "could have been the Guys of our time, a new avatar of Baudelaire's 'dandy.'"[1] Demuth, despite his intimate involvement with the avant-garde of his day, was in many respects something of an anachronism, a late survivor of the fin-de-siècle aesthete. Witty, sociable, impeccably attired, and exquisitely debauched, he combined the true dandy's love of elegant trivialities with that aristocratic reserve, sometimes bordering on heroism, peculiar to the breed. Even the violent diabetic attacks that he

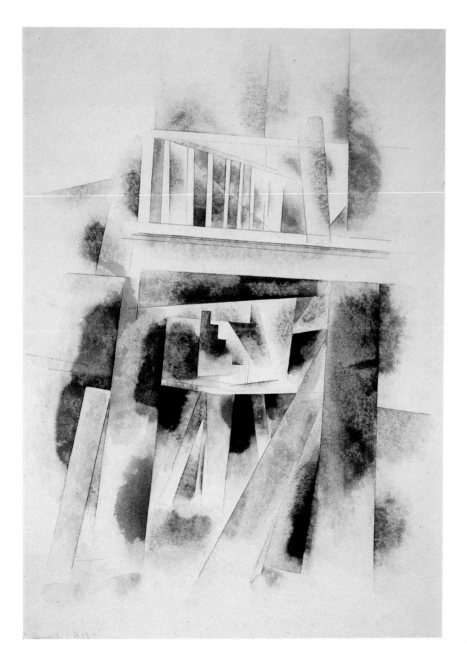

Demuth, *Architecture*

Architecture
1918
watercolor on paper
14 x 10 in.
(35.6 x 25.4 cm.)
Collection of Mr. and Mrs. James H. Beal, intended gift to the Museum of Art, Carnegie Institute

Grapes and Turnips
1926
watercolor on paper
16 ⅞ x 23 ⅜ in.
(42.9 x 59.4 cm.)
Collection of Mr. and Mrs. James H. Beal, intended gift to the Museum of Art, Carnegie Institute

The Artist on the Beach (at Provincetown)
1934
watercolor on paper
8 ⁷⁄₁₆ x 11 in.
(21.4 x 27.9 cm.)
Collection of Mr. and Mrs. James H. Beal, intended gift to the Museum of Art, Carnegie Institute

suffered after 1919 disturbed his charming demeanor only momentarily. He was thoroughly cosmopolitan, at ease in the most sophisticated circles of New York and Paris; but, paradoxically, he always returned to the family home at Lancaster, in the heart of the Pennsylvania Dutch country. Much of his best work was done in the little whitewashed studio overlooking his mother's garden.

Architecture was painted in 1918 at Provincetown, Massachusetts, where Demuth spent most of his summers until the early 1920s. Although he would have become familiar with Cubism during his third and longest visit to Paris (1912–14), Demuth did not begin to work in this manner until 1917 during a trip to Bermuda with Marsden Hartley and the French Cubist Albert Gleizes. Unlike most American modernists, Demuth had little interest in Cubism's dynamic and expressive possibilities, preferring the decorative style of Gleizes to the brutal dismemberment of forms practiced by Braque and Picasso. He was far from being a strict Cubist. Following an initial period of experimentation, he modified his cubism in the direction of greater realism, as in his precisionist architectural views, and even then he considered it appropriate only for certain subjects. In his figural works and flower pieces he remained faithful to his earlier manner, with its loose, fluid drawing and amorphous washes of color.

During the 1920s Demuth's diabetes forced him to spend most of his time at Lancaster under the constant care of his mother. Regular injections of insulin improved his condition; but the drug, whose use was still in the experimental stages, was not always predictable in its effects, and Demuth sometimes refused to take it. Though he concealed his illness behind a mask of indolence, he admitted to his friend Alfred Stieglitz that he no longer had the strength to do figure pieces.[2] The 1920s were nevertheless productive years. In addition to several larger works (for example, *My Egypt*, 1927, Whitney Museum of American Art), Demuth painted small, beautifully crafted still lifes, using fruits and vegetables purchased by his mother at Lancaster's central market and flowers from her garden. He was clearly thinking of Cézanne when he painted these works and possibly recalling the great still-life tradition that had developed in nearby Philadelphia during the preceding century, a tradition of which Demuth, a student of Pennsylvania folk art and an avid collector of Victoriana, was undoubtedly aware. In *Grapes and Turnips* (1926) a lingering sense of Cubist form imparts a crystalline, gemlike quality to the models. "This is not voluptuous fruit;" wrote Albert Gallatin of the subject of the late still lifes, "it comes from a country whose *vin du pays* is iced water."[3] Demuth achieved his remarkable effects with the simplest of means. "It seems to me any watercolorist who looks for a minute at his work can understand his 'special effects'," the artist George Biddle observed.[4] Few watercolorists, however, could equal Demuth's precision and control. For example, the fine, thin lines of white seen in *Grapes and Turnips* were achieved free hand, without the aid of masking.

In 1930 and 1934 Demuth managed to leave his Lancaster home and renew his summer visits to Provincetown. He also returned to portraying the human figure on these occasions. Demuth's figural compositions reflect a side of his personality summed up by his remark, "But I love Broadway and—well, and vulgarity, and gin."[5] He took as much delight in Harlem night clubs, vaudeville acrobats, and Turkish baths—the subjects of some of his early works—as in the *fêtes galantes* of Watteau and

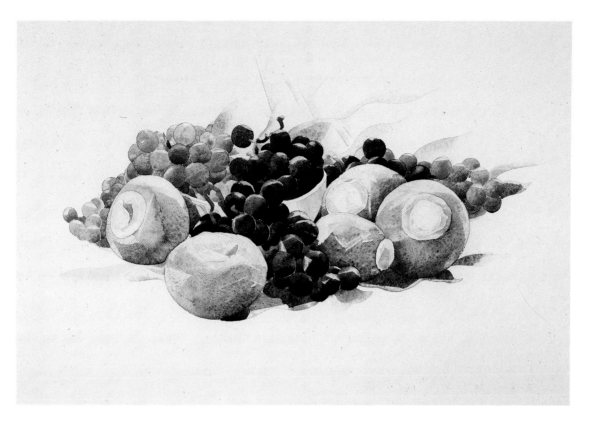

Demuth, *Grapes and Turnips*

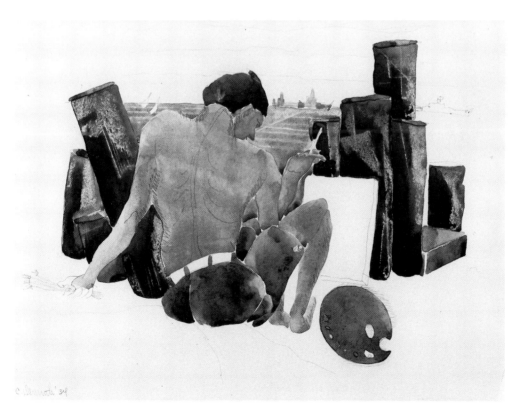

Demuth, *The Artist on the Beach*
(at Provincetown)

the music of Ravel. A taste for low pleasures is, of course, a mark of the true dandy. Demuth celebrated his return to the figure in 1930 with an outburst of vulgarity—a lively series of watercolors (now in the collection of the Sterling Memorial Library, Yale University) depicting sailors romping on the beach. *The Artist on the Beach*, a rare self-portrait, forms part of a rather more respectable series showing vacationers at Provincetown in the summer of 1934. In this, the only drawing in which he represented himself as an artist, Demuth gives little indication of his facial features, but the slight deformity of his body, the result of a childhood hip disorder that left him permanently lame, is unmistakable. According to his friend Susan Street, "He always sat crooked . . . with one shoulder *much* higher than the other, and with his neck strained into a funny position because of where his shoulders were."[6] Stylistically, this watercolor is similar to Demuth's earlier figural works but executed with much greater sharpness and precision.

Architecture, *Grapes and Turnips*, and *The Artist on the Beach* come from the fine collection of Demuth drawings owned by Mr. and Mrs. James H. Beal of Pittsburgh. Mrs. Beal became interested in Demuth's work while researching the life of another Lancaster artist, her ancestor the early nineteenth-century portraitist Jacob Eichholtz. During her visits to Lancaster, she often enjoyed the company of Robert Locher and Richard Weyand, Demuth's close friends and the inheritors of his home and watercolors.[7]

KN

NOTES: 1. Stuart Preston, "Among Current Shows," *New York Times* (11 April 1954), section 2, 9; quoted in Emily Farnham, "Charles Demuth: His Life, Psychology and Works" (Ph.D. diss., Ohio State University, Columbus, 1959), 158. The most recent treatment of Demuth is Philadelphia Museum of Art, *Pennsylvania Modern: Charles Demuth of Lancaster*, (1983), exh. cat. by Betsy Fahlman. 2. Henry McBride, "Charles Demuth, Artist," *Magazine of Art* XXXI (January 1938): 23. 3. Albert Gallatin, *Charles Demuth* (New York, 1927), 9. 4. Farnham, 951. 5. Charles Demuth, "You Must Come Over," unpublished manuscript of a play, Weyand Scrapbook No. I, 82-83; quoted in Emily Farnham, *Charles Demuth: Behind a Laughing Mask* (Norman, Oklahoma, 1971), 3. 6. Farnham, 1971, 40. 7. The Beal collection of Demuth's watercolors is discussed and fully illustrated in Henry Adams, "The Beal Collection of Watercolors by Charles Demuth," *Carnegie Magazine* LVI (November/December 1983): 21-28.

GEORGIA O'KEEFFE

B . 1 8 8 7

Red Cannas
1919
watercolor on paper
19 ⅜ x 13 in.
(49.2 x 33 cm.)
Collection of Mr. and Mrs.
James A. Fisher, intended gift
to the Museum of Art,
Carnegie Institute

GEORGIA O'Keeffe has attained almost mythic stature, both through her powerful paintings and through the haunting photographs of her taken by Alfred Stieglitz and others, unforgettable images of quiet determination and strength. She remains a last survivor of the small band of early modernists in the United States, having outlived by nearly half a century her companions of that period. Charles Demuth died in 1935, Marsden Hartley in 1943, Arthur Dove in 1946, John Marin in 1953, and her husband, Alfred Stieglitz, in 1946.

Born in Sun Prairie, Wisconsin, in 1887, O'Keeffe was educated at a convent school in Madison and an Episcopal school in Virginia and then studied painting at the School of the Art Institute of Chicago, Teacher's College of Columbia University and the Art Students League in New York. For a brief period she supported herself doing free-lance advertising work in Chicago, and she also taught art in South Carolina, Virginia, and Texas. The real breakthrough in her work came in 1912 under the influence of Alon Bement, a timid painter himself, who introduced her to the principles of Arthur Wesley Dow.[1]

An associate of the Orientalist Ernest Fenollosa, Dow had absorbed Oriental ideas of design from his years as curator of Japanese prints at the Museum of Fine Arts, Boston. In his teachings he stressed not realism but principles of arrangement, a view he put forward eloquently in his textbook *Composition* (1899). Deeply influenced by Dow's views, and by his compositional exercises, O'Keeffe once said, in a phrase that Dow would certainly have endorsed, "Filling a space in a beautiful way—that is what art means to me."[2]

Besides exposing O'Keeffe to Dow's ideas, Alon Bement also introduced her to writings on modern art, notably Wassily Kandinsky's *On the Spiritual in Art* and Jerome Eddy's *The Cubists and Post-Impressionism*. Under these influences she began to produce compositions in charcoal and watercolor that recreated objects and internal emotional states in a dramatically simplified and abstract manner.

In 1916 O'Keeffe sent a group of these works to her friend Anita Pollitzer in New York, who showed them to Alfred Stieglitz, the controversial advocate of modern art. According to legend, Stieglitz exclaimed when he saw them, "At last a woman on paper!"[3] Without O'Keeffe's knowledge or permission, he exhibited her drawings at Gallery 291, giving her name on the label as Virginia O'Keeffe. O'Keeffe's visit to 291 to protest brought her in contact with him for the first time. Within a year (after her return from a short stint of teaching in Texas) the two had become lovers. At the time O'Keeffe was thirty and Stieglitz was fifty-three and married.

A photograph Stieglitz took of O'Keeffe during the first year or so of their relationship shows her seated at the base of a drainpipe, in a cluster of damp-loving plants, working on a watercolor of flowers.[4] Watercolor and charcoal were O'Keeffe's favored media during the teens; she did not work much in oil until the 1920s. During the period in which she taught in Texas, Virginia, and South Carolina, O'Keeffe produced a group of

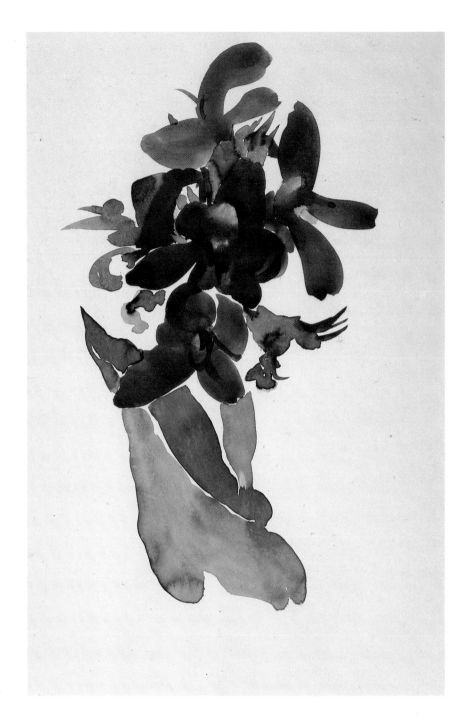

O'Keeffe, *Red Cannas*

completely abstract watercolors such as *Blue No. II* (1916, The Brooklyn Museum).[5] These first attempts at abstraction, like those of most American modernists, were O'Keeffe's most venturesome. After she went to New York her work gradually grew more figurative. She began to set aside watercolor, preferring large oil paintings with close-up views of flowers, the first of which she created in 1924.

Red Cannas, one of O'Keeffe's most miraculous and breathtaking watercolors, belongs to a group of four versions of this subject that the artist sold to Harold Diamond in about 1977. Two of the other three works are now owned by the Columbus Museum of Art and the Yale University Art Gallery; the third is currently unlocated. At the time of the sale O'Keeffe indicated that she had painted the group in 1919, which was within about a year of when her liaison with Stieglitz began. O'Keeffe frequently painted the same subject over and over again, perfecting the form. The book *Georgia O'Keeffe*, for example, reproduces five of six paintings she made of *Jack-in-the-Pulpit*, which progress from a fairly straightforward rendering toward an increasing abstraction of form.[6] This progression from realism to abstraction, in fact, seems typical of O'Keeffe's work within a particular series; and consequently the sequence of the located watercolors of *Red Cannas* can be deduced. The one in Columbus probably came first in the series, followed by the present example and finally the one at Yale.

The conception of the work relates not only to O'Keeffe's absorption of Dow's principles but to her very earliest influences. Both of O'Keeffe's grandmothers made watercolors of still lifes, in a naive and untutored folk style, and the flatness and decorative quality of *Red Cannas* bring American folk art to mind. In addition, the wet watercolor technique derives from O'Keeffe's high-school watercolor training. In writing about her years at the Chatham Episcopal Institute in Virginia, O'Keeffe recalled that she once worked in a very similar manner. She noted:

> I only remember two things that I painted in those years—a large bunch of purple lilacs and some red and yellow corn—both painted with the wet-paper method on full-sized sheets of rough Whatman paper. I must have painted a great deal with watercolor by that time or I wouldn't have had the freedom I had with that big sheet of white paper and the big brush I used. I remember wondering how I could paint the big shapes of bunches of lilacs and—at the same time—each little flower. I slapped my paint about quite a bit and didn't care where it spilled.[7]

In *Red Cannas* O'Keeffe exploited a similar technique, applying the design in large, wet, sure strokes, without pencil lines, in modulated tones of only three colors—pale jade green, watery blue-gray, and an intense reddish-violet. No corrections were possible, but none was necessary in this deceptively simple-looking act of "filling a space in a beautiful way."

HA

NOTES: 1. Mary Lynn Kotz, "A Day with Georgia O'Keeffe," *Art News* LXVI (December 1977): 43. 2. Laurie Lisle, *Portrait of the Artist: A Biography of Georgia O'Keeffe* (New York, 1980), 70. 3. Lisle, 85. 4. Lisle, 238. 5. Georgia O'Keeffe, *Georgia O'Keeffe* (New York, 1976), plate 10. 6. O'Keeffe, plates 38-42. 7. O'Keeffe, unpaginated.

GEORGE AULT

1891 — 1948

Smoke Stacks
1925
graphite on paper
13 ⅞ x 9 ⅞ in.
(35.3 x 25.1 cm.)
Patrons Art Fund,
83.4

ALTHOUGH the notice of George Ault's suicide in the *New York Times* referred to him as "an artist of national prominence," he emerges today as only a shadowy figure.[1] His father, Charles Henry Ault, was one of the founders of The Saint Louis Art Museum, president of the Cleveland-based Western Art Association, a founder of the National Arts Club of Grammercy Park, New York, and a charter member of the Salmagundi Club and City Club. George Ault, who was born in 1891 in Cleveland, was taken at the age of eight to London, where his father introduced American printing ink to Europe.

Educated in England, George Ault attended the Slade School and the St. John's Wood Art School in London, where he studied under Henry Tonks, Wilson Steer, Sir William Orchardson, and George Clausen. In these early years he spent his summers painting in Brittany, Normandy, and Picardy and frequently visited Paris. He returned to America in 1911, living in New Jersey and New York and frequently summering in Provincetown, Massachusetts, where he may well have encountered Charles Demuth. He moved to Woodstock, New York, in 1937. Throughout much of his life he suffered from poor health.

Ault's first recognition came in 1921 when his painting *A New York Skyline* (location unknown) was chosen for an exhibition, *Our Choice of the Independents*, sponsored by *International Studio* magazine. C. Lewis Hind, the English art critic who selected the show, declared that the works promised "a future for American art away from the stereotype of the moribund academic productions of the day." Three years later, Ault was discovered by Stephen Bourgeois, who included his work in an exhibition devoted to the "primitives of a new modern school of painting in America."[2]

Ault's paintings, described as puritanical in his day, present a world of bleak melancholy—a land of bare trees lifting their branches in longing towards a sunless sky, or of deserted cities of cement, concrete, and steel, filled with an unquenchable loneliness. A slight revival of interest in Ault's accomplishments began in 1960 when his work was included in the influential exhibition *The Precisionist View in American Art* (Walker Art Center, Minneapolis).[3] Ault remains, however, one of the most obscure and least studied masters of the Precisionist style.

Smoke Stacks seems to represent a view from one pier to another, with steamships docked between them. From this vantage point the elements of land-based and marine architecture would naturally appear jumbled, and Ault made them particularly difficult to recognize by rearranging objects as well as by simplifying and abstracting them. Among the recognizable elements in the drawing are a lifeboat, a cargo boom and rigging, the funnels of several ocean liners with their characteristic horizontal livery striping, and segments of warehouses with clearly rendered cornices. In the upper portion of the drawing a bridge cuts horizontally across the composition, its nether surface represented with diagonal stripes.

Ault deliberately applied shading in an arbitrary and top-heavy manner in order to emphasize the disjunction of shapes and to create an

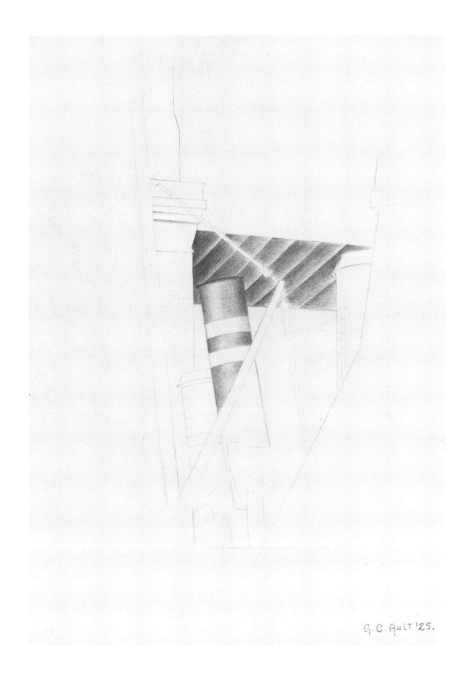

G.C. Ault '25.

Ault, *Smoke Stacks*

effect of disembodied, floating forms. His mode of representation relates most closely to the work of Charles Demuth, whom he probably knew in Provincetown, who had begun to experiment with similar effects based on those of analytical Cubism as early as 1917. Unlike Demuth, however, Ault did not use raylike lines to fracture forms but relied strictly on the physical outlines of objects to create his effect.

Marine architecture was a popular subject among modernist painters in the 1920s, being particularly well suited to the cylindrical mode of abstract painting developed by Fernand Léger. The architect and painter Le Corbusier praised the beauties of ocean liners in his widely

disseminated book *Towards a New Architecture*, which was translated into English in 1922; and in 1923 the American expatriate Gerald Murphy created a now-lost painting eighteen feet tall that depicted the smokestacks and ventilators of a Cunard ocean liner and was exhibited at the Salon des Independents in 1924.[4] Ault probably knew of some of these precedents in Europe and was also undoubtedly aware of Charles Demuth's creations on this theme, such as his *Paquebot Paris* (1921 or 1922, Columbus Museum of Art).

<div align="right">HA</div>

NOTES: 1. *New York Times*, 5 January 1949. 2. The account is based chiefly on biographical information distributed by the Vanderwoude Tananbaum Gallery, New York. 3. Walker Art Center, Minneapolis, *The Precisionist View in American Art* (1960), exh. cat. by Martin Friedman. 4. Calvin Tomkins, *Living Well Is the Best Revenge* (New York, 1962), 137.

PETER BLUME

B. RUSSIA, 1906

Study for "South of Scranton" (Crow's Nest)
1930
graphite on paper
13 ⅞ x 8 ¹⁵⁄₁₆ in.
(35.2 x 22.7 cm.)
Patrons Art Fund,
84.28.1

P ETER Blume was born in Russia in 1906, the son of a Jewish revolutionary who had taken part in the 1905 uprising against the Czar. At the age of five he was brought to New York, where his father had found work as a marker in the clothing industry. In his teens Blume studied art at the Educational Alliance and the Art Students League and supported himself with odd jobs while painting as much as possible in his free time. In the spring of 1925, when he was only nineteen, he persuaded Charles Daniel, one of the few dealers in New York who handled modern art, to take on his work. Soon afterward he developed his dinstinctive style, which combined an almost childlike whimsy in the juxtaposition of elements with meticulous treatment of each individual form. Blume's first large-scale painting was the enigmatic *Parade* (1931, The Museum of Modern Art), which showed a worker (posed for by Blume's friend, the leftist writer Malcolm Cowley) carrying a suit of armor in front of a factory. Blume's next major painting was *South of Scranton* (1931, The Metropolitan Museum of Art), for which this drawing is a study.[1]

South of Scranton was inspired by a trip Blume took in his Model T Ford in the spring of 1930 through the coal fields around Scranton, down to the steel mills of Bethlehem, and south by way of the Shenandoah Valley to Charleston, South Carolina. By the time he started home to Connecticut in June, Blume had already made five preparatory drawings for a painting based on his travels. Late in the fall, after several months of further planning, he began work on the canvas itself.

When he attempted to draw on his memories "to weld them into a picture that would be a record of my trip," Blume found that "things lost their logical connections, as they do in a dream."[2] The final painting combines scenes of several places: on the left is a mountain of waste coal in Pennsylvania, with a coal breaker and puffing locomotive; in the center stand a group of coal-town houses, many with false fronts; and on the right appears part of the superstructure of the German cruiser *Emden*, which Blume had seen in Charleston harbor, with German sailors in gym

suits leaping through space like birds to perform calisthenic exercises on deck. Carnegie Institute's drawing is a study of the crow's nest in this right-hand section of the painting.

Always a slow worker, Blume did not complete the canvas until October 1931, when he included it in a show of his work at the Daniel Gallery, New York. Although the painting received favorable mention in reviews, it did not sell, and soon afterward the Daniel Gallery closed, a casualty of the Great Depression. For several years Blume stored *South of Scranton* in a friend's apartment but retrieved it in 1934 for the First Municipal Art Exhibition at Radio City and the Carnegie International exhibition in Pittsburgh later in the year.[3]

At the International *South of Scranton* was suddenly thrust into national attention when all three judges—Elizabeth Luther Cary, art editor of the *New York Times*, American artist Gifford Beal, and Alfred H. Barr, Jr., director of The Museum of Modern Art—unanimously awarded the painting the first prize. At twenty-seven, Blume was the youngest artist ever to win the award.[4] Three years before, when Franklin Watkins's *Suicide in Costume* received the International's first prize, the work was widely denounced in the press as immoral. *South of Scranton* generated even more controversy over its surrealistic juxtaposition of scenes, which seemed incomprehensible to most viewers.

Modernism was still unfamiliar in the United States, and Blume's picture was variously dubbed "Abstract," "Expressionist," "Surrealist," and "Cubist." Margaret Bruening of the *New York Post* concluded, "It has no apparent artistic value," and Thomas Craven, the popular writer on modern art, termed it "a nonsensical pattern."[6] Martin Leisser, the aging Pittsburgh landscapist who had persuaded Andrew Carnegie to establish a school of painting at Carnegie Institute of Technology (now Carnegie-Mellon University), denounced the canvas as "a joke and an abomination."[7] One of those who attempted to criticize the painting on art historical grounds was the Reverend Thomas J. Glynn, who wrote to the *Pittsburgh Post Gazette*, "The Cubism in this picture is easily noticed from the pyramid of coal. . . . The cubist school of art is not popular among first-class artists."[8] Others tried to read social meaning into the work, as did Douglas Naylor of the *Pittsburgh Press*, who stated, "It seems reasonable to conclude that the cannon atop the queer turret is symbolic of capitalism."[9] The painting proved a popular subject for cartoon parodies, including one by Robert Benchley in *The New Yorker* and a photo-montage, published in the *Pittsburgh Press*, that portrayed such sites as the Allegheny County jail and the Banksville garbage dump and was titled "South of Dixmont," a reference to the city's insane asylum.[10]

In the balloting for the exhibition's Popular Prize, *South of Scranton* won only twenty-two votes; the winner, Frederick J. Waugh's *Tropic Seas*, received 1,920.[11] Because of the controversy that surrounded *South of Scranton*, the museum did not buy the painting. In 1943, however, it was acquired by The Metropolitan Museum of Art when it won one of two second prize purchase awards in the huge *Artists for Victory* exhibition there.[12]

This early study of the crow's nest in *South of Scranton* reveals Blume's links with the Precisionists even more clearly than the final painting.[13] Blume became familiar with Precisionism in 1925 when he began his association with the Daniel Gallery, which handled the work of Charles Demuth, Charles Sheeler, Preston Dickinson, and Niles Spencer. He first

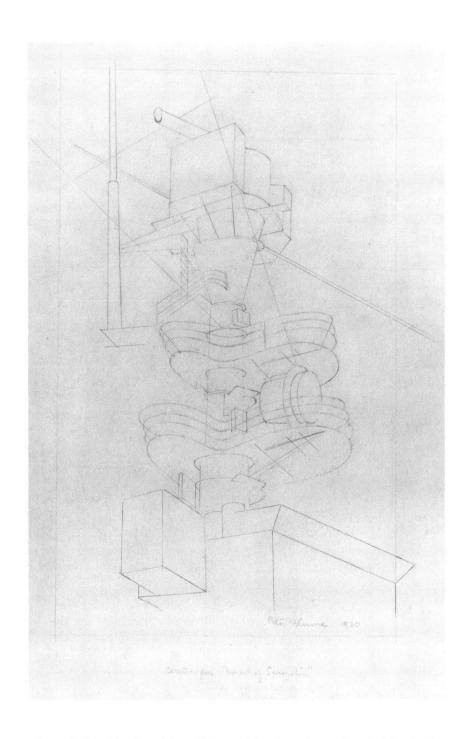

Blume, *Study for "South of Scranton" (Crow's Nest)*

adopted Precisionism himself in 1928 when he painted *The Bridge* (collection of Mr. and Mrs. James A. Fisher). Both Demuth and Sheeler preceded Blume in painting marine architecture, Demuth in his *Paquebot Paris* (1921 or 1922, Columbus Museum of Art) and Sheeler in his *Upper Deck* (1929, Fogg Art Museum, Harvard University).

Blume may also have been familiar with architectural drawings of the International Style by figures like Walter Gropius and Le Corbusier, which tended, as in this sketch, to create the illusion of weightlessness by eliminating shading and concentrating on crisply ruled outlines. In *Towards a New Architecture* (1927) Le Corbusier included illustrations of industrial buildings and ships similar to those that appear in *South of Scranton*. Unlike Le Corbusier, however, Blume did not present his structures as harbingers of good but treated them ironically, as instruments of the sort of mechanized behavior exemplified by the leaping sailors in the painting.

The crow's nest in this drawing is a more complex design than the one Blume finally settled on. Its intricacies recall the complicated factory machinery he had shown in his previous painting, *Parade*.

The dispute surrounding *South of Scranton* did bring Blume patronage in Pittsburgh. In 1938 Edgar Kaufmann, head of the Pittsburgh-based department store chain, invited Blume to make drawings on the site of Fallingwater, the now-famous house he had commissioned from Frank Lloyd Wright, which was then under construction. Shortly afterwards Kaufmann arranged for Blume to execute a painting of the Kaufmann family in front of the new building. Although this work was never completed, Blume did include a vignette of Fallingwater, as it was being built, on the left-hand side of *The Rock* (1948), one of his most ambitious paintings, which the Kaufmanns purchased and which Edgar Kaufmann, Jr., eventually donated to The Art Institute of Chicago. Ironically, a mere sixteen years after the fuss surrounding *South of Scranton*, *The Rock* received the Popular Prize at the 1950 Carnegie International.[14]

HA

NOTES: 1. The Currier Gallery of Art, Manchester, New Hampshire, *Paintings and Drawings: Peter Blume in Retrospect, 1925-1964* (1964), exh. cat. by Charles E. Buckley; Kennedy Galleries, New York, *Peter Blume* (1968), exh. cat. by Frank Getlein; *Pittsburgh Bulletin-Index*, 25 October 1934. 2. Peter Blume, "South of Scranton," *Carnegie Magazine* VIII (October 1934): 155. 3. Buckley, 14. 4. Penelope Redd, "Art Controversy Looms," *Pittsburgh Sun-Telegraph*, 19 October 1934; "Carnegie Art Prize Awarded to Unknown for 'Mystery Painting'," *New York World Telegram*, 19 October 1934. 5. "1934 Carnegie International," *News-Record of the Baltimore Museum of Art* VI (January 1935): unpaginated. This article was based on a press release circulated by Carnegie Institute, dated 19 October 1934, a copy of which is in the biographical file on the artist. 6. "Mr. Carnegie's Good Money," *Time* (29 October 1934): 38; Thomas Craven, "The Carnegie Art Exhibit," *Washington Herald*, 1 December 1934. 7. "Noted Painter Here Assails Prize Winners," *Pittsburgh Post Gazette*, 25 October 1934. 8. James Thrall Soby, "History of a Picture," *Saturday Review of Literature* XXX (26 April 1947): 32. 9. "Mr. Carnegie's Good Money," 38. 10. "Two Sniffs of 'Pinchot Poison,' 10 Shots on One Camera Plate," *Pittsburgh Press*, 21 October 1934; Robert Benchley, "The Prizewinner and Its Implications," *The New Yorker* (24 November 1934): 17. 11. "South of Scranton Badly Beaten in Popular Ballot," *Pittsburgh Press*, 3 December 1934. 12. Soby, 30. 13. Thanks to Frank Trapp, director of the Mead Art Museum, Amherst College, who, in a letter of 15 August 1984, provided information about the purpose and date of the museum's drawing, based on his discussion of it with the artist. The last drawing in this series was given to Gladys (Saltonstall) Billings, who later became Mrs. Van Wyck Brooks. It is listed in The Currier Gallery of Art, 23, cat. no. 34. 14. The Currier Gallery of Art, 16-17.

CHARLES SHEELER

1 8 8 3 — 1 9 6 5

Tulips
1931
black conte crayon on paper
26 x 19 in.
(66 x 48.1 cm.)
Collection of Mr. and Mrs.
James A. Fisher, intended gift
to the Museum of Art,
Carnegie Institute

CHARLES Sheeler's temperament did not conform to the usual image of an artist. A local newspaper reporter wrote of him in 1938, "He works like a day laborer, seven or eight hours a day, takes little recreation, looks more like a college professor than a painter, has none of the aspects of Bohemianism and observes a well-ordered regime. . . . Painfully inarticulate, he can be persuaded to wax with enthusiasm about a new photographic paper or camera."[1] Sheeler's creations, however, reveal a deeply poetic sensibility behind their immaculate surfaces.

Sheeler's earliest paintings show the influence of the flamboyant technical virtuoso William Merritt Chase, with whom he studied painting at the Pennsylvania Academy of the Fine Arts. He was more strongly influenced, however, by a fellow student, Morton Schamberg, who stimulated his interest in Cézanne, Cubism, and modern art. Sheeler first encountered modernism while traveling in Europe with Schamberg in 1909, and on their return to Philadelphia in the following year he began to produce Cézannesque still-life paintings that show an attempt to grasp Cubist principles of form. In 1912 Sheeler took up commercial photography as a source of income, and although impressionistic, soft-focus photography was then in vogue he concentrated from the first on crisply detailed, sharply focused effects. The clear vision of these photographs eventually transformed his style of painting to a meticulous, smooth-surfaced manner which was the exact antithesis of that of his early teacher Chase.

Schamberg died in 1918, and in the following year Sheeler moved to New York. For several years he earned his living as an assistant to the photographer Edward Steichen at Condé Nast Publications, but his presentation of personalities was bland and lacked the bravura necessary for high-fashion photography. Increasingly, Sheeler concentrated on commercial work, photographing such mundane objects as spark plugs, typewriters, movie projectors, plumbing fixtures, flatware, and tires for N. W. Ayer and Son, a Philadelphia advertising agency. Although he established contact with the modernist circles of both Alfred Stieglitz and Walter Arensberg, Sheeler was shy and undemonstrative and never played a significant role in either group.

About 1920 Sheeler began to paint urban subjects, basing his compositions on photographs, and as the decade progressed his work shifted from simplified and abstracted to very meticulous and detailed renderings. A major turning point in his career came in 1927 when he was assigned by the Ayer agency to make a photographic study of the Ford Motor Company's plant in River Rouge, Michigan. After six weeks of work, Sheeler produced thirty-two extraordinary photographs that presented a pristine view of American industry and were widely reproduced in both American and European publications. As a result of this series, Sheeler received an official invitation to photograph factories in Russia, an offer he declined because of his commitment to American subject matter.

164

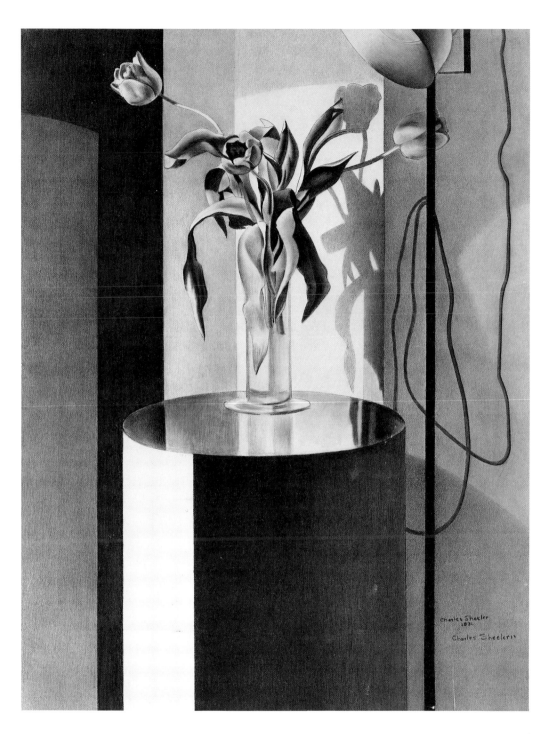

Sheeler, *Tulips*

Sheeler first expressed his new interest in machine-made forms in his painting *Upper Deck* of 1929 (Fogg Art Museum, Harvard University), and not long afterwards he began to produce canvases based on his photographs of the River Rouge plant, including four of the most important paintings of his career: *American Landscape* (1930, The Museum of Modern Art), *Classic Landscape* (1931, collection of Barney A. Ebsworth), *River Rouge Plant* (1932, Whitney Museum of American Art), and *City Interior* (1936, Worcester Art Museum). These works derived their intricacy of detail from photography but surpassed photography in the smoothness and clarity of their rendering of form.

Paintings like these established Sheeler as the leading master of the style now known as Precisionism, which discovered crisp, pure, geometric shapes resembling those of the Cubist painters in the industrial forms of the American landscape. Although Sheeler was not the first American to develop a Precisionist style (he was preceded by Charles Demuth and others), his works stand out for their formal strength and emotional detachment as well as their technical polish.

Carnegie Institute's small watercolor *River Rouge Industrial Plant* initiated Sheeler's great series of paintings of industrial subjects. It was made in 1928, soon after Sheeler had completed his photographic series of the site and a year before he painted his landmark canvas *Upper Deck*. Sheeler directly exploited this watercolor to create his lithograph *Industrial Series, No. 1* of 1928, a copy of which, in the Whitney Museum of American Art, is a work of precisely the same size, presenting the same image in reverse.[2] Sheeler's use of color, however, indicates that he did not make the watercolor merely as a study for the print. In fact, it served as the basis for his painting *American Landscape* (1930, The Museum of Modern Art), the first of the four major works he based on the River Rouge plant.

Sheeler included a larger vista in the finished painting than in the sketch, and he also adopted a more polished and meticulous technique. Such a procedure, in fact, was characteristic of him and can also be observed in his small oil study of 1935 for *City Interior* (William H. Lane Foundation), which is less expansive in viewpoint and less polished in handling than the final painting of the following year (Worcester Art Museum). None of these sketches and paintings was produced on the site; they were made in the studio. In fact, Sheeler worked many of his sketches on small pieces of glass or plexiglass, which evidently made it easier for him to trace directly from photographs.[3]

The large finished drawing *Tulips* of 1931 also reveals Sheeler's interest in photography, this time through the actual depiction of photographic apparatus. Some of Sheeler's earliest efforts to absorb the language of Cézanne and other modernist painters were studies of tulips; for example, his *Three White Tulips* of 1912 (William H. Lane Foundation).[4] In this later drawing he returned to the subject in his mature Precisionist style, achieving the same clarity of edges and control of tonal gradations that is evident in his oil paintings of this period. While ostensibly a realistic drawing, *Tulips* reveals Sheeler's manipulation of light-dark contrasts in several places to achieve more strikingly geometric effects. This is evident, for example, in his handling of the stem of the tulip and the edge of the photographer's lamp.

This drawing relates closely to the painting *Cactus* of the same year (Philadelphia Museum of Art), which shows the same photographer's

lamp and cylindrical, mirror-topped pedestal. A related painting, which also shows photographer's implements, is *View of New York*, also of 1931 (Museum of Fine Arts, Boston).[5]

Tulips was slightly larger in 1939 when it was shown at The Museum of Modern Art in the first retrospective exhibition of Sheeler's work. At some time after that date it was cropped at the bottom by about an inch and a half. The addition of a second signature on the work indicates that this change was made by the artist himself, and the original deckling of the paper on the other three edges is evidence that they were not changed.[6]

<div align="right">HA</div>

NOTES: 1. Anne Whelan, *The Bridgeport* [Connecticut] *Post*, 21 August 1938, 4. 2. Whitney Museum of American Art, New York, *Charles Sheeler: A Concentration of Works from the Permanent Collection of the Whitney Museum of American Art* (1980), exh. cat. by Patterson Sims, 23-24; Martin Friedman, *Charles Sheeler* (New York, 1975), 70; Donelson F. Hoopes, *American Watercolor Painting* (New York, 1977), 137. 3. Friedman, 72, 87. 4. Friedman, 18. 5. Friedman, 114-15. 6. Ernest Brace, "Charles Sheeler," *Creative Art* XI (October 1932): 97, 103-104; William Carlos Williams, *Charles Sheeler, Artist in the American Tradition* (New York, 1938), 157-58, illus., 127; Friedman, 91, illus., 93; Hirschl and Adler Galleries, New York, *Counterpoints in American Drawing: Realism and Abstraction, 1900-1940* (1983), exh. cat. by Stuart Feld, no. 111, illus.

JOHN KANE
1860 — 1934

JOHN Kane, who had worked as a manual laborer all his life, catapulted to fame when his naively rendered canvas *Scene from the Scottish Highlands* (c. 1927) was admitted to the Carnegie International exhibition of 1927. The painting was accepted at the insistence of Andrew Dasburg, a modernist who had rejected his early training under Kenyon Cox and developed a Cubist manner derived from the work of Cézanne and Picasso. At this time the pictorial effects of folk art were still associated with those of modernism, and Dasburg, in his discovery of Kane, created an American parallel to Picasso's role in promoting the work of the French folk painter Henri Rousseau.

Many believed Kane's inclusion in the 1927 International was an elaborate hoax, but the success that it brought to Kane continued in the few years that remained to him before his death from tuberculosis in 1934. His paintings were not only exhibited at successive Internationals, but were also shown at Harvard, The Art Institute of Chicago, the Cincinnati Art Museum, the Whitney Museum of American Art, and The Museum of Modern Art. Within three years of his first recognition he had sold works to such notables as Mrs. John D. Rockefeller and John Dewey, chairman of the department of philosophy at Columbia University.[2] Ironically, today the once well-known work of Andrew Dasburg has dropped into relative obscurity, while that of Kane is still prominently displayed in such institutions as The Museum of Modern Art.

Until recently no drawings by Kane had ever been exhibited or reproduced. In 1984, however, the Galerie St. Etienne located seventy-

Study for "Junction Hollow" and "Panther Hollow, Pittsburgh"
c. 1932–33
graphite on paper
8 ⅜ x 12 ¹³⁄₁₆ in.
(21.3 x 32.5 cm.)
Museum purchase: gift of Allegheny Foundation, 84.56.2

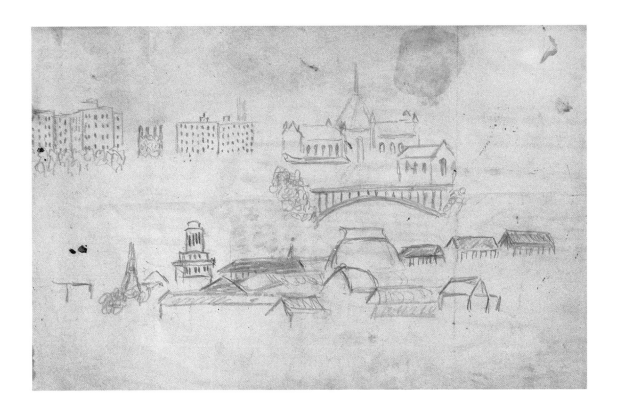

Kane, *Study for "Junction
Hollow" and "Panther Hollow,
Pittsburgh"*

one sheets of his sketches, many of them worked on both sides, which had remained in the possession of the artist's daughter, Margaret Corbett. According to Margaret Corbett, Kane spent hours in the public library copying from books, and several of the surviving drawings—for example, a group of studies from Charles le Brun's *Traité des Passions*—support her claim that he acquired training in this manner. The large majority of Kane's surviving sketches, however, like the four in Carnegie Institute, depict landscapes that he sketched from nature. While Kane sometimes painted outdoors in order to capture color effects accurately, he always completed his paintings in the studio. It appears that he initially composed most of his paintings in the studio as well, by assembling numerous tiny sketches. Because of this method of piecing together different images, many of Kane's paintings combine vantage points and show a greater number of elements than would actually be visible from a single place.[3]

The four drawings now in the Museum of Art, which came from the group discovered by the Galerie St. Etienne, all relate directly to paintings already in the collection. In the center of the drawing *Studies of Highlanders* is a man playing the bagpipes, a figure Kane used for the museum's *Scene from the Scottish Highlands*, the painting that first established his fame.[4] The drawing *Bridge* (c. 1930) presents the skeletal composition of the museum's painting *Bloomfield Bridge* (c. 1930), a design

168

that Kane later expanded into a more panoramic view of the same site, *Crossing the Junction* (1934, collection of H. J. Heinz Company).[5] The drawing *Six Houses Along Roadside on Hill* (c. 1928) depicts the group of houses in the lower part of the museum's painting *Nine Mile Run from Calvary Cemetery* (c. 1928). Kane also included these structures in another canvas showing *Nine Mile Run* (c. 1930, The Ackland Museum of Art, University of North Carolina, Chapel Hill).[6]

Study for "Junction Hollow" and "Panther Hollow, Pittsburgh" contains several vignettes that Kane sketched in the Oakland section of Pittsburgh from vantage points on the south bank of Panther Hollow, just across from Carnegie Institute. The sketch at the upper left shows two apartment buildings with the tower of the Episcopal Church of the Ascension rising between them. The drawing at the upper right shows Central Catholic High School and the Forbes Avenue Bridge. The design at the bottom of the sheet shows, from left to right, St. Paul's Cathedral, Carnegie-Mellon University (with the distinctive cylindrical tower of Hamerschlag or Machinery Hall on the left), and the glass-roofed Phipps Conservatory in Schenley Park. The verso of the sheet contains a sketch of the University of Pittsburgh's Cathedral of Learning. Kane employed the sketches at the upper left and the lower portions of the recto for the museum's painting *Panther Hollow* (c. 1930–34) and the drawing at the upper right of the recto for *Junction Hollow* (1932, Whitney Museum of American Art). The sketch of the Cathedral of Learning on the verso he made use of for both the Museum of Art's painting *Panther Hollow* and for The Metropolitan Museum of Art's painting *The Cathedral of Learning* (c. 1930).

<div align="right">HA</div>

NOTES: 1. "Art Jury Row Made John Kane Famous," *Pittsburgh Sun Telegraph*, 12 August 1934. For an account of Dasburg's work see Van Deren Coke, *Andrew Dasburg* (Albuquerque, New Mexico, 1979). 2. Marie McSwigan, *Sky Hooks: The Autobiography of John Kane*, reprinted in Leon Arkus, *John Kane, Painter* (Pittsburgh, 1971), 90, 94, 107. 3. Kane's drawings are discussed in Galerie St. Etienne, New York, *John Kane: Modern America's First Folk Painter* (1984), exh. cat. by Jane Kallir, unpaginated. 4. Arkus, cat. no. 69. 5. Arkus, cat. nos. 123, 124. 6. Arkus, cat. nos. 110, 111. 7. Arkus, cat. nos. 134, 135. 8. Arkus, cat. nos. 133, 135.

EDWARD HOPPER

1 8 8 2 — 1 9 6 7

Saltillo Rooftops
1943
graphite, watercolor, and
gouache on paper
21 ½ x 29 ⅝ in.
(54.6 x 75.2 cm.)
Gift of Mr. and Mrs. James H.
Beal, 60.3.3

ALTHOUGH he was always hostile to the development of abstract painting, Edward Hopper's art gives forth a distinctly modern feeling. In 1967, shortly after Hopper's death, James Thrall Soby commented that many of his (Soby's) friends among the Abstract Expressionist painters genuinely admired Hopper's work. "It always astonished me," Soby noted, "that these young artists exempted the late Edward Hopper from their acrimony against the realist tradition."[1] In fact, the mood of loneliness and alienation in Hopper's paintings harmonizes well with the existentialist philosophies of this century, while his compositions always went beyond mere realistic transcription to establish patterns and relationships of abstract form.

Hopper achieved success in watercolor at a time when his oil paintings were still being rejected from exhibitions. He took up the medium in 1923, not having used it seriously since his student days, except in his commercial work, and made a large group of watercolors of old buildings and lighthouses in Gloucester, Massachusetts, and in Portland and Cape Elizabeth, Maine. Late in 1923 The Brooklyn Museum purchased his *House with Mansard Roof*, the first painting he had sold since the Armory Show. In the following year he was taken up by the New York dealer Frank Rehn, who sold every watercolor on the wall, and five more as well, from the first show he put on of Hopper's work.[2]

Hopper's early watercolors were small and fresh in technique, and he generally completed them in a single sitting. In the 1940s and 1950s, however, in such works as *Saltillo Rooftops*, he moved to a larger scale and a more calculated sense of composition. He also worked on his watercolors for longer periods, sometimes as much as a month, carefully building up the colors "in a series of glazes," although always with translucent washes and never with opaque pigment. This resulted, as is evident in *Saltillo Rooftops*, in an extraordinary depth and richness of color, particularly in the shadows, and a new solidity in the realization of form.[3]

While it depicts Mexico rather than the United States, *Saltillo Rooftops* exemplifies the feeling of provincial desolation that Hopper captured so ably in his work. In the summer of 1943, having no gas to travel from New York to Cape Cod because of war rationing, Hopper made his first trip to Mexico by train. Displeased with the rush and bustle of Mexico City, he spent most of his time in Saltillo and Monterey. The stay in Saltillo proved the most productive, and from the roof of the Guarhado house he made three watercolors in addition to Carnegie Institute's: *Sierra Madre at Saltillo* (private collection), *Palms at Saltillo* (collection of Mr. and Mrs. Robert M. Bernstein), and *Saltillo Mansion* (The Metropolitan Museum of Art). In 1946 he returned to Saltillo, staying at the Hotel Ariape Sainz, where his room let out onto a large roof terrace from which he could paint. At this time he executed four more watercolors: *Roofs, Saltillo, Mexico* (Whitney Museum of American Art), *El Palacio* (Whitney Museum of American Art), *Church of San Esteban* (The Metropolitan Museum of Art), and *Construction, Saltillo* (collection of Charles E. Buckley). *Roofs, Saltillo, Mexico* contains virtually identical mountain

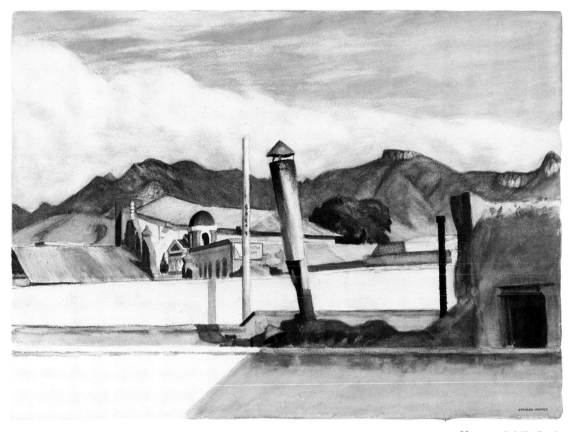

Hopper, *Saltillo Rooftops*

silhouettes to Carnegie Institute's *Saltillo Rooftops*, although the foreground buildings are not the same. In 1951 Hopper again visited Saltillo but apparently produced no work.[4]

Gail Levin, who visited Saltillo in 1983, exactly forty years after Hopper's first visit, found that the scene Hopper recorded in this and other watercolors had remained surprisingly intact, even to the assortment of chimneys and cornices and the sign of the El Palacio cinema that Hopper depicted in the watercolor in The Metropolitan Museum of Art.[5]

HA

NOTES: 1. National Collection of Fine Arts, Smithsonian Institution, Washington, D.C., *São Paulo 9* (1967), exh. cat. by William C. Seitz, et. al., 5. 2. Whitney Museum of American Art, New York, *Edward Hopper* (1964), exh. cat. by Lloyd Goodrich, 18-22. 3. Whitney Museum, 56. 4. Gail Levin, *Edward Hopper: The Art and the Artist* (New York, 1980), 303. Whitney Museum, 46, reproduces *Palms at Saltillo*, 1943; Levin reproduces *Roofs, Saltillo, Mexico*, 1946, and *El Palacio*, 1946. I am indebted to Deborah Lyons of the Hopper Collection, Whitney Museum of American Art, for providing information about Hopper's stay in Saltillo and the history of Carnegie Institute's watercolor. 5. Gail Levin, "In the Footsteps of Edward Hopper," *Geo* (February 1983): 45.

REGINALD MARSH

1 8 9 8 — 1 9 5 4

IN 1941, while he was in Pittsburgh to serve on an exhibition jury, Reginald Marsh met Marty (Martha) Cornelius, a talented young local artist who would later become a pioneer in art therapy for the mentally ill. They became close friends and began a lengthy correspondence that continued until Marsh's death. Marsh was clearly smitten with his correspondent. "You seem to have everything," he wrote her on March 8, 1945, "energy, beauty, and talent." A month later he declared that she had "one of the most extraordinarily articulate minds." The rare bond of sympathy between them allowed Marsh to open his mind to Cornelius, and his letters, copiously illustrated and frequently witty, are remarkable for their candor. Marsh freely discussed his views on life and art and even described his psychoanalysis in uninhibited detail. These letters, which Cornelius gave to the Museum of Art in 1968,[1] provide a unique record of Marsh's personality.

On April 20, 1945, Marsh sent Cornelius "a large watercolor drawing made last summer" in appreciation for the hospitality she and her family had shown him during a recent trip to Pittsburgh. "These drawings are now considered my best work," he told her. "This is the most interesting one I have around and hope you like it." The drawing, *Sideshow*, represents the artist in his most spirited and vulgar vein. Having begun his career as a delineator of the urban scene, particularly its low-life aspects, for the *New York Daily News* and *The New Yorker*, he continued, after turning to "serious" painting in the mid-1920s, to explore the tawdry world of vaudeville theaters, Harlem dance halls, dime-a-dance joints, movie palaces, night clubs. *Sideshow* is an image drawn from one of Marsh's favorite haunts, Coney Island's Luna Park.

For Marsh, the great appeal of Coney Island lay in its unlimited opportunities to observe the human body. He maintained, with the fervor of a nineteenth-century academician, that the human figure was the very foundation of art, and, like many American realists of his generation, he was a strict traditionalist in the matter of style. While working on his *Anatomy for Artists*,[2] he urged Cornelius:

> Study only the old masters—all modern stuff is flat: it is junk, ingratiating & decorative but unimportant, fit only for millionaires & communists. I am spending my days copying all the figure drawings of Michelangelo, Raphael, Vesalius, Dürer, Rembrandt, Delacroix, Géricault, etc.—They knew the *form*— the substance the shape. Picasso, Zorn, Sargent are frauds. Even we are better than they are—you and me—

At the bottom of this letter, dated February 3, 1945, he drew an incoherent scribble and labeled it "expressionism."

Marsh applied his traditional skills, however, to the most transient aspects of contemporary life. There is nothing even remotely classical about the figures gathered beneath Captain Ringman Mack's garish advertisement in *Sideshow*. Some, like the obese, middle-aged couple and the zoot-suited young black entranced by the barker, are frankly grotesque, though one, the young woman at the right, is beautiful.

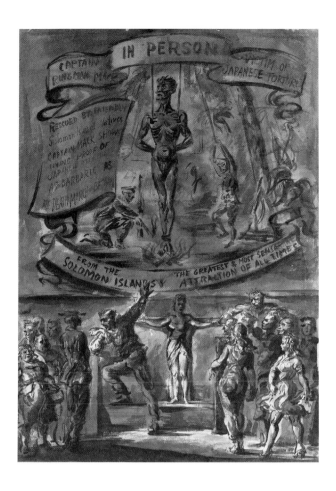

Marsh, *Sideshow*

Blonde, buxom, her light skirts agitated by the force of her stride to reveal Betty Grable pin-up legs, she is Marsh's modern Venus, a recurrent figure in his work. The artist was particularly susceptible to the sexual attractions of Coney Island. "In the summer evenings," he wrote to Marty Cornelius on May 13, 1945, "I sit alone among thousands on the beach at Coney Island—can gaze covetously and choose from many."

Marsh was also a traditionalist in technical matters. He liked to experiment, but he avoided modern innovations, preferring, instead, to revive the little used media of the past. In 1929 he began to paint in egg tempera, and in 1940 he adopted a medium developed by Jacques Maroger, former technical director of the Louvre laboratories, who claimed it was the lost formula used by the Van Eycks and other early oil painters. Marsh turned to watercolor in the early 40s as a respite from the exigencies of the Maroger medium. His monochrome watercolors were, as he pointed out to Cornelius, a great success. The essential character of his watercolor technique can be seen in *Sideshow*: fluid, sketchlike, with a brisk spontaneity admirably suited to the ephemeral nature of the subject.[3]

KN

NOTES: 1. "I believe they belong to posterity," wrote Marty Cornelius to Leon Arkus, director of the Museum of Art (25 June 1968). At this time she also donated Marsh's *Portrait of Marty Cornelius* (1945), in which she appears "dressed and posed in the guise of a pin-up girl" (Marsh to Cornelius, 11 December 1948, Museum of Art files). 2. Reginald Marsh, *Anatomy for Artists* (New York, 1945). 3. In his *Reginald Marsh* (New York, 1972), Lloyd Goodrich, a lifelong friend of the artist, provides an excellent account of his work and career.

JOHN WILDE

B. 1919

Untitled
1944
graphite with traces of white
gouache on paper
24 x 18 ⁹⁄₁₆ in.
(61 x 46.2 cm.)
Gift of Mr. and Mrs. Carl D.
Lobell, 82.83.3

JOHN Wilde, professor emeritus and former Alfred Sessler Distinguished Professor of Art at the University of Wisconsin, has been compared to Salvador Dali for his meticulously detailed rendering of bizarre and often disturbing images. Among his most memorable works are drawings he made while serving in the infantry in World War II. Wilde thoroughly hated both the war and the army, and he poured his despair, fear, and disgust into a remarkable series of highly personal documents.[1] Like other works in this series, *Untitled*, drawn in June 1944 while the artist was stationed in Washington, D.C., is a self-portrait accompanied by a column of surrealistic prose. He portrays himself as naked and vulnerable, his gaze haunted by suspicion and terror. These same emotions pervade the inscription, a paranoid fantasy on wartime security precautions:

> I. C.
> W.T.F. [Wednesday, Thursday, Friday]
> JNE 14–16
> 19'44 W.D.C. [Washington, D.C.]
> drawing of the la rootsies Ich am on standing on this time in this present confusion. This is ominous times and who can tell what in holy hell can happen to you or I. One thing make sure: wear your winter underwear in all kinds of weather—and never change in mid season. Read your liline [?] and keep your goddamn mouth shut except to tell the conductor to stop at the station—then best to get off one station before or after your destination, for some conspirator might be waiting for you at the station you plan to stop at.
> Bibl.: A. Dürer—Circa, 1520.

Both the use of the German Ich and the bibliographic reference indicate that Wilde in some way identified himself with Albrecht Dürer. Of all Dürer's works, the one that bears the closest resemblance to this drawing is a pen and ink self-portrait in the Kunsthalle, Bremen, made sometime during the second decade of the sixteenth century.[2] In this informal sketch, Dürer, naked except for a scanty pair of pants, points with his right hand to the area of his spleen. As in Wilde's drawing, an inscription supplements the image: "This is where the yellow spot is, and I am pointing to it with my finger: that is where it hurts." Wilde also points with his right hand (though to the woman's head rather than to himself), while holding his left arm in the same position as Dürer's and pressing the region of his own spleen. He may well have known that in Dürer's time the spleen was thought to be the organ of melancholy; in any case, the idea of pain and distress is central to both images.

"La rootsies" obviously refers to the woman's head, with its flowing, rootlike locks of hair, upon which the artist stands. This woman can be identified as his wife from an earlier drawing, one of the two *Wedding Portraits* of 1943 (Whitney Museum of American Art).[3] Wilde's message is clear: his wife provides the roots that anchor and sustain him in a hostile, tumultuous world. In another 1944 self-portrait, *Myself—April 1946*

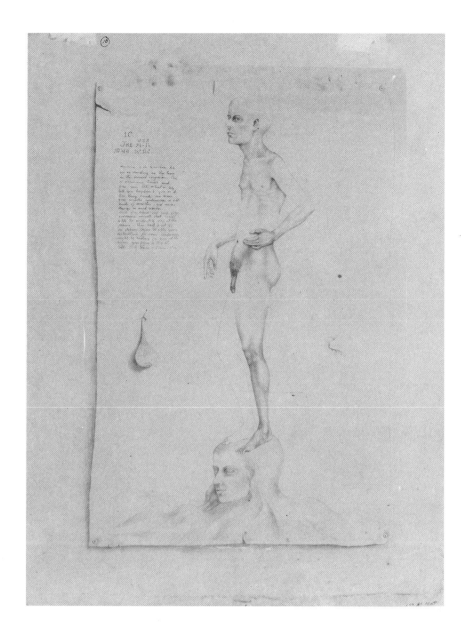

Wilde, *Untitled*

(collection of the artist), Wilde looked forward to the day when they could once more share a life together. Dressed in civilian clothes, sporting a mustache and a full head of hair, Wilde sits comfortably "in my room next to my bedroom in which I work. Here I work between long rests in the red bedroom. My wife HDPRAW [?] comforts me as I rest."[4]

KN

NOTES: 1. For discussion of these drawings see Rutgers University Art Gallery, New Brunswick, New Jersey, *Realism and Realities: The Other Side of American Painting 1940-1960* (1982), exh. cat. by Greta Berman and Jeffrey Wechsler, 68-70. 2. See Peter Strieder, *Albrecht Dürer: Paintings, Prints, Drawings* (New York, 1982), 24, 26, fig. 22. 3. Reproduced in Theodore E. Stebbins, Jr., *American Master Drawings and Watercolors* (New York, 1976), 336, fig. 297. 4. See Rutgers University Art Gallery, 68-69, fig. 79.

PAUL CADMUS

B . 1 9 0 4

Female Nude
1945
white gouache on black paper
15 ¼ x 12 ⅜ in.
(39 x 31.6 cm.)
Gift of Mrs. Howard Felding in
memory of Henry Boettcher,
80.66.1

PAUL Cadmus believes "people's noses should be rubbed in all sorts of things, pleasant and unpleasant."[1] He is probably best known for the unpleasant things, having launched his career in the 1930s with a series of scandals. The first of these was precipitated by *The Fleet's In!* (1934, Naval Historical Center, Washington, D.C.), a lively depiction of sailors on shore leave, aptly though unsympathetically described by the Secretary of the Navy as "a most disgraceful, sordid, disreputable, drunken brawl, wherein apparently a number of enlisted men are consorting with a party of streetwalkers and denizens of the red-light district."[2] At the insistence of the Navy the painting was excluded from the first exhibition of the Public Works of Art Project. The following year the Coney Island Showmen's League threatened Cadmus with a libel suit for *Coney Island* (1935, Los Angeles County Museum of Art), another unflattering image of Americans at play. Controversy erupted in 1940 over an attempt to remove *Sailors and Floosies* (1938, Whitney Museum of American Art) from San Francisco's Golden Gate International Exhibition, and that same year *Life* magazine refused to publish *The Herrin Massacre* (1940, collection of Thomas J. Lord and Robert E. White, Jr.), a gruesome rendition of a particularly bloody incident from a 1925 labor dispute. Since these earlier works, Cadmus has concerned himself more often with the pleasant aspects of life, but he has continued to validate his reputation as a brutal satirist with pictures such as *The Seven Deadly Sins* (1945–49, collection of Mr. and Mrs. Lincoln Kirstein), a series of allegorical personifications featuring lust wrapped in a transparent condom, and *Subway Symphony* (1975–76, Midtown Galleries, New York), a compendium of the human horrors that infest the subway system of New York.

During the heyday of Abstract Expressionism, critics disliked Cadmus less for his subject matter than for his total rejection of modernism. The style of his work to this day reflects the conservative training he received at the National Academy of Design between 1919 and 1926. Picasso, Pollock, and the other twentieth-century innovators have had no effect on him; his work, even his most grotesque caricatures, has been founded upon such master draftsmen of the past as Signorelli, Pollaiuolo, Mantegna, Michelangelo, and Ingres.

Nowhere is Cadmus's devotion to tradition more evident than in his highly regarded drawings of nudes. Numerically, these drawings constitute the major portion of his oeuvre. "I do many more drawings than paintings," says Cadmus, "because drawings are more saleable than paintings—they're less expensive."[3] They are also less time-consuming for the artist to produce, and Cadmus, a meticulous craftsman who usually works in the painstaking medium of egg tempera, is an extremely slow and far from prolific painter. Even his drawings show an emphasis on technical polish; they are not spontaneous sketches but finished works of art based on preliminary studies. *Female Nude* dates from 1945, the year Cadmus established his reputation as a draftsman by exhibiting forty drawings at New York's Midtown Galleries in his second one-man show.

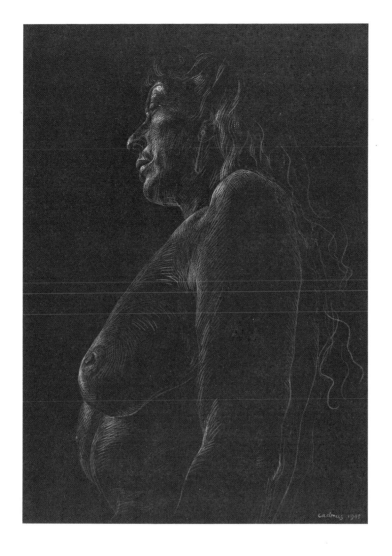

Cadmus, *Female Nude*

The unattractive model is an unusual choice for the artist, who normally prefers to use young, athletic males. This woman, with a bit of exaggeration, could easily serve as one of the repulsive creatures, perhaps a prostitute past her prime, found in the satirical paintings. Cadmus, however, avoids exaggeration in his drawings. Instead, employing the same delicate crosshatching that characterizes his tempera technique, he renders the model with the same precise observation and cool detachment that he would bring to a still life. Indeed, Cadmus has observed that models "should pose like apples or pears, except that they don't rot—at least not as quickly."[4]

KN

NOTES: 1. Quoted in Lincoln Kirstein, *Paul Cadmus* (New York, 1984), 107 (adapted from *Paul Cadmus: Enfant Terrible at 80*, David Sutherland Film, 1984). 2. "Removals," *Time*, 30 April 1934, 53. 3. Kirstein, 109. 4. Kirstein, 111.

SAUL STEINBERG

B. ROMANIA, 1914

Joy Continuous Miner
1954
watercolor, pen and ink, and
paper on paper
28 x 22 in.
(71.1 x 55.9 cm.)
Gift of Joy Manufacturing
Company, 54.23.4

BORN in Ramnicul-Sarat, Romania, Saul Steinberg studied philosophy and literature at the University of Bucharest, then attended the Reggio Politecnico at Milan, where he received a doctorate in architecture in 1940. His first published cartoons appeared in *Bertoldo*, a Milanese humor magazine, in 1936. In 1942 he moved to the United States, and after four years in the Navy settled in New York. Since the early 1940s Steinberg has reached a wide audience through the pages of *The New Yorker*, and his work, comprising paintings, drawings, and assemblages, has been exhibited at museums and galleries from Stockholm to São Paulo. His status as a "serious" artist has always been somewhat ambiguous. "I don't quite belong in the art, cartoon or magazine world," he once observed, "so the art world doesn't quite know how to place me."[1]

Although much of his work is undeniably funny, Steinberg has never been a typical "gag" cartoonist. In his exploration of modern life and the modern mind he delights in visual puns, elaborate architectural fantasies (the legacy of his early training), complex satirical allegories, and bizarre metaphysical conceits. His style, though unmistakable, is highly eclectic, deriving from "Egyptian painting, latrine drawings, primitive and insane art, Seurat, children's drawings, embroidery, Paul Klee."[2] This is only a partial list of his sources. Style, according to his friend Harold Rosenberg, the critic and art historian, is his "ultimate subject matter . . . the forms that things, places, people have assumed through moods of nature and through human invention and copying."[3] Frequently he uses several styles in the same drawing, as in *Techniques at a Party II* (1953), in which eighteen different persons are conveyed by eighteen different graphic styles.

Joy Continuous Miner, though not one of Steinberg's most profound images, is certainly one of his more charming. In 1954 *Fortune* magazine invited seven artists—Antonio Frasconi, Rufino Tamayo, Walter Murch, Matta, Ben Shahn, Hedda Sterne, and Saul Steinberg—to depict an automatic machine made by Pittsburgh's Joy Manufacturing Company for digging coal. *Fortune* described this machine as "a wonder to behold: the ripping head sinks into the working face, rears and swings and bites again. The caterpillar treads crawl, the chain conveyer fills to overflowing, and a mountain of coal builds up behind the flexible tail."[4] Like many of the other artists, Steinberg seized upon the continuous miner's obvious likeness to some ravenous, antediluvian beast. His droll contraption chews its way through earth in which an unlikely assortment of fossils and artifacts is embedded, including a guitar, a butterfly, and a Greek vase. The image is in some respects disquieting: the machine, disproportionately huge, threatens to undermine completely the sunny,

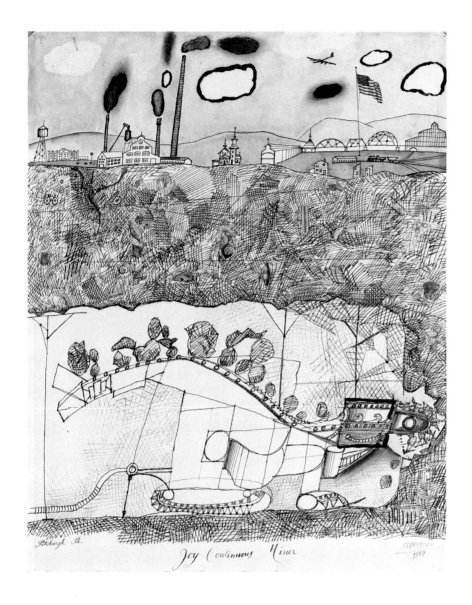

Steinberg, *Joy Continuous Miner*

childishly rendered scene of industrial prosperity above. Steinberg underlined its more sinister aspects by calling it a "monster," but *Fortune* suggested, tactfully, that "some may prefer to see it simply as a genial red-nosed dragon."[5]

KN

NOTES: 1. Quoted in Harold Rosenberg, *Saul Steinberg* (New York, 1978), 10. This monograph was published in conjunction with a major retrospective exhibition of Steinberg's work organized by the Whitney Museum of American Art. 2. Rosenberg, 25. 3. Rosenberg, 25. 4. "Seven Painters and a Machine," *Fortune*, June 1954, 127. Steinberg's drawing appears on page 131. 5. "Seven Painters," 130.

20TH-CENTURY ABSTRACTION

MORGAN RUSSELL

1886 — 1953

Study for "Synchromy in Green"
c. 1912–13
graphite on paper mounted on
cardboard
18 ¾ x 10 ⅞ in.
(47.6 x 27.6 cm.)
Gift of Rose Fried, 58.2

AMONG the modifiers of Cubism was the American-born Morgan Russell, the founder of the short-lived movement termed Synchromism. By the time he was twenty-six, in 1912, Morgan Russell had gained exposure to an impressive range of artistic influences. Initially, he had intended to follow his father's profession of architecture, but when he was in Europe for the first time in 1906 he was overwhelmed by Michelangelo's heroic nude figures. On his return to New York the following year he abandoned architecture to study sculpture with the academic master James Earle Fraser. He also took lessons in painting from Robert Henri, who stressed the importance of originality in an artist's work. In the spring of 1908 Russell returned to Europe, where he met Leo Stein and his sister Gertrude. At this time he first encountered both the Cubism of Picasso and the Fauvism of Matisse, with whom he studied sculpture in the following spring. The final impetus to Synchromism came in 1911 when Russell began attending the classes of the Canadian artist Percyval Tudor-Hart, who was deeply interested in color theory. It was in these classes that Russell first met Stanton Macdonald-Wright, a fellow American about his own age, who would become his partner in the development of the Synchromist movement.[1]

"Synchromism," which means, "with color," arose from Russell's idea that he might create painting in which sculptural forms achieved complete realization in two dimensions through the exploitation of color. In a series of manifestos, Russell and Macdonald-Wright trumpeted their work as a turning point in the history of Western art. Their views were supported by Macdonald-Wright's half-brother, the New York art critic Willard Huntington Wright, who in his book *Modern Painting, Its Tendency and Meaning* (1927) presented Synchromism as the culmination of the modern movement in painting that had begun with the work of Delacroix, the Impressionists, and Cézanne.[2] Despite these claims, Synchromism in practice was no more than a synthesis of several current styles and contained little, if anything, that was fundamentally original. Russell's handling of sculptural volumes was based on the spiraling forms of Michelangelo and grew out of his study of sculpture with Matisse. His fragmentation of physical forms was derived from the Cubism of Picasso. His use of color to define and even generate compositional forms had already been carried out by the Orphists, such as Franz Kupka and Robert and Sonia Delaunay. Even Russell's use of broadsides and statements was influenced by the Italian Futurists, for he had carefully read and clipped out a copy of *The Futurist Manifesto*.[3]

Carnegie Institute's drawing is a study for Russell's first Synchromist canvas, *Synchromy in Green,* which is now lost. This painting was first exhibited at the Salon des Indépendants in Paris in 1913 and was included later that year in the first Synchromist exhibition at Der neue Kunstsalon in Munich, and in a show of Synchromist works at the Bernheim-Jeune Gallery in Paris. A photograph of the painting reveals that it showed the interior of Russell's studio with the sculpture depicted in this drawing in the foreground. Russell had made this sculpture himself, and it appears in a photograph of his studio taken in about 1910.[4]

An early work by Russell, its style was not Cubist but naturalistic and showed a synthesis of the work of Michelangelo, Puget, and Rodin, three of Russell's early heroes. Its pose was a variation on that of Michelangelo's *Dying Slave* in the Louvre, a work that Russell sketched several times and used as the basis for several Synchromist paintings.[5] The pot of geraniums in front of the sculpture, which was omitted from the painting, provides contrast to the other cubical forms, and resembles two paintings of geraniums that Russell painted in Switzerland in the summer and fall of 1912, one of which was once owned by Leo Stein.[6]

Russell had been able to learn of Cubism first hand in 1911 by making pencil studies after Picasso's *Three Women* (1908, Hermitage Museum,

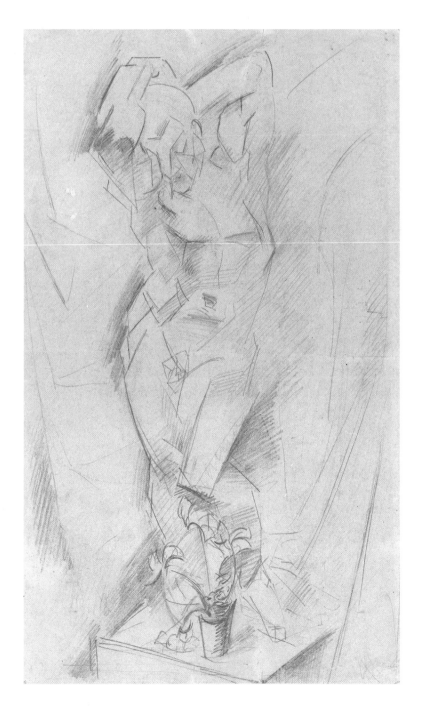

Russell, *Study for "Synchromy in Green"*

183

Leningrad), which then belonged to Gertrude Stein.[7] Like most Cubist followers, however, Russell did not grasp the spatial and metaphysical paradoxes of Cubism but presented fractured forms in a geometrically rational space. Consequently, in this drawing, Cubism does not serve to define new properties of space, but rather, as in Marcel Duchamp's *Nude Descending a Staircase* (1912, Philadelphia Museum of Art), serves chiefly to express dynamic energy and the uncoiling of movement. In fact, in their manifestos, Russell and Macdonald-Wright made it clear that they sought to create not a new kind of space but a new formal means for articulating geometric recession and sculptural volume. They declared, "We conceive space itself as having a distinct plastic significance which is expressed by color. . . . Space is expressed by a spectrum which extends itself, receding, as it were, in the sense of depth."[8] Russell later reused the pose of this statue as the basis of one of his most advanced Synchromist paintings, *Synchromy in Orange: To Form* (1913–14, Albright-Knox Art Gallery). A series of drawings reveals how his work evolved from life studies of a posed model to the final abstracted composition.[9]

As a movement, Synchromism proved remarkably short-lived. By about 1919 both Russell and Macdonald-Wright had abandoned experiments with abstraction and reverted to academic modes of representation. Not long afterwards Willard Huntington Wright abandoned art criticism to produce best-selling detective novels under the pseudonymn S. S. Van Dyne. Synchromism remains significant, however, as the first American avant-garde movement to gain attention in Europe, as well as one of the few attempts by American artists to make use of the language of Cubism in its early and experimental phases.

HA

NOTES: 1. Whitney Museum of American Art, New York, *Synchromism and American Color Abstraction, 1910-1925* (1978), exh. cat. by Gail Levin, 10-14. 2. Willard Huntington Wright, *Modern Painting, Its Tendency and Meaning* (New York, 1927), 277-304. 3. Whitney Museum, 16-19. 4. Whitney Museum, 13, figs. 8, 10. 5. Whitney Museum, 23. 6. Whitney Museum, 22, figs. 20, 21. 7. Whitney Museum, 14, plate 60. 8. Whitney Museum, 132. 9. Whitney Museum, 25-27.

MORTON LIVINGSTON SCHAMBERG

1882 — 1918

Composition
c. 1915–16
graphite and pastel on paper
7 ⅝ x 5 ¾ in.
(19.4 x 14.6 cm.)
Eva Weill Memorial Fund,
Oppenheim-Lehman Fund,
Copperweld Foundation Fund,
and Patrons Art Fund, 82.70

MORTON Schamberg died of influenza in 1918, when not quite thirty-seven years old, and was buried two days later on the date that would have been his birthday. His obituary described him as "a photographer and exponent of Futurist painting."[1] Today, although few of his works survive, he is ranked as one of the most significant early modernists in the United States. He was one of the first Americans to explore Cubism, the first to create paintings in a Precisionist style, and an important promoter of the modern aesthetic. His paintings, photographs, and artistic outlook particularly influenced his close friend Charles Sheeler, who carried his ideas forward into the 1920s and 30s.[2]

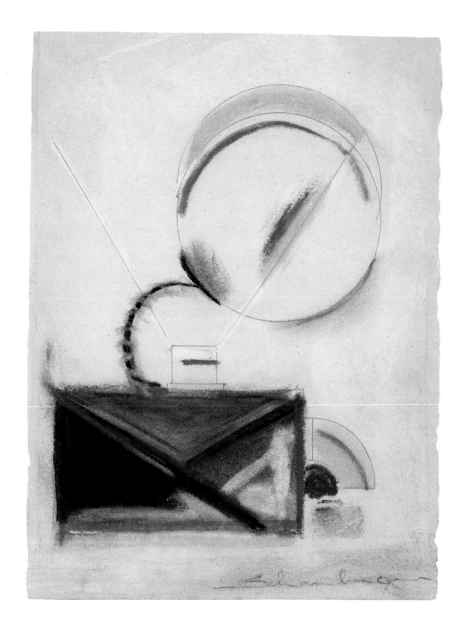

Schamberg, *Composition*

Born in Philadelphia in 1882, the youngest of four children in a prosperous and conventional German family, Schamberg attended Central High School, where many of the city's most prominent artists had studied. He later earned degrees in architecture at the University of Pennsylvania and in painting at the Pennsylvania Academy of the Fine Arts. At the Academy he befriended Charles Sheeler, who shared his shyness and introspection. They traveled together in Europe, shared a studio in Philadelphia, and rented a farmhouse together in Bucks County. The two worked in concert to develop a modern aesthetic in a climate often unsympathetic to such an endeavor.

Europe proved a strong antidote to the facile bravura Schamberg had acquired from William Merritt Chase at the Pennsylvania Academy. Through the influence of Leo Stein, Schamberg became interested in the early Renaissance masters, notably Piero della Francesca, and in modernist artists such as Cézanne, Picasso, and Matisse. From these sources he learned to emphasize structure and formal values, although he always retained, as well, a love of brilliant color that recalled his training in the Impressionist tradition.

The Armory Show, where he exhibited under the aegis of Walter Pach, his fellow student at the Pennsylvania Academy, spurred Schamberg to attempt increasingly radical experiments. Soon after the show, inspired by the works of the European artists who had exhibited, he began a group of Cubist figure paintings that, with their disjointed forms and violent color, establish Schamberg as one of the most adventurous American artists of his generation. During this period, Schamberg began to associate with Walter Arensberg and his circle of artists, a connection that put him in touch with the most advanced and controversial artistic ideas.

Oddly, these agitated Cubist paintings coincide in date with Schamberg's first accomplishments in photography, which convey a very different spirit. Schamberg took up the medium at the same time as Charles Sheeler, in 1912, strictly for commercial reasons. Unlike other photographers of the period, who used soft focus to create an impressionistic and mysterious effect, Schamberg and Sheeler both employed sharp focus and emphasized the clean geometry of forms. Along with Paul Strand, they were among the earliest to adopt the mode known today as "straight" photography, which soon became the accepted approach for all serious work in the medium.[3]

As it did for Sheeler, photography established a new direction for Schamberg in his painting. Schamberg's fame today rests on a small group of paintings, closely related to his photographic work, which show clearly rendered cut-away sections of machines in a manner that reveals not their practical function but their abstract qualities of form and design. Nine of Schamberg's machine paintings, all apparently executed in 1916, survive, along with a photograph of a lost work of 1915. William Agee has argued that these canvases "rank among the highest accomplishments of American art of that time," and he has maintained that the last two works in this series should be considered "the first Precisionist paintings."[4]

Recent research has revealed that Schamberg began making images of machines several months before Picabia began to do so in the summer of 1915. This is not to say, however, that Schamberg was not influenced by Picabia's mechanical word-objects, published in the magazine *291*, such as *Voilà Haviland*, or *Ici, C'est Ici Stieglitz*, his famous portrait of Stieglitz as a camera. No doubt these works, as well as Duchamp's *Chocolate Grinder* (1913, Philadelphia Museum of Art), which belonged to Walter Arensberg, played a role as great as Schamberg's own photography in encouraging him to adopt an increasingly crisp and direct manner of treatment. Indeed, Schamberg's machine images progress gradually from painterly, textured surfaces to a more linear and reductive manner. Only in the last two did he achieve a truly Precisionist style.

The year 1916 marked the peak of Schamberg's artistic energy, for in that period he not only produced his remarkable machine paintings, but also organized Philadelphia's *First Exhibition of Advanced Modern Art*, a display based on the Armory Show and including works by himself, Charles Sheeler, and the principal European modernists. But Schamberg's creative drive began to give out shortly afterward. Perhaps because he was in poor health and disillusioned by the events of World War I, he seems to have produced no oils during the last two years of his life. In 1918, however, influenced and assisted by Baroness Elsa van Freytag Laringhoven, he did exhibit an iconoclastic plumbing construction titled *God*, probably in direct response to the infamous urinal that Marcel Duchamp had submitted to the Society of Independent Artists the previous year.

Composition, one of twenty-three pastels rediscovered in 1983 shortly before the opening of an exhibition of Schamberg's work at the Salander-O'Reilly Galleries, relates directly to the group of machine paintings that Schamberg executed in 1915 and 1916, five of which he exhibited at the Bourgeois Gallery in New York in April 1916. While this drawing was formerly titled *Camera and Flash*, most of Schamberg's machine paintings depict textile machines. According to a family tradition, Schamberg derived several of them from machinery catalogues that he borrowed from his brother-in-law, a manufacturer of ladies' cotton stockings. The drawing relates most closely to Schamberg's *Painting VI* (c. 1916, with Salander-O'Reilly Galleries), which was formerly known as *Camera Flashlight* but has now been identified as a textile splicing or threading machine. *Composition* seems to depict a similar machine, though it is covered so that most of its internal workings and gear mechanisms are not visible. The antennalike graphite lines in the drawing, which do not resemble any part of a camera, probably represent threads, and the sections of the disks at the lower right may be spools or gears. The fact that the other twenty-two drawings in the group from which this was taken all seem to represent parts of textile machinery is a further reason to accept this identification of the subject.[5]

The drawing documents Schamberg's jump from the nineteenth-century to the modern aesthetic. In technique it reveals Schamberg's links with the academic tradition, for the use of pastel reflects his early study with William Merritt Chase, a well-known master in that medium. In conception, however, the drawing relates to Schamberg's most advanced works, the machine paintings of 1916.

<div align="right">HA</div>

NOTES: 1. Ben Wolf, *Morton Livingston Schamberg* (Philadelphia, 1963), 40. I am indebted to William Agee and Wilford Scott for their assistance. 2. William C. Agee, "Morton Livingston Schamberg (1881 [sic]-1918): Color and the Evolution of his Paintings," *Arts* LVII (November 1982): 108-19 (reprinted as Salander-O'Reilly Galleries, Inc., New York, *Morton Livingston Schamberg, 1881* [sic]-*1918* (1982), exh. cat. by William C. Agee with checklist by Pamela Ellison). 3. Van Deren Coke, "The Cubist Photographs of Paul Strand and Morton Schamberg," in Van Deren Coke, ed., *One Hundred Years of Photographic History* (Albuquerque, New Mexico, 1975), 36-42. 4. Agee, 116, 117; Barbara Rose, *American Art Since 1900* (New York, 1967), 102. 5. Agee, 117.

LOUIS LOZOWICK

B. RUSSIA, 1892 — 1973

Composition with Red Circles
1927
graphite, ink, and tempera on
card
13 ¹³⁄₁₆ x 11 ⁹⁄₁₆ in.
(35.1 x 29.4 cm.)
Mary Hillman Jennings
Foundation Fund,
84.1

BORN in a small village in the Ukraine, in a peasant's hut with a straw roof and a dirt floor, Louis Lozowick went on to become one of the leading chroniclers of the austere machine-made forms of American industry. That he ever left the rural countryside was due to his older brother, a radical who fled from Russia after the unsuccessful revolution of 1905 and took the young artist first to Kiev and then to the United States. Settling in New York, Lozowick continued the training he had begun at the Kiev art school by taking classes at the National Academy of Design under Leon Kroll. In 1913 he was introduced to modern art through the Armory Show. In 1915 he entered Ohio State University, and after graduating four years later with a Phi Beta Kappa key, he volunteered for military service. Released from the army in 1919, when World War I ended, he chose to settle in Paris, where he painted and attended lectures at the Sorbonne. He moved to Berlin in 1920, after an exhibition of his paintings of American subjects was enthusiastically received there, and remained in Germany until his return to the United States in 1924.

From the beginning of his career, Lozowick focused on the American industrial scene, treating forms in a crisp, sharp-edged precisionist manner. Like Charles Sheeler, Lozowick concentrated in the 1920s on formal experiments with simplified geometric shapes, and in the 1930s his work grew increasingly realistic and detailed in handling. Appropriately, in 1926, Lozowick joined Sheeler in a two-man show at J. B. Neumann's gallery in New York. Unlike Sheeler, however, who avoided political involvement, Lozowick served on the executive board of *The New Masses* and filled his work with explicit social content. He visited the Soviet Union in 1922, 1928, and 1931; and even in 1928, a time when Russia increasingly criticized modern art, he was honored by a one-man show in Moscow at the Museum of New Western Art. Also, unlike Sheeler, Lozowick concentrated not on painting but on printmaking, a medium that addressed a larger and less elite audience.[1]

Lozowick's 1920–24 sojourn in Berlin proved the most stimulating episode in his career, for as Marc Chagall later commented, Berlin in that period had become "a kind of caravansary where everyone traveling between Moscow and the West came together."[2] Fluent in both Russian and German, Lozowick established contact with the leading figures of the international avant-garde, in particular the Russian Suprematists and Constructivists.

Moscow, which had always maintained close cultural ties with Paris, had proved immensely receptive to modernist developments. Going beyond Cubism, the Russian radicals such as Kasimir Malevich had created an art of pure geometric elements. Such modernist works received official sanction in the early years of the Revolution, when old-fashioned ways were eagerly being discarded. In 1921, however, when Lenin proclaimed his New Economic Policy, the Soviet government began to discourage modern art as unsuitable for mass propaganda; Lenin himself denounced the Russian modernist movement as "a left-

wing infantile disorder."[3] The climate for artistic experiment grew increasingly unfavorable, and in 1922 Lissitzky, Kandinsky, Pevsner, Gabo, and other leading figures of the Russian avant-garde left the Soviet Union for the more hospitable atmosphere of Berlin.

In 1922 Lozowick saw the *Erste Russiche Kunstausstellung* at the Van Diemen Gallery in Berlin, and he soon began writing articles on Russian modernism, as well as a small book titled *Modern Russian Art*, which was published in 1925 by the Société Anonyme in New York. For this volume, Lozowick himself designed a striking cover in the Constructivist manner, composed of black letters on a red background.

A striking feature of this account is its detachment of tone. While Lozowick lucidly presented the theories that accompanied Constructivism, he endorsed none of them and at one point commented with regard to Malevich that he "led theorization to a point where rationalism borders dangerously on mysticism."[4] If Lozowick could not accept the theoretical claims put forward by the Russian modernists, however, he was happy to praise their new language of forms.[5]

Lozowick was particularly influenced by the work of El Lissitzky, who pursued Malevich's ideas in a less extreme manner, notably in a group of images he called *Prouns*, an acronym for "Project for the Affirmation of the New." These depicted pure geometric elements floating in illusionary space. In a summary of Lissitzky's position, Lozowick noted, "the artist

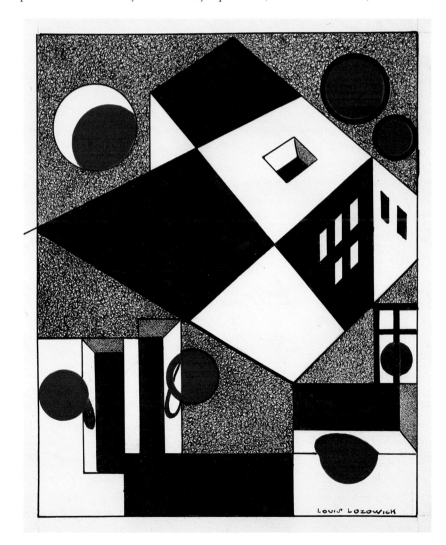

Lozowick, *Composition with Red Circles*

189

must change from one who represents existing objects into one who creates a new world of objects. He must communicate to his work the spirit of constructiveness and organization reigning in the life around him.''[6]

Lozowick, however, was never an orthodox Suprematist or Constructivist. In a revealing article on the Russian painter Eugene Zak, Lozowick came to the defense of eclecticism, arguing that at its best it was simply an attempt "to codify into esthetic law the habitual methods of all painters, ancient and modern," and he himself always attempted to combine the formal discoveries of the Russian avant-garde with more traditional methods of painting and design.[7] In 1926, for example, the year before he made *Composition with Red Circles*, Lozowick created a group of designs called "Machine Ornament," which he exhibited at J. B. Neumann's New Art Circle in New York. Combining elements based on machine parts with purely abstract shapes, these drawings related to Russian Constructivism and to the ornamental principles of Art Nouveau and of Arts and Crafts as they were promulgated by such writers as Walter Crane.[8]

In *Composition with Red Circles* Lozowick borrowed from the formal language of Russian Constructivism but subverted the mystical and ideological aspirations of the style. Both the shapes (circles and parallelograms) and the colors in the drawing (black, white, and red— the latter a color associated with the Russian revolution) come from the work of Malevich and Lissitzky. Indeed, Lozowick's drawing bears a general resemblance to a Constructivist composition by Lissitzky that he illustrated in *Modern Russian Art*.

The composition is far more crowded than Russian Constructivist designs, however, and brings to mind jazzy Art Deco architectural ornaments. Similar floating circles and geometric elements, for example, can be found in the early stained-glass windows of Frank Lloyd Wright. Lozowick himself inserted Constructivist elements into a number of commercial projects at this time, including poster designs, window displays, stage decor, and even a dress for Gilda Gray, the shimmy girl of the Ziegfield Follies. In 1926 he created a striking group of Constructivist stage sets for a production of George Kaiser's *Gas* at the Goodman Theater in Chicago.[9]

Lozowick, moreover, did not treat his shapes as pure geometric elements, as any orthodox Russian Constructivist would have, but endowed them with multiple readings, making it ambiguous whether they should be construed as flat or in perspective. The checkerboard pattern in the center of the design, for example, contains windowlike shapes, and evokes cubical building masses, but these cannot be resolved into any physically possible configuration. Similarly, the circular shapes are treated in different fashions: at the upper right as flat; at the lower right as bent; at the upper left as a porthole into space; and at the lower left as shapes that cast shadowlike forms onto their surroundings. Thus the drawing seems to mimic Constructivism but provides a spoof and a critique of its visual and intellectual pretensions.

HA

NOTES: 1. Louis Lozowick, "Excerpts Adapted from Taped Interviews," Student Center Art Gallery, Seton Hall University, South Orange, New Jersey, *Louis Lozowick, 1892-1973* (1973), exh. cat. by Barbara Kaufman, 2-4; Long Beach Museum of Art, Long

Beach, California, *Louis Lozowick, American Precisionist Retrospective* (1978), exh. cat. by John Bowlt; Janet Flint, *The Prints of Louis Lozowick, A Catalogue Raisonné* (New York, 1982). 2. E. Roditi, "Entretien avec Marc Chagall," *Preuves* (February 1958): 27. 3. Werner Hartmann, *Painting in the Twentieth Century* (New York, 1965), 196. 4. Louis Lozowick, *Modern Russian Art* (New York, 1925), 23-24. 5. Lozowick, 1925, 23. 6. Lozowick, 1925, 30, 35. 7. Louis Lozowick, "Eugene Zak," *Menorah Journal* XIII (June 1927): 283. 8. Walter Crane, *Line and Form* (London, 1902). 9. Flint, 17, illus., 20.

STUART DAVIS

1 8 9 2 — 1 9 6 4

S TUART Davis was born in 1892 in Philadelphia, where his father was art director of the *Philadelphia Press*, the newspaper that employed John Sloan, George Luks, William Glackens, and Everett Shinn, the artists who, along with Robert Henri, would make up the nucleus of The Eight. In 1909, because of his father's connections with this group of artists, Davis went to study at the Henri School in New York, where John Sloan was his principal teacher. After participating as one of the youngest artists in the Armory Show in 1913 and experimenting with a variety of Post-Impressionist influences in the 1910s, Davis achieved a remarkably sophisticated grasp of Cubism during the 1920s. He spent a year and a half in Paris in 1928–29, but his art seems to have taken decisive direction only after his return to New York, a place about which he said, "I was appalled and depressed by its giantism," and yet felt that "as an American I had need for the impersonal dynamics of New York City."[1] His artist friends at this critical moment in his career were Arshile Gorky, Jan Matulka, John Graham, David Smith, and Willem de Kooning, all of whom shared an enthusiastic interest in Picasso's Cubist works of the

Study for "House and Street"
1931
graphite and watercolor on paper
23 ½ x 40 in.
(59.7 x 101.6 cm.)
Edith H. Fisher Fund, 84.32

Davis, *Study for "House and Street"*

late 1920s. Davis was a decade older than most of the members of this loosely knit group, and he reached his full artistic stride before any of the other important American modernists of the 1930s. He achieved his mature style during the early years of the decade, when he became the only major painter to deal with the subject matter of the American Scene movement—then extraordinarily popular—while still maintaining his modernist ambitions.

Study for "House and Street" is a preliminary drawing for one of Davis's most important paintings (1931, Whitney Museum of American Art). Both the drawing and the painting embody the whole range of Davis's concerns in the early 1930s; his urban American subject and vernacular cubism combine his formal interest in that style, his awareness of Surrealism and Precisionism, and a developing social-political consciousness.

The drawing depicts the view from under a curved section of the elevated rapid transit system in lower Manhattan. To the right, the el sweeps in curving recession in front of blocks of buildings—including a glass cube of the artist's invention that anticipates a later style of architecture—under a sky inhabited by a smokestack and by two rectangles and a clover or club shape that are shorthand for clouds. The street is occupied by a single organic form, probably derived from Miro's Surrealist works, and is otherwise as empty as a de Chirico piazza. The vertical form in the center of the drawing is a steel girder, a support for the el. To the left is a building's wall detailed with bricks, windows, and fire escape ladders. Also on the wall are graphic symbols of modern communications technology (the bell insignia of the telephone company), political concerns (the name "Smith," referring to the New York politician Alfred Smith), and art theory ideas (the word "front," a conceptual emphasis of the flatness of Davis's modernist style). Davis conducted many of his most interesting and fruitful artistic experiments of the early 1930s in the graphic media of his drawings and prints. In particular, the strong, two-dimensional frontality of the pictorial space and the spare grid of lines describing the urban scene in *Study for "House and Street"* prefigure and are characteristic of the finished line drawings that soon came from Davis's hand and marked the crystallization of his mature style.

The sheet was initially prepared with a grid in red pencil in which each rectangle is in proportion to the rectangular dimensions of the painting. With the exception of a narrow painted border added to the painting, the drawing is the same size as *House and Street*. Davis used gridded studies for paintings mostly in the late 1920s and early 30s. The freshness of his pictorial concept as he articulated it in the drawing is clear in the freehand lines that describe the composition of *Study for "House and Street."*

Beginning in the 1940s, Davis returned frequently to earlier compositions as foundations for new pictures. Saying in 1947 that he liked the simplicity of *House and Street*,[2] Davis used its design as the basis for *The Mellow Pad*, a painting he worked on from 1945 until 1951 (collection of Edith and Milton Lowenthal) and, like *House and Street*, one of his masterpieces.

JRL

NOTES: 1. Stuart Davis, *Stuart Davis* (New York, 1945). 2. Stuart Davis Papers, Fogg Art Museum, Harvard University, Cambridge, Massachusetts, Index, 26JUL47.

JAN MATULKA

B. BOHEMIA, 1890—1972

JAN Matulka immigrated to the United States in 1907, settled with his family in New York, and took his formal art training at the conservative National Academy of Design from 1908 until 1917 and at the Art Students League in 1924–25. He joined the modern movement in America before 1920, and his frequent trips abroad (he maintained a studio in Paris from 1925 to 1934) made him one of the best-informed artists in New York about avant-garde European art. By virtue of his own artistic accomplishments and his inspirational teaching at the Art Students League between 1929 and 1931, when his students included Burgoyne Diller and David Smith, he was for a time in the 1930s a central figure in the coming of age of a second generation of American abstractionists.

At just the moment when he was teaching so effectively at the Art Students League his friendships with those other leading modernists on the New York scene—Stuart Davis, Arshile Gorky, and John Graham— were warmest, and his own art was most vital. Carnegie Institute's gouache belongs to this especially creative period in the artist's career, and it reflects the Cubist structural principles that were the foundation of Matulka's work. Although Picasso's art of the late 1920s most strongly

Untitled (Sailors Working on Deck)
c. 1932
graphite and gouache on paper
15 x 22 ⅛ in.
(38.1 x 56.2 cm.)
Museum purchase: bequest of
Mrs. John C. Crouch, 82.2

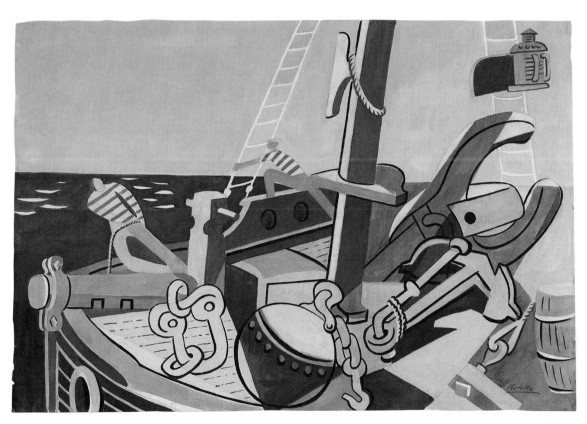

Matulka, *Untitled (Sailors Working on Deck)*

influenced Matulka and the close circle of modernists to which he belonged, it is Stuart Davis's distinctly American vernacular cubism that informs the style and content of *Untitled (Sailors Working on Deck)*. Matulka's most successful paintings of around 1930 were still lifes and, despite a horizon line where sea meets sky, this gouache fits that genre more readily than it fits marine painting traditions. Its flattened, abstracted, and reproportioned elements of naval architecture, ground tackle, rigging, running lights, cargo, and sailors are laid out as a composition on a ship's deck that is tilted up towards the picture plane like a Cubist tabletop. Matulka summered at the New England shore and, no doubt responding to the popularity of the regionalist impulse in the American Scene movement, his several paintings of nautical subjects of the early 1930s all have a feeling for the locale's vigorous maritime life under bright blue North Atlantic skies.[1]

JRL

NOTES: 1. The standard reference work for Matulka is National Museum of American Art, Smithsonian Institution, Washington, D.C., and Whitney Museum of American Art, New York, *Jan Matulka 1890-1972* (1980), exh. cat. by Patterson Sims and Mary A. Foresta, eds.

ILYA BOLOTOWSKY

B. RUSSIA, 1907—1981

Untitled
c. 1936–37
pen and ink on paper
11 ¼ x 15 ½ in.
(28.6 x 39.4 cm.)
Patrons Art Fund, 84.28.2

ILYA Bolotowsky arrived in New York in 1923, having left his native St. Petersburg in the wake of the Russian Revolution. His artistic training, entirely American, was taken at the National Academy of Design between 1924 and 1930. Here he received a solid grounding in nineteenth-century academic draftsmanship traditions and demonstrated a natural gift for drawing.[1] He is best known for his paintings in the Neo-Plastic style, a pictorial vocabulary that he embraced wholeheartedly only after World War II. In the 1930s, as Bolotowsky sought his individual voice, his work took inspiration from a broad range of contemporary manners, including Constructivism, de Stijl, and biomorphic Surrealism. Kasimir Malevich, Piet Mondrian, and Joan Miró each provided the young artist with visual ideas that he worked to develop, not infrequently all in the same painting.

Carnegie Institute's drawing is in the abstract, biomorphic Surrealist style and owes a debt to Miró, whose work Bolotowsky would have known from a number of one-artist exhibitions at Pierre Matisse Gallery in the mid-1930s, important works in the A. E. Gallatin collection at the Museum of Living Art housed in New York University's library, and frequent coverage in the Paris art journal *Cahiers d'art*, a magazine read religiously by the American modernists.

The dense crosshatching of the Bolotowsky drawing, also found in a number of drawings by American artists of the early and mid-1930s, was influenced largely by Picasso's crosshatched drawings of the late 1920s and, to a lesser degree, by Giorgio de Chirico. The most masterly of the American draftsmen working in this manner was Arshile Gorky, whom Bolotowsky knew personally and whose Surrealist drawings were shown

in New York, in December 1935, at the Guild Art Gallery exhibition *Abstract Drawings by Arshile Gorky*. These sources provide the visual precedents for Bolotowsky's very accomplished drawing, to which he brought his own characteristic combination of the geometric and the biomorphic by laying irregular curving forms against a large, squarish rectangle that, in another characteristic gesture, is tilted toward the diagonal.

Never inclined to take too seriously the tendency of artists in the 1930s to become involved in politics, the polemics of art theory, or the use of art to convey narrative content or symbolic ideas, Bolotowsky was instead a deeply committed formalist dedicated to non-objective abstract art. That is to say, his art did not derive its forms from nature but drew them exclusively from his own invention. With regard to Carnegie Institute's drawing, it is worth mentioning that Bolotowsky was never associated with the Surrealist circle and in fact had no particular sympathy for the movement's philosophies or programs; his interest was primarily in the "plastic values" of certain Surrealist artists' formal solutions.[2]

<div align="right">JRL</div>

NOTES: 1. The author is indebted to Deborah Rosenthal, for providing the manuscript of her forthcoming book on Bolotowsky. 2. See John R. Lane, "Ilya Bolotowsky's 'Abstraction,' 1936-1937," *Carnegie Magazine* LV (Summer 1981): 6.

<div align="right">Bolotowsky, Untitled</div>

CHARLES BIEDERMAN

B . 1 9 0 6

*Study for "New York,
January 1936"*
1936
gouache on paper
16 ⅞ x 13 ⅞ in.
(42.9 x 35.2 cm.)
Gift of the American Academy
and Institute of Arts and
Letters, Hassam and Speicher
Purchase Fund, 83.60

CHARLES Biederman's artistic career evolved largely in isolation after the early 1940s, when he eschewed the art world and city life to pursue his work independently in Red Wing, Minnesota. His paintings and drawings of the mid-1930s are distinct from his ensuing Constructivist and Neo-Plasticist reliefs of the late 1930s and the 1940s and his mature Structuralist style, which, since the 1950s, has manifested in abstract reliefs inspired by landscapes that have been characterized as "dialectic interpretation[s] of Monet's colors and Cézanne's proto-Cubist forms."[1] Before his voluntary exile, however, Biederman was close to the center of the budding abstractionist activity in New York in the 1930s. He was born in Cleveland and studied commercial art there before attending The Art Institute of Chicago from 1926 to 1929. In 1934 he moved to New York, where he met a number of the most important figures in the American modernist movement, including George L. K. Morris, A. E. Gallatin, and Pierre Matisse. Biederman had a one-artist exhibition at Matisse's gallery in March 1936 and was included in the exhibition *Five Contemporary American Concretionists: Biederman, Calder, Ferren, Morris and Shaw* organized by Gallatin and held the same month at the Paul Reinhardt Galleries.

It was at the time of his move to New York that the contemporary Cubist and Surrealist influences of Picasso, Braque, Gris, Miró, and Léger entered Biederman's art. In Carnegie Institute's gouache it is the latter's style that is most evident. Biederman met Léger, probably through the French artist's close friend Morris, and Léger was a highly visible presence on the American art scene in the fall of 1935 while his retrospective exhibition was on view at The Museum of Modern Art. Biederman has written about this moment in his personal development in a commentary captioned "Late Léger Influence, 1935–1936":

> These works reflect a turning to the mechanistic structuring of Léger for a non-representational solution. This direction no more led me to a non-imitative solution than it did for Léger himself. Léger's method was essentially to adopt mechanistic forms as merely a structuring device for continuing, as did Braque and Picasso in their ways, the simple expressionist rendering of the obsolete art of imitation.[2]

Biederman has said that Carnegie Institute's gouache was not used as a study for an oil and that, in his years as a painter, he actually employed preparatory studies in his painting process only a few times: "I often made studies for paintings but no sooner than I found myself face to face with a canvas a new image for a painting would arrive which I then proceeded to execute directly to the canvas, rather than do something I had already done."[3]

The artist discounts the significance of these early works, saying, "I make no claim to originality for most of my painting from 1927 to 1937. I was simply a student of European culture seeking to understand new art,"[4] and, "My purpose was not to find a way of painting that would interest me, but rather to undergo the influences of various principals in

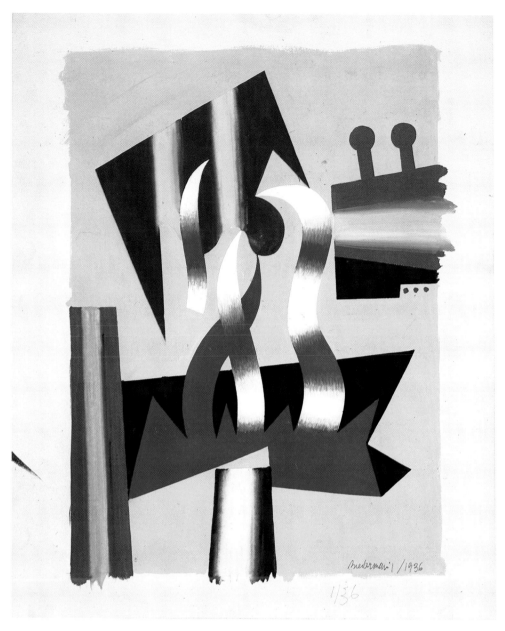

Beiderman, *Study for "New York, January 1936"*

art, to understand by doing, to first of all comprehend what was at the bottom of all this apparent diversity called modern art."[5] Nevertheless, the works he refers to contain much to admire, particularly an intriguing color personality and a plastic strength all their own, precisely the underlying characteristics that inform Biederman's later work.

JRL

NOTES: 1. Jan van der Marck, "Charles Biederman," in Museum of Art, Carnegie Institute, *Abstract Painting and Sculpture in America 1927-1944* (1983), exh. cat., John R. Lane and Susan C. Larsen, eds., 50. 2. Charles Biederman, "The Search: Paintings and Drawings 1927-1937," in The Minneapolis Institute of Arts, Minneapolis, *Charles Biederman: A Retrospective* (1976), exh. cat. by Gregory Hedberg, Leif Sjoberg, and Jan van der Marck, with commentaries by Charles Biederman, 49. 3. Letter from Charles Biederman to John R. Lane, 20 August 1984, Museum of Art files. 4. The Minneapolis Institute of Arts, 29. 5. Biederman to Lane, 20 August 1984.

ARSHILE GORKY

B. TURKISH ARMENIA, 1904—1948

Untitled
c. 1937–38
charcoal on paper
24 ¼ x 18 ½ in.
(61.6 x 47 cm.)
Gift of Mrs. Alexander C.
Speyer, Sr., in honor of the
Sarah M. Scaife Gallery,
72.41.1

ARSHILE Gorky, a key figure in the development of Abstract Expressionism, spent his life attempting to recover from his traumatic early years. Born in Turkish Armenia, he grew up during World War I, when the Armenian minority was persecuted by the Turks. His family was uprooted, many of his relatives were murdered, and his mother, to whom he was deeply attached, died of starvation. After several years of wandering and privation, the twelve-year-old boy managed to reach the United States, where he joined his father, who had emigrated earlier to escape conscription in the Turkish army. What Gorky did during his first years in the United States remains poorly documented, but by 1925 he was living in New York. By this time he had already committed himself to an artistic career and an alliance with the avant-garde.[1]

Around 1930 Gorky became part of a loosely knit group of modernist artists that included John Graham, Stuart Davis, and Willem de Kooning. In 1935 he joined the Federal Art Project where he was assigned to the mural division and executed a series of large abstract wall paintings for the Newark airport. He developed rapidly during the 30s and early 40s, mixing devices borrowed from Picasso with effects taken from Surrealism; his technique became increasingly fluid and his treatment of space more ambiguous. His mature style of the mid-1940s set the stage for the full flowering of Abstract Expressionism.

Throughout his life, Gorky was adept at fabrications. By the time he arrived in New York he had abandoned his given name, Voskanski Adoian, and taken on Arshile Gorky. Gorky in Russian means "the bitter one," and Arshile is a variant of Achilles; thus Gorky's adopted name evokes "the bitter Achilles" of the *Iliad*. In an early interview, Gorky declared that he was "a cousin of the famous writer, Maxim Gorky," a particularly brash dissemblance given that Maxim Gorky's name, too, was a pseudonym. Gorky even plagiarized his love letters to both his wives from those of the early modernist sculptor Henri Gaudier-Brzeska. Appropriately, given his mastery of the art of disguise, Gorky once volunteered during World War II to teach a class in camouflage.[2]

In his art, too, Gorky for many years borrowed his identity from other artists; first the Impressionists, then Cézanne, and finally Picasso, the most lasting and fertile influence. "During the period that I knew him," Stuart Davis once recalled, "Gorky's work was strongly influenced by certain styles of Picasso. This was apparent to everybody, and there was a tendency to criticize him as a naive imitator. I took a different view and defended his work at all times."[3] Gorky himself seems to have taken a perverse pride in his ability to mimic the Spanish master, a tendency that led him to be nicknamed "The Picasso of Washington Square."

Never interested in Picasso's analytic Cubist phase, Gorky concentrated instead on his later works, whose freely distorted anthropomorphic forms could be linked with the accomplishments of the Surrealists. He focused particularly on Picasso's achievements of 1927 and 1928 and closely studied Picasso's *The Studio* of that period.

Gorky drew actively during the early and mid-1930s, when he was often too poor to afford pigments, at which time he made a large number of drawings on the theme "Nighttime, Enigma, and Nostalgia."[5] Gorky's continuing commitment to drawing links him with the Old Masters and distinguishes him from the other members of the Abstract Expressionist group, most of whom preferred to develop their ideas spontaneously, directly on the canvas. *Untitled*, made around 1937 or 1938, shows Gorky's lingering dependence on Picasso in the period preceding his final mature style.[6]

The drawing owes a particular debt to Picasso's work of 1927 and 1928. Here, however, Gorky borrowed less from Picasso's painting *The Studio* than from a series of paintings and sculptures of strange beach figures that Picasso created in the same period, a series in which human anatomy is distorted with a violence that exceeds anything in Picasso's previous work. To expand his repertoire of forms, Gorky added wirelike parallel lines at the upper right, which derive not from Picasso's bather series but from a group of wire constructions that Picasso executed in 1928.[7]

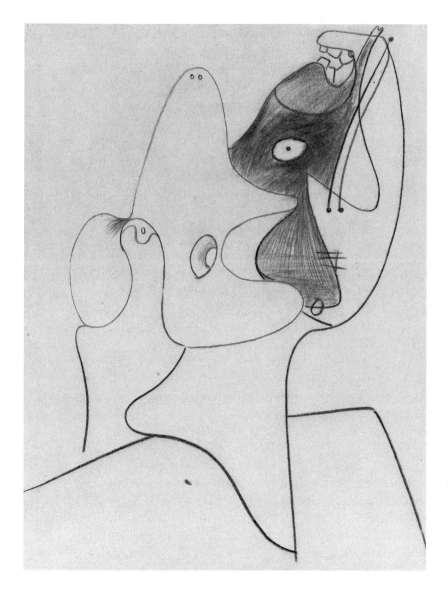

Gorky, *Untitled*

In addition, Gorky drew from a work by Picasso of precisely a decade later, the widely publicized *Guernica* (1937, The Prado). In the summer of 1937 the publisher Zervos produced a special issue of *Cahiers d'art* devoted entirely to the painting, with photographs that showed different stages of its progress; in the following year the painting was put on display at The Museum of Modern Art in New York. In Gorky's *Untitled* the violent expression of emotion and details like the teeth in the orifice at the upper right relate closely to the heads in *Guernica*; for example, the heads of the horse in the center and the prostrate man and screaming woman at the left.[8]

Gorky's imitation of Picasso was not literal but a free combination of elements from different episodes of the master's career. In essence, Gorky isolated a head like the ones in *Guernica* and transformed it into a freestanding sculpture like those of Picasso's beach figure scenes of ten years earlier.

Gorky's drawing conveys a distinctively individual sense of melancholy and shows certain personal preferences in the choice of forms, in particular the repetition of ovoid, flabby, distended shapes like the sagging oval at the left that resembles a stretched and wrinkled scrotum. Gorky also used line more ambiguously than Picasso. While most of this drawing can be interpreted as the image of a self-contained piece of modernist sculpture, it contains spatial ambiguities that encourage us to read the lines not as representations of external form but as outpourings of the artist's internal anguish, the result of a tumultuous personal life that, fraught with disasters, would end in suicide in 1948.

HA

NOTES: 1. The best study of Gorky is Harry Rand, *Arshile Gorky: The Implications of Symbols* (London, 1981). The first chapter summarizes the artist's biography. 2. Rand, 3-7. 3. Diane Kelder, *Stuart Davis* (New York, 1971), 181-82. 4. Irving Sandler, *The Triumph of American Painting* (New York, 1970), 47. 5. Rand, 52-70. 6. Jim Jordan, *Gorky: Drawings* (New York, 1969), 30, no. 50. 7. The Museum of Modern Art, New York, *Pablo Picasso, A Retrospective* (1980), exh. cat. by William Rubin, ed., 264-68. 8. The Museum of Modern Art, 309.

BURGOYNE DILLER

1 9 0 6 — 1 9 6 5

Untitled (Second Theme)
c. 1940
graphite, gouache, and ink on paper
11 ¹³⁄₁₆ x 8 ⅞ in.
(30 x 22.5 cm.)
Collection of Mr. and Mrs. James M. Walton, intended gift to the Museum of Art, Carnegie Institute

ALTHOUGH he was born in New York, Burgoyne Diller spent his youth in Battle Creek, Michigan, and he attended Michigan State University. In 1928 he returned to New York and for the next five years studied and worked at the Art Students League. There he had a number of teachers, the most influential being Jan Matulka and Hans Hofmann. Diller played an exceptional role as an administrator of the New York City WPA Federal Art Project beginning in 1935, in which capacity he arranged for placement of murals by American abstract artists in public buildings. He thereby became, in effect, the most important patron of the work of the leading American modernists of the 1930s. Diller was an early member of the American Abstract Artists and showed in the group's annual exhibitions in 1937, 1938, and 1939. He was a naval officer in the visual aids division during World War II, and after the war, in 1946, he

joined the art faculty of Brooklyn College. Diller had severe problems with alcoholism, which eventually led to his death in New York in 1965.

Diller's production of paintings and sculpture was quite limited, because of his administrative responsibilities during the 1930s and 40s and his drinking in later years. There exists, however, a rich body of drawings from the 1930s to the 1960s, and it is clear that to Diller these works had a highly important place in his creative life. Few of the drawings seem to be studies for paintings or sculptures that were executed, and this, along with the fact that he signed these drawings fairly often, suggests that he viewed them as independent works. Study of these copious drawings allows a broader assessment of Diller's creative powers.

Diller came to characterize his work by its relation to three formal themes, and he gave many of the objects he created after the mid-1930s the generic titles "First," "Second," or "Third Theme."[1] These titles, however, were applied in retrospect to the early works, since Diller did not articulate the "three theme" concept until 1951 and did not elaborate on the idea until ten years later. This history of Diller's titles is important because it helps to belie, as William C. Agee has pointed out, any notion that he was simply a doctrinaire formalist following a set of rigid rules. Rather, he was an artist whose evolution was based on a lengthy

Diller, *Untitled (Second Theme)*

empirical process.[2] Although Diller was first attracted to Russian Constructivism, by 1933–34 he had become deeply impressed by the Neo-Plasticism of Mondrian and Van Doesburg, examples of whose work could be seen in European art journals and more importantly, in the Museum of Living Art, A. E. Gallatin's collection of Cubist and geometric abstractionist paintings and sculpture housed in the New York University library.

Untitled (Second Theme) is a drawing of a monolithic, carved relief sculpture, which Diller never executed in three dimensions. Stylistically, it relates to other Diller drawings of about 1940, a date further reinforced by the fact that the artist's interest in sculpture was confined to the periods from 1934 to 1940 and from 1963 to 1965. It is interesting to note that the European Neo-Plasticists were not attracted to sculpture, and, except for a few pieces by Vantongerloo, de Stijl's three-dimensional contributions are restricted to decorative arts and architecture. It was Diller and his fellow Americans Charles Biederman and Harry Holtzman who explored the formal possibilities of the Neo-Plastic vocabulary in sculpture in the late 1930s and early 1940s. Diller's exposure to Hofmann's "push-pull" concepts, which dealt with the manipulation of advancing and receding properties of color, may have heightened his interest in three-dimensional formal issues; but certainly Mondrian's paintings—for instance, two that were in the Museum of Living Art, *Composition with Blue and Yellow*, 1932, and *Composition with Red*, 1936 (both Philadelphia Museum of Art)—are the main stylistic precedents for Diller's "Second Theme" works, which are characterized by bold rectangles of primary color contained within grids formed by the intersection of thin, straight, black lines. Although there are certain awkwardnesses in Diller's handling of the linear perspective to render a three-dimensional object in space, this drawing was executed with unusual strength and conviction. Its strong planes of crosshatching create shadows that suggest a light source from above and behind the relief sculpture and articulate its multilevel frontal surfaces. This effect is further enhanced by the advancing properties of red and the receding tendencies of blue. The image of the relief has an almost palpable presence.

Diller met Mondrian after the Dutch Neo-Plasticist settled in New York in 1940, but he did not know him well. Still, like many of the younger American artists in Mondrian's New York circle, Diller was deeply impressed by Mondrian's masterpiece of this American period, *Broadway Boogie Woogie* (1942–43, The Museum of Modern Art). During the mid-1940s Diller himself executed a large number of drawings and several paintings on what he would later call his "Third Theme," and which he described as having "elements submerged in activity."[3] Carnegie Institute's *Untitled (Third Theme)* exemplifies the kind of activated field of colors and lines that represents Diller's quite original response to the dynamism of Mondrian's last works.

JRL

NOTES: 1. The First Theme is one or a few rectangles arranged on a gridless picture plane; the Second Theme consists of rectangles within a grid; and the Third Theme is characterized by many rectangles within a complex grid. 2. Meredith Long & Co., Houston, *Burgoyne Diller: Drawing and the Abstract Tradition in America* (1984), exh. cat., essay by William C. Agee, 17. 3. Diller notebooks, Archives of American Art, Smithsonian Institution, Washington, D.C., quoted in Meredith Long & Co., 17.

ROLPH SCARLETT

B. CANADA, 1889—1984

ROLPH Scarlett's career is intertwined with the early history of what is now The Solomon R. Guggenheim Museum. In about 1934 Scarlett, who had no formal training, made himself known as a non-objective painter to the German-born aristocrat Hilla Rebay, curator of Solomon Guggenheim's collection and founding director of Art of Tomorrow, the Museum of Non-Objective Painting, which opened in New York in 1939 and is today the Guggenheim Museum. Based on her knowledge of Kandinsky's theories in *Uber das Geistige in der Kunst* (1912) and her study of theosophy and Eastern religions, Rebay held very strong and controversial views. As her biographer, Joan M. Lukach, has written, Rebay believed, "Art was the expression of man's spiritual nature, and a truly creative artist did not repeat forms already existing; however, with the guidance of a higher power (which she at times specifically named 'God'), one could create new forms united by a rhythm expressing cosmic forces."[1] She felt that Scarlett was her special discovery, and in 1939 she introduced him to the man who would become his mentor, the German painter Rudolph Bauer, whom Rebay considered to be, with Kandinsky, the foremost non-objective artist. She awarded Scarlett a Guggenheim Scholarship in 1938 and hired him in 1939 as the museum's weekend lecturer, a position that lasted eight years and made him one of the chief spokespersons for Rebay's theories. Over the years she persuaded Guggenheim to buy nearly one hundred of Scarlett's paintings, some sixty of which are still in the museum's collection.

In Kandinsky's and Bauer's geometric style Scarlett found the manner he wished to pursue. He said:

> Here one deals with a few geometrical elements and the problem is to create an organization that is alive as to color, and form, with challenging and stimulating rhythms, making full use of one's emotional and intuitive creative programming and keeping it under cerebral control, so that when it is finished it is a visual experience that is alive with a mysticism, inner order, and intrigue, and has grown into a world of art governed by esthetic authority.[2]

Although Bauer is not known to have painted a single work after immigrating to the United States in 1939,[3] Scarlett frequently sought the German's advice regarding the placement of geometrical forms and the choice of colors to pull his own compositions together. The younger artist regarded Bauer as a "wonderful teacher"[4] and has said he "worshiped [Bauer's] work."[5]

The irony is that Bauer was a very dry, doctrinaire, and theoretical artist; while his paintings look like Kandinsky's geometric abstractions from his Bauhaus and Paris periods, they seldom possess any vitality or character of their own. On the other hand, Scarlett's work (particularly the watercolors and gouaches he began making at Rebay's behest after she explained that "careful small sketches" were the first step in Bauer's

Untitled, No. 23
1940
gouache on paper
4 ½ x 6 ¹³⁄₁₆ in.
(11.4 x 17.3 cm.)
Leisser Art Fund,
83.30.2

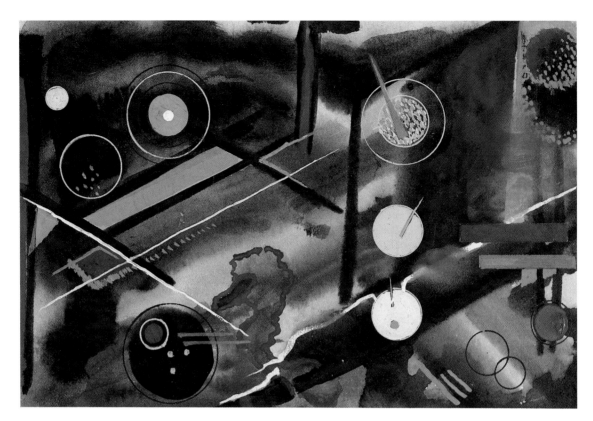

Scarlett, *Untitled, No. 23*

working method),[6] while lacking genuine stylistic individuality, has its own distinct lyric personality. Geometric forms of poetic delicacy float in a dreamy blue pictorial space of indeterminant dimensions in *Untitled, No. 23.* In works like this one Scarlett achieves his personal artistic goals based on an agenda whose priorities he set quite differently from Rebay's. For the welfare of his relationship with her, he must have gone to considerable pains to keep from disclosing this agenda. He has said:

> Rebay had a very emotional temperament and fancied herself a spiritualist. She would look into Bauer's work or Kandinsky's work and find something spiritualistic that could be read into it. Kandinsky did that too. It was a mistake. The main thing is not spiritualism or metaphysical phenomena. It's esthetics, order, form, color and rhythm.[7]

Scarlett's revelation is very interesting since it reinforces the more general notion that American abstract artists of the 1930s were eager to accept the formal innovations of European art but were inclined to discount the theoretic and spiritual baggage that frequently accompanied these advanced styles.

JRL

NOTES: 1. Joan M. Lukach, "Rolph Scarlett," in Museum of Art, Carnegie Institute, *Abstract Painting and Sculpture in America 1927-1944* (1983), exh. cat., John R. Lane and Susan C. Larsen, eds., 215. 2. "Memoirs of Rolph Scarlett as told to Harriet Tannin," unpublished typescript©1982 by H. Tannin, Kingston, New York, 78. 3. Joan M. Lukach, *Hilla Rebay: In Search of the Spirit in Art* (New York, 1983), 166. 4. "Memoirs," 66. 5. "Memoirs," 50. 6. "Memoirs," 84. 7. "Memoirs," 56.

JOHN GRAHAM

B. RUSSIA, 1881 — 1961

JOHN Graham had a double career, in which he first championed and then repudiated modern art. Firm facts are not easy to establish, for the artist delighted in fictionalizing the details of his life, but it appears that he was born in Kiev in 1881 and was named Ivan Gratianovich Dombrovsky. After the Russian Revolution, Dombrovsky escaped to the United States, where he took up the study of art, and by 1925 he had changed his name to John Graham and become a fervent proselytizer for abstract painting. Until the 1940s, Graham played an influential role not only as a painter, but as a writer, advisor to collectors, and mentor to several of the Abstract Expressionists, including Arshile Gorky, Willem de Kooning, and Jackson Pollock.

Around 1942, however, Graham rejected modern art in favor of what he called "classicism," renounced Picasso in favor of Raphael and Ingres, and immersed himself in the study of the occult, including alchemy, astrology, theosophy, and demonism. He also took on a new identity, signing his work "Ioannus Magus," often followed by a host of other titles. Although "John Graham," in his early career, had explored different modernist styles such as Surrealism and Synthetic Cubism, the work of "Ioannus Magus" took on a distinctly obsessive character, consisting almost entirely of fiendish self-portraits and depictions of wall-eyed women with wounded necks.[1]

Portrait of a Woman, a drawing on tracing paper, is closely related to the artist's painting *Woman in Black*, which the museum had acquired fourteen years earlier. Graham is known to have reworked his designs continually, making large numbers of tracings to perfect and refine every line.[2] In this case, both drawing and painting are dated twice, the drawing to 1943 and 1953 and the painting to 1943 and 1956. Both works show signs of extensive changes and revisions, and it is likely that Graham modified them continually over the course of many years, first adding and then subtracting elements until he was satisfied. Significantly, the creation of both works spans the artist's change of identity. First signed "John Graham," they were later reinscribed "Ioannus Magus."[3]

While many lines of the museum's drawing correspond precisely with those in the painting, their placement is not identical, and the proportions of the subject's head and the location of her features do not match. We can thus conclude that the museum's drawing was not a cartoon for the painting. Graham is recorded to have used translucent paper not simply to facilitate tracing but because he desired his drawings to be framed between two sheets of glass and hung so that the light would both reflect off and pass through them.[4] In creations of this type, as with *Portrait of a Woman*, he applied delicate touches of color to both sides of the paper. Despite the obvious similarity between the drawing *Portrait of a Woman* and the canvas *Woman in Black*, Graham evidently intended the work on paper to stand as an independent work.

Technical examination reveals that in the course of his work Graham made very similar changes to both painting and drawing. Probably the drawing, like the painting, went through at least three phases: an initial version was created in 1943 that probably closely resembled Graham's

Portrait of a Woman
1943–53
graphite, crayon, colored pencil, and ballpoint pen on both sides of tracing paper
23 ⅜ x 18 ¹¹⁄₁₆ in.
(59.3 x 47.5 cm.)
Constance Mellon Fund, William Frew Memorial Fund, and gift of Laura H. Baer, by exchange, 83.32

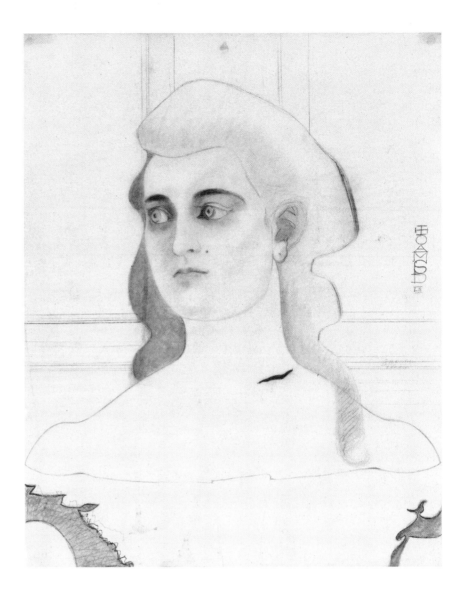

Graham, *Portrait of a Woman*

painting *Marya* of the following year.[5] This version was probably
executed entirely in graphite. A reworked version was made between
1944 and 1946, in which Graham changed the arrangement of the
woman's hair and added a wound to her neck. Graham did not eliminate
the lines in the background as he did in the painting. A final version was
completed in 1953. Between 1946 and 1953 Graham probably added the
lines in blue pencil and blue ballpoint pen and the heightening in blue
and red pastel. He may have added some of this heightening gradually,
over a long period of time. For example, Graham first outlined the wound
in pencil, later colored it in red, and finally covered most of the red with
blue ballpoint. Each of these changes seems to reflect a different
conception of the role of the wound in the design, and each was probably
made at a separate time.

While working on the drawing, Graham progressively added elements that increased the drama and psychological force of the effect. Thus, for example, he shaded the area surrounding the woman's eyes, which increased the intensity of her gaze, and drew the wound on her neck, which imbued the image with undercurrents of violence and erotic tension.

Graham was obsessed with wounds, and in the 1950s he carried this motif to extremes, depicting women with blunt instruments thrust through bloody gashes in their bodies. In 1961, when he was providing information about a drawing of his that had entered the collection of the Whitney Museum of American Art, Graham noted, "On the left side of her neck is a *wound* not lips. . . . In [the] history of art St. Sebastian has always attracted painters' interest, not because of his importance as a saint, but because of the attraction of wounds and blood." He added, "I personally like many wounds on women."[6]

One of Graham's most haunting images, *Portrait of a Woman* provides a remarkable illustration of the artist's attempt to purify and intensify his work after his repudiation of modernism. Graham worked towards a final result that combines a classical simplicity and purity of means with an underlying mood of ambiguously mixed violence, sexual desire, and anxiety. He himself once remarked, "I may be not so good as Raphael, but there's more tension in my canvases."[7]

HA

NOTES: 1. The author is indebted to Suzanne Tise and Kahren Hellerstedt who did extensive research on this drawing. The best biographical accounts of Graham are Eila Kokkinen, "Ioannus Magus Servus Domini St. Georgii Equitus," *Art News* XL (September 1965): 52-55, 64-66; John D. Graham, *System and Dialectics of Art* (Baltimore, 1971), introduction by Marcia Allentuck; Carl Goldstein, "Ivan Dombrovsky, John Graham and Ioannus Magus," *Bulletin of the Weatherspoon Gallery Association* (University of North Carolina, Greensboro, 1972); Hayden Herrera, "John Graham, Modernist Turned Magus," *Arts Magazine* LI (October 1976): 100-105; Eila Kokkinen, "John Graham During the 1940s," *Arts Magazine* LI (November 1976): 99-103; Carl Goldstein, "John Graham During the 1920s: His Introduction to Modernism," *Arts Magazine* LI (March 1977): 98-99; Harry Rand, "John Graham" in Museum of Art, Carnegie Institute, *Abstract Painting and Sculpture in America, 1927-1944* (1983), exh. cat., John R. Lane and Susan Larsen, eds., 157-60. 2. Kokkinen, 1976, 101. 3. The inscriptions on both painting and drawing are somewhat abbreviated renditions of the phrase "Ioannus Fotius Servus Domini," followed by the dates 1953 on the drawing and 1956 on the painting, both dates being expressed in Roman numerals. The Latin words refer to Graham's self-identification with Photius, a ninth-century philosopher and patriarch of Constantinople, who extended the Byzantine religious influence into Russia. The "I" of "Ioannus" in the inscription takes the form of the St. George cross. Graham received an award carrying this insignia in World War I, for bravery on the Romanian front while serving in the Russian army in the Circassian regiment of the Grand Duke Michael. See Kokkinen, 1965, 53. 4. Kokkinen, 1965, 65. 5. *Marya* is reproduced in Kokkinen, 1976, 103. It reveals that Graham ultimately derived this group of images from the famous portrait by Jean-Dominique Ingres, *Madame Moitessier Seated* (1856, National Gallery, London). See Robert Rosenblum, *Ingres* (New York, 1967), 164-65. According to Kokkinen, 1976, 102, Graham often began his paintings by tracing and retracing the contours from photostats of his favorite paintings. For Graham's interest in Ingres see Melvin P. Ladder, "Graham, Gorky, de Kooning and the 'Ingres Revival' in America," *Arts* LII (May 1978): 94-99. 6. Quoted in Allentuck, 1971. 7. "An Eccentric Revived," *Life*, 4 October 1968, 53.

CONTEMPORARY

PHILIP PEARLSTEIN

B . 1 9 2 4

PHILIP Pearlstein, a key figure in the development of what has been variously called New Realism, Sharp-Focus Realism, and Post-Abstract Realism, grew up in Pittsburgh. During his high-school years he studied art at Taylor Allderdice High School and attended Saturday morning classes at Carnegie Institute. He first received significant recognition as an artist when *Scholastic Magazine*'s Annual High School Art Exhibition, then held at Carnegie Institute, awarded him first and third prizes in painting for *Merry-Go-Round* and *Wylie Avenue Barbershop*. These pictures received national exposure in the pages of *Life* magazine.[1] Pearlstein repeated his triumph the following year, winning first prizes in painting and colored ink drawing. These early works reflect the then-popular realism of such artists as Reginald Marsh (who served on the *Scholastic* exhibition jury) and Thomas Hart Benton.

Pearlstein studied art at Carnegie Institute of Technology, then moved to New York in 1949 with his former classmate Andy Warhol. During the 1950s he experimented with the Abstract Expressionist style, but his paintings at this time, for all their bold brushwork, "were masquerading as Abstract Expressionism,"[2] and his sense of form remained essentially representational. In the early sixties he took up the subject with which he is most closely identified, the nude, and began to evolve a highly finished, coldly objective, naturalistic style utterly opposed to the subjective, painterly, emphatically two-dimensional qualities of Abstract Expressionism. Pearlstein, however, has frequently pointed out that neither he nor contemporary realists like Chuck Close, George Segal, and Alfred Leslie have turned their backs on modernism. Their aesthetic "has

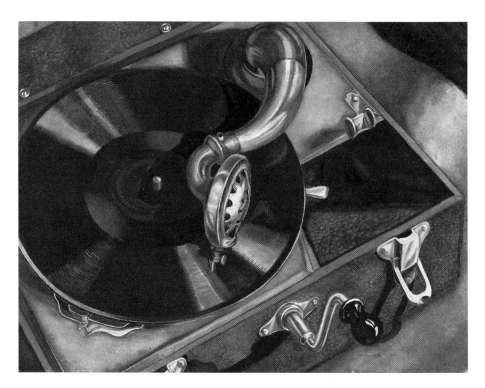

Pearlstein, *The Portable Phonograph (A Student Work)*

210

to do with taking realism as an art idea and using it for its own sake, rather than as a vehicle for social comment or any other kind of literary statement. . . . We all use realism as a vehicle, but we could have been abstractionists just as well, or conceptualists."[3]

Although Pearlstein carefully distinguishes his current realism from the realism of his early youth, his high-school works anticipated many characteristics of his mature style. This goes beyond such obvious similarities as a concern with the human figure or a preference for the linear over the painterly. For example, Pearlstein's refusal to idealize his models, tending instead to concentrate on their least attractive features, was already apparent in his *Wylie Street Barbershop* of 1941. In the caption to this painting *Life* advised its readers, "Note smart exaggeration of perspective to emphasize barber's feet and spittoon."[4] Even more striking are the points of resemblance between *The Portable Phonograph*, a remarkably accomplished watercolor made when the artist was seventeen, and a recent work like *Two Models, One Seated on Floor in Kimono* (1980, Museum of Art, Carnegie Institute). Both are painted in a rather dry, meticulous technique; both feature unorthodox vantage points and an unusual cropping of forms. The curving arm of the phonograph foreshadows the curving thighs of the models. It is, of course, one thing to render a machine with cool, dispassionate objectivity, and quite another to treat a human figure in the same way, but the comparison reveals the fundamental continuity of Pearlstein's vision.

KN

NOTES: 1. "Youngest Generation of American Artists Holds Whopping Good Show at Pittsburgh," *Life*, 16 June 1941, 56-57. 2. Tape-recorded interview between Henry Adams and the artist, quoted in Henry Adams, "The Pittsburgh Background of Pearlstein's Realism," *Carnegie Magazine* LVII (May/June 1984): 21. 3. Sanford Sivitz Shaman, "An Interview with Philip Pearlstein," *Art in America* LXIX (September 1981): 120. 4. *Life*, 57.

MARK ROTHKO

B. RUSSIA, 1903—1970

THROUGHOUT his career Mark Rothko aimed at transcending ordinary experience. From about 1950 on he worked in large, slightly amorphous abstract shapes floating against a simple ground. Like other Abstract Expressionist artists, however, Rothko in the early 1940s worked in a style that was heavily influenced by Surrealism—especially the work of Joan Miró. Although he shared concerns and to some degree a common style with Jackson Pollock, Arshile Gorky, and Barnett Newman, Rothko's work—even in the middle 1940s when he made the two watercolors on either side of this sheet—differed from theirs in being more concerned with light and with insubstantial, almost transient, forms and effects.

Rothko's subjects at this time seem to have come to him as he worked. As he described the process, "They began as an unknown adventure in an unknown space. It is at the moment of completion that in a flash of recognition, they are seen to have the quality and function which was intended."[1]

Untitled (recto)
1945
watercolor, tempera, and ink on paper

Untitled (verso)
1945
watercolor, pencil, and ink on paper
40 13/16 x 26 7/8 in.
(103.7 x 68.3 cm.)
Gift of The Mark Rothko Foundation, Inc., 85.14.1, 2

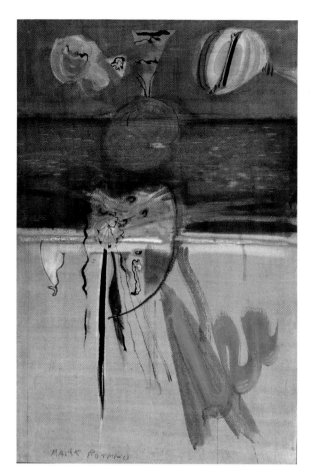

Rothko, *Untitled* (recto)

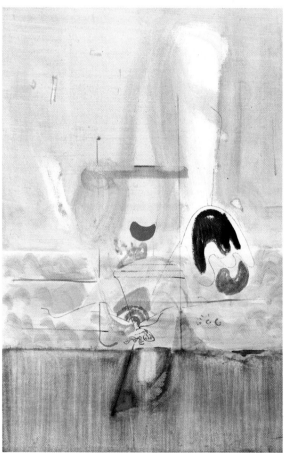

Rothko, *Untitled* (verso)

212

The space in these two watercolors is indeed highly ambiguous. On the recto, one tends to see the light gray area at the top as sky, the broken dark gray zone in the middle as ocean, and the light blue-gray foreground as a beach. Yet the figures occupy positions that contradict this reading, making the background read simply as horizontal planes of color. The figures themselves are amorphous: in the upper area of the sheet two of the shapes are fairly clearly outlined at the top in black ink, but their lower portions dissolve into a blur of the blue, orange, and gray washes they are painted on, as if the ground were consuming the figures.

Exactly what the figures are, or even where they begin and end, is difficult to establish. The central figure on the recto may be a dancing person, and on the verso there is a suggestion of a red flag or pennant above a woman with what could be her arms outlined in pencil marks. Next to her is a very Miróesque biomorphic shape on an indistinct pedestal that could indicate an altar. The titles Rothko chose for his watercolors and paintings at this time, such as *Olympian Play*, *The Furies*, and *Slow Swirl by the Edge of the Sea*, do at least suggest a concern with Greek myths and the ocean. He described his subjects himself in the most general terms:

> They move with internal freedom, and without need to conform with or to violate what is probable in the familiar world.
>
> They have no direct association with any particular visible experience, but in them one recognizes the principle and passion of organisms.[2]

Although these two watercolors are especially difficult to read in terms of their subject matter, that same obscurity probably accounts for some of their power as works of art. Robert Goldwater once described Rothko as "an artist to whom the subconscious represents not the further but the nearer shores of art,"[3] and the very indecipherability of the two images frees the viewer to respond to their ambiguous space and luminous color. The figures are in fact almost vestigial; one senses especially strongly in these works the pull toward pure abstraction that would cause Rothko to abandon figuration entirely in the late 1940s.

The date of these watercolors is problematic. In 1968, when Rothko made an inventory of his works, he numbered the verso of this sheet to indicate his belief that he had made the work in 1944. The simplified forms, clearly defined background areas, and generally dark tonality of both recto and verso, however, relate more closely to works he made in 1945 and 1946.[4]

JC

NOTES: 1. Mark Rothko, "The Romantics Were Prompted," *Possibilities* I (Winter 1947-48): 84. 2. Rothko, 84. 3. Robert Goldwater, "Reflections on the Rothko Exhibition," *Arts* XXXV (March 1961): 45. 4. Information from Bonnie Clearwater, November 1984, Museum of Art files. See her *Mark Rothko: Works on Paper* (New York, 1984), plates 9-19.

ANDY WARHOL

B . 1 9 3 0

DURING the 1960s Andy Warhol, an enigmatic, inarticulate figure with silver-sprayed hair and dark glasses, emerged as king of the New York underground and leader of the movement known as Pop Art. His first canvases to achieve wide attention were his silk screens of Campbell's soup cans—mechanically reproduced, deliberately banal images that repudiated the free brushwork and individualistic qualities of Abstract Expressionist painting. Warhol challenged conventional notions of artistic creativity and turned over the production of his works to a group of assistants, known as "the factory," who turned out likenesses of soup cans, celebrities, car wrecks, and electric chairs on request. Not exclusively a painter, Warhol also became involved with a rock-and-roll band; with films that depicted violence, perverse sexual activity, and boredom; with a magazine of interviews with celebrities; and with several books of snapshots and tape-recorded interviews. After one of the actresses in his films shot and nearly killed him in 1968—an episode that only increased his notoriety—Warhol adopted a more genteel persona, changing his attire from black leather jackets to Brooks Brothers blazers. He has continued, however, to produce and sponsor paintings, prints, films, and books under the rubric Andy Warhol Enterprises.

Although he emerged as a public figure only in the 1960s, many of Warhol's viewpoints and attitudes were shaped in the 1940s during his years in Pittsburgh. The son of Czechoslovakian immigrants, Warhol, originally named Andrew Warhola, came of age during the period of the Great Depression, the New Deal, and World War II. Warhol's father, who worked in the coal mines of West Virginia, had died in 1942 of poisoning from bad drinking water, and from that time on the family existed near the subsistence level. After school and in his spare time Warhol worked selling vegetables and later as a window display decorator in a department store. Warhol's fascination with glamor in his mature work was thus a response to early experience with poverty and deprivation.[1]

Warhol left high school at sixteen to enter Carnegie Institute of Technology (now Carnegie-Mellon University), where he majored in pictorial design. The Museum of Art owns a dozen drawings Warhol made at this time, all drawn with broken, unshaded outlines in a manner reminiscent of Ben Shahn.

Untitled stands out among this group of works both for its accomplished draftsmanship and its political content. Warhol produced the drawing during his last year at Carnegie Tech for a design course taught by Robert Lepper. Philip Pearlstein, who was a close friend of Warhol in this period, has recalled that Lepper, who studied at the New Bauhaus in Chicago, was "the most effective teacher" on the faculty.[2] His teaching stressed analysis of the overall content of each task before beginning a picture, and he encouraged students to illustrate literary subjects because he felt they offered a complex set of elements that stimulated the imagination. In addition, Lepper was interested in political issues, although he was not an activist.

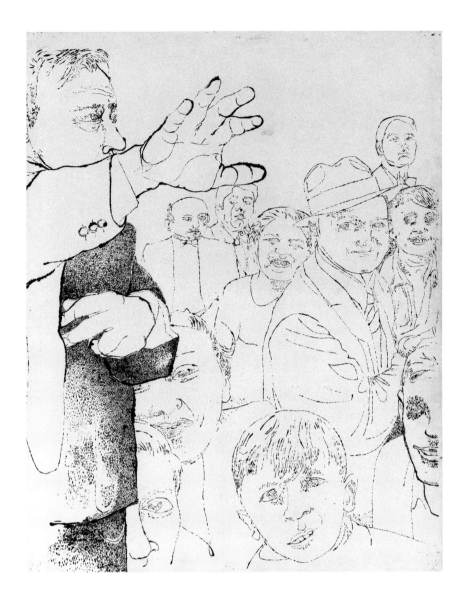

Warhol, *Untitled*

Robert Lepper has recalled Warhol as "a small thin boy who had a great talent for avoiding personal contact. He began his third year, when I met him for the first time, with a bad reputation."[3] Lepper, however, became one of Warhol's defenders:

> At that time it was customary for the works of the students from the semester to be taken before the entire faculty and judged. The jury was composed of ten or twelve faculty members who agreed on the grades. After one of these judging sessions it became apparent that there would be problems because of a certain Andrew Warhola. Several jurors were of the opinion that *Andy could not draw*. He was therefore a candidate for expulsion. . . . After many quarrels it came to a close victory for his supporters. In the third year I was one of those who defended him.[4]

Warhol, in fact, did outstanding work for Lepper's classes, and several of his drawings were selected to hang in the corridors of the university. For one of his assignments he chose to illustrate Robert Penn Warren's *All the King's Men*, an account of a corrupt political boss named Willie Stark, clearly based on Huey Long, Louisiana governor from 1928 to 1930 and

U.S. Senator from 1930 until his assassination in 1935. Warhol chose to depict a very early scene in which Willie Stark speaks informally to a crowd in his home town:

> "You tell 'em Willie!" somebody yelled back in the crowd. Then they started to laugh.
> The "Boss" lifted up his right hand about as high as his head, out in front of him, palm down, and waited till they stopped laughing and whistling. Then he said: "No, I'm not here to ask you for anything. A vote or anything else."[5]

The resemblance of Stark's gesture to a fascist salute was undoubtedly intentional. In fact, Huey Long has often been compared with Hitler.

In addition to emphasizing content, Lepper encouraged his students to use innovative materials and methods. In this instance Warhol employed a blotted ink technique, pressing paper onto freshly inked lines to create a sort of monotype with a wide range of values and interesting accidental effects. This interest in blurred reproduction of an original image anticipates his later silk-screen prints, with their sloppy, mass-produced, deliberately careless effects.

HA

NOTES: 1. Rainer Crone, *Andy Warhol* (New York, 1970), 12. 2. Würtembergischer Kunstverein, Stuttgart, *Andy Warhol: Das zeichnerische Werk, 1942-1975* (1976), exh. cat. by Rainer Crone, 16. 3. Würtembergischer Kunstverein, 17. 4. Würtembergischer Kunstverein, 17. 5. Robert Penn Warren, *All the King's Men* (New York, 1970), 11.

DAVID SMITH

1906 — 1965

Figure Study, March 18, 1953
1953
gouache on paper
29 ¾ x 42 ½ in.
(75.6 x 108 cm.)
Carnegie International Prize Fund, 61.49.1

11-5-54
1954
ink on paper
16 ¹⁵⁄₁₆ x 21 ⅛ in.
(43 x 53.7 cm.)
Gift of G. David Thompson, 62.9

August 12, 1961
1961
ink, gouache, and graphite on paper
26 ⁵⁄₁₆ x 41 in.
(66.8 x 104.1 cm.)
Gift of Candida Smith, 61.43

DAVID Smith, widely considered the most important American sculptor of the twentieth century, brought about major changes in both the techniques and conception of sculpture. Traditionally sculpture dealt with massed form, usually representations of the human figure. Smith, however, worked with modular pieces of prefabricated steel that had little formal significance in themselves but served as definers of empty space.

Smith's novel handling of sculptural space grew out of his systematic exploration of welding, a technique he was the first to exploit fully. His inspiration came from the work of Pablo Picasso, who, with the technical help of Julio Gonzalez, constructed several welded works in 1928 and 1929. Smith saw a photograph of one of these in *Cahiers d'art* and immediately recognized the potential of welding to create a new language of sculptural form. Smith's attraction to steel as a medium was undoubtedly related in part to its associations with masculinity and strength. In explaining his interest in the material, Smith once declared, "The metal itself possesses little art history. What associations it possesses are those of this century: power, structure, movement, progress, suspension, destruction, brutality."[1]

Born in 1906 in Decatur, Indiana, Smith moved in the mid-1920s to New York, where he took classes from Jan Matulka, who taught him

about Cubism, Constructivism, and Surrealism. He noted afterwards: "Matulka was a guy I'd rather give more credit than anyone else."[2] In addition, he studied with Kimon Nicolaides, author of the still-popular textbook *The Natural Way to Draw*, whom he later credited with instilling in him a "sensitivity to line."[3] Significantly, Smith never received solid training in traditional academic painting techniques. He belonged to the first generation of American artists that was trained from the beginning in the vocabulary of modern art and that built upon the achievements of Picasso.

After working for several years as a painter, Smith took up sculpture in 1931. By 1933 he had begun to work with welded forms, and in 1940 he moved to Bolton Landing in upstate New York. There he built a studio-workshop he called "Terminal Iron Works," where he worked for the remainder of his career, alternating long periods of lonely creativity with short binges in New York City.

Four of Carnegie Institute's five drawings by Smith came into the collection as an outgrowth of a controversy the artist created at the Carnegie International in 1961. In October 1960 Gordon Bailey Washburn, the director of the museum, wrote to invite Smith to participate in the exhibition. Smith declined, citing the time required to prepare for the shows and his failure to win previous contests. By March 1961, however, Smith had been persuaded to show in the International on the condition that he also be given a one-man show to be chosen by the assistant director, Leon Arkus, in a room free of paintings that might distract from the effect of his work. At the time of the International, Smith insisted that all his sculptures be shown in a group, and consequently they were packed into one room, except for one that was too tall and had to be

placed in the hallway, and another that was returned to Bolton Landing. Because Smith was engaged in a dispute with his dealer, he set the prices so high as to discourage sales. Arkus, unaware of this conflict, wrote Smith a letter noting that his prices were the highest in the show, even higher than Picasso's, and urged him to consider lowering them.[4]

On October 24, 1961, Gordon Washburn wrote to inform Smith that he had received the Third Prize for Sculpture of $1,000, placing him behind the Swiss master Alberto Giacometti, who won First Prize, and the less well-known American sculptor, George Sugarman, who came in second. Smith was apparently most offended to be ranked below Sugarman, and on October 26 he sent off a neatly typed letter to the Fine Arts Committee of Carnegie Institute declining his prize. This epistle, later published in the *New York Times*, declared:

> Gentlemen:
> I do not wish to accept the prize your guest jury has honored me with.
>
> I wish the money involved returned to Institute direction, and I hope applied to use for purchase.
>
> I believe the awards system in our day is archaic.
>
> In my opinion all costs of jury, travel, miscellaneous expenses of the award machinery could be more honorably extended to the artist by purchase.
>
> A few years ago I was chairman of a panel in Woodstock, New York, wherein the prize system was under discussion. The majority of artists spoke against the prize system. Dr. Taylor, then President of the Metropolitan Museum, was recognized as a speaker for the prize system. He spoke eloquently and defended this as of being the donor's prerogative and ended by summing up that the prize system is longstanding and honorable and goes back to the days of Ancient Rome when a prize was given for virginity. After the applause—a hand was raised for recognition by painter Arnold Blanch. His question—would the last speaker care to qualify the technical merits for second and third prize.
>
> Thank you and greetings.
>
> David Smith.[5]

In a note of about the same date to his friend James Truitt, Smith summed up the situation: "Was Pittsburgh & back—got 3rd prize refused it at once. 3rd class virtue I don't want—rather be old whore. Will stay out of competitions now."[6]

Smith's gesture, in fact, had little moral justification, for he had declined the option of entering his work *hors concours*. He himself seems to have felt contrite two weeks later, for on November 7, 1961, he wrote to Arkus: "Tell Gordon I hope I handled the news OK. I'm not too handy but I did the best I could with it. Didn't see the Pittsburgh papers. Canaday [the art critic for the *New York Times*] called—I settled, kept it from scandal or pique—next time will withdraw from prize contest/Working hard—8 new big ones 1961—haven't been shown—want another show? for 61."[7]

Arkus proposed in a letter of November 3 that Carnegie Institute use the refused prize money to purchase two drawings by Smith, one that Arkus had seen in the hallway at Bolton Landing and another of the artist's two children. Gordon Washburn, in fact, had praised Smith's

draftsmanship in the catalogue of the International, saying that Smith's open constructions "often suggest heroic iron drawings in space" and regretting that some of Smith's "beautiful drawings" could not be included in the show. In his conciliatory letter of November 7, already cited, Smith expressed interest in Arkus's offer, commenting, "Drawings—we could come to easy disposition—My 2 big ones (600 size) and I could give you one to boot. The 2 girls I've kept for myself out of sentiment. Let me think. But I've others better as for drawing." By November 14 Smith had worked out what he wanted to do and sent a postcard: "You buy 2—I give 2 one each in name of each daughter. One you chose in hall—Remember—They will be my best." Finally, on December 20, Smith sent the works to the museum with a letter remarking, "I hope they are all liked—If not—I doubt I have better."

Smith, *11-5-54*

The two works Arkus purchased were figure studies dated March 18 and May 14, 1953. Both drawings are built up in several layers of gouache and black ink mixed with egg yolk on light buff paper. At least two different brushes were used, probably a lightly loaded pig-bristle brush and another that was softer and broader. Smith used the gouache to define areas and the black ink to create edges and lines. The complex interweaving of lines over gouache, and gouache over lines, and the interweaving of lines over each other, create multiple readings and interpretations of the resulting forms. In a radio talk show in New York in 1950 Smith specifically associated this technique with the discoveries of the Cubists, noting, "The overlay of shapes, being a Cubist invention,

permits each form its own identity and when seen through each other highly multiplies the complex of associations into new unities."[8]

When oriented by their signatures, both drawings present anthropomorphic but unrecognizable forms, vaguely reminiscent of the late work of Gorky. Drip marks, in both ink and gouache, indicate that the drawings were hung this way to dry. However, both drawings become more recognizable when they are turned from the horizontal to the vertical. *Figure Study, March 18, 1953* proves to contain a head in profile, possibly faced by another head, and in its general composition resembles Picasso's *Girl Before a Mirror* (1932, The Museum of Modern Art). *Figure Study, May 14, 1953* seems to depict a nude female figure with a guitar beside her and in general conception recalls Picasso's paintings of this subject, such as *Girl with a Mandolin* (1910, The Museum of Modern Art).[9] Both drawings, consequently, provide a remarkably clear illustration of how Smith began with the visual language of Picasso and then expanded this vocabulary in the direction of greater visual ambiguity and abstraction.

In addition to the two works that the museum purchased, Smith added *April 4, 1961* and *August 12, 1961* as gifts from his two daughters. The first celebrates the seventh birthday of Rebecca; the second, the sixth birthday of Candida. To some extent the two works seem to evoke the personalities of the two girls. Candida's is more stable, centered, and balanced, while Rebecca's is more energetic and full of movement, being done in a manner that recalls Smith's sculpture *Running Daughter* (1956, David Smith Estate).[10]

Both drawings are in a calligraphic style that resembles Oriental ideograms. Smith made large numbers of drawings of this type: a photograph reproduced in *David Smith by David Smith* shows a group of more than twenty of them laid out on the floor of his studio.[11] In a lecture at The Museum of Modern Art in the 1950s, Smith declared his enthusiasm for Oriental brushwork as a means of autonomous gestural expression:

> Certain Japanese formalities seem close to me, such as the beginning of a stroke outside the paper continuing through the drawing space, to project beyond, so that in the included part it possesses both the power of the origin and the projection. This produces the impression of strength and if drops fall they become attributes or relationships. . . . Another Japanese concept demands that when representing an object suggesting strength— like rocks, talons, claws, tree branches—the moment the brush is applied the sentiment of strength must be invoked ·and felt through the artist's system and so transmitted into the object painted.[12]

Following the example of Picasso, who invented a form of imaginary script in the 1940s, Smith often devised enigmatic alphabets of abstract forms, such as his welded steel sculpture *The Letter* (1950), of which he wrote that it contained, "All kinds of unGreek Greek. They look like Greek and they are Greek because 'Greek' is something you don't understand."[13] In another statement Smith noted:

> Probably I resent the word world (Joyce, etc., excepted) because it has become the tool of pragmatists, has shown limited change, has rejected creative extension. . . . Judging from cuneiform,

Smith, *August 12, 1961*

Chinese and other ancient texts, the object symbols formed identities upon which letters and words later developed. Their business and exploitation use has become dominant over their poetic-communicative use.[14]

In drawings such as *April 4, 1961* and *August 12, 1961* Smith challenged traditional forms of writing to create a "visual language" that communicated at a deeper and more primitive level.

In addition to the works that the museum acquired directly from Smith, it obtained one more, titled *11-5-54*, the date it was made, as a gift from G. David Thompson, the controversial financier and collector of modern art. Unlike the other four drawings, *11-5-54* relates directly to Smith's sculpture. The two linear constructions prefigure Smith's tower series; for example, *Tower 1* (1962–63, David Smith Estate).[15] The drawing shows three linear constructions, the two on the outside created almost entirely from straight lines and the one in the center combining lines with more organically treated blotted forms. The juxtaposition of shapes, in fact, resembles the juxtaposition of Smith's actual sculpture to the tree and hills in the field where he placed them at Bolton Landing.

That Smith made this drawing specifically as a sculptural study is evident from his inclusion of a base for the two flanking towers. These supports vary, and the central unit lacks a base, showing that Smith was already concerned with unifying the forms of the bases with the sculpture, a problem that preoccupied him increasingly in the 1960s.

Significantly, the towers at right and left were not drawn with a brush but were created by dipping a straight-edge into ink and then stamping lines onto the paper. This created a remarkably varied, blotted effect, and in addition mimicked the manner in which Smith eventually constructed his welded tower structures from prefabricated linear units.

221

Unlike artists such as Gorky, with whom he shared an interest in Picasso, Surrealism, and abstract anthropomorphic forms, Smith possessed only rudimentary skills as a figurative draftsman, and his drawings have little graphic elegance. They succeed as major artistic statements through their emotional and gestural urgency and because they intimately reveal Smith's inventive thinking as a sculptor. Often they possess a diagrammatic quality, providing a curious mix of the effects of Abstract Expressionist painting and the illustrations to *Popular Mechanics*. Smith once declared, with specific reference to his drawings, "I never intend a day to pass without asserting my identity; my work records my existence."[16] Like Picasso, who may have inspired him to regularly date his drawings, Smith saw his sketches as an opportunity to provide a daily record of his artistic ideas, unbounded by the physical difficulties and limitations of sculpture.

HA

NOTES: 1. Gordon Bailey Washburn, "Seven One-Man Shows in the 1961 Pittsburgh International," *Carnegie Magazine* (October 1961): 262. The best biographical and interpretive study of David Smith is Stanley E. Marcus, *David Smith: The Sculptor and His Work* (Ithaca, New York, 1980). 2. Cleve Gray, ed., *David Smith by David Smith* (New York, 1968), 24. 3. Gray, 24. 4. Marcus, 133-36. 5. Museum of Art files. See also *David Smith*, Garnett McCoy, ed. (New York, 1973), 209. 6. Marcus, 135. 7. This and the other letters cited, unless otherwise noted, are in the files of the Museum of Art, Carnegie Institute. 8. Whitney Museum of American Art, New York, *David Smith, The Drawings* (1979), exh. cat. by Paul Cummings, 21. 9. The Museum of Modern Art, New York, *Pablo Picasso: A Retrospective* (1980), exh. cat. by William Rubin, ed., 291, 137. 10. Gray, 94-95. 11. Gray, 85. 12. Whitney Museum, 26. 13. McCoy, 185. 14. McCoy, 79. 15. Gray, 104-105. 16. Gray, 104.

SAM FRANCIS

B. 1923

Yellow into Black
1958
watercolor and gouache on paper
30 ¼ x 22 ³⁄₁₆ in.
(76.8 x 56.4 cm.)
Print Purchase Fund, 58.43

ALTHOUGH Sam Francis was born in California and has lived there most of his life, he came to artistic maturity in France, where he worked from 1950 until 1958. His paintings from the early and middle 1950s, with their light colors and all-over composition, are typical School of Paris work, owing more to Monet than to Abstract Expressionism. In 1957 Francis spent several months in New York and Japan, and his work of the late 1950s, like this watercolor, combines the methods of American Action Painting and Japanese brush drawing with l'art informel of Paris.

Sherman Lee once noted that some of Francis's works have "much in common with 'flung ink' (haboku) landscapes of the revered 15th-century master Sesshu,"[1] and in fact some of his paintings and watercolors of the late 1950s reflect the spare, asymmetrical compositions and spontaneous brushwork of Japanese art. In *Yellow into Black*, as in a number of his paintings of that period, Francis left a large part of the surface blank, another common practice in Oriental and especially Japanese art. The result is an austere image in distinct contrast to the overall decorative lushness that characterized Francis's work both before and after the late 1950s.

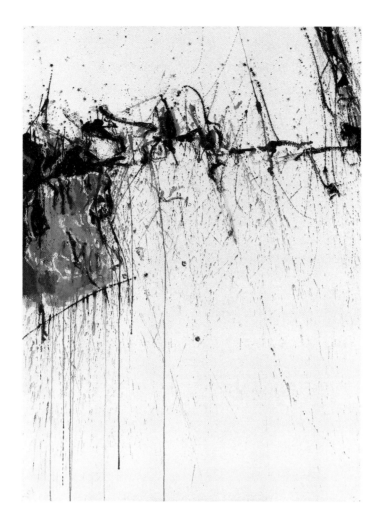

Francis, *Yellow into Black*

Yellow into Black demonstrates, as well, the influence of Abstract Expressionist painting and drawing on Francis's work. In 1957, when he left France, the first European exhibitions of the soon-to-be-triumphant New York School were being held in Paris, and Francis must surely have seen the work of Jackson Pollock, among others, while he was in New York that year. In some ways, *Yellow into Black*, with its vigorous gestural composition and dripping pigment, resembles an isolated and magnified detail of one of Pollock's paintings. Yet Francis did not adopt the complex structure of Abstract Expressionism, but only a kind of pure Action Painting, and works like this one thus gain in immediacy what they lack in complexity. That Francis's embrace of Abstract Expressionism was only partial is also indicated by his choice of medium. Watercolors are rare in the work of the New York School artists in the 1950s, in part because the medium resists a heavily impastoed application and because its transparency can emphasize ambiguity of the picture plane. Francis, however, used watercolor here in an individual way, as pure intense pigment, which gives the work an unusual concentration and spontaneity.

JC

NOTES: 1. Cleveland Museum of Art, *Some Contemporary Works of Art* (1958), exh. cat. by Sherman Lee, 16. See also Peter Selz, *Sam Francis* (New York, 1975), 61-62.

FRANZ KLINE

1910 — 1962

Gray Antique
1958
watercolor and gouache on
paper
10 ⁷⁄₁₆ x 14 ⅞ in.
(26.5 x 37.8 cm.)
Leisser Art Fund, 58.40

FRANZ Kline's black and white abstract paintings from the early 1950s were shattering in their power and impact. Leo Steinberg found them "huge and terrifying."[1] For Steinberg, the experience was like being in an elevator falling out of control or being flung up against a wall. His reaction can be explained in part by the ambiguous flatness of the paintings. Their massive, slashing black strokes seem to attack the white "spaces" that read as background but are often, in fact, superimposed on the black. Even at this period, however, Kline sometimes slightly mitigated the taut conflict between flatness and depth by overlapping the black forms with small areas of gray. In later works, like *Gray Antique*, he painted the black strokes over areas of color, thus creating successive planes of depth. Inevitably the drama of absolute contradiction in the pure black and white works was diminished in the artist's more complex compositions with color, and he made occasional missteps, such as the indistinct and not entirely resolved white shape at the right of this sheet.

In fact, for the more determined formalist critics, the entire body of Kline's late work was a mistake, a retreat from the tension, ambiguity, and denial of three-dimensional space that made his work of the early 1950s so strong.[2] In some of his late works, there is a breakdown of the tense structure of the earlier black and white compositions, and the real sense that nothing has quite replaced it. Frank O'Hara noted, for example, "As the density and complexity of Kline's content deepened from embattled clarity to tragic awareness, the means of a previous complexity could not be simply restated in another context."[3] Kline himself spoke of his work in terms of "the nature of anguish."[4]

In later works such as *Gray Antique*, it is possible to see a different intent than that which guided the early works, and another achievement. As early as 1950 Kline had painted canvases in color before covering them with black and white; in the work in color of the late 50s he explored new ground.[5] In this drawing, the many layers of paint, looking as if they were applied and then peeled away at random, make the surface seem distressed, as if the work itself were dissolving. It is at once organic and disordered, suggesting the impermanence of time and the mutability of space. These late works by Kline are thus problematic, raising as they do the possibility of dissolution and failure.

JC

NOTES: 1. Leo Steinberg, "Month in Review," *Arts Magazine* XXX (April 1956): 42-43. 2. See, for example, Donald Judd, et al., "In the Galleries," *Arts Magazine* XXXVI (February 1962): 44. 3. Frank O'Hara, "Introduction and Interview" in Whitechapel Gallery, London, *Franz Kline: A Retrospective Exhibition* (1964), exh. cat., 10. 4. O'Hara, 14. 5. Henry F. Gaugh, "Franz Kline: The Abstractions with Color" in The Phillips Collection, Washington, D.C., *Franz Kline: The Color Abstractions* (1979), exh. cat., unpaginated.

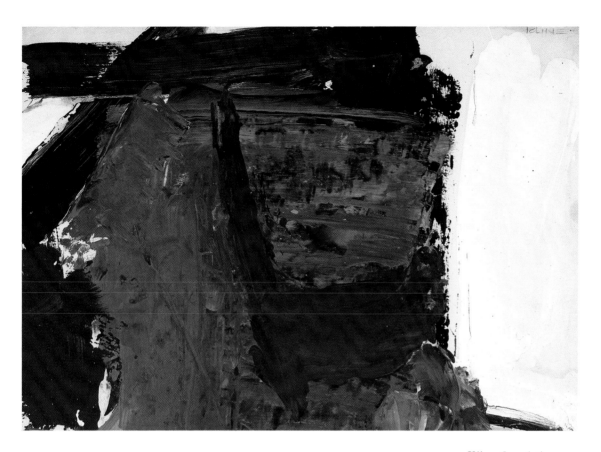

Kline, *Gray Antique*

FRANK STELLA

B. 1936

FRANK Stella is one of the first painters to work exclusively in an abstract style, and his influence may be discerned in numerous facets of contemporary art. His commitment to abstraction has remained constant throughout his prolific and ingeniously varied production, including the box-and-stripe paintings of the 1960s, the Black paintings, the Protractor series, and the Playskool constructions of the 1980s. Although his work rarely sold through the 1960s, his contribution to the contemporary art scene has long been acknowledged by critics and artists, and the intellectual acumen that accompanies his image making was recognized in his prestigious appointment as Harvard University's Charles Eliot Norton Professor of Poetry for 1983–84. In a 1984 *New Yorker* profile Calvin Tomkins paid further tribute to Stella's accomplishment, noting, "Stardom of this magnitude has descended on very few living artists."[1]

Stella grew up under the influence of the Abstract Expressionists. From early studies with Patrick Morgan at Phillips Academy, Andover, he found he liked to think in abstract units, organizing nonfigurative shapes across the picture surface. "It seemed to me the thing to do; a painting could just be involved with squares, and that would be enough."[2]

At Princeton, where he majored in history, not yet taking seriously the idea of a career in art, Stella became, in his own words, "a very hot expressionist painter." Principally influenced by Adolf Gottlieb, Mark Rothko, and subsequently Jasper Johns, Stella responded intensely to the "openness of the gesture, the directness of the attack," that characterized their work, and he turned to large canvases to accommodate his ideas.[3]

A crucial point in Stella's development occurred a few months before his graduation from Princeton when, in January 1958, he saw Johns's first one-artist show at the Leo Castelli Gallery in New York. With its flags, numbers, and targets, Johns's work was not abstract, but what struck him most, Stella recalled, "was the way [Johns] stuck to the motif . . . the idea of stripes—the rhythm and interval—the idea of repetition."[4]

Inspired by the Johns show, Stella began to study pattern and an all-over surface that did not distinguish between figure and ground. In a concerted and defiant reaction against what he perceived as the emotional and inchoate qualities of Abstract Expressionism, Stella sought to impose on his art a new order and symmetry, working with the nonfigurative pictorial elements that had engaged him since his Andover days. The so-called box-and-stripe pictures, of which the Pittsburgh gouache is an excellen example, make up this intermediate stage between Stella's Abstract Expressionist work and the rationally ordered, "insolently static" compositions that, when they were exhibited in 1959 at The Museum of Modern Art, firmly established the reputation of the twenty-three-year-old artist.[5] The box-and-stripe pictures show Stella combining the brilliant colors, lavish use of pigment, and "spontaneous" composition of Abstract Expressionism with his nascent sense for order.

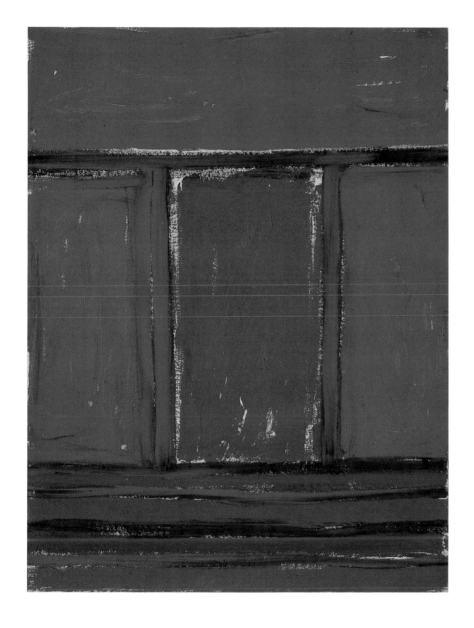

Stella, *Untitled*

Stella thought very much in terms of the associative property of titles, and his box-and-stripe paintings of 1958–59 are called, for example, *Coney Island* and *Astoria*, referring to places around New York City and evoking their mood or his emotional relationship with them. It is significant that Stella assigned his paintings place names, since the box-and-stripe works retained lingering references to landscape format and illusionistic space that would be eradicated in the Black paintings. For example, Stella used the title *Red River Valley* for a painting of 1958 (Fogg Art Museum, Harvard University), which seems to relate most closely to the Carnegie Institute gouache. Stella described the central form in this image as a "doorway,"[6] and perhaps intended the same for the gouache. The museum's gouache, for many years in the collection of the artist's first

227

wife, the critic Barbara Rose, stands out in this group, for it is untitled and has been painted on paper. At this time it was rare for Stella to work out an idea on paper before realizing it on canvas, and thus it is not clear whether the gouache was meant to be a study for an unidentified painting, an exercise, or, as its compelling size and presence would suggest, an independent drawing.

Untitled is certainly a pivotal work, for it represents the moment when the artist began to pursue an interest in structure that revolutionized the art of his time, leading to more intellectually-based trends, such as Minimalism and its off-shoots. Powerfully illustrated, this gouache is Stella's predilection for order, which would later impress more hostile critics as "intractably simple-minded."[7] At this instant, however, he retained the vestiges of the expressive painterly handling of his Abstract Expressionist phase, an aesthetic that he finally rejected in favor of a new rationalism.

<div align="right">EAP</div>

NOTES: 1. Calvin Tomkins, "Profiles: Frank Stella," *The New Yorker* (10 September 1984): 53. 2. "Frank Stella—Portion of an Interview," *Members Newsletter* of The Museum of Modern Art (Spring 1970): unpaginated, from a 1966 interview with Alan Solomon for a program in the series "U.S.A. Artists," produced by Lane Slate for National Educational Television. 3. "Frank Stella—Portion of an Interview." 4. William Rubin, *Frank Stella* (New York, 1970), 12. 5. Robert Rosenblum, *Frank Stella* (London, 1971), 16. 6. Mentioned in a conversation with Caroline Jones, assistant director for curatorial affairs, Fogg Art Museum, Harvard University, fall 1983. I am grateful to her and to Peter Freeman, Blum-Hellman Gallery, New York, for sharing their ideas about this drawing. 7. Rosenblum, 16.

AKIRA ARITA

B. JAPAN, 1947

Fennel
1976
graphite on paper
39 ⅞ x 29 ⅞ in.
(101.1 x 75.9 cm.)
Leisser Art Fund, 81.15.1

BORN in Osaka, Japan, Akira Arita came to the United States in the mid-1960s to study art at the Rhode Island School of Design. Had the term not already been used twenty-five years earlier for a different kind of work, one would be tempted to describe Arita's style as "magic realism." His paintings and drawings focus so exclusively on a single subject that it takes on a kind of talismanic aura, as if it had magical significance. His subjects themselves—paint buckets, vegetables, folded paper—are quite ordinary, but each image is so relentlessly concentrated, and its soft-focus background so impossibly regular and featureless, that the work assumes a strange power. In fact, Arita's world is oddly like that of the Franco-Polish artist Balthus, but without Balthus's erotic obsessions.

Gene Baro wrote of Arita, on the occasion of an exhibition of his work at Carnegie Institute:

> He transcends the standard of the brilliantly descriptive and moves us into a realm of drawing that is full of mysteries—the mystery, for instance, of light, in which the object has a glowing,

Arita, *Fennel*

floating life; the mystery of place, in which forms speak to one another across ambiguous spaces. Out of a kind of drawing that seems to state things all too clearly, Arita has made a visual language full of echoes and resonances. His images can be like things seen in a dream; they appear to hold meanings beyond literalness; they stay in our consciousness like memories of things once known. And yet it is their final unknowableness that makes art of these images.[1]

JC

NOTES: 1. Museum of Art, Carnegie Institute, *Akira Arita: Drawings* (1982), exh. checklist, unpaginated.

BRICE MARDEN

B. 1938

Untitled
1979
pen and ink on paper
29 ¾ x 22 ⅜ in.
(75.6 x 56.8 cm.)
Contemporary American
Drawings Fund, bequest of Mrs.
John C. Crouch, Patrons Art
Fund, and National
Endowment for the Arts, 82.43

BRICE Marden became widely known during the early 1970s for his paintings in single, muted, uninflected colors. While they provoked a great deal of comment on their insistent and immutable objecthood—the fact that they were nothing more than pigment on a rectangular support and had no relation to the illusionistic world of traditional painting— Marden clearly saw his work as related to ordinary life. He named his paintings after rock stars such as Bob Dylan and Patti Smith, elements of Greek architecture, and even the Annunciation to the Virgin. As early as 1963, when he was still in art school, Marden called his work "highly emotional," and in 1975 he defined the goal of the artist as striving "to make his expression explicit because he wants to affect man. By so doing he works to keep man's spirit alive."[1]

Marden, *Untitled*

Marden's paintings are simultaneously monolithic and meditational, decisively flat yet very slightly translucent, like human skin. A few of his drawings, with their large areas of graphite overlaid with wax, resemble the format and surface of his paintings. Most of the drawings, however, have a different structure; instead of planes of color, they are composed of lines in ink, which Marden applies with a twig or stick, a technique that gives the drawings a tremulous, uncertain quality. The surfaces of the drawings, unlike the immaculate surfaces of the paintings, are often marked by spills and splotches of ink. This sense of improvisation, together with the feathery beginnings and ends of each line, and the comparatively small size of the image relative to the sheet, emphasize their vulnerability. In fact many of Marden's drawings have about them a sense that they exist only provisionally, that they are endangered, somehow almost bedraggled, relics of the artist's struggle to make art. Marden's choice of the title *Suicide Notes* for a portfolio of his drawings expresses a similar feeling.[2]

Marden's drawings, including this one, have also been seen as "powerfully stretched energy diagrams," and the artist himself has likened them to a "chassis" and a "bone structure."[3] Marden often divides the surface of his drawings, as he does here, with horizontal and vertical lines at fairly regular but not rigid intervals. This manner recalls the late work of Mondrian and the drawings of Josef Albers, one of Marden's teachers. Despite the varying widths and densities of the lines and the fact that each overlaps or underlies another, Marden adheres carefully to the basic flatness he cultivates so assiduously in his paintings. Klaus Kertess described this ambiguous process:

> The plane is shattered but not broken . . . the multiplicity of lines is never permitted to form discrete shapes in space, and always congeals into an organic unity. Many of them still rely directly on a grid, but now it is layered and irregular like a tartan plaid or a series of screens slowly sliding and shifting on the page—more a veil than a skin. They embrace the plane more than they declare it.[4]

Yet even in these carefully structured drawings, Marden's work retains a quality of fragility and poignance.

JC

NOTES: 1. Whitechapel Art Gallery, London, *Brice Marden: Paintings, Drawings and Prints (1975-1980)* (1981), exh. cat. by Nicholas Serota, Stephen Bann, and Roberta Smith, 54, 56. 2. Brice Marden, *Suicide Notes* (Lausanne, Switzerland, 1974). 3. Hermann Kern, "Brice Marden: Painter and Graphic Artist" in Kunstraum, Munich, *Brice Marden: Drawings, 1964-1978* (1979), exh. cat., 99; Whitechapel Art Gallery, 56. 4. Klaus Kertess, "The Drawings of Brice Marden," in Kunstraum, 16-17.

THEO WUJCIK

B. 1936

Jasper Johns
1980
graphite on three sheets of
paper taped together
40 ³/₁₆ x 64 in.
(102.1 x 162.6 cm.)
The Bryan Foundation
Acquisition Fund,
81.27

AS both a printmaker and draftsman Theo Wujcik is a master of his craft. His drawings in silverpoint, an extremely difficult medium, are technical *tours de force*, spare, subtly rendered, with perfectly balanced tonalities and delicately executed details.[1] Carnegie Institute's graphite drawing of Jasper Johns reveals this skill and the apparent effortlessness of the artist's imagemaking.

Yet one can hardly see a single example of Wujcik's work without feeling slightly uneasy and wondering precisely what it is that he is driving at. One writer called his engravings "stark and compelling, even somewhat forbidding."[2] In *Jasper Johns*, we see a very ordinary looking middle-aged man gazing out at us sharply and a little suspiciously. But the combination of the very large scale of the drawing—it is much bigger than life-size—and its seemingly straightforward message is unsettling. Something similar happens in other drawings and prints by Wujcik: for example, his portraits of James Rosenquist, in which the artist's face is obscured by a visor, and of Ed Ruscha, whose face is only partially visible and whose eyelid bears the word Hollywood executed in ironic imitation of Ruscha's own style. Wujcik's work is thus a little like Warhol's and Lichtenstein's paintings of the early 1960s, in which a graphically powerful image is revealed to have, in effect, no message. Because Wujcik's subjects are well-known artists and because our expectations are raised by our awareness of the long tradition of artists' portraits and self-portraits, his work is not only enigmatic but also paradoxically meaningful, as if he were making a veiled critique of the whole notion of meaning in art and of the mythical persona of the artist.

JC

NOTES: 1. Theodore E. Stebbins, Jr., *American Master Drawings and Watercolors* (New York, 1976), 391-93. 2. Suzanne Boorsch, "Theo Wujcik," *Art News* V (March 1980): 120.

Wujcik,
Jasper Johns

WILLIAM BECKMAN

B. 1942

WILLIAM Beckman is best known for his strikingly realistic portraits of members of his family. These are extraordinary images, sometimes slightly larger than life, painted in a manner that reveals the artist's admiration for and close study of the work of fifteenth-century German and Dutch masters such as Jan van Eyck, Holbein, and Dürer. Beckman's work, like theirs, is almost preternaturally believable, and his subjects have about them an air of solid, breathing presence.

Beckman makes many pencil and charcoal drawings for every painting, but they are not the obsessive studies one might expect after seeing his paintings. Instead, like this drawing for a portrait of his wife Diana and daughter Deirdra (1980, with Allan Stone Gallery, New York), they are generalized figure studies that concentrate on light and tonality. In both the drawing and the painting Beckman is entirely faithful to the actual appearance of his subject. The study of his wife shows her in gym clothes, standing in a relaxed, informal posture. Nevertheless, the silvery sheen of the artist's pencil strokes has the effect of idealizing the image, as if it were seen through a gray, dreamlike haze. In contrast, the detail and intensely specific color in the painting render the figure more palpable.

Over the drawing Beckman has made a grid of faint lines that divides the whole surface into squares and has the effect of distancing and

Study for "Diana and Deirdra"
1980
graphite on paper
29 x 23 in.
(73.7 x 58.4 cm.)
Contemporary American Drawings Fund and National Endowment for the Arts, 82.22.1

Beckman, *Study for "Diana and Deirdra"*

abstracting the figure. For most artists this would indicate the last step before transferring the image to the surface to be painted, which would be divided into a similar grid. Beckman's method is somewhat different: "I never transfer a drawing to the panel using a grid. I redraw directly from the model, but with the grid, I can glance at the drawing and know exactly where the arm should be in that square. It's like having two models."[1]

In fact this drawing represents only the beginning of well over a thousand hours of modeling by the artist's wife, a process that clearly requires a high degree of communication and collaboration between the artist and his subject. Something of that relationship is revealed here in the forthrightness and determination of Diana Beckman's expression and in the way she has posed.

JC

NOTES: 1. Quoted in John Arthur, "William Beckman," *American Artist* XLVI (November 1982): 90.

MEL BOCHNER

B . 1 9 4 0

Color Study for "Syncline"
1980
graphite and casein on paper
10 ¼ x 20 ³⁄₁₆ in.
(26 x 51.3 cm.)
Collection of the artist, intended gift to the Museum of Art, Carnegie Institute, FA 81.41.3

MEL Bochner's *Syncline* was painted on a wall at Carnegie Institute in May 1981. Shortly after the installation Bochner explained his choice of title:

This piece deals with opposing forces, and so I chose a geological dictionary to look for titles. It's not an illustration since the paintings came first. A syncline occurs in plate tectonics; where two land masses meet and one slides under the other, you get a syncline, a slippage. A similar kind of force happens across this curve, a slippage that goes outside and inside. But the word is only an analogy; it's not the meaning. It's just the title, and I don't see a title as being a lot more than an identification.[1]

Although the composition of *Syncline* is clearly and carefully worked out, on first viewing it seems to be a more or less arbitrary assemblage of geometric shapes executed in bright but harmonious colors. In fact, it is based on four units made up of triangles, squares, and pentagons, whose presence is implied but not immediately apparent. Bochner described this substructure in the following terms:

There are four units in this piece—the blue, the brown, the yellow and the violet. Each one of those four units is composed of three tangent parts—a pentagon, a square, and a triangle. What interests me about these shapes is that each one of the four units is identical in area. However, depending on the order of the three parts, that is, if the square is tangent to the pentagon and the triangle is tangent to the pentagon; or the square and the pentagon are tangent to the triangle; or the triangle and the

234

Bochner, *Color Study for "Syncline"*

square are tangent to the pentagon on opposite sides; or the triangle is tangent to the square which is tangent to the pentagon, you get a completely different character of shape. The character of the yellow shape is not the same as the character of the violet shape. So, the same shapes can convey entirely different thoughts and meanings.[2]

Bochner works out these complex and precise relations between the elements of his wall paintings by first using maquettes for the larger geometric shapes. Then he makes charcoal drawings to determine the size and position of the interior bands. Next comes a series of small color studies on paper which lead up to a full-scale painted study on his studio wall. After the studio installation Bochner made a series of three works on paper related to *Syncline*. Although they are preliminary to the public installation of the finished work and are clearly intended to be used in making it, they are in no way studies in the traditional sense. What they record is not the artist's creative process—that is, his search for a formal and iconographical unity—but rather the solution itself, already arrived at. In reality, these drawings are more like memoranda for the artist's own use, maps for reinstalling the painting in another location. In 1980 it had been executed on the walls of the Sonnabend Gallery in New York and also at the Pittsburgh Plan for Art.

The first drawing, in pencil and red pencil, is a series of measurements of various parts of the composition. The second, in the same media with the addition of blue pencil, is a schematic color diagram of the pigments to be used, the artist's reminders to himself of how many coats of casein to use, and a record of the results he wished to avoid: "keep from going

opaque," "get density," and so on. The last drawing is really another version of the second drawing—another reminder, this time in casein rather than in words, of which colors go where.

The drawings thus share with Bochner's other work a determined objectivity, a thoroughgoing intelligence that is found everywhere in the artist's oeuvre. There is nothing overtly "expressive" here, and the drawings are clearly meant for use, almost like architectural plans. They are tools that do not take into account the sites at which *Syncline* was painted—a fact made evident by their being centered on the sheet with ample margins all around, quite unlike the final installation on the wall at Carnegie Institute, which almost touches the floor at the right and has far more blank space above than below it.

In fact, Bochner's drawings on paper deliberately preserve their separateness from the work of art itself. The wall painting, as Bochner has pointed out, "has no back," unlike these sheets of paper, the verso of which the artist used for another apparently unrelated composition. Moreover, their scale is enormously reduced, making impossible the experience of multiple points of view and the dependence on peripheral vision that are crucial to the effect of the finished work. On the wall Bochner's work takes on a mysterious life of its own. Resolutely matter-of-fact and two-dimensional, it has at the same time an oddly ethereal third dimension. Robert Pincus-Witten perceptively observed that he found Bochner to be "a kind of sculptor more than just a draftsman,"[4] a remark that probably originated in the complex and slightly disorienting experience of viewing Bochner's full-size work.

Here, in the drawings, no such illusory and indefinable three-dimensionality can occur. What they give us instead is a sense of the artist's resoluteness and the integrity with which he goes about making his art. Bochner's refusal to attempt to reproduce in another form the effects possible only in the full-scale work comes through strongly in the drawings; their honesty and absolute clarity give them an ascetic power.

JC

NOTES: 1. Mel Bochner, talk at Museum of Art, Carnegie Institute, 30 April 1981. 2. Bochner. 3. Bochner. 4. Robert Pincus-Witten, *Postminimalism* (New York, 1977), 113.

CHUCK CLOSE

B. 1940

Gwynne
1981
fingerprints and stamp-pad ink
on gray-green paper
29 x 21 ¾ in.
(73.6 x 55.2 cm.)
Wilbur Ross, Jr., Fund, Mary
Oliver Robinson Memorial
Fund, Patrons Art Fund,
Contemporary American
Drawings Fund, and National
Endowment for the Arts, 82.44

ALTHOUGH for some years the human figure has been his only subject, Chuck Close has tended to regard it purely as a "source of information" rather than an exemplar of what he sees as "outworn humanist notions."[1] Working always from photographs, he records human features objectively and dispassionately, reproducing every flaw and imperfection. In the late 1960s his images were more or less direct transcriptions of his photographic sources onto paper or canvas, but in recent years he has resorted to formal devices such as grids and mechanically graded shading to emphasize the conceptual basis of his work and to remove it from the traditional realm of portraiture.

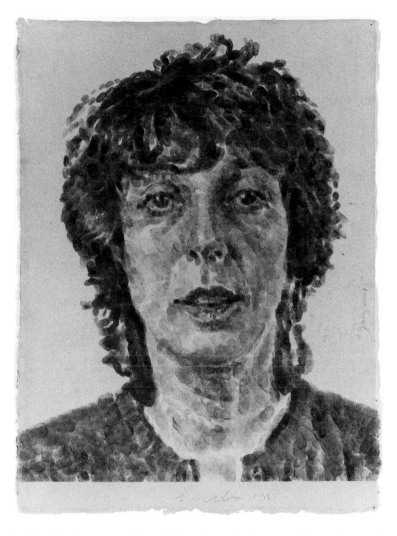

Close, *Gwynne*

Yet despite the impersonality of Close's technique and intention and the purely formal, abstract beauty of his paintings and drawings, the human content of his work inevitably remains. We as viewers simply cannot refrain from reading pictures of human faces for meaning or from responding to them as if they were in some sense the person represented. In this drawing, as in most of Close's work, the sitter is a friend and something of his feeling for her comes through despite his expressed intentions to the contrary. The real subject of the drawing, the quality that gives it resonance as a work of art, is not its conceptual basis but the tension between the human reality of Gwynne herself and the deliberately crude technique that Close has used in depicting her. Despite his rigorous formalism and his use of the nonart medium of stamp-pad ink applied with the tips of his fingers, something of this subject's essence is inseparable from her likeness. Her liquid eyes, alert expression, and mouth open as if about to speak come through more powerfully because her image seems threatened with dissolution back into the fingerprints of which it is made. Something similar happens in Close's paintings, whose extremely large size and merciless focus make the viewer identify with the sitter's vulnerability and possible embarrassment.

JC

NOTES: 1. Quoted in Cindy Nemser, "An Interview with Chuck Close," *Artforum* (January 1970): 8; and William Dyckes, "The Photo as Subject: The Paintings and Drawings of Chuck Close," *Arts Magazine* (February 1974): 48.

ROMARE BEARDEN

B . 1 9 1 4

BORN in Charlotte, North Carolina, in 1914, Romare Bearden spent two or three years in the Pittsburgh neighborhood of Lawrenceville with his maternal grandparents, who raised him from the age of seven until he rejoined his parents in New York. Bearden often returned in the summers to both Charlotte and Pittsburgh, and he lived more or less constantly in Pittsburgh's East Liberty community before graduating from Peabody High School in 1929. Since then Bearden has lived in Harlem except for a stint in the army and four years in Paris from 1950 to 1954.

In the early 1940s Bearden's work reflected the Social Realist style then dominant in this country, but through most of the next decade he painted abstractly. In 1963, however, he joined Spiral, a group of artists devoted specifically to black subjects, and at about the same time he returned to figuration and took up the art of collage as his primary medium of expression. Over the next decade Bearden depicted life in the streets of Harlem in a fractured, jazzy, sometimes frenetic style that owed something to both Cubism and African art. Sometimes he turned as well to the steel mills he knew from his childhood in Pittsburgh, but his generalized treatment of these scenes was never recognizable as autobiography. In the late 1970s, however, Bearen began to focus on his own memories; as he did so his style became more direct, and he returned in part to the representational mode of his early years as an artist.

In *Pittsburgh Memories* Bearden has created a complex amalgam of twentieth-century forms of expression combined with Italian art of the fourteenth century, which he had admired and studied years before. The scene is his grandmother's roominghouse in Lawrenceville, in early morning or evening, as a man carrying a lunch box departs for work and a woman prepares food for another man and a child inside. Although the light in the room falls in fractured planes in the manner of Cubist or Precisionist paintings, the subject itself is presented without modernist distortions. The space, however, is not rational but magical, with the inside and outside of the house visible at once and the exterior behind rather than in front of the interior. The faces at the windows are much larger than the figures below, and the deep blue color of the sky behind them is at odds with the dawn or twilight of the rest of the sky. The deep blue is, however, the shade of the skies in Giotto's Arena Chapel frescoes in Padua. And the space itself, almost flat and without the orthogonal lines of recession found in Western painting after the Renaissance, resembles the half-real, half-ideal world of trecento Italian painting.

To some degree these fourteenth-century qualities must have been deliberate. Bearden once said that his artistic purpose was "to redefine the image of man in the terms of the Negro experience I know best," and there is, in *Pittsburgh Memories* and other recent works of Bearden's, a sense of timeless narrative. Although the scene he depicts is clearly from his

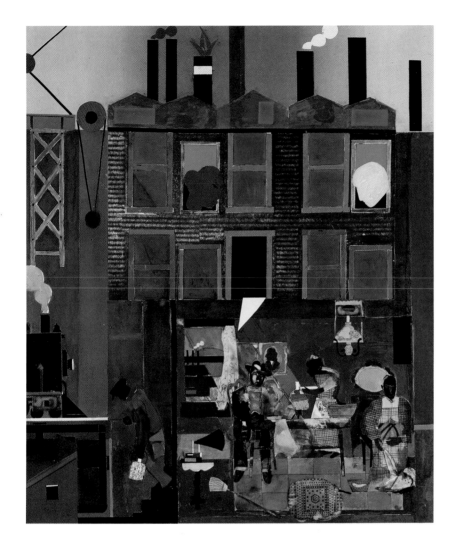

Bearden, *Pittsburgh Memories*

memory, it has about it both the specific existence of a particular time and the implication that the action he depicts is quintessential and somehow forever continuing. Ralph Ellison perceptively described Bearden's work as dominating "all the world and time through technique and vision. His mission is to bring a new visual order into the world, and through his art he seeks to reset society's clock by imposing upon it his own method of defining the times."[2]

JC

NOTES: 1. Quoted in M. Burch Washington, *The Art of Romare Bearden: The Prevalence of Ritual* (New York, 1972), 7. 2. The Art Gallery, State University of New York at Albany, *Romare Bearden: Paintings and Projections* (1968), exh. cat., introduction by Ralph Ellison.

COLLECTION
CHECKLIST

This checklist summarizes information on American drawings in the collection of the Museum of Art, Carnegie Institute. The checklist does not list individually 79 drawings and watercolors by Lawrence Saint (1885–1961) and 346 drawings by Samuel Rosenberg (1896–1972). The Saint collection consists of studies of stained glass connected with Saint's exploration of medieval stained glass windows. The Rosenberg drawings are sketches and studies from the artist's studio that were given to the museum after the artist's death by his son, Murray Z. Rosenberg, M.D.

The checklist is arranged alphabetically by artist's last name. Works by the same artist follow chronologically, earliest first. Works of the same date follow alphabetically. Works by unidentified artists are placed according to nationality and period.

Dimensions are given for sheet unless otherwise specified. Height precedes width. The medium of the signature and inscription is the same as at least one medium of the drawing unless otherwise specified. A single slash indicates line breaks in an inscription. A double slash in inscription, exhibition history, and bibliography separates references. The abbreviation [illeg.] replaces an indecipherable mark; [?] indicates doubt about whatever immediately precedes it. Underscore in a signature reproduces an underscore on the drawing.

Until 1963, the museum was known as Department of Fine Arts, Carnegie Institute. In 1963, the name became Museum of Art, Carnegie Institute. Exhibition references before 1963 are cited as Carnegie Institute; after 1963 they are cited as Museum of Art, Carnegie Institute.

MOA Masterpieces
Museum of Art, Carnegie Institute, 29 January–3 April 1983, *Masterpieces of American Drawing and Watercolor from the Collection of the Museum of Art, Carnegie Institute.*

Carnegie Institute, *Lists*
Carnegie Institute, *Lists of Paintings, Drawings and Japanese Prints in the Permanent Collection of the Department of Fine Arts: A Preliminary Publication, Subject to Revision.* Published in 1912; bound with an addendum, 1917.

Childe Hassam in MOA
Museum of Art, Carnegie Institute, 5 June–22 August 1982, *Childe Hassam in the Collection of the Museum of Art, Carnegie Institute.*

ABBEY, EDWIN AUSTIN
1852—1911

1. *The Tinker's Song,* 1880
(illus. p. 77)

pen and ink on cardboard
11 ¼ x 7 ⅜ in. (28.6 x 18.7 cm.)
signed and dated center left: E. A. Abbey 1880
Purchase, 14.4

Provenance:
Wesley Harper, Inc., New York.

Exhibitions:
Carnegie Institute, 17 June–13 August 1941, *Drawings by*
E. A. Abbey // Museum of Art, Carnegie Institute, 29
January–3 April 1983, *MOA Masterpieces.*

Bibliography:
Selections from the Poetry of Robert Herrick (New York, 1882),
illus. opposite 46 // Carnegie Institute, *Lists* (1917).

ALEXANDER, JOHN WHITE
1856—1915

2. *Frank Stockton,* 1886
(illus. p. 82)

charcoal on paper
21 x 16 ½ in. (53.3 x 41.9 cm.)
signed and dated upper left: J. W. Alexander—86
Andrew Carnegie Fund, 06.3.1

Provenance:
Century Company, New York.

Exhibitions:
Museum of Art, Carnegie Institute, 29 January–3 April
1983; Flint Institute of Arts, Flint, Michigan, 18 December
1983–5 February 1984, *MOA Masterpieces,* no. 1.

Bibliography:
The Century XXXII (July 1886): frontispiece // Carnegie
Institute, *Lists* (1917).

Remarks:
This drawing was shipped to Detroit Publishing Company
for reproduction on postcards on 20 April 1918. An erased
signature "J. W. Alexander 86" is visible at lower right.

AMERICAN, 19TH CENTURY

3. *William Bartlett of Newport, Massachusetts,*
c. 1810

watercolor on ivory
2 ¹¹⁄₁₆ x 2 ⅛ in. (6.8 x 5.4 cm.)
Bequest of Edgar W. and Bernice Chrysler Garbisch,
81.21.2

Provenance:
Estate of the donors, New York.

AMERICAN, 19TH CENTURY

4. *Merchant Ship,* c. 1818

watercolor and iron gall ink on paper
14 ½ x 19 ⅝ in. (36.8 x 49.8 cm.)
Bequest of Edgar W. and Bernice Chrysler Garbisch,
81.21.1

Provenance:
Estate of the donors, New York.

Exhibitions:
Museum of Art, Carnegie Institute, 29 January–3 April
1983; Flint Institute of Arts, Flint, Michigan, 18 December
1983–5 February 1984, *MOA Masterpieces,* no. 2.

Remarks:
Although this work was previously titled *Clipper Ship,* the
vessel it portrays lacks the sleekness of body and height of
mast to warrant that designation. It is actually an ocean-
going merchant ship of the early nineteenth century. The
ship's American flag contains twenty-one stripes, the
number employed after Illinois joined the Union in 1818.
This suggests the approximate date of the work. The coastal
sailing vessel in the distance flies a tri-color flag, the red-
white-and-blue of France.

AMERICAN, 19TH CENTURY

5. *Portrait of a Man,* c. 1820

watercolor on ivory
5 ¼ x 3 ¾ in. (13.3 x 9.5 cm.)
Bequest of Edgar W. and Bernice Chrysler Garbisch,
81.21.3

Provenance:
Estate of the donors, New York.

AMERICAN, 19TH CENTURY

6. *St. John's Chapel, Broadway,* c. 1825

graphite, pen and ink, brush and ink, gouache, and
copper paint on paper
14 ⅞ x 19 ½ in. (37.8 x 49.5 cm.)
Bequest of Edgar W. and Bernice Chrysler Garbisch,
81.21.4

Provenance:
Estate of the donors, New York.

Exhibitions:
Museum of Art, Carnegie Institute, 29 January–3 April
1983; Flint Institute of Arts, Flint, Michigan, 18 December
1983–5 February 1984, *MOA Masterpieces,* no. 3.

Remarks:
The subject is St. John's Chapel in New York City, which
was designed by John McComb, Jr. (1763–1853). It was
built in 1807 but destroyed in 1918 to make room for a
railroad freight terminal. The costumes of the figures date
to about 1820.

ANLIKER, ROGER
b. 1 9 2 4

7. *Fireworks at La Coruna,* 1956–57

gouache on paper
21 ½ x 29 ¾ in. (54.6 x 75.6 cm.)
signed and dated lower right: Anliker 1956–57
Gift of Mr. and Mrs. James H. Beal, 60.3.1

Provenance:
The artist.

Exhibitions:
Hewlett Gallery, Carnegie Institute of Technology, Pittsburgh, 1958 // Carnegie Institute, 17 January–21 February 1960, *Roger Anliker* // Westmoreland Museum of Art, Greensburg, Pennsylvania, 22 January–27 February 1963, *Roger Anliker* // Museum of Art, Carnegie Institute, 12 August–11 September 1977, *Some Pittsburgh Artists from the Permanent Collection.*

ANSHUTZ, THOMAS
1 8 5 1 — 1 9 1 2

**8. *Two Boys by a Boat,* 1895
(illus. p. 127)**

graphite and watercolor on paper
10 x 13 ⅜ in. (25.4 x 34 cm.)
inscribed verso: sketches of boats
Gift of Mrs. Carl Selden, 82.100

Provenance:
The donor, New York.

Remarks:
Two published related works are: *Two Boys and a Boat, Near Cape May,* 1894, watercolor on paper, in Graham Gallery, New York, *Thomas Anshutz 1851–1912,* exh. cat., no. 70, illus. // *Two Boys by a Boat,* 1894, watercolor on paper, in Ruth Bowman, "Nature, the Photograph and Thomas Anshutz," *Art Journal* XXXIII (Fall 1973): 37. The composition is related to a photograph by Anshutz in the Archives of American Art.

ANTHONY, CAROL
b. 1 9 4 3

9. *Carl Sandburg,* 1976

crayon, oil, and gouache on paper
9 ¹¹⁄₁₆ x 10 in. (24.3 x 25.4 cm.), sight
signed and dated, graphite, lower right: 1976 Carol Anthony // inscribed, graphite, lower left: Carl Sandburg // inscribed center: He will be lonely enough / to have time for the work / he knows as his own. / Tell him solitude is / creative if he is strong / and that final decisions / are made in silent rooms.
National Endowment for the Arts and Women's Committee of the Museum of Art, 76.23.1

Provenance:
Harriet Griffin Gallery, New York.

ARITA, AKIRA
b. Japan, 1 9 4 7

**10. *Fennel,* 1976
(illus. p. 229)**

graphite on paper
39 ⅞ x 29 ⅞ in. (101.1 x 75.9 cm.)
signed lower center: ARITA 1976
Leisser Art Fund, 81.15.1

Provenance:
The artist.

Exhibition:
Museum of Art, Carnegie Institute, 12 June–8 August 1982, *Akira Arita: Drawings,* no. 22.

ARMSTRONG, DAVID
b. 1 9 4 7

11. *Extended Family,* 1982

watercolor on paper
48 x 76 in. (101.6 x 193 cm.)
Gift of Harold H. Stream III, 83.44

Provenance:
The donor.

Exhibition:
Southern Alleghenies Museum of Art, Loretto, Pennsylvania, 24 September–27 November 1983, *Painters of the Pennsylvania Landscape.*

ARTSCHWAGER, RICHARD
b. 1 9 2 4

12. *Door, Window, Table, Basket, Mirror, Rug,* 1975

graphite and pen and ink on paper
28 ⅞ x 21 ½ in. (73.3 x 54.6 cm.)
signed and dated lower right: Artschwager '75 // inscribed, ballpoint pen, lower left: 49–B
Contemporary American Drawings Fund, Patrons Art Fund, and National Endowment for the Arts, 82.42

Provenance:
Leo Castelli Gallery, New York.

Exhibition:
Museum of Art, Carnegie Institute, 9 October–12 December 1982, *Recent Acquisitions: Works on Paper.*

ASHE, E. M.
1 8 7 0 — 1 9 4 3

13. *Woman Arranging Hair,* c. 1900

charcoal and pastel on gray paper
21 x 16 in. (55.4 x 40.6 cm.)
signed, charcoal, lower left: E. M. Ashe
Purchase, 10.6.1

Exhibition:
Irene Kaufmann Settlement House, Pittsburgh, 17 November 1925.

AUDUBON, JOHN JAMES
b. Haiti, 1 7 8 5 — 1 8 5 1

14. *Benjamin Page,* 1819
(illus. p. 34)

graphite, charcoal, and white chalk on a pink ground on paper
11 ⅜ x 9 in. (28.9 x 22.9 cm.)
signed, dated, and inscribed verso: John J. Audubon /
fecit September 1819 / Shippingport, KY
Gift of Benjamin Page, 76.66

Provenance:
Benjamin Page; Anna Lea Bakewell, New Haven;
Benjamin Page, Jr., Pittsburgh; the donor (great-great-
grandson of the sitter), Bridgehampton, New York.

Exhibitions:
University of Pittsburgh, 1938, *Paintings by Pittsburgh Artists
of the Nineteenth Century,* no. 1 // National Audubon Society,
New York, 1951, *Second Audubon Centennial Exhibition:
Audubon as a Portrait Painter,* no. 5 // Princeton University
Library, 1959, *The World of John James Audubon,* no. 24 //
Munson-Williams-Proctor Institute, Utica, New York, 11
April–30 May 1965; Pierpont Morgan Library, New York,
15–30 July 1965, *Audubon Watercolors and Drawings,* no. 28,
plate 26 // Museum of Art, Carnegie Institute, 29
January–3 April 1983, *MOA Masterpieces,* no. 4.

Bibliography:
B. G. Bakewell, *The Family Book of Bakewell, Page, Campbell*
(Pittsburgh, 1896), illus. opposite 72 // "Audubon in
Pittsburgh," *The Cardinal* I (July 1924): 17, illus. opposite
20 // Bayard H. Christy, "Auduboniana," *The Cardinal* III
(January 1931): 205 // Munson-Williams-Proctor Institute,
Utica, New York, *Audubon Watercolors* (1965), exh. cat. by
Edward Dwight, no. 28, plate 26.

AULT, GEORGE
1 8 9 1 — 1 9 4 8

15. *Smoke Stacks,* 1925
(illus. p. 159)

graphite on paper
13 ⅞ x 9 ⅞ in. (35.2 x 25.1 cm.)
signed and dated lower right: G. C. Ault '25
Patrons Art Fund, 83.4

Provenance:
Vanderwoude Tananbaum Gallery, New York.

Exhibition:
Vanderwoude Tananbaum Gallery, New York, 16
November–11 December 1982, *George Ault: Works on Paper
with Related Paintings 1920s to 40s.*

AVINOFF, ANDREY
b. Russia, 1 8 8 4 — 1 9 4 9

16. *Begonias,* n.d.

graphite and watercolor on paper
11 ½ x 8 ¹³⁄₁₆ in. (29.2 x 20.8 cm.)
signed, ink, lower right: [illeg.]
Gift of Mr. and Mrs. John B. Sutton, Jr., 59.54

Provenance:
The donors, Pittsburgh.

BACHARDY, DON
b. 1 9 3 4

17. *Portrait of a Young Woman,* n.d.

ink and graphite on paper
19 x 14 in. (48.3 x 35.6 cm.), sight
Bequest of C. Hale Matthews III, 81.26.1

Provenance:
Estate of the donor, New York.

18. *Portrait of a Young Woman,* n.d.

graphite on paper
18 ⅞ x 14 in. (47.9 x 35.6 cm.), sight
Bequest of C. Hale Matthews III, 81.26.2

Provenance:
Estate of the donor, New York.

BAKER, DWIGHT C.
1 8 5 6 — 1 9 4 1

19. *Boy and Dog,* 1872

graphite and pen and ink on paper
14 x 11 ¼ in. (35.6 x 28.6 cm.)
Gift of Robert E. Baker, 74.22.1

Provenance:
The donor, Pittsburgh.

Remarks:
A letter of May 1974 from the artist's son (Museum of Art
files) relates family history and notes that Dwight Baker
"exhibited artistic ability early." He learned cabinet-
making, carpentry, and wagon-making from his uncle at
sixteen and at twenty-nine built his own wood and iron-
working shop, which he operated for fifty years. His lifetime
"hobby," however, was "sketching."

20. *Deer Jumping over Ravine,* 1872

pen and ink on card
13 ⅞ x 18 ¼ in. (35.2 x 46.4 cm.)
signed and dated lower right: D. C. Baker 1872
Gift of Robert E. Baker, 74.22.2

Provenance:
The donor, Pittsburgh.

BARKER, WALTER W.
b. 1921

21. *Untitled,* n.d.

brush and ink and watercolor on paper
22 ⅛ x 30 in. (56.2 x 76.2 cm.)
Gift of Morton D. May, 56.28.2

Provenance:
The donor, St. Louis.

22. *Untitled,* n.d.

watercolor on paper
22 x 30 in. (55.9 x 76.2 cm.)
signed and dated, ballpoint pen, verso: Walter Barker
1955 // inscribed verso: M. D. May
Gift of Morton D. May, 56.28.3

Provenance:
The donor, St. Louis.

BARNET, WILL
b. 1911

23. *Big Duluth I,* 1958

ballpoint pen and gouache on paper mounted on paper
8 ½ x 4 ¹⁵⁄₁₆ in. (21.6 x 12.5 cm.), image
signed and dated lower right: Will Barnet '58
Gift of Mr. and Mrs. James H. Beal, 63.1.2

Provenance:
With Peter H. Deitsch, New York, until 1963; the donors,
Pittsburgh.

24. *Great Lake,* 1958

graphite, pen and ink, and gouache on paper mounted on
paper
8 ⁷⁄₁₆ x 5 ⅜ in. (21.4 x 13.7 cm.), image
signed lower center: Will Barnet
Gift of Mr. and Mrs. James H. Beal, 63.1.3

Provenance:
With Peter H. Deitsch, New York, until 1963; the donors,
Pittsburgh.

BARSE, GEORGE RANDOLPH
1861 — 1938

25. *Moths,* c. 1899

graphite heightened with white on brownish paper
44 ½ x 37 ½ in. (113 x 95.3 cm.), sight
inscribed center: ELECTRIC LIGHT
Andrew Carnegie Fund, 06.24

Provenance:
G. R. Barse, Jr.

Remarks:
This drawing was a design for a ceiling, executed for the
entrance hall of a house on 55th Street in New York, dated
1899.

BASKIN, LEONARD
b. 1922

26. *Head,* c. 1965

graphite and brush and ink on laid paper
18 ⅛ x 22 ⅝ in. (46.1 x 57.5 cm.)
Gift of Mr. and Mrs. James H. Beal, 67.3.1

Provenance:
The donors, Pittsburgh.

BEARDEN, ROMARE
b. 1914

27. *Pittsburgh Memories,* 1984
(illus. p. 239)

collage on board
28 ⅝ x 23 ½ in. (72.7 x 59.7 cm.)
signed, ballpoint pen, lower left: *Romare Bearden*
Gift of Mr. and Mrs. Ronald R. Davenport and Mr. and
Mrs. Milton A. Washington, 84.63

Remarks:
This work was commissioned for the Museum of Art by the
donors.

BEAUX, CECILIA
1863 — 1942

28. *Sketch of Ida Tarbell,* 1917–18

crayon on paper
12 ⅜ x 10 in. (31.4 x 25.4 cm.)
signed lower left: Cecilia Beaux // inscribed lower left: Ida
Tarbell / Sketch
Purchase, 18.25.1

Provenance:
American Artists' War Emergency Fund, New York.

BECHTLE, C. RONALD
b. 1924

29. *October LXXXI,* 1981

watercolor on paper
21 ¹⁵⁄₁₆ x 16 ¼ in. (55.2 x 41.2 cm.), sight
signed lower right: Bechtle LXXXI // inscribed, felt tip
pen, verso: C, "October", LXXXI, C Ronald Bechtle
Gift of the artist, 84.16

Provenance:
The artist, Stamford, Connecticut.

BECKMAN, WILLIAM
b. 1 9 4 2

30. Study for "Diana and Deirdra", 1980
(illus. p. 233)

graphite on paper
29 x 23 in. (73.6 x 58.4 cm.)
Contemporary American Drawings Fund and National
Endowment for the Arts, 82.22.1

Provenance:
Allan Frumkin Gallery, New York.

Exhibition:
Museum of Art, Carnegie Institute, 9 October–12
December 1982, *Recent Acquisitions: Works on Paper.*

BELLOWS, ALBERT F.
1 8 3 0 — 1 8 8 3

31. Farm House, c. 1870

graphite and white gouache on buff paper
7 x 9 in. (17.8 x 22.9 cm.)
inscribed lower left: thick dark green moss on tree trunks /
thick leaves // inscribed lower right: yellow [?] house /
trees in light-brownish yellow // stamped lower right:
A. F. Bellows sale 1884
Andrew Carnegie Fund, 06.13

Provenance:
C. Klackner, New York.

Bibliography:
Carnegie Institute, *Lists* (1917).

32. Landscape, c. 1870

charcoal on paper
12 ¼ x 17 ½ in. (31.1 x 44.5 cm.)
Andrew Carnegie Fund, 06.23

Provenance:
H. Wunderlich and Company, New York.

Bibliography:
Carnegie Institute, *Lists* (1917).

BENDINER, ALFRED
1 8 9 9 — 1 9 6 4

33. Madrid, 1953

watercolor on paper
17 ⅝ x 21 ½ in. (44.8 x 54.6 cm.)
signed and inscribed, graphite, lower right: Alfred
Bendiner (8.5.B.) // inscribed, graphite, lower right: —
Madrid orange crayon—B + B // inscribed, graphite,
verso: —SPAIN / #129.—"Madrid"—W. C. 15.1953 /
MADRID
Gift of Mrs. Alfred Bendiner, 82.80.9

Provenance:
The donor, Philadelphia.

34. Travel Is So Broadening, 1960

pen and ink on paper
10 ¾ x 8 ⅜ in. (27.3 x 21.3 cm.)
Gift of Mrs. Alfred Bendiner, 82.53.3

Provenance:
The donor, Philadelphia.

Remarks:
The drawing was made on a sheet of hotel stationery with
the letterhead of the Skirvan Hotels, Oklahoma City.

35. Vancouver Boats I, 1962

pen and colored inks and brush and colored inks on paper
12 x 14 ⅞ in. (30.5 x 37.8 cm.)
inscribed and dated lower right: Vancouver B. C. 1962 //
inscribed, graphite, verso: #40 "Vancouver Boats I /
W.C. + ink / Great Britain
Gift of Mrs. Alfred Bendiner, 82.53.5

Provenance:
The donor, Philadelphia.

36. Beach on Vazore—Portugal, n.d.

ink, graphite, and watercolor on paper
19 ¾ x 25 ⅝ in. (50.2 x 65.1 cm.)
signed lower right: Alfred Bendiner // inscribed lower left:
Beach Vazore—Portugal // inscribed lower center: dos
cabecai
Gift of Mrs. Alfred Bendiner, 82.80.2

Provenance:
The donor, Philadelphia.

37. Edgartown, n.d.

watercolor on paper
15 ½ x 19 in. (39.4 x 48.3 cm.)
signed, graphite, lower right: Alfred Bendiner // inscribed,
graphite, lower left: [illeg.]
Gift of Mrs. Alfred Bendiner, 82.80.3

Provenance:
The donor, Philadelphia.

38. Guggenheim Museum, n.d.

pen and ink, brush and ink, and wash on paper
13 ⅜ x 20 ½ in. (34 x 52.1 cm.)
signed and inscribed verso: No. 25.00 "Guggenheim" /
ink and wc, ITALY,G
Gift of Mrs. Alfred Bendiner, 82.53.1

Provenance:
The donor, Philadelphia.

39. House of Knights Templars, Rhodes, n.d.

watercolor on paper
25 x 18 ¾ in. (63.5 x 47.6 cm.)
Gift of Mrs. Alfred Bendiner, 82.80.5

Provenance:
The donor, Philadelphia.

40. *Kiosk,* n.d.

colored pencil on cardboard
12 ⅞ x 10 ½ in. (32.7 x 26.7 cm.)
signed, graphite and black pencil, lower right: Alfred
Bendiner // inscribed, graphite, lower left: Kiosk
Gift of Mrs. Alfred Bendiner, 82.53.2

Provenance:
The donor, Philadelphia.

41. *Mexico City,* n.d.

ink on laminated linen
15 ⅛ x 22 ⁹⁄₁₀ in. (38.4 x 57.3 cm.)
signed lower right: Alfred Bendiner // inscribed lower
right: Mexico City / Philadelphia 5 // inscribed, graphite,
verso: 7.634A "Mexican Shop"—print on linen
Gift of Mrs. Alfred Bendiner, 82.80.10

Provenance:
The donor, Philadelphia.

42. *The River,* n.d.

watercolor on paper
15 x 20 in. (38.1 x 50.8 cm.)
inscribed verso: no. 30–34, "the River"—w.c., U.S.A., G
Gift of Mrs. Alfred Bendiner, 82.53.4

Provenance:
The donor, Philadelphia.

BIEDERMAN, CHARLES
b. 1906

**43. *Study for "New York, January 1936",* 1936
(illus. p. 197)**

gouache on paper
16 ⅞ x 13 ⅞ in. (42.9 x 35.2 cm.)
signed and dated, graphite, lower right: Biederman
1/1936 // signed and dated, graphite, verso: *Charles
Biederman* 1/1936
Gift of the American Academy and Institute of Arts and
Letters, Hassam and Speicher Purchase Fund, 83.60

Provenance:
The artist, Red Wing, Minnesota; with Grace Borgenicht
Gallery, New York.

Exhibitions:
The Minneapolis Institute of Arts, 17 October–2 January
1977, *Charles Biederman: A Retrospective,* no. 131.

Bibliography:
The Minneapolis Institute of Arts, *Charles Biederman:
A Retrospective* (1976), exh. cat. with commentaries by
Charles Biederman, 49.

Remarks:
This work is related to a series of gouaches and oils dating to
1936–37, particularly *New York, 1936* and *New York,
January 1936* (nos. 130 and 135 in *Charles Biederman: A
Retrospective*), but no painting was actually executed from
this study.

BIRCH, REGINALD BATHURST
1856—1943

44. *Red Riding Hood,* c. 1900

graphite and pen and ink on cardboard
17 ⅜ x 10 ⅝ in. (44.1 x 27 cm.)
inscribed verso: (unpublished) / Stock
Andrew Carnegie Fund, 06.12.1

Provenance:
Frederick Keppel and Company, New York.

Bibliography:
Carnegie Institute, *Lists* (1917).

BLAKELOCK, RALPH A.
1847—1919

**45. *Redwoods, California,* 1869
(illus. p. 114)**

graphite and pen and ink on paper mounted on board
11 x 8 ⅜ in. (28 x 21.3 cm.)
signed lower left: Blakelock // inscribed and dated lower
left: Redwoods-Cal. Aug. 1869 // inscribed center right:
shadow / light
Andrew Carnegie Fund, 06.18.2

Provenance:
New York Cooperative Society.

Exhibitions:
Museum of Art, Carnegie Institute, 29 January–3 April
1983; Flint Institute of Arts, Flint, Michigan, 18 December
1983–5 February 1984, *MOA Masterpieces,* no. 6.

Bibliography:
Carnegie Institute, *Lists* (1917).

**46. *Untitled* c. 1870
(illus. p. 116)**

graphite, pen and ink, and wash on paper mounted on
board
5 ⅞ x 3 ¼ in. (14.9 x 8.3 cm.)
Andrew Carnegie Fund, 06.18.1

Provenance:
New York Cooperative Society.

Exhibitions:
Museum of Art, Carnegie Institute, 29 January–3 April
1983; Flint Institute of Arts, Flint, Michigan, 18 December
1983–5 February 1984, *MOA Masterpieces,* no. 5.

Bibliography:
Carnegie Institute, *Lists* (1917).

BLASHFIELD, EDWIN HOWLAND
1848—1936

**47. *Study Fragment from "Decoration in Court of
Appeals, New York",* 1899**

graphite on paper
11 ⅛ in. (28.3 cm.), diameter
signed and dated lower right: Edwin Howland Blashfield
1899
Andrew Carnegie Fund, 07.5

Provenance:
The artist, New York.

Bibliography:
Ernest Knauff, "An American Decorator: Edwin H. Blashfield," *The International Studio* XIII (March 1901): illus., 27 // Carnegie Institute, *Lists* (1917).

B L U M , R O B E R T F R E D E R I C K
1 8 5 7 — 1 9 0 3

48. *Boulangerie Française,* **1879**

graphite on paper mounted on cardboard
10 ⅝ x 9 1/16 in. (27 x 24.5 cm.)
Andrew Carnegie Fund, 06.3.2

Provenance:
Century Company, New York.

49. *Jefferson Reading the Declaration of Independence,* **1880**

graphite, brush and ink, and gouache on buff paper
12 ½ x 9 ⅝ in. (31.8 x 24.5 cm.)
signed and dated center: Blum 1880
Andrew Carnegie Fund, 06.3.3

Provenance:
Century Company, New York.

50. *A Shoe-Shop,* **1888**

pen and ink on cardboard
8 x 10 ⅜ in. (20.3 x 26.4 cm.)
signed and dated lower center: Blum 88
Andrew Carnegie Fund, 06.3.5

Provenance:
Century Company, New York.

Bibliography:
Carnegie Institute, *Lists* (1917).

51. *An Election Clerk Writing Out Ballots,* **1890**

pen and ink wash on paper mounted on cardboard
11 ⅞ x 10 ⅝ in. (30.2 x 27 cm.)
signed lower left: Blum // inscribed lower right: an election clerk // inscribed lower left: [illeg.] election clerk writing out ballots. $10.
Andrew Carnegie Fund, 06.19.1

Provenance:
Charles Scribner's Sons, New York.

Exhibitions:
Museum of Art, Carnegie Institute, 29 January–3 April 1983; Flint Institute of Arts, Flint, Michigan, 18 December 1983–5 February 1984, *MOA Masterpieces,* no. 7.

Bibliography:
J. H. Wigmore, "Starting a Parliament in Japan," *Scribner's Magazine* (July 1891), illus., 34.

52. *A "Wakaishi"—A Japanese Bachelor Who Manages Public Festivities,* **1891**
(illus. p. 91)

pen and ink and ink wash heightened with white on paper mounted on cardboard
12 ½ x 9 ⅛ in. (31.8 x 23.2 cm.)
signed center left: Blum
Andrew Carnegie Fund, 06.19.2

Provenance:
Charles Scribner's Sons, New York.

Exhibitions:
Museum of Art, Carnegie Institute, 29 January–3 April 1983; Flint Institute of Arts, Flint, Michigan, 18 December 1983–5 February 1984, *MOA Masterpieces,* no. 8.

Bibliography:
John H. Wigmore, "Starting a Parliament in Japan," *Scribner's Magazine* (July 1891): 40 // Carnegie Institute, *Lists* (1917) // Henry Adams, "John La Farge and Japan," *Apollo* (February 1984): 121–29, illus., 126.

53. *Some Types of Japanese Babies (All Kinds of Babies),* **c. 1891**

graphite on buff cardboard
8 x 7 ¼ in. (20.3 x 18.4 cm.)
signed lower left: Blum
Andrew Carnegie Fund, 06.19.3

Provenance:
Charles Scribner's Sons, New York.

Bibliography:
Sir Edwin Arnold, "JAPONICA: Fourth Paper— Japanese Ways and Thoughts," *Scribner's Magazine* IX (March 1891): illus., 330 // Carnegie Institute, *Lists* (1917).

54. *Japanese Girl with Habatshi,* **n.d.**

graphite and pastel on fine-grained sandpaper
11 ⅞ x 15 in. (30.2 x 38.1 cm.)
Andrew Carnegie Fund, 06.9.1

Provenance:
Henrietta Haller, New York; W. J. Baer, New York.

Exhibition:
Irene Kaufmann Settlement House, Pittsburgh, 14 November 1927.

Bibliography:
Carnegie Institute, *Lists* (1917).

55. *Monk and Donkey* **n.d.**

pen and ink on buff cardboard
9 ¼ x 12 in. (23.5 x 30.5 cm.)
signed lower right: Blum
Andrew Carnegie Fund, 06.3.4

Provenance:
Century Company, New York.

Bibliography:
Carnegie Institute, *Lists,* (1917).

56. *Study for "A Man in Macaroni Costume",* **n.d.**

pen and ink on paper
11 ¾ x 7 ¼ in. (29.8 x 18.4 cm.)
stamped lower right: ⌊Blum⌋
Andrew Carnegie Fund, 06.2

Provenance:
W. J. Baer, New York.

Exhibition:
Irene Kaufmann Settlement House, Pittsburgh, 17 November 1925.

Remarks:
This drawing was shipped to the Detroit Publishing Company for reproduction on postcards on 20 April 1918.

57. *Study for "Girl in Colonial Dress",* n.d.

graphite on paper
12 ⅛ x 8 ½ in. (30.8 x 21.6 cm.)
stamped lower right: ⌊Blum⌋
Andrew Carnegie Fund, 06.9.3

Provenance:
Henrietta Haller, New York; W. J. Baer, New York.

Exhibition:
Irene Kaufmann Settlement House, Pittsburgh, 14 November 1927.

Bibliography:
Carnegie Institute, *Lists* (1917).

Remarks:
This drawing was shipped to the Detroit Publishing Company for reproduction on postcards on 20 April 1918.

BLUME, PETER
b. Russia, 1906

**58. *Study for "South of Scranton" (Crow's Nest),*
1930**
(illus. p. 162)

graphite on paper
13 ⅞ x 8 ¹⁵⁄₁₆ in. (35.2 x 22.7 cm.)
signed and dated lower right: Peter Blume 1930 //
inscribed lower center: sketch for "South of Scranton"
Patrons Art Fund, 84.28.1

Provenance:
James Maroney, Inc., New York.

Exhibitions:
The Currier Gallery of Art, Manchester, New Hampshire, 18 April–31 May 1964, *Peter Blume in Retrospect: 1925 to 1964,* no. 34 // James Maroney, Inc., New York, February 1984, *A Small Group of Especially Fine American Works on Paper.*

Bibliography:
The Currier Gallery of Art, Manchester, New Hampshire, *Peter Blume in Retrospect: 1925–1964, Paintings and Drawings* (1964), exh. cat. by Charles E. Buckley, no. 34 // James Maroney, Inc., New York, *A Small Group of Especially Fine American Works on Paper* (1984), exh. cat., no. 12.

BLUMENFELD, ROCHELLE REZNIK
b. 1936

59. *Flight,* n.d.

watercolor on paper
22 ¼ x 30 ¼ in. (56.5 x 76.8 cm.), sight
signed watercolor, lower right: RR Blumenfeld
50th Annual Associated Artists of Pittsburgh Exhibition Purchase Prize, 60.19

Provenance:
The artist, Pittsburgh.

Exhibition:
Carnegie Institute, 1960, *50th Annual Associated Artists of Pittsburgh Exhibition.*

BLUMENSCHEIN, E. L.
1874—1960

60. *An Indian Chief,* 1917–18

graphite, pen and ink, and ink wash on paper
9 x 11 in. (22.9 x 27.9 cm.)
signed lower right: E. L. Blumenschein
Purchase, 18.25.2

Provenance:
American Artists' War Emergency Fund, New York.

BLYTHE, DAVID GILMOUR
1815—1865

61. *Portrait of the Artist,* c. 1848
(illus. p. 40)

graphite on paper
8 ¼ x 5 ½ in. (21 x 14 cm.)
signed center right: D. G. Blithe // inscribed lower center: D. G. Blythe from nothing
Mr. and Mrs. James H. Beal Fund, 54.31.5

Provenance:
Thomas Blythe (brother of the artist), East Liverpool, Ohio; estate of his son, Heber Blythe, East Liverpool, Ohio.

Exhibitions:
Carnegie Institute, 22 December–31 January 1933, *David G. Blythe,* no. 2 // East Liverpool Historical Society, East Liverpool, Ohio, 11–14 October 1934, no. 20 // Whitney Museum of American Art, New York, 7 April–7 May 1936, *Paintings by David G. Blythe,* no. 37 // Butler Art Institute, Youngstown, Ohio, 20 March–12 April 1942, *Ohio Painters of the Past,* no. 4 // Butler Art Institute, Youngstown, Ohio, 10 October–2 November 1947, *David G. Blythe,* no. 2 // Columbus Gallery of Fine Arts, Columbus, Ohio, 7–31 March 1968, no. 1 // National Collection of Fine Arts, Washington, D. C.; Memorial Art Gallery, Rochester, New York; Museum of Art, Carnegie Institute, 1980–81, *The World of David Gilmour Blythe* // Museum of Art, Carnegie Institute, 29 January–3 April 1983, *MOA Masterpieces,* no. 10.

Bibliography:
Columbus Dispatch, 10 March 1898, 10 // Tom T. Jones, "The Reviewing Stand," *East Liverpool Review*, 1 December 1932 // John O'Connor, Jr., "Painting by David G. Blythe," *Carnegie Magazine* VI (January 1933): 230, illus., 229 // Evelyn Abraham, "David G. Blythe, American Painter and Woodcarver," *Antiques* XXVII (May 1935): 181 // John O'Connor, Jr., "A Pittsburgh Scene," *Carnegie Magazine* XVI (January 1943): 227 // Butler Art Institute, Youngstown, Ohio, *David G. Blythe* (1947), exh. cat., frontispiece // Dorothy Miller, *The Life and Work of David G. Blythe* (Pittsburgh, 1950), 95, frontispiece // Bruce William Chambers, "David Gilmour Blythe (1815–1865): An Artist at Urbanization's Edge" (Ph.D. diss., University of Pennsylvania, University Park, 1974), 257, 398–99 // National Collection of Fine Arts, Smithsonian Institution, Washington, D.C., *The World of David Gilmour Blythe* (1980), exh. cat., by Bruce W. Chambers, no. 262.

Remarks:
In the *East Liverpool Review*, Tom T. Jones wrote:
> Mr. Barth was enabled to find in the collection of Heber Blythe a well preserved photograph of David G. Blythe arrayed in the habit of a former day. Then there was an exceedingly interesting and almost unprecedented departure by Mr. Blythe noted when upon an old piece of paper was discovered a pencil drawing of the artist himself. With his own hand he had indited his own name to the bit of parchment and added the laconic words, "from nothing." This served to reveal that from his memory he had drawn his own likeness even to the extent of the inclusion of the high hat in the mode he affected which resembled that Abraham Lincoln habitually wore.
>
> The reproduction of his own face under these circumstances is a most striking departure and indicates that his was one carrying the features of a thinker and one given to deep moods. It also serves to recall that he was a man of tall proportions, one who had been a man of physical vigor in his active years.

62. *A Free-Trade Man,* c. 1854–58
(illus. p. 42)

graphite and pen and ink on paper
11 ¼ x 7 ¾ in. (28.6 x 19.7 cm.)
inscribed lower left: A Free-Trade Man—/Boots Del.
Mr. and Mrs. James H. Beal Fund, 54.31.4

Provenance:
Dr. Benjamin Ogden, East Liverpool, Ohio; Dr. Charles B. Ogden, East Liverpool, Ohio; Millard E. Blythe; Heber H. Blythe; estate of Heber H. Blythe.

Exhibitions:
East Liverpool, Ohio, 1934, *Centennial Historical Society Exhibit*, no. 3 // Columbus Gallery of Fine Arts, Columbus, Ohio, 8–31 March 1968, no. 2 // The Minneapolis Institute of Arts, 1 September–26 October 1976; Whitney Museum of Art, 23 November–23 January 1977; The Fine Arts Museums of San Francisco, 19 February–17 April 1977, *American Master Drawings and Watercolors*, no. 180 // National Collection of Fine Arts, Washington, D.C.; Memorial Art Gallery, Rochester, New York; Museum of Art, Carnegie Institute, 1980–81, *The World of David Gilmour Blythe (1815–1865)*, no. 260 // Museum of Art, Carnegie Institute, 29 January–3 April 1983, *MOA Masterpieces*, no. 9.

Bibliography:
Tom T. Jones, "The Reviewing Stand," *East Liverpool Review*, 1 December 1932 // Dorothy Miller, *The Life and Work of David G. Blythe* (Pittsburgh, 1950), 76, 125 // Bruce William Chambers, "David Gilmour Blythe (1815–1865): An Artist at Urbanization's Edge," (Ph.D. diss., University of Pennsylvania, University Park, 1974), nos. 18, 20, 21 // Theodore E. Stebbins, Jr., *American Master Drawings and Watercolors* (New York, 1976), illus., 180 // National Collection of Fine Arts, Smithsonian Institution, Washington, D.C., *The World of David Gilmour Blythe* (1980), exh. cat. by Bruce William Chambers, no. 260.

Remarks:
This work is also titled *William Bleakley*.
In the *East Liverpool Review*, Tom T. Jones wrote:
> He once made a pen and ink sketch of William Bleakley, an Englishman, born in England and a brother of John S., and James Bleakley of the pioneer Rockingham and yellow ware pottery here known as the Woodward and Bleakley plant. Mr. Bleakley was an uncompromising Democrat and Blythe an ardent Republican. Although arguing often they were much together. This sketch was in after years reproduced by a half tone process by John C. Bragden and published in an East Liverpool paper. The original of this sketch was found among the papers of Dr. Benjamin Ogden, pioneer physician in this city, and passed to his son the late Dr. Charles B. Ogden.

BOCHNER, MEL
b. 1940

63. *Color Study for "Syncline",* 1980
(illus. p. 235)

graphite and casein on paper
10 ¼ x 20 ³⁄₁₆ in. (26 x 51.3 cm.)
Collection of the artist, intended gift to the Museum of Art, Carnegie Institute, FA81.41.3

Provenance:
The artist, New York.

Exhibition:
Pittsburgh Plan for Art, 2–30 May 1982, *Roots and Branches: Pittsburgh's Jewish History.*

64. *Working Drawing for "Syncline",* 1980

graphite and red pencil on two sheets of paper pasted together
10 x 20 in. (25.4 x 50.8 cm.)
Collection of the artist, intended gift to the Museum of Art, Carnegie Institute, FA81.41.1

Provenance:
The artist, New York.

Exhibition:
Pittsburgh Plan for Art, 2–30 May 1982, *Roots and Branches: Pittsburgh's Jewish History.*

65. *Working Drawing for "Syncline",* 1980

graphite and colored pencil on two sheets of paper pasted together
10 x 20 in. (25.4 x 50.8 cm.)
Collection of the artist, intended gift to the Museum of Art, Carnegie Institute, FA81.41.2

Provenance:
The artist, New York.

Exhibition:
Pittsburgh Plan for Art, 2–30 May 1982, *Roots and Branches: Pittsburgh's Jewish History.*

Remarks:
There is a sketch in graphite and pen and ink on the verso of this drawing.

BOLOTOWSKY, ILYA

b. Russia, 1907 — 1981

66. *Untitled,* c. 1935
(illus. p. 195)

pen and ink on paper
11 ¼ x 15 ½ in. (28.6 x 39.4 cm.)
signed, graphite, verso: I. B.—553 // inscribed, graphite, verso: [initial of estate executor]
Patrons Art Fund, 84.28.2

Provenance:
Estate of the artist; with Washburn Gallery, New York.

BOYD, EDWARD FINLEY

1878 — 1964

67. *Untitled,* n.d.

pastel and gouache on red paper mounted on cardboard
10 ⅜ x 13 ⅝ in. (26.4 x 34.6 cm.)
signed lower right: E. F. Boyd
Gift of Mr. and Mrs. John Boyd, 81.19.1

Provenance:
The donors, Westport, Connecticut.

68. *Untitled,* n.d.

pastel and gouache on olive-green paper
10 ¼ x 13 ¾ in. (26 x 35 cm.)
Gift of Mr. and Mrs. John Boyd, 81.19.2

Provenance:
The donors, Westport, Connecticut.

BRENNAN, ALFRED

1853 — 1921

69. *Sword and Pistols,* 1882

pen and ink on paper
9 ¹³⁄₁₆ x 15 ⅛ in. (24.9 x 38.4 cm.), irregular
signed upper right: BRENNAN // inscribed center left: sword and pistols / (Gold-mounted) voted by the General Assembly of the State of Connecticut to their fellow/citizen Captain Isaac Hull in testimony of their sense of his virtues, gallantry and naval skill, / and a Malay Creese captured // inscribed upper center: ·MDCCCLXXXII·// inscribed, graphite, verso: made for [crossed out] / not used 30 00
Andrew Carnegie Fund, 06.3.7

Provenance:
Century Company, New York.

BRUSH, GEORGE DEFOREST

1855 — 1941

70. *Head of a Boy,* 1917–18

crayon on paper
13 ⅜ x 9 ⅜ in. (34 x 23.8 cm.)
signed center right: Geo. DeForest Brush
Purchase, 18.25.3

Provenance:
American Artists' War Emergency Fund, New York.

BUKOVNIK, GARY ALAN

b. 1947

71. *Red Tulips,* 1981

watercolor on paper mounted on panel
25 ½ x 97 ½ in. (64.8 x 247.7 cm.), overall
signed and dated lower right of right panel: Gary A. Bukovnik 1981
Museum purchase: gift of the Hunt Foundation, 81.48

Provenance:
The artist, San Francisco.

Exhibitions:
Museum of Art, Carnegie Institute, 9 October–12 December 1982, *Recent Acquisitions: Works on Paper //* Concept Art Gallery, Pittsburgh, 31 March–2 May 1984, *Flowers.*

Remarks:
This work is mounted as a three-panel folding screen.

BURCHFIELD, CHARLES E.

1893 — 1967

72. *Moon through Young Sunflowers,* 1916
(illus. p. 149)

gouache, graphite, and watercolor on paper
19 ⅞ x 14 in. (50.5 x 35.6 cm.)
signed and dated upper right and lower right: Chas Burchfield 1916 // inscribed verso: Moonlight on Corn
Gift of Mr. and Mrs. James H. Beal, 67.3.5

Provenance:
With Frank K. M. Rehn Galleries, New York, until 1956;
the donors, Pittsburgh.

Exhibitions:
Whitney Museum of American Art, New York, 11
January–26 February 1956; Baltimore Museum of Art, 14
March–22 April 1956; Museum of Fine Arts, Boston, 9
May–17 June 1956; San Francisco Museum of Art, 11
July–19 August 1956; Los Angeles County Museum of Art,
5 September–14 October 1956; The Phillips Gallery,
Washington, D.C., 4 November–11 December 1956;
Cleveland Museum of Art, 3 January–10 February 1957,
Charles Burchfield // Munson-Williams-Proctor Institute,
Utica, New York, 9 April–31 May 1970, *The Nature of
Charles Burchfield—A Memorial Exhibition*, no. 157 // Museum
of Art, Carnegie Institute, 29 January–3 April 1983, *MOA
Masterpieces*, no. 11 // The Metropolitan Museum of Art,
New York, 30 January–25 March 1984, *Charles Burchfield
Retrospective*.

Bibliography:
Charles Burchfield. Letter to Mrs. James Beal, 17 January
1956 (Archives of American Art) // Munson-Williams-
Proctor Institute, Utica, New York, *Charles Burchfield,
Catalogue of Paintings in Public and Private Collections* (1970),
no. 157 // Museum of Art, Carnegie Institute, *Catalogue of
Painting Collection* (1973), 31 // John I. H. Bauer, *Life and
Work of Charles Burchfield, 1893–1967, The Inlander* (New
York, 1982), 40, illus., 27.

Remarks:
Burchfield said in his letter to Mrs. James Beal on 17
January 1956:

> I was so pleased you got the 'lightening' and
> 'Moon Through Young Sunflowers'—I must
> confess I felt too that many of these early things
> were 'buried' and wondered why no one ever
> picked them up. But all's well that ends well; they
> have a good home with you.

73. *Swamp Landscape,* 1919

purple pencil on cardboard
10 ¼ x 14 ⅛ in. (26 x 35.9 cm.)
signed in monogram and dated lower right: CEB 1919 //
dated and inscribed verso: 1919 / 18–Swamp Landscape
Gift of Mr. and Mrs. James H. Beal, 67.3.7

Provenance:
The artist until 1953; the donors, Pittsburgh.

Exhibition:
The Print Club of Cleveland and Cleveland Museum of
Art, 4 November–31 December 1953, *The Drawings of
Charles E. Burchfield*, no. 60.

Remarks:
This drawing was purchased by Mrs. Beal from the 1953
Cleveland Museum of Art exhibition.
Burchfield signed many of his works with a distinctive
monogram in which his middle initial, E, is incorporated
into a ram's-horn shape that signifies his birth sign, Aries.

74. *Wires Down,* 1920
(illus. p. 150)

graphite, wash, and gouache on paper mounted on
cardboard
18 ¾ x 30 ⅞ in. (47.6 x 78.4 cm.)
signed and dated lower right: Chas. Burchfield–1920
Gift of Mr. and Mrs. James H. Beal, 46.20.2

Provenance:
With Frank K. M. Rehn Galleries, New York, until 1946;
the donors, Pittsburgh.

Exhibitions:
Galerie de la Chambre Syndicale des Beaux-Arts, Paris,
1924, *Exhibition of American Art*, as Ice Storm // Whitney
Museum of American Art, New York, 11 January–26
February 1956; Baltimore Museum of Art, 14 March–22
April 1956; Museum of Fine Arts, Boston, 9 May–17 June
1956; San Francisco Museum of Art, 11 July–19 August
1956; Los Angeles County Museum of Art, 5 September–14
October 1956; The Phillips Gallery, Washington, D.C., 4
November–11 December 1956; Cleveland Museum of Art,
3 January–10 February 1957, *Charles Burchfield*, no. 35 //
Munson-Williams-Proctor Institute, Utica, New York, 9
April–31 May 1970, *The Nature of Charles Burchfield—A
Memorial Exhibition* // Museum of Art, Carnegie Institute, 29
January–3 April 1983, *MOA Masterpieces*, no. 12.

Bibliography:
Charles Burchfield. Letters to Mrs. James Beal, 18
December 1945 and 21 June 1946 (Archives of American
Art) // Charles Burchfield. Letter to John O'Connor, 1 July
1946 (Museum of Art files) // Munson-Williams-Proctor
Institute, Utica, New York, *Charles Burchfield, Catalogue of
Paintings in Public and Private Collections* (1970), no. 591, illus.,
99 // Carnegie Institute, Museum of Art, *Catalogue of
Painting Collection* (1973), 31.

Remarks:
In reference to this work, Burchfield wrote to John
O'Connor, acting director, on 1 July 1946:

> There is no such actual scene as depicted in it. It is
> a concentration of studies, some material from
> Salem, Ohio, and some from East Liverpool and
> West Virginia. . . . I guess little needs to be said
> about the mood of the picture—early morning
> after a freezing rain has congealed on everything,
> bringing down wires, etc. I have tried to
> emphasize wetness, half-light and bleakness.

A second, partially erased signature and date appear on the
lower right of this work.

75. *Rock Creek Bank,* 1932

graphite and watercolor on paper mounted on board
26 ¹⁵⁄₁₆ x 40 ⅛ in. (68.4 x 101.9 cm.)
signed in monogram and dated lower right: CEB / 1932
Bequest of Charles J. Rosenbloom, 74.7.37

Provenance:
Estate of the donor, Pittsburgh.

Bibliography:
Munson-Williams-Proctor Institute, Utica, New York,
*Charles Burchfield, Catalogue of Paintings in Public and Private
Collections* (1970), no. 793.

Remarks:
This work depicts a view of Brumries, Clinton Street, and
Union Road in Gardenville, New York, where Burchfield
was living at the time.

76. *Cruciform House in Pennsylvania,* 1935

charcoal and crayon on paper mounted on card
12 ½ x 17 ½ in. (31.8 x 44.5 cm.)
signed in monogram and dated lower right: CEB 1935
Gift of Mr. and Mrs. James H. Beal, 67.3.2

Provenance:
The artist until 1953; the donors, Pittsburgh.

Exhibition:
The Print Club of Cleveland and Cleveland Museum of Art, 4 November–31 December 1953, *The Drawings of Charles E. Burchfield*, 24, no. 110.

Remarks:
This drawing was purchased by Mrs. Beal from the 1953 Cleveland Museum of Art exhibition.

77. *Huddled Houses,* 1938

crayon on cardboard
11 x 17 in. (27.9 x 43.2 cm.)
signed in monogram and dated lower right: CEB 1938 // inscribed upper left: [illeg.] but hazy with blue sun haze // inscribed lower left: rails—reflect sun at S—reflect bright sky all / their length—[illeg.] sunlit areas // inscribed center: [illeg.] sunshot // inscribed lower right: elder bushes
Gift of Mr. and Mrs. James H. Beal, 67.3.3

Provenance:
The artist until 1953; the donors, Pittsburgh.

Exhibition:
The Print Club of Cleveland and Cleveland Museum of Art, 4 November–31 December 1953, *The Drawings of Charles E. Burchfield*, 24, no. 116.

Remarks:
This drawing was purchased by Mrs. Beal from the 1953 Cleveland Museum of Art exhibition.

78. *The Great Elm,* 1939–41

watercolor on five pieces of paper glued together
33 x 53 in. (83.3 x 134.6 cm.), sight
signed in monogram and dated lower left: CEB 1939–41
Gift of Mr. and Mrs. James H. Beal, 44.9

Provenance:
With Frank K. M. Rehn Galleries, New York, until 1944; the donors, Pittsburgh.

Exhibitions:
Albright Art Gallery, Buffalo, New York, 14 April–15 May 1944, *Charles Burchfield: A Retrospective Exhibition of Water Colors and Oils 1916–43*, no. 72 // The Tennessee Botanical Gardens and Fine Arts Center, Nashville, Tennessee, 24 May–27 August 1965 // Munson-Williams-Proctor Institute, Utica, New York, 9 April–3 May 1970, *The Nature of Charles Burchfield—A Memorial Exhibition*.

Bibliography:
Charles Burchfield. Letter to Mrs. James Beal, 7 December 1944 (Archives of American Art) // Munson-Williams-Proctor Institute, Utica, New York, *Charles Burchfield, Catalogue of Paintings in Public and Private Collections* (1970), no. 949, illus., 195 // Museum of Art, Carnegie Institute, *Catalogue of Painting Collection* (1973), 31.

Remarks:
Charles Burchfield wrote Mrs. Beal on 7 December 1944:

> I have just heard the thrilling news from Mr. Rehn that my *Great Elm* has gone into the permanent collection of the Carnegie Institute, and that you are responsible and have supplied the means. . . . *The Great Elm* is one of which I am particularly fond. In the first place, the tree itself is one of the glories of Western New York, and I

feel that what I did of it was so inadequate, but I put into it all I could. I swear it would be impossible to stand under this tree and look in thru its branches without believing in God. Of course one may look at a blade of grass and marvel, but this tree with its unusual flat wide-spreading shape, really forces you to acknowledge the greatness of its creator.

> If we ever may have the pleasure of a visit from you here in Gardenville, I should love to take you out there (it is only six miles from our home) and let you stand under it. It is an experience almost as potent as Niagara Falls.

> The man who owns the farm on which it grows told me a revealing little incident about it. Given in 1901, it was already famous, and the committee backing the Pan-American Exposition tried to buy the tree from the present owners' grandfather for $50.00. They planned to transplant it, and use it as part of their decorative scheme and then discard it. Fortunately the grandfather was a thoroughbred, and would not even consider it, though he was far from well-to-do

The Great Elm depicts a scene at Baker and Milestrip roads near the artist's home in Orchard Park, New York.

79. *Maple Tree,* 1944

crayon on cardboard
17 ¼ x 10 ¾ in. (44.2 x 27.3 cm.)
signed in monogram and dated lower left: CEB 1944
Gift of Mr. and Mrs. James H. Beal, 67.3.4

Provenance:
The artist until 1953; the donors, Pittsburgh.

Exhibition:
The Print Club of Cleveland and Cleveland Museum of Art, 4 November–31 December 1953, *The Drawings of Charles E. Burchfield*, 25, no. 129.

Remarks:
This drawing is one of three detail studies for the reconstruction of Burchfield's watercolor *Mid–June* (1917–44, Albright-Knox Gallery, Buffalo). The drawing was purchased by Mrs. Beal from the 1953 Cleveland Museum of Art exhibition.

80. *Oak Branch,* 1944

crayon on two sheets of paper mounted on card
14 x 17 ⅜ in. (35.6 x 44.1 cm.), irregular
signed in monogram and dated center left: CEB 1944 // inscribed lower center: Autumnal Fantasy
Gift of Mr. and Mrs. James H. Beal, 67.3.6

Provenance:
The artist until 1953; the donors, Pittsburgh.

Exhibition:
The Print Club of Cleveland and Cleveland Museum of Art, 4 November–31 December 1953, *The Drawings of Charles E. Burchfield*, 25, no. 127.

Remarks:
Oak Branch is a detail for *Autumnal Fantasy* (1916–44, collection of Dr. and Mrs. Theodor Braasch).
This drawing was purchased by Mrs. Beal from the 1953 Cleveland Museum of Art exhibition.

81. *Sun Glitter,* 1945

watercolor on paper enlarged with horizontal strips and mounted on board
30 x 25 ⅛ in. (76.2 x 63.8 cm.)
signed in monogram and dated lower right: CEB 1945
Gift of Mr. and Mrs. James H. Beal, 46.20.1

Provenance:
With Frank K. M. Rehn Galleries, New York, until 1944; the donors, Pittsburgh.

Exhibition:
Munson-Williams-Proctor Institute, Utica, New York, 9 April–3 May 1970, *The Nature of Charles Burchfield—A Memorial Exhibition.*

Bibliography:
Charles Burchfield. Letter to Mrs. James Beal, 21 June 1946 (Archives of American Art) // Charles Burchfield. Letter to John O'Connor, 1 July 1946 (Museum of Art files) // Munson-Williams-Proctor Institute, Utica, New York, *Charles Burchfield, Catalogue of Paintings in Public and Private Collections* (1970), no. 994 // Museum of Art, Carnegie Institute, *Catalogue of Painting Collection* (1973), 31.

Remarks:
Charles Burchfield wrote to Mrs. Beal on 21 June 1946: "... don't let anyone kid you about the title—after all, why not Sea Shells, or Sun Glare or Sun Shimmer or what have you? What's in a name?"
Burchfield mentions this work in a letter to John O'Connor, acting director 1 July 1946:

> The locale was our drive here at Gardenville, with part of our house. Everything—house, trees, etc. are much as they are in real life, except that I have translated them all into the realm of phantasy. It is one of those blistering hot bright days in summer when the flicker of sunlight almost hurts the eyes as it seems to pervade and saturate all space, even into shade. The song of a cicada jars the air, and sets some rhythms in motion. The sky, what little can be seen, seems to be *white* hot.

82. *Crystalline Composition,* n.d.

graphite and gouache on paper mounted on board
9 x 12 in. (22.9 x 30.5 cm.)
Gift of Bernard Danenberg, 70.33

Provenance:
Bernard Dananberg Galleries, Inc., New York.

C A D M U S , P A U L
b. 1 9 0 4

**83. *Female Nude,* 1945
(illus. p. 177)**

white gouache on black paper
15 ¼ x 12 ⅜ in. (39 x 31.6 cm.)
signed and dated lower right: Cadmus 1945
Gift of Mrs. Howard Felding in memory of Henry Boettcher, 80.66.1

Provenance:
The donor, Sarasota, Florida.

Exhibition:
Museum of Art, Carnegie Institute, 29 January–3 April 1983, *MOA Masterpieces.*

C A R R O L L , J O H N
1 8 9 2 — 1 9 5 9

84. *Nude,* n.d.

graphite and ink wash on paper
18 x 11 ⅞ in. (45.7 x 30.2 cm.)
signed lower right: John Carroll
Gift of Mr. and Mrs. James H. Beal, 83.62.1

Provenance:
With Frank K. M. Rehn Galleries, New York; the donors, Pittsburgh.

C A R T E R , C L A R E N C E H .
b. 1 9 0 4

85. *Bauxite Plant, Surinam,* 1944

graphite and watercolor on paper
15 ⅝ x 23 in. (39.7 x 58.4 cm.)
signed and dated lower left: Clarence H. Carter 44 // inscribed, ink, verso: <u>aluminum</u>: / Surinam Bauxite Company, Moengo, Dutch Guiana
Museum purchase: gift of Alcoa Foundation, 82.7

Provenance:
Hirschl & Adler Galleries, New York.

Exhibition:
Museum of Art, Carnegie Institute, 9 October–12 December 1982, *Recent Acquisitions: Works on Paper.*

C H A S E , H A R R Y
1 8 5 3 — 1 8 8 9

86. *On the Trave,* n.d.

graphite on paper
5 ¾ x 8 ⅝ in. (14.6 x 21.9 cm.)
inscribed lower right: On the Trave
Andrew Carnegie Fund, 06.4

Provenance:
Mrs. Harry Chase, Bayonne, New Jersey.

Exhibition:
Irene Kaufmann Settlement House, Pittsburgh, 17 November 1925.

Bibliography:
Carnegie Institute, *Lists* (1917).

87. *The Hard Heart,* 1882

graphite on cardboard
9 x 15 ½ in. (22.9 x 39.4 cm.)
signed lower left: F. S. CHURCH // inscribed lower left:
Original Sketch for Etching / THE HARD HEART
COPYRIGHT: 1882
Andrew Carnegie Fund, 06.12.3

Provenance:
Frederick Keppel and Company, New York

Bibliography:
Carnegie Institute, *Lists* (1917).

88. *Sketch at Westport Point, Massachusetts,* 1889

graphite, pen and green ink, and white gouache on olive-
green paper mounted on sketch board
11 ⅝ x 18 in. (29.5 x 45.7 cm.)
signed lower left: F. S. Church // inscribed lower left:
Sketch at / Westport Point Mass / Sep. 89 / F. S. Church
// stamped verso: From H. Scott / 164 East 10th Street /
New York // inscribed, crayon, verso: F. S. Church /
Carnegie Hall NY / $100
Andrew Carnegie Fund, 07.6

Provenance:
The artist, New York.

Bibliography:
Carnegie Institute, *Lists* (1917).

89. *Beneath the Sea,* c. 1900

charcoal on paper mounted on board
8 ¾ x 19 ¾ in. (22.2 x 50.2 cm.)
signed, graphite, lower left: F. S. Church // inscribed,
graphite, lower left: Beneath the Sea / (copyright) Sketch
for Painting
Andrew Carnegie Fund, 06.12.2

Provenance:
Frederick Keppel and Company, New York.

Bibliography: Carnegie Institute, *Lists* (1917).

90. *Lower East Side, First Avenue, No. 21,* 1979

pen and colored inks on paper
16 ½ x 14 in. (41.9 x 35.6 cm.)
signed and dated, graphite, lower left: Michael Clark
1979
Gift of Mrs. H. Davidson Swift, 80.6

Provenance:
The donor, Washington, D.C.

91. *And Hung It on the Wall,* 1899

graphite, pen and ink, and ink wash on paper mounted on
board
12 ½ x 10 in. (31.8 x 25.4 cm.)
signed center right: Walter Appleton Clark
Andrew Carnegie Fund, 06.12.4

Provenance:
Frederick Keppel and Company, New York.

Exhibition:
Irene Kaufmann Settlement House, Pittsburgh, 14
November 1927.

Bibliography:
Henry Van Dyke, "A Lover of Music," *Scribner's Magazine*
XXV (April 1899): illus., 402 // Carnegie Institute, *Lists*
(1917).

92. *The Stoker,* 1905

crayon on paper mounted on board
18 ⅜ x 11 ⅜ in. (46.7 x 28.9 cm.)
signed lower left: Walter Appleton Clark / 1905
Andrew Carnegie Fund, 06.5

Provenance:
The artist, New York.

Exhibition:
Irene Kaufmann Settlement House, Pittsburgh, 17
November 1925.

Bibliography:
Scribner's Magazine XXXIX (January 1906): illus., 96 //
Carnegie Institute, *Lists* (1917).

Remarks:
This drawing was shipped to the Detroit Publishing
Company on 20 April 1918 to be reproduced on postcards
along with a poem by William Harvey Woods entitled
"Stoker."

**93. *Gwynne,* 1981
(illus. p. 237)**

fingerprints and stamp-pad ink on gray-green paper
29 x 21 ¾ in. (73.6 x 55.2 cm.)
signed and dated lower center: C. Close 1981 // inscribed
center right: "gwynne"
Wilbur Ross, Jr., Fund, Mary Oliver Robinson Memorial
Fund, Patrons Art Fund, Contemporary American
Drawings Fund, and National Endowment for the Arts,
82.44

Provenance:
The Pace Gallery, New York.

Exhibitions:
Museum of Art, Carnegie Institute, 9 October–12
December 1982, *Recent Acquisitions: Works on Paper* // The
Pace Gallery, New York, 25 February–26 March 1983,
Chuck Close.

COLE, ERNEST

94. *The Artist's Father (and Nude Figures),* **n.d.**

red crayon on paper mounted on cardboard
10 ¾ x 7 ⅝ in. (27.3 x 19.4 cm.)
signed, ink, lower center: Ernest Cole
Purchase, 17.34.2

Provenance:
Scott and Fowles.

Exhibition:
Irene Kaufmann Settlement House, Pittsburgh, 14
November 1927.

Bibliography:
Carnegie Institute, *Lists* (1917).

COOPER, COLIN CAMPBELL
1856—1937

95. *Malines Cathedral, Belgium,* **1917–18**

graphite and charcoal on two pieces of paper glued
together
12 ⅜ x 10 ¼ in. (31.4 x 26 cm.)
signed, crayon, lower right: Colin Campbell Cooper
Purchase, 18.25.4

Provenance:
American Artists' War Emergency Fund, New York.

COOPER, W. DOUGLAS
b. 1946

96. *Paddington Station,* **1969**

charcoal on twenty-five pieces of paper pasted together
118 ½ x 94 ½ in. (301 x 240 cm.)
inscribed verso: English / London / 8 x 10
Leisser Art Fund, 70.43.2

Provenance:
The artist, Pittsburgh.

97. *Forbes Avenue,* **1970**

charcoal on paper
37 ft. 7 ¼ in. x 29 ft. 10 in. (11.5 x 9.1 m.)
Leisser Art Fund, 70.43.1

Provenance:
The artist, Pittsburgh.

COTTINGHAM, ROBERT
b. 1935

98. *Central National Bank,* **1976**

graphite on tracing paper
23 ⅜ x 16 ⁵⁄₁₆ in. (59.4 x 43 cm.)
signed lower right: Cottingham
Contemporary American Drawings Fund and National
Endowment for the Arts, 82.22.2

Provenance:
Fendrick Gallery, Washington, D.C.

Exhibition:
Museum of Art, Carnegie Institute, 9 October–12
December 1982, *Recent Acquisitions: Works on Paper.*

COUSE, EANGER IRVING
1866—1936

99. *Indian Hunter,* **1917–18**

crayon on paper
11 x 14 ⅛ in. (28 x 35.9 cm.)
signed lower left: E I Couse
Purchase, 18.25.5

Provenance:
American Artists' War Emergency Fund, New York.

COX, KENYON
1856—1919

100. *Drapery Study for Figure of Contemplation,
Minnesota State Capitol,* **1904**

graphite on laid tracing paper mounted on board
19 ¼ x 15 in. (48.9 x 38.1 cm.)
signed and dated lower left: Kenyon Cox. 1904 //
inscribed lower center: Drapery Study for Figure of
Contemplation— / Minnesota State Capitol
Andrew Carnegie Fund, 06.6.8

Provenance:
The artist, New York.

Bibliography:
Carnegie Institute, *Lists* (1917).

101. *Drapery Study for Figure of Law, Minnesota
State Capitol,* **1904**

graphite on laid tracing paper mounted on board
15 ¾ x 19 ½ in. (40 x 49.5 cm.)
signed and dated center right: Kenyon Cox. 1904 //
inscribed lower right: Drapery Study for Figure of
Law— / Minnesota State Capitol
Andrew Carnegie Fund, 06.6.2

Provenance:
The artist, New York.

Bibliography:
Carnegie Institute, *Lists* (1917).

102. *Drapery Study for Figure of Letters, Minnesota
State Capitol,* **1904**

graphite on laid tracing paper mounted on board
19 ¼ x 15 ½ in. (48.9 x 39.4 cm.)
signed and dated center right: Kenyon Cox. 1904 //
inscribed lower center: Drapery Study for Figure of
Letters— / Minnesota State Capitol
Andrew Carnegie Fund, 06.6.3

Provenance:
The artist, New York.

Bibliography:
Carnegie Institute, *Lists* (1917).

103. *Nude Study for Figure of Contemplation, Minnesota State Capitol,* 1904

graphite on laid tracing paper mounted on board
19 ⅛ x 14 ¾ in. (48.6 x 37.5 cm.)
signed and dated center left: Kenyon Cox. 1904 //
inscribed lower center: Nude Study for Figure of
Contemplation— / Minnesota State Capitol
Andrew Carnegie Fund, 06.6.4

Provenance:
The artist, New York.

Bibliography:
Carnegie Institute, *Lists* (1917).

104. *Nude Study for Figure of Law, Minnesota State Capitol,* 1904

graphite on laid tracing paper mounted on board
19 ⅜ x 15 ⅜ in. (49.2 x 39.1 cm.)
signed and dated center left: Kenyon Cox. 1904 //
inscribed lower left: Nude Study for Figure of Law— /
Minnesota State Capitol
Andrew Carnegie Fund, 06.6.5

Provenance:
The artist, New York.

Bibliography:
Carnegie Institute, *Lists* (1917).

105. *Nude Study for Figure of Letters, Minnesota State Capitol,* 1904

graphite on laid tracing paper mounted on board
19 ⅜ x 15 ⅝ in. (49.2 x 39.7 cm.)
signed and dated center right: Kenyon Cox. 1904 //
inscribed lower center: Nude Study for Figure of
Letters— / Minnesota State Capitol
Andrew Carnegie Fund, 06.6.6

Provenance:
The artist, New York.

Bibliography:
Carnegie Institute, *Lists* (1917).

106. *Scale Drawing for the Contemplative Spirit of the East, Minnesota State Capitol,* 1904
(illus. p. 103)

graphite, sepia, and ink on canvas
23 x 46 in. (58.4 x 116.8 cm.)
inscribed, signed, and dated lower right: Copyright, 1904
by / Kenyon Cox // inscribed upper left: The East /
Contemplation-Letters-Law // inscribed upper right:
Decoration in Minnesota State Capitol / Scale
Drawing–2 inches to 1 foot.
Andrew Carnegie Fund, 06.6.7

Provenance:
The artist, New York.

Exhibition:
Museum of Art, Carnegie Institute, 29 January–3 April
1983, *MOA Masterpieces*, no. 13.

Bibliography:
Carnegie Institute, *Lists* (1917).

CROZIER, WILLIAM
b. Scotland, 1933

107. *Landscape,* 1960

oil on paper
21 x 18 ½ in. (53.3 x 47 cm.)
Leisser Art Fund, 61.50.4

Exhibition:
Carnegie Institute of Technology, Pittsburgh, October
1961, *Drawing International,* no. 23.

DAINGERFIELD, ELLIOTT
1859—1932

108. *Marche Funèbre,* 1917–18

crayon on paper
10 x 12 ½ in. (25.4 x 31.8 cm.)
signed lower left: E. D.
Purchase, 18.25.6

Provenance:
American Artists' War Emergency Fund, New York.

DALLA PICCOLA WOOD, TERESA
b. 1941

109. *Mundane Existence Series III,* 1981

graphite, colored pencil, and photograph on paper
35 ¾ x 23 ⅞ in. (90.8 x 60.6 cm.)
signed and dated lower right: TERESA DALLA
PICCOLA WOOD '81 // inscribed lower right:
MUNDANESERIES #3
71st Annual Associated Artists of Pittsburgh Exhibition
Purchase Prize, 81.11.1

Provenance:
The artist, Pittsburgh.

Exhibition:
Museum of Art, Carnegie Institute, 1981, *71st Annual
Associated Artists of Pittsburgh Exhibition.*

DARLEY, FELIX OCTAVIUS
CARR
1822—1888

110. *The Story of the Battle,* c. 1863
(illus. p. 62)

graphite and ink wash on paper
12 ¼ x 16 ⅜ in. (31.1 x 41.6 cm.)
signed, ink, lower left: F. O. C. Darley fecit // inscribed,
ink, lower right: the property of Mrs. F. O. C. Darley
Andrew Carnegie Fund, 07.15

Provenance:
The artist, Claymont, Delaware, until 1888; his wife, Jane
Colburn Darley, until 1907; Doll and Richards, Boston.

Bibliography:
Carnegie Institute, *Lists* (1917).

Remarks:
Thomas Sully painted a copy of this drawing (unlocated), which he mentioned in his account book. See Edward Biddle and Mantle Fielding, *The Life and Works of Thomas Sully* (Philadelphia, 1921), 387, no. 2590.

111. *Illustration for a Poem,* **n.d.**

graphite and Chinese white on uncut woodblock
5 7/16 x 3 15/16 in. (13.9 x 10.1 cm.)
signed lower left: Darley // inscribed verso: Lenore / page 238 / "And are ye Coner[illeg.] / Bear back, I say. / Dandries[?] poems F. O. C. Darley
Andrew Carnegie Fund, 18.41.1

Provenance:
George H. Whittle, New York.

DAVIES, ARTHUR B.
1862—1928

112. *Drawing No. 6,* **c. 1912–18**
(illus. p. 141)

colored chalk on two sheets of gray laid paper pasted together, mounted on two sheets of red Japanese paper with gold flecks pasted together
17 5/8 x 11 in. (44.8 x 27.9 cm.), sheet
21 1/16 x 15 5/16 in. (54.9 x 38.9 cm.), mount
Purchase, 18.19

Provenance:
Macbeth Gallery, New York.

Exhibitions:
Irene Kaufmann Settlement House, Pittsburgh, 14 November 1927 // Museum of Art, Carnegie Institute, 29 January–3 April 1983, *MOA Masterpieces,* no. 14.

Remarks:
This drawing was probably included in Macbeth Gallery, New York, 1918, *Loan Exhibition of Paintings, Watercolors, Drawings, Etchings and Sculpture by Arthur B. Davies at the Macbeth Galleries,* though it does not appear in the exhibition catalogue.

DAVIS, CHARLES HAROLD
1856—1933

113. *Landscape,* **n.d.**

graphite on paper
7 3/4 x 10 1/2 in. (19.7 x 26.7 cm.)
signed lower left: C. M. D.
Andrew Carnegie Fund, 07.7

Provenance:
The artist.

Bibliography:
Carnegie Institute, *Lists* (1917).

DAVIS, STUART
1892—1964

114. *Study for "House and Street",* **1931**
(illus. p. 191)

graphite and watercolor on paper
23 1/2 x 40 in. (59.7 x 101.6 cm.)
Edith H. Fisher Fund, 84.32

Provenance:
The artist; Mrs. Stuart Davis, New York; with Grace Borgenicht Gallery, New York.

Exhibitions:
Lawrence Rubin Gallery, New York, 30 January–1 March 1971, *Stuart Davis: Major Drawings on Canvas and Paper from 1928 to 1964,* no. 1 // The Brooklyn Museum, Brooklyn, New York, 21 January–19 March 1978; Fogg Art Museum, Harvard University, 15 April–28 May 1978, *Stuart Davis: Art and Art Theory,* no. 72 // Rahr-West Museum, Manitowoc, Wisconsin, 31 March–8 May 1932; Terra Museum of American Art, Evanston, Illinois, 14 May–17 June, 1983; Minnesota Museum of Art, St. Paul, 3 July–25 September 1983, *Stuart Davis: The Formative Years 1910–1930,* no. 27.

Bibliography:
The Brooklyn Museum, *Stuart Davis: Art and Art Theory* (1978), exh. cat. by John R. Lane, 146–47, no. 72 // Rahr-West Museum, Manitowoc, Wisconsin, *Stuart Davis: The Formative Years 1910–1930* (1983), exh. cat. by Lewis Kachur, unpaginated.

Remarks:
This drawing is the study for the painting *House and Street* (1931, Whitney Museum of American Art, New York), which provides the underlying design for *The Mellow Pad* (1945–51, collection of Edith and Milton Lowenthal) and for *Pad No. 3* (1947, private collection). There are a related sketchbook study from 1926 (collection of Mrs. Stuart Davis) and a related painting, *Downtown Street* (1931, Rahr-West Museum, Manitowoc, Wisconsin). The latter shares only a few elements and seems to be a different view of the same general locale. The drawing is neither signed nor dated, and there are no other inscriptions.

DEFAZIO, RAYMOND
b. 1936

115. *Untitled (Street in Greensburg, Pennsylvania),*
1981

graphite and watercolor on board
15 x 22 7/8 in. (38.1 x 58.1 cm.)
signed and dated lower right: R. Defazio + 1981
Gift of Mary Jo and James L. Winokur, 83.98

Provenance:
The donors, Pittsburgh.

DEMUTH, CHARLES
1883—1935

116. *Architecture,* **1918**
(illus. p. 151)

watercolor on paper
14 x 10 in. (35.6 x 25.4 cm.)
signed and dated lower left: Demuth 1918
Collection of Mr. and Mrs. James H. Beal, intended gift
to the Museum of Art, Carnegie Institute

Provenance:
Robert Locher, Lancaster, Pennsylvania, 1935; with
Kraushaar Galleries, New York, by 1939 until 1948; the
donors, Pittsburgh.

Exhibitions:
Rhode Island School of Design, Providence, 1939, as
House, Provincetown // The Museum of Modern Art, New
York, 7 March–11 June 1950, *Charles Demuth*, no. 72 //
Museum of Art, Carnegie Institute, 18 June–1 November
1957, *Exhibition of Watercolors and Drawings from the Collection
of Mr. and Mrs. James H. Beal* // Katonah Gallery, Katonah,
New York, 12 April–19 May 1964, *Charles Demuth*, no. 5 //
Museum of Art, Carnegie Institute, 18 November 1971–9
January 1972, *Forerunners of American Abstraction*, no. 8.

Bibliography:
Alvord L. Eiseman, "Catalogue Raisonné of the Complete
Works of Charles Demuth" (forthcoming), no. 1 // Richard
Weyand, "The Work of Charles Demuth," cat. MS.
(unlocated), no. 73 // The Museum of Modern Art, New
York, *Charles Demuth* (1950), exh. cat. by Andrew Ritchie,
no. 72 // Emily Farnham, "Charles Demuth: His Life,
Psychology and Works" (Ph.D. diss., Ohio State
University, Columbus, 1959), no. 296.

117. *Grapes and Turnips,* **1926**
(illus. p. 153)

watercolor on paper
16 7/8 x 23 3/8 in. (42.9 x 59.4 cm.)
signed and dated center right: C. Demuth 1926
Collection of Mr. and Mrs. James H. Beal, intended gift
to the Museum of Art, Carnegie Institute

Provenance:
Philip L. Goodwin, New York; with Downtown Gallery,
New York, until 1947; Mrs. James H. Beal, Pittsburgh.

Exhibitions:
Whitney Museum of American Art, New York, 15
December 1937–16 January 1938, *Charles Demuth Memorial
Exhibition*, no. 39 (lent by Philip Goodwin) // Museum of
Art, Carnegie Institute, 18 June–1 November 1957,
*Exhibition of Watercolors and Drawings from the Collection of Mr.
and Mrs. James H. Beal* // Museum of Art, Carnegie
Institute, 18 November 1971–9 January 1972, *Forerunners of
American Abstraction*, no. 16.

Bibliography:
Alvord L. Eiseman, "Catalogue Raisonné of the Complete
Works of Charles Demuth" (forthcoming), no. 5 // Richard
Weyand, "The Work of Charles Demuth," cat. MS.
(unlocated) // Emily Farnham, "Charles Demuth: His Life,
Psychology and Works" (Ph.D. diss., Ohio State
University, Columbus, 1959), no. 490.

118. *The Artist on the Beach (at Provincetown),* **1934**
(illus. p. 153)

watercolor on paper
8 7/16 x 11 in. (21.4 x 27.9 cm.)
signed and dated, graphite, lower left: C. Demuth '34.
Collection of Mr. and Mrs. James H. Beal, intended gift
to the Museum of Art, Carnegie Institute

Provenance:
Robert Locher, Lancaster, Pennsylvania, 1935; Richard
Weyand, Lancaster, Pennsylvania, 1956; Mr. Savage (?);
with Maynard Walker Gallery; Mrs. James H. Beal,
Pittsburgh.

Exhibitions:
Museum of Art, Ogunquit, Maine, 1960, *Eighth Annual
Exhibition*, no. 20 (lent by Maynard Walker Gallery) //
Katonah Gallery, Katonah, New York, 12 April–19 May
1964, *Charles Demuth* // Museum of Art, Carnegie Institute,
18 November 1971–9 January 1972, *Forerunners of American
Abstraction*, no. 19.

Bibliography:
Alvord L. Eiseman, "Catalogue Raisonné of the Complete
Works of Charles Demuth" (forthcoming), no. 5 // Richard
Weyand, "The Work of Charles Demuth," cat. MS.,
(unlocated), no. 54 // Emily Farnham, "Charles Demuth:
His Life, Psychology and Works" (Ph.D. diss., Ohio State
University, Columbus, 1959), no. 663 // Museum of Art,
Carnegie Institute, *Forerunners of American Abstraction* (1972),
exh. cat. by Herdis Bull Teilman.

DEWING, THOMAS WILMER
1851—1938

119. *Head of a Girl,* **before 1906**
(illus. p. 139)

silverpoint on paper
14 11/16 x 10 1/16 in. (37.3 x 27 cm.)
signed, graphite, lower right: T. W. Dewing
Andrew Carnegie Fund, 06.7

Provenance:
The artist, New York.

Exhibitions:
Irene Kaufmann Settlement House, Pittsburgh, 14
November 1927 // Museum of Art, Carnegie Institute, 29
January–3 April 1983, *MOA Masterpieces*, no. 15.

Bibliography:
Carnegie Institute, *Lists* (1917).

Remarks:
Head of a Girl was shipped to the artist for repairs 2 February
1910. On 20 April 1918 it was shipped to the Detroit
Publishing Company to be reproduced on postcards.

DIELMAN, FREDERICK
b. Germany, 1847—1935

120. *A Visit From the Bumboat, Near Troy*, 1879
(illus. p. 75)

graphite heightened with Chinese white on tan paper
6 x 6 ¾ in. (15.2 x 17.1 cm.)
signed center right: FD
Andrew Carnegie Fund, 06.3.8

Provenance:
Century Company, New York.

Exhibition:
Lyman Allyn Museum, New London, Connecticut, 11
March—23 April 1945, *Work in Many Media by Men of the
Tile Club: Thirteenth Anniversary Exhibition.*

Bibliography:
"The Tile Club Afloat," *Scribner's Magazine* XIX (March
1880): illus., 654, Troy // Carnegie Institute, *Lists* (1917).

Remarks:
This drawing was sent to the Detroit Publishing Company
on 20 April 1918 for reproduction on postcards.

DILLER, BURGOYNE
1906—1965

121. *Untitled (Second Theme)*, c. 1940
(illus. p. 201)

graphite, gouache, and ink on paper
11 ¹³⁄₁₆ x 8 ⅞ in. (30 x 22.5 cm.)
Collection of Mr. and Mrs. James M. Walton, intended
gift to the Museum of Art, Carnegie Institute

Provenance:
Estate of the artist until 1965; with Meredith Long &
Company, Houston; Mr. and Mrs. James M. Walton,
Pittsburgh.

Remarks:
This piece is neither signed nor dated. On the verso, in
graphite, are the sign of the estate trustee and the estate
inventory number, 82-51.

122. *Third Theme*, c. 1945

graphite, crayon, and colored pencil on paper
8 ½ x 8 ⅛ in. (21.6 x 20.6 cm.)
Leisser Art Fund, 81.3.6

Provenance:
Meredith Long Company, Houston.

DIX, HARRY
1907—1968

123. *San Francisco Gothic*, c. 1941

pen and ink on scratchboard
13 ⅛ x 17 ¼ in. (33.3 x 43.9 cm.)
signed lower right: Harry Dix
Anonymous gift, 42.8

Remarks:
Museum records for this work indicate that it is the drawing
for a painting of the same title that received second prize in
the Carnegie Institute exhibition *Directions in American
Painting*, 23 October—14 December 1941.

DODGE, WILLIAM DE LEFTWICH
1867—1935

124. *Wolfe Reciting Gray's Elegy*, c. 1903

graphite on paper
20 x 29 in. (50.8 x 73.7 cm.)
signed lower right: W. de L. Dodge
Andrew Carnegie Fund, 07.8

Provenance:
The artist, New York.

Bibliography:
Carnegie Institute, *Lists* (1917).

Remarks:
This drawing is a study for a painting in the lobby of the
King Edward Hotel, Toronto. The painting was sold
during renovations to the hotel in 1980.

DOUGHERTY, PAUL
1877—1947

125. *A Rocky Coast*, 1917–18

graphite and charcoal on paper
9 ½ x 12 ½ in. (24.1 x 31.8 cm.)
signed lower right: Paul Dougherty
Purchase, 18.25.7

Provenance:
American Artists' War Emergency Fund, New York.

DOVE, ARTHUR
1880—1946

126. *Houses on the Shore*, 1935

pen and ink and watercolor on paper
5 x 7 in. (12.7 x 17.8 cm.)
signed lower center: Dove
Gift of Sara M. Winokur and James L. Winokur to honor
Mr. and Mrs. Richard M. Scaife, 72.50.1

Provenance:
The donors, Pittsburgh.

Exhibition:
Museum of Art, Carnegie Institute, 17 October 1973–6
January 1974, *Art in Residence: Art Privately Owned in the
Pittsburgh Area.*

EATON, WYATT
1849—1896

127. *Little Girl,* n.d.

crayon on laid paper
7 ¾ x 4 ⅝ in. (19.7 x 11.8 cm.)
Andrew Carnegie Fund, 06.16.1

Provenance:
Macbeth Gallery, New York.

Bibliography:
Carnegie Institute, *Lists* (1917).

128. *Reverend Levi and Mrs. Warner,* n.d.

pen and ink on paper
10 ¾ x 11 ⅝ in. (27.3 x 29.5 cm.)
inscribed lower left: DRAWN BY WYATT EATON
FROM THE BRONZE BY OLIN L. WARNER
Andrew Carnegie Fund, 06.3.9

Provenance:
Century Company, New York.

EVANS, GRETE HOLST
b. 1916

129. *The Sea Has Many Voices,* n.d.

torn paper collage
20 x 27 ⅞ in. (50.8 x 70.8 cm.), sight
55th Annual Associated Artists of Pittsburgh Exhibition
Purchase Prize, 65.19

Exhibition:
Museum of Art, Carnegie Institute, 1965, *55th Annual
Associated Artists of Pittsburgh Exhibition.*

FEININGER, LYONEL
1871—1956

**130. *Old Stove of 1773,* 1892
(illus. p. 93)**

graphite and crayon heightened with white gouache on
paper mounted on paper
7 ⁷⁄₁₆ x 10 ⅛ in. (18.9 x 25.7 cm.)
signed, ink, lower right: Feininger // inscribed lower left:
Old Stove of 1773, Boston Sept. 1, 1892
Gift of Sara M. Winokur and James L. Winokur to honor
Mr. and Mrs. Richard M. Scaife, 71.12

Provenance:
The artist; Margaret Spicer-Simpson; the donors,
Pittsburgh.

Exhibition:
Museum of Art, Carnegie Institute, 29 January–3 April
1983, *MOA Masterpieces,* no. 17.

Bibliography:
Art Quarterly XXXIV (Winter 1971): 498.

FERRARA, JACKIE

131. *DD40–1, DD40–2,* 1977

graphite and ink on two sheets of graph paper matted
together
21 ⅝ x 16 ⁹⁄₁₆ in. (54.9 x 42.1 cm.), sight, overall
signed lower right of right sheet: FERRARA // inscribed
upper left of left sheet: DD40 / 1 A3, A2-xF8-A3, A2 //
inscribed upper edge of right sheet: DD40 / 2 4 / 77
Contemporary American Drawings Fund and National
Endowment for the Arts, 82.41.1

Provenance:
Max Protetch Gallery, New York.

Exhibition:
Museum of Art, Carnegie Institute, 9 October–12
December 1982, *Recent Acquisitions: Works on Paper.*

132. *Drawing for Future Project,* 1982

graphite and ink on graph paper
17 ¹⁄₁₆ x 22 in. (44.7 x 55.9 cm.)
signed lower right: FERRARA
Contemporary American Drawings Fund and National
Endowment for the Arts, 82.41.2

Provenance:
Max Protetch Gallery, New York.

Exhibition:
Museum of Art, Carnegie Institute, 9 October–12
December 1982, *Recent Acquisitions: Works on Paper.*

FETT, WILLIAM
b. 1918

133. *Untitled,* 1952

gouache on paper
19 ¹³⁄₁₆ x 27 ⁵⁄₁₆ in. (50.3 x 69.4 cm.)
inscribed, ballpoint pen, verso: W M Fett /
© 1952 / 3 / M. May
Gift of Morton D. May, 56.28.4

Provenance:
The donor, St. Louis.

FORMICOLA, JOHN
b. 1941

134. *Light Grid,* n.d.

graphite and colored pen on paper
15 x 11 in. (38.1 x 27.9 cm.)
signed lower right: Formicola // inscribed lower left: Light
Grid
Gift of Benjamin Bernstein, 72.26

Provenance:
With Marian Locks Gallery, Philadelphia; the donor,
Philadelphia.

FOSTER, BEN
1852—1926

135. *The Meadow Brook*, 1917–18

charcoal on paper
9 9/16 x 12 7/16 in. (24.3 x 31.6 cm.)
signed lower left: Ben Foster
Purchase, 18.25.8

Provenance:
American Artists' War Emergency Fund, New York.

FRANCIS, SAM
b. 1923

**136. *Yellow into Black*, 1958
(illus. p. 223)**

watercolor and gouache on paper
30 1/4 x 22 3/16 in. (76.8 x 56.4 cm.)
Print Purchase Fund, 58.43

Provenance:
The artist, Los Angeles.

137. *Untitled*, n.d.

gouache on paper mounted on board
22 7/8 x 31 1/2 in. (58.1 x 80 cm.)
Gift of Mr. and Mrs. Leon Anthony Arkus, 75.21.1

Provenance:
The donors, Pittsburgh.

FRANCK, FREDERICK
b. 1909

138. *Albert Schweitzer at His Desk, Lambarene*, 1958

pen and ink on paper
12 1/2 x 19 1/4 in. (31.8 x 48.9 cm.)
signed lower left: Franck // dated and inscribed lower left: July 15 ' 58 / L14
Gift of John O'Connor, Jr., 59.37

Provenance:
The donor.

FROST, A. B.
1851—1928

139. *Enoch's Garden*, n.d.

graphite, brush and ink, and white gouache on cardboard
18 3/16 x 15 1/16 in. (46.2 x 39.7 cm.)
signed lower right: A. B. Frost
Andrew Carnegie Fund, 06.19.4

Provenance:
Charles Scribner's Sons, New York.

Bibliography:
Carnegie Institute, *Lists* (1917).

GENTILCORE, ROLAND
b. 1916

140. *Balance*, 1970

gouache and printed plastic on card
15 x 19 7/16 in. (38.1 x 49.4 cm.)
signed and dated lower right: Gentilcore '70
62nd Annual Associated Artists of Pittsburgh Exhibition Purchase Prize 76.16.1

Provenance:
The artist, Pittsburgh.

Exhibition:
Museum of Art, Carnegie Institute, 1976, *62nd Annual Associated Artists of Pittsburgh Exhibition*.

Remarks:
The verso of the sheet is a printed advertisement.

GEORGE, THOMAS
b. 1918

141. *CP—Seven 1961*, 1961

pastel on paper
24 5/8 x 18 7/16 in. (62.5 x 46.8 cm.), sight
signed lower right: George
Gift of Mr. and Mrs. Lawrence C. Woods, Jr., 74.36

Provenance:
The donors.

GIBSON, CHARLES DANA
1867—1944

**142. *As the old men looked, young Dan Bogan came stumbling into the shop*, 1889
(illus. p. 89)**

pen and ink on card
11 x 17 1/2 in. (27.9 x 44.5 cm.)
signed lower right: C. D. Gibson
Andrew Carnegie Fund, 06.19.5

Provenance:
Charles Scribner's Sons, New York.

Exhibitions:
Museum of Art, Carnegie Institute, 29 January–3 April 1983; Flint Institute of Arts, Flint, Michigan, 18 December–5 February 1984, *MOA Masterpieces*, no. 18.

Bibliography:
Sarah Orne Jewett, "The Luck of the Bogans," *Scribner's Magazine* X (January 1889): illus., 111 // Carnegie Institute, *Lists* (1917) // Fairfax Downey, *Portrait of an Era as Drawn by C. D. Gibson: A Biography* (New York, 1936), illus., 95.

GIFFORD, ROBERT SWAIN
1840—1905

143. *Old Trees,* 1883
(illus. p. 126)

charcoal on laid paper mounted on board
7 ½ x 13 in. (19.1 x 33 cm.)
signed lower right: R. Swain Gifford
Andrew Carnegie Fund, 06.16.2

Provenance:
Macbeth Gallery, New York.

Exhibition:
Museum of Art, Carnegie Institute, 29 January–3 April 1983, *MOA Masterpieces,* no. 19.

GLACKENS, WILLIAM
1870—1938

144. *In Town It's Different,* 1898
(illus. p. 97)

graphite, charcoal, ink wash, and gouache on paper
18 ⅛ x 11 ¹⁵⁄₁₆ in. (46 x 30.3 cm.)
signed and dated lower right: W. Glackens '98
Andrew Carnegie Fund, 06.18.3

Provenance:
New York Cooperative Society.

Exhibition:
Museum of Art, Carnegie Institute, 29 January–3 April 1983, *MOA Masterpieces,* no. 20.

Bibliography:
E. S. Martin, "An Urban Harbinger," *Scribner's Magazine* XXVI (August 1899): frontispiece // Carnegie Institute, *Lists* (1917) // Henry Adams, "Masterpieces of American Drawing and Watercolor," *Carnegie Magazine* LVI (January/February 1983): 22, 28, fn. 9.

145. *Vitourac Had Never Before Been the Scene of Such a Splendid Fete,* 1901
(illus. p. 98)

graphite and brush and ink on paper mounted on cardboard
9 x 13 ⅜ in. (22.9 x 34 cm.)
signed lower center: W. Glackens // stamped verso: Scribner's Magazine, 150–155 Fifth Avenue, N.Y.
Andrew Carnegie Fund, 06.19.7

Provenance:
Charles Scribner's Sons, New York.

Bibliography:
Eleanor Stuart, "The Stranger Within Their Gates," *Scribner's Magazine* XXX (December 1901): 750–61, illus., 757 // Carnegie Institute, *Lists* (1917).

146. *They Huddled with Heads Bent Low,* 1902
(illus. p. 98)

graphite, charcoal, ink wash, and gouache on paper mounted on board
15 ⁷⁄₁₆ x 19 in. (39.2 x 48.3 cm.)
signed, watercolor, lower left: W. Glackens
Andrew Carnegie Fund, 06.19.6

Provenance:
Charles Scribner's Sons, New York.

Exhibition:
Museum of Art, Carnegie Institute, 29 January–3 April 1983, *MOA Masterpieces,* no. 21.

Bibliography:
Arthur Ruhl, "The Cattle-Man Who Didn't," *Scribner's Magazine* XXXI (January 1902): 110–119 // Carnegie Institute, *Lists* (1917) // Henry Adams, "Masterpieces of American Drawing and Watercolor," *Carnegie Magazine* LVI (January/February 1983): 20, illus., 21.

GORKY, ARSHILE
b. Turkish Armenia, 1904—1948

147. *Untitled,* 1937–38
(illus. p. 199)

charcoal on paper
24 ¼ x 18 ½ in. (61.6 x 47 cm.)
Gift of Mrs. Alexander C. Speyer, Sr., in honor of the Sarah M. Scaife Gallery, 72.41.1

Provenance:
Martha Jackson Gallery, New York.

Exhibitions:
M. Knoedler & Company, Inc., New York, 25 November–27 December 1969, *Gorky Drawings,* no. 50 // Museum of Art, Carnegie Institute, 17 October 1973–6 January 1974, *Art in Residence: Art Privately Owned in the Pittsburgh Area.*

Bibliography:
M. Knoedler & Company, Inc., New York, *Gorky Drawings* (1969), exh. cat. by Jim M. Jordan, no. 50, illus., 31.

GORSON, AARON HENRY
1872—1933

148. *Man at the Forge,* c. 1928

pastel on bluish laid paper
25 x 19 in. (63.5 x 48.3 cm.)
Director's Discretionary Fund, 79.37

Provenance:
Ira Spanierman, Inc., New York.

Exhibition:
Museum of Art, Carnegie Institute, 25 May–26 June 1967, *Aaron H. Gorson.*

GOTO, JOSEPH
b. 1920

149. *Untitled,* 1958

brush and ink on paper
49 ¾ x 37 ½ in. (126.4 x 95.3 cm.)
signed and dated lower left: Joseph Goto 58
Gift of Sara M. Winokur and James L. Winokur to honor Mr. and Mrs. Richard M. Scaife, 72.1.2

Provenance:
The donors, Pittsburgh.

150. *Study for Tower Iron, Sculpture No. 5,* **1969**

brush and ink on paper mounted on board
50 x 37 ½ in. (127 x 95.3 cm.), sight
signed and dated lower left: Joseph Goto 58
Gift of Sara M. Winokur and James L. Winokur to honor
Mr. and Mrs. Richard M. Scaife, 72.1.1

Provenance:
The donors, Pittsburgh.

GRAHAM, JOHN
b. Russia, 1881—1961

151. *Portrait of a Woman,* **1943–53**
(illus. p. 206)

graphite, crayon, colored pencil, and ballpoint pen on
both sides of tracing paper
23 ⅜ x 18 ¹¹⁄₁₆ in. (59.3 x 47.5 cm.)
signed center right: GRAHAM [Cyrillic] // inscribed in
monogram center right: IOANNUS
Constance Mellon Fund, William Frew Memorial Fund,
and gift of Laura H. Baer by exchange, 83.32

Provenance:
David Kravat; Zabriskie Gallery, New York.

Remarks:
This drawing is related to Graham's painting *Woman in
Black* (1943, Museum of Art, Carnegie Institute).

GREENE, BALCOMB
b. 1904

152. *Collage,* **1936**

paper mounted on cardboard
9 ¾ x 14 ⁹⁄₁₆ in. (24.8 x 37 cm.)
signed and dated, graphite, lower right: Balcomb Greene
'36
Gift of Mrs. James H. Beal, 62.27

Provenance:
The donor, Pittsburgh.

GROLL, ALBERT LOREY
1866—1952

153. *Arizona,* **n.d.**

graphite on paper mounted on board
10 ¾ x 14 ½ in. (27.3 x 36.8 cm.)
signed lower left: A L Groll // inscribed lower left:
Arizona
Andrew Carnegie Fund, 06.8

Provenance:
The artist, New York.

Bibliography:
Carnegie Institute, *Lists* (1917).

GUERIN, JULES
1866—1946

154. *Packet Making Night Landing,* **1903**

crayon and chalk on fabric mounted on cardboard
27 ¹³⁄₁₆ x 19 ¾ in. (70.6 x 50.2 cm.)
signed lower right: —Jules Guerin—
Andrew Carnegie Fund, 06.19.8

Provenance:
Charles Scribner's Sons, New York.

Exhibition:
Irene Kaufmann Settlement House, Pittsburgh, 14
November 1927.

Bibliography:
Willis Gibson, "The Old Route to Orleans," *Scribner's
Magazine* XXXIII (January 1903): illus., 17, as Packet
Making Night Landing—Arkansas Shore // Carnegie
Institute, *Lists* (1917).

HALF, GERTRUDE TEMELES
b. 1920

155. *Falling Red,* **n.d.**

gouache on paper
22 x 26 in. (55.9 x 66 cm.)
50th Annual Associated Artists of Pittsburgh Exhibition
Purchase Prize, 60.21

Provenance:
The artist, Pittsburgh.

Exhibition:
Carnegie Institute, 1960, *50th Annual Associated Artists of
Pittsburgh Exhibition.*

156. *Mosaic,* **1960**

torn paper on paper
28 x 22 in. (71.1 x 55.9 cm.)
signed graphite, lower left: Gertrude Temeles Half
50th Annual Associated Artists of Pittsburgh Exhibition
Purchase Prize, 60.22

Provenance:
The artist, Pittsburgh.

Exhibition:
Carnegie Institute, 1960, *50th Annual Associated Artists of
Pittsburgh Exhibition.*

HALL, SUSAN
b. 1943

157. *The Journey,* **1980**

charcoal, pastel, and graphite on paper
39 ¼ x 27 ¹¹⁄₁₆ in. (99.7 x 70.3 cm.)
signed and dated lower right: Susan Hall 1980 // inscribed
lower left: The Journey
Gift of Hamilton Gallery of Contemporary Art in memory
of Gene Baro, 83.23

HAMMER, JOHN J.
1838—1906

158. *Church, Rome,* 1884

graphite and watercolor on paper
9 ¾ x 15 in. (24.8 x 38.1 cm.)
signed, inscribed, and dated, ink, lower right: John J.
Hammer Rome 1884
Bequest of Mrs. Josiah Cohen, 47.13.1

Provenance:
Estate of the donor.

159. *House, Rome,* 1884

graphite and watercolor on paper mounted on board
9 ¾ x 15 in. (24.8 x 38.1 cm.)
signed, inscribed, and dated, ink, lower right: John J.
Hammer Rome 1884
Bequest of Mrs. Josiah Cohen, 47.13.2

Provenance:
Estate of the donor.

160. *House with Young Boy in the Foreground, Capri,* 1884

graphite and watercolor on paper mounted on board
11 ¼ x 16 ¼ in. (28.6 x 41.3 cm.)
signed, inscribed, and dated, ink, lower right: John J.
Hammer Capri 1884
Bequest of Mrs. Josiah Cohen, 47.13.3

Provenance:
Estate of the donor.

HASELTINE, WILLIAM STANLEY
1835—1900

**161. *Rocky Coastline, New England,* 1860s
(illus. p. 44)**

graphite and ink wash on paper
15 x 22 ¼ in. (38.1 x 56.5 cm.)
inscribed verso: Photographed in Paris Bornes
Maronteaux 36 av Chatillon sixties 123
Museum purchase: gift of Robert S. Waters Charitable
Trust, 83.34

Provenance:
Davis and Langdale Company, Inc., New York.

Exhibitions:
Davis and Langdale Company, Inc., New York, 5
March–2 April 1983, *William Stanley Haseltine (1835–1900),
Drawings of a Painter,* no. 5.

Bibliography: Elizabeth Aldrich, "Haseltine's Epic
Rocks," *Art/World* VII (March 1983): 6, illus., 1.

HASKELL, JANE
b. 1923

162. *Study for "Dark Window",* 1982

oil pastel on canvasette
15 ⅞ x 11 ¹⁵⁄₁₆ in. (40.4 x 30.4 cm.)
signed and dated, graphite, lower right: J. HASKELL '82
// inscribed lower left: STUDY FOR DARK WINDOW
Gift of Mr. and Mrs. Jerome Lieber, 84.97

HASSAM, FREDERICK CHILDE
1859—1935

163. *Gateway, Alhambra,* c. 1883

pastel on paper
8 ⅞ x 7 ½ in. (22.5 x 19.1 cm.)
signed and dated, graphite, lower left: Childe Hassam
1883 [?]
Andrew Carnegie Fund, 07.14.28

Provenance:
The artist, New York.

Exhibition:
Museum of Art, Carnegie Institute, 5 June–22 August
1982, *Childe Hassam in MOA.*

Bibliography:
Carnegie Institute, *Lists* (1917) // Gail Stavitsky, "Childe
Hassam in the Collection of the Museum of Art, Carnegie
Institute," *Carnegie Magazine* LVI (July/August 1982): 28,
illus., 29.

Remarks:
The drawing was executed on the verso of paper containing
a fragment of printed "Rules of Conduct" for visitors to
Carnegie Institute.
 Kathleen Burnside (Hassam catalogue raisonné project,
Hirschl & Adler Galleries, New York). Letter, 29 January
1982, states:

> Although the signature and date are very faint, I
> believe the date would be read . . . correctly as
> 1883. The signature with the crescent shape
> preceding it is characteristic of the artist's early
> (mid-1880s) signature. Moreover, we know that
> Hassam traveled to Spain on his first European
> trip in 1883, at which time exhibition records
> document that he visited the Alhambra in
> Granada. We have record of an 1883 watercolor
> titled *The Alhambra* (private collection, New
> York) but it is quite different stylistically from
> [Carnegie Institute's] pastel.

164. *Hydrangeas,* 1887

pen, brush and ink, and gouache on blue-green paper
17 ⅜ x 11 ⅞ in. (44.1 x 30.1 cm.)
signed and dated, crayon, lower right: CH 1889
Andrew Carnegie Fund, 07.14.30

Provenance:
The artist, New York.

Exhibitions:
Carnegie Institute, 24 October–15 December 1940, *Graphic Art of Childe Hassam* // Museum of Art, Carnegie Institute, 5 June–22 August 1982, *Childe Hassam in MOA*.

Bibliography:
Carnegie Institute, *Lists* (1917).

165. Hogarth House, Cheswick, 1889

watercolor on paper
5 ¼ x 8 ¹⁄₁₆ in. (13.3 x 21.9 cm.)
signed and dated, graphite, lower left: CH. 1889
Andrew Carnegie Fund, 07.14.24

Provenance:
The artist, New York.

Exhibition:
Museum of Art, Carnegie Institute, 5 June–22 August 1982, *Childe Hassam in MOA*.

Bibliography:
Carnegie Institute, *Lists* (1917) // Gail Stavitsky, "Childe Hassam in the Collection of the Museum of Art, Carnegie Institute," *Carnegie Magazine* LVI (July/August 1982): 28, illus., 30.

Remarks:
Kathleen Burnside (Hassam catalogue raisonné project, Hirschl & Adler Galleries, New York). Letter, 29 January 1982, states:

> We have an exhibition record for a watercolor by this title with a slight variation in spelling: *Hogarth's House, Chiswick*. The Chiswick watercolor was shown at the Art Galleries of Noyes, Cobb & Co., Boston, Mass., no year, (4/1–4/15) . . . (Although the catalogue is undated, it has been suggested that the show was held in 1890 or shortly after Hassam's return to America from Paris.) In 1902, a *Hogarth's House, Chiswick* (probably the same work) was exhibited at the gallery of Doll and Richards, Boston, Mass.

166. Terrace, Florence, 1897

graphite, pen and ink, and gouache on paper
5 ⅞ x 9 ¼ in. (14.9 x 23.5 cm.)
signed and dated lower left: Childe Hassam 1897
Andrew Carnegie Fund, 07.14.27

Provenance:
The artist, New York.

Exhibitions:
Carnegie Institute, 24 October–15 December 1940, *Graphic Art of Childe Hassam* // Museum of Art, Carnegie Institute, 5 June–22 August 1982, *Childe Hassam in MOA*.

Bibliography:
Carnegie Institute, *Lists* (1917).

Remarks:
The sheet has a sketch of a woman on the verso.
 Kathleen Burnside (Hassam catalogue raisonné project, Hirschl & Adler Galleries, New York). Letter, 29 January 1982, states:

> Hassam's third trip to Europe in 1897 took in much of Italy. However, very few works are recorded as being executed in Florence, where this sketch was presumably done. While we do not know of any oil that relates directly to [Carnegie

Institute's] work, there is an oil painting titled *View of Florence from San Miniato* [1897, private collection] . . . both works might have been done on the same terrace.

167. Hyde Park Corner, Night Study, c. 1898

pastel on brown paper
10 ¹¹⁄₁₆ x 8 in. (27.1 x 20.3 cm.)
signed lower left: C.H.
Andrew Carnegie Fund, 07.14.25

Provenance:
The artist, New York.

Exhibitions:
Irene Kaufmann Settlement House, Pittsburgh, 14 November 1927 // Carnegie Institute, 24 October–15 December 1940, *Graphic Art of Childe Hassam* // Museum of Art, Carnegie Institute, 5 June–22 August 1982, *Childe Hassam in MOA*.

Bibliography:
Carnegie Institute, *Lists* (1917) // Gail Stavitsky, "Childe Hassam in the Collection of the Museum of Art, Carnegie Institute," *Carnegie Magazine* LVI (July/August 1982): 31, illus., 32.

Remarks:
Kathleen Burnside (Hassam catalogue raisonné project, Hirschl & Adler Galleries, New York). Letter, 29 January 1982, states:

> This drawing, while not a study for any work we have recorded, is definitely related to a number of drawings and watercolors executed by Hassam when he was in England in 1898. In particular . . . a watercolor titled *Regent Street* [1898, private collection]. There is another drawing of this type in the collection of the Indianapolis Museum of Art which is titled *Regent Circus*.

168. Gloucester, Outer Harbor, 1899

pen and ink on laid paper
7 ¹⁵⁄₁₆ x 8 in. (20.2 x 20.3 cm.)
signed lower left: CH. 1899 // inscribed lower left: Gloucester [illeg.]
Andrew Carnegie Fund, 07.14.12

Provenance:
The artist, New York.

Exhibitions:
Carnegie Institute, 24 October–15 December 1940, *Graphic Art of Childe Hassam* // Museum of Art, Carnegie Institute, 5 June–22 August 1982, *Childe Hassam in MOA*.

Bibliography:
Carnegie Institute, *Lists* (1917).

Remarks:
This drawing relates to an oil painting titled *Gloucester* (1902, formerly in the collection of the Paine Art Center in Oshkosh, Wisconsin). (Kathleen Burnside, Hassam catalogue raisonné project, Hirschl & Adler Galleries, New York. Letter, 29 January 1982.)

169. Portrait of a Young Girl, 1899

chalk and gouache on brown paper
10 ⅜ x 4 ¾ in. (26.4 x 12 cm.)
signed and dated center right: CH 1899
Andrew Carnegie Fund, 07.14.5

Provenance:
The artist, New York.

Exhibition:
Carnegie Institute, 24 October–15 December 1940, *Graphic Art of Childe Hassam*.

Bibliography:
Carnegie Institute, *Lists* (1917).

170. *The Duet,* c. 1899

chalk on brown paper
8 ½ x 8 ⅜ in. (21.6 x 21.3 cm.)
inscribed, ink, lower right: To John W. Beatty from Childe Hassam
Gift of John W. Beatty, Jr., 64.10.3

Provenance:
The donor, Pittsburgh.

Exhibition:
Museum of Art, Carnegie Institute, 5 June–22 August 1982, *Childe Hassam in MOA*.

Remarks:
This drawing relates in general to a number of paintings done by Hassam of women at pianos. Related works include *Improvisation* (1899, oil on canvas, National Museum of American Art), *The Sonata* (1911, oil, private collection), and *The Duo* (1899, chalk and gouache, Fogg Art Museum, Harvard University). (Kathleen Burnside, Hassam catalogue raisonné project, Hirschl & Adler Galleries, New York. Letter, 29 January 1982.)

171. *Gloucester, Inner Harbor,* c. 1899

graphite and pastel on laid paper
8 ⅞ x 8 in. (22.5 x 20.3 cm.)
signed, watercolor, lower right: C.H.
Andrew Carnegie Fund, 07.14.13

Provenance:
The artist, New York.

Exhibitions:
Carnegie Institute, 24 October–15 December 1940, *Graphic Art of Childe Hassam* // Museum of Art, Carnegie Institute, 5 June–22 August 1982, *Childe Hassam in MOA*.

Bibliography:
Carnegie Institute, *Lists* (1917) // Gail Stavitsky, "Childe Hassam in the Collection of the Museum of Art, Carnegie Institute," *Carnegie Magazine* LVI (July/August 1982): 31, illus., 31.

Remarks:
This drawing depicts the same general scene as that shown in both *Gloucester Harbor* (1899, collection of Dr. and Mrs. John J. McDonough) and one in the Norton Gallery of Art, West Palm Beach, Florida. (Kathleen Burnside, Hassam catalogue raisonné project, Hirschl & Adler Galleries, New York. Letter, 29 January 1982.)

172. *The Horizon of the Poor,* 1900

graphite and pen and ink on card
7 ¾ x 5 ⅜ in. (19.7 x 14.3 cm.)
signed and dated lower left: C.H. [illeg.] 19–19<u>00</u> //
inscribed lower left: The horizon of the poor
Andrew Carnegie Fund, 07.14.3

Provenance:
The artist, New York.

Exhibition:
Carnegie Institute, 24 October–15 December 1940, *Graphic Art of Childe Hassam*.

Bibliography:
Carnegie Institute, *Lists* (1917).

Remarks:
This drawing was executed on the back of an engraved invitation from the 21st Annual Reception, The Art Institute of Chicago, 1899.

Kathleen Burnside (Hassam catalogue raisonné project, Hirschl & Adler Galleries, New York). Letter, 29 January 1982, states:

> We have record of a work by this title which was exhibited at the Boston Art Club, Mass., 1901 (4/6–4/27) in the 64th Exhibition (of Water colors), no. 165. I do not know if this exhibition record pertains to your drawing.

173. *Arrangement, Newport,* 1901

pastel on brown paper
6 ½ x 9 ½ in. (16.5 x 24.1 cm.)
signed and dated, graphite, lower left: C.H. 1901
Andrew Carnegie Fund, 07.14.20

Provenance:
The artist, New York.

Exhibitions:
Irene Kaufmann Settlement House, Pittsburgh, 14 November 1927 // Carnegie Institute, 24 October–15 December 1940, *Graphic Art of Childe Hassam* // Museum of Art, Carnegie Institute, 5 June–22 August 1982, *Childe Hassam in MOA*.

Bibliography:
Carnegie Institute, *Lists* (1917).

Remarks:
The drawing was executed on the verso of a pamphlet cover for The Booklovers Library, Philadelphia.

A related work is *Catboats, Newport* (1901, oil on canvas, Pennsylvania Academy of the Fine Arts, Philadelphia). (Kathleen Burnside, Hassam catalogue raisonné project, Hirschl & Adler Galleries, New York. Letter, 29 January 1982.)

174. *The Cliffs at "The Breakers," Newport,* 1901

pastel on black paper
8 ⅞ x 8 ¼ in. (22.5 x 20.9 cm.)
signed lower left: CH // inscribed and dated lower left: The Breakers / Newport 1901
Andrew Carnegie Fund, 07.14.16

Provenance:
The artist, New York.

Exhibition:
Museum of Art, Carnegie Institute, 5 June–22 August 1982, *Childe Hassam in MOA*.

Bibliography:
Carnegie Institute, *Lists* (1917).

Remarks:
The drawing was executed on the verso of a printed pamphlet: "Banking & Trust Accounts."

175. *Duke Street, Newport,* 1901

pen and ink and crayon on light blue paper
10 $^{15}/_{16}$ x 8 $^{15}/_{16}$ in. (27.8 x 22.7 cm.)
signed lower left: CH // inscribed and dated lower left:
Newport 1901
Andrew Carnegie Fund, 07.14.19

Provenance:
The artist, New York.

Exhibitions:
Carnegie Institute, 24 October–15 December 1940, *Graphic Art of Childe Hassam* // Museum of Art, Carnegie Institute, 5 June–22 August 1982, *Childe Hassam in MOA.*

Bibliography:
Carnegie Institute, *Lists* (1917) // Gail Stavitsky, "Childe Hassam in the Collection of the Museum of Art, Carnegie Institute," *Carnegie Magazine* LVI (July/August 1982): 36, fn. 6.

Remarks:
The sheet has crayon sketches on the verso, which is a printed advertisement for D. Milch, Manufacturer of High Grade Picture Frames, New York, dated 19 November 1900.

Kathleen Burnside (Hassam catalogue raisonné project, Hirschl & Adler Galleries, New York). Letter, 29 January 1982, states:

> We have record of a painting by this title (1901) . . . [which] was on the New York art market in 1979 . . . current location [unknown]. . . . It is definitely of the same subject as your drawing but there have been slight changes in vantage point and composition.

176. *Wharves, Newport,* 1901

colored pencil on paper
10 x 8 in. (25.4 x 20.3 cm.)
signed, inscribed, and dated lower left: C. H. / Newport, 1901
Andrew Carnegie Fund, 07.14.17

Provenance:
The artist, New York.

Exhibitions:
Carnegie Institute, 24 October–15 December 1940, *Graphic Art of Childe Hassam* // Museum of Art, Carnegie Institute, 5 June–22 August 1982, *Childe Hassam in MOA.*

Bibliography:
Carnegie Institute, *Lists* (1917) // Gail Stavitsky, "Childe Hassam and the Carnegie Institute: A Correspondence," *Archives of American Art Journal* XXII (June 1982): illus., 5, fig. 7 // Gail Stavitsky, "Childe Hassam in the Collection of the Museum of Art, Carnegie Institute," *Carnegie Magazine* LVI (July/August 1982): 36, fn. 6.

Remarks:
This drawing may be a preliminary study for *Newport Harbor* or *Newport Waterfront* (1901, Flint Institute of Arts, Flint, Michigan). (Kathleen Burnside, Hassam catalogue raisonné project, Hirschl & Adler Galleries, New York. Letter, 29 January 1982.)

177. *White Church, Newport,* 1901
(illus. p. 136)

pastel on onion-skin paper
9 $^{15}/_{16}$ x 8 in. (25.2 x 20.3 cm.)
signed, crayon, lower left: CH. // inscribed and dated lower left: Newport 1901
Andrew Carnegie Fund, 07.14.18

Provenance:
The artist, New York.

Exhibitions:
Carnegie Institute, 24 October–15 December 1940, *Graphic Art of Childe Hassam* // Museum of Art, Carnegie Institute, 5 June–22 August 1982, *Childe Hassam in MOA* // Museum of Art, Carnegie Institute, 29 January–3 April 1983, *MOA Masterpieces,* no. 22.

Bibliography:
Carnegie Institute, *Lists* (1917) // Gail Stavitsky, "Childe Hassam and the Carnegie Institute: A Correspondence," *Archives of American Art Journal* XXII (June 1982): illus., 5, fig. 6 // Gail Stavitsky, "Childe Hassam in the Collection of the Museum of Art, Carnegie Institute," *Carnegie Magazine* LVI (July/August 1982): 31, illus., 27.

178. *Cos Cob, The Bridge and Docks,* 1902

charcoal and watercolor on paper mounted on cardboard
11 $^{1}/_{8}$ x 10 in. (28.3 x 25.4 cm.)
signed and dated lower right: Childe Hassam 1902
Andrew Carnegie Fund, 07.14.10

Provenance:
The artist, New York.

Exhibitions:
Carnegie Institute, 24 October–15 December 1940, *Graphic Art of Childe Hassam* // Museum of Art, Carnegie Institute, 5 June–22 August 1982, *Childe Hassam in MOA.*

Bibliography:
Carnegie Institute, *Lists* (1917) // Gail Stavitsky, "Childe Hassam in the Collection of the Museum of Art, Carnegie Institute," *Carnegie Magazine* LVI (July/August 1982): 33, illus., 33.

179. *Rocky Headland, Isles of Shoals,* 1903

crayon and gouache on brown cardboard
9 x 11 $^{1}/_{2}$ in. (22.9 x 29.2 cm.)
signed and dated, graphite, lower left: CH . 1903
Andrew Carnegie Fund, 07.14.26

Provenance:
The artist, New York.

Exhibitions:
Carnegie Institute, 24 October–15 December 1940, *Graphic Art of Childe Hassam* // Museum of Art, Carnegie Institute, 5 June–22 August 1982, *Childe Hassam in MOA.*

Bibliography:
Carnegie Institute, *Lists* (1917).

180. *Brooklyn Bridge,* c. 1904

pastel on gray-blue paper
5 $^{1}/_{4}$ x 7 $^{7}/_{8}$ in. (13.3 x 20 cm.)
Andrew Carnegie Fund, 07.14.2

Provenance:
The artist, New York.

Exhibitions:
Carnegie Institute, 24 October–15 December 1940, *Graphic Art of Childe Hassam* // The Brooklyn Museum, Brooklyn, New York, 28 April–27 July 1958, *75th Anniversary of Brooklyn Bridge Exhibition* // Museum of Art, Carnegie Institute, 7 June–22 August 1982, *Childe Hassam in MOA* // The Brooklyn Museum, Brooklyn, New York, 19 March–5 September 1983, *The Great East River Bridge, 1883–1983*, as Brooklyn Bridge in Winter.

Bibliography:
Carnegie Institute, *Lists* (1917) // Gail Stavitsky, "Childe Hassam in the Collection of the Museum of Art, Carnegie Institute," *Carnegie Magazine* LVI (July/August 1982): illus., 32 // The Brooklyn Museum, Brooklyn, New York, *The Great East River Bridge, 1883–1983* (1983), exh. cat. by Lewis Kachner, illus., 155, no. 127.

Remarks:
This drawing is apparently a study for the oil painting *Brooklyn Bridge, Winter* (1904, Telfair Academy of Arts and Sciences, Savannah, Georgia). (Kathleen Burnside, Hassam catalogue raisonné project, Hirschl & Adler Galleries, New York. Letter, 29 January 1982.)

181. *Arrangement of Nudes and Laurel,* c. 1905

pastel on charcoal gray paper
8 ⅛ x 8 ⁹⁄₁₆ in. (20.6 x 21.7 cm.)
Andrew Carnegie Fund, 07.14.8

Provenance:
The artist, New York.

Exhibitions:
Carnegie Institute, 24 October–15 December 1940, *Graphic Art of Childe Hassam* // Museum of Art, Carnegie Institute, 5 June–22 August 1982, *Childe Hassam in MOA.*

Bibliography:
Carnegie Institute, *Lists* (1917) // Gail Stavitsky, "Childe Hassam in the Collection of the Museum of Art, Carnegie Institute," *Carnegie Magazine* LVI (July/August 1982): 33, illus., 32.

Remarks:
This drawing may be a preliminary study for *June* (1905, American Academy of Arts and Letters, New York). *June* was exhibited at Carnegie Institute in the Carnegie International (2 November 1905–1 January 1906, cat. no. 108, illus.); it was awarded the medal of the third class. See Adeline Adams, *Childe Hassam* (New York, 1938), 57, 90. (Kathleen Burnside, Hassam catalogue raisonné project, Hirschl & Adler Galleries, New York. Letter, 29 January 1982.)

182. *The Boat Landing,* c. 1906 (illus. p. 137)

graphite, pastel, and gouache on brown paper
7 ¾ x 5 ⅜ in. (19.7 x 13.7 cm.)
Andrew Carnegie Fund, 07.14.15

Provenance:
The artist, New York.

Exhibition:
Museum of Art, Carnegie Institute, 5 June–22 August 1982, *Childe Hassam in MOA.*

Bibliography:
Carnegie Institute, *Lists* (1917).

183. *Autumn Landscape, Arrangement,* n.d.

pastel on blue paper
signed, graphite, lower right: CH.
Andrew Carnegie Fund, 07.14.23

Provenance:
The artist, New York.

Exhibition:
Museum of Art, Carnegie Institute, 5 June–22 August 1982, *Childe Hassam in MOA.*

Bibliography:
Carnegie Institute, *Lists* (1917).

Remarks:
This drawing was executed on the verso of a printed program cover for Carnegie Institute Founder's Day 1902.

184. *The Beach, Newport,* n.d.

graphite and crayon on paper
4 ⅛ x 6¼ in. (10.5 x 15.9 cm.)
Andrew Carnegie Fund, 07.14.4

Provenance:
The artist, New York.

Exhibition:
Carnegie Institute, 24 October–15 December 1940, *Graphic Art of Childe Hassam.*

Bibliography:
Carnegie Institute, *Lists* (1917).

Remarks:
This drawing was made on the verso of part of a document printed with names.

185. *Catboats, Newport Harbor,* n.d.

crayon on laid paper
8 ⅛ x 11 ¾ in. (20.6 x 29.8 cm.)
signed lower left: CH.
Andrew Carnegie Fund, 07.14.6

Provenance:
The artist, New York.

Exhibitions:
Carnegie Institute, 24 October–15 December 1940, *Graphic Art of Childe Hassam* // Museum of Art, Carnegie Institute, 5 June–22 August 1982, *Childe Hassam in MOA.*

Bibliography:
Carnegie Institute, *Lists* (1917) // Gail Stavitsky, "Childe Hassam in the Collection of the Museum of Art, Carnegie Institute," *Carnegie Magazine* LVI (July/August 1982): 36, fn. 6, illus., 33.

Remarks:
This drawing was executed on a sheet of stationery with a printed letterhead: Ramon Guiteras, M.D. 75 West 55th Street, NY

186. *Connecticut Trout Stream,* n.d.

pastel and gouache on black paper
10 ⅜ x 7 ¾ in. (26.4 x 19.7 cm.)
Andrew Carnegie Fund, 07.14.1

Provenance:
The artist, New York.

Exhibitions:
Carnegie Institute, 24 October–15 December 1940, *Graphic Art of Childe Hassam* // Museum of Art, Carnegie Institute, 5 June–22 August 1982, *Childe Hassam in MOA*.

Bibliography:
Carnegie Institute, *Lists* (1917).

Remarks:
The drawing was executed on the verso of a printed pamphlet for the Boston Art Club, Sixty-Seventh Exhibition, 1903.

187. *East Gloucester,* n.d.

pastel on light green laid paper
8 ¼ x 10 ¾ in. (21 x 27.3 cm.)
Andrew Carnegie Fund, 07.14.11

Provenance:
The artist, New York.

Exhibition:
Carnegie Institute, 24 October–15 December 1940, *Graphic Art of Childe Hassam*.

Bibliography:
Carnegie Institute, *Lists* (1917).

188. *East Gloucester Street, Summer Morning,* n.d.

crayon, watercolor, and gouache on laid paper
8 x 10 ¼ in. (20.3 x 26 cm.)
signed lower right: CH
Andrew Carnegie Fund, 07.14.14

Provenance:
The artist, New York.

Exhibition:
Museum of Art, Carnegie Institute, 5 June–22 August 1982, *Childe Hassam in MOA*.

Bibliography:
Carnegie Institute, *Lists* (1917).

189. *14th July, Paris, Old Quarter,* n.d.

graphite and gouache on light blue-green paper
8 ½ x 5 ⅝ in. (21.6 x 14.3 cm.)
Andrew Carnegie Fund, 07.14.29
Provenance:
The artist, New York.

Exhibition:
Museum of Art, Carnegie Institute, 5 June–22 August 1982, *Childe Hassam in MOA*.

Bibliography:
Carnegie Institute, *Lists* (1917) // Gail Stavitsky, "Childe Hassam in the Collection of the Museum of Art, Carnegie Institute," *Carnegie Magazine* LVI (July/August 1982): 23, illus., 29.

190. *Little Bridge,* n.d.

crayon on green paper
7 ¾ x 9 in. (19.7 x 22.9 cm.)
Andrew Carnegie Fund, 07.14.22

Provenance:
The artist, New York.

Exhibitions:
Carnegie Institute, 24 October–15 December 1940, *Graphic Art of Childe Hassam* // Museum of Art, Carnegie Institute, 5 June–22 August 1982, *Childe Hassam in MOA*.

Bibliography:
Carnegie Institute, *Lists* (1917).

Remarks:
The drawing was executed on the verso of a printed pamphlet: "Opera Glasses and Kindred Articles."

191. *Nude Study,* n.d.

charcoal and pastel on black paper
10 ⅝ x 8 1/16 in. (27 x 21.9 cm.)
Andrew Carnegie Fund, 07.14.7

Provenance:
The artist, New York.

Exhibition:
Museum of Art, Carnegie Institute, 5 June–22 August 1982, *Childe Hassam in MOA*.

Bibliography:
Carnegie Institute, *Lists* (1917).

192. *Nude Study,* n.d.

pink crayon on lime-green paper
7 ⅞ x 5 ½ in. (20 x 14 cm.)
Andrew Carnegie Fund, 07.14.9

Provenance:
The artist, New York.

Exhibition:
Carnegie Institute, 24 October–15 December 1940, *Graphic Art of Childe Hassam*.

Bibliography:
Carnegie Institute, *Lists* (1917).

193. *Street and White Church, Newport,* n.d.

graphite and crayon on green paper
8 ⅞ x 5 ⅞ in. (22.5 x 14.9 cm.)
Andrew Carnegie Fund, 07.14.21

Provenance:
The artist, New York.

Exhibitions:
Carnegie Institute, 24 October–15 December 1940, *Graphic Art of Childe Hassam* // Museum of Art, Carnegie Institute, 5 June–22 August 1982, *Childe Hassam in MOA*.

Bibliography:
Carnegie Institute, *Lists* (1917).

HAYES, DAVID
b. 1 9 3 1

194. *Drawing for Landscape Sculpture,* **1980**

ink and gouache on paper
22 ⅛ x 30 in. (56.2 x 76.2 cm.)
signed and dated, graphite, lower right: David Hayes
1980 // inscribed and dated verso: DRAWING FOR
LANDSCAPE SCULPTURE / INK. GOUACHE ON
PAPER / 1980
Gift of the artist, 80.36

Provenance:
The artist.

195. *Groups of Animals,* **1957**

charcoal on paper mounted on cardboard
19 x 25 in. (48.3 x 63.5 cm.)
signed and dated, ink, lower right: David K. Hayes / 1957
Barbara Schefler Memorial Fund, 59.36

Provenance:
The artist.

HIGGINS, EUGENE
1 8 7 4 — 1 9 5 8

196. *The Little Mother (Dutch Interior),* **n.d.**

pen and ink on cardboard
6 ⅜ x 5 ⅛ in. (16.2 x 13 cm.)
signed lower left: Higgins
Purchase, 17.6

Provenance:
George Busse.

HIGHLANDS, DELBERT
b. 1 9 3 5

197. *Study #7 for "Cockpit",* **1967**

graphite and gouache on board
10 x 8 ⅛ in. (25.4 x 20.6 cm.)
Gift of Mr. and Mrs. Leon Anthony Arkus, 78.21.1

Provenance:
The donors, Pittsburgh.

HILAND, JOSEPH
b. 1 9 5 2

198. *Untitled No. 1,* **1981**

charcoal and graphite on paper
85 9/16 x 117 ½ in. (148.8 x 298.5 cm.)
signed and dated lower right: Hiland 81
Leisser Art Fund, 81.46.4.1

Provenance:
The artist, Philadelphia.

199. *Untitled No. 2,* **n.d.**

charcoal and graphite on paper
82 ½ x 87 ½ in. (209.5 x 222.3 cm.)
signed verso: Joseph Hiland
Leisser Art Fund, 81.46.4.2

Provenance:
The artist, Philadelphia.

HILLIARD, WILLIAM HENRY
1 8 3 6 — 1 9 0 5

200. *Untitled,* **n.d.**

graphite and ink wash on paper
3 ¾ x 6 in. (9.5 x 15.2 cm.)
inscribed verso: shouting boys shouting boys
Andrew Carnegie Fund, 06.21.1

Provenance:
Albert Rosenthal, Philadelphia.

Exhibition:
Cayuga Museum of History and Art, Auburn, New York,
April 1939, *Old Masters of Auburn.*

Bibliography:
Carnegie Institute, *Lists* (1917).

201. *Untitled (Farm Scene),* **n.d.**

graphite, pen and ink, and ink wash on cardboard
8 ¾ x 6 ¾ in. (22.2 x 17.1 cm.)
Andrew Carnegie Fund, 06.21.2

Provenance:
Albert Rosenthal, Philadelphia.

Bibliography:
Carnegie Institute, *Lists* (1917).

HIOS, THEO
b. 1 9 1 0

202. *Moonlight,* **1964**

pastel on mulberry paper
26 x 36 in. (66 x 91.4 cm.)
signed lower right: Hios
Gift of Themis Hios, 74.28

Provenance:
The donor, New York.

HOMER, WINSLOW
1 8 3 6 — 1 9 1 0

203. *Pumpkins Among the Corn,* **1878**
(illus. p. 53)

pen and ink on scratchboard
7 ⅜ x 10 ¾ in. (18.7 x 27.3 cm.)
Andrew Carnegie Fund, 06.3.12

Provenance:
Century Company, New York.

Exhibitions:
National Gallery of Art, Washington, D.C., 22 November–4 January 1959; The Metropolitan Museum of Art, New York, 27 January–8 March 1959, *Winslow Homer Retrospective* // Museum of Art, Carnegie Institute, 29 January–3 April 1983, *MOA Masterpieces*, no. 25.

Bibliography:
"Glimpses of New England Farmlife," *Scribner's Monthly* XVI (August 1878): illus., 520 // Eugene J. Hall, *Lyrics of Home-Land* (Chicago, 1882), illus., 77 // Carnegie Institute, *Lists* (1917) // Gordon Hendricks, *The Life and Work of Winslow Homer* (New York, 1979), illus., 321 (CL-600) // David Wilkins, "Winslow Homer at Carnegie Institute," *Carnegie Magazine* LV (January 1981): 9–12, illus., 8.

204. *A Wreck near Gloucester,* 1880
(illus. p. 56)

graphite and watercolor on paper
14 $^{13}/_{16}$ x 19 $^{5}/_{8}$ in. (37.6 x 50 cm.)
signed and dated, ink, lower left: Winslow Homer 1880
Purchase, 17.3.2

Provenance:
Edward C. Stedman, New York, until 1905; M. Knoedler & Company, New York; Dr. Alexander Humphreys until 1917.

Exhibitions:
Doll and Richards Gallery, Boston, December 1880 // Carnegie Institute, 1–27 November 1917, *Watercolors by Homer and Sargent* (traveled to Cleveland, Toledo, Detroit, Minneapolis, Milwaukee, Saint Louis, and Rochester until 12 July 1918) // Carnegie Institute, 9 September–26 October 1923, *Watercolors by Winslow Homer*, no. 43 // Irene Kaufmann Settlement House, Pittsburgh, 22 November 1928 // Carnegie Institute, 13 February–26 March 1936, *Exhibition of American Genre Paintings*, no. 49 // Carnegie Institute, 1937, no. 49 // Columbus Museum of Fine Arts, Columbus, Ohio, 4 March–9 April 1952, *Paintings from the Pittsburgh Collection* // Weirton Women's Club, Weirton, West Virginia, 17 March–26 May 1954 // Westmoreland Museum of Art, Greensburg, Pennsylvania, 17 April 1961–24 January 1962, *American Painting, Eighteenth, Nineteenth, and Twentieth Centuries, from the Collection of the Carnegie Institute* // Mariners' Museum and The Virginia Museum of Fine Arts, Richmond, Virginia, 28 August–9 December 1964, *Homer and the Sea*, no. 18 // Albright-Knox Art Gallery, Buffalo, New York, 8 July–28 August 1966, *Watercolors by Winslow Homer* // Museum of Art, Carnegie Institute, 29 January–3 April 1983; Flint Institute of Arts, Flint, Michigan, 18 December 1983–5 February 1984, *MOA Masterpieces*, no. 26.

Bibliography:
Carnegie Institute, *Lists* (1917) // Carnegie Institute, *Exhibition of American Genre Paintings* (1936), exh. cat., no. 49 // Gordon Hendricks, *The Life and Work of Winslow Homer* (New York, 1979), illus., 321 (CL-604), 19, illus., 18 // David Wilkins, "Winslow Homer at Carnegie Institute," *Carnegie Magazine* LV (January 1981): 9–12.

205. *Portrait of a Woman,* 1880

charcoal and gouache on card backed with fabric
19 $^{5}/_{8}$ x 14 in. (49.8 x 35.6 cm.)
signed and dated lower left: Homer 1880
Gift of Mrs. Charles Homer, 18.33.1

Bibliography:
Gordon Hendricks, *The Life and Work of Winslow Homer* (New York, 1979), illus., 321 (CL-599) // David Wilkins, "Winslow Homer at Carnegie Institute," *Carnegie Magazine* LV (January 1981): 12–14, illus., 15.

206. *Fisher Girls,* 1882
(illus. p. 53)

graphite on paper
8 $^{1}/_{4}$ x 11 $^{3}/_{4}$ in. (21 x 29.8 cm.)
signed and dated lower right: W. H. June 1882
Carnegie Special Fund, 04.5.2

Provenance:
Macbeth Gallery, New York.

Exhibition:
Museum of Art, Carnegie Institute, 29 January–3 April 1983, *MOA Masterpieces*, no. 24.

Bibliography:
Carnegie Institute, *Lists* (1917) // Gordon Hendricks, *The Life and Work of Winslow Homer* (New York, 1979), 321 (CL-598), illus., 163, fig. 259 // David Wilkins, "Winslow Homer at Carnegie Institute," *Carnegie Magazine* LV (January 1981): 15–16, illus. on cover.

207. *Figures on the Coast,* 1883
(illus. p. 54)

charcoal on paper
6 $^{11}/_{16}$ x 12 $^{1}/_{4}$ in. (17 x 31.1 cm.)
signed lower left: Homer
Carnegie Special Fund, 04.5.1

Provenance:
Macbeth Gallery, New York.

Exhibition:
Museum of Art, Carnegie Institute, 29 January–3 April 1983, *MOA Masterpieces*, no. 23.

Bibliography:
Carnegie Institute, *Lists* (1917) // Gordon Hendricks, *The Life and Work of Winslow Homer* (New York, 1979), illus., 321 (CL-597) // David Wilkins, "Winslow Homer at Carnegie Institute," *Carnegie Magazine* LV (January 1981): 15, illus., 16 // Henry Adams, "Masterpieces of American Drawing and Watercolor," *Carnegie Magazine* LVI (January/February 1983): 20, 22, illus., 27.

208. *Escort of a General,* 1887

crayon and pen and ink on cardboard
9 $^{1}/_{8}$ x 15 in. (23.2 x 38.1 cm.)
inscribed upper left: a 9112
Andrew Carnegie Fund, 06.3.11

Provenance:
Century Company, New York.

Exhibition:
Irene Kaufmann Settlement House, Pittsburgh, 17 November 1925.

Bibliography:
Carnegie Institute, *Lists* (1917) // Julian Grossman, *Echo of a Distant Drum, Winslow Homer and The Civil War* (New York, 1974), 182 // Gordon Hendricks, *The Life and Work of Winslow Homer* (New York, 1979), illus., 321 (CL-596) // David Wilkins, "Winslow Homer at Carnegie Institute," *Carnegie Magazine* LV (January 1981): illus., 6.

Remarks:

The accession card for this work quotes a comment by Lloyd Goodrich, 1940: "Almost the same as the group in the background of the oil painting, *Prisoners from the Front*, owned by the Metropolitan Museum."

This drawing was probably made in 1887 (the date Hendricks assigns to it) from sketches made in the 1860s at the time of the Civil War. Lucretia Giese, letter, 27 July 1984, mentions the stylistic similarity of this drawing with others by Homer that were reproduced as illustrations in a book entitled *Battles and Leaders*, published by *The Century Magazine* in 1887. She suggests that the published illustrations were reworked drawings from the Civil War period, like *Escort of a General*, though this one was not reproduced.

209. *Relief of Outer Picket*, 1887

crayon and pen and ink on cardboard
11 x 17 ¼ in. (28 x 43.8 cm.)
Andrew Carnegie Fund, 06.3.13

Provenance:
Century Company, New York.

Bibliography:
Carnegie Institute, *Lists* (1917) // Julian Grossman, *Echo of a Distant Drum, Winslow Homer and The Civil War* (New York, 1974), 182 // Gordon Hendricks, *The Life and Work of Winslow Homer* (New York, 1979), illus., 321 (CL-601) // David Wilkins, "Winslow Homer at Carnegie Institute," *Carnegie Magazine* LV (January 1981): 6, illus., 7.

Remarks:
This drawing was probably done in 1887 (the date Hendricks assigns to it) from sketches made in the 1860s at the time of the Civil War.

Lucretia Giese, letter, 27 July 1984, notes that a related drawing, which is a study for the painting *Defiance* (c. 1864), is in the Cooper-Hewitt Museum, New York.

210. *The Baggage Guard*, 1887

crayon and pen and ink on paper mounted on board
9 ⅛ x 18 ¼ in. (23.2 x 46.4 cm.)
signed and dated lower right: Homer '65
Andrew Carnegie Fund, 06.3.10

Provenance:
Century Company, New York.

Exhibition:
Irene Kaufmann Settlement House, Pittsburgh, 17 November 1925.

Bibliography:
"Ranson's Division at Fredericksburg," *The Century Magazine*, (February 1888): illus., 324 // Carnegie Institute, *Lists* (1917) // Julian Grossman, *Echo of a Distant Drum, Winslow Homer and The Civil War* (New York, 1974), 163 // Gordon Hendricks, *The Life and Work of Winslow Homer* (New York, 1979), 191, illus., 320 (CL-595) // David Wilkins, "Winslow Homer at Carnegie Institute," *Carnegie Magazine* LV (January 1981): illus., 6.

Remarks:
Lucretia Giese, letter, 27 July 1984, mentions related drawings in the Cooper-Hewitt Museum, New York, and the National Gallery of Art, Washington, D.C.

Hendricks dates the drawing to 1887. It may, however, be another of the drawings that Homer reworked from sketches he made in the 1860s.

211. *Watching from the Cliffs*, 1892
(illus. p. 58)

watercolor on paper
14 x 20 in. (35.6 x 50.8 cm.)
signed and dated lower left: Winslow Homer 1892
Purchase, 17.19

Provenance:
Gustav Reichard; David T. Watson; American Art Association through M. Knoedler & Company until 1917.

Exhibitions:
Carnegie Institute, 1–27 November 1917, *Watercolors by Homer and Sargent*, no. 6 (traveled to Cleveland, Toledo, Detroit, Minneapolis, Milwaukee, Saint Louis, and Rochester until 12 July 1918) // Carnegie Institute, November 1918, *Exhibition of Prints and Drawings, Recent Accessions to the Collections of the Department of Fine Arts*, no. 33 // Carnegie Institute, 9 September–26 October 1923, *Watercolors by Winslow Homer*, no. 15 // Irene Kaufmann Settlement House, Pittsburgh, 22 November 1928 // Carnegie Institute, 13 February–26 March 1936, *Exhibition of American Genre Paintings*, no. 50 // Carnegie Institute, 1937, no. 111 // Macbeth Gallery, *Winslow Homer Centenary Exhibition*, New York, 1938 // Columbus Museum of Fine Arts, Columbus, Ohio, 4 March–9 April 1952, *Paintings from the Pittsburgh Collection* // Weirton Women's Club, Weirton, West Virginia, 17 March–26 May 1954 // Albright-Knox Art Gallery, Buffalo, New York, 8 July–28 August 1966, *Watercolors by Winslow Homer*, no. 34 // Carnegie Institute, 29 January–3 April 1983, *MOA Masterpieces*, no. 27.

Bibliography:
Carnegie Institute, *Lists* (1917) // M. Knoedler & Company, *American Art Association Catalogue* (1917), no. 93, illus. // Macbeth Gallery, New York, *Winslow Homer Centenary Exhibition* (1938), exh. cat. // Gordon Hendricks, *The Life and Work of Winslow Homer* (New York, 1979), 321 (CL-602) // David Wilkins, "Winslow Homer at Carnegie Institute," *Carnegie Magazine* LV (January 1981): 15, illus., 16.

HOPPER, EDWARD
1882 — 1967

212. *Saltillo Rooftops*, 1943
(illus. p. 171)

graphite, watercolor, and gouache on paper
21 ½ x 29 ⅝ in. (54.6 x 75.2 cm.)
signed lower right: Edward Hopper
Gift of Mr. and Mrs. James H. Beal, 60.3.3

Provenance:
With Frank K. M. Rehn Galleries, New York, until 1947; the donors, Pittsburgh.

Exhibitions:
Frank K. M. Rehn Galleries, New York, 29 November–23 December 1943, *Watercolors by Edward Hopper*, no. 3 // Walker Art Center, Minneapolis, 27 February–23 March 1945; Detroit Institute of Arts, 3 April–1 May 1945; The Brooklyn Museum, New York, 15 May–12 June 1945; M. H. deYoung Memorial Museum, San Francisco, 20 July–10 August 1945, *American Watercolor and Winslow Homer* // Pennsylvania Academy of the Fine Arts,

Philadelphia, 20 October–25 November 1945, *The Forty-Third Annual Philadelphia Watercolor and Print Exhibition, and the Forty-Fourth Annual Exhibition of Miniatures*, no. 252 ∥ The Art Institute of Chicago, 6 June–18 August 1946, *The Fifty-Seventh Annual American Exhibition, Water Colors and Drawings*, no. 32 ∥ Albertina, Vienna; Syracuse Museum of Fine Arts, Syracuse, New York, 1949–50, *Amerikanische Meister des Aquarelles*, no. 32 ∥ Whitney Museum of American Art, New York, 11 February–26 March 1950; Museum of Fine Arts, Boston, 13 April–14 May 1950; Detroit Institute of Arts, 4 June–21 July 1950, *Edward Hopper Retrospective Exhibition* ∥ The American Pavilion, Venice, 14 June–19 October 1952, *XXVI Biennale di Venezia*, no. 29 ∥ Gillespie Company, Pittsburgh, 1953 ∥ Whitney Museum of American Art, New York, 29 September–29 November 1964; The Art Institute of Chicago, 18 December 1964–31 January 1965; Detroit Institute of Arts, 18 February–21 March 1965; City Art Museum of St. Louis, 7 April–9 May 1965, *Edward Hopper*, no. 131 ∥ William A. Farnsworth Library and Art Museum, Rockland, Maine, 9 July–5 September 1971; Pennsylvania Academy of the Fine Arts, Philadelphia, 24 September–31 October 1971, *Edward Hopper, 1882–1967: Oils, Watercolors, Etchings*, no. 91 ∥ Andrew Crispo Gallery, New York, 16 May–15 July 1974, *Ten Americans*, no. 92 ∥ Museum of Art, Carnegie Institute, 29 January–3 April 1983, *MOA Masterpieces*, no. 28.

Bibliography:
"Edward Hopper," *Art News* XLII (December 1943): illus., 30 ∥ Walker Art Center, Minneapolis, *American Watercolor and Winslow Homer* (1945), exh. cat. by Lloyd Goodrich, illus., 65 ∥ Lloyd Goodrich, *Edward Hopper* (Harmondsworth, England, 1949), plate 25 ∥ Whitney Museum of American Art, New York, *Edward Hopper Retrospective Exhibition* (1950), exh. cat. by Lloyd Goodrich, no. 128, 25 ∥ Lloyd Goodrich, *Edward Hopper* (New York, 1971), illus., 262 ∥ "Rare Realist" *MD* (September 1973): 40 ∥ William A. Farnsworth Library and Art Museum, Rockland, Maine, *Edward Hopper 1882–1967: Oils, Watercolors, Etchings* (1971), exh. cat. by John W. McCoy, no. 41 ∥ Whitney Museum of American Art, New York, *Edward Hopper* (1964), exh. cat. by Lloyd Goodrich, no. 131.

HORTER, EARL
1881 — 1940

213. *Broadway and 186th Street,* before 1920 (illus. p. 109)

crayon and wash on paper
16 ⅛ x 11 ¼ in. (41 x 28.6 cm.)
inscribed, graphite, lower center: Broadway and 186th St. by Earl Horter
Purchase, 20.20

Provenance: Frederick Keppel & Company, New York.

HORTON, WILLIAM S.
1865 — 1936

214. *Figures on a Beach,* 1918

charcoal and gouache on paper
7 ¹³⁄₁₆ x 9 ¹⁵⁄₁₆ in. (19.8 x 25.2 cm.), sight
signed and dated lower left: W.S. Horton 1918
Gift of Richard M. Scaife, 81.6

Provenance:
The donor, Pittsburgh.

Exhibition:
Hirschl & Adler Galleries, Inc., New York, 26 October–19 November 1960, *William S. Horton*, no. 34.

HUFF, WILLIAM S.
b. 1927

215. *Parquet Deformation-Variant II,* 1965–66

pen and ink on paper
39 ⁵⁄₁₆ x 28 in. (99.9 x 71.1 cm.)
Gift of the artist, 81.23

Provenance:
The artist, Pittsburgh.

Bibliography:
Douglas R. Hofstadter, "Metamagical Themas, Parquet Deformations: Patterns of Tiles that Shift Gradually in One Dimension," *Scientific American* 249 (July 1983): 14–20.

HUGHES, JOSEPH
b. 1941

216. *Untitled No. 3,* 1970

watercolor on Japan paper
22 ½ x 17 ½ in. (57.2 x 44.5 cm.)
signed and dated, graphite, lower right: J. H. 3/70
Gift of John Hudson, 84.43.3

Provenance:
The donor, Irwin, Pennsylvania.

HUNT, WILLIAM MORRIS
1824 — 1879

217. *The Faggot Gatherer,* 1852–55 (illus. p. 113)

black crayon on paper faded to green-gray
14 ⅜ x 12 ¾ in. (36.5 x 32.4 cm.), irregular
signed, graphite, lower right: WM Hunt
Andrew Carnegie Fund, 06.15.1

Provenance:
Helen M. Knowlton, Boston.

Exhibitions:
The Dixon Gallery and Gardens, Memphis, Tennessee, 21 November 1982–2 January 1983; Terra Museum of American Art, Evanston, Illinois, 8 January–13 February 1983; Worcester Art Museum, Worcester, Massachusetts, 3 March–30 April 1983, *An International Episode: Millet, Monet and Their North American Counterparts.*

Bibliography:
Carnegie Institute, *Lists* (1917) // Theodore E. Stebbins, Jr., *American Master Drawings and Watercolors* (New York, 1976), 197 // The Dixon Gallery and Gardens, Memphis, Tennessee, *An International Episode: Millet, Monet and Their North American Counterparts* (1982), exh. cat. by Laura L. Meixner, 24, illus., 117.

218. *Nude Sketches,* n.d.

charcoal and chalk on greenish paper
22 ½ x 17 ⅞ in. (57.2 x 45.4 cm.)
Andrew Carnegie Fund, 06.15.2

Provenance:
Helen M. Knowlton, Boston.

Bibliography:
Carnegie Institute, *Lists* (1917).

Remarks:
There is a sketch of a nude on the verso of the sheet.

HUNTINGTON, DANIEL
1816—1906

219. *Mount Washington,* 1862
(illus. p. 45)

graphite and white chalk on darkened olive-green paper
10 ½ x 17 ½ in. (26.7 x 44.5 cm.)
inscribed and dated lower right: Mt. Washington / Madison Gorham Aug 18/62
Andrew Carnegie Fund, 06.10

Provenance:
The artist.

Bibliography:
Carnegie Institute, *Lists* (1917).

IPSEN, ERNEST
1869—1951

220. *Head of an Old Salt,* 1917–18

crayon on paper
11 ⅝ x 9 ⅞ in. (29.5 x 25.1 cm.)
signed and dated lower right: E. L. Ipsen / 1918
Purchase, 18.25.9

Provenance:
American Artists' War Emergency Fund, New York.

IZU, DAVID
b. 1951

221. *Requiem for Gene Baro,* 1984

graphite on paper
15 x 41 ¾ in. (38.1 x 106 cm.)
signed lower right: D. Izu // inscribed and dated lower left and lower right: Nascent 900 marks / 787 erasures emerge 1507 marks / 800 erasures disperse 7986 marks / 1500 erasures eminate / 9944 marks 306 erasures / Requiem for Gene Baro 3/13/84 // inscribed, dated, and signed verso: Dedicated to the memory of Gene Baro / is presented to the Carnegie Institute, Museum of Art, Summer of 1984 / David Izu
Gift of the artist, 84.70

Provenance:
The artist, Oakland, California.

JACQUETTE, YVONNE
b. 1934

222. *Madison Square Garden,* 1981

black crayon on vellum
19 ⅞ x 16 in. (50.5 x 40.6 cm.)
signed and dated lower right: Jacquette 1981 // inscribed lower left: crayon on reversed woodcut
Contemporary American Drawings Fund and National Endowment for the Arts, 82.22.3

Provenance:
Brooke Alexander, Inc., New York.

Exhibition:
Museum of Art, Carnegie Institute, 9 October–12 December 1982, *Recent Acquisitions: Works on Paper.*

Remarks:
The drawing was made on the verso of a woodcut.

JOHNSON, EASTMAN
1824—1906

223. *My Jew Boy,* 1852
(illus. p. 37)

graphite and crayon heightened with white chalk on brown paper
14 1/16 x 12 7/16 in. (37.1 x 31.6 cm.)
inscribed and dated lower right: Hague Feb. / 52 / My Jew Boy
Andrew Carnegie Fund, 06.11

Provenance:
Mrs. Eastman Johnson, New York.

Exhibitions:
National Portrait Gallery, Washington, D.C., 1 May–31 July 1980, *American Portrait Drawings* // Museum of Art, Carnegie Institute, 29 January–3 April 1983, *MOA Masterpieces,* no. 29.

Bibliography:
William Walton, "Eastman Johnson, Painter," *Scribner's Magazine* XL (September 1906): 268 // Carnegie Institute, *Lists* (1917) // Theodore E. Stebbins, Jr., *American Master Drawings and Watercolors* (New York, 1976), 185 // National Portrait Gallery, Washington, D.C., *American Portrait Drawings* (1980), exh. cat. by Marvin Sadik and Harold Francis Peter, 70, illus., 71 // Henry Adams, "Masterpieces of American Drawing and Watercolor," *Carnegie Magazine* LVI (January/February 1983): 20, 22, 27, illus., 22.

Remarks:
Mrs. Eastman Johnson. Letter to John Beatty, October 1906, states: "I am pleased you like the Jew Boy and think it very intense + vigorous. I think there is a note of who that boy was in his letters."

JOHNSON, LESTER
b. 1 9 1 9

224. *City Scene I*, 1972

ink and pastel on paper
27 ¾ x 35 ⅜ in. (70.5 x 89.9 cm.)
signed lower right: Lester Johnson
Gift of Sara M. Winokur and James L. Winokur to honor Mr. and Mrs. Richard M. Scaife, 75.32.1

Provenance:
The donors, Pittsburgh.

KANE, JOHN
1860 — 1934

225. *Studies of Highlanders*, c. 1927

graphite on paper
8 x 10 in. (20.3 x 25.4 cm.)
Museum purchase: gift of Allegheny Foundation, 84.56.1

Provenance:
Family of the artist; Galerie St. Etienne, New York.

226. *Study for "Nine Mile Run Seen from Calvary"*, c. 1928

graphite on paper
8 ⅜ x 12 ¹³⁄₁₆ in. (21.3 x 32.5 cm.)
Museum purchase: gift of Allegheny Foundation, 84.56.4

Provenance:
Estate of the artist; Galerie St. Etienne, New York.

Remarks:
This drawing is a study for *Nine Mile Run Seen from Calvary* (oil on canvas, c. 1928, Museum of Art, Carnegie Institute).

227. *Study for "Pittsburgh Landscape–Bloomfield Bridge"*, c. 1930

graphite on paper
9 ½ x 12 ¹³⁄₁₆ in. (24.1 x 32.5 cm.)
Museum purchase: gift of Allegheny Foundation, 84.56.3

Provenance:
Family of the artist; Galerie St. Etienne, New York.

Remarks:
Sketches of a hill with small buildings and AMOCO gas tank are on the verso of the sheet.

228. *Study for "Junction Hollow" and "Panther Hollow, Pittsburgh"*, c. 1932–33 (illus. p. 168)

graphite on paper
8 ⅜ x 12 ¹³⁄₁₆ in. (21.3 x 32.5 cm.)
Museum purchase: gift of Allegheny Foundation, 84.56.2

Provenance:
Estate of the artist; Galerie St. Etienne, New York.

Remarks:
The verso of the sheet is a study for *The Cathedral of Learning* (c. 1930, oil on canvas, Museum of Art, Carnegie Institute).

KARFIOL, BERNARD
1886 — 1952

229. *Three Nudes Seated*, n.d.

pen and ink on paper
15 x 21 in. (38.1 x 53.3 cm.)
signed lower right: B. Karfiol
Anonymous gift, 37.4.1

Provenance:
The donor.

KARLSEN, ANNE MARIE
b. 1 9 5 6

230. *Untitled*, 1981

graphite, modeling paste, acrylic, and gouache on paper
29 ⅛ x 21 ⅜ in. (74 x 54.3 cm.)
signed and dated verso: Anne Marie Karlsen '81
Leisser Art Fund, 81.105

Provenance:
The artist, Los Angeles.

KATZEN, LILA
b. 1 9 3 2

231. *Orbis à Deux*, 1975

pen and ink, watercolor, and silver tape on paper
47 x 94 ¼ in. (119.4 x 239.4 cm.), sight
signed lower right: L. Katzen // inscribed lower right: ORBIS A DEUX // stamped lower right: ORIGINAL WORK ©1975 [numeral five added in graphite]
L Katzen
Gift of Leon Anthony Arkus, 80.57

Provenance:
The donor, Pittsburgh.

KAUFMAN, LOIS
b. 1 9 2 6

232. *The Harvest,* 1960

ink and watercolor on paper
49 x 34 ⅞ in. (124.4 x 88.6 cm.), sight
signed, graphite, lower left: LSK
Gift of Sara M. Winokur and James L. Winokur to honor
Mr. and Mrs. Richard M. Scaife, 60.18

KAUFMANN, ROBERT D.
1 9 1 3 — 1 9 5 9

233. *Cactus Forms,* 1954

ink on brown paper
20 ¾ x 31 ¾ in. (52.7 x 80.6 cm.), sight
signed and dated lower left: LK 54
Bequest of the artist, 60.44

Provenance:
Estate of the artist.

Exhibition:
The Guild Hall, East Hampton, New York, 17
September–9 October 1977, *Robert D. Kaufmann
Retrospective.*

KELLER, ARTHUR
1 8 6 7 — 1 9 2 4

234. *The Good News,* c. 1900

charcoal on cardboard
24 ¼ x 18 ⅛ in. (61.6 x 46 cm.)
signed lower left: A I Keller
Purchased through the Art Society of Pittsburgh, 10.6.2

Bibliography:
Carnegie Institute, *Lists* (1917).

235. *Colonial Maid,* 1917–18

charcoal on paper
12 ⅜ x 10 in. (31.4 x 25.4 cm.)
signed, crayon, lower right: A I Keller
Purchase, 18.25.10

Provenance:
American Artists' War Emergency Fund, New York.

KELLY, ELLSWORTH
b. 1 9 2 3

236. *Plant,* 1957

watercolor on paper
23 x 17 ½ in. (55.2 x 44.5 cm.)
Gift of friends in memory of G. David Thompson, 58.58

Exhibition:
Westmoreland Museum of Art, Greensburg, Pennsylvania,
20 September–18 October 1959, *Flower Paintings.*

KELLY, MARIE TUICILLO
b. 1 9 1 6

237. *The Hunters,* 1952

ink on paper
23 x 29 in. (58.4 x 73.7 cm.)
signed and dated lower right: Kelly '52
Gift of Edward Duff Balken, 53.5.3

Provenance:
The donor, Pittsburgh.

238. *The Menagerie,* 1951

graphite, pen and ink, and gouache on paper
23 x 29 in. (58.4 x 73.7 cm.)
signed and dated lower right: Kelly '51
Gift of Edward Duff Balken, 53.5.2

Provenance:
The donor, Pittsburgh.

KENSETT, JOHN FREDERICK
1 8 1 8 — 1 8 7 2

**239. *Elm,* 1862
(illus. p. 47)**

graphite on paper
11 ¼ x 8 ⅛ in. (28.6 x 20.6 cm.)
inscribed and dated lower left: Elm Sept 17 62
Mr. and Mrs. George R. Gibbons, Jr., Fund, 84.10

Provenance:
The artist until 1872; Vincent Colyer until 1888; Louise
Colyer Weed until 1910; Edward F. Weed until c. 1955;
private collection until 1973; Babcock Galleries, New York,
until 1984.

Exhibitions:
Museum of Art, Pennsylvania State University, University
Park, 27 August–22 October 1978; Babcock Galleries,
New York, 1–30 November 1978, *John F. Kensett Drawings,*
no. 68.

Bibliography:
Museum of Art, Pennsylvania State University, University
Park, *John F. Kensett Drawings* (1978), exh. cat. by John
Paul Driscoll, intro., 9, plate 68.

240. *Illustration for "Hetabel",* c. 1853

graphite on paper
3 9/16 x 5 ⅞ in. (9.1 x 14.9 cm.)
Andrew Carnegie Fund, 16.30.1

Provenance:
Macbeth Gallery, New York.

Exhibition:
Museum of Art, Carnegie Institute, 29 January–3 April
1983, *MOA Masterpieces,* no. 30, as Two Pencil Sketches.

Bibliography:
Richard Haywarde (Frederick Swartwout Cozzens),
Prismatics (New York, 1853), illus., 53 // Carnegie Institute,
Lists (1917) // Museum of Art, Pennsylvania State
University, University Park, *John F. Kensett Drawings*
(1978), exh. cat. by John Paul Driscoll, 13.

Remarks:
This drawing illustrated Richard Haywarde's poem "Hetabel" in *Prismatics*, cited above.

Driscoll notes that the former title of the drawing, *St. Lenorewoods*, may be a corruption of St. Leonard's Hill, mentioned by Kensett in a letter of 1844: "The scene of my labors has been in the grounds of Captain Harcourter called St. Leonard's Hill. . . . The park contains some of the stateliest trees I have yet met with."

241. *Illustration for "A Babylonish Ditty"*, c. 1853

graphite on paper
3 ⅝ x 5 ⅞ in. (9.2 x 14.3 cm.)
inscribed verso: original drawing by Kensett / one of the early school of American landscape painters— / This is an illustration made / for 'Prismatics' first book / Frederic S. Cozzens had published / in the early fifties
Andrew Carnegie Fund, 16.30.2

Provenance:
Macbeth Gallery, New York.

Exhibitions:
Museum of Art, Carnegie Institute, 29 January–3 April 1983, *MOA Masterpieces*, no. 30, as Two Pencil Sketches.

Bibliography:
Richard Haywarde (Frederick Swartwout Cozzens), *Prismatics* (New York, 1853), 133 // Carnegie Institute, *Lists* (1917).

Remarks:
This drawing illustrated Richard Haywarde's poem "A Babylonish Ditty" in *Prismatics*, cited above.

KIENBUSCH, WILLIAM
1914—1980

242. *Dogtown Landscape*, 1954

pen and ink and gouache on paper mounted on board
26 ¾ x 34 ¾ in. (67.9 x 88.3 cm.)
signed and dated lower right: Kienbusch 54
Gift of Peggy J. Sweeney and Carol J. Schaffer in memory of Mr. and Mrs. Alexander H. Jackson, 84.21.2

Provenance:
Estate of Mrs. Alexander H. Jackson, Pittsburgh, until 1984; the donors, Pittsburgh.

243. *Coast Hurricane Island*, 1955

casein on paper mounted on board
26 ¹³⁄₁₆ x 40 ½ in. (68.1 x 102.9 cm.)
signed and dated, graphite, lower right: Kienbusch 55
Gift of Mrs. James H. Beal, 56.49

Provenance:
The donor, Pittsburgh.

KLINE, FRANZ
1910—1962

244. *Gray Antique*, 1958
(illus. p. 225)

watercolor and gouache on paper
10 ⁷⁄₁₆ x 14 ⅞ in. (26.5 x 37.8 cm.)
signed, graphite, upper right: KLINE
Leisser Art Fund, 58.40

Provenance:
Sidney Janis Gallery, New York.

Remarks:
This gouache was purchased at about the same time as *Siegfried* (1958, oil on canvas), which was shown in the 1958 Carnegie International exhibition and purchased by the Museum of Art in 1959.

KOEHLER, FLORENCE
1861—1944

245. *Rock and Succulents*, n.d.

gouache on paper
18 ⅛ x 11 ⅛ in. (46 x 28.3 cm.)
stamped verso: Estate of Florence Koehler 1861—1944 M.E.S.
Gift of Mrs. Henry D. Sharpe, 51.29

Provenance:
The donor.

KOERNER, HENRY
b. Austria, 1915

246. *Family with Sparkle Plenty*, 1949

gouache on board
13 ½ x 13 ½ in. (34.3 x 34.3 cm.)
signed and dated lower right: Koe 1949
Gift of Milton Porter, 82.15

Provenance:
Concept Art Gallery, Pittsburgh; the donor, Pittsburgh.

Exhibition:
Museum of Art, Carnegie Institute, 9 October–12 December 1982, *Recent Acquisitions: Works on Paper*.

Bibliography:
Museum of Art, Carnegie Institute, *From Vienna to Pittsburgh: The Art of Henry Koerner* (1983), exh. cat. by Gail Stavitsky and Henry Adams, no. 19, illus., 49.

Remarks:
This drawing is a study for the painting *The Family* (1948–49), which disappeared in a cab in New York in 1966 or 1967 and resurfaced in Los Angeles in 1983.

KOPMAN, BENJAMIN
1887—1965

247. *Against the Wall,* n.d.

brush and ink on paper
7 x 9 ⅞ in. (17.8 x 25.1 cm.)
signed upper right: Kopman
Gift of G. David Thompson, 42.6

Provenance:
The donor, Pittsburgh.

KUNIYOSHI, YASUO
b. Japan, 1893—1953

248. *Figure,* 1929

graphite on paper
17 ½ x 13 ¾ in. (44.5 x 34.9 cm.)
signed and dated lower right: Yasuo Kuniyoshi 29 //
inscribed lower right: reine nancel
Anonymous gift, 37.4.2

Provenance:
With Charles Daniel, New York, until 1930; the donor.

249. *Mother and Child,* 1946–47

pen and ink and brush and ink on card
21 ⅛ x 14 ⅜ in. (53.7 x 36.5 cm.)
signed lower left: Kuniyoshi
Gift of Mr. and Mrs. James H. Beal, 51.27.29

Provenance:
With Downtown Gallery, New York, until 1948; the donors, Pittsburgh.

LA FARGE, JOHN
1835—1910

250. *Head,* 1856

red chalk on beige paper
7 ⁷⁄₁₆ x 6 ⅝ in. (18.9 x 16.8 cm.)
inscribed on attached strip of paper: #991 early study at Couture's studio / Paris 1856 // stamped lower left: [seal with Oriental characters]
Purchase, 22.10.3

Provenance:
Sale, American Art Galleries, New York, [29–31 March] 1911, cat. no. 741; Mrs. George L. Heins, New York; Grace Edith Barnes (executrix of the artist's estate), New York.

Exhibitions:
Ferargil Galleries, New York, 21 January–1 February 1923 // Carnegie Institute, 13–27 October 1932.

Bibliography:
Henry Adams, "John La Farge, 1835–1870: From Amateur to Artist" (Ph.D. diss., Yale University, New Haven, Connecticut, 1980), I, 107; III, plate 25 // Henry A. La Farge, "The Early Drawings of John La Farge," *The American Art Journal* XVI (Spring 1984): 15 // Henry A. La Farge, catalogue raisonné MS. (New Canaan, Connecticut), D56.25.

Remarks:
Henry A. La Farge. Letter, 13 December 1984, Museum of Art files, explains that around 1922 Mrs. Heins "apparently turned to Miss Barnes for help in disposing of her things. Although the JLF estate was settled in 1911, Miss Barnes as executrix of the estate continued to be active in winding up his affairs, selling left-overs from the studio, publishing his writings, etc., and would have been a natural person for Mrs. Heins to turn to."

There is a priced copy of the American Art Galleries sale catalogue in the library of The Metropolitan Museum of Art, New York.

251. *Head of Frank,* 1858

graphite and white wash on paper
10 ⅝ x 7 ⅞ in. (27 x 20.3 cm.)
signed lower right: JLF // inscribed lower right: Frank 1858 // stamped lower left: [seal with Oriental characters]
Purchase, 22.10.2

Provenance:
Mrs. George L. Heins, New York [?]; Grace Edith Barnes (executrix of the artist's estate), New York.

Exhibitions:
Ferargil Galleries, New York, 21 January–1 February 1923 // Carnegie Institute, 13–27 October 1932.

Bibliography:
Henry Adams, "John La Farge, 1835–1870: From Amateur to Artist" (Ph.D. diss., Yale University, New Haven, Connecticut, 1980), I, 134; III, plate 51 // Henry A. La Farge, "The Early Drawings of John La Farge," *The American Art Journal* XVI (Spring 1984): illus., 22–23, fig. 21 // Henry A. La Farge, catalogue raisonné MS. (New Canaan, Connecticut), D58.2.

Remarks:
This work is a portrait of the artist's brother, Francis La Farge. A related drawing by La Farge is in the Pierpont Morgan Library, New York.

252. *Head of a Girl,* c. 1858

graphite heightened with white on brown paper mounted on card
9 x 5 ⅞ in. (22.9 x 14.9 cm.)
Purchase, 13.9.2

Provenance:
Estate of the artist, New York.

Exhibition:
Ferargil Galleries, New York, 21 January–1 February 1923.

Bibliography:
Henry Adams, "John La Farge, 1835–1870: From Amateur to Artist" (Ph.D. diss., Yale University, New Haven, Connecticut, 1980), I, 134; III, plate 50 // Henry A. La Farge, catalogue raisonné MS. (New Canaan, Connecticut), D58.14.

Remarks:
Henry A. La Farge's unpublished catalogue raisonné suggests that this drawing represents the artist's first cousin Alice Frith (later Mrs. Charles du Vivier, 1841–1927). Compare La Farge catalogue raisonné MS. D58.16, which is inscribed "Alice."

253. *Head of Little Girl*, c. 1859–60

graphite on tinted paper mounted on cardboard
5 ⅜ x 4 ⁹⁄₁₆ in. (13.7 x 11.6 cm.)
Purchase, 22.10.4

Provenance:
Mrs. George L. Heins, New York [?]; Grace Edith Barnes (executrix of the artist's estate), New York.

Exhibition:
Ferargil Galleries, New York, 21 January–1 February 1923.

Bibliography:
Henry A. La Farge, catalogue raisonné MS. (New Canaan, Connecticut), D58.13.

Remarks:
This is a likeness of the artist's youngest sister, Aimée La Farge (later Mrs. George L. Heins, 1852–1938).

254. *Figure of a King*, 1867–68

graphite and Chinese white on uncut woodblock
6 ½ x 5 in. (16.5 x 12.7 cm.)
inscribed verso: WELLS 42 ANN ST NY
Purchase, 22.10.7.3

Provenance:
Sale, American Art Galleries, New York, [29–31 March] 1911, cat. no. 840; Mrs. George L. Heins, New York; Grace Edith Barnes (executrix of the artist's estate), New York.

Bibliography:
John La Farge. Letters to Horace E. Scudder, 28 August 1867 and 9 February 1868 (Horace E. Scudder Papers, Houghton Library, Harvard University, MS. Am 801.4) // Henry A. La Farge, catalogue raisonné MS. (New Canaan, Connecticut), D67.80 // *Print Collector's Quarterly* V (December 1915): 491.

Remarks:
Anne L. Stolzenbach. Letter to Henry A. La Farge, 12 May 1934 (La Farge Family Papers, Division of Manuscripts and Archives, Yale University, New Haven, Connecticut, Box 5, Folder 8) documents that Edward Duff Balken either donated this drawing to the museum or contributed the funds for its purchase. This also applies to checklist nos. 256–259.

This may be an illustration for a ballad of King Estmere. La Farge's source for the ballad would have been the edition of Percy's *Reliques of Ancient English Poetry* (London, 1867), II, 296. See La Farge's letters to Horace Scudder, cited above.

255. *The Last Arrow of Will of Cloudeslie*, 1867–68

pen and ink, brush and ink, gouache, and Chinese white on uncut woodblock
6 ¾ x 5 ⅜ in. (17.1 x 13.7 cm.)
inscribed, crayon, verso: The Last Arrow / of Will of Cloudeslie / RW Gilder / AW Drake [crossed out]—& Co / 745 Broadway / NY
Purchase, 22.10.7.1

Provenance:
Sale, American Art Galleries, New York, [29–31 March] 1911, cat. no. 840; Mrs. George L. Heins, New York; Grace Edith Barnes (executrix of the artist's estate), New York.

Bibliography:
John La Farge. Letters to Horace E. Scudder, 28 August 1867 and 12 February 1868 (Horace E. Scudder Papers, Houghton Library, Harvard University, MS. Am. 801.4) // *Print Collector's Quarterly* V (December 1915): 489 // Henry A. La Farge, catalogue raisonné MS. (New Canaan, Connecticut), D67.20.

Remarks:
The crayon inscription refers to Richard Watson Gilder and A. W. Drake, the editor and the art editor at *The Century Magazine*.

John La Farge letter to Horace Scudder of 28 August 1867 mentions a ballad of William of Cloudsly [sic]; letter of 12 February 1868 refers to a woodblock with a picture of "Wm. of Cloudesely [sic] on it. I think it better not to finish it."

Henry A. La Farge's catalogue raisonné notes that this is an "unfinished drawing for the series of La Farge's illustrations of tales and ballads in *The Riverside Magazine for Young People* (1867–70), edited by Horace E. Scudder (1838–1902). La Farge's source for the ballad of William of Cloudeslie, notable outlaw in the reign of Henry II, was probably the edition of Percy's *Reliques of Ancient English Poetry* (London, 1867), III, 76, illustrating the lines, "Cloudeslie bent a wel good bowe / That was of trusty tree."

La Farge also made a watercolor version of this subject. See Henry A. La Farge, catalogue raisonné, W67.4; illus. in Reichard and Co., New York (1890), cat. no. 28, as The Last Arrow of Will of Cloudeslie; Doll and Richards, Boston (189?), cat. N; (1893), cat. J; (1896), cat. no. 37; Montross Gallery, New York (1901), cat. no. 98.

256. *Heads of Man and Angel*, c. 1867–68

crayon and Chinese white on uncut woodblock
3 ⅜ x 3 ⅞ in. (8.6 x 9.8 cm.)
inscribed verso: drawn in crayon / work out
Purchase, 22.10.7.4

Provenance:
Sale, American Art Galleries, New York, [29–31 March] 1911, cat. no. 840; Mrs. George L. Heins, New York; Grace Edith Barnes (executrix of the artist's estate), New York.

Bibliography:
Henry A. La Farge, catalogue raisonné MS. (New Canaan, Connecticut), D67.77.

Remarks:
See Remarks, checklist no. 254.

Henry A. La Farge's catalogue raisonné proposes that "the resemblance of the bearded man to James Russell Lowell suggests that this may have been intended to represent him as the prototypical poet, or for a frontispiece to a publication of his poems." This design may also be connected with a group of illustrations of the Gospels that La Farge started but did not complete. See H. Barbara Weinberg, *The Decorative Work of John La Farge* (New York, 1977), 57.

257. *Interior of a Room*, c. 1867–68

graphite, pen and ink, and Chinese white on uncut woodblock
2 ½ x 2 ½ in. (6.4 x 6.4 cm.)
Purchase, 22.10.7.2

Provenance:
Sale, American Art Galleries, New York, [29–31 March] 1911, cat. no. 840; Mrs. George L. Heins, New York; Grace Edith Barnes (executrix of the artist's estate), New York.

Bibliography:
Henry A. La Farge, catalogue raisonné MS. (New Canaan, Connecticut), D67.76.

Remarks:
See Remarks, checklist no. 254.

Henry A. La Farge's catalogue raisonné notes, "All of the objects represented are recognizable as furnishings in the living room of La Farge's house at Sunnyside Place, Newport, R. I."

An unfinished pencil sketch of the same subject is on the verso of this woodblock.

258. *Sketch,* 1867–68

graphite, pen and ink, and Chinese white on uncut woodblock
3 x 3 ⅞ in. (7.6 x 9.8 cm.), irregular
Purchase, 22.10.7.5

Provenance:
Sale, American Art Galleries, New York, [29–31 March] 1911, cat. no. 840; Mrs. George L. Heins, New York; Grace Edith Barnes (executrix of the artist's estate), New York.

Bibliography:
John La Farge. Correspondence with Horace E. Scudder, 1867–68 (Horace E. Scudder Papers, Houghton Library, Harvard University, MS. Am.801.4) // Henry A. La Farge, catalogue raisonné MS. (New Canaan, Connecticut), D67.79.

Remarks:
See Remarks, checklist no. 254.

Henry A. La Farge's catalogue raisonné suggests, "The studies reflect La Farge's preoccupation with the problems of satisfactory reproduction of original drawings for book illustration."

259. *Sketches,* c. 1867–68

graphite, pen and ink, ink wash, and Chinese white on uncut woodblock
3 ½ x 3 ¹⁵⁄₁₆ in. (8.9 x 10 cm.), irregular
Purchase, 22.10.7.6

Provenance:
Sale, American Art Galleries, New York, [29–31 March] 1911, cat. no. 840; Mrs. George L. Heins, New York; Grace Edith Barnes (executrix of the artist's estate), New York.

Bibliography:
John La Farge. Correspondence with Horace E. Scudder, 1867–68 (Horace E. Scudder Papers, Houghton Library, Harvard University, MS. Am.801.4) // Henry A. La Farge, catalogue raisonné MS. (New Canaan, Connecticut), D67.78.

Remarks:
See Remarks, checklist no. 254.

260. *A Woman in Japanese Costume at an Easel,* 1868
(**illus. p. 64**)

ink wash and Chinese white on uncut woodblock
5 ¾ x 4 ³⁄₁₆ in. (14.6 x 10.6 cm.)
Inscribed verso: "Illustration for a story—unpublished / 1868." // labeled verso: Accession no. 13 (Wood blocks) / John La Farge 'Figure' / Drawing on wood
Purchase, 18.41.2

Provenance:
George H. Whittle, New York.

Bibliography:
Leonard's Gallery, Boston (1879), cat. no. 1, dated 1868 // Henry Adams, "John La Farge and Japan," *Apollo* CXIX (February 1984): illus., 126, no. 16 // Henry A. La Farge, catalogue raisonné MS. (New Canaan, Connecticut), D68.3.

Remarks:
A related work, *In the Garden* (Leonard's Gallery, Boston, 1879, cat. no. 15), is one of four compositions made for an unpublished story.

This may be the drawing that inspired Richard Henry Stoddard's poem "The Lady of the East (on a Drawing by John La Farge)," *Century Magazine* XXV (February 1883): 582.

261. *Madonna,* c. 1886–87

graphite on paper
7 ⅜ x 3 ¹³⁄₁₆ in. (18.7 x 9.7 cm.)
inscribed lower left: No. 2 **B**. // stamped lower left: [seal with Oriental characters]
Purchase, 13.9.1

Provenance:
Sale, American Art Galleries, New York, [29–31 March] 1911, cat. no. 733; N. E. Montross, New York; Grace Edith Barnes (executrix of the artist's estate), New York.

Exhibitions:
Vose Galleries, Boston, 1911, no. 75 // Ferargil Galleries, New York, 21 January–1 February 1923 // Carnegie Institute, 13–27 October 1932.

Bibliography:
Henry A. La Farge, catalogue raisonné MS. (New Canaan, Connecticut), D86.35, as Madonna in Adoration.

Remarks:
This drawing was sent to Detroit Publishing Company on 20 April 1918 to be reproduced on postcards.

Henry A. La Farge's catalogue raisonné suggests that this is "possibly an alternate study for figure of The Virgin in the Ascension painting, Church of The Ascension, New York."

262. *Allegorical Figure with Lyre,* c. 1889

graphite, ink, and gouache on paper mounted on card
6 ⁹⁄₁₆ x 4 in. (16.7 x 10.2 cm.)
signed and dated lower left: LF. 89 // stamped lower left: [seal with Oriental characters] // inscribed mount: G4044
Purchase, 22.10.5

Provenance:
Mrs. George L. Heins, New York [?]; Grace Edith Barnes (executrix of the artist's estate), New York.

Exhibitions:
Ferargil Galleries, New York, 21 January–1 February 1923.

Bibliography:
Henry A. La Farge, catalogue raisonné MS. (New Canaan, Connecticut), W89.1.

Remarks:
This work is believed to be a design for glass.

Henry A. La Farge's catalogue raisonné notes, "Figure inspired by a wall painting in Pompeii reproduced in Louis Barre, *Herculaneum et Pompei, Receuil general des peintures, bronzes, mosaiques, etc.* (Paris, 1875–76), IV, Pl. 12, 'La Sambuque'. La Farge had a copy of this book in his library."

263. *Angels*, 1890

graphite on card
13 ¾ x 10 ⅞ in. (34.9 x 27.6 cm.)
signed lower left: LF JLF
Purchase, 22.10.1

Provenance:
Sale, American Art Galleries, New York, [29–31 March] 1911, cat. no. 835; Mrs. George L. Heins, New York; Grace Edith Barnes (executrix of the artist's estate), New York.

Exhibitions:
Museum of Fine Arts, Boston, 1910–1911 // Ferargil Galleries, New York, 21 January–1 February 1923 // Carnegie Institute, 13–27 October 1932.

Bibliography:
Henry A. La Farge, catalogue raisonné MS. (New Canaan, Connecticut), D89.11.

Remarks:
This drawing is a study for the stained glass window *Angels and the Book*, memorial to Henry Hotchkiss (1801–1871) of New Haven. It was given to Center Church, New Haven, Connecticut, in 1890 by his son Henry Hotchkiss and two daughters. The window is now in the collection of a granddaughter of Hotchkiss, Mrs. Robert N. Ganze, of Washington, D.C., and Martha's Vineyard, Massachusetts.

264. *Sitting Siva Dance*, c. 1894
(illus. p. 68)

graphite and gouache on card
13 ¾ x 21 ¹³⁄₁₆ in. (34.9 x 55.4 cm.)
inscribed lower center: Samuelu Aolele flying
cloud Tulagono the Law Aotoa cloud that
hangs Apslu / This measurement
Purchase, 17.8

Provenance:
Sale, American Art Galleries, New York, [29–31 March] 1911, cat. no. 577 as South Sea Seated Dance at Night; Macbeth Gallery, New York.

Exhibitions:
Ferargil Galleries, New York, 21 January–1 February 1923 // The Metropolitan Museum of Art, New York, 1936, no. 58 // Cleveland Museum of Art, 22 June–4 October 1937, *American Painting from 1860–1937* // Peabody Museum, Salem, Massachusetts, 1 February–1 May 1978, *South Sea Paintings* // Museum of Art, Carnegie Institute, 29 January–3 April 1983, *MOA Masterpieces*, no. 32.

Bibliography:
Durand-Ruel Galleries, New York, *Paintings, Studies, Sketches and Drawings: Mostly Records of Travel, 1886 and 1890–91* (1895), exh. cat., no. 66 // John La Farge, "Passages from a Diary in the Pacific," *Scribner's Magazine*

XXIX (May 1901): 680 // John La Farge, *Reminiscences of the South Seas* (New York, 1912), illus. opposite 188 // Henry A. La Farge catalogue raisonné MS. (New Canaan, Connecticut), W90.90.

Remarks:
A large (95 x 61 ½ in.) unfinished oil version of this work was found in La Farge's studio at his death. Grace Edith Barnes, in a letter to R. C. Vose, 15 January 1912, mentions a large, unfinished oil version of the picture.

A related work is discussed in Philip Hendy, *European and American Paintings in the Isabella Stewart Gardner Museum* (Boston, 1974), 133.

See memorandum from John Davis Hatch, 5 January 1935, in curatorial file of Isabella Stewart Gardner Museum, Boston, regarding conversations with Bancel La Farge and Henry A. La Farge.

In an inscription to his son Bancel La Farge, which he wrote on the related watercolor in the Isabella Stewart Gardner Museum and dated 19 December 1890, Boston, Massachusetts, and which was published in the 1895 Durand-Ruel catalogue cited above, La Farge described his doubts about this work and his problems with its execution.

Henry A. La Farge. Letter, 13 December 1984, Museum of Art files, discusses the problem of the two versions of this drawing.

265. *First Sketch for Three-paneled Window, One Done in Color*, 1896

graphite, colored pencil, and gouache on paper
8 ¹³⁄₁₆ x 11 ⅜ in. (22.4 x 28.9 cm.)
inscribed lower right: Return to John La Farge, 57 W. 10th St.
Purchase, 22.10.6

Provenance:
Grace Edith Barnes (executrix of the artist's estate), New York.

Exhibitions:
Ferargil Galleries, New York, 21 January–1 February 1923.

Bibliography:
Henry A. La Farge, catalogue raisonné MS. (New Canaan, Connecticut), W96.8.

Remarks:
This is a study for a memorial window with three lights in memory of Fanny Garretson Russell, in the Onteora Club Church, Tannersville, New York.

The figures are adapted from Fra Angelico's musical angels in the Linaiuoli altarpiece, Museo di San Marco, Florence.

LEWITT, SOL
b. 1940

266. *A Point Equidistant from Three Points*, 1974

graphite and ink on paper
23 ¹⁄₁₆ x 23 ¹⁄₁₆ in. (60 x 60 cm.)
signed and dated verso: Sol LeWitt January 18, 1974 // inscribed verso:

A point equidistant from three points which would be formed by the intersection of three sets of lines; the first line of the first set if it were drawn from the center of the page to the upper right

corner, the second line of the first set if it were drawn from the midpoint of the right side to a point halfway between the midpoint of the top side and the upper left corner; the first line of the second set if it were drawn from a point halfway between the intersection of the first set of lines and a point halfway between the center point of the page and the midpoint of the bottom side and halfway between the center of the page and the lower right corner to a point halfway between the center of the page and a point halfway between the midpoint of the left side and the lower left corner, the second line of the second set if it were drawn from a point halfway between the bottom of the page and the lower right corner to a point halfway between the upper left corner and the midpoint of the left side; the first line of the third set if it were drawn from a point halfway between the intersection of the second set of lines and a point halfway between the center of the page and the midpoint of the top side and the point halfway between the midpoint of the left side and the upper left corner to the upper right corner, the second line of the third set from a point halfway between the upper left corner and a point halfway between the midpoint of the left side and the upper left corner to a point halfway between the intersection of the first set of lines and a point halfway between the midpoint of the top side and the upper right corner // signed and dated verso: Sol LeWitt January 18 1974

Gift of Mel Bochner to honor Miss Helen Lee and the Tam-O-Shanters, 80.64

L O E W E , M I C H A E L
b. 1 9 5 0

267. *Collage No. 2,* 1980

paper mounted on cardboard
7 ½ x 7 ¹⁵⁄₁₆ in. (19.1 x 20.7 cm.), image
inscribed and dated, graphite, lower right: [illeg.] '80
Leisser Art Fund, 80.48.9

Provenance:
Impressions Gallery, Boston.

268. *Collage No. 5,* 1980

paper and watercolor mounted on cardboard
6 ³⁄₁₆ x 7 ¹⁄₁₆ in. (15.7 x 19.4 cm.), image
Leisser Art Fund, 80.48.8

Provenance:
Impressions Gallery, Boston.

L O Z O W I C K , L O U I S
b. Russia, 1 8 9 2 — 1 9 7 3

269. *Composition with Red Circles,* 1927
(illus. p. 189)

graphite, ink, and tempera on card
13 ¹³⁄₁₆ x 11 ⁹⁄₁₆ in. (35.1 x 29.4 cm.)
signed lower right: Louis Lozowick
Mary Hillman Jennings Foundation Fund, 84.1

Provenance:
Estate of the artist until 1983; Hirschl & Adler Galleries, New York.

Exhibition:
Hirschl & Adler Galleries, New York, 12 November–30 December 1983, *Realism and Abstraction: Counterpoints in American Drawing, 1900–1940,* no. 127.

Bibliography:
Hirschl & Adler Galleries, New York, *Realism and Abstraction: Counterpoints in American Drawing, 1900–1940* (1983), exh. cat., no. 127, illus., 108.

M A G E R , G U S
1 8 7 8 — 1 9 5 5

270. *Ontario Trout,* 1929

graphite and gouache on paper mounted on card
15 ⅞ x 10 in. (40.3 x 25.4 cm.), sheet
19 ¾ x 13 ⅞ in. (50.2 x 35.2 cm.), mount
signed lower right: Mager // inscribed and dated lower right: Ontario /Sept., '29
Gift of Robert Mager, 58.7

Provenance:
The donor, Murrysville, Pennsylvania.

M A R C A - R E L L I , C O N R A D
b. 1 9 1 3

271. *Untitled,* n.d.

pen and colored inks on paper
18 ¹⁄₁₆ x 12 ⁷⁄₁₆ in. (47.3 x 31.6 cm.)
signed lower right: Marca-Relli
Gift of Mr. and Mrs. Donald S. Steinfirst, 71.53

Provenance:
The donors, Pittsburgh.

M A R D E N , B R I C E
b. 1 9 3 8

272. *Untitled,* 1979
(illus. p. 230)

pen and ink on paper
29 ¾ x 22 ⅜ in. (75.6 x 56.8 cm.)
signed and dated lower center: B. Marden 79
Contemporary American Drawings Fund, bequest of Mrs. John C. Crouch, Patrons Art Fund, and National Endowment for the Arts, 82.43

Provenance:
Pace Gallery, New York.

Exhibition:
Museum of Art, Carnegie Institute, 9 October–12 December 1982, *Recent Acquisitions: Works on Paper.*

MARSH, REGINALD
1898—1954

273. *Tank Cars* 1933

graphite and watercolor on paper
14 x 19 ¹⁵⁄₁₆ in. (35.4 x 50.7 cm.)
Bequest of Felicia Meyer Marsh, 79.24.2

Provenance:
Estate of the donor.

Exhibition:
Museum of Art, Carnegie Institute, 29 January–3 April
1983, *MOA Masterpieces*, no. 33.

274. *Untitled,* 1933

graphite and watercolor on paper
15 ½ x 22 ¾ in. (39.8 x 57.8 cm.)
inscribed lower right: WL No.-225 // stamped lower right:
F. MARSH COLLECTION
Bequest of Felicia Meyer Marsh, 79.24.1

Provenance:
Estate of the donor.

**275. *Sideshow,* 1944
(illus. p. 173)**

graphite and watercolor on paper mounted on board
31 ½ x 22 ½ in. (80 x 57.2 cm.), sheet
33 ⅜ x 24 ⅞ in. (84.8 x 63.2 cm.), mount
signed and dated lower right: Reginald / Marsh 44
Gift of Marty Cornelius (Martha C. Fitzpatrick), 74.14

Provenance:
The donor, Ligonier, Pennsylvania.

Exhibition:
Museum of Art, Carnegie Institute, 29 January–3 April
1983, *MOA Masterpieces*, no. 34.

Remarks:
Reginald Marsh. Letter to Pittsburgh artist Marty
Cornelius, 20 April 1945, Museum of Art files, says of
Sideshow:

> Under separate post I have sent you in a tube a
> large watercolor drawing made last summer
> 22 x 30—These drawings are now considered
> my best work. This is the most interesting one I
> have around and hope you like it.

276. *Windy Day,* n.d.

watercolor on paper
22 ⅜ x 31 in. (56.8 x 78.7 cm.)
stamped lower right: F. MARSH COLLECTION
Bequest of Felicia Meyer Marsh, 79.24.3

Provenance:
Estate of the donor.

Remarks:
There is a sketch in pen and ink and ink wash on the verso of
the sheet.

277. *Untitled,* n.d.

brush and ink and crayon on composition board
16 x 12 in. (40.6 x 30.5 cm.)
signed and dated verso: Marsh 1949
Bequest of Felicia Meyer Marsh, 79.24.4

Provenance:
Estate of the donor.

Remarks:
There is a sketch in crayon, oil, ink, and varnish on the verso
of the sheet.

278. *Untitled,* n.d.

watercolor and brush and ink on masonite
11 ¹⁵⁄₁₆ x 9 in. (30.3 x 22.8 cm.)
Bequest of Felicia Meyer Marsh, 79.24.5

Provenance:
Estate of the donor.

Remarks:
There is a sketch in watercolor and ink on the verso of the
sheet.

MARTIN, HOMER DODGE
1836—1897

**279. *Sand Dunes, Lake Ontario,* c. 1874
(illus. p. 122)**

charcoal, crayon, and gouache on buff paper
12 ³⁄₁₆ x 19 ½ in. (31 x 49.5 cm.)
inscribed lower left: Sand Dunes, Lake Ontario
Carnegie Special Fund, 04.5.4

Provenance:
Macbeth Gallery, New York.

Bibliography:
Carnegie Institute, *Lists* (1917).

Remarks:
This drawing is a study for *Sand Dunes, Lake Ontario* (1874,
Museum of Fine Arts, Houston) and is also related to *Sand
Dunes, Lake Ontario* (1887, The Metropolitan Museum of
Art, New York).

280. *Cedar River,* 1875

crayon and white gouache on grayish-green paper
11 ¹¹⁄₁₆ x 19 ¹³⁄₁₆ in. (29.7 x 50.3 cm.)
signed lower right: HD Martin // inscribed and dated
lower right: Cedar River / Aug. 25 75—
Carnegie Special Fund, 04.5.3

Provenance:
Macbeth Gallery, New York.

Bibliography:
Carnegie Institute, *Lists* (1917).

MASSEY, JACK
b. 1925

281. *Untitled,* n.d.

spray-paint, paper, and silver tape mounted on black
paper
19 ⅜ x 15 ⅝ in. (49.2 x 39.7 cm.)
Gift of Mr. and Mrs. Leon Anthony Arkus, 78.21.2

Provenance:
The donors, Pittsburgh.

MASTER OF THE FROSSARD FORGERIES

282. *Portrait of George Washington*, c. 1893–96

gouache on deerskin
11 ½ x 10 ¹¹⁄₁₆ in. (29.2 x 27 cm.), sight
signed right: J T
Bequest of Mrs. Edwin R. Sullivan, 22.3.1

Provenance:
Estate of the donor, Pittsburgh.

Bibliography:
"Carnegie Institute Makes Important Discoveries in the Realm of History and Art," *Pittsburgh Gazette Times*, 23 July 1922 // *Carnegie Magazine* V (February 1932): 263, 264, illus. on cover.

Remarks:
This forged work originally attributed to John Trumbull (1756–1843), was bought by Mr. and Mrs. Edwin R. Sullivan in 1899 from the auctioneer Draper, who had probably purchased it at an auction at the American Art Galleries in New York in 1896.

For an account of Trumbull forgeries see Theodore Sizer, *The Works of Colonel John Trumbull* (New Haven, Connecticut, 1967), xiii–xiv.

MATULKA, JAN
b. Bohemia, 1890 — 1972

283. *Untitled (Sailors Working on Deck)*, c. 1932 (illus. p. 193)

graphite and gouache on paper
15 x 22 ⅛ in. (38.1 x 56.2 cm.)
signed lower right: Matulka
Museum purchase: bequest of Mrs. John C. Crouch, 82.2

Provenance:
Robert Schoelkopf Gallery, New York.

Exhibition:
Museum of Art, Carnegie Institute, 9 October–12 December 1982, *Recent Acquisitions: Works on Paper*.

Bibliography:
John R. Lane, "American Abstract Art of the '30s and '40s," *Carnegie Magazine* LVI (September/October 1983): illus., 16.

McCARTER, HENRY
1865 — 1942

284. *All Is Fresh and New: Easter Hymn*, c. 1895

graphite, pen and ink, and gouache on two pieces of cardboard
15 ⅞ x 10 ³⁄₁₆ in. (40.3 x 25.9 cm.), left
10 ¹⁄₁₆ x 15 ¹⁵⁄₁₆ in. (27 x 40.5 cm.), right
signed lower right of right sheet: Henry McCarter
Andrew Carnegie Fund, 06.19.9

Provenance:
Charles Scribner's Sons, New York.

Bibliography:
Thomas Blackburn, "An Easter Hymn," *Scribner's Magazine* XVII (April 1895): 422–27, illus., 426 // Sadakichi Hartmann, *A History of American Art*, Vol. II (New York, 1901), 127.

Remarks:
Hartmann notes: "Of special technical interest was also his 'Easter Hymn.' His style exercised a very strong influence upon all the young illustrators of the day."

MELCHERS, GARI
1860 — 1932

285. *Peace (Study for Four Figures for Mural Decoration in Congressional Library, Washington, D.C.)*, c. 1900

crayon, charcoal, and pastel on grayish-green paper mounted on grayish paper
31 ⅜ x 43 ¼ in. (79.7 x 109.9 cm.), irregular
signed lower right: Gari Melchers
Andrew Carnegie Fund, 06.17

Provenance:
The artist, The Netherlands.

Bibliography:
Carnegie Institute, *Lists* (1917).

MISS, MARY
b. 1944

286. *Shored Bank (Detail from a Construction)*, 1977

graphite on paper
22 ¼ x 29 ⅞ in. (56.5 x 75.9 cm.)
signed and dated verso: Mary Miss 77 // inscribed upper center: Detail Shored bank—steps
Contemporary American Drawings Fund and National Endowment for the Arts, 82.41.3

Provenance:
Max Protetch Gallery, New York.

Exhibitions:
Museum of Art, Carnegie Institute, 9 October–12 December 1982, *Recent Acquisitions: Works on Paper*.

MITCHELL, JOAN
b. 1926

287. *Untitled*, c. 1965

watercolor on paper
10 ⅝ x 8 ¼ in. (27 x 21 cm.)
signed lower right: J. Mitchell
Gift of Sara M. Winokur and James L. Winokur to honor Mr. and Mrs. Richard M. Scaife, 73.54.1

Provenance:
The donors, Pittsburgh.

288. *Untitled,* **n.d.**

charcoal and watercolor on paper
14 ¹⁵⁄₁₆ x 10 ¹⁵⁄₁₆ in. (37.9 x 27.8 cm.)
signed lower center: J Mitchell
Gift of Sara M. Winokur and James L. Winokur to honor
Mr. and Mrs. Richard M. Scaife, 75.32.2

Provenance:
The donors, Pittsburgh.

MONTGOMERY, KATHLEEN
b. 1 9 4 5

289. *Graphite on Paper,* **1982**

graphite on paper
23 x 35 in. (58.4 x 88.9 cm.)
Leisser Art Fund, 83.30.1

Provenance:
The artist, Pittsburgh.

MORAN, THOMAS
b. England, 1 8 3 7 — 1 9 2 6

290. *Landscape,* **1870s**
(illus. p. 73)

graphite, pen and ink, ink wash, and Chinese white on
uncut woodblock
6 x 5 ⅛ in. (15.2 x 13 cm.)
signed in monogram lower edge: TM // signed verso:
Thos Moran // inscribed upper left: Do not cut line
around any part
Purchase, 18.41.3

Provenance:
George H. Whittle, New York.

Bibliography:
Thurman Wilkins, *Thomas Moran, Artist of the Mountains*
(Norman, Oklahoma, 1966), 260.

Remarks:
This seems to be the only extant uncut woodblock by
Moran.

291. *North Peak,* **c. 1873**
(illus. p. 72)

graphite, pen and ink, brush and ink, and gouache on
paper
10 x 16 in. (25.4 x 40.6 cm.)
signed in monogram lower left: TMORAN
Andrew Carnegie Fund, 06.3.14

Provenance:
Century Company, New York.

Bibliography:
Carnegie Institute, *Lists* (1917).

MORRILL, MICHAEL
b. 1 9 5 1

292. *Replacement la,* **1980**

charcoal and oil on paper
42 ⅜ x 30 ⅜ in. (107.6 x 77.2 cm.)
signed, inscribed, and dated, graphite, verso: M. Morrill
Replacement la 1980
Leisser Art Fund, 83.12.1.1

Provenance:
The artist, Pittsburgh.

293. *Replacement qui,* **1980**

charcoal and oil on paper
42 ¾ x 30 ⅜ in. (108.6 x 77.2 cm.)
signed, inscribed, and dated, graphite, verso: M. Morrill
Replacement qui 1980
Leisser Art Fund, 83.12.1.2

Provenance:
The artist, Pittsburgh.

294. *Replacement costi,* **1980**

charcoal and oil on paper
42 ½ x 30 ½ in. (108 x 77.5 cm.)
signed, inscribed, and dated, graphite, verso: M. Morrill
Replacement costi 1980
Leisser Art Fund, 83.12.1.3

Provenance:
The artist, Pittsburgh.

MORRIS, GEORGE L. K.
1 9 0 5 — 1 9 7 5

295. *Tribal Rites # 2,* **1937**

gouache on paper
16 ¼ x 12 ¼ in. (41.3 x 31.1 cm.), sight
signed in monogram lower right: GLKM // dated lower
left: 1937
Gift of Dr. and Mrs. John R. Lane in honor of James M.
Walton, 84.96

Provenance:
The artist, New York.

Exhibitions:
Hirschl & Adler Galleries, New York, 1974, *George L. K.
Morris: Abstract Art of the 1930s,* no. 46 // American Academy
of Arts and Letters, New York, 1976, *Memorial Exhibition:
Thomas Hart Benton, George L. K. Morris,* no. 64.

Bibliography:
American Academy of Arts and Letters, New York,
Memorial Exhibition: Thomas Hart Benton, George L. K. Morris
(1976), exh. cat. by Michael Rapvano, no. 64.

MOUNT, WILLIAM SIDNEY
1807—1868

296. *Landscape with Figures,* 1840s

graphite on paper
4 ¼ x 6 ¹⁵⁄₁₆ in. (10.8 x 17.6 cm.)
Gift of Senator and Mrs. H. John Heinz III, 79.71.3

Provenance:
The donors, Pittsburgh.

NEUTRA, RICHARD
1892—1970

297. *Elevation of L.A. County Hall of Records,* n.d.

graphite on tracing paper mounted on gray card
12 ⅜ x 10 ⁷⁄₁₆ in. (31.4 x 26.5 cm.)
signed lower center: Richard Neutra // inscribed center:
STAGGERED / T. C. JOINTS / HORIZONTALS:
[illeg.] / RED GLASS MOSAIC NORTH FRONT /
FINS ON
Gift of the artist, 62.31.1

Provenance:
The artist.

298. *Hall of Records, L.A., View from N.E.,* n.d.

graphite on tracing paper mounted on gray card
8 ½ x 10 ¾ in. (21.6 x 27.3 cm.)
signed lower left: Richard Neutra // inscribed upper,
middle, and lower right: HALL OF RECORDS, L.A. /
VIEW FROM N.E. / EXISTING STREET TREE /
BLACK T.C. / WHITE T.C. / CURVED /
BACKWALL / HEARING / ROOM / POOL / RED
GLASS MOSAIC / ON UNDERSIDES OF / ALL
STAFF LOUNGE BALCONY
Gift of the artist, 62.31.2

Provenance:
The artist.

299. *L.A. Hall of Records,* n.d.

graphite on tracing paper mounted on gray card
8 ¹⁵⁄₁₆ x 7 ⅝ in. (22.7 x 19.4 cm.)
signed lower left: Richard Neutra // inscribed lower right:
L.A. HALL OF RECORDS
Gift of the artist, 62.31.3

Provenance:
The artist.

300. *L.A. Hall of Records, North Front,* n.d.

graphite on tracing paper mounted on gray card
8 ⅝ x 10 ¹⁵⁄₁₆ in. (21.9 x 27.8 cm.)
signed lower right: Richard Neutra // inscribed lower
right: POOL / COUNTY MAP MURAL / "MEMORY
OF A COUNTY" / L.A. HALL OF RECORDS /
NORTH FRONT
Gift of the artist, 62.31.4

Provenance:
The artist.

301. *Mt. Whitney from the Oyler House Living Room Table,* 1959

graphite on tracing paper mounted on gray card
7 ⅞ x 10 ⅞ in. (20 x 27.6 cm.)
signed and dated lower right: Richard Neutra 59 //
inscribed upper left: MT. WHITNEY FROM THE /
OYLER HOUSE LIVING ROOM TABLE
Gift of the artist, 62.31.5

Provenance:
The artist.

302. *The Two Inyo County Homes,* 1958

graphite on tracing paper mounted on gray card
8 ⅛ x 10 ¹⁵⁄₁₆ in. (20.6 x 27.8 cm.)
signed lower left: Richard Neutra // inscribed and dated
lower center: THE TWO INYO COUNTY HOMES /
OYLER-SORRELS-1958
Gift of the artist, 62.31.6

Provenance:
The artist.

NEWMAN, ROBERT LOFTIN
1827—1912

303. *The Storm,* c. 1898
(illus. p. 134)

charcoal on board
4 ¾ x 7 ¹⁄₁₆ in. (12.1 x 19.4 cm.)
signed lower right: R. L. Newman
Andrew Carnegie Fund, 07.9

Provenance:
Sadakichi Hartmann, Bronx, New York, until 1907.

Exhibition:
Addison Gallery of American Art, Andover, Massachusetts,
April 1959, *The American Line: 100 Years of Drawing,* no. 51.

Bibliography:
Carnegie Institute, *Lists* (1917) // Addison Gallery of
American Art, Andover, Massachusetts, *The American Line:
100 Years of Drawing* (1959), exh. cat. by Bartlett H. Hayes,
Jr., no. 51, illus.

NICKLE, ROBERT
b. 1919

304. *Collage,* 1966

plastic and paper mounted on paper
10 ¹³⁄₁₆ x 10 ³⁄₁₆ in. (27.5 x 25.9 cm.)
signed and dated verso: Robert Nickle / 1966
National Endowment for the Arts and Women's
Committee of the Museum of Art, 76.23.2

Provenance:
Acquavella Contemporary Art, Inc., New York.

OAKLEY, VIOLET
1874—1961

305. *Venetian Girl,* **1918**
(illus. p. 105)

crayon on paper
12 ½ x 10 ⅞ in. (31.8 x 27.6 cm.)
signed and dated upper left: Violet / Oakley / 1918 //
stamped verso: L. Cornelissen & Son / 22, Great Queen
Street, W. O. / Back / No. 6
Purchase, 18.25.11

Provenance:
American Artists' War Emergency Fund, New York.

O'KEEFFE, GEORGIA
b. 1887

306. *Red Cannas,* **1919**
(illus. p. 156)

watercolor on paper
19 ⅜ x 13 in. (49.2 x 33 cm.)
Collection of Mr. and Mrs. James A. Fisher, intended gift
to the Museum of Art, Carnegie Institute

OLDS, HERBERT
b. 1937

307. *Collection,* **n.d.**

charcoal and watercolor on paper mounted on board
33 ¹¹/₁₆ x 43 ¾ in. (85.6 x 111.1 cm.), sheet
37 x 48 in. (94 x 121.9 cm.), mount
signed lower right: Herbert Olds
71st Annual Associated Artists of Pittsburgh Exhibition
Purchase Prize, 80.3.2

Provenance:
The artist, Pittsburgh.

Exhibition:
Museum of Art, Carnegie Institute, 1980, *71st Annual
Associated Artists of Pittsburgh Exhibition.*

OLINSKY, IVAN G.
1878—1962

308. *Head of a Girl,* **1917–18**

charcoal on paper
12 ⅝ x 10 ½ in. (32.1 x 26.7 cm.), irregular
signed and dated, crayon, center right: Ivan G. Olinsky /
1918 // inscribed lower right: Sanguine [crossed out]
Purchase, 18.25.16

Provenance:
American Artists' War Emergency Fund, New York.

Remarks:
This drawing is a study for a painting *Springtime* (1918,
Butler Institute of American Art, Youngstown, Ohio). The
drawing was originally titled *Lettice.*

OLSON, CHUCK
b. 1953

309. *Gift,* **1982**

graphite, charcoal, and acrylic on paper
49 ¾ x 38 in. (126.4 x 96.5 cm.)
signed and dated center right: Olson 82
74th Annual Associated Artists of Pittsburgh Exhibition
Purchase Prize, 84.54

Provenance:
The artist, Pittsburgh.

Exhibition:
Museum of Art, Carnegie Institute, 1984, *74th Annual
Associated Artists of Pittsburgh Exhibition.*

PALUZZI, RINALDO
b. 1927

310. *Untitled,* **1962**

charcoal and pen and ink on paper
25 x 18 ⅞ in. (63.5 x 47.9 cm.)
Gift of Mr. and Mrs. James H. Beal, 67.3.11

Provenance:
The donors, Pittsburgh.

PARRISH, FREDERICK MAXFIELD
1870—1966

311. *Girl by a Fountain,* **1918**
(illus. p. 107)

crayon on paper
11 ¼ x 9 ¹⁵/₁₆ in. (28.6 x 25.2 cm.)
signed lower left: Maxfield Parrish
Purchase, 18.25.12

Provenance:
American Artists' War Emergency Fund, New York.

Exhibitions:
Brandywine River Museum, Chadds Ford, Pennsylvania,
15 May–15 September 1974, *Maxfield Parrish: Master of
Make-Believe,* no. 98 // Museum of Art, Carnegie Institute,
29 January–3 April 1983, *MOA Masterpieces,* no. 35.

PARSONS, BETTY
1900—1982

312. *Flowers,* **1969**

felt-tip pen and watercolor on paper
10 ⅝ x 8 in. (27 x 20.3 cm.)
signed and dated, ballpoint pen, lower right:
Betty Parsons / 69
Gift of Steingrim Laursen, 79.2.1

Provenance:
The donor, Copenhagen, Denmark.

313. *Untitled,* 1971

felt-tip pen and watercolor on paper
8 ¼ x 5 ³/₁₆ in. (21 x 13.2 cm.)
signed and dated, ballpoint pen, lower right:
Betty Parsons / 71
Gift of Steingrim Laursen, 72.2.2

Provenance:
The donor, Denmark.

P A S C I N , J U L E S
b. Bulgaria, 1 8 8 5 — 1 9 3 0

314. *Café Scene,* c. 1906

graphite, pen and ink, and ink wash on cardboard
8 ⁷/₁₆ x 10 ⅞ in. (21.4 x 27.6 cm.)
inscribed verso: Nachden sie die Angaben uber Jahrgang
[illeg.] Nummer der simplicissimus Fehlen [?] in die
Publication die Zeichnung offenbar unterblieben
Inscribed lower center: Ich denk in gref [illeg.]
ohwermutig [?] geworden, um nun kauft er mit Sierum
Na ja, denk, Sie hat 200 pfennig [illeg.]
Gift of G. David Thompson, 57.12.1

Provenance:
The donor, Pittsburgh.

Exhibition:
Museum of Art, Carnegie Institute, 29 January–3 April
1983, *MOA Masterpieces,* no. 36.

Remarks:
The label on the verso of this drawing indicates it was
submitted, with the inscribed material as a caption, to the
German satirical magazine *Simplicissimus,* but was not
published.

P E A R L S T E I N , P H I L I P
b. 1 9 2 4

315. *The Portable Phonograph (A Student Work),*
1941–42
(illus. p. 210)

graphite and gouache on paper mounted on board
12 x 15 ⅞ in. (30.5 x 40.3 cm.)
Gift of the artist, 84.20

Provenance:
The artist, New York.

Exhibition:
Museum of Art, Carnegie Institute, 19 May–15 July 1984
Philip Pearlstein Retrospective.

Bibliography:
Henry Adams, "The Pittsburgh Background of Pearlstein's
Realism," *Carnegie Magazine* LVII (May/June 1984):
23–24, illus., 22.

P E H R , H A L L S T E N
1 8 9 7 — 1 9 6 6

316. *Figures in Landscape,* 1958

poster paint and wash on Japan paper
12 x 17 ⅛ in. (30.5 x 43.5 cm.)
signed and dated, watercolor, lower left: Pehr 58
Gift of Sara M. Winokur and James L. Winokur to honor
Mr. and Mrs. Richard M. Scaife, 62.33

Provenance:
Otto Seligman Gallery, Seattle, until 1962; the donors,
Pittsburgh.

317. *Church in the Snow,* 1961

poster paint and gouache on laid paper
11 ⅜ x 8 ⅝ in. (28.9 x 22 cm.)
signed and dated, ballpoint pen, lower right: Pehr 1961
John O'Connor, Jr., Fund, 62.26

Provenance:
Otto Seligman Gallery, Seattle.

P E N N E L L , J O S E P H
1 8 6 0 — 1 9 2 6

318. *Drawing No. 1 for Washington Irving's*
***"Alhambra",* c. 1896**

graphite on paper
8 ⅜ x 5 ½ in. (21.3 x 14 cm.)
signed lower right: Jo Pennell
Purchase, 17.5.6

Provenance:
E. Weyhe, New York.

319. *Drawing No. 2 for Washington Irving's*
***"Alhambra",* c. 1896**

graphite on paper
8 ⅜ x 5 ½ in. (21.3 x 14 cm.)
signed lower left: Jo Pennell
Purchase, 17.5.7

Provenance:
E. Weyhe, New York.

320. *Fish Ponds of the Alhambra,* c. 1896

graphite on paper
8 ⅜ x 5 ⁷/₁₆ in. (21.3 x 13.8 cm.)
stamped verso: Gilby & Herrmann 7, Plum Tree London
E.O. Late Zorn, Bahnson & Co.
Purchase, 17.5.2

Provenance:
E. Weyhe, New York.

Exhibition:
Irene Kaufmann Settlement House, Pittsburgh, 2
December 1926.

Remarks:
This early study is very closely related to the illustration
reproduced in Washington Irving, *The Alhambra* (London,
1896), 66.

321. *The Generalife: Alhambra,* c. 1896

graphite on paper
5 ⅜ x 8 ⅜ in. (13.7 x 21.3 cm.)
signed lower center: Jo Pennell
Purchase, 17.5.4

Provenance:
E. Weyhe, New York.

Exhibition:
Irene Kaufmann Settlement House, Pittsburgh, 2 December 1926.

322. *Group of Trees Beside Brook, Near Osuna, Spain,* c. 1896

graphite and pen and ink on paper
4 1/16 x 6 ⅝ in. (11.7 x 16.8 cm.)
inscribed verso: 29 Group of trees / beside brook / page 22 Alhambra / Jos Pennell
Purchase, 17.5.1

Provenance:
E. Weyhe, New York.

323. *The Hall of Ambassadors, Alhambra,* c. 1896

graphite on paper
5 x 7 ½ in. (12.7 x 19.1 cm.)
signed in monogram lower right: JoP
Purchase, 17.5.3

Provenance:
E. Weyhe, New York.

Exhibition:
Irene Kaufmann Settlement House, Pittsburgh, 2 December 1926.

324. *Spain,* c. 1896

graphite on paper
8 ⅜ x 5 ½ in. (20.8 x 14 cm.)
signed upper left: J Pennell
Purchase, 17.5.5

Provenance:
E. Weyhe, New York.

325. *Caen (Sketch of a Canal),* 1899 (illus. p. 101)

pen and ink on paper mounted on card
5 ⅞ x 9 ¼ in. (14.9 x 23.5 cm.)
signed in monogram lower right: JoP
Andrew Carnegie Fund, 06.12.5

Provenance:
Frederick Keppel & Company, New York.

326. *The Pergola, Hudson River,* n.d.

charcoal on paper mounted on cardboard
11 ⅜ x 8 11/16 in. (28.9 x 22.1 cm.)
Purchase, 10.6.3

PICCILLO, JOSEPH
b. 1937

327. *Summer Fragments,* 1970

graphite and charcoal on paper
29 9/16 x 41 ⅜ in. (75.1 x 105.1 cm.)
signed right: Joseph Piccillo // inscribed and dated center right: 'Summer Fragments' Sept. 1970
Gift of Louis M. Meyers, 73.19

Provenance:
The donor, Pittsburgh.

PLOEGER, JOHN
b. 1943

328. *Chickenwire,* 1972

graphite on paper
29 ⅞ x 21 ⅞ in. (75.9 x 55.6 cm.)
signed and dated lower right: John Ploeger 72
Gift of John Hudson, 84.43.1

Provenance:
The donor, Irwin, Pennsylvania.

PORTLAND, JACK
b. 1946

329. *Oh No You Don't You,* 1981

graphite, gouache, and pastel on paper
9 x 12 3/16 in. (22.9 x 31 cm.)
signed and dated lower center: Portland 81 // inscribed, signed, and dated lower center: oh no you don't you Portland 81
Leisser Art Fund, 81.46.9.1

Provenance:
The Fountain Gallery of Art, Portland, Oregon.

330. *Oh Papa Doo,* n.d.

gouache and pastel on paper
29 ⅝ x 22 ¾ in. (75.2 x 57.8 cm.)
Leisser Art Fund, 81.46.9.2

Provenance:
The Fountain Gallery, Portland, Oregon.

PRENDERGAST, CHARLES
1869 — 1948

331. *Antibes,* 1927

graphite and wash on paper mounted on glassine mounted on card
10 3/16 x 13 5/16 in. (25.9 x 35.4 cm.)
signed lower left: C P per E. P. // inscribed mount upper right: Antibes
Director's Discretionary Fund, 69.13

Provenance:
Hirschl & Adler Galleries, New York.

Exhibitions:
Museum of Fine Arts, Boston, 2 October–3 November 1968; Rutgers University Art Gallery, New Brunswick, New Jersey, 17 November–22 December 1968; The Phillips Collection, Washington, D.C., 11 January–16 February 1969, *The Art of Charles Prendergast* // Hirschl & Adler Galleries, New York, 5–22 March 1969, *The Art of Charles Prendergast*, no. 51.

Bibliography:
Charlotte C. Stewart, "New Accessions/Prendergast and Davies," *Carnegie Magazine* XLIV (March 1970): 97–100 // Richard J. Wattenmaker, *The Art of Charles Prendergast* (Greenwich, Connecticut, 1968), no. 68, illus., 105.

PRENDERGAST, MAURICE BRAZIL

b. Canada, 1 8 5 9 — 1 9 2 4

332. *Woman on a Garden Path,* c. 1895
(illus. p. 131)

graphite and watercolor on paper
12 ³⁄₁₆ x 9 ⅛ in. (31 x 23.2 cm.)
signed lower right: Prendergast
Leisser Art Fund, 54.34.5

Provenance:
Peter H. Deitsch, New York.

333. *The Picnic,* 1901
(illus. p. 133)

graphite and watercolor on paper
15 ⁵⁄₁₆ x 22 ⅛ in. (40.5 x 56.2 cm.)
signed lower right: Prendergast // inscribed verso: Picnic May Day Central Park
Gift of Mr. and Mrs. James H. Beal, 73.4

Provenance:
The donors, Pittsburgh.

Exhibition:
Museum of Art, Carnegie Institute, 29 January–3 April 1983, *MOA Masterpieces*, no. 37.

Remarks:
This work was formerly titled *The Picnic, May Day, Central Park.*

334. *Women with Horse,* 1914

graphite and crayon on paper
8 ¹¹⁄₁₆ x 11 ¾ in. (22.1 x 29.8 cm.)
signed in monogram lower right: MP // stamped lower left: E. Prendergast Collection
Gift of Mrs. Charles Prendergast, 74.51

Provenance:
The donor, Westport, Connecticut.

335. *In the Summertime,* c. 1914–20

graphite, pastel, watercolor, and gouache on paper
13 ¹⁵⁄₁₆ x 19 ¹⁵⁄₁₆ in. (35.4 x 50.6 cm.)
signed lower center: Prendergast
Leisser Art Fund, 55.17.1

Provenance:
Peter H. Deitsch, New York.

336. *Swampscott Beach,* c. 1917
(illus. p. 133)

graphite, watercolor, pastel, and gouache on paper
15 ⅝ x 22 ¹⁄₁₆ in. (39.7 x 57.5 cm.)
signed lower right: Prendergast
Gift of Edward Duff Balken, 49.5.10

Provenance:
The donor, Pittsburgh.

Exhibitions:
University of Maryland Art Gallery, College Park; University Museum, Austin, Texas; Columbus (Ohio) Gallery of Fine Arts; Des Moines (Iowa) Fine Arts Center; Herbert F. Johnson Museum, Cornell University, Ithaca, New York, September 1976–April 1977, *Maurice Prendergast*, no. 96 // Davis and Long Company, New York, 3–28 May 1977 // Museum of Art, Carnegie Institute, 29 January–3 April 1983, *MOA Masterpieces*, no. 38.

Bibliography:
John O'Connor, Jr., "*Swampscott Beach* by Maurice Prendergast," *Carnegie Magazine* XXIV (December 1950): 518–20 // Eleanor Green, "Art of Impulse and Color," in University of Maryland Art Gallery, College Park, *Maurice Prendergast* (1976), exh. cat., 163 // Henry Adams, "Masterpieces of American Drawing and Watercolor," *Carnegie Magazine* LVI (January/February 1983): 22.

PYLE, HOWARD

1 8 5 3 — 1 9 1 1

337. *There they sat, just as little children in the town might sit upon their father's door-step,* 1888
(illus. p. 83)

pen and ink on cardboard
8 ¼ x 6 ¼ in. (21 x 15.9 cm.)
signed lower right: H·P // stamped verso: Scribner's Magazine / 158–155 Fifth Ave., N.Y.
Andrew Carnegie Fund, 06.19.11

Provenance:
Charles Scribner's Sons, New York.

Exhibition:
Museum of Art, Carnegie Institute, 29 January–3 April 1983, *MOA Masterpieces*.

Bibliography:
Howard Pyle, *Otto of the Silver Hand* (New York, 1888), illus., 6 // Carnegie Institute, *Lists* (1917).

Remarks:
This drawing illustrates the following passage from *Otto of the Silver Hand*:

> There they sat, just as little children in the town might sit upon their father's door-step; and as the sparrows might fly around the feet of the little town children, so the circling flocks of rooks and daws flew around the feet of these air-born creatures.

338. *Heading-Birds of Cirencester,* n.d.

pen and ink on cardboard
4 x 9 ⅜ in. (10.2 x 23.8 cm.), irregular
signed in monogram lower right: HP
Andrew Carnegie Fund, 06.19.10

Provenance:
Charles Scribner's Sons, New York.

Bibliography:
Carnegie Institute, *Lists* (1917).

QUALTERS, ROBERT
b. 1934

339. *Hazelwood*, 1983

ink, graphite, pastel, and gouache on paper
23 ¼ x 31 ⅛ in. (58.4 x 79.1 cm.)
inscribed, signed, and dated lower right: with apologies
R. Q. '83 // inscribed lower center: And was Jerusalem
builded here / among these dark Satanic Mills?—Wm.
Blake. From MILTON/THEY CALL IT, ("Bow of
Burning gold!"), THE "POVERTY LIGHT."—When
it's out,—the mill workers are out too. / AND WHEN
THESE SATANIC MILLS ARE DARK AT LAST,
WILL THE "Countenance Divine / Shine forth upon our
clouded hills?" // AND IN OUR NEW JERUSALEM,
WILL THE MAILMAN BRING US BILLS?
73rd Annual Associated Artists of Pittsburgh Exhibition
Purchase Prize, 83.54

Exhibition:
Museum of Art, Carnegie Institute, *73rd Annual Associated
Artists of Pittsburgh Exhibition*, 1983.

QUAYTMAN, HARVEY
b. 1937

340. *Untitled*, 1976

charcoal, paper, and plaster on paper
40 x 32 in. (101.6 x 81.3 cm.)
signed and dated lower right: Harvey Quaytman 1976
National Endowment for the Arts and Women's
Committee of the Museum of Art, 76.23.3

Provenance:
David McKee, Inc., New York.

REINHART, CHARLES STANLEY
1844—1896

341. *Study for "Awaiting the Absent"*, 1883
(**illus. p. 80**)

crayon and gouache on blue paper faded to green
mounted on canvas
28 ½ x 18 ¾ in. (72.4 x 47.6 cm.)
signed lower left: C. S. Reinhart // inscribed and dated
lower left: Paris—83
Gift of Charles Stanley Reinhart, Jr., Liliane Reinhart
Bennet, and John Reinhart Bennet, 51.8

Provenance:
Mrs. William S. Terriberry, Old Lyme, Connecticut; the
donors.

Exhibitions:
Lyman Allyn Museum, New London, Connecticut, 11
March–23 April 1945, *Work in Many Media by Men of the
Tile Club: Thirteenth Anniversary Exhibition*, no. 122 //
Museum of Art, Carnegie Institute, 29 January–3 April
1983, *MOA Masterpieces*, no. 40.

342. *Sketchbook*, c. 1888–96

graphite on paper
5 ⅛ x 8 in. (13 x 20.3 cm.)
Appropriation, 83.28

Provenance:
Richard W. Graves.

Remarks:
This book, consisting of thirty-six pages, contains studies
and notations related to Reinhart's painting *Awaiting the
Absent* (1888), which was donated to Carnegie Institute in
1897 by Andrew Carnegie.

343. *An Open Window*, 1896

pen and ink on paper
11 ¹⁵⁄₁₆ x 12 ½ in. (30.3 x 31.8 cm.)
signed and dated upper center: C.S. Reinhart '96
Andrew Carnegie Fund, 06.19.12

Provenance:
Charles Scribner's Sons, New York.

Bibliography:
Lewis Morris Iddings, "The Art of Travel," *Scribner's
Magazine* XXI (March 1897): illus., 356 // Carnegie
Institute, *Lists* (1917).

344. *At the Frontier: Travel by Land*, 1896

pen and ink on paper
9 ¹⁵⁄₁₆ x 9 ¹⁵⁄₁₆ in. (25.2 x 25.2 cm.)
signed and dated lower left: C. S. Reinhart '96 // stamped
verso: Scribner's Magazine / 158–156 Fifth Ave., N.Y.
Andrew Carnegie Fund, 06.19.13

Provenance:
Charles Scribner's Sons, New York.

Bibliography:
Lewis Morris Iddings, "The Art of Travel," *Scribner's
Magazine* XXI (March 1897): illus., 358, as At the
Frontier, ordered about like convicts // Carnegie Institute,
Lists (1917).

345. *The English Family Who Never Pay for Extra
Luggage*, 1896

graphite and pen and ink on card
13 ⅞ x 14 ⅛ in. (35.2 x 35.9 cm.)
signed lower right: C. S. Reinhart '96 // stamped verso:
Scribner's Magazine / 158–156 Fifth Ave., N.Y.
Andrew Carnegie Fund, 06.19.14

Provenance:
Charles Scribner's Sons, New York.

Bibliography:
Lewis Morris Iddings, "The Art of Travel," *Scribner's
Magazine* XXI (March 1897): illus., 354 // Carnegie
Institute, *Lists* (1917).

346. *Merci, Monsieur,* 1896

pen and ink on paper
12 ½ x 7 ½ in. (31.8 x 19.1 cm.)
signed and dated lower left: C.S.R. / '96 // inscribed
verso: Reinhart, C.S. 13399 B / Merci Monsieur / Travel
by Land. / March 1897 // labeled verso: The original is
the property of / Charles Scribner's Sons and is to be /
returned to them in good condition. From / Scribner's
Magazine / 158–156 Fifth Ave., New York // stamped
verso: Scribner's Magazine / 158–156 Fifth Ave., N.Y.
Andrew Carnegie Fund, 06.19.15

Provenance:
Charles Scribner's Sons, New York.

Bibliography:
Lewis Morris Iddings, "The Art of Travel," *Scribner's
Magazine* XXI (March 1897): illus., 355 // Carnegie
Institute, *Lists* (1917).

347. *Lee's Surrender at Appomattox,* 1896

graphite, wash, and gouache on cardboard
14 ⅞ x 23 3/16 in. (37.8 x 58.9 cm.)
signed and dated upper left: C. S. Reinhart '96
Gift of Charles Stanley Reinhart, Jr., and Liliane
Reinhart Bennet, 41.4.2

Provenance:
The donors.

Bibliography:
General Horace Porter, "Campaigning with Grant,"
Century Magazine LIII (November 1896): 16–19.

Remarks:
Reinhart died shortly after undertaking the series of
illustrations for "Campaigning with Grant." This drawing,
the first in the series, was published posthumously.

348. *Charles D. Warner,* n.d.

crayon on paper
13 13/16 x 10 ½ in. (35.1 x 26.7 cm.)
signed lower right: C. S. Reinhart
Gift of Charles Stanley Reinhart, Jr., and Liliane
Reinhart Bennet, 41.4.1

Provenance:
The donors.

**349. *Mr. John Brougham as "Sir Lucius
O'Trigger",* n.d.**

graphite and crayon on paper
16 3/16 x 10 ½ in. (41.1 x 26.7 cm.)
signed lower right: Reinhart // inscribed lower center:
Mr. John Brougham as "Sir Lucius O'Trigger".
Andrew Carnegie Fund, 06.3.15

Provenance:
Century Company, New York.

Bibliography:
Carnegie Institute, *Lists* (1917).

**350. *Why, Sir, and the Lady Grew Absolutely
Splendid,* 1896**

pen and ink on paper
12 ¼ x 13 ⅞ in. (31.1 x 35.2 cm.)
signed lower right: C. S. Reinhart // stamped verso:
Scribner's Magazine / 158–156 Fifth Ave., N.Y.
Andrew Carnegie Fund, 06.19.16

Provenance:
Charles Scribner's Sons, New York.

Bibliography:
Ben H. Ridgely, "The Comedies of a Consulate," *Scribner's
Magazine* XIX (May 1896), illus., 626.

Remarks:
Scribner's caption for this drawing was: "'Why, sir,' and the
lady grew absolutely spendid in her indignation, 'I have
never had the cholera in my whole life.'"

REMINGTON, FREDERIC
1861 — 1909

**351. *Texas Type,* 1888
(illus. p. 86)**

pen and ink on cardboard
15 1/16 x 8 ⅞ in. (39.7 x 22.5 cm.)
signed lower center: Remington
Andrew Carnegie Fund, 06.3.17

Provenance:
Century Company, New York.

Exhibitions:
Irene Kaufmann Settlement House, Pittsburgh, 17
November 1925 // Archer M. Huntington Art Gallery,
University of Texas, Austin, 25 February–10 April 1983;
Art Museum of South Texas, Corpus Christi, 1 July–14
August 1983; Amarillo Art Center, Amarillo, Texas, 3
September–30 October 1983, *Images of Texas: 1883–1983.*

Bibliography:
Theodore Roosevelt, "Sheriff's Work on a Ranch," *The
Century Magazine* XXXVI (May 1888): 39 // Theodore
Roosevelt, *Ranch Life and the Hunting Trail* (New York,
1899), 129 // Carnegie Institute, *Lists* (1917) // Archer M.
Huntington Art Gallery, University of Texas, Austin, *Texas
Images and Visions* (1983), exh. cat. by William H.
Goetzmann and Becky Duval Reese, 72, illus., 73.

Remarks:
On 20 April 1918 the drawing was sent to the Detroit
Publishing Company for reproduction on postcards.

**352. *An Incident of the March,* 1891
(illus. p. 87)**

pen and ink and ink wash on cardboard
16 ¾ x 21 ½ in. (42.5 x 54.6 cm.)
signed lower right: Frederic Remington.—
Andrew Carnegie Fund, 06.3.16

Provenance:
Century Company, New York.

Exhibitions:
Irene Kaufmann Settlement House, Pittsburgh, 8 October
1923 // The Cadet Fine Arts Forum, United States Military
Academy, West Point, New York, 19 May–6 June 1979,
Frederic Remington: The Soldier Artist // Museum of Art,
Carnegie Institute, 29 January–3 April 1983, *MOA
Masterpieces,* no. 39.

Bibliography:
John G. Bourke, "General Crook in the Indian Country," *The Century Magazine* XLI (March 1891): 643–60, illus., 650 // Carnegie Institute, *Lists* (1917) // The Cadet Fine Arts Forum, United States Military Academy, West Point, New York, *Frederic Remington: The Soldier Artist* (1979), exh. cat. by Peggy Samuels and Harold Samuels, illus., 37 // Arthur John, *The Best Years of the Century: Richard Watson Gilder, Scribner's Monthly, and the Century Magazine, 1870–1909* (Urbana, Illinois, Chicago, and London, 1981), unpaginated.

Remarks:
On 20 April 1918 the drawing was shipped to the Detroit Publishing Company for reproduction on postcards.

RIMMER, WILLIAM
b. England, 1816 — 1879

353. *Sadak in Search of the Waters of Oblivion*, late 1860s
(illus. p. 71)

graphite on cardboard
16 ¾ x 12 ¹⁄₁₆ in. (42.5 x 32.1 cm.)
signed lower right: W. R. // inscribed lower center: Sadak in Search of the Waters of Oblivion
Andrew Carnegie Fund, 07.10

Provenance:
Caroline Rimmer, Boston.

Exhibitions:
Whitney Museum of American Art, New York, 5–27 November 1946; Museum of Fine Arts, Boston, 7 January–2 February 1947, *William Rimmer, 1816–1879*, no. 86 // National Collection of Fine Arts, Smithsonian Institution, Washington, D.C., 28 January–6 March 1954.

Bibliography:
Carnegie Institute, *Lists* (1917).

Remarks:
The subject of this drawing is taken from the story "Kalasrade," the ninth tale in James Ridley's *The Tales of the Genii* (London, 1762).

The drawing was executed on a sheet of cardboard printed with a decorative border.

ROBINSON, BOARDMAN
1876—1952

354. *Crouching Figure*, n.d.

graphite, pen and ink, and ink wash on paper
12 ⁹⁄₁₆ x 11 ⁹⁄₁₆ in. (31.9 x 29.4 cm.), irregular
signed lower right: BR // stamped in monogram lower right: EDB
Anonymous gift, 43.3.1

Provenance:
The donor, Pittsburgh.

Remarks:
The stamp on this work is Edward Duff Balken's collector's mark, which is listed in Frits Lugt, *Les Marques de Collections de Dessins & d'Estampes* (Amsterdam, 1921), no. 843; *Supplément* (1956), 120. This information applies also to checklist nos. 356, 357, 368–71.

355. *The Sea*, n.d.

crayon, brush and ink, and gouache on card
20 ⁵⁄₁₆ x 24 ⅝ in. (51.6 x 62.5 cm.)
signed lower center: Boardman Robinson // inscribed lower center: Sufferer of the rail [crossed out] Damit [illeg.]
Gift of Kenneth Seaver, 25.6.2

Provenance:
The donor.

356. *Seated Figure*, n.d.

pen and ink and ink wash on paper
8 ⁷⁄₁₆ x 10 ⅞ in. (22.5 x 27.6 cm.)
signed lower left: Boardman Robinson // inscribed verso: Seated Figure // stamped in monogram lower left: EDB
Anonymous gift, 43.3.2

Provenance:
The donor.

Remarks:
See Remarks, checklist no. 354.

357. *Standing Figures*, n.d.

pen and ink wash on paper
15 x 8 in. (38.1 x 20.3 cm.), irregular
signed lower left: Boardman Robinson // inscribed verso: Portrait Sketch // stamped in monogram lower right: EDB
Anonymous gift, 43.3.3

Provenance:
The donor.

Remarks:
See Remarks, checklist no. 354.

ROSAS, MEL
b. 1950

358. *Construction III*, 1980

charcoal on paper
10 ¾ x 27 ⅝ in. (27.3 x 70.2 cm.)
signed and dated verso: Mel Rosas / "80"
Contemporary American Drawings Fund and National Endowment for the Arts, 82.22.4

Provenance:
Fendrick Gallery, Washington, D.C.

Exhibition:
Museum of Art, Carnegie Institute, 9 October–12 December 1982, *Recent Acquisitions: Works on Paper*.

ROSATI, JAMES
b. 1912

359. *Untitled 1966*, 1966

oil on cardboard
13 ½ x 19 ½ in. (34.3 x 49.5 cm.)
Gift of the artist, 70.57.2

Provenance:
The artist, New York.

360. *Construction 2-67,* 1967

cardboard on cardboard
12 ¼ x 15 ¾ in. (31.1 x 40 cm.)
Gift of the artist, 70.57.1

Provenance:
The artist, New York.

361. *Untitled 1967,* 1967

crayon on paper
15 ½ x 10 ⅝ in. (39.4 x 27 cm.)
signed in monogram, colored pencil, lower left: JR
Gift of the artist, 70.57.3

Provenance:
The artist, New York.

R O S E N B E R G, J A M E S N A U M B E R G
1 8 7 4 — 1 9 6 1

362. *Path of Light,* 1954

gouache on board
21 x 27 ¼ in. (53.3 x 69.2 cm.), sight
Gift of Mrs. Josiah Cohen, 43.5

Provenance:
The donor.

Exhibition:
Archives of American Art, The Detroit Institute of Arts, Detroit, Michigan, 3–29 October 1961, *The Archives of American Art, James N. Rosenberg.*

Bibliography:
Archives of American Art, The Detroit Institute of Arts, Detroit, Michigan, *The Archives of American Art, James N. Rosenberg,* exh. cat., intro. by E. P. Richardson, no. 15.

R O S E N B E R G, S A M U E L
1 8 9 6 — 1 9 7 2

The museum's collection includes 346 sketches and studies by Rosenberg, gift of Murray Z. Rosenberg, M.D., 78.27.1

363. *Study for "Greenfield Hill",* c. 1932

crayon on paper
10 ⁵⁄₁₆ x 7 ¹⁵⁄₁₆ in. (25.9 x 20.2 cm.)
Gift of Mrs. Samuel Rosenberg, 82.86

Provenance:
The donor, Pittsburgh.

Remarks:
This drawing is a study for *Greenfield Hill* (1932, oil on canvas, Museum of Art, Carnegie Institute).

R O S E N M E Y E R, B E R N A R D J.
b. 1 8 7 0

364. *Study of a Little Girl,* n.d.

chalk on cardboard
8 ⅞ x 7 ⁵⁄₁₆ in. (22.5 x 18.6 cm.), irregular
Purchase, 10.6.4

Bibliography:
Carnegie Institute, *Lists* (1917).

R O T H, R U B I
b. 1 9 0 5

365. *Dockside (on the East River),* n.d.

wash and gouache on board
18 x 24 in. (45.7 x 61 cm.)
signed lower right: Rubi Roth
Gift of Mr. and Mrs. Howard Zusman, 82.104.2

Provenance:
The donors, Sewickley, Pennsylvania.

R O T H K O, M A R K
b. Russia, 1 9 0 3 — 1 9 7 0

366a. *Untitled (recto),* 1945
(illus. p. 212)

watercolor, tempera, and ink on paper
39 ½ x 26 ⁵⁄₁₆ in. (100.3 x 66.8 cm.), image
40 ¹³⁄₁₆ x 26 ⅞ in. (103.7 x 68.3 cm.), sheet
signed, crayon, lower left: Mark Rothko

366b. *Untitled (verso),* 1945

watercolor, graphite, and ink on paper
39 ¹⁵⁄₁₆ x 25 ¹⁵⁄₁₆ in. (101.4 x 65.9 cm.), image
40 ¹³⁄₁₆ x 26 ⅞ in. (103.7 x 68.3 cm.), sheet
signed, crayon, upper center (upside down): Mark Rothko
// inscribed, crayon, upper center (upside down): 1010.44
Gift of The Rothko Foundation, Inc., 85.14.1–2

Exhibition:
High Museum of Art, Atlanta, 15 October–26 February 1983, *Mark Rothko Subjects.*

Bibliography:
High Museum of Art, Atlanta, *Mark Rothko Subjects* (1983), exh. cat. by Anna Chave, illus., 4.

Remarks:
Rothko frequently painted on both sides of his watercolors during his surreal period. He probably signed this work with black crayon during the 1968–69 inventory of his collection, when he assigned inventory numbers to his works. The digits following the decimal point denote the year Rothko thought he painted the work.

Rothko produced the surreal watercolors between 1944 and 1946. It is likely that this watercolor was painted in 1945 as the watercolors of 1944 usually contain several biomorphic forms and are lighter in color. During 1945 he began simplifying the forms. (Bonnie Clearwater, curator, Rothko Foundation. Letter, December 1984, Museum of Art files.)

RUSSELL, MORGAN
1886 — 1953

367. Study for "Synchromy in Green", c. 1912–13 (illus. p. 183)

graphite on paper mounted on cardboard
18 ¾ x 10 ⅞ in. (47.6 x 27.6 cm.)
Gift of Rose Fried, 58.2

Provenance:
The donor, New York.

Exhibition:
Museum of Art, Carnegie Institute, 29 January–3 April 1983, *MOA Masterpieces*, no. 42.

Remarks:
This drawing is a study for the painting *Synchromy in Green* (1913), now lost. See Whitney Museum of American Art, New York, *Synchromism and American Color Abstraction, 1910–1925* (1978), exh. cat. by Gail Levin, 13, 25, fig. 8.

RUZICKA, RUDOLPH
b. Bohemia, 1883 — 1978

368. Along the Allegheny River, Pittsburgh, 1911

chalk and charcoal on paper
7 ⅝ x 9 ½ in. (19.4 x 24.1 cm.)
signed and dated lower left: R. Ruzicka 1911 // inscribed lower left: No. 3 // stamped in monogram: EDB
Anonymous gift, 37.4.3

Remarks:
This is a drawing for a woodcut of the same title; it depicts the old 16th Street Bridge. See Remarks, checklist no. 354.

369. Pittsburgh (No. 1), 1911

graphite and charcoal on paper
7 ¼ x 9 ⅛ in. (18.4 x 23.2 cm.)
signed lower right: R. Ruzicka // inscribed and dated lower right: Pittsburgh 1911 no. 1 // stamped in monogram lower right: EDB
Anonymous gift, 37.4.4

Remarks:
See Remarks, checklist no. 354.

370. Pittsburgh (No. 2), 1911

red chalk and charcoal on paper
6 ¹³⁄₁₆ x 9 in. (17.3 x 22.9 cm.)
signed lower right: R. Ruzicka // inscribed lower left: Pittsburgh No. 2 // inscribed and dated lower right: To Edward Duff Balken 1911 // stamped in monogram lower right: EDB
Anonymous gift, 37.4.5

Remarks:
See Remarks, checklist no. 354.

371. Pittsburgh (No. 4), 1911

graphite and traces of chalk on paper
6 ¹⁄₁₆ x 8 ¾ in. (16.8 x 22.2 cm.)
signed lower left: R. Ruzicka // inscribed and dated lower left: 1911 / Pittsburgh / no. 4 // stamped verso: EDB
Anonymous gift, 37.4.6

Remarks:
See Remarks, checklist no. 354.

372. Coal Barges at Allen Point, N.Y., 1912

graphite and gouache on cardboard
5 ¾ x 6 ¾ in. (14.6 x 17.1 cm.), irregular
signed upper right: R.R. // dated upper right: Jan. 1912
Andrew Carnegie Fund, 17.28.1

Provenance:
The artist, Pittsburgh.

Bibliography:
Carnegie Institute, *Lists* (1917).

373. Design for personal Christmas card, n.d.

graphite and gouache on cardboard
5 ¹¹⁄₁₆ x 5 ¹¹⁄₁₆ in. (14.4 x 14.4 cm.)
signed and dated lower right: R. Ruzicka / 1917 // signed lower right: ·R·
Anonymous gift, 37.4.7

Remarks:
There is a graphite sketch of lilies of the valley on the verso.

SAINT, LAWRENCE B.
1885 — 1961

374. The museum's collection includes 79 watercolors and drawings by Saint, Purchase, 16.8.1 through 16.8.79.

SAINT-MÉMIN, CHARLES BALTHAZAR JULIEN FÉVRET DE
b. France, 1770 — 1852

375. Mrs. Samuel Richards (Mary Smith), c. 1800

charcoal heightened with white on reddish paper mounted on wood stretcher
21 ⁷⁄₁₆ x 15 ¼ in. (54.5 x 38.7 cm.), image
22 ¼ x 17 ¼ in. (56.5 x 43.8 cm.), mount
Gift of the children of Eleanor Merrick: Herbert DuPuy Merrick, Eleanor Merrick Bissell, Lavina Merrick Cooper, Marguerite Merrick Wick, in memory of their grandfather, Herbert DuPuy, 62.17.6

Provenance:
The donors.

Exhibitions:
Musée Municipal de Dijon, Palais des Etats de Bourgogne, 1965, *Charles-Balthazar-Julien Févret de Saint-Mémin* // Museum of Art, Carnegie Institute, 29 January–3 April 1983, *MOA Masterpieces*, no. 43.

Bibliography:
Musée Municipal de Dijon, Palais des Etats de Bourgogne, *Charles-Balthazar-Julien Févret de Saint-Mémin, artiste, archéologue, conservateur du Musée de Dijon* (1965), exh. cat., 57, no. 132.

376. Samuel Richards, c. 1800
(illus. p. 32)

charcoal heightened with white on reddish paper
mounted on wood stretcher
22 x 16 ¾ in. (55.9 x 42.5 cm.), image (irregular)
22 ⁵⁄₁₆ x 17 ⅛ in. (56.7 x 43.5 cm.), mount
Gift of the children of Eleanor Merrick: Herbert DuPuy
Merrick, Eleanor Merrick Bissell, Lavina Merrick
Cooper, Marguerite Merrick Wick, in memory of their
grandfather, Herbert DuPuy, 62.17.8

Provenance:
The donors.

Remarks:
Samuel Richards was the owner of the Batsto Iron Works in
Burlington County, New Jersey.

SCARLETT, ROLPH
b. Canada, 1889—1984

377. Untitled No. 23, 1940
(illus. p. 204)

gouache on paper
4 ½ x 6 ¹³⁄₁₆ in. (11.4 x 17.3 cm.)
signed, graphite, verso: SCARLETT
Leisser Art Fund, 83.30.2

Provenance:
Washburn Gallery, New York.

Exhibitions:
Washburn Gallery, New York, 26 April–14 May 1983,
Rolph Scarlett: Drawings and Watercolors, no. 63.

Bibliography:
John R. Lane, "American Abstract Art of the '30s and
'40s," *Carnegie Magazine* LVI (September/October 1983):
illus., 18.

SCHAMBERG, MORTON
LIVINGSTON
1882—1918

378. Composition, c. 1915–16
(illus. p. 185)

graphite and pastel on paper
7 ⅝ x 5 ¾ in. (19.4 x 14.6 cm.)
signed lower right: Schamberg
Eva Weill Memorial Fund, Oppenheim-Lehman Fund,
Copperweld Foundation Fund, and Patrons Art Fund,
82.70

Provenance:
Salander-O'Reilly Galleries, Inc., New York.

Exhibition:
Salander-O'Reilly Galleries, Inc., New York, 3
November–31 December 1982; Columbus Museum of Art,
Columbus, Ohio, 22 January–13 March 1983;
Pennsylvania Academy of the Fine Arts, Philadelphia, 15
April–6 May 1983; Milwaukee Art Museum, 11
February–27 March 1984; Marriner S. Eccles Federal
Reserve Board Building, Washington, D.C., 11 April–30
May 1984; Arts Club of Chicago, 17 September–3
November 1984, *Morton Livingston Schamberg*.

Bibliography:
Salander-O'Reilly Galleries, Inc., New York, *Morton
Livingston Schamberg: Color and the Evolution of His Paintings*
(1982), exh. cat. by William C. Agee, with checklist by
Pamela Ellison, no. 56.

SCHIRM, DAVID
b. 1945

379. The Huddle of Wild Ideas and Wet Hair, 1980

graphite on paper
22 ¼ x 30 ¹⁄₁₆ in. (56.5 x 77.8 cm.)
Contemporary American Drawings Fund and National
Endowment for the Arts, 82.10

Provenance:
Siegel Contemporary Art, Inc., New York.

Exhibition:
Museum of Art, Carnegie Institute, 9 October–12
December 1982, *Recent Acquisitions: Works on Paper*.

SCHUSSELE, CHRISTIAN
b. France, 1824—1879

380. Untitled, 1853

graphite, pen and ink, and ink wash on paper mounted on
cardboard
11 ¹⁵⁄₁₆ x 8 ⁷⁄₁₆ in. (30.3 x 21.4 cm.), sheet
13 ⁷⁄₁₆ x 9 ¹³⁄₁₆ in. (34.1 x 24.9 cm.), mount
signed lower left: C. Sch // inscribed and dated lower
center: G[illeg.]Ass. April.53
Andrew Carnegie Fund, 07.11

Provenance:
Albert Rosenthal, Philadelphia.

Bibliography:
Carnegie Institute, *Lists* (1917).

SCHWALB, HARRY
b. 1924

381. Spinners Spinning, 1967

ink on rice paper
36 x 36 in. (91.4 x 91.4 cm.), sight
signed and dated lower center: H Schwalb 1967
58th Annual Associated Artists of Pittsburgh Exhibition
Purchase Prize, 68.9.2

Provenance:
The artist, Pittsburgh.

Exhibition:
Museum of Art, Carnegie Institute, *58th Annual Associated
Artists of Pittsburgh Exhibition*, 1968.

SCHWEIKHER, PAUL
b. 1903

382. *Sketch for a House on a Steep Slope*, 1965

graphite and chalk on tracing paper
12 x 12 in. (30.5 x 30.5 cm.)
signed in monogram and dated, red pencil, center left:
PS 65 // signed in monogram and dated, red pencil,
lower right: PS 65
Gift of the artist, 65.28

Provenance:
The artist, Pittsburgh.

Exhibitions:
Harvard University, Cambridge, Massachusetts,
October–November 1968; Yale University, New Haven,
Connecticut, November 1968.

SEIDEL, JOCHEN
1924—1971

383. *I'm Improved By Teaching*, 1969

charcoal on paper
24 1/16 x 18 1/16 in. (62.5 x 47.3 cm.)
Gift of Dr. Mel Roman, 82.98.2

Provenance:
The donor, New York.

SHAW, JOSHUA
b. England, 1776—1860

**384. *Environs of Pittsburgh, Pennsylvania*, c. 1825
(illus. p. 35)**

pen and ink and graphite on paper
9 3/4 x 14 in. (24.8 x 35.6 cm.)
inscribed and signed verso: Environs of Pittsburgh, Pa /
J Shaw
Gift of Guy R. Bolton, 13.1.2

Provenance:
The donor.

Exhibitions:
Carnegie Institute, 29 October 1916, *City Charter Centennial
Exhibition* // Department of Fine Arts, University of
Pittsburgh, 6–31 October 1947, *Pittsburgh and Its Rivers* //
Westmoreland Museum of Art, Greensburg, Pennsylvania,
26 September–29 November 1981, *Southwestern Pennsylvania
Painters, 1800–1945.*

Bibliography:
Carnegie Institute, *Lists* (1917) // Stefan Lorant, *Pittsburgh,
The Story of an American City* (New York, 1964), illus., 82.

385. *Sketches at Pittsburgh*, c. 1825

pen and ink and graphite on paper
14 1/8 x 9 3/4 in. (35.9 x 24.8 cm.)
signed lower right: J.S // inscribed and signed verso:
Sketches at Pittsburgh / J. Shaw—
Gift of Guy R. Bolton, 13.1.1

Provenance:
The donor.

Exhibitions:
Carnegie Institute, 29 October 1916, *City Charter Centennial
Exhibition* // Department of Fine Arts, University of
Pittsburgh, 6–31 October 1947, *Pittsburgh and Its Rivers* //
Museum of Art, Carnegie Institute, 29 January–3 April
1983, *MOA Masterpieces*, no. 44 // Museum of Art, Carnegie
Institute, 28 April–25 June 1984, *European Drawings from the
Permanent Collection.*

Bibliography:
Carnegie Institute, *Lists* (1917).

SHECHTER, LAURA
b. 1944

386. *Still Life with a Dark Blue Cup*, 1980

silverpoint on clay-coated paper
6 x 10 in. (15.2 x 25.4 cm.)
signed and dated lower left: L. Shechter 80 // inscribed,
signed, and dated verso: "Still Life with a dark blue
cup" / Laura Shechter / 8/5/80
Dorothy and Milton Wasserman Fund, 80.49

Provenance:
The artist, New York.

SHEELER, CHARLES
1883—1965

387. *River Rouge Industrial Plant*, 1928

graphite and watercolor on paper mounted on paper
8 3/8 x 11 1/4 in. (21.3 x 28.6 cm.)
signed and dated lower right: Sheeler 1928
Gift of G. David Thompson, 57.12.7

Provenance:
The donor, Pittsburgh.

Exhibitions:
Department of Art, State University of Iowa, Iowa City, 17
March–17 April 1963, *Sheeler Retrospective* // National
Collection of Fine Arts, Smithsonian Institution,
Washington, D.C., 1 December 1965–16 January 1966,
Roots of Abstract Art in America, 1910–1930 // National
Collection of Fine Arts, Smithsonian Institution,
Washington, D.C., 9 October–24 November 1968;
Philadelphia Museum of Art, 9 January–16 February
1969; Whitney Museum of American Art, New York, 10
March–27 April 1969, *Charles Sheeler* // Museum of Art,
Carnegie Institute, 18 November 1971–9 January 1972,
Forerunners of American Abstraction, no. 90 // Detroit Institute
of Arts, 1 August–24 September 1978, *The Rouge: The Image
of Industry in the Art of Charles Sheeler and Diego Rivera* // Terry
Dintenfass, Inc., New York, 10–30 May 1980, *Charles
Sheeler (1880–1965) Classic Themes: Painting, Drawing and
Photography* // The Cleveland Museum of Art, 11 November
1980–2 February 1981, *Art and Industry: American Realism* //
Columbus Museum of Art, Columbus, Ohio, 11 April–31
May 1981, *American Realism and the Industrial Age.*

Bibliography:
Museum of Art, Carnegie Institute, *Forerunners of American
Abstraction* (1971), exh. cat. by Herdis Bull Teilman, no. 90
// Martin Friedman, *Charles Sheeler* (New York, 1975), illus.,
70 // Donelson F. Hoopes, *American Watercolor Painting* (New
York, 1977), illus., 137.

388. *Tulips,* **1931**
(illus. p. 165)

black conte crayon on paper
26 x 19 in. (66 x 48.3 cm.)
Collection of Mr. and Mrs. James A. Fisher, intended gift
to the Museum of Art, Carnegie Institute

Provenance:
With Downtown Gallery, New York; Mr. and Mrs. John S.
Sheppard, New York, by 1925; Mrs. Alfred E. Poor, New
York, until 1980; with Hirschl & Adler Galleries, New
York; private collection until 1983; Mr. and Mrs. James A.
Fisher, Pittsburgh.

Bibliography:
Ernest Brace, "Charles Sheeler," *Creative Art* (October
1932): 97, 103–104 // Constance Rourke, *Charles Sheeler,
Artist in the American Tradition* (New York, 1938; reprint
1969), 8, 157–58, illus., 127 // The Museum of Modern Art,
New York, *Charles Sheeler: Paintings, Drawings, Photographs*
(1939), exh. cat. with intro. by William Carlos Williams,
no. 85, illus. // Martin Friedman, *Charles Sheeler* (New York,
1975), 91, illus., 93.

SHEETS, MILLARD
b. 1907

389. *The Camel Woman (India Village Series),* **1944**

graphite, charcoal, and watercolor on paper mounted on
masonite
30 x 24 ¹⁄₁₆ in. (76.2 x 62.5 cm.)
signed lower right: Millard Sheets
Gift of Mrs. James H. Beal, 49.1

Provenance:
The donor, Pittsburgh.

Exhibitions:
Laguna Beach Museum of Art, Laguna Beach, California,
23 September–13 November 1983; The Museum, Texas
Technical University, Lubbock, 4 December–8 January
1984; The Monterey Peninsula Art Museum, Monterey,
California, 21 January–4 March 1984, *Millard Sheets: Six
Decades of Painting.*

Bibliography:
Laguna Beach Museum of Art, Laguna Beach, California,
Millard Sheets: Six Decades of Painting (1983), exh. cat. by
William G. Otton, illus., 35.

SHEPPARD, JOSEPH
b. 1930

390. *Studies of a Horse's Head from a Greek
Bronze,* **1976**

charcoal and Chinese white on blue paper
17 ¼ x 25 ¾ in. (43.8 x 65.4 cm.), sight
signed and dated lower right: Sheppard 76
Gift of the artist, 83.43

Provenance:
The artist.

SHINN, EVERETT
1873–1953

391. *Untitled, Woman Draped No. 3,* **n.d.**

chalk on buff paper
15 ¼ x 11 ⅜ in. (38.7 x 28.9 cm.)
Andrew Carnegie Fund, 06.20

Provenance:
The artist, New York.

Remarks:
This drawing was probably a study for a decorative scheme.

SHIRAS, MYRNA

392. *Art-Tea,* **n.d.**

xerox paper, thread, cheesecloth, and cardboard mounted
in plexiglas
26 ⅞ x 23 in. (68.3 x 58.4 cm.), mount
inscribed and signed upper right: sewn into paper,
M. Shiras
Gift of the artist in honor of Anne Shiras, 83.25

Provenance:
The artist.

Exhibition:
Hewlett Gallery, Carnegie-Mellon University, Pittsburgh,
15 January–9 February 1983, *Ardine Nelson and Myrna
Shiras.*

SHIRLAW, WALTER
1838–1910

393. *Center of Portuguese and Italian Quarters,* **n.d.**

graphite on paper mounted on cardboard
11 ½ x 7 ⁷⁄₁₆ in. (29.2 x 18.9 cm.)
Andrew Carnegie Fund, 06.19.18

Provenance:
Charles Scribner's Sons, New York.

Bibliography:
Carnegie Institute, *Lists* (1917).

394. *Florence,* **n.d.**

charcoal on paper
19 ½ x 14 ⅛ in. (49.5 x 35.9 cm.)
signed in monogram lower left: WS
Purchase, 11.7

Provenance:
Mrs. Walter Shirlaw, New York.

Bibliography:
Carnegie Institute, *Lists* (1917).

395. *Free Sea Bathing/City Point,* **n.d.**

charcoal on card
12 x 19 in. (30.5 x 48.3 cm.)
signed lower left: W. Shirlaw
Andrew Carnegie Fund, 06.19.19

Provenance:
Charles Scribner's Sons, New York.

Bibliography:
Carnegie Institute, *Lists* (1917).

SHOUMATOFF, ELIZABETH
b. Russia, 1 8 8 8 — 1 9 8 0

396. *Andrey Avinoff,* 1943

watercolor on paper
38 x 30 in. (96.5 x 76.2 cm.)
signed lower right: Elizabeth Shoumatoff
Gift through Carnegie Museum of Natural History, 48.21

SINGER, WILLIAM H., JR.
1868 — 1943

397. **The Old Farm, n.d.**

pastel on board
21 ¼ x 17 ¾ in. (54 x 45.1 cm.)
signed lower right: W. H. Singer, Jr.
Gift of the Singer Memorial Foundation, courtesy of Mrs.
Albert Fraser Keister, 72.47

Provenance:
Mrs. Albert Fraser Keister, Sewickley, Pennsylvania.

SMILLIE, JAMES D.
1 8 3 3 — 1 9 0 9

398. *Pastoral Landscape,* 1869

charcoal heightened with white chalk on green paper
13 ³/₁₆ x 19 ⅞ in. (33.5 x 50.5 cm.)
signed in monogram and dated lower right: JDS Feb '69
Mrs. Paul B. Ernst Fund, 81.13.1

Provenance:
Estate of the artist; with Jill Newhouse, New York.

Exhibitions:
Jill Newhouse, New York, 3–28 March 1981, *James D. Smillie Drawings,* no. 4 // Museum of Art, Carnegie Institute, 29 January–3 April 1983, *MOA Masterpieces,* no. 45.

SMITH, DAVID
1 9 0 6 — 1 9 6 5

399. *Figure Study, March 18, 1953,* 1953
(illus. p. 217)

gouache on paper
29 ¾ x 42 ½ in. (75.6 x 108 cm.)
signed and dated upper right: $\Delta\Sigma$ 3/18/53
Carnegie International Prize Fund, 61.49.1

Provenance:
The artist, Bolton Landing, New York.

Bibliography:
David Smith. Correspondence with Museum of Art, Carnegie Institute, 1961 (Museum of Art files) // Stanley E. Marcus, *David Smith: The Sculptor and His Work* (Ithaca, New York, 1983), 135–36.

400. *Figure Study, May 14, 1953,* 1953

gouache on paper
29 ¾ x 42 ¹¹/₁₆ in. (75.5 x 108.4 cm.)
signed and dated upper right: $\Delta\Sigma$ 5/14/53
Carnegie International Prize Fund, 61.49.2

Provenance:
The artist, Bolton Landing, New York.

Bibliography:
David Smith. Correspondence with Museum of Art, Carnegie Institute, 1961 (Museum of Art files) // Stanley E. Marcus, *David Smith: The Sculptor and His Work* (Ithaca, New York, 1983), 135–36.

401. *11-5-54,* 1954
(illus. p. 219)

brush and ink on paper
16 ¹⁵/₁₆ x 21 ⅛ in. (43 x 53.7 cm.)
signed and dated lower center: $\Delta\Sigma$ 11/5/54
Gift of G. David Thompson, 62.9

Provenance:
The donor, Pittsburgh.

Bibliography:
David Smith. Correspondence with Museum of Art, Carnegie Institute, 1961 (Museum of Art files) // David Smith, *David Smith on David Smith* (New York, 1968), illus., 104.

402. *April 4, 1961,* 1961

brush and ink, gouache, and graphite on paper
26 ¼ x 41 in. (66.7 x 104.1 cm.)
signed and inscribed lower right: David Smith daughter Rebecca / April 4, 1961 // inscribed verso: In framing lay whole sheet / on background mount / let full edges show. / 11/17/61 Mr. Arkus Mr. Washburn—This is a gift from daughter Rebecca Smith / Regards to you David S
Gift of Rebecca Smith, 61.44

Provenance:
The artist, Bolton Landing, New York, until 1961; the donor, Bolton Landing, New York.

Bibliography:
David Smith. Correspondence with Museum of Art, Carnegie Institute, 1961 (Museum of Art files) // Stanley E. Marcus, *David Smith: The Sculptor and His Work* (Ithaca, New York, 1983), 135–36.

403. *August 12, 1961,* 1961
(illus. p. 221)

brush and ink, graphite, and gouache on paper
26 ⁵/₁₆ x 41 in. (66.8 x 104.1 cm.)
signed and dated lower right: David Smith Aug 12 1961 // inscribed lower right: daughter Dida // inscribed verso: 11/16/61 Mr. Arkus, Mr. Washburn This is a gift from Candida Smith—Regards to you David S.
Gift of Candida Smith, 61.43

Provenance:
The artist, Bolton Landing, New York, until 1961; the donor, Bolton Landing, New York.

Bibliography:
David Smith. Correspondence with Museum of Art, Carnegie Institute, 1961 (Museum of Art files) // Stanley E. Marcus, *David Smith: The Sculptor and His Work* (Ithaca, New York, 1983), 135–36.

SMITH, F. HOPKINSON
1838—1915

404. *A Deserted House*, n.d.

graphite, charcoal, and white gouache on light gray-blue laid paper
11 ¹³⁄₁₆ x 18 ⁹⁄₁₆ in. (30 x 47.1 cm.)
Andrew Carnegie Fund, 06.3.18

Provenance:
Century Company, New York.

Exhibitions:
Lyman Allyn Museum, New London, Connecticut, 11 March–23 April 1945, *Work in Many Media by Men of The Tile Club: Thirteenth Anniversary Exhibition*, no. 150.

Bibliography:
Carnegie Institute, *Lists* (1917) || Lyman Allyn Museum, New London, Connecticut, *Work in Many Media by Men of the Tile Club: Thirteenth Anniversary Exhibition* (1945), exh. cat. by William Douglas, no. 150.

SMITH, JESSIE WILCOX
1838—1935

405. *I Heard the Bed Creak*, 1903

charcoal on cardboard
13 ⁵⁄₁₆ x 19 ⁵⁄₁₆ in. (33.8 x 49 cm.)
signed lower right: J.W.S.
Andrew Carnegie Fund, 06.19.20

Provenance:
Charles Scribner's Sons, New York.

Bibliography:
Josephine Daskan, "The Blue Dress," *Scribner's Magazine* XXXIII (April 1903): 463 || Carnegie Institute, *Lists* (1917).

406. *She and Eleanor Would Sit*, 1903

charcoal on cardboard
13 ⅝ x 20 ¹⁄₁₆ in. (34.6 x 52.4 cm.)
Andrew Carnegie Fund, 06.19.21

Provenance:
Charles Scribner's Sons, New York.

Bibliography:
Josephine Daskan, "The Blue Dress," *Scribner's Magazine* XXXIII (April 1903): 459 || Carnegie Institute, *Lists* (1917).

SMITH, LEON POLK
b. 1906

407. *Collage*, n.d.

paper on paper
13 ⅞ x 10 ⅞ in. (35.2 x 27.6 cm.)
signed, red pencil, lower right: Leon Smith
Gift of Sara M. Winokur and James L. Winokur to honor Mr. and Mrs. Richard M. Scaife, 62.10

Provenance:
The donors, Pittsburgh.

SOLMAN, JOSEPH
b. Russia, 1909

408. *Storefront (Ice Cellar)*, 1932

gouache on black paper
10 x 10 ⅝ in. (25.4 x 27 cm.)
signed and dated lower left: JS / '32 || signed lower right: JS
Dorothy and Milton Wasserman Fund, 81.33

Provenance:
Gallery Schlesinger Boisante, New York.

Exhibitions:
Museum of Art, Garnegie Institute, 9 October–12 December 1982, *Recent Acquisitions: Works on Paper* || A. M. Alder Fine Arts, Inc., New York, 5–26 March 1983, *Joseph Solman Retrospective*.

SPEICHER, EUGENE
1883—1962

409. *Nude*, n.d.

graphite, charcoal, and pastel on paper
14 ⅞ x 9 in. (37.8 x 22.9 cm.)
signed lower right: Eugene Speicher
Gift of Mr. and Mrs. James H. Beal, 83.62.2

Provenance:
With Frank K. M. Rehn Galleries, New York, until 1983; the donors, Pittsburgh.

410. *Portrait—Head of a Woman*, n.d.

crayon and graphite on paper
16 ¼ x 12 ⅜ in. (41.3 x 31.4 cm.)
signed lower left: Eugene Speicher || inscribed lower right: Property of Frank Rehn / with my compliments
Patrons Art Fund, 81.71

Provenance:
Frank K. M. Rehn Galleries, New York; Martin Diamond Gallery, New York.

Exhibition:
Museum of Art, Carnegie Institute, 9 October–12 December 1982, *Recent Acquisitions: Works on Paper*.

SPRUANCE, BENTON
1904—1967

411. *Remainders*, 1958

graphite and gouache on paper
25 ¹³⁄₁₆ x 19 ¹³⁄₁₆ in. (65.6 x 50.3 cm.)
signed center right: BS.
Gift of Mr. and Mrs. James H. Beal, 67.3.13

Provenance:
The donors, Pittsburgh.

412. *Web of Dream*, 1960

charcoal and chalk on paper
24 x 19 in. (61 x 48.3 cm.)
signed lower right: BS
Gift of Mr. and Mrs. James H. Beal, 67.3.14

Provenance:
The donors, Pittsburgh.

413. *A Child Offered Us a Quail in a Slipper of Rose-Colored Satin*, n.d.

graphite on paper
23 ¾ x 18 ¾ in. (60.3 x 47.6 cm.)
signed lower right: Spruance
Gift of Mr. and Mrs. James H. Beal, 60.3.5.1

Provenance:
The donors, Pittsburgh.

414. *Roads of the Earth, We Follow You (Authority over All the Signs of the Earth)*, n.d.

graphite on paper
16 x 23 ¾ in. (40.6 x 60.3 cm.)
signed lower right: BS
Gift of Mr. and Mrs. James H. Beal, 60.3.5.2

Provenance:
The donors, Pittsburgh.

Remarks:
This is the eighth lithograph in the "Anabasis" series.

S T A V I T S K Y , E L L E N
b. 1 9 5 1

415. *No. 239*, 1980

thread and cardboard on paper
15 ¹⁄₁₆ x 11 ³⁄₁₆ in. (39.7 x 28.4 cm.)
inscribed, dated, and signed verso: no. 239 1980 Ellen Stavitsky / To the Museum of Art, Carnegie Institute, with / best wishes / Ellen Stavitsky Sept. 26, 1981
Gift of Joseph M. Erdelac, 81.75.1

Provenance:
The artist, New York, until 1981; the donor.

416. *No. 1030A*, 1981

acrylic and paper on paper
15 ³⁄₁₆ x 11 ¼ in. (38.6 x 28.6 cm.)
inscribed, dated, and signed verso: no. 1030A 1981 Ellen Stavitsky
Gift of Joseph M. Erdelac, 81.75.2

Provenance:
The artist, New York, until 1981; the donor.

S T E E L E , F R E D E R I C D O R R
1 8 7 3 — 1 9 4 4

417. The Cry Baby, 1905

graphite, pen and ink, and ink wash on paper
14 ¹¹⁄₁₆ x 14 ⅞ in. (37.3 x 37.8 cm.)
signed and dated lower right: Steele Feb 1905
Purchase, 10.6.5

Bibliography:
Carnegie Institute, *Lists* (1917).

418. *Aunt Tabithy*, 1906

charcoal and ink wash on paper mounted on cardboard
18 ³⁄₁₆ x 13 ⅞ in. (46.2 x 35.2 cm.)
signed and dated lower right: Steele '06
Purchase, 10.6.6

Bibliography:
Carnegie Institute, *Lists* (1917).

S T E I N , R O N A L D J A Y
b. 1 9 3 0

419. *A Memoriam to Wanda Landowska*, 1959

paper mounted on paper mounted on board mounted on painted paper
18 x 24 in. (45.7 x 61 cm.)
signed and dated lower left: R. Stein 1959 // inscribed lower left: Das Wohltemperiste Klavier
Gift of Maurice Kimmel, 59.40

Provenance:
The donor, Milwaukee.

S T E I N B E R G , S A U L
b. Romania, 1 9 1 4

**420. *Joy Continuous Miner*, 1954
(illus. p. 179)**

watercolor, pen and ink, and paper on paper
28 x 22 in. (71.1 x 55.9 cm.)
signed and dated lower right: STEINBERG 1954 // inscribed lower center: Joy Continuous Miner // inscribed lower left: Pittsburgh Pa.
Gift of Joy Manufacturing Company, 54.23.4

Provenance:
Fortune Magazine, New York, until 1954; the donor, Pittsburgh.

Exhibitions:
Contemporary Arts Association of Houston, Texas, 25 September–9 November 1958, *The Art of the Machine* // American Federation of Arts, *World at Work*, traveling exhibition, 1 May 1955–1 May 1956 // L'Exposition de l'Industrie, Paris, 18 June–4 July 1955, *Minerale* // College of Mineral Studies, Pennsylvania State University, University Park, October 1956 // Huntington Galleries, Huntington, West Virginia, September 1956, *Paintings Commissioned by Joy Manufacturing Company* // Pennsylvania State University, University Park, September 1957–April 1958, *God-Made Matter and Man-Made Forms* // Portland Art Association, Portland, Oregon, April 1960 // Art Associates of Lake Charles, Lake Charles, Louisiana, 13–22 October 1960, *The Trojan Horse*.

421. *Untitled*, n.d.

pen and ink and brush and ink on music paper
14 ⅝ x 9 ½ in. (37.1 x 24.1 cm.), sight
signed lower right: Steinberg
Bequest of C. Hale Mathews III, 81.26.31

Provenance:
Estate of the donor, New York.

STELLA, FRANK
b. 1 9 3 6

422. *Untitled,* c. 1958
(illus. p. 227)

gouache on paper
26 x 19 ⅞ in. (66 x 50.5 cm.)
Gift of Mrs. George L. Craig, Jr., in memory of her
husband, 84.30

Provenance:
The donor, Pittsburgh.

STELLA, JOSEPH
1 8 7 7 — 1 9 4 6

423. *Bridge,* c. 1908
(illus. p. 146)

charcoal on laid paper
14 ⁹/₁₆ x 23 ½ in. (37 x 59.7 cm.)
signed lower right: Joseph Stella // stamped verso: Rabin
& Krueger Gallery, Newark, New Jersey
Howard N. Eavenson Memorial Fund, 58.62

Provenance:
Rabin & Krueger Gallery, Newark, New Jersey; Zabriskie
Gallery, New York.

Exhibitions:
Museum of Art, Carnegie Institute, 18 November 1971–9
January 1972, *Forerunners of American Abstraction*, no. 100 //
Museum of Art, Carnegie Institute, 29 January–3 April
1983, *MOA Masterpieces*, no. 46.

Bibliography:
Museum of Art, Carnegie Institute, *Forerunners of American
Abstraction* (1972), exh. cat. by Herdis Bull Teilman, no.
100.

424. *Old Man Sleeping in a Field,* c. 1908
(illus. p. 145)

gouache and chalk on paper
11 x 16 ¹³/₁₆ in. (27.9 x 42.7 cm.)
signed lower left: J. Stella
Copperweld, Hafner Fund and Fine Arts Discretionary
Fund, 84.52

Remarks:
For another drawing of the same model see Rabin &
Krueger Gallery, Newark, New Jersey, *Drawings of Joseph
Stella*, exh. cat. by William H. Gerdts, plate 30.

425. *Industrial Scene, New Jersey,* 1920

charcoal on paper
18 ½ x 23 ⅜ in. (47 x 59.4 cm.)
signed upper right: Stella // signed, graphite, center right:
Joseph Stella // signed and dated lower right: Joseph
Stella 1920 // signed and dated, charcoal and graphite,
center left: Joseph Stella 1920
Director's Discretionary Fund, 77.38.1

Provenance:
Zabriskie Gallery, New York.

Exhibitions:
The Cleveland Museum of Art, 11 November 1980–2
February 1981, *Art and Industry: American Realism* //
Columbus Museum of Art, Columbus, Ohio, 11 April–31
May 1981, *American Realism and the Industrial Age* // Museum
of Art, Carnegie Institute, 29 January–3 April 1983, *MOA
Masterpieces*, no. 46.

Bibliography:
"Joseph Stella, Discovery of America: Autobiographical
Notes," *Art News* LIX (November 1960): 41–43.

Remarks:
This drawing was formerly titled *Pittsburgh Night*.

426. *Collage No. 8,* c. 1922
(illus. p. 147)

paper, paint, and mud on paper
16 ⁵/₁₆ x 11 in. (42.2 x 27.9 cm.)
Print Purchase Fund, 61.11

Provenance:
Zabriskie Gallery, New York.

Exhibitions:
Museum of Art, Carnegie Institute, 18 November 1971–9
January 1972, *Forerunners of American Abstraction*, no. 109 //
The Solomon R. Guggenheim Museum, New York, 23
January–21 March 1976; Kunsthalle, Baden Baden,
Germany, 18 May–11 July 1976; Kunsthalle, Bremen,
Germany, 18 July–29 August 1976, *American Drawings*.

Bibliography:
Museum of Art, Carnegie Institute, *Forerunners of American
Abstraction* (1972), exh. cat. by Herdis Bull Teilman, no.
109.

STERNE, MAURICE
1 8 7 8 — 1 9 5 7

427. *Standing Figure,* n.d.

graphite on laid Japan paper mounted on paper
19 ⁷/₁₆ x 10 ⅜ in. (49.4 x 25.9 cm.), mount
signed lower right: Sterne
Andrew Carnegie Fund, 16.27.13

Provenance:
Martin Birnbaum.

Exhibition:
The Museum of Modern Art, New York, 15 February–25
March 1933, *Maurice Sterne Retrospective Exhibition
1902–1932*, no. 126.

Bibliography:
Carnegie Institute, *Lists* (1917).

STERNER, ALBERT E.
1 8 6 3 — 1 9 4 6

428. *Untitled (Girl at Piano),* 1900

chalk on buff paper
18 ⁷/₁₆ x 7 in. (47.9 x 17.8 cm.)
signed and dated lower left: Albert Sterner/1900
Andrew Carnegie Fund, 07.12.2

Provenance:
The artist, New York.

Bibliography:
Carnegie Institute, *Lists* (1917).

429. *Illustration for "Fenwick's Career",* **n.d.**

charcoal and Chinese white on card
24 ¾ x 15 ¹⁵⁄₁₆ in. (62.9 x 40.5 cm.)
Andrew Carnegie Fund, 07.12.1

Provenance:
The artist, New York.

S Y M O N S , G A R D N E R
1 8 6 3 — 1 9 3 0

430. *Winter Landscape,* **1917–18**

charcoal on paper
9 ⅝ x 12 ⅝ in. (24.4 x 32.1 cm.)
signed, crayon, lower right: Gardner Symons
Purchase, 18.25.13

Provenance:
American Artists' War Emergency Fund, New York.

T A Y L O R , C H A R L E S
1 8 8 5 — 1 9 2 9

431. *Etaples,* **1900**

graphite on paper
8 ⅗ x 10 ⅛ in. (22.2 x 25.7 cm.)
signed and dated lower right: C. J. Taylor 1900 //
inscribed center left: Etaples-strut along the shore /
sketches made on a bicycle tour
Purchase, 18.24

Provenance:
The artist.

T C H E K A L I A N , S A M
b. China, 1 9 2 9

432. *Untitled,* **c. 1970**

wash and gouache on paper
22 ⅜ x 30 ¹⁄₁₆ in. (56.8 x 77.8 cm.)
Gift of John Hudson, 84.43.2

Provenance:
The donor, Irwin, Pennsylvania.

T H O M P S O N , R A L S T O N
1 9 0 4 — 1 9 7 5

433. *The Mill,* **n.d.**

graphite and ink wash on paper
14 ⁹⁄₁₆ x 19 ⅜ in. (37 x 49.2 cm.)
signed lower right: Ralston Thompson
Gift of Mrs. Ralston Thompson, 82.85.4

Provenance:
The donor.

T O R L A K S O N , J A M E S
b. 1 9 5 1

434. *Southern Pacific No. 3196,* **1980**

graphite and gouache on paper
23 ¾ x 35 ¹¹⁄₁₆ in. (60.3 x 90.6 cm.)
Patrons Art Fund, 81.16

Provenance:
John Berggruen Gallery, San Francisco.

T R Y O N , D W I G H T W .
1 8 4 9 — 1 9 2 5

435. *River Maas,* **1880**

chalk on buff paper
6 ⁷⁄₁₆ x 10 ⁷⁄₁₆ in. (16.4 x 26.5 cm.)
signed lower left: D W Tryon // inscribed lower left:
R Maas 1880
Andrew Carnegie Fund, 07.13.4

Provenance:
The artist.

Bibliography:
Carnegie Institute, *Lists* (1917).

Remarks:
The drawing was executed on the verso of a printed table of
contents from a catalogue of goods sold at the Parisian
department store Au Bon Marché.

436. *River Maas,* **1880**

chalk on buff paper
6 ¹¹⁄₁₆ x 10 ⅜ in. (17 x 26.4 cm.)
signed lower left: DW Tryon // inscribed and dated lower
left: R Maas 1880
Andrew Carnegie Fund, 07.13.5

Provenance:
The artist.

Bibliography:
Carnegie Institute, *Lists* (1917).

437. *Landscape—Sketch,* **c. 1880**

graphite and chalk on brown cardboard
3 ¾ x 5 ⅛ in. (9.5 x 13 cm.)
signed lower right: D.W.T.
Andrew Carnegie Fund, 07.13.1

Provenance:
The artist.

Exhibitions:
Irene Kaufmann Settlement House, Pittsburgh, 14 November 1927.

Bibliography:
Carnegie Institute, *Lists* (1917).

438. *Landscape—Sketch*, c. 1880

graphite and chalk on brownish paper
9 ⁹⁄₁₆ x 12 ¹⁵⁄₁₆ in. (24.3 x 32.9 cm.)
inscribed and dated lower left: sky opalescent white / purp[?] in darkest tones / [illeg.] / ground [illeg.] / May 9
Andrew Carnegie Fund, 07.13.2

Provenance:
The artist.

Bibliography:
Carnegie Institute, *Lists* (1917).

439. *Landscape*, n.d.

graphite on paper
10 x 7 in. (25.4 x 17.8 cm.)
inscribed lower center: ground grn & —yell brown stones pink and gry purple oat.—bn gn dark // inscribed lower center: sky wht warm & H-g'y blue showing thro very grey / dark gg clouds mottled trees telb dark & bn gn Sepeb 11–4 p.m.
Andrew Carnegie Fund, 07.13.3

Provenance:
The artist.

T W A C H T M A N , J O H N H.
1 8 5 3 — 1 9 0 2

**440. *Low Tide: A Stranded Vessel*, 1880
(illus. p. 124)**

graphite with traces of pastel on laid paper
8 ⁹⁄₁₆ x 13 ¹³⁄₁₆ in. (21.7 x 35.1 cm.)
Andrew Carnegie Fund, 06.25.1

Provenance:
Alden Twachtman, Greenwich, Connecticut.

Exhibitions:
Irene Kaufmann Settlement House, Pittsburgh, 14 November 1927 // Lyman Allyn Museum, New London, Connecticut, 11 March–23 April 1945, *Work in Many Media by Men of the Tile Club: Thirteenth Anniversary Exhibition*, no. 157 // Museum of Art, Carnegie Institute, 29 January–3 April 1983, *MOA Masterpieces*, no. 47.

Bibliography:
Carnegie Institute, *Lists* (1917) // Lyman Allyn Museum, New London, Connecticut, *Work in Many Media by Men of the Tile Club: Thirteenth Anniversary Exhibition* (1945), exh. cat. by William Douglas, no. 157.

Remarks:
On 20 April 1918 the drawing was shipped to the Detroit Publishing Company for reproduction on postcards.

441. *Sketch: A Canal*, n.d.

graphite on paper
6 ⁵⁄₈ x 9 ⅞ in. (16.8 x 25.1 cm.)
Andrew Carnegie Fund, 06.25.2

Provenance:
Alden Twachtman, Greenwich, Connecticut.

Exhibitions:
Irene Kaufmann Settlement House, Pittsburgh, 17 November 1925 // Lyman Allyn Museum, New London, Connecticut, 11 March–23 April 1945, *Work in Many Media by Men of the Tile Club: Thirteenth Anniversary Exhibition*, no. 156.

Bibliography:
Carnegie Institute, *Lists* (1917) // Lyman Allyn Museum, New London, Connecticut, *Work in Many Media by Men of the Tile Club: Thirteenth Anniversary Exhibition* (1945), exh. cat. by William Douglas, no. 156.

T W I G G S , R U S S E L L G.
b. 1 8 9 8

442. *What Immortal Hand or Eye?*, 1956

watercolor on paper
21 ½ x 29 ⅜ in. (54.6 x 74.6 cm.)
signed and dated lower right: Twiggs '56
Gift of Mr. and Mrs. James H. Beal, 65.1.3

Provenance:
The donors, Pittsburgh.

Exhibition:
Colorado Springs Fine Arts Center, 7 July–18 September 1966, *New Accessions, USA, 1966*.

443. *White Figure*, 1961

charcoal on paper
33 ⅝ x 27 ⅝ in. (85.4 x 70.2 cm.), sight
signed and dated lower left: Twiggs—'61
52nd Annual Associated Artists of Pittsburgh Exhibition Purchase Prize, 62.24.4

Provenance:
The artists, Pittsburgh.

Exhibitions:
Carnegie Institute, *52nd Annual Associated Artists of Pittsburgh Exhibition*, 1962 // Westmoreland Museum of Art, Greensburg, Pennsylvania, 26 January–8 March 1964, *Retrospective Exhibition of the Work of Russell Twiggs* // Museum of Art, Carnegie Institute, 12 August–11 September 1977, *Some Pittsburgh Artists from the Permanent Collection*.

V A N D E R P O E L , J. H.
b. Holland, 1 8 5 7 — 1 9 1 1

444. *Pencil Study*, n.d.

graphite on paper
11 ¹⁵⁄₁₆ x 9 in. (30.3 x 22.9 cm.)
signed lower right: JH . VanderPoel
Andrew Carnegie Fund, 17.32

Provenance:
Mrs. J. H. VanderPoel, Chicago.

Bibliography:
Carnegie Institute, *Lists* (1917).

VIGIL, PAUL
b. 1 9 3 3

445. *Tesuque Buffalo Dancers,* 1954

graphite, ink, and gouache on paper
23 x 29 in. (58.4 x 73.7 cm.)
signed and dated lower right: Paul Vigil / 54'
Edward Duff Balken Fund, 54.32

Provenance:
The artist.

VOELKER, ELIZABETH
b. 1 9 3 1

446. *Forsythia,* 1951

pen and ink on laid Japan paper
13 ⅞ x 29 ⁵⁄₁₆ in. (35.2 x 74.5 cm.)
dated and signed lower right: 3/25/51 Voelker
48th Annual Associated Artists of Pittsburgh Exhibition
Purchase Prize, 53.15

Provenance:
The artist, Pittsburgh.

Exhibitions:
Carnegie Institute, *48th Annual Associated Artists of Pittsburgh Exhibition,* 1953 // Museum of Art, Carnegie Institute, 12 August–11 September 1977, *Some Pittsburgh Artists from the Permanent Collection.*

WALL, ALFRED S.
1 8 2 5 — 1 8 9 6

447. *Landscape,* n.d.

graphite, wash, and gouache on paper mounted on cardboard
15 ¼ x 22 ⁷⁄₁₆ in. (38.7 x 57 cm.), sheet
16 ½ x 23 ¾ in. (41.9 x 60.3 cm.), mount
signed lower left: A. S. Wall
Gift of John Frazer, 07.16.1

Provenance:
The donor, Pittsburgh.

448. *Landscape,* n.d.

wash and gouache on paper mounted on cardboard
15 ¾ x 22 ⅜ in. (40 x 56.8 cm.), sheet
19 ⁷⁄₁₆ x 27 in. (49.4 x 68.6 cm.), mount
signed lower left: A. S. Wall
Gift of John Frazer, 07.16.2

Provenance:
The donor, Pittsburgh.

449. *The Mill Stream,* n.d.

graphite on green paper
6 ⅝ x 5 in. (16.8 x 12.7 cm.)
signed lower left: A. S. Wall // inscribed verso: mill stream
Purchase, 17.35.1

Provenance:
Mrs. A. S. Wall, Pittsburgh.

Bibliography:
Carnegie Institute, *Lists* (1917).

450. *Pencil Study,* n.d.

graphite and traces of white gouache on paper
14 ⅜ x 10 ⅛ in. (36.5 x 25.7 cm.)
signed lower right: A. S. Wall // inscribed verso: Pencil Study
Purchase, 17.35.3

Provenance:
Mrs. A. S. Wall, Pittsburgh.

Bibliography:
Carnegie Institute, *Lists* (1917).

451. *Study of Trees,* n.d.

graphite on paper
14 ⅜ x 10 ¹⁄₁₆ in. (36.5 x 27 cm.)
signed lower right: A. S. Wall // inscribed verso: Study of Trees
Purchase, 17.35.2

Provenance:
Mrs. A. S. Wall, Pittsburgh.

Remarks:
Sketches in graphite are on the verso of the sheet.

WARHOL, ANDY
b. 1 9 3 0

452. *Untitled (Four Animal Images),* 1946

graphite on seven sheets of paper pasted together and mounted on cardboard
38 x 26 in. (96.5 x 66 cm.), mount
Gift of Russell G. Twiggs, 77.20.2

Provenance:
The donor, Pittsburgh.

Exhibition:
Württembergischer Kunstverein, Stuttgart, Germany; Kunsthalle Düsseldorf; Kunsthalle Bremen; Städtische Galerie im Lenbachhaus, Munich; Haus am Waldsee, Berlin; Museum des 20. Jahrhunderts, Vienna; Kunstmuseum, Luzern, 1976, *Andy Warhol, Das zeichnerische Werk 1942–1975.*

Bibliography:
Württembergischer Kunstverein, Stuttgart, Germany, *Andy Warhol, Das zeichnerische Werk 1942–1975* (1976), exh. cat. by Rainer Crone, illus., 111, no. 93.

453. *Untitled (Seven Animal Images),* 1946

graphite on eleven sheets of paper pasted together and mounted on cardboard
38 x 26 in. (96.5 x 66 cm.), mount
Gift of Russell G. Twiggs, 77.20.4

Provenance:
The donor, Pittsburgh.

Exhibitions:
Württembergischer Kunstverein, Stuttgart, Germany;
Kunsthalle Düsseldorf; Kunsthalle Bremen; Städtische
Galerie im Lenbachhaus, Munich; Haus am Waldsee,
Berlin; Museum des 20. Jahrhunderts, Vienna;
Kunstmuseum, Luzern, 1976, *Andy Warhol: Das
zeichnerische Werk 1942–1975.*

Bibliography:
Württembergischer Kunstverein, Stuttgart, Germany,
Andy Warhol: Das zeichnerische Werk 1942–1975 (1976), exh.
cat. by Rainer Crone, illus., 112, no. 94.

454. *Untitled (Three Male Images),* 1946

graphite on ten pieces of paper pasted together mounted
on cardboard
38 x 26 in. (96.5 x 66 cm.), mount
Gift of Russell G. Twiggs, 77.20.3

Provenance:
The donor, Pittsburgh.

Exhibitions:
Württembergischer Kunstverein, Stuttgart, Germany;
Kunsthalle Düsseldorf; Kunsthalle Bremen; Städtische
Galerie im Lenbachhaus, Munich; Haus am Waldsee,
Berlin; Museum des 20. Jahrhunderts, Vienna;
Kunstmuseum, Luzern, 1976, *Andy Warhol, Das zeichnerische
Werk 1942–1975.*

Bibliography:
Württembergischer Kunstverein, Stuttgart, Germany,
Andy Warhol, Das zeichnerische Werk 1942–1975 (1976), exh.
cat. by Rainer Crone, illus., 113, no. 95.

455. *Study of Hand I,* 1948

graphite on paper
24 ⅛ x 19 in. (61.3 x 48.3 cm.), irregular
Gift of Murray Z. Rosenberg, M.D., 78.27.4

Provenance:
The donor, Storrs, Connecticut.

Remarks:
This drawing has been pasted together with *Study of Hand II.*

456. *Study of Hand II,* 1948

graphite on paper
8 ⁹⁄₁₆ x 11 in. (21.7 x 27.9 cm.)
Gift of Murray Z. Rosenberg, M.D., 78.27.5

Provenance:
The donor, Storrs, Connecticut.

Remarks:
This drawing has been pasted together with *Study of Hand I.*

457. *Untitled,* 1948–49
(illus. p. 215)

pen and ink on paper
29 ¹⁄₁₆ x 23 ¹⁄₁₆ in. (75.2 x 60 cm.)
Gift of Russell G. Twiggs, 68.25.1

Provenance:
The donor, Pittsburgh.

Exhibitions:
School of Fine Arts, Miami University, Oxford, Ohio, 23
November–6 December 1969, *Pittsburgh Exhibitions* ǁ
Württembergischer Kunstverein, Stuttgart, Germany;
Kunsthalle Düsseldorf; Kunsthalle Bremen; Städtische
Galerie im Lenbachhaus, Munich; Haus am Waldsee,
Berlin; Museum des 20. Jahrhunderts, Vienna;
Kunstmuseum, Luzern, 1976, *Andy Warhol, Das zeichnerische
Werk 1942–1975.*

Bibliography:
Württembergischer Kunstverein, Stuttgart, *Andy Warhol,
Das zeichnerische Werk 1942–1975* (1976), exh. cat. by Rainer
Crone, 68, illus., 115, no. 97.

Remarks:
This drawing illustrates the character based on Huey Long
in Robert Penn Warren's novel *All the King's Men.*

458. *Untitled,* 1948–49

pen and ink and black construction paper on board
28 x 22 in. (71.1 x 55.8 cm.)
signed verso: Andy Warhola
Gift of Russell G. Twiggs, 68.25.2

Provenance:
The donor, Pittsburgh.

Exhibitions:
Württembergischer Kunstverein, Stuttgart, Germany;
Kunsthalle Düsseldorf; Kunsthalle Bremen; Städtische
Galerie im Lenbachhaus, Munich; Haus am Waldsee,
Berlin; Museum des 20. Jahrhunderts, Vienna;
Kunstmuseum, Luzern, 1976, *Andy Warhol, Das zeichnerische
Werk 1942–1975.*

Bibliography:
Württembergischer Kunstverein, Stuttgart, *Andy Warhol,
Das zeichnerische Werk 1942–1975* (1976), exh. cat. by Rainer
Crone, 68, illus., 115, no. 97.

459. *Seated Female Nude,* 1949

crayon and graphite on paper
24 x 19 in. (61 x 48.3 cm.)
Gift of Murray Z. Rosenberg, M.D., 78.27.9

Provenance:
The donor, Storrs, Connecticut.

460. *Study of Boy's Head with Outstretched Arm,*
1949

graphite on paper
20 ½ x 18 in. (52.1 x 45.7 cm.), irregular
Gift of Murray Z. Rosenberg, M.D., 78.27.3

Provenance:
The donor, Storrs, Connecticut.

461. *Study of Boy with Hands on Shoulder,* 1949

graphite on paper
24 x 19 in. (61 x 48.3 cm.)
Gift of Murray Z. Rosenberg, M.D., 78.27.7

Provenance:
The donor, Storrs, Connecticut.

462. *Study of Pair of Hands,* 1949

graphite on paper
22 x 8 ½ in. (55.9 x 21.6 cm.)
Gift of Murray Z. Rosenberg, M.D., 78.27.6

Provenance:
The donor, Storrs, Connecticut.

463. *Study of Pair of Hands,* 1949

graphite on paper
24 x 19 in. (61 x 48.3 cm.)
Gift of Murray Z. Rosenberg, M.D., 78.27.8

Provenance:
The donor, Storrs, Connecticut.

WATTS, CHRISTOPHER JOHN

b. England, 1947

464. *Perimeters and Interiors,* 1980

graphite and presstype on paper
23 1/16 x 31 1/16 in. (60 x 80.3 cm.)
Gift of Sara M. Winokur and James L. Winokur to honor
Mr. and Mrs. Richard M. Scaife, 81.34.1–4

Provenance:
The donors, Pittsburgh.

WEBER, MAX

b. Russia, 1881—1961

465. *Untitled,* 1907

pen and ink and ink wash on paper mounted on paper
5 ⅝ x 3 ¾ in. (14.3 x 9.5 cm.)
signed and dated lower left: Max Weber '07
Gift of Kenneth Seaver, 25.6.1

Provenance:
The donor.

WEIR, JULIAN ALDEN

1852—1919

466. *At the Piano,* 1917–18

crayon on paper
14 x 10 ⅝ in. (35.6 x 27 cm.)
signed lower right: J. Alden Weir // signed lower left:
J. Alden Weir [crossed out]
Purchase, 18.25.14

Provenance:
American Artists' War Emergency Fund, New York.

Bibliography:
The Metropolitan Museum of Art, New York, *J. Alden
Weir, An American Impressionist* (1983), exh. cat. by Doreen
Bolger Burke, 120, 186, 199.

Remarks:
There are sketches on the verso of the sheet.

467. *Nude, A Girl Kneeling,* n.d.

graphite on paper
18 ⅞ x 12 9/16 in. (47.9 x 31.9 cm.)
signed, charcoal, lower left: J. Alden Weir
Andrew Carnegie Fund, 06.22

WELLS, CADY

1904—1954

468. *Taos Mountain,* 1934–35

watercolor on paper
21 x 29 ½ in. (53.3 x 74.9 cm.), sight
Gift of Mason Wells, 59.13.1

Provenance:
The donor, Belvedere, California.

WEST, BENJAMIN

1738—1820

469. *Sketches,* 1775

graphite and pen and ink on laid paper
8 ¾ x 14 ⅞ in. (22.2 x 37.8 cm.), irregular
inscribed: To / Benj^n West Esq^r / Newman Street / No
14 / London // stamped in sealing wax: YORK
Gift of Mr. and Mrs. Charles J. Rosenbloom, 59.10.1

Provenance:
The donors, Pittsburgh.

Remarks:
The sketches are on the verso of a letter to West from
"Henry Tho . . . ," York, 3 June 1775:

> Sir / I rec.^d the picture about / a
> week ago, & waited till this time in order to give / you some
> account of its reception in this country / It has
> been by everybody that has seen it here / very
> much admir'd, both as to the propriety of the
> cha. / acter & the finishing–& the likeness is so
> strong / as to have been found out, without any
> hint given / of the person intended by it; Whether
> the Yorkshire / connoisseurs are not more milder
> judges than the / Southern I cant say! I should
> have liked to have / heard what was really said of
> it in the South. / I cannot be afr'd by any thing
> that is said / against it.—I don't think your
> demand is unrea / : sonable & shall give orders for
> you to be paid. / I am / Sir your most / obed^t. . . . /
> Henry Tho. . . . [paper torn away]

470. *Sketches,* 1783

graphite and pen and ink on paper
6 ½ x 8 in. (16.5 x 20.3 cm.)
inscribed recto: Benj^m West Esq // inscribed verso: Mr.
Abbison [?] / Spring Gardens / 82 / Sonerselly office [?] /
Sir / I suppose you have done with the / two Drawings of
Alfred, if you have, please / to let the Bearer have them / I
am Sir / your oblig'd Serv^t / John Boydell Cheapside /
May. 13, 1783
Gift of Mr. and Mrs. Charles J. Rosenbloom, 59.10.2

Provenance:
The donors, Pittsburgh.

471. *The Sages of Greece,* c. 1790–1800

pen and ink and ink wash on paper mounted on card
4 ¹³⁄₁₆ x 6 ¹⁵⁄₁₆ in. (12.2 x 17.6 cm.), sheet
8 ³⁄₁₆ x 10 in. (20.8 x 25.4 cm.), mount
signed mount lower center: B. West // signed verso: Benj
West // inscribed and signed verso: The Sages of Greece /
Benj West
Gift of Mr. and Mrs. Charles J. Rosenbloom, 58.35.2

Provenance:
The donors, Pittsburgh.

Exhibition:
Museum of Art, Carnegie Institute, 29 January–3 April
1983, *MOA Masterpieces*, no. 48c.

Remarks:
The drawing is on its original mount.

**472. *Entrance to the Terrace at Windsor Castle,*
c. 1795–1805
(illus. p. 28)**

graphite and pastel on paper mounted on card
6 ¹¹⁄₁₆ x 9 ⅜ in. (17 x 23.8 cm.), sheet
10 ⅞ x 13 ⅜ in. (27.6 x 34.6 cm.), mount
signed mount lower center: B. West // signed verso: Benj
West // inscribed verso: Entrance to the Terrace at
Windsor—Taken from The Little Park, Benj West.
Gift of Mr. and Mrs. Charles J. Rosenbloom, 58.35.1

Provenance:
The donors, Pittsburgh.

Exhibition:
Museum of Art, Carnegie Institute, 29 January–3 April
1983, *MOA Masterpieces*, no. 48a.

Remarks:
The drawing is on its original mount.

473. *Landscape Near Windsor,* c. 1795

pen and ink and ink wash on paper mounted on card
6 ¹⁵⁄₁₆ x 9 ¼ in. (17.6 x 23.5 cm.), sheet
11 ³⁄₁₆ x 13 ⅜ in. (28.4 x 34 cm.), mount
signed verso: Benj. West // inscribed and signed verso:
A Landscape Near Windsor Benj West
Gift of Mr. and Mrs. Charles J. Rosenbloom, 58.35.3

Provenance:
The donors, Pittsburgh.

Exhibition:
Museum of Art, Carnegie Institute, 29 January–3 April
1983, *MOA Masterpieces*, no. 48b.

Remarks:
The drawing is on its original mount.

474. *Scene at Chevening in Kent,* c. 1795

crayon on blue paper mounted on card
4 ⁹⁄₁₆ x 7 ⁵⁄₁₆ in. (11.6 x 18.6 cm.), sheet
10 ⅝ x 13 ⁵⁄₁₆ in. (27 x 33.8 cm.), mount
signed mount lower center: B. West // signed verso:
Benj West // inscribed and signed verso: Scene at
Chevening in Kent / Benj West
Gift of Mr. and Mrs. Charles J. Rosenbloom, 58.35.4

Provenance:
The donors, Pittsburgh.

Exhibition:
Museum of Art, Carnegie Institute, 29 January–3 April
1983, *MOA Masterpieces*, no. 48d.

Remarks:
The drawing is on its original mount.

**475. *View of Windsor Castle on the Road from
Datchet,* c. 1795**

pen and ink and ink wash on paper mounted on card
6 ½ x 8 ¹¹⁄₁₆ in. (16.5 x 22.1 cm.), sheet
11 ½ x 18 ¾ in. (29.2 x 47.6 cm.), mount
signed lower left: BW. // signed verso: Benj West //
inscribed and signed verso: View of Windsor Castle on
the Road from Datchet / Benj West
Gift of Mr. and Mrs. Charles J. Rosenbloom, 58.35.5

Provenance:
The donors, Pittsburgh.

Exhibition:
Museum of Art, Carnegie Institute, 29 January–3 April
1983, *MOA Masterpieces*, no. 48e.

WEST, TROY
b. 1935

476. *Soul Tracing,* 1971

glass, pastel, and graphite on paper
18 x 24 in. (45.7 x 61 cm.)
signed and dated lower right: Troy 71
62nd Annual Associated Artists of Pittsburgh Exhibition
Purchase Prize, 72.16.3

Provenance:
The artist, Pittsburgh.

Exhibition:
Museum of Art, Carnegie Institute, *62nd Annual Associated
Artists of Pittsburgh Exhibition*, 1972.

WHISTLER, JAMES ABBOTT
McNEILL
1834–1903

**477. *Portrait of a Young Girl,* c. 1872–74
(illus. p. 120)**

pastel on paper mounted on board
8 ⅞ x 6 ⁹⁄₁₆ in. (22.5 x 16.7 cm.)
signed in monogram, crayon, center left
Gift of George W. Wyckoff in memory of Elizabeth
McKay Wyckoff, 73.37

Provenance:
The donor, Pittsburgh.

Bibliography:
Andrew McLanen Young, et al., *The Painting of James
McNeill Whistler*, Vol. I (New Haven, Connecticut, 1980),
no. 111.

Remarks:
This drawing is related to the painting *The Blue Girl, Portrait
of Miss Eleanor Leyland* (destroyed).

478. *Study of a Gown*, c. 1872–74
(illus. p. 118)

pastel on brown paper
11 ⁵⁄₁₆ x 7 ¼ in. (28.7 x 18.4 cm.)
Andrew Carnegie Fund, 06.12.6

Provenance:
Frederick Keppel and Company, New York.

Exhibition:
Museum of Art, Carnegie Institute, 29 January–3 April
1983, *MOA Masterpieces*, no. 49.

Bibliography:
Carnegie Institute, *Lists* (1917).

Remarks:
This drawing is related to the painting *Symphony of Flesh
Color and Pink, Portrait of Mrs. Frances Leyland* (1874, Frick
Collection, New York).

479. *A Lady Standing*, c. 1881
(illus. p. 121)

pastel on brown paper mounted on cardboard
10 ¹¹⁄₁₆ x 5 ¹⁵⁄₁₆ in. (27.1 x 15.1 cm.)
Andrew Carnegie Fund, 06.14

Provenance:
M. Knoedler & Co., New York.

Exhibition:
Museum of Art, Carnegie Institute, 29 January–3 April
1983, *MOA Masterpieces*.

Bibliography:
Carnegie Institute, *Lists* (1917).

Remarks:
This drawing was identified by Knoedler at the time of
purchase as "Tillie Graves," which was probably a
corruption of Alice "Tinnie" Greaves, the sister of
Whistler's boatman friends Walter and Henry Greaves.

WHITTREDGE, THOMAS
WORTHINGTON
1 8 2 0 — 1 9 1 0

480. *Forest Interior*, c. 1882
(illus. p. 49)

pen and ink on card
11 ¹¹⁄₁₆ x 11 ⅝ in. (29.7 x 29.5 cm.)
signed lower left: W. Whittredge
Museum purchase: gift of H. J. Heinz II Charitable and
Family Trust, 81.104

Provenance:
Thomas Colville, Inc., New Haven, Connecticut;
Alexander Gallery, New York.

Exhibitions:
Museum of Art, Carnegie Institute, 9 October–12
December 1982, *Recent Acquisitions: Works on Paper* //
Museum of Art, Carnegie Institute, 29 January–3 April
1983, *MOA Masterpieces*, no. 50.

Bibliography:
Henry Adams, "Masterpieces of American Drawing and
Watercolor," *Carnegie Magazine* LVI (January/February
1983): 28.

Remarks:
This drawing is related to the painting *Forest Interior* (1882,
The Art Institute of Chicago). It was probably made after
the painting as a study for an etching, although no copy of
the etching has been located.

WILDE, JOHN
b. 1 9 1 9

481. *Untitled*, 1944
(illus. p. 175)

graphite with traces of white gouache on paper
24 x 18 ³⁄₁₆ in. (61 x 46.2 cm.)
inscribed lower center: I.C. / W. T. F. [Wednesday,
Thursday, Friday] / JNE 14–16 / 19'44 W. D. C.
[Washington D.C.] / drawing of la rootsies Ich am
standing on this time / in this present confusion. This / is
ominous times and / who can tell what in holy / hell can
happen to you or I. / One thing make sure: wear / your
winter underwear in all / kinds of weather—and never /
change in mid season. Read your liline [?] and keep
your / goddamn mouth shut, except / to tell the conductor
to stop at the / station— then best to get off / one station
before or after your / destination, for some conspirator /
might be waiting for you at the /station you plan to stop
at. / Bibl.: A. Dürer—Circa, 1520.
Gift of Mr. and Mrs. Carl D. Lobell, 82.83.3

Provenance:
The donors, New York.

WILES, IRVING RAMSEY
1 8 6 2 — 1 9 4 8

482. *Jersey and Mulberry*, n.d.

ink on paper
14 x 17 ¼ in. (35.6 x 43.8 cm.)
signed lower right: I. R. Wiles
Andrew Carnegie Fund, 06.19.22

Provenance:
Charles Scribner's Sons, New York.

Bibliography:
A. C. Bunner, "Jersey and Mulberry," *Scribner's Magazine*
(June 189_): 641 // Carnegie Institute, *Lists* (1917).

483. *Sketch of a Young Girl*, 1917–18

charcoal on paper
12 ⅜ x 9 ¹⁵⁄₁₆ in. (31.4 x 25.2 cm.)
signed lower right: Irving R. Wiles
Purchase, 18.25.15

Provenance:
American Artists' War Emergency Fund, New York.

WILLIAMS, EMMETT
b. 1 9 2 5

484. *The Boy and The Bird,* 1979

graphite on paper
8 ½ x 6 ¼ in. (21.6 x 15.8 cm.)
signed, inscribed, and dated lower left: Emmett Williams, BC, 1979
Gift of George Heimbach, 80.95.1

Provenance:
The donor.

WILT, RICHARD H.
b. 1 9 1 5

485. *Harris Point Pine, Maine,* n.d.

watercolor on paper
30 x 22 ⅛ in. (76.2 x 56.2 cm.)
Gift of Mr. and Mrs. James H. Beal, 59.28

Provenance:
The artist, until 1959; the donors, Pittsburgh.

WINBERG, JOHN Y.
b. 1 9 2 6

486. *Labyrinth,* n.d.

felt-tip pen on paper mounted on paper mounted on cardboard
10 ⁹⁄₁₆ x 10 ⁹⁄₁₆ in. (26.8 x 26.8 cm.), first mount
signed lower right: JOHN Y. WINBERG
63rd Annual Associated Artists of Pittsburgh Exhibition Purchase Prize, 73.21.2

Provenance:
The artist, Gibsonia, Pennsylvania.

Exhibition:
Museum of Art, Carnegie Institute, *63rd Annual Associated Artists of Pittsburgh Exhibition,* 1973.

WINKLER, JOHN W.
1 8 9 0 — 1 9 7 8

487. *Rae Lakes—Foxtail Pine,* 1943

crayon on paper
18 ⁵⁄₁₆ x 11 ⅜ in. (48.1 x 28.9 cm.)
inscribed and dated center left: RAE LAKES FOXTAIL PINE (Pinus balfouriana) 1943 No 57F
Mrs. John C. Lane and Director's Discretionary Fund, 81.2

Provenance:
The artist, El Cerrito, California.

WOFFORD, PHILIP
b. 1 9 3 5

488. *Hidden Idol: Animals,* 1981

charcoal, crayon, and acrylic on paper
41 ⅞ x 47 ¾ in. (106.3 x 121.3 cm.)
Gift of the Nancy Hoffman Gallery, 82.34

Provenance:
The donor, New York.

Exhibition: Museum of Art, Carnegie Institute, 9 October–12 December 1982, *Recent Acquisitions: Works on Paper.*

WUJCIK, THEO
b. 1 9 3 6

**489. *Jasper Johns,* 1980
(illus. p. 232)**

graphite on three sheets of paper taped together
40 ³⁄₁₆ x 64 in. (102.1 x 162.6 cm.)
signed and dated lower center: Theo Wujcik 1980
The Bryan Foundation Acquisition Fund, 81.27

Provenance:
Brooke Alexander, Inc., New York.

ZALOPANY, MICHELE
b. 1 9 5 5

490. *Vertical Sufferings,* 1984

charcoal on paper
71 ½ x 77 in. (182.3 x 198.1 cm.)
The Tillie and Alexander C. Speyer Foundation Fund for the Purchase of Contemporary Art, 84.47.3

Provenance:
Penny Pilkington/Wendy Olsoff Gallery, New York.

ZEDLER, VINCE
20th Century

491. *Heppenstall-Diamond H,* 1953

graphite, wash, and gouache on paper
22 ¾ x 30 ¼ in. (57.8 x 76.8 cm.)
signed and dated lower left: Vince Zedler / '53'
Gift of Heppenstall Company, 83.68

Provenance:
The donor, Pittsburgh.